ART BEYOND THE WEST

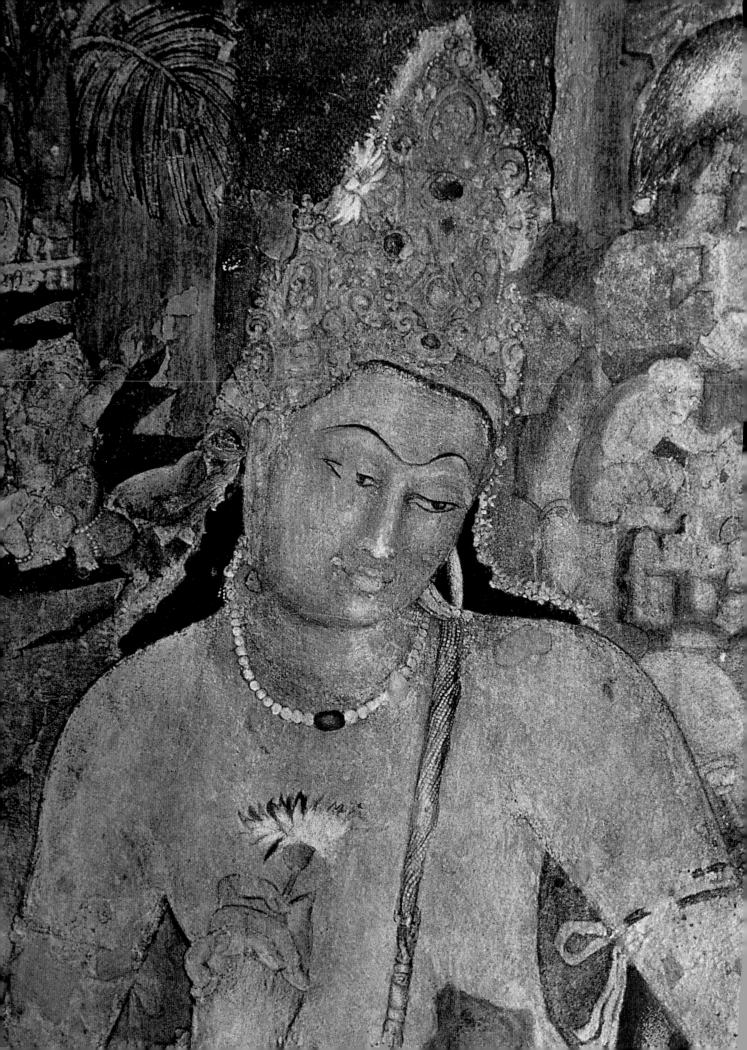

MICHAEL KAMPEN O'RILEY

AFTERWORD BY ANNE D'ALLEVA

ART BEYOND THE WEST:

THE ARTS OF AFRICA, INDIA AND SOUTHEAST ASIA, CHINA, JAPAN AND KOREA, THE PACIFIC, AND THE AMERICAS

HARRY N. ABRAMS, INC., PUBLISHERS

FRONT COVER:
Detail of embroidered mantle. Cerro
Colorado. Late Paracas, 300–100 BCE.
Museum of Fine Arts, Boston

Hopewell artist, mica in the shape of a
hand. Woodland period, 200 BCE–400 CE.
Ohio Historical Society, Columbus

BACK COVER:
Moai. Easter Island. Pre-15th century CE

FRONTISPIECE:
The Beautiful Bodhisattva' Padmapani.
Cave 1, Ajanta, India. c. late 5th century CE

Editor: Kara Hattersley-Smith
Designer: Karen Stafford
Maps: Eugene Fleury
Picture research: Julia Ruxton

This book was designed and produced by
Calmann & King Ltd, London
www.calmann-king.com

Library of Congress Cataloging-in-Publication Data

Kampen-O'Riley, Michael.
 Art beyond the west : the art of Africa, India and Southeast Asia, China, Japan and
Korea, the Pacific, and the Americas / Michael Kampen O'Riley.
 p. cm.
 Includes bibliograpical references and index.
 ISBN 0-8109-1433-6 (hc)
 1. Art. I. Title.

N5300 .K292 2002

2001027923

Printed in Hong Kong

To my distinguished mentor, Hubert Humphrey, and his unending quest for human rights, global understanding, and world peace.

ACKNOWLEDGMENTS

The following individuals read portions of the manuscript, made many important suggestions, and contributed immeasurably to its early development: Eli Bentor and John Henry Drewal (Africa), Daniel White (India and Southeast Asia), Catherine Pagani (China), Dale K. Haworth (Japan and Korea), Carol Ivory (the Pacific), Rebecca Stone-Miller and Ann Paul (South America), Dorie Reents-Budet (the Maya), Patricia Sarro, Rex Koontz, and Cynthia Kirstan-Graham (Mexico), and Janet C. Berlo (North America). Cynthia Glenn also read many parts of the manuscript and gave me valuable advice on every stage of development.

In its final stages, chapters of the text were read by Anne D'Alleva, Donald Dinwiddie, Robert A. Rorex, Mikelle Smith, and Lee Ann Wilson.

I would like to thank the Southern Regional Educational Board of Atlanta for Travel grants to work in the libraries of the University of Florida, Gainesville, and Tulane University, New Orleans. Special thanks must be given to the editorial staff at Calmann & King Ltd, London, including Lee Ripley Greenfield, Kara Hattersley-Smith, Julia Ruxton, and Karen Stafford, who oversaw the thousands of tasks that made this book possible.

MICHAEL KAMPEN O'RILEY
ASHEVILLE, NORTH CAROLINA, 2001

CONTENTS

3: India and Southeast Asia 60

4: China 108

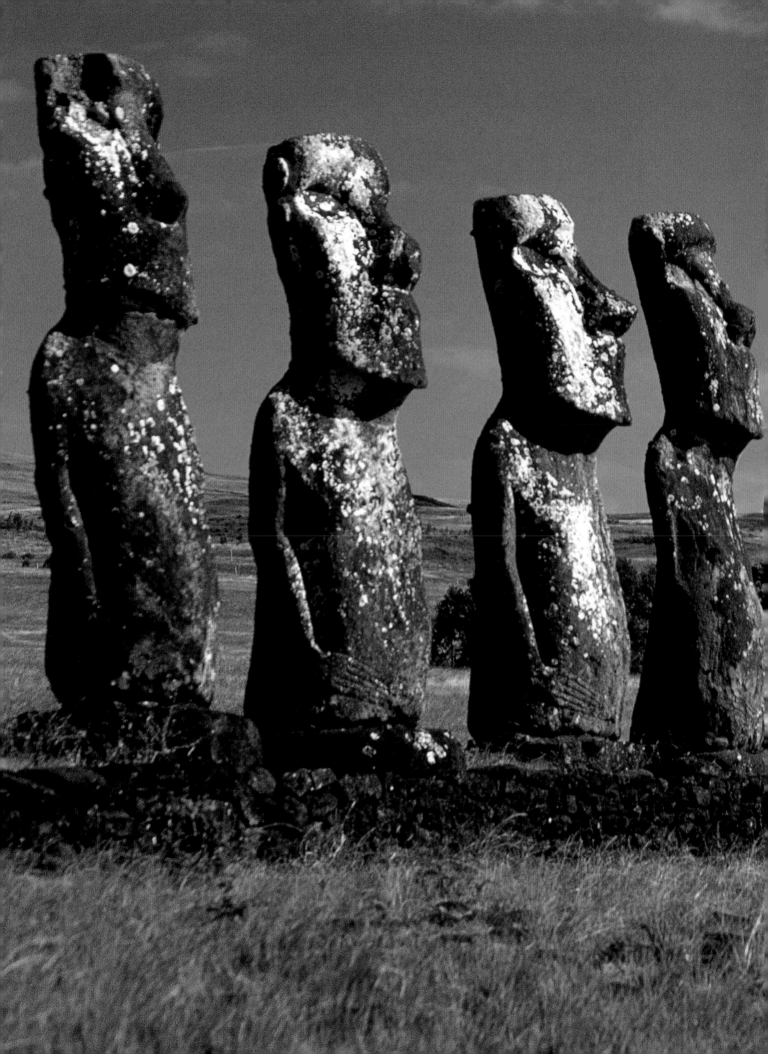

CHAPTER ONE
INTRODUCTION: ART BEYOND THE WEST

Equator

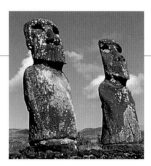

INTRODUCTION: ART BEYOND THE WEST

Art beyond the West surveys the art traditions of Africa, India and Southeast Asia, China, Korea and Japan, the Pacific islands, and Pre-Columbian and Native America. These traditions are often called "Non-Western." Although the term is tendentious insofar as it defines the material it covers in terms of the West—that which is *not* Western—it has no intended negative connotations.

The arts of these diverse cultures from around the world, many of which have existed for thousands of years to the present, represent multiple and distinct lines of cultural development. Texts have surveyed these areas individually or in groups, focusing on Asia, or Africa, the Pacific islands, and the Americas. The art of these diverse peoples, accounting for about half the lands on earth, are included in this study for readers who want a comprehensive survey of all the major art styles in the vast world beyond the West.

Separate chapters are devoted to each of the regions in which the major non-Western art traditions have developed. Varieties of Islamic art that developed in Africa and Asia are examined in context with those areas. Individual chapters in the text are organized around large geographic areas and survey the arts within them through history as they related to certain all-important and pervasive cultural ideals. This approach to the art beyond the West explains it contextually, in terms of the thinking of the artists and patrons who created it. Below is a brief introductory survey of the ideas around which the chapters in this text are organized.

Additional information supplementing the text is located in boxes within each chapter. Boxes focus on important technical, methodological, cross-cultural, and aesthetic issues related to the text. While the boxed information is as important as the text itself, it is presented in this manner because it is specialized and detailed material that lies outside the mainstream and flow of the text.

This text uses many terms that may be new to most readers. They include academic terms used by art historians and other scholars and non-English words used by the people who created and used the art illustrated in this text. These terms are explained in context with the discussions of the art in the chapters to follow and they are assembled in glossaries at the end of the book. This system follows the familiar model of foreign language textbooks and it allows readers to test themselves on the vocabulary they will need to read each successive chapters.

Seeing the foreign terms and their approximate English equivalents, readers should remember that the full and original meaning of an African mask, a Japanese Zen Buddhist landscape painting, or a Maya temple can never be fully framed in the English language and understood by one who has not been part of the language and culture in which the art was produced. As a case in point, the Chinese meaning of *qi*, translated here as "character" or "disposition," will vary depending upon the context in which it is used,

the time in which the writer lived, and a host of other determining factors. Yet, accepting these limitations, translations do help us understand ideas in other languages; while it is logically impossible fully to understand the art of another culture and time, the experience of encountering the many new concepts and ideas in this text can be enlightening. Some of the terms used in this introduction that the reader will need later in the book are listed in the glossary.

AFRICA

The art of Africa has great antiquity and diversity. Paintings on stone outcrops in South Africa are some of the oldest known works of art in the world (c. 27,500 BCE). This tradition developed independently from the prehistoric arts of Europe and lasted until modern times. To the north, the grasslands that had long supported hunters and fishers began to become progressively drier after 6000 BCE, turning into the vast Sahara desert between sub-Sahara Africa from North Africa and the Mediterranean world. However, caravans crossing the desert maintained contacts between North and sub-Sahara Africa and in some areas, the Christian and Islamic traditions from the north were fully integrated into the African traditions. With the diaspora that spread African culture to many parts of the world, African culture became an important part of the New World culture along the Atlantic coast from Brazil through the Caribbean to the United States.

Much of the art produced by peoples speaking about a thousand different languages on this large continent over the last 30,000 years has not survived. However, surveying the archaeological remains and arts of recent times which have been studied by modern scholars, the diversity of African thought is staggering. To approach the art, we must look at some widespread ideas that characterize it, such as certain widely held ideas about the power and importance of the spirit world. Many African groups believe that the ancestors and other spirits in this invisible other world have the power to affect the way things happen in our world of daily existence. By contacting these spiritual beings through rituals that include music, dance, prayers, and displays of art, they can communicate with the other world and work with it to control the world around them. For example, the Yoruba of Nigeria perform the elaborate and intense *Gelede* ritual to honor certain women elders or "mothers," ancestors, and deities (FIG. 1.1). Not all works of art were created for such rituals, but the belief in the spirit world remains an important part of African art to this day.

Christian art and culture spread south along the Nile River in the early Middle

1.1 Costumed performer, *Gelede* ritual. Yoruba, Nigeria

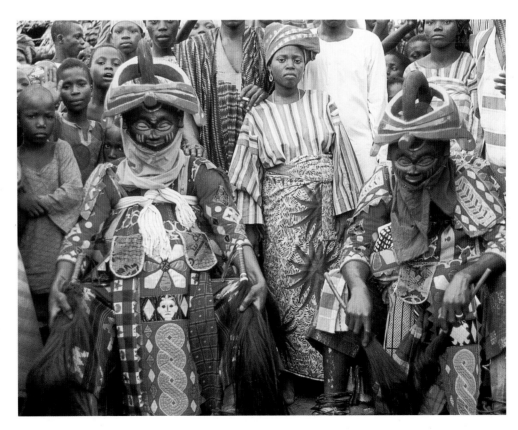

Ages and after the eighth century CE, Muslim traders carried their faith to many parts of Africa. Muslims, followers of the Islamic faith, believe in one god, Allah, who revealed his wisdom to his prophet, Muhammad (c. 570–632), in writings known as the *Koran*. His followers spread their faith west through Africa to Spain and east through Asia. Today, there are about a billion Muslims around the world.

The *Koran* says that statues or idols are "crimes" originating in Satan, that Allah created everything, and artists who usurp this right of creation are guilty of satanic crimes. This longstanding prohibition against representation in the arts encouraged Muslims to emphasize non-representational forms of art—architecture for places of worship, calligraphy to present the words of Allah in beautiful forms of handwriting, and decorative arts to reflect the magnificence of Allah's paradise. While the Arabic language of Muhammad and the *Koran* remains the primary language of Islam, its arts take many forms, absorbing influences from cultures around the world.

INDIA AND SOUTHEAST ASIA

This large geographic region includes a wide variety of ancient cultures and languages and many present-day countries. Civilization emerged in the Indus River Valley in present-day Pakistan around 2700 BCE, and the great religions of ancient India—Brahmanism, Buddhism, Hinduism, and Jainism developed in the first millennium BCE. Until modern times, India was a mosaic of regional kingdoms and it had no centralized government, but scholars use the modern name to refer to this area in earlier times.

Indian art spread with Buddhism and Hinduism to Southeast Asia and the Buddhist art and culture of India spread northeast to China, Korea, and Japan. Many regional varieties of Indian art developed along with the spread of its religions.

1.2 *Seated Buddha Preaching the First Sermon.* Sarnath, India. 5th century CE. Chunar sandstone, height 5'3" (1.60 m). Archaeological Museum, Sarnath

While they differ in many ways, some of the basic ideas of the Indian religions that inspired the art and architecture of these areas have common threads. They believe that the world around us in which we live is an illusion, and that the only reality is an eternal and universal spirit, the *Brahman*, and that the followers of the religions should strive to ascend to it. To most Westerners, this conception of reality and illusion may seem inverted. But, as we will see, this "inversion" is basic to the Indian religions and their ideals in art. Through devotion to the gods, meditation, and discipline (yoga, meaning "to yoke") they attempt to "yoke" themselves or bond with the *Brahman*. The image of the Buddha in figure 1.2 shows him

as the supreme meditator, a spiritualized *yogin* ascetic seated cross-legged on a throne with the large round orb of the sun behind his head symbolizing his universal spirit. Such images help the faithful by giving visual and tangible form to the formlessness of the supreme being. The shrines and temples where they worshiped were often conceived as replicas or microcosms of the universe the gods had created, where worshipers could make symbolic journeys through the universe of the gods and rise above the material world. Thus, the art is essential to the religions and worshipers, just as a basic understanding of the religions is essential to the reader who hopes to understand their arts.

Islamic groups from Central Asia arrived in India around 1000 CE, and by 1200, large portions of northern India were under Islamic rule. In the early sixteenth century, a group known as Mughals who claimed to be descendants of Tamerlane from Central Asia and Genghis Khan of Mongolia built an empire in northern India with capitals at Delhi and Agra that remained strong until the late seventeenth century. The Muslim and earlier indigenous traditions in the arts in India declined during British colonial rule that lasted until 1947.

CHINA

Chinese culture is extremely ancient. Sedentary Neolithic societies began to emerge around 7000 BCE and by about 2205, portions of China may have been unified under the Xia Dynasty kings. Over its long history, as ruling dynasties in a succession of capitals built and lost empires reaching into Central Asia, the territorial dimensions of China have changed. Long before the arrival of Buddhism in China in the fourth and fifth centuries, the Chinese had developed religious ideas that inspired them to deposit treasures in the tombs of leaders. In 1974, the tomb of Qin Shihhuangdi (died c. 206 BCE), the first emperor of China, was discovered. The pits around it contain an army in effigy—nearly 10,000 lifesize ceramic warriors, chariots, and horses (FIG. 1.3). Chinese laws and customs forbid the opening of the emperor's tomb itself, but ancient literary descriptions of its contents suggest that even greater wonders lie inside.

1.3 Four-horse chariot and driver from the tomb of Emperor Shihhuangdi. Lintong, near Xi'an, Shenxi. 221–206 BCE. Painted terracotta, bronze, gilt and gold; 10'6" × 3'2" (3.2 × 0.96 m)

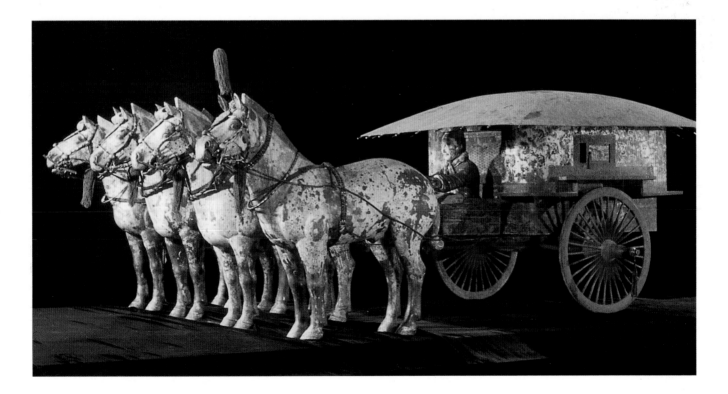

By the sixth century BCE, the Chinese developed codes of social ethics (Confucianism) and principles to direct their private, spiritual lives (Daoism). Invaders from the north and west, along with traders arriving by the caravan routes known as the Silk Road, were constantly bringing new ideas from many lands to China. In that past 500 years, the Chinese have been exposed to the art of the West. As the Chinese absorbed outside influences and developed their own ideas about art and culture, each of the many periods of Chinese art developed its own, distinct character. As a result, the long history of Chinese art and culture is exceedingly complex.

Those seeking to get an overview of Chinese art are aided by the amazing literary tradition in China which provides a wealth of information about how the Chinese viewed their arts. By the twelfth century CE, Chinese writers record that some painters trained in the government-sponsored academy were working for the court while another élite group of educated gentlemen remained independent from this system of education and patronage. Later, after the arrival of the Europeans, Chinese artists would wrestle with the problem of whether to incorporate elements of Western art in their work or ignore it altogether. This issue, which became an important one wherever the Europeans colonized, still remains a concern throughout the world beyond the West.

JAPAN AND KOREA

The Buddhist art and culture of China spread northwest to Korea and Japan, where the arts were already well developed around a native religion known as Shintoism ("The Sacred Way" or "Way of the Gods"). The Shinto worshiped nature spirits in rocks, trees, and water known as *kami* in a quest for spiritual purity and harmony with nature. These emphases have long encouraged Japanese artists to respect natural materials, unspoiled nature, and rusticity, and to create forms of art that are at once simple and deceptively complex. As the Chinese and Korean art forms arrived in Japan, the Japanese studied, refined, and simplified them, investing them with a new sense of the Shinto aesthetic to create a long series of magnificent and distinctly Japanese styles of art.

THE PACIFIC

People from Southeast Asia began migrating into the Pacific as early as 40,000 BCE and reached the most remote islands by about 900 CE. Scholars have divided the island groups into Melanesia, Micronesia, and Polynesia, which includes Hawaii, Easter Island, and New Zealand. Many distinct regional cultures, languages, and art styles developed on the thousands of islands separated by vast expanses of water. Around 1000 CE, the inhabitants of Easter Island began setting up the giant stone heads and torsos (up to seventy feet—21.3 m—tall). Known as *moai*, these have become internationally recognized icons of Polynesian culture (FIG. 1.4). They are great images of strength, or *mana* ("sacred power"), a concept that spread from island to island with the voyagers in the Pacific. Some Pacific people believe it is an invisible spiritual force that links people in this world with their ancestors and the spirits in the other world. Finely made works of art can have *mana*, and with time, as they are used in rituals honoring the gods, that *mana* can increase. Certain locations may be sacred and have *mana*. At times, when *mana* is manifest in objects of great beauty, the concept of *mana* is closely linked with Western ideas of art, but, like so many other ideas from cultures beyond the West, the subtleties of the Pacific image of *mana* or spiritual power can never be entirely explained in Western terms.

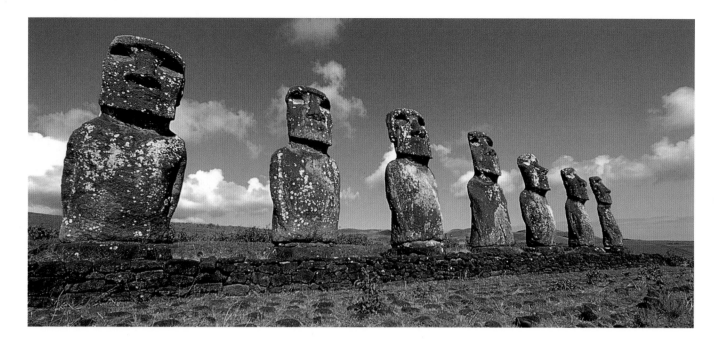

THE AMERICAS

1.4 *Moai*. Easter Island. Pre-15th century CE

North and South America were populated by groups of people who began migrating from Siberia to Alaska before 30,000 BCE near the end of the last ice age. Some writers believe the Polynesians made contact with the Americas, others believe the Americas developed in isolation, with no outside contacts. The art of the Americas in Latin America predating the arrival of Columbus and the Spanish conquest is called Pre-Columbian. The term "Native American" is generally used to describe the culture of the native population in North America. Much of their surviving art postdates the time of Columbus.

The first Europeans to land in the Americas were astonished to find Native American cultures that had been entirely unknown to Europe. Some of them had large cities, empires, and magnificent traditions in the arts. Beginning in the sixteenth century, some chroniclers began to study the American civilizations, but progress was slow and it was not until the late twentieth century that scholars began to understand the Native American cultures on their own terms.

The ancient Maya in present-day Guatemala believed that their leaders, who had lived with the gods before coming to earth, could revisit that celestial world through their temples, tall structures with tiny doors and dark interior spaces. These constructs symbolized mountains with caves leading away from this world. With their art, rituals, and architecture, they were able to maintain contact with the gods and the wisdom they needed to rule. In many parts of the Americas it is the shaman who travels beyond this world to speak to the gods. While concepts vary from place to place, this role of art in the quest for power and wisdom is very widespread in the Americas.

WESTERN AND NON-WESTERN ART

In geographic terms, the West may be described as Europe and its colonial extensions where European languages, arts, and cultures have existed in the past or present. However, the border between the Western and non-Western worlds of Africa, Asia, the Pacific islands, and Native America has not always been distinct. At times, trade routes have connected the Mediterranean world with Central Asia, China, India, and sub-Sahara Africa. Any attempt

to define the West must take this into account. The art and culture of the West have also changed over the centuries as its frontiers expanded from Greece and Rome, through Europe and its international network of colonies.

Histories of Western art usually begin outside the West, with Egypt in Africa and Western Asia, regions with arts that influenced the early development of the Greek and Roman or Classical art in antiquity. These surveys follow the Western tradition through the Middle Ages, Renaissance, Baroque, and modern periods in Europe and her colonies, some of which became independent Western nations. By the late twentieth century, Western art had become fully international, appearing in many of the regions around the world. For centuries, artists from non-Western nations colonized by the West have incorporated ideas and forms from the Western tradition.

As the societies in many parts of the world beyond the West were exposed to Western art and culture, they were forced to make certain difficult decisions that would affect their own futures. With its technological superiority, Western culture could hardly be ignored, especially when Western traders and colonists often gained considerable control over the economies of the non-Western societies they reached. Fully embracing all things Western, one would almost certainly lose all sense of cultural identity and pride. The question often became, how much and what kinds of Western influences could be permitted before that loss took place?

People around the world looked for ways to take the best from their own past and combine it with the best the West had to offer. This process of selection and adaptation took place at different rates around the world. In the late nineteenth century, as the Japanese in every field of study including the arts were making concerted efforts to Westernize their country, the Chinese remained somewhat more reluctant to embrace Western art. A late nineteenth-century movement in India to embrace the art and culture of their British overlords was stymied by an early twentieth-century anti-Western *swadeshi* (indigenousness) movement. It rejected the Eurocentric thinking of the British and looked for ways to revive the native culture of India in the arts. Nevertheless, in India and most of the cultures outside the West, including Africa, the Pacific islands, and Native America, there was some form of twentieth-century avant-garde movement. Usually, it was led by artists who had studied in Europe or at home with European art teachers schooled in the abstract styles of modernism. By the late twentieth century, many of the avant-garde were going beyond the basic imitation of Western art and finding highly inventive ways to combine Western and non-Western thinking in the arts to create works that commented meaningfully on the meeting of these contrasting worlds of thought.

With the complexity of these mixes, at times, it is a challenge to draw a Western–non-Western border on a map of the Americas. Visiting the Neoclassical plantation homes in the Carolinas and Georgia in the early nineteenth century, nobody would have doubted that the young republic was firmly rooted in the traditions of the West. But the basketry, woodcarvings, and pottery of the slaves reflected their roots in Africa. The great Baroque cathedrals of Mexico City and other capitals of Latin America that were parts of the Spanish and Portuguese empires are based on prototypes in Europe. However, many of the people attending services in them live in remote country villages, speak Native American languages, and have been little influenced by Western ways. Some of the Native American Catholic churches in the *pueblo* cities of the Southwestern United States built by local inhabitants working under the direction of Spanish leaders are simplified adobe versions of European Baroque churches. They seem to straddle this ever-moving, fragmented cultural frontier that runs through many parts of the world where Western art and thought mix with their counterparts in the non-Western world.

While some artists living in each of the areas surveyed in this text continue to work in their traditional, native styles, others have looked for ways to combine their native

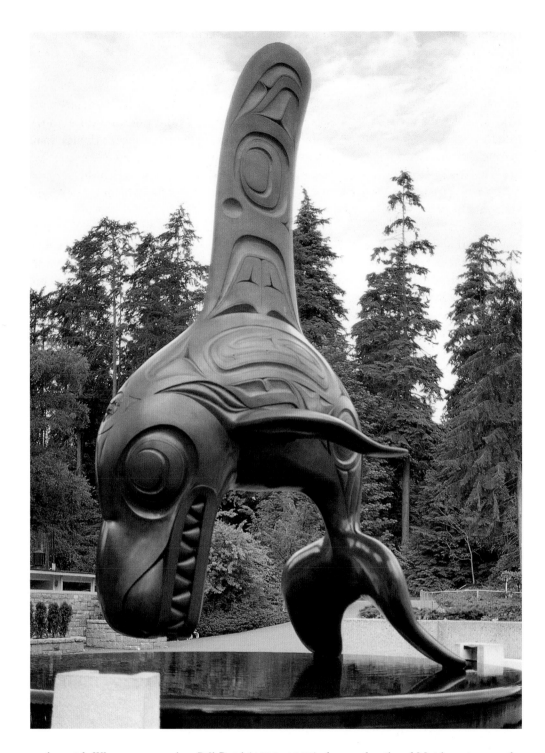

1.5 Bill Reid, *Killer Whale*. 1984. Bronze, height c. 17' (5.2 m). Vancouver Aquarium, Stanley Park, Vancouver

styles with Western art styles. Bill Reid (1920–1998), from a family of Haida artists on the Northwest Pacific Coast in Canada, drew upon the artistic traditions he had known as a youngster to create his bronze *Killer Whale* (FIG. 1.5). These include the metalworking techniques he learned as a jewelry maker, and his knowledge of modern art. While many of the linear, decorative surface forms on the body of the whale are traditionally Haida, the use of bronze, the sleek shape of the whale, and the suggestion that the animal is in midair reflect Western ideas. While some critics in the past questioned the value of mixing Western with non-Western forms and ideas, and placed higher value on "pure" forms of Native American art, few would do so today, and Reid's work played an important role in the resurrection of Haida traditions and pride in the late twentieth century.

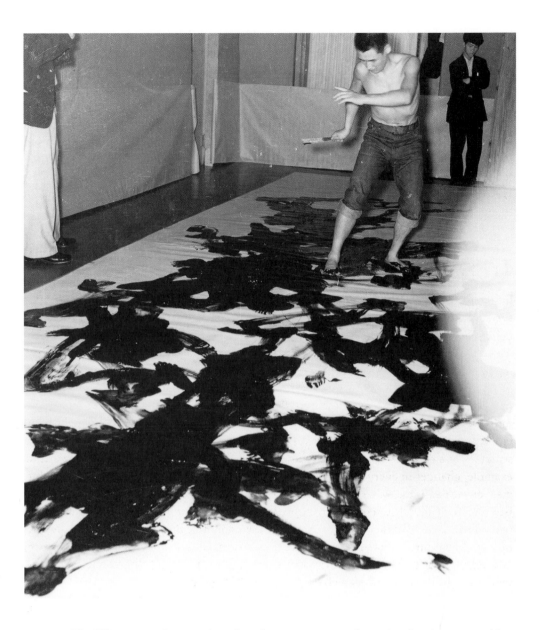

1.6 Shiraga Kazuo, performance at the Second Gutai Art Exhibition. Ohara Kaikan Hall, Tokyo. October 1956

The Western traditions also played an important role in the development of late twentieth-century art in Asia. From 1954 to 1972, a collective organized in Osaka, known as the Gutai group, created a wide variety of experimental art forms. Under the credo of their leader who said "Create what has never existed before," they worked outside the parameters of their own Japanese traditions and produced works that reflected contemporary trends in art in Europe and the United States without directly imitating them. A photograph of Gutai artist Shiraga Kazuo (born 1924) at the Second Gutai Art Exhibition in Tokyo (1956), shows him in a performance piece, painting with his feet (FIG. 1.6). He is working on the floor like his Western contemporary Jackson Pollock, while creating forms that reflect one of the most important forms of traditional Japanese art, calligraphy.

A century earlier, Japanese art had a profound influence on the art of the West. When Japan reopened its doors to the outside world in the 1850s after more than two centuries of severely restricting outside contacts, the West became fascinated with Japanese art and culture. This vogue became known as *Japonisme* (French for "Japanese style"). Many of the European artists began to collect Japanese prints, some of which came to the West as packing and wrapping paper for other Japanese goods. Japanese aesthetics played an important part in what became known as the Arts and Crafts movement in Europe and North America during the

late nineteenth and early twentieth centuries. Along with Japanese art, some adventurous thinkers in the West at this time were fascinated with the art of Africa, the Pacific, and Native America. This important twentieth-century preoccupation with what was then called "primitive" art will be discussed in context with the material in the text.

Seeing these interactions between Western and non-Western traditions serves as a reminder that when dealing with the art beyond the West it is important to remain aware of the fact that these worlds have never been entirely separate and have been part of a large international context of development. This text takes advantage of these situations where such exciting cross-fertilization has taken place, to show how the meeting of Western and non-Western cultures has offered artists new opportunities to create works of art unbounded by traditional lines of thought.

THE ART IN CONTEXT

In summary, the chapter introductions focus on one or more ideas that are fundamental to the art and thought of a culture or group of related cultures—the all-important ideals, beliefs, and principles that shaped their arts. Although not all areas of the Pacific had the idea of *mana*, and not all Japanese art reflects the ancient values of Shintoism, understanding something about the values expressed in the belief systems manifest in *mana* and Shintoism gives the reader tools with which to approach Pacific and Japanese art. However, it is important to understand that these introductory "doors" to the thinking in the art of a culture are not intended to be pathways through the entire mazes of their thought. They are entryways, nothing more, portals designed to orient readers entering into the complex structure of a culture's history of art and thought. The thinking behind Japanese art, for example, changes in every period as foreign influences vary and internal lines of development create new ideas, values, and styles of art. Cultures are not static, and all too often, people have created cultural stereotypes that obscure the true diversity and richness of the culture behind the "type." While these fundamental ideas cannot begin to explain the full diversity of thought within a culture as it developed over space and time, they are highlighted in the chapter introductions to provide threads around which the rest of the diverse intellectual content of the art discussed in each chapter may be understood.

To understand more deeply the original sense of experience audiences had when viewing the art, it is essential to go beyond these philosophical ideas and attempt to understand the original dramatic context in which the art was seen by the communities for which it was created. Often, these presentations are dramatic multimedia spectacles that may include oratory, costuming, music, and dance. Many of them take place around or in architectural settings, theaters that contribute to the full experience of the arts in context. The text includes images of these events that show the arts in context and schematic drawings of architecture with numbers identifying their main features. Following the numbers, readers can "walk through" the architectural spaces and mentally reconstruct the settings wherein the arts were experienced by their original audiences.

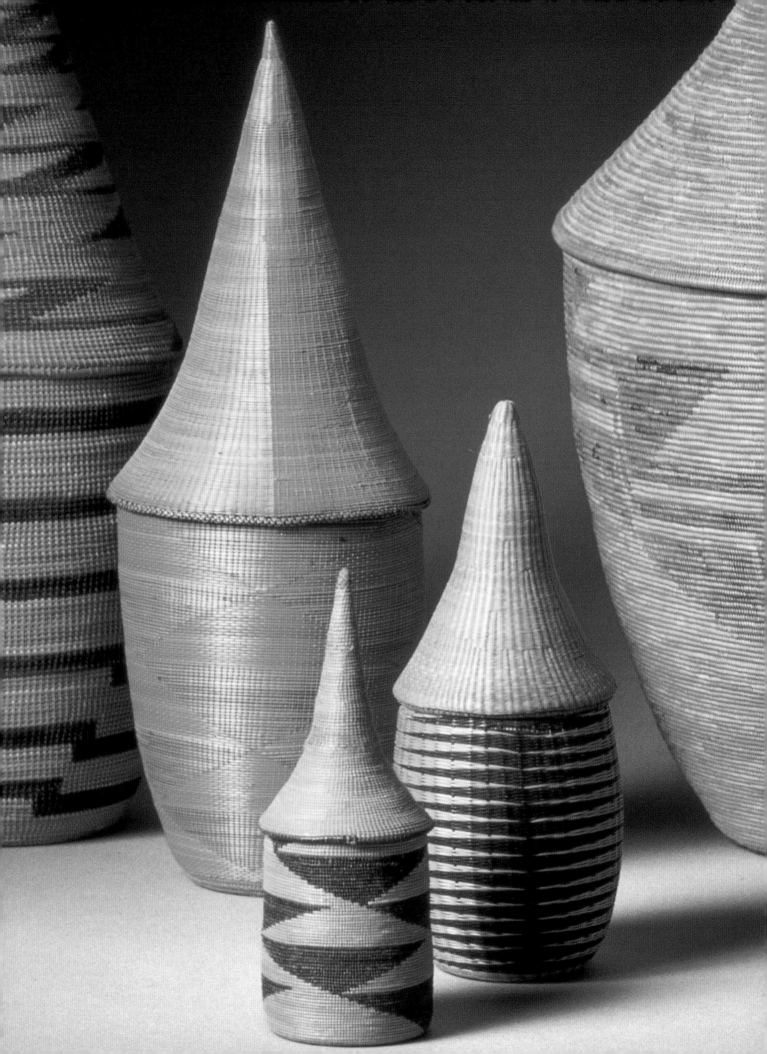

CHAPTER TWO
AFRICA

Equator

AFRICA

This chapter covers the indigenous arts of sub-Sahara Africa, which is divided into southern, East, central, and West Africa. The arts of North Africa, ancient Egypt, and the Nile River drainage area in Nubia and Ethiopia that have traditionally been regarded as parts of the ancient and medieval cultures of the Mediterranean world are discussed in this chapter when they are involved with the art of sub-Sahara Africa. (See *Methodology*: What is an Authentic African Work of Art," page 26.)

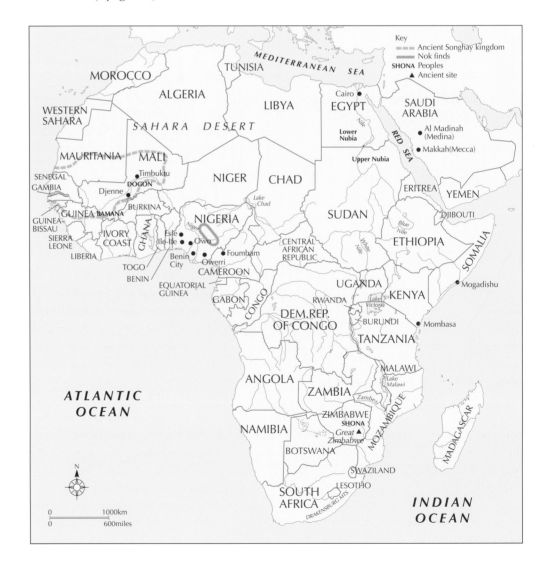

TIME CHART

Beginning of San painting on rock outcrops (c. 27,500 BCE)

Native copper smelted in Nigeria (c. 2000 BCE)

Iron ore smelted in Nigeria (c. 700–500 BCE)

Nok ceramic sculptures in Nigeria (c. 600/500 BCE–200 CE)

The Ghana kingdom, West Africa (8th–11th centuries CE)

Pre-Pavement Era at Ile-Ife (900–1200)

Early Pavement Era at Ile-Ife (1200–1400)

Muslim traders arrive in West Africa (10th century)

Bronze heads cast at Ile-Ife, Nigeria (c. 1100–1500)

Oduduwa, king of Ile-Ife, sends his son Oranmiyan to found a new dynasty at Benin City (13th century)

Zenith of Great Zimbabwe, Shona capital (c. 1250–1400)

The Mali kingdom, West Africa (13th–16th centuries)

Benin: Early Period (1400–1500)

The Songhay kingdom, West Africa (15th–16th centuries)

Iguegha of Ile-Ife brings bronze casting to Benin (early 15th century)

Arrival of Portuguese in Benin (1486)

Benin: Middle Period (1550–1700)

Benin: Late Period (1700–1897)

Destruction of Benin City by British (1897)

Yoruba artist Olowe (c. 1860–1938)

INTRODUCTION

Over the last 30,000 years, artists living in the vast region known as sub-Sahara Africa, with about 1,000 distinct languages, have produced a variety of art works in many distinct styles. No single religious or cultural idea can explain why so many African cultures and individuals placed such a high value on art. At best, we can point to some widespread cultural ideals about spirits and their veneration that inspired some of the most important works discussed in this chapter.

Many African groups believe in an invisible other world of sacred ancestors, spirits, and deities that mediate in the affairs of this world. By conducting certain time-honored ritual performances, they believe they can recreate their past history—the time when their ancestors lived—in present time and communicate with these otherworldly beings. These rituals are often multimedia performances that include costumed and masked dancers representing spirits or deities, music, prayers, and offerings. During the rituals the performers may become embodiments of the otherworldly characters they represent and focal points for the worshipers around them, acting as visible symbols of the union of the past and present, this world and the other.

What is an Authentic African Work of Art?

The question is deceptively complex. For example, a mask made by an African artist trained by a skilled and recognized artist within that society, one that will be used in rituals by his/her society, would surely qualify as an authentic piece of African art. But what about a mask made by that same artist for sale to an art collector outside his/her African cultural context, a mask that will never be used and given meaning through the performance of rituals? Would not that work lack a certain spiritual dimension that would preclude it from being a fully authentic African work? That mask, however, may be more authentic than another mask made by an untrained artist working for the same collector. What about works by trained African artists imitating styles of other periods and times, and works by African artists raised outside Africa in the Americas? What if such artists have access to better tools and can work more skillfully than the authentic African artists working in small African communities? Would the technical superiority of their work have any significance in this context? Many examples of mass-produced, so-called "airport" or "tourist" art are very well crafted and many scholars are now taking a fresh look at these traditionally overlooked art forms. If an African-American artist returns to Africa and studies with a recognized artist, can that individual recapture certain rights to his or her heritage and create true African works of art? Clearly, one would not consider a work by a non-African for sale to a collector or tourist to be "authentic." But what about all the possible categories in between the genuine article and the out-and-out fake? It would seem that it is difficult or impossible to make firm judgments about the authenticity of many categories of African art that lie between these ends of the spectrum.

The African concept of dance is an intensely passionate, all-encompassing vision of dancer, costume, masks, other works of art, and the spiritual heritage of the cultures united in patterns of movement. The isolation and segmentation of body parts in response to the complex rhythmic music emphasize the flexibility, endurance, and power of the dancer's frame. Through their strength, grace, and beauty, the dancers transcend the commonplace of this world and communicate with the spirit world. These concerns with power and grace are also expressed in the visual arts. Even the most common static poses of figures in African art—standing, carrying and balancing objects, seated (to convey authority), or kneeling (paying honor)—are positions and icons of power. The bent knees and elbows of African statues accent the flexibility, animation, and readiness of the figure to move. In themselves, the shapes of the sculptures also convey this image of power. Often, the sculptors attack the wood with strong, staccato strokes that reflect the overlapping multi-metric rhythms of African music. Accenting each feature and form with equal intensity, they give full strength and vitality to every part of the face and image.

Unlike the traditional Western notion of sculpture as a composition of static forms, African art is often meant to be in motion and depends upon these movements and its ritual context for its meaning. The Dogon of Mali in West Africa display masks, sculpture, and other art works at dance rituals designed to transport the souls of the deceased out of their villages. The dancers' costumes include bright vests of red broadcloth strips covered in white cowrie shells, beads, brightly colored fiber skirts over indigo pants, and *Kanaga* masks

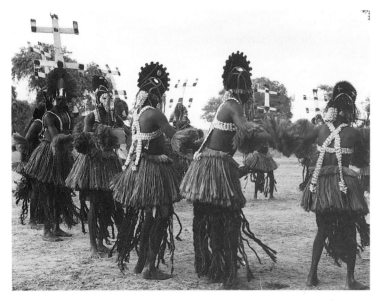

2.1 Masked *Kanaga* dancers. Dogon, Mali, West Africa. 1959

with towering antennae-like head crests (FIG. 2.1). The long, graceful, spinning and leaping movements of the Dogon dancers are intensified by the tall, double crosses on the crests of their masks, which may represent a bird or mythical crocodile. The dances of the Dogon and other groups link the religion, ethics, and the world view of Africa and fuse the reality of this world with the other world of spiritual beings. Looking at the African masks and headdresses as they are placed against the flat walls of quiet, softly lit rooms in art galleries and museums, or reduced in scale and rendered motionless on the pages of a textbook, it is important to remember that the meaning and expression of African art cannot be conveyed in the frozen silences of such foreign environments. In these unnatural settings, the sculptures are little more than mute reminders of the religious rituals of dance and music for which there were originally created. Looking at African works of art that have been denied their full and original sense as part of the motions and music that framed their rhythms and those of African life, Western spectators must make a major effort to use their imagination as they attempt to restore this art to its proper context.

Many African groups have their own, distinct ideas about beauty in art. Nearly a thousand years ago, the Yoruba at Ile-Ife in Nigeria were placing cast metal and modeled clay heads of royal ancestors and other art works on altars and honoring the heads in ceremonies of ancestor worship. The heads, a mixture of what might be called realistic and idealized forms, are universally recognized for their stunning beauty. Some of the ancient principles of the Yoruba sense of beauty may be preserved in contemporary Yoruba thinking.

Using rough translations of Yoruba words into English, the modern Yoruba believe that their High-God and Creator is the source of all outer beauty and inner beauty manifest in one's "character" or "essential nature." To capture that sense of inner beauty and power in images of their royal ancestors, they made heads with a sense of "youthfulness" and "dignity." Beautiful art needs to have "symmetry," "balance," "clarity of form," "clarity of line," "luminosity," "delicacy," and "ornamentation." The Yoruba have distinct terms for a "relative likeness" that captures the essence of a subject and a kind of "clarity" in which the artists accent important features. The true artist who creates works that reflect a kind of "inner sight" and "inventiveness" creates a beauty that is "composed," "collected," or "cool." The Yoruba and other African groups also have many words and principles for judging the way art is presented in dance rituals. The Yoruba call a good critic or aesthetician "one who knows beauty." (See "Analyzing Art and Architecture: Yoruba Aesthetics," page 28.)

Many other African groups have similar terms for aesthetic matters. The Bamana of Mali call art "things that can be looked at without limit," and the Dan of Liberia and Côte d'Ivoire have distinct words for beauty and ugliness in art. Until very recently, African art was little understood or appreciated in the West, but seeing the distinctive and sophisticated philosophies behind it, Western viewers can begin to recognize the importance of African art and the roles it played in the life and culture of a continent.

THE HISTORY OF AFRICAN ART HISTORY

African archaeology and ethnology are underfunded and in their infancy, yet scholars are beginning to rediscover the historical dimensions of African art and recognize the cultural diversity of the art-producing groups in this large continent. The city of Benin, with its well-documented history, gives some indication of the yet unreconstructed historical depth of sub-Saharan Africa. For a long time, the inventiveness and subtlety of African art were obscured by the spread of the colonial religions and the institution of slavery, which uprooted many Africans and reduced them to states of poverty. In the past, Western thinkers had generally regarded African art as craft (objects with functional uses) rather than as "fine art." This view limited the appeal of African art to Western art collectors and art historians.

Yoruba Aesthetics

The complex system of aesthetics the Yoruba use to criticize their arts and ceremonials has been documented by ethnologists and Nigerian scholars working with the complexities of the tonal Yoruba language. Because many of these words cannot be translated into English, they are set in parentheses with their rough English equivalents. Olórun, the High-God and Creator, is the source of all beauty (*ewà*), including inner beauty, a true form of beauty manifest in a person's character and morality (*ewà inú*), and outer or superficial beauty (*ewà ode*). In many African languages, the same word is used for "goodness" and "beauty." Canons of beauty include ideals of good composition with symmetry (*didógba*), balance (*ogbogba*), clarity of form and line (*ifarahon*), luminosity and delicacy (*didon*), and ornamentation that enhances beauty (*ohun èso*). True beauty (*ewà tútú*) is composed, collected, controlled, and cool.

While Olórun is not represented in the arts, the lesser gods are shown in symbolic terms that emphasize their characteristics and beauty (*ewà*). A sculpture should contain a relative likeness (*jijora*) and capture the most essential characteristics of its subject without being too realistic or too abstract. Applied to the human figure and face, jijora means something like "resembling mankind."

The closely related principle of clarity of form and line (*ifarahon*) requires artists to include all the important information about a subject. Works of art with *jijora* and *ifarahon* that capture the essential and important parts of their subject matter reflect inner sight (*oju-inu*), inventiveness (*ifarabale*), and are said to be cool (*itutu*). The words for "cool" and "good character" are nearly synonymous in Yoruba. In many parts of sub-Sahara Africa, the widely applied concept of coolness also encompasses notions of moderation, strength, smartness, repose, and peace. In so doing, it is an all-embracing ideal with social as well as artistic applications. By incorporating small bends and curves (*gigun*) in their work, artists and builders soften, or "cool," the austere qualities inherent in pure, straight lines and geometrical forms.

The critical traditions of judging art and dance among the Yoruba and many African groups are so highly developed that "criticism" is regarded as an art form in itself. Among the Yoruba, a good critic (*amewa*) is "one who knows beauty," or to use a Western term, an "aesthetician."

The way in which the colonial powers laid out the present-day countries in Africa, without respect for the continent's existing cultural and political organization, symbolizes the way African art has been mistreated in Western thought. Throughout much of the twentieth century, its style and content were often analyzed in modernist terms by people who knew little about its original cultural context. But in recent years, as archaeological and ethnological projects have been gathering new information about African art history and more African scholars enter the field, African art has begun to be understood and respected on its own terms. The terminology scholars use to discuss African art has also changed radically. Many of the old terms, such as "tribal," are no longer relevant as scholars in the West begin to recognize that Africa had great individual artists who transcended communal lines of thought. Because the names of most African artists have been lost, works have long been attributed to groups and seen as the expression of communal genius. (See *"In Context:* Artists and Attributions," page 29.) The traditional image of African art in terms of anonymous masks and statuary has been expanded, and this chapter includes works in a wide variety of materials and sizes that reflect the genius of recognized African artists.

AFRICAN PREHISTORY

At the end of the last glacial period, until about 6000 BCE, the Sahara was a land of lakes, rivers, and grasslands, home to fishing, hunting, and gathering peoples with pottery and tools and weapons of stone and wood. As this region became progressively drier and groups migrated to its edges, many became herders, cultivated domestic varieties of wheat and barley, and settled down in villages. Often, these settlements consisted of round earthen houses surrounding cattle pens. Native copper was smelted in Nigeria by 2000 BCE and the more difficult task of smelting iron ores was mastered between 700 and 500 BCE in Nigeria and elsewhere in sub-Sahara Africa. With the development of metalworking and other highly specialized professions came the flow of trade goods, the development of larger communities, and more complex societies.

Eventually, the Sahara became a broad expanse of arid desert, but the African lands south of it were never entirely cut off from North Africa and the rest of the world. East Africa around the headwaters of the Nile lies south of Nubia, a land that had remained in contact with Egypt since ancient times. Well after the pastoralists and their herds had abandoned the Sahara for more hospitable climates, caravans of Berbers were still crossing the desert to trade Phoenician, Greek, and Roman goods for African gold. Their role was assumed by the Muslims and by the eighth century CE African merchants on the east coast of Africa were exchanging their gold, copper, and ivory with the Arabs, Indians, and Persians for manufactured goods and luxury items that included Chinese porcelains. By the early fifteenth century, European traders had arrived in West Africa, opening the way for the infamous slave trade and colonization of Africa in the nineteenth century.

At present, it remains difficult to survey the early history of African art. While there are reports by Arab and European travelers in Africa, there are few written documents by the Africans artists and patrons who understood the art and its cultural context. Missionaries, termites, floods, and fire took their toll on African art, much of which was made with perishable materials such as wood and fibers. In addition, works that were made for particular ritual purposes were often discarded after those rituals were completed. As a result, to Western writers, African art often appeared to lack historical depth. But, when

IN CONTEXT

Artists and Attributions

Nobody knows the names of the great Benin artists who created the finest bronzes, but two groups of related pieces have been attributed to artists known as the "Master of the Circled Cross" and the "Master of the Leopard Hunt." When art historians discover a group of related works that appear to be the work of a single artist, they often name the unknown artist for one of the most characteristic works in the group. As more related works are discovered, they may be attributed to that same master. Occasionally, the true name of the artist may be uncovered. Works attributed to the "Master of Buli" (a town in the Democratic Republic of Congo) turned out to be the work of one Ngongo ya Chintu of another nearby village in the Democratic Republic of Congo. Thus, works formerly attributed to the Master of Buli are now given to Ngongo ya Chintu.

The fact that the Benin and Ile-Ife heads are not signed, however, does not mean that the artists were anonymous or of low status. Artists in Africa, Oceania, and other societies without writing were not unknown to their contemporaries. African artists were often well recognized by their peers, and contemporary artists continue to be well respected in sub-Saharan Africa.

Pablo Picasso and African Art

African art was little known or appreciated in the West until the early twentieth century. At that time, a small group of artists and writers in Paris began visiting the Musée d'Ethnographie in the Palais du Trocadéro. Pablo Picasso was there in 1907, and along with other early admirers of African art, he was fascinated by what he what he called the sacred and magical power of the art. Picasso described it as "a kind of mediation between themselves and the unknown hostile forces that surround them, in order to overcome their fear and horror by giving it a form and image." Picasso said that African art changed his approach to painting, and enabled him to see art as "a form of magic designed to be a mediator between this strange, hostile world and us, a way of seizing the power by giving form to our terrors as well as our desires."

The lack of contextual understanding for African art shown by Picasso persisted throughout much of the twentieth century. The inventiveness and subtlety of African art were also obscured by the institution of slavery, which uprooted many Africans and reduced them to states of poverty. Moreover, Western thinkers tended to regard African art as craft, not "fine art," because the art often had a function. In fact, Picasso, who focused on his personal reactions to African art, marginalized the importance of Africa when talking about his painting. He once said that the smells and sights of one exhibition "depressed me so much I wanted to get out fast." Later, when asked about African art, Picasso said "African art? Never heard of it!"

permanent materials such as fired clay and bronze were available and utilized, as they were in Nigeria, there is good evidence that many forms of African art collected in the nineteenth and twentieth centuries derive from very ancient concepts and traditions.

The low status of enslaved Africans outside Africa, the poverty that has persisted in many areas after its abolition, and the socioeconomic conditions in Africa during the colonial period caused many Westerners to underestimate the depth of meaning and the philosophical sophistication of African art and culture. Also, for many, the abstract nature of much African art did not demonstrate that African artists had the technical ability to render forms in their "correct" naturalistic proportions. The earliest Western audiences for African art failed to appreciate the expressive forces of the powerful, rhythmic forms and patterns of African art and its deeply rooted basis in religious thought and ritual performances. Moreover, despite the fact that the African Diaspora spread the knowledge of that continent around the world, and its heritage has been such an important part of American history from Brazil through the Caribbean to the United States, for many thinkers, African art and thought have continued to represent an exotic, foreign world of thought.

Westerners have looked upon African art for many reasons. African art was attractive to the "Primitivists" of the early twentieth century, who saw it as a potential source of spiritual strength and the renewal of Western civilization. (See *"Cross-Cultural Contacts:* Pablo Picasso and African Art," above.) From a strictly formal point of view, African art appealed to many non-African artists, collectors, and writers in the twentieth century, but until one understands the thinking and emotions behind it, African art remains the curious "other." (See *"Analyzing Art and Architecture:* Primitivism: An Art-Historical Definition," page 31.)

SOUTHERN AFRICA

Southern Africa is home to the oldest known works of art on the continent. This area includes the present-day countries of Namibia, Botswana, Zimbabwe, Mozambique,

Swaziland, Lesotho, and South Africa. A prehistoric African tradition of painting on stone outcrops, beginning around 27,500 BCE, developed independently from prehistoric art in Europe or other parts of the world. These earliest known inhabitants of southern Africa and creators of Africa's longest-running art tradition are called the San (also known as the Bushman, a name with negative connotations). They produced paintings and engravings at over 15,000 known sites, most of which are located in mountainous regions. Some of these paintings represent complex narratives of conflicts and a variety of daily activities. Repainted and superimposed images suggest that some sites were revisited repeatedly and had special ritual significance.

THE EARLIEST SOUTHERN AFRICAN ART

San folklore was recorded in the late nineteenth century, when the last San painters were active and the culture was in decline. It suggests that San art illustrates the activities of healers who went into trances, made contact with supernaturals, and used their powers to heal, bring rains, and attract game. As a record of these events and experiences, the art played a part in the ritualism of the San for thousands of years.

The eland, the largest and slowest of the African antelope, was an important subject in San art. It was a prime source of food and its potent scent symbolized power. A painting from the Game Pass shelter in the Natal Drakensberg shows men taking on eland features

ANALYZING ART AND ARCHITECTURE

Primitivism: An Art-Historical Definition

At the end of the nineteenth century, well after the West had accepted Asian art, scholars and artists in Europe and the Americas were still reluctant to accept the art of Africa as "fine" art. Even into the mid-twentieth century, works from these areas were regarded as artifacts or crafts and called "primitive." The term "primitivism," comes from *primitif*, a nineteenth-century French art-historical word used in reference to certain late medieval and early Renaissance Italian and Flemish painters. Eventually, the term was applied to the traditions listed above. The term was fully canonized with Frans Boas' *Primitive Art* (1927) and Robert Goldwater's *Primitivism in Modern Art* (1938).

Following the evolutionary theories of Darwin, many late nineteenth- and early twentieth-century writers thought the "primitive" styles of art in Africa, the Pacific, and the Americas contained certain "prime" forms from which Western art had evolved. So little archaeological and ethnological field work had been done at this time that they did not recognize the intellectual complexity of the art and its associated rituals. Moreover, the Western theorists also failed to see these traditions as mature lines of thought that were distinct from the Western tradition.

Although the original connotations of the term "primitive," as it was applied to the art of Africa, the Pacific and the Americas, were entirely positive, the term itself was misleading and the more recent connotations of the term that developed outside art history since the mid-twentieth century link that "primitivism" with technological underdevelopment and the culture of poverty. Meaning "early," "primitive" implies that the art of these societies did not pass beyond an early stage in its development. Using Western standards of technological development as a yardstick to evaluate the arts of people around the world, such terms as "primitive" or "barbaric" have strong overtones of colonialism and racism. "Tribal" has been suggested as an alternative to "primitive," but along with such terms as "ethnic" and "native," it has certain negatively charged emotional connotations. Some writers have capitalized "Primitive" to emphasize its historical character or set it in quotation marks, but the issues of whether and how to use "primitive," "primitivism," and other related terms remain matters of debate.

2.2 Scene of men taking on eland features as they approach a dying eland. Game Pass shelter. Kamberg, Natal Drakensberg, southern Namibia. Undated. Pigment on rock

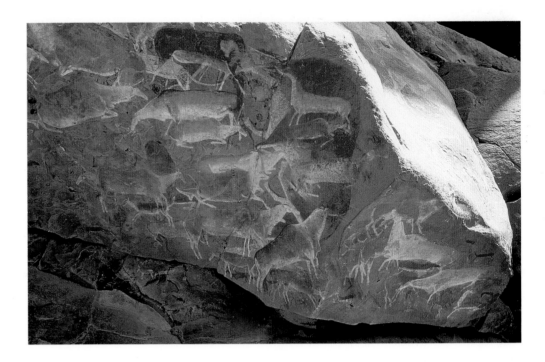

as they approach a dying eland they have impaled with a poisoned spear (FIG. 2.2). As in most known San paintings, the active figures are generally shown in silhouette. According to San informants, at this point, the men would begin to tremble and sweat profusely and bleed from the nose—like the poisoned eland—going into a deathlike trance as they danced and appropriated the animal's powers. Among other things, the San believed that the power they absorbed from the eland would deflect "arrows of sickness" from themselves. This important theme in San art is depicted in a variety of ways in many locations, and the metaphor of the dying eland and the men leaving this world to enter trances is part of a larger concept of eland iconography in San society, which included various rites of passage.

GREAT ZIMBABWE

By the first millennium CE, groups of southern African herders began congregating in large villages, often on hilltops for defensive purposes. These inhabitants were also skilled in carving ivory, and smelting and forging metals. The most powerful of the cities, Great Zimbabwe, capital of the Shona kingdom and home of its ruler, reached its zenith about 1250–1450 CE (FIG. 2.3). The divine priest-king of the Shona received tribute from his dependencies in the form of gold, copper, tin, ivory, cattle, and exotic skins, and traded with the Arabs at the port of Sofala on the Indian ocean for such luxury items as fine Indian cloth and Ming vases. By the fourteenth century, the trade-rich Shona king ruled roughly a million people in an area about the size of present-day Spain.

The name of the site comes from a Shona world, *zimbahwe* or *zimbabwe*, which originally meant "court" or "royal palace" and is now used to describe any stone ruin. The Great Zimbabwe includes the Hill Ruin (c. 1250), the Valley Ruins, and the Great Enclosure (c. 1350–1450), a group of structures encircled by a wall up to 30 feet high, 20 feet thick at its base, and about 292 feet in diameter. The Great Enclosure and many of the regional Shona centers are known for their carefully patterned dry stones wall, a technique of building still used in present-day Venda communities in southern Africa. Although the Great Enclosure, the largest stone structure in all of sub-Sahara Africa, has been badly looted, the few surviving pieces of sculpture and pottery suggest that it was once a thriving art center housing many great treasures.

Soapstone images of birds of prey with human features found in the ruins may represent the king. Stones set in a band of chevrons along the upper walls may also symbolize the king as an eagle and lightning, both of which are believed to link the sky and earth in a zigzag pattern. To give the stonework stability, the walls are "battered" (sloped inward toward the top). Some of the latest additions, such as a solid conical tower resembling a Shona granary, have finely dressed stones and seem to reflect the growing skill of the local masons. Along with the curved inner walls, oval-shaped rooms, and another solid tower, these masonry forms reflect the shapes of pottery and clay buildings elsewhere in sub-Sahara

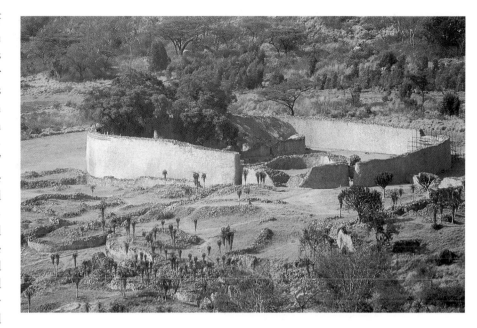

2.3 The Great Enclosure, Great Zimbabwe. c. 15th century CE

Africa. The round, flowing, and organic contours of the walls also create spaces that are flexible and relate to the landscape and patterns of human movements around them.

The Portuguese arrived in sub-Sahara Africa shortly after the political importance of Great Zimbabwe had passed on to other areas in South Africa. These outsiders ultimately undermined the economy of the region by disrupting its long-established trade routes. While no more cities on the scale of the Great Zimbabwe were built, individual artists continued to produce items for everyday and ritual use. Many of the masks and carved figures used in highly secretive rituals were never seen by the art collectors who arrived by the nineteenth century, so these important works are not preserved in museum collections.

EAST AFRICA

The earliest evidence of human prehistory and many of the earliest known human-made tools come from East Africa. Many important works of art come from the present-day countries of Mozambique, Tanzania, Kenya, Rwanda, Burundi, Somalia, Ethiopia, and Sudan. While little is preserved about the beliefs and rituals of the most ancient cultures, in more recent times much of the art from this region has been made to commemorate major events and changes in the community life. These rites of passage include the initiation of boys and girls into adulthood, the installation of chiefs, funerals, and other activities honoring the spirits of the dead.

MAKONDE AND GIRYAMA

Many of the masks made by the Makonde in Mozambique and Tanzania were used in their ceremonial initiation dances. The adults would tell the young boys being initiated that a figure wearing a mask with deep-set eyes, long hair, and a fiercely aggressive expression was a spirit who had returned from the dead. The mask was but part of an elaborate costume that concealed the body of the person dancing with it. Later, the adults tested the courage of the boys by asking them to attack and unmask the frightening spirit dancers.

The final rite of passage, death, is traditionally surrounded by many complex rituals. Among the Giryama of Kenya, following a funeral ceremony, the deceased may appear

2.4 Funerary post. Kenya, Giryama. Wood, height 51¼" (130.5 cm). Private collection

to a wealthy kinsman in a dream and ask for a new place to reside outside the grave-yard. That relative might then commission a carved funerary post to be erected in a special precinct outside the cemetery or in the village (FIG. 2.4). Memorial poles might also be raised to honor someone whose body was never found, for whom there was no grave. Often the faces are very naturalistic, individualized, and expressive, but they are probably not intended as portraits. The bodies are usually decorated with geometric forms such as triangles and rectangles, and painted red, white, and black. These forms may refer to events in the life and death of the person being honored. As the ances-tors slip from memory, the poles decay and disappear.

The prominence given to the location of the pole in the community might reflect the wealth and power of the ancestor and the individual who commissioned it. Offerings of coconut oil, chickens, and goats might be given to the spirit residing in the pole. It was generally believed that it was safer to conduct these ceremonies in a community of the living than in a cemetery, where potentially dangerous spirits might be lingering. A properly consecrated pole and well-conducted ritual that appeased the deceased ancestor without disturbing other spirits was considered to be a source of vitality and harmony for the community.

RWANDA

Basketry remains a very important art form in many parts of Africa, including Rwanda, where the women of the ruling Tutsi groups excelled in the produc-tion of fine coiled baskets with precise stitching. Their flat, saucer-shaped trays and round, house-shaped baskets with tall, conical "roof" lids mix the pale gold color of the grass with patterns of blacks and brick reds (FIG. 2.5). The tech-nique is very time-consuming, but the finished pieces have a monumentality that makes the smallest of them appear much taller than it is. African tech-niques and styles of basketmaking continue to be practiced by women living along the southern Atlantic coast of the United States and are discussed with African-American folk art in this chapter (see pages 54–6).

ETHIOPIA

Egyptian and Syrian missionaries Christianized portions of East Africa along the upper reaches of the Nile River between the fourth century CE and the sixth, and introduced varieties of early medieval Christian art. However, Chris-tian art and thought took on an African and distinctive Ethiopian character when they arrived in East Africa as the scriptures were translated from the Greek to the Ethiopian Ge'ez. The early medieval manuscripts may have been illustrated by Ethiopian artists, but unfortunately, no examples predating 1350 have survived. A seventeenth-century Gospel showing Matthew with raised hands (a traditional early Christian pose for prayer) and the facing page with his writ-ings in Ge'ez bears little relationship to any of its ancient Egyptian or Syrian sources (FIG. 2.6). Working with bold patterns of red, black, orange, and white ink on parchment (a dried and treated animal skin), the artist has captured the saint's sense of inspiration and the divinity of his words within the elaborate frame on the facing page.

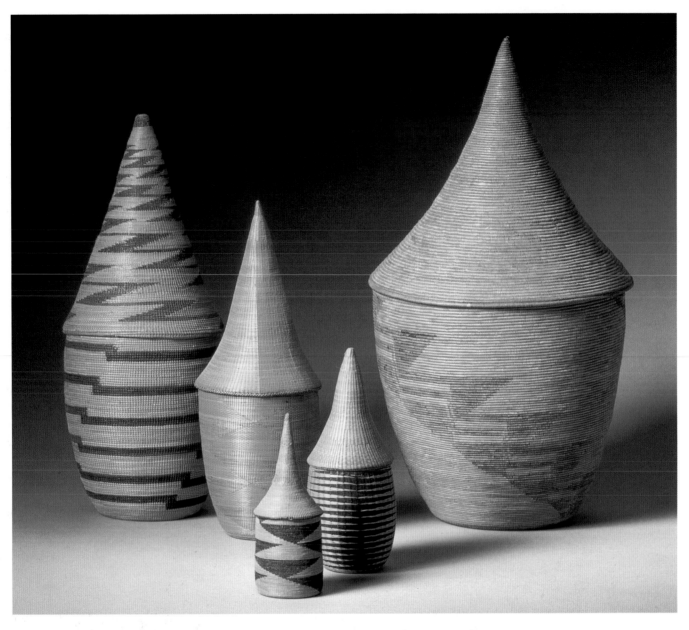

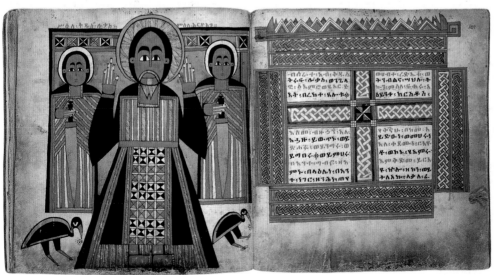

2.5 Five miniature baskets. Rwanda and Burundi, Tutsi. Early 20th century CE. Grass, black, and red dye; height 11" (28 cm), 9" (23 cm), 4³/₈" (11 cm), 5¹/₂" (14 cm), and 13" (33 cm). Collection of W. and U. Horstmann

2.6 Four Gospels. Ethiopia, Lasta. 17th century. Parchment. 10¹/₂" × 9³/₄" (26.8 × 24.9 cm). The British Library, London

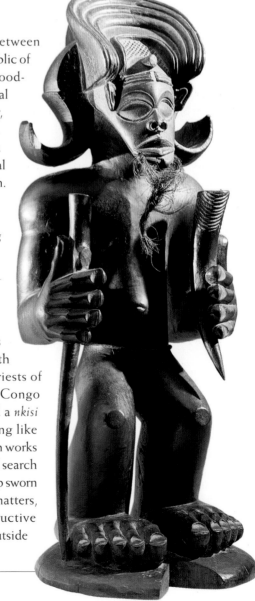

CENTRAL AFRICA

Central Africa is a vast region of diverse climates, including large rainforests and open and wooded savannas. Many of the most important works of art come from Gabon, Congo, the Democratic Republic of Congo (formerly Zaire) and northern Angola. The present political boundaries established in colonial times bear little relationship to the cultural boundaries of the indigenous African groups living in this area.

The veneration of ancestors who may work as intermediaries connecting the living with the gods of the other world is an especially important form of worship in central Africa. The political powers passed down from these ancestors from one chief to another at their initiation ceremonies are often symbolized by staffs with ornate, carved ivory handles. The kneeling position of the figure in figure 2.7, with its hands resting on its thighs, signifies obedience while the turned head symbolizes watchfulness, attributes claimed by the staff's succession of owners. Many staff figures represent women, because it is through female fertility that the powers of the ancestors and gods are passed down from one generation to the next. The sculptor has exploited the smoothness and consistent grain of the ivory and modeled the features of the woman with great delicacy to capture the softness of human flesh along with the cultural ideals of behavior that applied to chiefs and their followers alike.

CHOKWE AND KONGO

The Chokwe who live around the border between present-day Angola and the Democratic Republic of Congo are renowned for the skill of their woodcarvers. One of their best-preserved memorial or effigy statues honors a mythical ancestor, prince, great hunter, and civilizing hero named Chibunda Ilunga (FIG. 2.8). It shows him as a powerful man, with large hands and feet, a royal headdress, long beard, staff, and flintlock gun. The miniature figures perched on the ridges of his headdress are helpful spirits on the lookout for game and predators. The bold carving of the prince's exaggerated muscularity gives this figure a sense of monumentality and power that belies its actual size.

Some African rituals are communal festivals; others are relatively private ones in which individuals and religious leaders communicate with the spirit world, often with the aid of works of art. Specially trained priests of the Kongo in the Democratic Republic of Congo use a type of carved wooden statue called a *nkisi nkondi* (FIG. 2.9). The name means something like "hunter" and is used because the priests use such works to "hunt" for solutions to village problems and search for wrongdoers, including those who do not keep sworn oaths. A good "hunter" can also solve legal matters, counsel married couples, control the destructive powers of nature, and protect a village from outside

2.7 *Mvuala* (staff handle). Angola/The Democratic Republic of Congo, Solongo. 19th or 20th century CE. Ivory, height 4¹/₄" (11 cm). Private Collection, Brussels

2.8 Figure of the "Civilizing Hero" Chibunda Ilunga. Angola/The Democratic Republic of Congo, Chokwe. 19th–20th century. Wood and human hair

enemies. Not all "hunters" are human figures; some are wild animals belonging to the ancestral spirits who could mediate between the living and the dead.

The most potent "hunter" images cannot be stored in ordinary houses; they are carefully guarded by their priest-owners, who know how to unleash and direct their powers. After receiving the carved body and head of a "hunter" from a sculptor, the priest begins this process by putting medicines and fetishes in the container on top of the head and in the box over the stomach. These fetishes may include relics of dead ancestors or bits of clay from a cemetery that help the priest and "hunter" contact the spirits of the dead. The priest may also give the "hunter" a headdress and attach horns, snake heads, or beads to it, drive nails, blades, and other sharp objects into its body, and attach miniature images of the musical instruments the priest will play in the rituals when he unleashes the powers of the "hunter."

A client asking a priest to unleash the power of his "hunter" will swear an oath before the figure and thrust a nail or blade into its body to bind him/herself with the spiritual forces residing in the statue. Nails are usually not driven into the face or the box over the hole in the torso where potent magical ingredients are stored to attract the spirits. If an animal has been stolen, bits of its hair or a rag the animal has touched may be attached to the "hunter" so it will know what it is being asked to find.

Pounding new nails, blades and other bits of metal into a *nkisi nkondi*, invoking it with strong and colorful language, and at times, insulting the "hunter" by questioning its powers, are supposed to anger the "hunter" and bring it into action, searching for answers or attacking the wrongdoer. Sometimes the metal pieces are removed after the "hunter figure" has found a solution to a given problem. The large number of skewers on the body of the "hunter" and the open holes where old ones have been removed or fallen out show how often the figure was called upon to work its powers and bear testimony to its effectiveness as a "hunter."

As nails and blades are driven into a "hunter" searching for an offender, the Kongo believe that the wrongdoer will begin to suffer intense pain. Thus, someone suffering from a headache or body pains may suspect that an enemy is at work with a priest and "hunter." He or she may then consult another priest with a proven "hunter" to perform a curing ceremony, prescribe medicines, and alleviate the pain.

Although colonial administrators attempted to repress their use after 1920, some "hunters" remain at work today. Many others, with their rough, prickly cloaks of highly

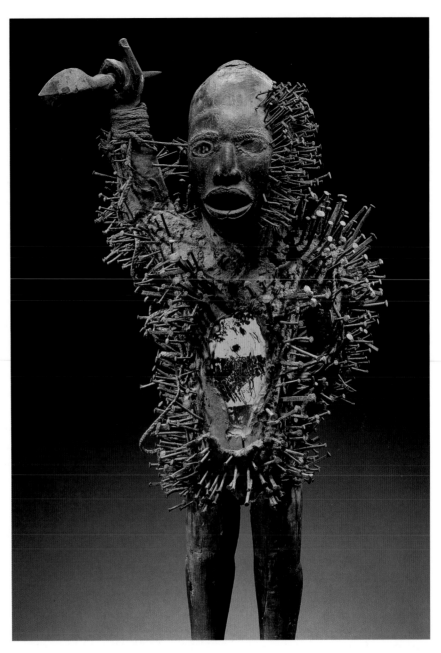

2.9 *Nkisi nkondi* ("hunter figure"). The Democratic Republic of Congo, Kongo. Collected 1905. Wood, metal, glass, and mixed media; height 38" (97 cm). Barbier-Müller Collection, Geneva

*Any attempt to interpret the Nok
figures illustrates the difficulties
encountered by archaeologists
working with early materials for
which there are no written records.
Images depicting human
deformities or diseases may
possibly have been used in curing
ceremonies and the double-headed
figures could express the
male/female duality in nature.
Archaeologists have also
hypothesized that the figures
represent important leaders, revered
ancestors, or mythological figures
that might have been used in
connection with ancestral and
funerary ceremonies. Further, they
could have been set on finials over
shrines, on altars, or, in some
cases, possibly worn as pendants.
To add to the list of unknowns, we
cannot determine why the style
died out or exactly when and how
the Nok techniques of sculpture
were passed on (if indeed they
were) to later groups in Nigeria.*

decorative skewers, attracted art collectors and have been preserved in museums. However, the full impact and meaning of such pieces cannot be fully appreciated outside the contexts in which they were originally used, along with songs, dances, and sacrifices and the spirit of belief that surrounded them among the Kongo.

WEST AFRICA

The most important art-producing areas in West Africa lie along the coast from Cameroon to Senegal and inland around the upper Niger River in Mali and Mauritania. Scholars continue to debate whether the ironworking technology that spread west from the modern Nigeria–Cameroon border around 500 BCE was imported or developed in that region. With iron tools, it was possible to clear the forest and build productive farms. As the food production increased and the population grew, some groups became urbanized and developed highly specialized art and craft traditions. Many of the best-known African works of art come from the sites of Ile-Ife and Benin in Nigeria, the Cameroon, and Djenné in Mali.

NIGERIA

Nigeria has been home to a long succession of important styles of sculpture in which the artists explored ways to represent realistic and idealized images of the human head and figure. Following the decline of the widespread Nok tradition (c. 500 BCE–200 CE) of making modeled and fired clay sculptures in central Nigeria, the metal sculptors in the sites of Igbo Ukwu, Ile-Ife (Yoruba), and Benin (Edo) produced a long series of spectacular heads, some of which may be portraits of their rulers. To this day, the Yoruba people have continued to produce important works of art in the ancient Nigerian traditions.

Nok

The Nok style is named for the type-site in northern Nigeria where the first examples of the style were found. Most of the figures are human, but the artists also portrayed snakes, monkeys, elephants, and rams. The Nok people grew grains and used bellows with clay nozzles to ventilate furnaces that were hot enough to fire clay and smelt metal ores. Any related art forms that they may have produced in wood or other perishable materials have long since perished.

Although the figurines may have been used in shrines, on altars, or deposited in graves, few pieces have been found in these original ritual contexts. The figurines appear to have been washed out of their original settings by floods and no complete figures have been recovered. All known Nok figures have large heads and short stout bodies, the largest of which (about four feet tall) have nearly lifesize heads. These heads were made by hand, without the use of molds, and later joined with bodies. The scale of the heads may reflect a later, widespread African belief that the head, as the site of one's individuality, is the spiritual essence of the body.

The Nok style contains a number of substyles that may represent regional variations and formal changes that took place over the centuries. Within these stylistic variations, most Nok heads share a number of basic features (FIG. 2.10). The pupils in their eyes are usually deep round holes ringed with triangular or circular eyelids. Mouths are normally pursed or open but teeth are seldom shown. Noses may have wide perforated nostrils. Nok sculptors show a preference for closely matched sets of crescent-shaped lines, gently swelling volumes, and smooth, well-finished surfaces.

Lost Wax Metal Casting

The artists of Nigeria were skilled in the use of the lost wax method of casting (in French *cire perdue*) large hollow figures in bronze (composed of copper and tin), brass (copper and zinc), and related alloys. The process involves a series of important steps (see FIG. 2.11). First, an inner mold closely resembling the shape of the desired piece, such as a head, is made out of heat-resistant clay. The artists then apply a layer of wax to the clay and detail it to make the desired image. After installing a set of wax rods and a drain cup beneath the head, to allow the wax to drain, the wax and clay core are encased in a thick outer clay mold. When it has dried, the mold is heated so the wax melts, drains, and leaves a thin open space between the inner and outer molds. The mold is then inverted and hot molten metal in a liquid state is poured in through the drain and cavities left by the wax rods to fill the spaces where the wax image of the head was "lost." Once the metal cools the inner and outer clay molds are removed revealing the metallic replica of the wax image. The drain rods (now cast in metal) are cut away, along with any other unwanted projections and the piece is detailed to create the finished work. Since the mold is destroyed while removing the head, multiple copies of the image cannot be made by this method of casting.

While jewelry and small figurines may be cast in solid metal, the lost wax, hollow-casting method presents certain advantages when working on a larger scale. The weight and expense of a solid bronze head would be excessive and large masses of solid bronze tend to crack and distort while cooling. Traditionally, thin-walled cast bronzes, such as the early Benin pieces in Nigeria, have been much admired for their lightness and technical virtuosity.

Ile-Ife

From c. 1200 to c. 1400 CE, the Yoruba capital at Ile-Ife was the most important art center in Nigeria. This period is called the Pavement Era because the Yoruba paved certain rectangular areas within the city with rows of stones and pottery fragments laid in herringbone patterns. Libations may have been poured into broken vessels in the middle of the paved areas during rituals, in the same way that the rituals are carried out in Yoruba lodges today. Raised platforms at the end of the pavement were probably altars where works of art, including memorial images of the heads of divine rulers and important ancestors, were displayed (FIG. 2.11). The head, associated in Yoruba thought with knowledge, character, and judgment, was the most important image in their art. The possible sources of the Ile-Ife style in the immediate area are many, but none of them is sufficient to explain the blend of realism and idealism, the sense of beauty, developed by the Yoruba in Ile-Ife.

The Yoruba developed their style of portraiture making terracotta, stone, and wooden heads in the pre-Pavement Era and later, they applied these skills to the creation of cast metal portrait heads and figures. They used the lost wax method of casting large hollow figures in bronze (composed of copper and tin), brass (copper and zinc), and related alloys. (See "*Materials and Techniques*: Lost Wax Metal Casting," above.) Heads such as figure 2.11, which was buried with other brass objects at the back of the king's palace at Ile-Ife, may have been used to display the royal regalia in the annual rites of renewal and other ceremonies of royal ancestor worship. The small holes dotting the face were probably used to attach a wig, crown, and neck rings. A beaded veil covering the face may have been attached to a crown. Such veils are still worn by Yoruba leaders to shield their subjects from the power of their voice and presence. The dramatic quality of the man's narrow, piercing eyes, the majesty of his bearing, and his "youthfulness" (*iwa odomode*) suggested by the smooth features, combine to

2.11 Head of an *Oni* (king). From the Wunmonije Compound in Ile-Ife. 11–12th century CE. Zinc and brass; height 12¼" (31 cm). National Commission for Museums and Monuments, Nigeria

2.12 The ruler of Orangun-Ila, Airowayoye I, with a beaded scepter, crown, veil, and foot stool. Yoruba, Nigeria. 1977

create an idealized image of the Ile-Ife ruler. In a system of thought that interweaves aesthetics with moral precepts, this ideal stresses the traditional Yoruba themes of honor, and respect, the value of one's "inner qualities" (*inu*) over the "exterior self" (*ode*). In essence, modern Yoruba aesthetics center around the phrase *iwa l'ewa* ("character is beauty," or "essential nature is beauty").

As the late nineteenth-century Yoruba kings began to lose some of their power, the beadwork on their clothing, scepters, and crowns became increasingly elaborate. A guild of beadworkers linked to Obalufon (god of beadworking, weaving, and coronations) or Olokun (god of the sea) worked for the Yoruba royalty or priesthood. The beaded veil covering the face of a Yoruba ruler, Airowayoye I of Orangun-Ila, protects the viewers from the power of his eyes (FIG. 2.12). It hangs from the edges of his crown, the most important part of his regalia, which is tall to emphasize his head, the central place of his power, character, and beauty. Medicines and other ritually potent materials are placed inside such crowns to add to the ruler's power, which he must share with the "mothers" or witches represented by the bird heads on his tall conical crown. Yoruba kings do not have absolute authority over their domains. Groups of respected Yoruba elders select the kings-to-be from the royal families, review them periodically, and have the power to dispose of them.

2.13 Benin, Nigeria. Plan of Benin City in the 19th century

Benin

Before the Yoruba city of Ile-Ife ceased to be a major art center, in the fifteenth century, its sculptural traditions spread to a number of neighboring sites. These included Esie, Owo, and Benin, 150 miles (240 km) to the southeast, the capital of a highly centralized kingdom of Edo-speakers ruled by a "divine king" (*Oba*). More is known about the art and history of Benin than about any other locality in sub-Sahara Africa.

When the Portuguese arrived in 1486, Benin was a thriving metropolitan center with palace complexes housing altars decorated with metal bells, figures, heads, wooden musical instruments, and carved ivory tusks. Figure 2.13 is a plan of Benin City as it was in the nineteenth century. The inner city—housing the king's palace, house of the town chief, and the workshops of the royal metal, ivory, wood, and leather guilds—was surrounded by

2.14 View of Benin City illustrated in Olfert Dapper's *Naukeurige Beschrijvinge der Afrikaensche*, Gewesten, 1668

a wall with nine gates and a moat. The palace, at the hub of a network of wide avenues leading in all directions, faced north, the world direction associated with Ogiwu, god of thunder and power, and overlooked the artists' workshops. Royal councilors, descendants of the first dynasty of kings (the Ogiso "Rulers of the Sky," c. 900–1250), and keepers of the ancient traditions, lived in compounds within the outer city. The palace of the queen mother, a very important councilor to her son (but who was not allowed to see him once he became king), was outside the outer city wall.

An image of a royal procession leaving the palace, based on early descriptions and drawings of the inner city, shows the Benin king in a leopard-skin cloak on horseback with his entourage (FIG. 2.14). They are led by leopards on leashes and drummers followed by members of the court around

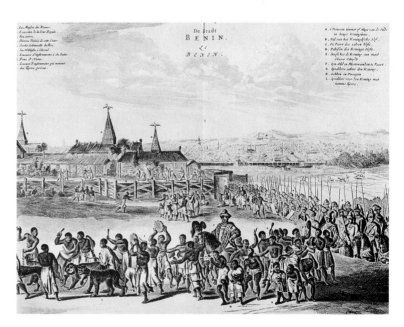

2.15 Altar dedicated to *Oba* Ovonramwen. Benin, Nigeria. c. 1914

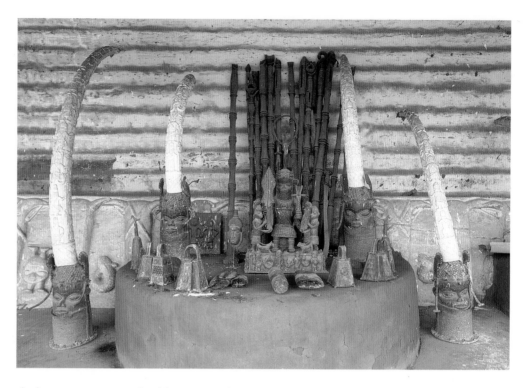

the king, musicians, and nobles wearing leopardskins. In the background, the large metal birds on the roof tops of the palace may symbolize the king's role as the overseer of the destiny of his people. Giant sculptured pythons (not visible in the illustration) descending the length of these roofs with their mouths over doorways link the sky and earth and suggest that those entering the world of the palace (symbolically entering the python) are moving from the everyday world to another place and time. Inside the palace were altars to the kings and queens, and brass relief plaques on the pillars, rafters, and doors depicting such important palace activities as hunting, war, and other royal ceremonies. Foreign visitors to Benin before it was destroyed at the end of the nineteenth century talked of its long, wide streets and said its palace was the grandest in West Africa.

The earliest Benin artists working for the first Benin dynasty of kings predating the thirteenth century may have made terracotta heads in the manner of their contemporaries at Ile-Ife. These heads appear to have been the models for the later bronze heads commissioned by artists working for the current dynasty founded in the thirteenth century by Oranmiyan from Ile-Ife. Around 1300, Oguola, the fourth *Oba* in that Ife-Benin dynasty, asked the king of Ile-Ife to send him a master metalcaster. Iguegha, the artist Oguola received from Ile-Ife, is still worshiped by the members of the *Iguneromwon*, the Benin bronzecasters' guild that bears his name. Oguola and his successors (to modern times) commissioned members of the *Iguneromwon* to make a wide variety of important ritual items for their royal altars (FIG. 2.15). With its durability, metal was the ideal material for images of the *Obas* and other royal personages, who were believed to be spiritual as well as physical beings with eternal lives.

The sculptural styles at Benin can be observed as they change over a period of four centuries. Although legend says brass heads were cast during the reign of *Oba* Oguola (late fourteenth century), the earliest known heads may be no earlier than the fifteenth century. Traditionally, all of the bronzes and ivories in Benin produced by members of royal guilds belonged to the divine *Oba*, who could loan or parcel them out as favors to his nobles. Even the chiefs and leaders of the bronzecasting guild had to be content with terracotta or wooden heads on their family altars. Altars in the palace were maintained by the specially trained *Iwebo*, keepers of the royal regalia. The palace with its altars represented the physical and spiritual center of the Benin kingdom. Upon the death of an *Oba*, his

successor commissioned artists to make memorial images of him and his family for a new altar. Through these images, the living *Oba* paid homage to his ancestors and maintained the Benin traditions of leadership. This ancient tradition of ancestor veneration, in which deceased leaders continued to have power over the living, remains a vital force in many modern African religions.

The smallest, most highly naturalistic, and thinly cast heads appear to have been made in the Early Period (1400–1500 CE) under strong influences from Ile-Ife. Traditionally, these thin-walled bronzes have been much admired for their lightness and technical virtuosity. Heads became more stylized in the Middle Period (1550–1700), and in the Late Period (1700–1897) they are larger, heavier, and even more highly stylized. While modern collectors prize the early thin-walled pieces for the excellence of their casting, the thickness of the later works may have been intentional, to reflect the wealth the Benin *Obas* accumulated through trade with Europe.

The *Queen Mother* exemplifies the sophistication and dignity of the Early Period of Benin art (FIG. 2.16). She wears royal coral-bead necklaces and an elegant peaked headdress that sweeps upward in a curve that echoes the forward thrust of her lower face, uniting the profile of the work in a single dominant C-shaped movement. Even in such early works, the Benin sculptors have abandoned some of the realism of Ile-Ife to create idealized or stylized images of such important nobles. The development of these images of power parallels the Benin perfection of the methods of metalcasting. In terms of their technical excellence, the light, thin-walled early Benin bronzes are comparable to the finest works of the ancient Greco-Roman and Renaissance metalsmiths.

The altars remained intact until the palace was burned by a British naval expedition in 1897. The palace collection was confiscated and sold without being fully documented, so it is difficult to tell which works were originally grouped together on altars. Later, some of the altars were restored, and the *Oba* was reinstated in 1914. The Benin dynasty, representing one of the longest reigns in human history, continues to rule to this day. In 1979, Eredia-Uwa was installed as the thirty-eighth *Oba* in the dynasty begun by Oranmiyan in the thirteenth century.

Altars remain very important focal points of religious devotion and activities among Edo-speaking people today. Most households have at least one altar-shrine to Olokun ("Owner of ocean"), god of the seas, wealth, and fertility. Worshipers gather at an altar of Olokun to give prayers and ask for his blessings. The Edo believe that he can increase a family's wealth and raise a woman's social status in the community by giving her more children. The most basic altars are equipped with waterpots, miniature canoes with paddles (symbolizing social mobility), white chalk markings, coral beads, and cowrie shells (a form of currency and symbol of prosperity). In wealthy homes, altars may include carved wooden images of Olokun enthroned in his palace beneath the sea along with his attendants and wives, one of whom may be the central figure in the installation. In figure 2.17, Madame Agbonavbare of Benin, wearing a ritual dress decorated with cowrie shells, is seated on the dance floor before her Olokun shrine. This includes a variety of statues with facial and body features reflecting the traditional Nigerian styles of sculpture, and strings of cowrie beads hanging from the ceiling, and it features the colors red (sacrifice and blood) and white (purity).

Someone who dreams about swimming in the ocean may be a candidate for the Olokun priesthood. Following a period of instruction and initiation, a new priest or priestess is expected to create all the objects needed for an altar. He or she must also infuse all of these objects with life forces and spiritual powers and create songs, dances, costumes, and prayers that

2.16 *Queen Mother.* Nigeria, Benin. Early 16th century CE. Bronze, lifesize. British Museum, London

are powerful enough to reach the spiritual world, attract Olokun, and ensure his blessings. In this process, each priest(ess) has the "artistic license" to be a creative, multimedia performance artist. Before a ritual, the area around the altar must be swept clean and the objects on it will be purified with medicines. A priestess such as Madame Agbonavbare will also be purified and robed before she conducts a ritual. Dancing with animated, acrobatic spinning motions, she will enter a trance to attract the spirits to the dance floor and altar. The ritual will end with slower, resting songs as the spirits depart and the priestess returns to the material world. Altars to the African gods and goddesses are also important in the Americas, from Brazil through the Caribbean to the United States.

The Modern Yoruba and their Neighbors

Although Ile-Ife declined as a major center of the arts, the Yoruba courts continued to commission important works of art. Olowe (c. 1860–1938) spent much of his career at the Yoruba palace at Ise directing up to fifteen assistants, carving posts, chairs, doors, bowls, drums and other ritual objects for his royal patrons. He created his most famous work, a set of doors (1910–1914), while working for the regional king of Ikere Ekiti (FIG. 2.18). The doors separated a veranda where the king was seated during certain ceremonials from a shrine displaying an image of the king's head.

2.17 Madame Agbonavbare of Benin wearing a ritual dress decorated with cowrie shells, seated before her Olokun shrine

The ten panels on the doors document the visit of the British commissioner of the Ondo province, Captain Ambrose, who visited the Ikere Ekiti court in 1897. In the fourth register, the enthroned king with a beaded crown and his principal wife on the left await the arrival of Ambrose (to the right). The commissioner is riding in a litter carried by African porters and accompanied by guards, a flautist, and shackled pack bearers. Above the king we see his armed bodyguards; below are military men and more of the king's wives, who appear as witches, symbolizing the king's power. Shortly after Captain Ambrose's visit, a civil war broke out among the Yoruba and the British intervened, establishing a colonial government. Thus, Olowe's door documents a bittersweet moment in Yoruba history, a diplomatic prelude to their takeover by Britain.

Working within the Yoruba craft traditions, Olowe has developed a personal style characterized by the use of figures in high relief, decorative backgrounds, and well-structured rhythms that integrate the narrative content with the shape of the doors. To document the event, Olowe combines the traditional Yoruba figure and face types with the spectacle of the newcomers to express the dignity of his ruler on the eve of the Yoruba's political and social crisis. Olowe's doors were shipped to England and shown at the British Empire Exhibition, London, in 1924. Later, in exchange for the doors, the king, whom Olowe shows seated on a spindly folding chair, received a British-made throne.

The much-studied *Gelede* ritual of the Yoruba is performed to serve and honor the women elders or "mothers," ancestors, and deities. As guardians of society, the elders have powers that go far beyond those of fertility and may be equal to or greater than those of the gods. *Gelede* rituals begin with the night songs and dances performed in the marketplace, an area under the authority of a woman on the king's council of chiefs. Many women

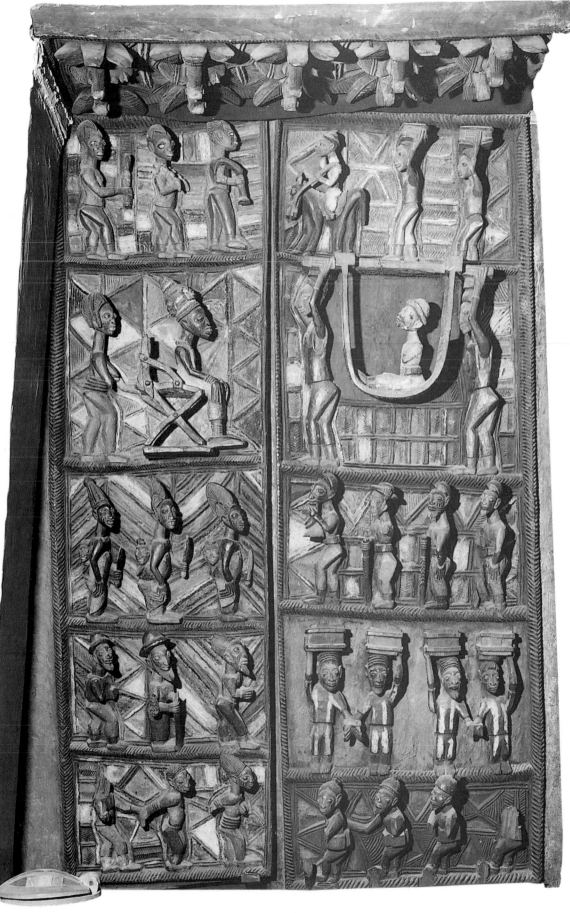

2.18 Olowe of Ise, door from the king's palace at Ikere, Yoruba, Nigeria. 1910–14. Wood, height c. 6' (1.83 cm). The British Museum, London

work in the market, where they can accumulate wealth and status independently from their husbands. The market, at the heart of society, is a Yoruba symbol for the transitory nature of worldly existence. It is also a place of transformation where spirits can enter our phenomenal world and the "mothers" can make contact with the other world.

The calmness of the masks used in the night songs and dances represents the "inner sight" (*ori inu*) and reflects the balance and patience of the "mothers" (see FIG. 1.1). The Yoruba believe that the *ori inu* is the seat of one's "essential nature" (*iwa*), "spiritual essence" or "individuality" (*iponri*), and the "life force" (*ase*) that pervades the cosmos. The mask contrasts strongly with the rich, colorful detailing of the performers' costumes and the rhythmic energy of the music to which the pairs of dancers move as they recreate the movements of the gods.

The excitement of the first night portion of the ritual reaches a climax with the appearance of a male performer, Oro Efe, who chants and dances in stately sweeping, curving, and spiral movements. With an authority granted by the *Iyalase*, the woman head of the ritual and the "mothers," Oro Efe is able to speak on any matter with total immunity from communal sanctions. At this point and elsewhere in the performance, the *Gelede* has an educational function as it reinforces traditional values, including the role of men and women in Yoruba life. And, as the *Gelede* honors and pampers the powerful "mothers," the ceremonials also attempt to ensure peace within the society by harnessing the patience and indulgence of the "mothers" while "cooling" their potential destructive powers.

The costumes worn in the later afternoon portions of the *Gelede* ritual, in which dancers compete for the attention of the audience, are highly elaborate images of power. In recent years, some of them have incorporated contemporary images such as airplanes, automobiles,

2.19 Igbo *mbari* house. Owerri, Lower Nigeria. Photograph 1982

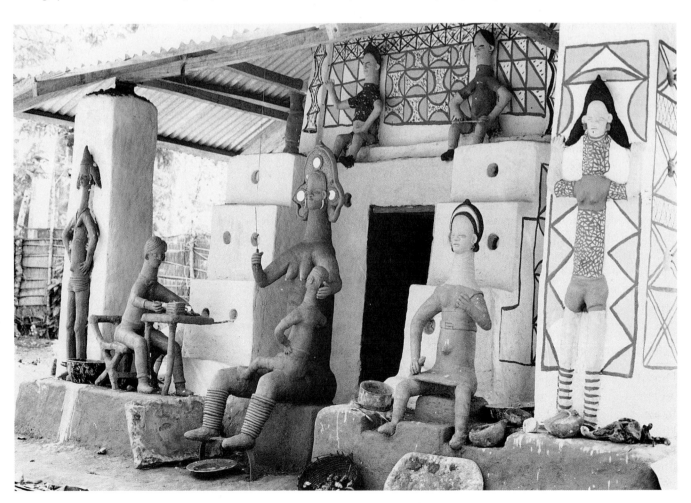

motorcycles, and tourists with cameras. As a lavish, multimedia and interactive musical and dance production that invites and receives audience participation, the *Gelede* is honored in a well-known Yoruba saying, "The eyes that have seen *Gelede* have seen the ultimate spectacle."

In lower Nigeria, among the Igbo around Owerri, complex rituals accompany every state of planning and construction of *mbari* houses, or shrines for Ala, their earth goddess (FIG. 2.19). Each stage of the project, from the decision to build the house to its final unveiling, is accompanied by lengthy and elaborate rituals of offerings and prayers. Communities may build a *mbari* house if they have had poor rains, bad harvests, or if people have died suddenly for no apparent reason. These events may indicate that Ala has been neglected, unhappy, and in need of propitiation.

The decision to build a *mbari* house is a serious one; its construction can be very expensive, requiring the full-time services of many people for up to two years. The antiquity of this idea is not known but the rituals and art forms were fully developed by 1900. Since 1946, when the largest recorded house (with 230 sculptures) was built, the number and size of the *mbari* houses have declined as more Igbo have become Christians and started to attend schools in Europe.

Once the community leaders decide that a house must be built, they select a sacred site and commission an artist/overseer to work with the local priests and diviners. An Igbo artist (*onyeoka*, "person of skill") normally serves a six- to ten-year apprenticeship and works with a recognized artist on about fifteen *mbari* houses before becoming an independent master. Even then, an artist will normally have to supplement his income with part-time work such as farming.

Workers are selected from each family or lineage and sequestered in a special compound until the house is finished. The houses are built of clay, wood, and thatch and consist mainly of porches or niches in which sculptured clay figures can be publicly displayed. In addition to the members of Ala's large family, the sculptures may represent generic types from the community. Recently, these have included policemen (to protect the house), football players, boxers, telephone operators, motorcyclists, and other contemporary character types. After the last and most important statue is finished, that of Ala, the sculptures and house are painted. Murals may be decorative, with large bold geometric forms, or they can represent mythological themes related to Ala.

Before the *mbari* house is unveiled to the public, a group of community leaders pay a formal visit to critique it. If they find cracks in the sculptures or smudges in the painting, they will insist that the *onyeoka* make certain changes. Their motives are basic; they want Ala to be proud of her house, to be happy, and return the favor by providing for the well-being of the community. The quality of an artist's work is judged on the reaction of those who see it and of Ala, who may punish or reward the town. If Ala is pleased and the community prospers, the artist may receive well-paying commissions in the future. Once the *mbari* is finished, the house and sculptures belong to the gods and are not to be repaired by human hands. In time, they will decay and return to the earth to which they were dedicated.

CAMEROON

Directly east of Nigeria, the Cameroon grasslands with their majestic volcanic mountains are home to many kingdoms, including the Bamum. In the early twentieth century, it was ruled by a great patron of the arts, King (*Fon*) Njoya (c. 1870–1933). Seeing the power of the Islamic kingdoms and Christian colonialists in Africa, Njoya combined elements of their religions with indigenous Bamum thought to create new spiritual doctrines for his people living in this period of great change. While he looked to the future, Njoya also documented the pre-colonial learning of his culture, established a school to teach it, and restored his

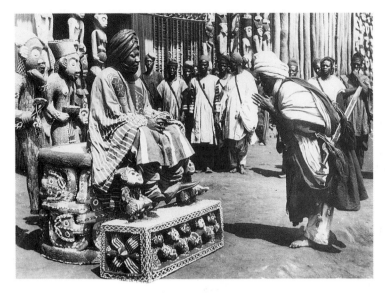

father's enormous late nineteenth-century palace at Foumban.

Figure 2.20 shows Njoya seated on a throne at Foumban in 1912, holding an audience with a man who bows and holds his hand in front of his mouth so his breath and saliva will not reach the king. This type of Bamum throne with figures behind the king's seat and a footrest can best be studied by looking at a very well-preserved throne of this period which Njoya gave to Wilhelm II of Germany in 1908 (FIG. 2.21). The figures in the back are twins, court guardians, and fertility symbols. The male on the right holds a ritual drinking horn while the female carries an offering bowl, shapes resembling a phallus and womb, symbolizing the king's role as father of his people. Armed guards on the footrest stand over images of councilors, symbolizing Njoya's use of traditional wisdom in his rule. The double-headed serpents on the seat symbolize his strength in battle. The thick covering of cowrie shells, a form of currency, and bright, reflective beads represent prosperity and the king's duty to use his strength and wisdom to bring good fortune to his people.

Thrones such as this were kept inside the palace and moved by specially appointed royal throne bearers when the king held audiences such as this in front of the palace. When Njoya restored the palace, he added rows of sculptured figures of men and women wearing royal headdresses to the facade around this portal. Passing through the portals, visitors entered an enormous complex of courtyards and buildings covering nearly twenty acres and housing about 3,000 people—the king's wives, children, servants, and court officials (FIG. 2.22). The central areas of the palace belonged to the king, those on the right to his wives and the princes, and the left section was the administrative center of his government. In each section, the most private areas associated with the royal family and their rituals were located toward the back of the palace. The most sacred areas were the royal cemetery, throne room, and a room near the king's bedroom where the skulls of the royal ancestors were kept along with the most sacred ritual objects used in court ceremonials.

Spacious as this palace was, in 1915 Njoya commissioned one of his sons to build him another palace at Foumban, a three-story European-

2.20 King Njoya seated on a throne in front of portal of his palace at Foumban, Cameroon. 1912

2.21 Throne of King Nsa'ngu. Cameroon, Bamum. Late 19th century CE. Wood, glass beads, and cowrie shells; height 68½" (1.74 m). Staatliche Museen zu Berlin, Preussischer Kulturbesitz, Museum für Völkerkunde, Berlin

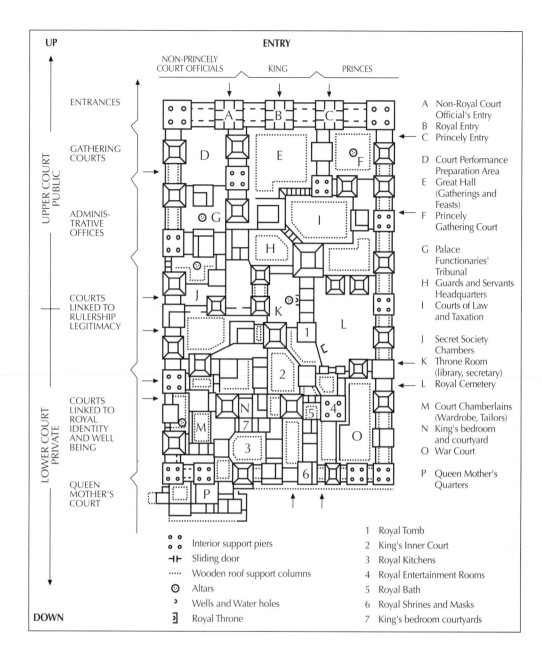

Within the figure, the following labels appear:

UP

ENTRY

NON-PRINCELY COURT OFFICIALS KING PRINCES

ENTRANCES

GATHERING COURTS

ADMINISTRATIVE OFFICES

COURTS LINKED TO RULERSHIP LEGITIMACY

COURTS LINKED TO ROYAL IDENTITY AND WELL BEING

QUEEN MOTHER'S COURT

UPPER COURT PUBLIC

LOWER COURT PRIVATE

DOWN

A Non-Royal Court Official's Entry
B Royal Entry
C Princely Entry
D Court Performance Preparation Area
E Great Hall (Gatherings and Feasts)
F Princely Gathering Court
G Palace Functionaries' Tribunal
H Guards and Servants Headquarters
I Courts of Law and Taxation
J Secret Society Chambers
K Throne Room (library, secretary)
L Royal Cemetery
M Court Chamberlains (Wardrobe, Tailors)
N King's bedroom and courtyard
O War Court
P Queen Mother's Quarters

○ ○
○ ○ Interior support piers
⊣⊢ Sliding door
····· Wooden roof support columns
⊙ Altars
ᴈ Wells and Water holes
Ǝ Royal Throne

1 Royal Tomb
2 King's Inner Court
3 Royal Kitchens
4 Royal Entertainment Rooms
5 Royal Bath
6 Royal Shrines and Masks
7 King's bedroom courtyards

style palace with Roman and Islamic-style arches. Njoya lived there until 1931, when the French placed him under house arrest at the capital, Yaounde, where he died two years later.

MALI AND MAURITANIA

From the eighth century CE to the sixteenth, three large and important kingdoms ruled the upper Niger River drainage area in present-day Mali and nearby Mauritania, also known as the western Sudan: Ghana (from the eighth century to the eleventh), Mali (from the thirteenth century to the sixteenth), and Songhay (fifteenth and sixteenth centuries). Ghana was already a powerful kingdom when the Islamic faith arrived there in the eighth century with the caravans of traders from Tunisia and Egypt in North Africa carrying textiles, metalworking, and ceramics which they exchanged for African gold and ivory (See "*Religion*: Islamic Religion and Thought," page 50). Before the discovery of the Americas in the sixteenth century, West Africa was the major source of gold in Europe. As the economy of Ghana flourished,

Islamic Religion and Thought

Followers of the Islamic faith (from *Islam*, an Arabic word meaning "submission to the will of God") believe in Allah ("the One God") and his prophet Muhammad (c. 570–632 CE). They are known as *Muslims* (from the Arabic word meaning "one who submits to the will of Allah"). Allah revealed his timeless wisdom to Muhammad in Arabic through the *Qu'ran,* or *Koran* ("revelation" or "recitation").

In Islamic thought, Muhammad (or Mohammed) is the last of a long line of prophets that includes those in the Old Testament and Jesus Christ. In his youth, Muhammad lived in Mecca, home of the *Ka'ba,* a large cubic shrine housing a black stone. According to Muslim legend, the archangel Jibra'il (Gabriel) gave this stone to Isma'il, son of Abraham. In Muhammad's youth, there were many fetishes and statues attached to the shrine, including those of a regional god, Allah, whom the *Hanifa* (Arabic theologians) associated with the god of Israel and Christendom.

In 610, Muhammad began to have visions in which Gabriel revealed the wisdom of Allah to him. When Muhammad began preaching that Allah was the one supreme god, he was forced to flee Mecca and take refuge in Medinet-en-Nabi ("City of the Prophet"), now known as Medina. The Muslims count their lunar years from the date of this flight, the *hijra* or *hegira,* 622 CE, in the Western calendar. Eight years later, Muhammad and his army of zealous converts captured Mecca, removed the fetishes and statues from the *Ka'ba,* and rededicated it to Allah.

Regarding art, the Koran says that "statues" or "idols" (*al-ansab*) "are a crime originating in Satan" and that "God is the creator of everything." Artists who create images or idols are guilty of "crimes" because they are wrongfully usurping the power of Allah. In some Islamic traditions, God will ask artists to create living images at the end of the world—but not before. This thinking may reflect the prohibition against making "graven" images in the Second Commandment of the Hebrews and Christians: "Thou shalt not make to thyself a graven thing, nor the likeness of anything that is in heaven above, or in the earth beneath, nor of those things that are in the waters under the earth" (Exodus 20: 4). These important, longstanding questions regarding figural imagery in art still remain important in contemporary Islamic culture.

With these prohibitions, Muslim art is usually "aniconic" or nonfigural, and emphasizes calligraphy, the embellished words of Allah in the Koran, and decorative forms that often celebrate the glory of Allah and his watery, garden paradise in the other world. Combining a plethora of swirls, guilloches, floral and vegetal forms, wreaths, and rosettes, the Islamic artists created decorative patterns of unrivaled richness.

the trade-rich cities there became important centers for Muslim learning and culture. Arab chroniclers tell how "the divine Ghana" or king presiding in a domed pavilion wore gold ornaments, had weapons embossed in gold, and rode horses with gold inlay on their hooves.

While the African leaders fused elements of the Muslim religion with their own beliefs and values, artists moving from city to city working for these leaders did much the same with the arts. Perhaps this blending of Islamic art and thought can best be demonstrated by looking at the regional African variety of the Islamic mosque (in Arabic, *masjid,* or "place of prostration in prayer").

The earliest mosques were modeled after the courtyard of Muhammad's home in Medina, which had a covered porch along the south wall facing Mecca, under which Muhammad stood when addressing his congregation. Muhammad's followers faced him and the wall, directing their prayers to Allah toward Mecca. Later mosques such as those in North Africa at the other end of the trans-Saharan caravan routes built by the Fatimid rulers (910–1171 CE) were much larger than the Prophet's home, but they preserved its basic plan. The al-Hakim mosque in Cairo (FIG. 2.23) is a walled courtyard with five rows of columns (an enlarged version of Muhammad's porch) in front of the wall facing Mecca. In the tradition

of Muhammad, learned men addressed the congregation at this mosque from a pulpit along that wall. Criers called the Muslims to prayer five times a day from the tall towers on the corners of the mosque known as *minarets* (from an Arabic word meaning "lighthouses"). While this and other Fatimid mosques of this period were decorated with stone, wood and stucco reliefs, following the Muslim custom, the reliefs do not represent human figures. Allah is present through his spoken and written words in the Koran and the symbols of the Muslim Paradise.

The orientation, general floor plan, and towers of the Great Mosque at Djenne resemble those of the al-Hakim and other Fatimid mosques in North Africa (FIG. 2.24). Many later mosques in the region were based on the original Djenne mosque, which may have been much more lavishly decorated than the second version (c. 1835) and the modern mosque (1906–1907) that exists today. All three mosques were made of puddled clay and adobe bricks, a mixture of clay, straw or other binders set in molds and dried in the sun. Sun-dried bricks are not as durable as bricks fired at higher temperatures in kilns. The protruding wooden poles that give the walls and towers of the mosque a prickly appearance are permanent and functional; they support the workers who replaster it each spring at an annual festival to protect the clay from erosion by wind and rain. The projecting poles also relieve the flatness of the mosque's outer face, giving it a decorative quality that reflects the traditional Islamic delight in surfaces embellished with richly colored and textured patterns. Other public buildings and houses in this area have similar shapes and decorations.

The entrance to the right resembles the carved wooden mask types used in this area and the conical shapes are highly functional and durable ones, related more closely to giant African termite mounds than earlier Islamic towers. The tapered towers with their rounded edges and conical summits, the strongly accented rhythms of the projecting buttresses, the

2.23 Reconstruction drawing of the al-Hakim mosque, Cairo. 990 and 1013 CE

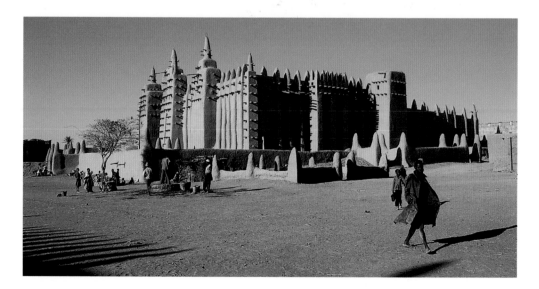

2.24 The Great Mosque, Djenne, Mali. 14th century CE

2.25 Male *Chi Wara* Antelope Headdress. Bamana, Mali. 19th–20th century CE. Wood

To quote Robert Ferris Thompson in African Art in Motion, *"Africa thus introduces a different art history, a history of danced art, defined in the blending of movement and sculpture, textiles, and other forms, bringing into being their own inherent goodness and vitality. Dance can complete the transformation of a cryptic object into doctrine; dance redoubles the strength of visual presence; dance spans time and space . . . dance extends the impact of a work of art to make a brilliant image seem more brilliant than could be imagined by ordinary men."*

textured surfaces, and the decorative effects of the protruding poles express a respect for the utilitarian character of the clay and a locally developed sense of design.

The small rural mosques in the Sudan depart even further from the Islamic prototypes in terms of floor plan and elevation to become important expressions of the local building traditions. Over the years, later mosques became progressively more sub-Saharan and less tied to Islamic prototypes. In the creation of this African–Islamic style, the builders have converted the simplest of materials, sun-baked bricks and layers of clay, into magnificent sculptural–architectural monuments. After the French, who ruled this area, built pavilions based on the mosques of Djenne and Timbuktu for a series of early twentieth-century expositions, the mosque of Djenne became a universally recognized symbol of the western Sudan.

The Islamic traditions continue to exist alongside the indigenous art and dance traditions of the Dogon (see Introduction) and other groups including the Bamana, who create a wide variety of carved wooden headdresses worn by dancers. Bamana legends explain how the *Chi Wara*, a mythic farming beast combining features of humans, the antelope, and anteater brought agriculture to the Bamana people (FIG. 2.25). Wearing antelope head-dresses, the young dancers leap and spin, imitating the graceful movements of the antelopes to invoke the favors of the fertility spirits and to instruct the members of the *Chi Wara* society in correct agricultural practices. These dances are performed by the most athletic young farmers to the accompanying music of drums and women singing praises to the ideal farmers. They are designed to ensure the success of the planting season and inspire the workers toiling in the fields.

Paired dancers with headdresses representing the male and female principles symbolize human fertility and the union of the sun (male) and earth/water (female) in agriculture. With their long, flowing raffia fringes (signifying water), the dancing *Chi Wara* couples combine the ingredients and ideals that give life to the fields. The antelope horns may represent the millet stalk, a staple food of the Bamana. Zigzag motifs along the antelope's neck can symbolize the movement of the sun from solstice to solstice or the angled patterns of the antelope's gallop.

In the ritual dances, the rhythmic energy of the open framework of forms in the headdress comes alive. The harmony of these forms becomes part of the larger context of the art, dance, music, and rituals, past and present, that encompasses the spiritual and physical worlds as the philosophy of the Bamana *Chi Wara* society is danced into motion. To Western thinkers, accustomed to looking at monumental and unmoving sculptures in heavy stone and metal, the pace of African art as it is "danced" into meaningful patterns of form is an aesthetic revelation.

CÔTE D'IVOIRE AND LIBERIA

The importance of verticality and motion is beautifully expressed by the Dan "long spirits" (*gle gbee*), dancers who perform on ten-foot (3-meter) stilts. Wearing fur turbans, flying raffia skirts, and long, brilliantly striped pants as they step, spin, and leap, the dancers perform a sacred act, heroically fighting to maintain their transcendental positions and balance against the pull of gravity and the witches. As they struggle, sometimes resting on the roofs of houses, they represent the essence of the total body dance concept of performance art in Africa. They symbolize the idea of complete involvement, the maximum strength needed to rise above the ordinary world and enter the mythic realm of the spirits.

The Dan have a term, *nyaa ka* ("moving with flair," or "looking right"), that emphasizes the importance of vitality and style in their performances. They also have more general terms for awe or terror (*gbuze*), ugliness (*ya*), and beauty (*se, li*, or *manyene*) in their arts and performances. To express their appreciation for an exceptionally fine performance, they may cry *Yaaa titi* ("bravo").

THE AFRICAN DIASPORA AND AFRICAN-AMERICAN FOLKLORE ART

The prolonged cataclysm in which the Africans were captured and exported to the Americas as slaves is known as the African Diaspora. Most of the slave trade routes ran from the western coast of Africa to the Atlantic coast of the Americas from Brazil through the Caribbean to the United States. As prisoners, the slaves departed Africa in chains, without their ceramics, wooden sculptures, metals, basketry, textiles, and other material possessions. However, they did carry some of their technical skills for working these materials with them and applied those skills as they became the working backbone of the New World plantation economy. Ship manifests often indicated that certain slaves were artisans and therefore of special value on the auction block. Because slaves received little or no compensation for their work, plantation owners exploited their skills and trained other slaves to become potters, woodworkers, metalworkers, basketmakers, and seamstresses. A plantation-trained slave was a valuable commodity on the secondary slave market. Booker T. Washington called plantations the nation's first industrial training schools.

Unfortunately, few of the African religious and art traditions survived during the acculturation of the Africans in the Americas. Slaves were trained to make utilitarian Western products and their religious practices were suppressed as they were Christianized. Many white authorities banned the production of African drums because they feared that the dances would incite riots. Also, until recently, the folk art of slaves was of little interest to serious collectors and much of it perished. There are, however, a few notable examples of African art forms that managed to survive the Diaspora.

Many of the African-Americans living on the long-isolated sea islands of South Carolina and Georgia still speak an African language called Gullah (from "Angola"). They also make baskets that closely resemble the present-day baskets of coastal West Africa, from which many of their ancestors came.

Slaves working in pottery mills or shops owned by wealthy white farmers in the southeastern states produced large quantities of wide-mouthed storage vessels decorated with olive-green, grey, and brown slips. A potter from South Carolina who signed his works "Dave" often inscribed his works with rhyming couplets. Other slave potters from this region made vessels with faces on one side. The facial expressions vary greatly; some are smiling, laughing, or singing, others are growling or malign. The white porcelain eyes and teeth of the face on the vessel in figure 2.26, resembling cowrie shells, contrast strongly with the dark brown glazed face. Faces with similar wide-eyed expressions appear on wooden statues from the Kongo in Africa, the original homeland of many South Carolina slaves. Often, vessels were broken and thrown on new graves, and it is possible that the expressive faces represent protective spirits of African origin who were believed to accompany the deceased to the other world. The face vessels have been found over a wide area west and north of the areas in the South, where they were most likely made. They may have also been carried as "protection" by runaway slaves in search of freedom following the escape routes known as the Underground Railroad.

Quilting bees or parties were important communal events on the plantations because they allowed slaves to socialize and renew some of their African ties. In quilts, the fabric in the design, the cotton interlining, and the muslin

2.26 Face vessel. Bath, South Carolina. c. 1850. Stoneware, ash glaze, height 8³/₈" (21.5 cm). Augusta Museum of History

backing are "quilted" or joined through stitchery. Some quilts with symbols that were widely understood among slaves were displayed outdoors to tell fugitives along the Underground Railroad that they had found a place of refuge. A distinctly African-American type of quilt with large patches, each representing a story, provided a kind of pictorial "Bible" for slaves, few of whom were literate. After Harriet Powers (1837–1911), a former slave, exhibited a quilt at the Cotton States and International Exposition in Atlanta, she was commissioned to produce a quilt by the wives of Atlanta University professors for the chair of the university board of trustees (FIG. 2.27). The artist explained the images on her quilt in detail when it was purchased by the Smithsonian Institution in 1898.

Five of the ten panels representing Old Testament scenes show Moses, Noah, Jonah, and Job, figures featured in black spirituals who had been delivered from their persecutors. These figures, and the general message of the quilt about suffering and salvation through Christ, reflect the post-Emancipation period preoccupation with deliverance from slavery to freedom. Other panels such as the central one, representing a shower of stars in 1833 that many observers thought heralded the end of the world and the Second Coming, represent the power of God as revealed though such apocalyptic events and the black southern folk tales that could be enjoyed in visual terms by a predominately nonliterate audience.

By the late twentieth century art critics and collectors began to pay serious attention to the African folk arts. However, the work of one very talented folk artist, James Hampton (1904–1964), was unknown to the art world during his lifetime. His life project, a spectacular assemblage known as the *Throne of the Third Heaven of the Nations' Millennium General Assembly*, was discovered in a garage in Washington, D.C., after he died (FIG. 2.28). It is a visionary image of the Second Coming based on the last book of the New Testament, the Revelation by St. John the Divine, in which God residing in the Third Heaven is surrounded by shining

2.27 Harriet Powers, pictorial quilt. c. 1895–8. Pieced, appliquéd, printed cotton embroidered with plain and metallic yarns; 5'9" × 8'9" (1.75 × 2.67 m). Museum of Fine Arts, Boston

2.28 James Hampton, *Throne of the Third Heaven of the Nations' Millennium General Assembly*. 1950–64. Gold and silver aluminum foil, colored Kraft paper, and plastic sheets over wood, paperboard, and glass; height 10'6" (3.19 m). National Museum of American Art, Smithsonian Institution, Washington, D.C.

angels. Hampton's *Third Heaven* is made of paper, gold, and silver foil over pieces of furniture and other found objects he collected around the neighborhood. The centerpiece of this assemblage of 180 individual pieces is a winged throne—an armchair with a red velvet seat behind a pulpit and altar. It is surrounded by pulpits, vases, offertory tables, plaques, and thrones. The left side refers to Jesus, the New Testament, and Grace while the right side of the throne represents the Old Testament, Moses, and the Law. To a degree, the composition resembles Romanesque and Gothic portal sculptures on cathedrals in Europe, but here, images of the heavenly figures are conspicuously absent.

Hampton, who called himself St. James, was the pastor of his own church and seems to have believed that he was working under the presence and hand of God, as did St. John the Divine when he wrote the Revelation. Hampton claimed to have a vision of Moses (1931), the Virgin Mary and Star of Bethlehem (1949), and Adam (1949) in Washington, D.C. An inscription on his work, "made on Guam, April 14, 1945," suggests that Hampton's apocalyptic vision was also inspired by his military service in the Pacific during World War II. Hampton wrote on his works in a mysterious script, like St. John the Divine, whom God asked to record all he saw in his vision of the Second Coming in a cryptic language.

SUMMARY

The diversity of the art produced in sub-Sahara Africa over the last 30,000 years reflects the cultural variety of the many groups of people who have inhabited this vast continent. Sculptural styles in Africa range from the idealized portrait heads of the Nigerian courts at Ile-Ife and Benin to the highly abstract wooden masks of the Bamana in the Sudan, with their repeating curves and sharply angled forms. African art has served many purposes and played important roles in the private and public rituals. Along with prayers, offerings, music, and dances, the art was designed to communicate with the unseen spirits and beings of the other world. To be effective, the art had to reflect certain ideals of beauty. Among some groups that have been carefully studied, such as the Yoruba, these ideals might be highly complex.

In the years to come, students in the West will undoubtedly learn much more about the meaning of African art as more African scholars steeped in the traditions of the arts, languages, and cultures of Africa enter this field. African art also continues to inspire contemporary African artists in many parts of the world. Using the process anthropologists call "reintegration," some African artists are incorporating elements of their African heritage with Western styles of art. The very complex, philosophical issues surrounding contemporary African art and its roles inside and beyond Africa are discussed in Chapter 8.

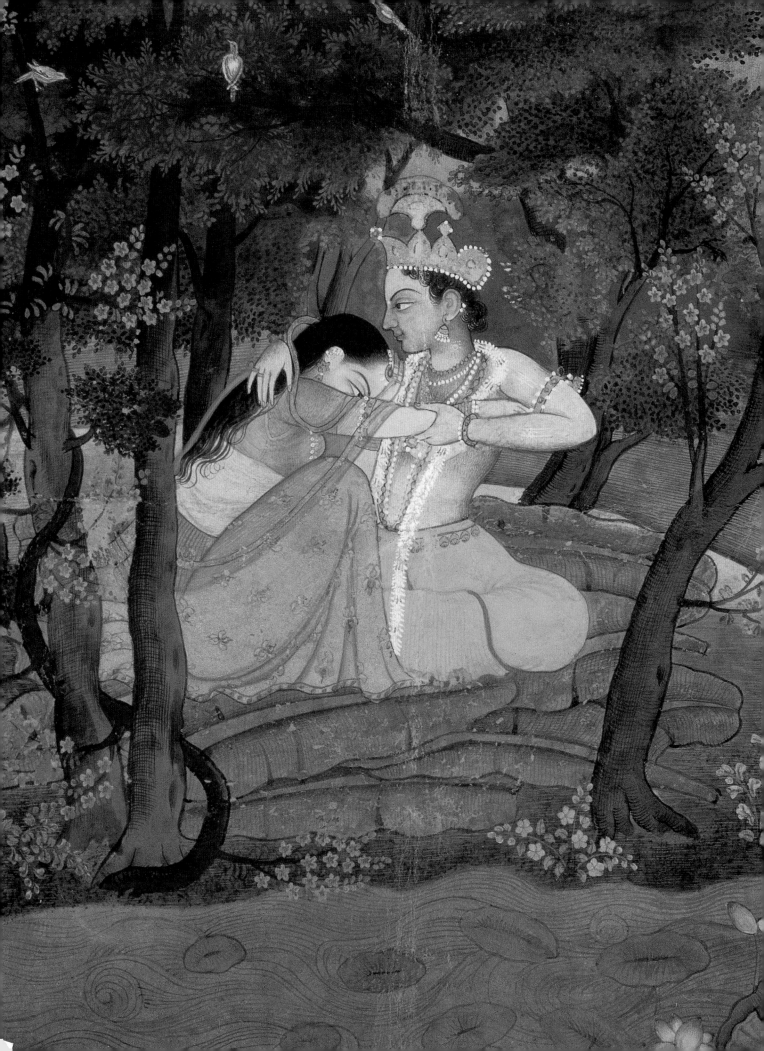

CHAPTER THREE
INDIA
AND
SOUTHEAST ASIA

Equator

INDIA AND SOUTHEAST ASIA

The Indian subcontinent is a large diamond-shaped land bordered by the Indus River valley to the northwest, the snow-capped Himalayas to the northeast, the Arabian Sea to the west, and the Bay of Bengal to the east. Although before modern times this subcontinent was not a country but a collection of regional kingdoms, it produced and shared many common forms of art, religion, and culture. It was from this matrix that varieties of Indian art and culture spread to northwest Afghanistan, Pakistan, Nepal, Tibet, Sri Lanka, Burma, Thailand, Cambodia, Vietnam, Malaysia, and portions of Indonesia.

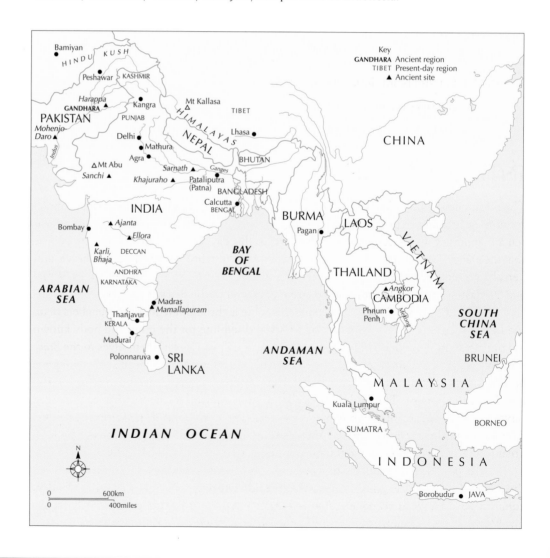

TIME CHART

Indus Valley Civilization (c. 2700–1200 BCE)

The Vedic Period (1500–322 BCE)

 Aryan Invasions (c. 1500–1000 BCE)

 Upanisads developed (800–600 BCE)

 Mahavira, founder of Jainism (599–527 BCE)

 The historic Buddha (c. 563–483 BCE)

 Alexander the Great campaigns in Gandhara (327–326 BCE)

Maurya Period (322–185 BCE)

 Emperor Ashoka (269–232 BCE)

 Shunga Period (185–72 BCE)

Andhra Period (70 BCE–320 CE)

Kushan Period (30–320 CE)

Gupta Period: North India (320–500)

Pallava Period: South India (500–750)

Chola Kingdom (846–1173)

Mughal Empire: North India (1526–1858)

British Rule (1858–1947)

INTRODUCTION

The great religions of India—Brahmanism, Hinduism, Buddhism, and Jainism—have common roots in the literary and philosophical writings of India in the first millennium BCE. These ideas remain important to the religions and their arts to this day. For example, all of them believe that the material world around us (*maya*) is an illusion. Only the *Brahman*, the all-inclusive, universal, and eternal spiritual reality that extends to all temporal and divine beings, is real and everlasting, and the faithful should strive to ascend to the *Brahman*.

There are several ways to achieve this. One is through meditation. Members of all the Indian religions use a form of meditation and discipline for the mind and body known as yoga (meaning "to yoke"). Through yoga, they attempt to "yoke" themselves to the *Brahman*. By complete devotion to the gods and the renunciation of personal and earthly desires and pleasures, Hindus strive toward this eternal state of pure consciousness and bliss, which they call *moksa*. The Buddha was able to yoke himself to the *Brahman* and achieve nirvana, a supreme form of enlightenment that freed him from all earthly concerns and desires. The Jains call the ancients who founded their religion "pathfinders" and strive to live in great purity as they follow the pathfinders to the *Brahman*.

As part of their meditation, the members of these Indian religions practice *darsana*, the act of visualizing the gods. To help them in this visualization process, religious leaders commissioned artists to produce sculptured and painted images of the gods in easily recognizable visual forms, such as humans or animals. Images were not only aids to meditation

but also products of it, as artists discovered their images through intense meditation as they attempted to give form to the formless. The Buddhists showed the Buddha as a powerful man and the supreme meditator, the perfect image of total inner peace. To convey this ideal of human perfection and spiritual purity, his features are often idealized and very smooth. This image of the human body as a symbol of repose and complete detachment is also manifest in Hindu and Jain art. It is part of a distinctive Indian sense of beauty in which sensuous figures, rich ornamentation, pronounced textures, and intense colors express a delight in the world as a gift of the gods—a world filled with the spiritual energy of the gods themselves.

The great Indian religions provided permanent homes for their religious images in shrines and temples, architectural replicas or microcosms of the universe the gods had created. This enabled worshipers to make symbolic journeys through the universe as they worshiped and meditated in the presence of the gods who had created it. These symbolic passages replicated the ones they wanted to make as they rose above the material world and ascended to the transcendental realm.

This conception of the place of worship as a microcosm of the universe shaped the design of Indian temples and shrines and the placement of art in those spaces. The Hindus envision their temples as cosmic mountains, with a small inner chamber or sacred cave called the "womb chamber" at the heart of those mountains. This part of the temple, accented by the tall peak-like tower above it, might contain symbolic images of the male and female principles that represent the unity of the cosmos.

Buddhist temple complexes are often designed with some tall temples in the center surrounded by walls and smaller temples to replicate the Buddhist image of the universe with the sacred Mount Meru the center, ringed by lesser mountains, oceans with island continents, and a huge wall. Another distinctive type of Buddhist place of worship, the stupa, is a large hill-like shrine that symbolizes the World Mountain and dome of heaven. The first stupas included relics of the Buddha. Some of the larger stupas are circled by walkways, relief sculptures, fences, and gates. Walking around the stupa and relics of the Buddha while looking at images of the Buddha's path to spiritual enlightenment, the faithful can join him in his passage to nirvana. Ascending from one level to the next while walking around some of the largest stupas, pilgrims also make a symbolic ascent from the mundane world to the elevated realm of the spirits.

In India, high-ranking priests known as brahmins speculated on the nature of Indian art and developed the concept of *rasa*, which lies at the heart of traditional Indian aesthetics. *Rasa* is the emotional reaction of pleasure and satisfaction that the visual arts, music, poetry, and drama can give to the senses and spirit of the viewer. Reacting to art, the viewer becomes one with the *rasa*-inspiring object and all creation. He or she can transcend the surrounding world and harmonize with the ultimate bliss of the *Brahman*. For art to do this, however, it must go beyond mere description: it must have style and be capable of conveying universal ideas that appeal to the viewer's heart and instincts. In Indian thought, the cumulative experience of the emotions of many past lives within everyone can be activated into spiritual responses by art, leading to the pure bliss of *Brahman* and the ultimate fulfillment of the inner being. However, the artists did not necessarily belong to the brahmin caste and it is not entirely clear to what degree they understood and followed the theories of the brahmin aestheticians as they made the art.

Although the names of the architects and artists who created these magnificent monuments have not been preserved, as the individuals entrusted to design and oversee the construction of the holy works of art, they were highly revered in Indian society. Modern spectators continue to marvel at the way they managed to create such moving and revealing expressions of the great Indian religious philosophies that believe in the reality of the *Brahman*, the unreality of this world, and that religiously inspired art and architecture can bridge the gap

between the seen (unreal) and unseen (but real) worlds. Their works have helped centuries of worshipers to cross the bridge that leads from the illusory nature of this existence to the invisible reality of the spirit.

THE INDUS VALLEY

The earliest Indian civilization around the Indus River in present-day Pakistan and reaching Afghanistan and northwest India predates the development of Buddhism, Hinduism, and Jainism. It is known as the Indus Valley or Harappan civilization (after Harappa, one of its major cities). The economy was based on the cultivation of wheat, barley, and peas, and on trade with the Mesopotamians and others to the west. The presence of Indus Valley seals in Mesopotamian cities of known dates helps to place the Indus valley civilization at around 2700–1200 BCE. This makes the Indus Valley civilization roughly contemporary with the Old, Middle, and Late Kingdoms in Egypt, the Sumerian, Akkadian, and Old Babylonian periods in Mesopotamia, and Minoan civilization in the Aegean Sea.

No royal tomb, palace, or large public art work has yet been found, but the Indus Valley builders constructed well-planned cities with walled neighborhoods, broad avenues, granaries, and baths. Wooden and kiln-fired brick buildings in the most extensively excavated city, Mohenjo-Daro ("city of the dead"), were organized in rectangular blocks around two major roads intersecting at right angles (FIG. 3.1). Houses in the city (which had c. 35,000 inhabitants) were up to three stories tall and constructed around central courtyards. A large reservoir or bath with a brick floor sealed with bitumen may have provided water for local residences, some of which had sewer systems. Alternatively, it may have been used for general bathing and ritual purification ceremonies.

In contrast to the cylindrical seals found in Mesopotamia, most of the roughly 2,000 known Indus Valley seals are rectangular stamps carved from fine-grained steatite, a soft greenish-gray stone. Modern plaster impressions from the ancient seals reveal that the ancient miniaturists were highly skilled at capturing the textures of animal hides and could render anatomical details with such accuracy that they could suggest the underlying skeletal structures of the animals (FIG. 3.2). A bull with muscular flanks, bulging shoulders, and thin bony legs stands on a ground line below characters in the Indus Valley script (FIG. 3.2, left). In later Indian art, the bull will be associated with the Hindu god Shiva and male potency, themes that may have been important in the Indus Valley culture as well. By emphasizing the striations around the bull's neck and his tall crescent-shaped horns, which blend with the shapes of the script, the artist has created a unified composition of linear and modeled forms. The calmness and fluidity with which the anatomy of the bull is treated, characteristics of the Indus Valley imagery in general, stand in marked contrast to the hardness of the figures from this period in Mesopotamian carvings.

Figures seated in yoga positions (that of a "holy man," *yogin*, or "holy woman," *yogini*) and many other the subjects on the seals reappear later in Buddhist and Hindu art (FIG. 3.2, right). The practice of yoga, which includes "breath control" (*prana*), is used by members of many religions in India. Its purpose is to "yoke" oneself to universal, divine forces. This continuity of thought, through time and among the Indian religions, unites elements of the Indus Valley civilization with later epochs of Indian history. However, the

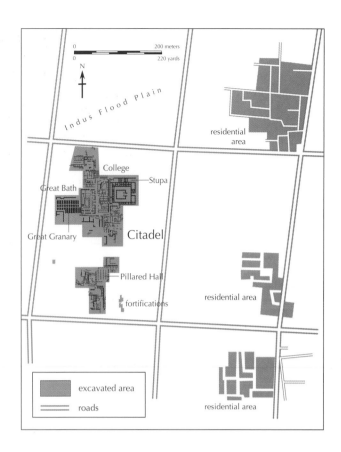

3.1 Plan of Mohenjo-Daro, Pakistan, showing residential areas and citadel. c. 2300 BCE and later

3.2 Seal and seal impression from Indus Valley civilization: (left) seal, horned bull with hieroglyphics; (right) seal impression, *yogin,* "holy man," or *yogini,* "holy woman," with hieroglyphs. Pakistan, Mohenjo-Daro. 3rd millennium BCE. Width 1³/₈" (3.2 cm). National Museum, Karachi; National Museum, New Delhi, respectively

3.3 *Dancing Figure.* Pakistan, Harappa. c. 2300–1750 BCE? Limestone, height 3⁷/₈" (9.8 cm). National Museum of India, New Delhi

script—with about 400 known signs—remains undeciphered, making it difficult for scholars to interpret the symbolism of the bulls and other recurring themes on the seals and to reconstruct the details of the early Indian religious beliefs. The most that can be said is that this was a highly structured, organized urban culture with an agricultural economy, which probably worshiped gods and goddesses of fertility and may have practiced elements of asceticism and yogic meditation.

These same qualities of smoothness, repose, and fluidity in the arts are even more evident when they appear on a somewhat larger scale in the carving of a figure from Harappa (FIG. 3.3). The figure's legs are broken and its head may have been fastened by dowels inserted in the saucer-shaped depression in the neck. Even in its fragmentary condition, the organic qualities of the form are astonishing and surpass those of any known Mesopotamian figurines of this period. In marked contrast to the tense, rock-hard muscularity of the Egyptian rulers and gods of this period, the man from Harappa is soft and relaxed. Unlike the Grecian ideal of the athletic male who was capable of moving with strength and grace, the muscles of this figure are reposed, as they would be during meditation. In a manner that will remain part of the Indian tradition, the body expresses this kind of control and inner strength, which are fundamental to all forms of Indian religion. The realism that gives this figure such a strong sense of immediacy and individuality may be derived from techniques used in modeling clay.

The artist who carved this torso seems to be interested not only in how the body looks, but how the relaxed muscle groups interact with the skeleton supporting them. The turning, twisting figure whose left knee was raised demonstrates an understanding of how the human spine flexes with weight shifts—an idea that will not appear in Western sculpture until the early fifth century BCE. Nor will this remarkable sense of the body in motion be seen again in the known stone carvings of India until centuries later with the emergence of Buddhist art in the fourth century BCE. The appearance in later Indian art of this mobile figure, in what is known as the *tribhanga* ("three bends") pose, has caused some authorities to question its early date.

THE ARYAN MIGRATIONS AND THE VEDIC PERIOD (1500–322 BCE)

During the period from around 1500 BCE to around 1000 BCE, groups of Aryan speakers emigrated from the Caucasus Mountains between the Caspian and Black Seas into India. The Aryans spoke a language called Sanskrit, which became the classic literary language of India. It is used today in sacred contexts, and many languages still spoken in this region derive from it. In addition to their language, the Aryans appear to have brought a strong set of beliefs and traditions to India which included the *Vedas*, ancient poetic hymns and philosophical writings directed to the gods that give this period its name.

The Aryans practiced a hierarchical social order which placed warriors (*kshatriya*) at the apex and provided the basis for the religiously sanctioned social class (or caste) system that persisted throughout Indian history. Many of the deities described in the *Vedas* and worshiped by the Aryans are associated with the forces of nature. The gods were representations of natural forces such as Indra (thunder), Varuna (sky), and Surya (the sun). As no images survive, it is believed that the Aryans were aniconic, that they did not make images. It is possible, however, that images were made out of perishable materials such as woods, which have not survived.

New philosophical texts, the *Brahmanas* and *Upanisads* (c. 800–600 BCE), reflecting Aryan and non-Aryan ideas, expanded upon the cryptic Vedic hymns and explained the relationship of the individual to the universe. They outlined the principles of the *Brahman* ("universal soul") and the system of reincarnation known as *samsara*, the cycle in which the "interior self" or "soul" (*atman*) within all sentient beings returns again and again in human or animal bodies. It is only by understanding the true nature of the *Brahman* that the *atman* can be released from the cycle of rebirths. The *Upanisads* also explain the principle of *dharma* (what one "ought" to do according to one's station in life), and *karma* (a person's actions and the effect they have on the progress of his/her *atman* in future bodies). The Buddhist, Hindu, and Jain adaptations of these ideas are explained in the boxes below. (See "*Religion*: Buddhism," page 66; "*Religion*: Hinduism," page 84; and "*Religion*: Jainism," page 93.)

BUDDHIST ART

THE MAURYA PERIOD (322–185 BCE)

In 327–326 BCE, the Greek armies of Alexander the Great marched through the Persian-held region of Gandhara along the northern Afghanistan border to the Punjab in India. After the death of Alexander in 323 BCE, the Greeks were driven back to Gandhara by Chandragupta Maurya, who founded the Maurya dynasty (322–185 BCE). Chandragupta's grandson Ashoka (ruled c. 273–232 BCE) solidified the Maurya rule over northern and central India though a series of bloody campaigns and converted to Buddhism. Both Greek and Persian influences can be seen in the works he commissioned. A lost text by Megasthenes, a Greek scribe and ambassador to India, said Ashoka's palace at Pataliputra (modern Patna) on the Ganges River was based on the Achaemenid palace at Persepolis and the city was protected by a high wall with 570 towers, sixty-four gates, and a deep moat over 600 feet (183 m) wide.

Ashoka and his predecessors also erected a series of imperial pillars throughout their empire bearing edicts and Buddhist teachings. Such tapered sandstone pillars had long been used in India to display laws, standards, and other symbols of rulers. In Ashoka's time, a famous, highly polished memorial pole stood in Deer Park at Sarnath, where the Buddha had preached his first sermon. The well-preserved capital of one of Ashoka's imperial columns erected at Sarnath has been adopted as the modern symbol of the Republic of India (FIG. 3.4).

Buddhism

The Buddhist religion developed out of the teachings of Siddhartha Gautama (563–483 BCE), who lived in the foothills of Nepal, near the present border with India. He was the son of Queen Maya and King Shudodhana and would later be called the Buddha ("the Enlightened or Awakened One" or "one who has gained wisdom"). He is also called Shakyamuni ("sage of the Shakya clan"). In response to his deep concern for the sufferings of all living beings, Siddhartha left his palace and family to become a wandering ascetic. Through meditation, he achieved nirvana, a release from all earthly desires, and began teaching a new code known as the Eightfold Path (right views, right aspirations, right speech, right conduct, right livelihood, right effort, right mindfulness, and right contemplation). This path would lead his followers away from the suffering in life caused by ignorance. It was a reaction against the older Veda-based religion in India, with its hierarchical social order, caste system, and hereditary class of priests. Buddhism made religion accessible to everyone.

The Buddha's teachings were collected into a series of texts known as *Sutras*. The early Theravada ("School of the Elders") or Hinayana ("Lesser Vehicle") variety of Buddhism has long been associated with monastic communities. The Mahayana ("Greater Vehicle") variety of Buddhism, which appeared around 1 CE, appealed to the masses. It saw the Buddha as divine, wanted everyone to achieve buddha-hood (a higher state than nirvana), and recognized many Buddhas, from the past, present, and future. Mahayana Buddhism also stressed the importance of the *bodhisattvas*, "those who have *bodhi*, wisdom or enlightenment," also known as "buddhas-in-the-making." *Bodhisattvas* are compassionate and accessible saint-like beings who reached the threshold of nirvana, but delayed their own enlightenment so they could reach back to help others. The very important and popular *bodhisattva* Avalokitesvara ("the being capable of enlightened insight"), known as Guanyin in China and Kwannon in Japan, was often illustrated in the arts. While the Buddha usually wears a monkish robe, the *sanghati*, the *bodhisattvas* wear princely garb, as the Buddha had done in his youthful days.

In addition to the historical Shakyamuni Buddha, Mahayana Buddhism also recognized numerous buddhas in the past, present, and future. These included Maitreya (a *bodhisattva* who will become the Buddha of the future) and the Amitabha Buddha of infinite light, space, and time who dwells in a paradise known as the Western Pure Land. The Buddhists did not believe that the spirits of the Buddha and the *bodhisattvas* dwelt within the works of art, but visual images were important aids for meditators and worshipers.

Ashoka may have imported sculptors from Persia and the nearby Hellenistic kingdom of Bactria in northern Afghanistan and Uzbekistan to work on this and other projects. The front quarters of four lions are "addorsed" (or "back to back"), as they are on the capitals of Persian columns. The crispness and ornamental treatment of the lions' neatly patterned curls, their sinewy legs, and the lustrous finish reflect the styles of Achaemenid Persian sculpture in Persepolis and Susa.

The lions symbolize the Buddha as Shakyamuni ("lion of the Shakya clan") and the world quarters or directions radiating out from the column over which the Mauryan and Buddhist laws extended. That law, and Buddhist wisdom were represented by a large wheel known as the *dharmacakra* mounted on the backs of the lions. It also represented the Wheel of Life and was a solar symbol because, like the sun, it brought light to the world. Turning it, one controlled the sun, an important symbol of the universal power of the Buddha and the Maurya rulers. As the Buddha taught the law, he set the wheel in motion and became the *chakravartin* ("Turner of the Wheel" or "World Ruler"). At this early date in the history of Buddhist art, the Buddha is not yet shown in human form and he appears here only in symbolic form, as the Wheel of the Law. Other symbols or icons of the Buddha appearing elsewhere in the art of this period include the Bodhi tree (representing his Enlightenment), a riderless horse, and footprints.

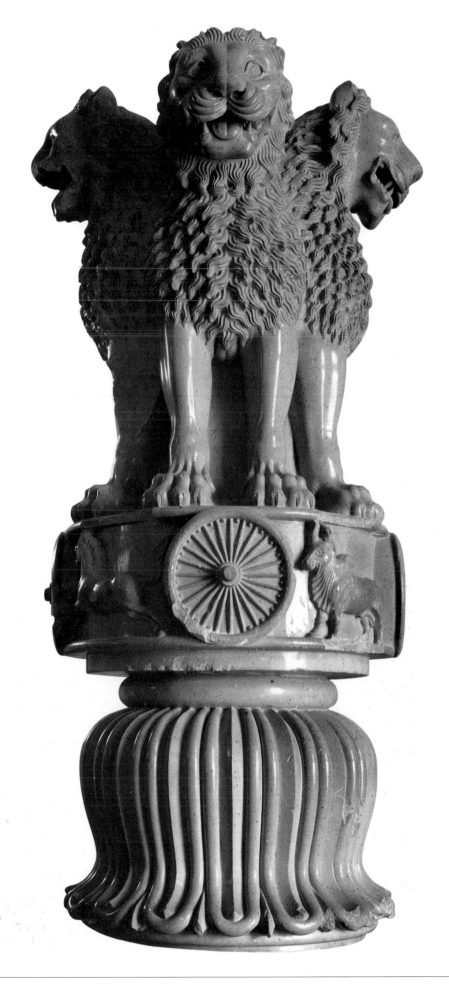

3.4 Lion capital of a column erected by Emperor Ashoka (ruled 272–232 BCE). India, Pataliputra. Polished sandstone, height 7' (2.13 m). Archaeological Museum, Sarnath

Wheels also appear on the base below the lions' feet, along with animals (bull, elephant, horse, and lion) that may symbolize the four great rivers of the world. They resemble images from the Hellenistic Greek region of Bactria, northwest of Gandhara. The base is an inverted, bell-shaped lotus, an important symbol in later Buddhist art and architectural iconography. The lotus flower, which is clean and pure even though it grows out of muddy waters, symbolizes the purity of the divine when it is manifest in the material world.

THE SHUNGA (185–72 BCE) AND EARLY ANDHRA (70 BCE–FIRST CENTURY CE) PERIODS

After the fall of the Maurya dynasty, the Shunga dynasty (185–72 BCE) ruled in the north central region of India and the Satavahana family governed the Andhra region (central and southern India). Although many of the Indian leaders were not Buddhist, these periods were very important ones for the development of Buddhist art and architecture, which took on new monumental forms.

The relatively small burial or reliquary mounds erected in sacred places for wealthy individuals and rulers in the Maurya period became lavish and imposing centers of Buddhist worship known as stupas. After the Buddha was cremated, his remains were allegedly distributed to eight localities in India and enshrined in stupas, where they became focal points of Buddhist devotional practice. Ashoka is said to have opened these stupas and further distributed the remains.

By the Shunga period, stupas had become large hemispheric mounds with masts symbolizing the World Axis. A stupa built by Ashoka in the village of Sanchi in central India was enlarged in the first century BCE to become a massive, hemispheric monument (FIG. 3.5). Known as the *Mahastupa* ("Great Stupa"), the dome-shaped monument symbolizing the arc of the sky may contain some of the remains of the Buddha which Ashoka redistributed during his reign. The stone *vedika* ("railing" or "fence") around the shoulder of the

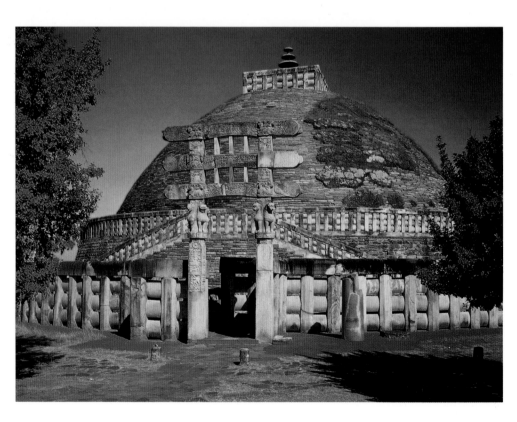

3.5 The Great Stupa, Sanchi, India. Shunga and early Andhra periods, 3rd century BCE–early 1st century CE. Height 65' (19.8 m)

mound, which separates the sacred and profane worlds, is carved in imitation of slotted wooden rail fences. The *vedika*, eleven feet (3.35 m) high, was added in the first century BCE and may be a stone imitation of the wooden fence enclosing Ashoka's original stupa. *Toranas* ("gates") in the *vedika* point to the cardinal points of the compass. A double stairway leads to an elevated terrace, a pathway around the shoulder of the drum enclosed by the upper *vedika*. The brick and rubble mass of the dome, with a stone facing from the Shunga period, may originally have been covered with stucco and whitewashed.

A *yasti* ("mast" or "World Axis"), with a three-tiered *chattra* ("umbrella") symbolizing the Buddha, law, and the community of monks, rises within the square fence or *harmika* crowning the mound. This is the realm of the gods at the summit of the symbolic cosmic mountain. As the axis of the universe, the stupa unites the heavenly and earthly realms of existence. Moving in a clockwise direction around the stupa, retracing the path of the sun across the sky, pilgrims encircle the symbolic World Mountain and *mandala* (literally, a circle or an arc), a diagram of the Buddhist cosmos. In India, two and three-dimensional *mandalas* are parts of the religious iconography of each major religion.

The ornate *toranas* (thirty-five feet or 10.7 m tall), which may have been preceded by simpler stone or wooden prototypes, were added in the Andhra period (FIG. 3.6). The tall, square gate posts are crowned by addorsed elephant capitals and other animals and three

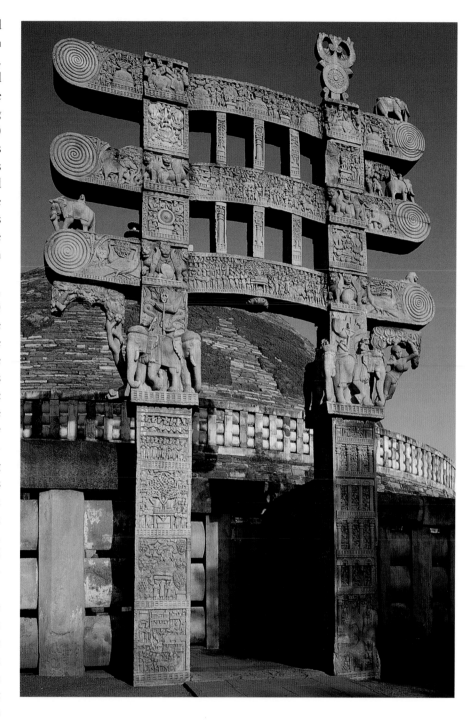

superimposed, curved architraves terminating in tightly bound volutes that may reflect the shapes of their wooden prototypes. These architraves illustrate detailed *jatakas*, stories about the lives of the Buddha, who is not shown in human form in this period; his presence is indicated by symbols such as the lotus, the wheel, footsteps, or an empty throne.

Bracket figures outside the capitals below the architraves on this torana represent tree goddesses known as *yakshis* (male gods are called *yakshas*) (FIG. 3.7). They are ancient, pre-Buddhist spirits associated with the generative or productive forces of nature, water, and the strength of the inner breath (*prana*). Here, the *yakshi*, in a diaphanous garment evident only in its hems, appears to be nude. Her prominent breasts and sexual parts personify the sap that gives life to the flowers and fruit of the tree. She assumes a *tribhanga* ("three bends") pose similar to that of the miniature stonecarved figure from Harappa. The voluptuous figures

3.6 Eastern *torana* ("gateway"), the Great Stupa, Sanchi. Completed 1st century BCE

3.7 *Yakshi* bracket figure from the east gate of the Great Stupa, Sanchi. Stone, height c. 60" (1.52 m). Early Andhra period, 1st century BCE

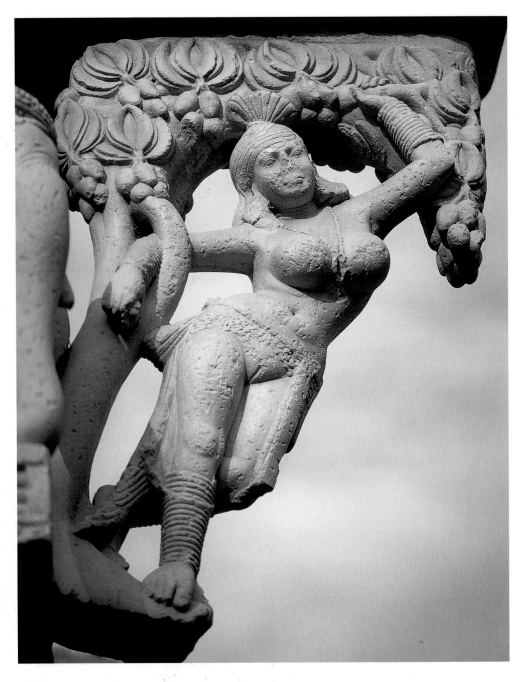

grasp trees and hang there like fruit, and literally dance in the air before the visitors approaching the grand solemnity of the massive stupa in the background.

Smaller stupas were incorporated in the *chaitya* halls, Buddhist assembly halls and places of worship. The ancient assembly halls that were made of wood and other perishable materials have long since perished, but many of the rock-cut chaityas carved from the second century BCE onward in the western Indian region known as the Deccan remain well preserved to this day. Technically, such *chaityas* are sculptural images of architectural facades and interiors. As rock-cut images of the wooden *chaityas*, the elaborate facades with horseshoe-shaped entryways, interior columns, and raftered ceilings are purely decorative and do not perform the architectural functions of the forms they imitate. This idea of "carving" architectural forms may have been inspired by the royal rock-cut tombs of Persia, such as those at Naqsh-I-Rustam, in which the facades reflect those of contemporary Persian palaces. The rock-cut sanctuaries also underline the importance of caves as places of worship and

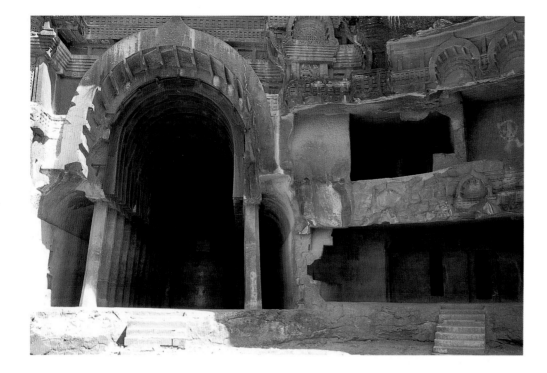

meditation in earlier Indian religions. Along with the *chaityas*, the builders excavated large numbers of "monks' cells," *viharas*, to house the growing numbers of monks in the Buddhist communities. With the Hindu and Jain rock-cut places of worship, these monuments (roughly 1200 in number) preserve a wealth of information about the art and architecture of this early period of Indian art.

The manner in which the traditional wood *chaitya* hall was translated into stone can best be seen by looking at the facade of the very early rock-cut temple at Bhaja from the first century BCE (FIG. 3.8). The stonecarvers began by constructing a long tunnel at the apex of the vault and carved downward to the floor level so that a minimum of scaffolding had to be constructed. The monumental arch over the entryway is carved in imitation of contemporary wooden *chaitya* hall facades. Around the entryway are sculptured images of smaller halls with arched roofs and multi-story, balconied pavilions with railings and windows (some showing people within) which provide a panoramic view of an ancient Buddhist community. The wooden doors and wall that once protected the entryway are missing, so the polygonal, inward-tilted columns (reflecting construction techniques in wood) and portions of the stupa inside the hall are now visible through the open vault.

The interior decorations of this architectural type are more fully developed in the nave of the *chaitya* hall at nearby Karli, dating from the second century CE (FIGS. 3.9, 3.10). It is a large rock-cut space, 124 feet (37.8 m) long, forty-six feet (13.26 m) wide and forty-five feet (13.7 m) high. Thirty-seven closely set octagonal columns run the length of the hall and behind the stupa at the back so that worshipers can walk around it. While the seven columns in the curve around the stupa have no decorative capitals, the thirty columns along the sides of the hall rising out of globular pot-shaped bases terminate in ornate capitals. These capitals are composed of inverted and fluted bell-shaped lotus blossoms (a motif that can be traced back to the imperial columns of Ashoka) supporting stepped platforms and *mithuna* ("couples") symbolizing fertility and harmony riding on kneeling elephants and horses. The sculptures on these closely spaced capitals, which give the impression of being a continuous high relief running along the nave, may represent the nobility coming to pay homage to the Buddha and his stupa at the far end of the hall. The importance of the rites of worship at the stupa is emphasized by the relief-carved fences around

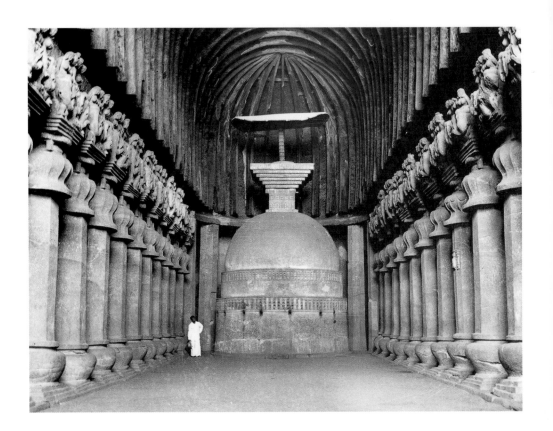

3.9 Interior of the *chaitya* hall at Karli, India. Early 2nd century CE

3.10 Plan of the *chaitya* hall at Karli, with numbers keyed to major features in the drawing: (a) vestibule; (b) nave; (c) side aisles; (d) stupa

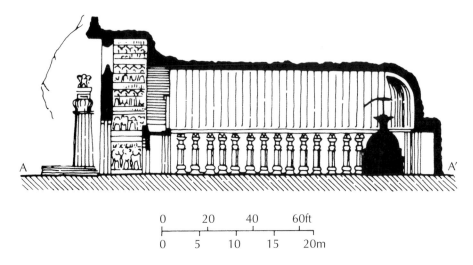

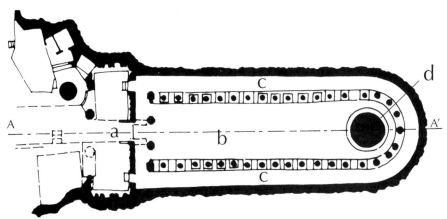

it that mark the circular paths followed by worshipers, and by the tall, prominent *chattra* on the *yasti* that symbolizes the World Axis around which everything in the Buddhist world is centered.

A shaft of light streaming in the doorway through the original facade of this *chaitya* would have highlighted the rows of columns, sculptured capitals, and bold shape of the stupa at the far end. Even without that facade, the lighting inside is dramatic and the high barrel vaults amplify the faintest sounds of footsteps and voices as they echo down the nave. In the dim light of the hall, which may have been augmented by lamps and torches in ancient times, the massive columns and ribs crossing the vault over the stupa are so dramatic and convincingly functional that it is easy to forget that, in truth, the hall is a bubble of space inside a massive cliff. The hollowed-out architectural spaces here, and in other Indian rock-cut temples, confound any sense of material reality, of mass and space, and of what is "real" and "unreal." They give the visitor the impression of being inside masonry and wooden buildings rather than of being inside cliffs and the earth. What appear to be functional architectural forms are, in fact, sculptures. As highly realistic illusions of architecture, the rock-cut temples are a reminder of an important axiom in Indian thought—the world, that which is visible, is an illusion, and the *Brahman*, that which is invisible, is real. As expressions of this idea, the mysterious cave-like spaces of a rock-cut *chaitya* can help bridge this gap between the seen and unseen worlds and give a sense of presence to the formless spiritual reality of Brahman.

THE KUSHAN (30–320 CE) AND LATER ANDHRA (FIRST CENTURY CE–320 CE) PERIODS

The Kushans, known as the Yueh-chin when they lived in the region of Central Asia that now corresponds to southern Mongolia and northwestern China, were nomadic Caucasians who migrated south to what are now Pakistan, Afghanistan, and northern India. They established an empire that extended from Gandhara into northern India, with capitals at Peshawar in the north and Mathura, near Delhi, in India. Two very important developments in the early Kushan period changed the course of Buddhism and Buddhist art in India and Asia. The severe, monkish form of Buddhism that had been prevalent (known as Hinayana or Theravada Buddhism) was supplemented by Mahayana Buddhism, in which the Buddha was a god and savior surrounded by a cosmology of compassionate *bodhisattvas* (those who have wisdom, *bodhi*, as their goal). These changes made the religion more accessible and attractive to ordinary people. Secondly, by 30 CE, trade along a set of interconnected caravan routes known as the Silk Road linking China with the Mediterranean world in the West was at its height. The economic importance of the commerce and wealth generated by this road, spanning a quarter of the globe, can hardly be overestimated. As the Parthians around the northern portions of present-day Iran began to block the Silk Road, caravans detoured through the Kushan territories in northern India. This trade brought the Kushans into contact with the culture and art of the Romans, whose expanding empire in the East along the Silk Road nearly touched the Buddhist world.

Under Kanishka (early second century CE), who established an empire that extended from Central Asia to northern India, Indians trained in Roman styles worked in Gandhara, a region previously exposed to the arts of the Persians, Greeks, and Maurya emperors. They created a hybrid Eastern–Western style that represents the easternmost extension of Roman influence in the arts. The combination of Mahayana Buddhism, in which the Buddha was worshiped, and the latest developments in Roman art, in which the gods, rulers, and other heroic figures were portrayed as regal men and women, helped inspire Kushan artists in Gandhara to create monumental images of a Romano-Indian Buddha. Under these

influences, the Buddha was envisioned as a human-turned-divine who had transcended all earthly boundaries of time, space, and gender. He was the supreme meditator who overcame his own ego and earthly desires to become the ideal monk and teacher, the embodiment of wisdom and compassion who could show humankind the way to self-realization.

Some of the earliest examples may have been made by itinerant Roman-trained sculptors who adapted their skills to the new subject matter, adding Buddhist symbols and the characteristic Buddha hand gestures or *mudra* (a repertoire of symbolic gestures that convey certain ideas such as teaching, setting the Wheel of the Law in motion, blessings, and meditation). The most celebrated Gandhara Buddhas may be the works of skilled sculptors from this region, with some knowledge of Roman art, who have fully integrated the Roman styles into their work. They show the Buddha with a Roman nose, cupid-bow lips, and wavy locks of hair—features resembling many Roman portraits of noblemen, emperors, and the gods, especially idealized images of the full-faced Apollo (FIG. 3.11). The Classical Roman patterns of folds in the Buddha's toga have been somewhat simplified into alternating patterns of sharp folds and smaller creases that seem to convey the sense of repose and peace in the Buddha's enlightenment. Conversely, the *ushnisha* (a knot of hair over the head symbolizing superior spiritual knowledge), *urna* (tuft of hair or mole between the brows), the ears elongated from heavy jewelry worn in his youthful princely days, and the *mudra* are typically Indian.

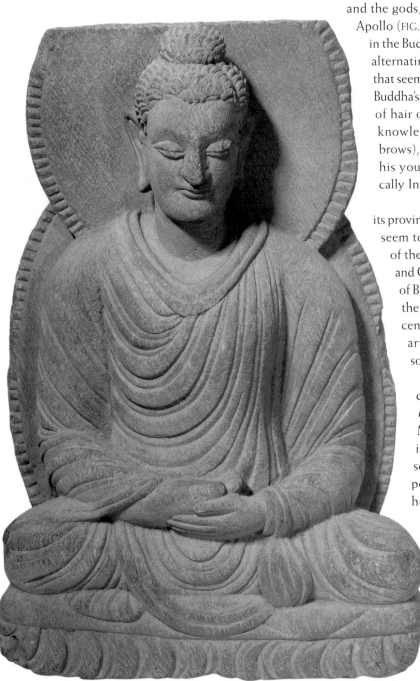

3.11 *Seated Buddha.* Gandhara, India. 2nd century CE. Gray schist, height 43" (1.31 m). National Museums of Scotland, Edinburgh

Ultimately, the Classical style, as filtered through its provincial, Eastern Romanized practitioners, does not seem to have been perfectly suited to the portrayal of the Indian ideals of internal, transcendental bliss, and Gandhara art did not influence the development of Buddhist art in the rest of the Indian world. Also, the Classical tradition was in decline by the third century CE, and the subsequent history of Buddhist art in India derives almost entirely from local sources.

About the time the Gandhara artists were creating their Romanized versions of the Buddha, Kushan artists in north central India at Mathura were developing a more typically Indian image of the Buddha and his *bodhisattvas*. The sculptors in this area had already carved royal portraits of Kushan leaders in thick robes and heavy Kushan boots, and robust images of *yakshis*. A rigidly frontal image of Kanishka with large feet and hands holding a sword and mace portrays him in the spirit of the inscription across his mantle, which calls him "The great King, the King of Kings, His Majesty Kanishka" (FIG. 3.12). From other images of Kanishka, it seems likely that the head on this statue was massive and bearded. With its strong silhouette, this rather flat, hard-edged figure conveys a great sense of authority.

Kanishka's uniform—puffy padded boots and a thick mantle that falls in stiff folds—reflects the ruler's Kushan heritage, his warrior-horsemen forefathers who lived and fought in the cool northern highlands. In this ceremonial outfit, completely unsuited to everyday use in the heat of Mathura, the idol-like image of the mountaineer–warrior–king seems to capture the essence of the conquering hero who had built an empire that incorporated some of the Hellenistic lands in this area and exceeded the dimensions of the earlier holdings of Ashoka.

THE GUPTA PERIOD (320–500 CE)

By the late Kushan period, around 300 CE, Mathura sculpture had lost its early robust character and begun to take on a new sense of delicacy and sensuality. While the Kushan dynasties that supported the Mathura artists declined, those traditions were continued and reached a magnificent climax under the patronage of the Gupta rulers (320–640). The period was named after Chandragupta I, who was crowned in Pataliputra (320), the ancient Mauryan capital. At their peak, under Chandragupta II (375–415), the Guptas controlled an empire that included northern India and parts of the south during what has been called the "classical" period of Indian art.

The single most famous Gupta image of the Buddha from Sarnath represents him as a spiritualized *yogin* ascetic with a large nimbus, seated cross-legged on a Lion Throne (see FIG. 1.2). Although the Buddha may appear to be nude, the hemlines of his sheer muslin garment, known as a *sanghati*, are visible at his neck, wrist, and ankles. In some sculptures from this period, the *sanghati* literally disappears as if it had been soaked in water. The large round nimbus or sun orb surrounding the Buddha's head represents the universal spirit of the Buddha. The deer and six disciples turning the Wheel of the Law in the register below refer to the Deer Park at Sarnath, where the Buddha preached his first sermon. Like the orb of the sun behind him, the wheel of the Buddha's law brings light to all parts of the earth.

The figure bears the distinguishing marks of the Buddha—the *ushnisha*, *urna*, and *mudra*. The Buddha holds his hands in the *acakra mudra*. This is the hand gesture for teaching in which the Buddha sets the Wheel (*chakra*) of the Law (*dharma*) in motion and counts the principles of his Eightfold Path of Righteousness on his fingers. The texture of the carefully patterned snailshell curls in the Buddha's hair contrasts with the smoothness of his idealized body as it appears through his *sanghati*. The winged lions on the back of the throne symbolize royalty, the Buddha as the lion of the Shakya clan, and the regal roar and authority of his preaching.

The Buddha's idealized features, which fuse human beauty with a sense of spiritual purity, can be explained in part by certain metaphors that abound in Buddhist poetry and prose of this period. They equate the hero's brow to the arc of a bow and his eyes to lotus buds or a fish. The beauty of his idealized features and his serene, downcast eyes reflect his inward focus, away from the transitory world around him, and is emphasized by the concentric circles on the nimbus behind his head. The textures of the repeating patterns of detailed foliate forms in the nimbus and on the back of the throne contrast with the smoothness of the Buddha's body which, in its serene pose, reflects his state of enlightenment, tranquility,

3.12 *Kanishka I*. India, Uttar Pradesh, Mathura. Kushan period, c. 120 CE. Red sandstone, height 5'4" (1.62 m). Museum of Archaeology, Mathura

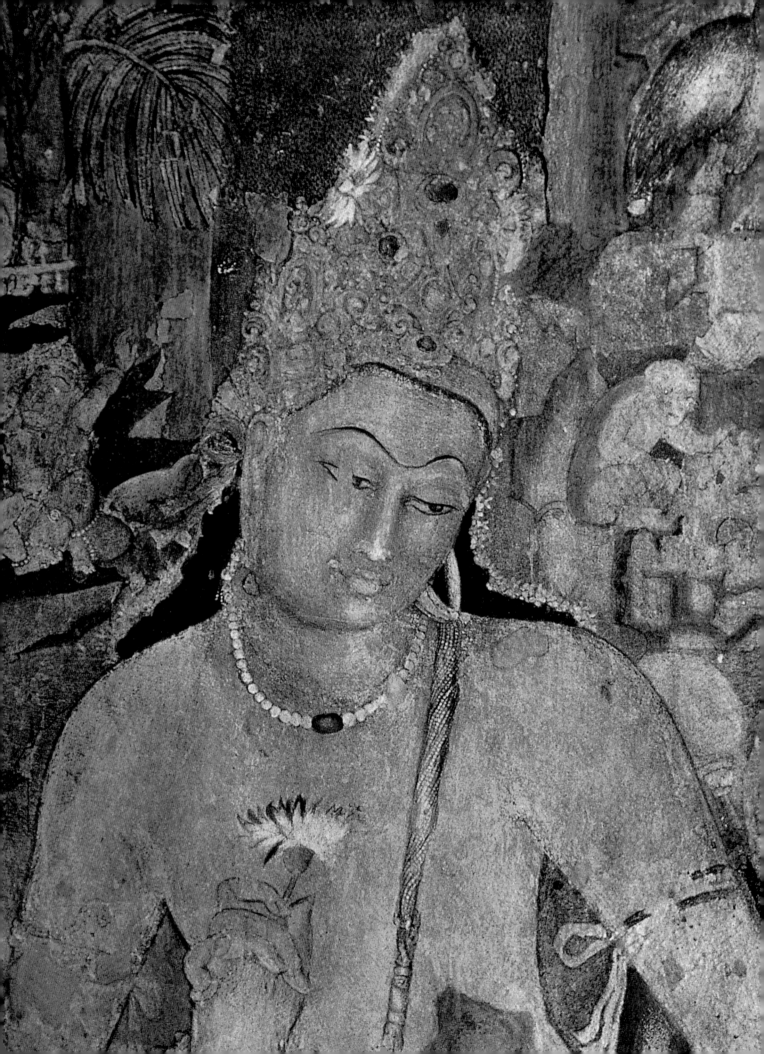

inner spiritual strength, and otherworldliness. In such works as this, the Guptas achieved a delicate balance between detailed and idealized forms that is one of the characteristics of this classical period of Indian art.

The idealism of the Sarnath Buddha is also expressed in the finest surviving paintings from this period, in the rock-cut *chaityas* and *viharas* of Ajanta in the Deccan region of western India. Much of the rock-carving (four *chaitya* halls and twenty-five *viharas*) and painting was done during the rule of the Vakataka rulers in this area during the late fifth century. The temples, sculptures, and paintings in this large horseshoe-shaped ravine are some of the most astonishing monuments in India. The paintings were applied to a moist coat of lime over layers of clay, cow dung, and other elements that had been spread onto the rock faces of the walls. Most of the paintings relate episodes from the *jatakas*, stories about the lives of the Buddha. Many of them were very large and illustrate more than one tale. The compositions devised by the painters as they experimented with the representation of figures in space are somewhat more daring and inventive than those attempted by the contemporary stonecarvers. Unfortunately, today the paintings exist only in fragments, so the full spectacle of their grandeur, with surrounding sculptures and rock-cut architectural details, has been lost.

The *bodhisattva* Padmapani, in the *tribhanga* pose, holds a blue lotus and wears across his chest a jeweled tiara, pearls, and a sacred thread woven from seed pearls (FIG. 3.13). This style of painting depends heavily upon lines to define features and uses very little shading or modeling. The resulting smoothness of the *bodhisattva's* body, devoid of anatomical detailing, the down-turned eyes, arched brows, and the full but narrow mouth resemble the features of the Buddha from Sarnath. As in many of the Ajanta paintings, Padmapani's blissful, dreamy eyes, languorous pose, and transcendent character express depths of emotion that are seldom found in Gupta sculpture. He seems to be impervious to the menagerie of smaller figures, peacocks, monkeys, and fantastic creatures around him. The idealized features of the *bodhisattva*, who remains calm like an island of spiritual disengagement in the sea of activity around him, are bathed in a soft, glowing light with no shadows. As one on the edge of nirvana, who has glimpsed the reality of the *Brahman*, he is aloof and spiritually disengaged, knowing that the sights and sounds around him are a grand illusion of unreality.

THE SPREAD OF BUDDHIST ART

Buddhist art spread outward from India in every direction, west to Afghanistan, north to Kashmir, northeast to Nepal, Tibet, China, Korea, and Japan, south to Sri Lanka (Ceylon), and southeast through Burma to Indonesia. Buddhist art in China, Korea, and Japan is discussed with the art of those countries in Chapters 4 and 5.

Afghanistan

The sculptors at Bamiyan, Afghanistan, attempted to express the magnitude of the new Mahayana Buddhist ideal, the Vairocana Buddha (the "Body of Bliss" or "the Buddha Essence"). This is the eternal form of the Buddha, of which his earthly body is no more than a transient manifestation. Some sculptors at Bamiyan tried to express this idea through scale. The largest Buddhas there (120 and 175 feet tall; 36.5 and 53.3 m) were very impressive, until they were destroyed by the fundamentalist Islamic Taliban in February 2001 (FIG. 3.14). Encased in a deep, close-fitting niche, like a relic buried in a stupa, the larger of the colossal Buddhas of Bamiyan towered over the surrounding landscape. Chinese, Indian, and Western Asian styles of art once mingled freely in Bamiyan, an international trading center on the southern part of the Silk Road. The body of the Buddha, which may have been gilded, was clothed in a string-type drapery (applied lime plaster and paint). This technique of rendering the *sanghati* as a semitransparent cover visible only in its folds was derived in large part from

3.14 *Colossal Buddha.* Bamiyan, Afghanistan. Stone, height 180' (55 m). 2nd–5th century CE; destroyed in 2001 by the Taliban, a fundamentalist Islamic regime

Gupta sculptures in styles such as that of the Buddha from Sarnath. The double halo, formed by the carvings on the cliff behind the Buddha's head and the body-shaped niche, were copied as far east as Japan. In fact, the colossus was so popular that it spawned a lively trade in miniature replicas, which were carried to the far ends of the passing caravan route that connected northern China with the eastern Mediterranean.

Nepal and Tibet

As the Muslim invaders in northern India destroyed the Buddhist and Hindu centers of worship there in the eleventh and twelfth centuries, many of the monks fled to Nepal and moved north through the towering ranges of the Great Himalayas into Tibet. Combining

elements of the native Tibetan mystical religion known as Bon with Mahayana Buddhism and its complex pantheon of deities, the communities of Buddhist monks created a highly mystical form of Tantric or Vajrayana (the "diamond path" or "thunderbolt path") Buddhism. Many related varieties of the religious sect took root in the isolated valleys and monastic establishments of this remote and decentralized land, as the Buddhist ideas were interpreted by highly revered local religious leaders known as lamas ("none superior"). The lamas were regarded as reincarnations of earlier deceased lamas and *bodhisattvas*, and they had great authority within their communities. The apotheosis was complete when a lama was elevated to become the chief lama, the Dalai ("ocean"). He was believed to be the reincarnation of past lamas and the *bodhisattva* Avalokiteshvara, who strives to lead all people to enlightenment and freedom from *samsara*. Thus, Tibetan Buddhism is also called Lamaism.

The Lamaists believe that through a supreme effort, an individual can awaken the Buddha spirit within and achieve enlightenment in a single lifetime. Art became important as an aid to this time-shortened quest. Originally, along with Buddhism, Tibet received its art styles from northern India and Nepal. But in much the same way the Tibetans made changes in the Indian religion, they looked beyond India to the decorative arts of Central Asia and to China to create their own distinctive styles of painting, sculpture, and architecture.

Some elements of the Gupta or Ajanta style of painting are preserved in the best-known type of painting to come from Nepal and Tibet, the *thangkas* (literally, "rolled up cloth"). These portable hanging scrolls representing important religious and historical figures could be rolled up as they were moved from one location to another in the sparsely populated Tibetan highlands, with their remote valleys and small monastic establishments. The *thangka* represents Buddhist authority figures: political leaders, revered teachers, lamas, *bodhisattvas*, and the Buddha himself. Once the *thangka* was consecrated, inscriptions indicated that the Tibetans believed that the revered subjects the *thangkas* represented were joined with their images. Therefore, the *thangka* image had to represent the essence and importance of that figure, showing it frontally, in a hieratic position of authority surrounded by a symmetrical composition of attendants and religious symbols.

A thirteenth-century *thangka* from central Tibet represents Manjushri, a high-ranking *bodhisattva* and symbol of wisdom (FIG. 3.15). He dwelt in the heavenly Pure Land and is shown here with lotus blossoms (symbols of purity), enthroned in the cross-legged position of a *yogin* before a tall multi-platformed temple flanked by two smaller temples. Additional images of Manjushri above the temples and at the base of the *thangka* show him with two or four arms, wielding a sword to cut through ignorance. At times he is also shown with a book, the *Sutra of Transcendent Wisdom*. The presence of these and other symbols in such *thangkas* may be explained by monks traveling with them from one monastery to another. The careful balance of this composition would seem to reflect the Tibetan Buddhist emphasis on order, balance, and harmony in their cosmology, and the careful manner in which they constructed their hierarchy of Buddhist figureheads, some of which were drawn from Hinduism

3.15 *Manjushri*. Central Tibet. Thangka, gouache on cotton, height 22" (55.9 cm). Private Collection

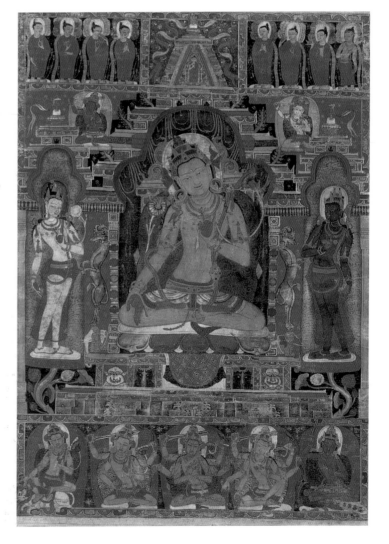

and Central Asia. The brilliance of the reds and golds of this and other *thankgas* would have made such images easily visible to all who saw them, even in the dim light of the candles and lamps of the monasteries.

As early as the eleventh century, the Tibetans began making portraits of nobles, monks, lamas, and other venerated religious leaders that seem to be based on first-hand observations of individuals. While these images on *thangkas* are realistic, they are also icons that elevated the historical subjects to semi-divine status. The authority vested in the Dalai Lamas and their power to lead their followers to enlightenment made them some of the most important icons in Tibetan art. The fifth Dalai Lama (died 1682), allied with the Mongols, unified Tibet, consolidated all political and religious powers in his person, and expressed his triumphs in the construction of a series of hilltop monasteries, including the Potala monastery–palace at Lhasa (FIG. 3.16).

This monastery–palace incorporated earlier buildings on this location with wall paintings dating back to the eighth century and followed a time-honored Tibetan system of construction. The basic building form used in the Potala, derived from the traditional Tibetan farmhouse, consists of a rectangle with tapered and whitewashed walls of sunbaked brick, narrow windows, interior column supports, and an enclosed courtyard. The red palace around an atrium at the center of the complex where the tomb of the fifth Dalai Lama is located became the religious center of all Tibet. The topographical demands of this site did not allow the builders to follow the traditional Buddhist *mandala* plan in which a tall central temple (symbolizing Mount Meru) would have been surrounded by lower temples and walls representing the Buddhist cosmos. The roof treatment, with Buddhist emblems such as the Wheels of the Law, deer (from the Buddha's first sermon), and finials in the form of mythic creatures, is only faintly visible in the photograph. When viewed from the plains below, the powerful simplicity of the earth-hugging trapezoidal forms rising out of

3.16 The Potala monastery–palace, Lhasa, Tibet

3.17 *Ananda Attending the Parinirvana of the Buddha.* Gal *vihara*, near Polonnaruva, Sri Lanka. 12th century CE. Granulite, height c. 23' (7 m)

the hill with their many eye-like windows expresses the political and spiritual power of the Dalai Lama as well as the austerity of life in this harsh Himalayan climate, while preserving the look of Tibetan folk architecture.

Sri Lanka

Legend has it that a son and daughter of Ashoka carried Buddhism to Sri Lanka, a large island off the southern tip of the Indian mainland, in the late third century BCE. Thereafter, it remained a stronghold of Hinayana Buddhism. Many of the Sri Lankan painters and sculptors made extensive use of freely flowing lines, which gave their works an energetic quality and sensuality. The latest important works on the island are the temples, stupas, and late twelfth-century monumental rock-cut sculptures at Polonnaruva, a royal city from the eighth century to the thirteenth. The period of the greatest artistic activity came during the reign of the last great monarch, Parakrama Bahul. The sculptors of a scene showing the Buddha's favorite disciple, Ananda, attending the Buddha's nirvana, present elements of the Sri Lankan style on a monumental scale (FIG. 3.17). Even though the Buddha is prone, the narrow string-like folds in his *sanghati* and the lines around his shoulder, down his arm, hip, and legs retain a sense of energy and movement. This gracefulness became an important element in southeast Asian Buddhist art. Yet, in keeping with the ancient Hinayana form of Buddhism they followed, the arts seem to be purposefully archaic.

Burma

From the ninth century to the thirteenth, before Burma was invaded by the Siamese and by the Chinese under Khubilai Khan, Buddhist art flourished in the administrative center of Pagan. The most famous and venerated shrine among the roughly 2,000 Buddhist monuments in this area, the Ananda Temple, was dedicated in 1090 (FIG. 3.18). A solid block of masonry

3.18 The Ananda temple. c. 1100. Pagan, Burma

in the heart of the cruciform-shaped terrace platforms, framed by four colossal statues of the Buddha (roughly thirty-four feet or 10.4 m tall), supports the central spire, which rises to a height of 165 feet (50.3 m). The elegant shape of this spire is reflected in the smaller towers on the corners of the terraces and a myriad of spikes and pinnacles ornamenting the skyline. The source for the cruciform plan of this mountain of brick, white stucco, and gilding appears to have been the Brahmanic architecture of nearby Bengal, India.

Indonesia

The cruciform plan underwent considerable modifications when it was used for the construction of an enormous and profusely decorated mountain-shaped stupa at Borobudur (or Barabudur) on the island of Java in Indonesia (FIG. 3.19). The origins of the monument are obscure; it may have been built around 800 CE and was not known by the outside world until the nineteenth century. The stupa, built over a crest of a small hill, is about 408 feet (124.5 m) on each side, 105 feet (32 m) tall, and is decorated with over ten miles (16 km) of relief sculptures in open-air galleries. The stairways that bisect all four sides of the structure are oriented to the cardinal directions. Borobudur represents Mount Meru, the centerpiece of the Buddhist and Hindu universes, and the name of this monument may mean "mountain of the Buddhas."

The base and first five levels, which are rectangular, represent the terrestrial world. Reliefs on the ground level of the stupa illustrate the plight of mankind moving through endless cycles of birth, death, and reincarnation. The walls of the next four tiers show scenes from the life of the Buddha taken from the *jatakas* and the *sutras* (scriptural accounts of the Buddha). The three round, uppermost levels of the structure represent the celestial realm and support seventy-two stupas. Each of them originally contained a statue of the preaching Buddha seated in a yoga position, and they surround the largest, uppermost stupa.

Borobudur is the ultimate diagram of the Buddhist cosmos and existence. Moving around it and ascending to the summit, pilgrims can relive their own previous lives and those of the Buddha, and see things to come in the future. They ascend from the human Sphere

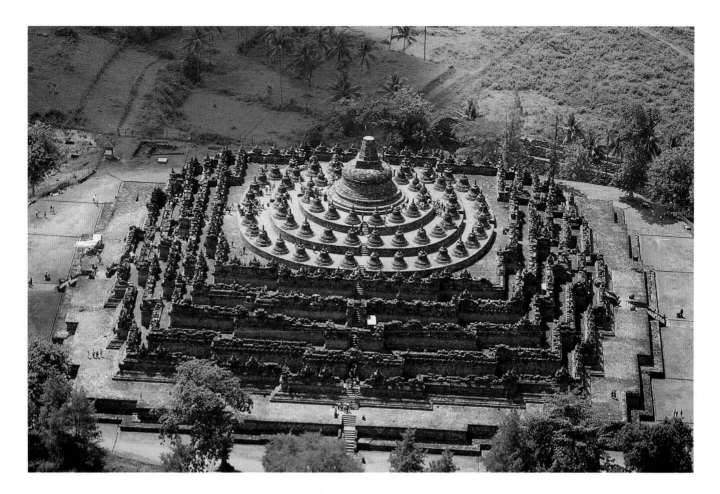

of Desire to the Sphere of Form, and finally arrive at the uppermost stupas, the Sphere of Form-lessness, which symbolizes the Buddha's ultimate achievement in nirvana. Combined, the symbolism of the architecture and the reliefs to be viewed while encircling it outline a microcosm of all earthly and heavenly existence in a consummate statement of the Mahayana Buddhist philosophy. In the physical act of following the galleries clockwise around the monument, ascending upward from reliefs representing the world of desire, past the stories of the Buddha who escaped from *karma* to images of such *bodhisattvas* as Maitreya, the Buddha of the Future, the devotees follow in the Buddha's footsteps. Unlike Hinayana Buddhism and the stupa at Sanchi, both of which provide a single step toward release from *karma*, Mahayana Buddhism and Borobudur present the ascent as many-leveled, but as capable of being achieved in one lifetime.

3.19 Borobudur, Java. Aerial view. Late 8th century

HINDU ART

As Buddhism spread throughout most of Asia, Hinduism replaced Buddhism as the main religion in India. Hinduism is a composite of many forms of worship, each with its own rich mythology and pantheon of gods (see "*Religion:* Hinduism," page 84). Hindu artists incorporated and transformed elements of Buddhist art to illustrate these gods and teach their dogmas. In parts of India, the Buddha was identified as an incarnation of Vishnu, an important Hindu deity. The Hindus believe they can form a strong personal bond with a deity (*bhakti*) and share in its wisdom and blessings. The first Hindu sculptures appeared at about the time the *Bhagavad Gita* discussed this important concept (second century BCE) and by the sixth century CE, the image-types of Hindu deities were well established.

Hinduism

Hinduism is comprised of many interrelated sects focusing on the ancient wisdom of the Vedas and of various gods and goddesses. Depending upon the sect, the most important gods are Brahma the Creator, Vishnu, Shiva, and the goddess Devi. Vishnu, whose consort is Lakshmi ("good fortune"), is illustrated in many forms or aspects as a boar, man–lion, fish, and Krishna the herdsman–warrior. Shiva also has many roles and forms. He is the protector of animals and the great *yogin* who meditates in the Himalayas. As a cosmic dancer, Shiva destroys and recreates the world. In his triple aspect as Mahadeva, Lord of Lords, Shiva is Aghora ("destruction"), Tatpurusa ("preservation"), and Vamadeva ("creation"). For many Hindus, Shiva, who incorporated the character of many of the Hindu gods into his identity, is the supreme god. However, the goddess Devi can take forms symbolizing beauty, benevolence, and wealth, as well as power and wrath. As Durga ("she who is difficult to go against"), Devi is a very powerful warrior goddess of virtue and protector of civilization. At times, she may be stronger and more revered than Shiva or Vishnu.

However, all the Hindu gods, with their multiple forms or aspects, are essentially one because they are manifestations of the one all-inclusive and eternal spiritual reality, *Brahman*, encompassing all temporal and divine beings. Hindu deities come from the *Brahman*, or Formless One, exist in the Subtle Body level, and enter the Gross Body when they manifest themselves in our world.

The brahmins are an ancient, highly trained class of priests dating back to Vedic times that perform many of the Hindu sacrifices and rituals. The practice of reciting prayers and placing offerings in fires so the flames will carry messages to the gods may date back to the Indus Valley period. The priests watch over the correctness and purity of these and other rituals aimed at the propitiation of the gods and achievement of *moksa*. This is a state of pure consciousness and bliss, achieved by those who have escaped *samsara*, the ongoing cycle of birth, death, and reincarnation. To achieve *moksa*, the Hindu must renounce all desires and consider every action a sacrifice to the gods.

These rules and principles for the attainment of *moksa* are explained in Hindu writings, the *Puranas* (book-length mythic poems about the gods) and *Tantras* (ritual forms for propitiating them). The literature also provided artists with a rich collection of visual images to illustrate. One of the most important Hindu texts embodying the Krishna myth, the *Bhagavad Gita* ("Song of the Lord (Krishna)"), explains how the faithful can bond with the godhead through *bhakti* (an individual's love of God), meditation, and reason. The concept of *bhakti* emphasizes the importance of a personal, intimate, and loving relationship with a god—as opposed to the performance of traditional rituals. Through this bonding, the wisdom and truths of the gods are revealed directly to the faithful. Thus, *bhakti* yoga became one of the Hindu answers to *moksa*.

HINDU ART AND ARCHITECTURE IN SOUTHERN INDIA

Hindu art flourished in southern India under the Pallava dynasty (c. 500–750 CE), which ruled from Kanchi, just west of Madras. Many of the rock-cut monuments at Mamallapuram ("City of Mamalla") were carved during the reign of Mamalla I (630–668 CE). The granite outcrops and cliffs covering several square miles along the coast of the Bay of Bengal were converted into a series of monuments that have long attracted throngs of pilgrims and tourists. The most famous of these monuments, an unfinished cliff carving, may represent *The Descent of the Ganges* or *The Penance of Arjuna* (FIG. 3.20). In the great *Mahabharata* war epic, Arjuna was one of the legendary Pandava brothers who underwent penance beside a river to enlist the aid of Shiva in a battle. He is seated beside a small shrine to Shiva to the left of the cleft in the cliff. During the rainy season, water from a cistern above cascades down the center of the relief, over cobra-headed spirits of water and earth, *nagas*, illustrating the

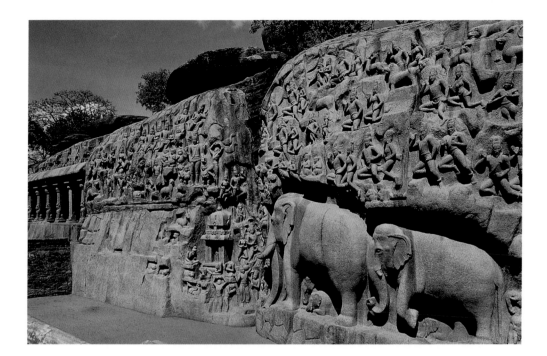

3.20 *The Descent of the Ganges* (or *The Penance of Arjuna*). Mamallapuram, India. Pallava period, 7th century

descent of the sacred river goddess Ganga to the earth as it was filtered through Shiva's hair. All of creation, the river deities, lions, bears, cats, mice, deer, *devas* (gods), and a pair of slightly larger than lifesize elephants with their calves, converge upon the sacred waters. Room for each animal and person was created by carving out individual pockets of space along the face of the cliff. While the elephants, which occupy a prominent position in the relief, are highly naturalistic, the lions, with their schematic, curly manes, recall the heraldic style of the much earlier Indian sculptures from the Maurya period. The enormous relief is not a narrative as such and gives little sense of any space or time in which the individual figures exist because, in fact, it represents all space and all time—the eternal present.

3.21 The *Dharmaraja Ratha*. Mamallapuram, India. Pallava period, mid-7th century

A number of "vehicles of the gods", *rathas*, were carved from a series of boulder outcrops (FIG. 3.21). These works, most likely commissioned by Mamalla I, provide a kind of historical museum of the mid-seventh-century southern Indian Hindu architectural types used during Mamalla's reign. The wooden, brick, and masonry building types built at this time around Mamallapuram have been translated into monumental stone sculptures. By reproducing the architecture in sculptural form, the two art forms are inextricably fused in monuments that may confound the viewer's sense of what is architecture and what is sculpture. The technology required to carve these large architectural sculptures is similar to that developed earlier by the sculptors of the Buddhist cave-temples. But here the process is reversed; the *rathas* are envisioned as masses in space, not spaces within a mass.

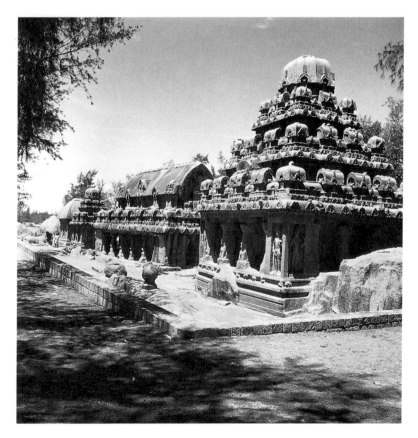

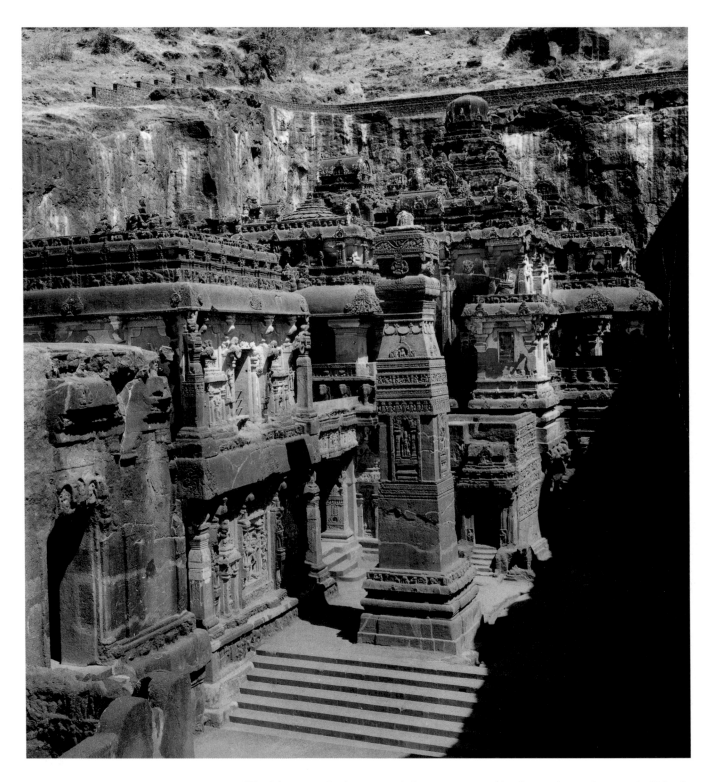

3.22 Kailasanatha temple. Ellora, India. Early medieval period, Rashtrakuta dynasty, c. 760–800

The *Dharmaraja Ratha* is a good illustrative example of an early southern-styled Hindu temple. Had the *ratha* been completed, it would have had pillared porches bordered by sculptures set in niches on all four sides and a *garbhagriha* ("womb chamber," the sanctuary or inner chamber housing the image). One of these exterior statues is a portrait of the patron, Mamalla I, posed stiffly, like a god. Above, each level of the tall, three-stepped, pyramidal *vimana* (roof) below the octagonal capstone is lined by small sculptured images of shrines with barrel vaults. Faces peer out from the small horseshoe-shaped windows in the shrines and the windows on the cornice. These vaults resemble those of an adjacent shrine

and the tall gateways of Hindu temples that were built in this area a millennium later. Work on the unfinished *rathas* may have stopped with the death of Mamalla I in 668.

Another very dramatic step in the development of the sculptured Hindu temple took place a century later at Ellora in the Deccan, an important ancient pilgrimage site for Hindus, Buddhists, and Jains alike. About thirty-two cave temples at Ellora were begun in the days of King Krishna I (ruled 756–773) of the Rashtrakuta dynasty (FIGS. 3.22, 3.23). The monolithic, rock-cut Kailasanatha temple complex (757–790) was dedicated to Shiva as the Lord of Kailasa, the great snow-capped mountain in western Tibet where his throne was said to be located. The temple was originally whitewashed to simulate the color of Shiva's snow-covered mountain.

The enormous amount of hard volcanic rock that had to be quarried in the cutting of the temple can be gauged by looking at the dimensions of the cliffs in the background, which are 120 feet (36.6 m) tall. The box-shaped courtyard excavated around the temple measures 276 by 154 feet (84.1 × 46.9 m, roughly the size of a football field) and the temple (which is 96 feet (29.3 m) high) is three times the height of the tallest *ratha* at Mamallapuram.

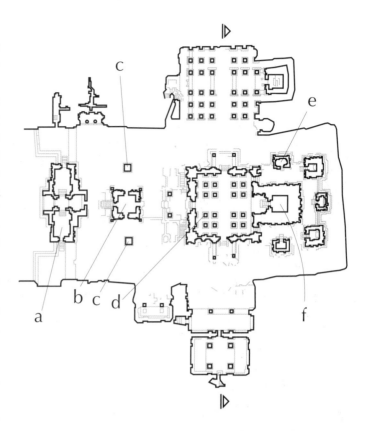

3.23 Ground plan of the upper story of the Kailasanatha temple and neighboring rock-cut temples at Ellora with numbers keyed to main features: (a) *gopura*; (b) Nandi shrine; (c) elephants; (d) *mandapa*; (e) subsidiary shrines; (f) *garbhagriha*

Visitors approach the Kailasanatha temple through an entrance gate or *gopura* (a) in a high sculptured wall, to the Nandi shrine, named for the bull that Shiva rides (b), flanked by a pair of elephants (c) and freestanding piers, to the columned assembly hall, or *mandapa* (d), and to the subsidiary shrines (e) or the thick walled *lingam* shrine in the "womb chamber" (*garbhagriha*) or sacred cavern in the cosmic mountain/temple (f). Additional rock-cut shrines are located in the walls behind the colonnade around the courtyard. The plan of this and other early Hindu temples reflects the designs of the Buddhist *chaitya* hall temples. The rich detailing of the freestanding towers, decorative niches, statuary, and the four-tiered *vimana* ("central tower") are elaborations on the styles of temple design at Mamallapuram. The deeply shadowed columns, cornices, and niches holding statues of deities add drama to the texture of highlights and dark shadows. A set of five shrines encircling the main sanctum and the side porches of the *mandapa* give the temple many right-angled wall faces that add to the profusion of complex architectural and sculptural forms filling the walled courtyard.

To compound the spectacle of the exposed, sculptured Kailasanatha temple, the Rashtrakutan builders cut shrines with columnar halls and monumental relief sculptures into the side walls of the enclosure. The *mandapa* of the Lankesvara temple to the left is similar in design to the Kailasanatha temple, but larger, with more massive piers. The works at Ellora extend far beyond the area seen here and include Buddhist, Hindu, and Jain cave-temples. Combining the technology and splendor of the earlier Hindu rock-cut temples at Mamallapuram with the cave-temples at Bhaja and Karli, the builders at Ellora have created what may be the most impressive set of rock-cut monuments in India. Looking at the Kailasanatha temple, Krishna I, who commissioned it, said: "How is it possible that I built this other than by magic?"

Because of its geographic position and the strength of its kingdoms, southern India was able to continue its indigenous artistic traditions after 1000 CE, while the Muslims took over much of northern India by 1200 CE. The political conditions in the early years of the Chola dynasty (c. 850–1310) under the rule of Rajaraja I, known as the "king

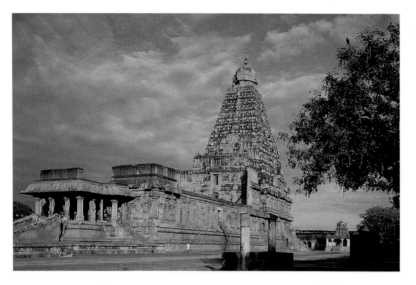

3.24 The Rajarajeshvara or Brihadesvara temple to Shiva at Thanjavur (Tanjore), India. c. 1000 CE

of kings," are reflected in the fortifications and moat surrounding the temple in his capital at Thanjavur. The temple, known as the Rajarajeshvara or Brihadesvara temple to Shiva, represents one of the high points of the southern Indian style of temple construction.

Visitors approaching the wall precinct, measuring 877 by 455 feet (267 × 139 m), enter through a gate tower on an axis leading to the *vimana*, which rises to a height of 216 feet (66 m; FIG. 3.24). Steps passing the open, columnar shrine to Nandi (Shiva's bull mount) lead to a colonnaded porch, flat-roofed *mandapa* halls, an enclosure with thirty-six columns, and the square shrine. The inner ambulatory of the shrine is lit by windows that are flanked by niches containing monumental statues representing aspects of Shiva and other Hindu deities. Worshipers move through a succession of progressively smaller and darker spaces until they arrive at the cult image, a *lingam* (plural *linga*), in the *garbhagriha*. The *lingam* is a symbol of male sexuality, specifically, that of Shiva. Some of the earliest examples are highly explicit: later *linga* tend to be more abstract and geometric and appear with the *yoni*, a circle and symbol of female sexuality. In yet other temples, the symbols are invisible and said to be made of ether. The walls of *garbhagrihas* tend to be plain and dark so nothing within distracts the worshiper from the rather simplified images of the *lingam* and *yoni* in the heart of the temple. The rite of circumambulation around the *lingam* shrine is as important to the Hindus as the rite is for the Buddhist worshiping at stupas. (See "*Analyzing Art and Architecture*: The Hindu Temple: Symbolism and Terminology," below.)

ANALYZING ART AND ARCHITECTURE

The Hindu Temple: Symbolism and Terminology

To ensure the purity of a temple and make certain that the god or gods to whom a temple is dedicated will take up residence there, every step of the planning and construction of that temple has to follow precise ritual procedures. Sites with fertile ground are preferred. Any spirits living there are "removed," and cows (sacred animals) are pastured on the temple grounds before construction begins. Descriptions of these rituals were recorded in texts by the sixth century CE. They include the recitation of mystic syllables, or mantras, designed to attract the deities.

The axis of a Hindu temple runs east to west, as does the sun. Many other features of its design are also determined by astronomical and astrological factors. Most important, to attract the gods who dwell throughout the cosmos, Hindu temples are designed as *mandalas*, specifically, the *mandala* of the Cosmic Man, the father of humanity. A checkerboard pattern of squares (usually sixty-four) belonging to lesser deities surrounds the square (the *garbhagriha*) housing the *Brahman* at the heart of the temple. Although non-Hindus may see this chamber as dark, in Hindu thought, it is filled with the pure light of *Brahman*. In most Hindu temples dedicated to Shiva, this inner chamber houses an image of Shiva in his first or Formless emanation of the *Brahman*. The *mandapas* represent the second, Subtle Body, state of the threefold emanation of the gods. Mystic forms of numerology accentuate the universal, cosmic symbolism of the temple. Once consecrated, the temple becomes a place for individual devotion, prayers and offerings to the deity, as well as more public rituals such as dancing and sacrifices in the *mandapas*.

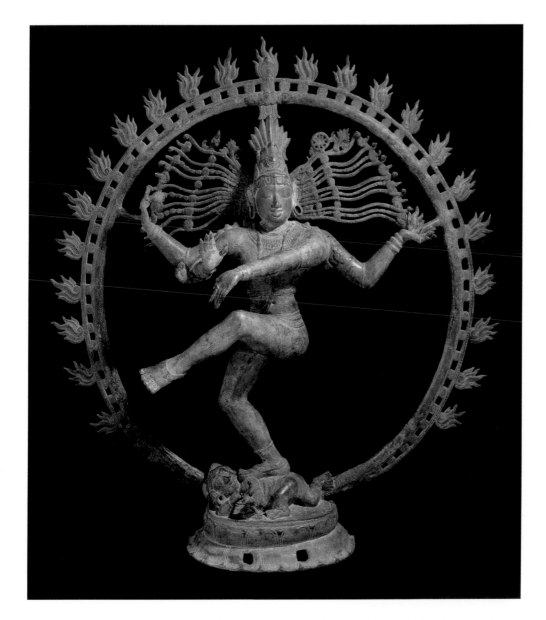

3.25 *Shiva as Nataraja, Lord of the Dance.* India. Chola period, 11–12th century. Bronze, height 32" (82 cm). Museum Rietberg, Zürich

A monolithic, eight-ribbed *stupika* ("capstone") topped by a gold-plated finial rises above the steep thirteen-leveled pyramidal *vimana*. This giant tower is decorated with ribbed domes, *chaityas*, window motifs, and dwarfs. Local legends say that a ramp four and one-half miles (7 km) long was constructed to roll the eighty-ton helmet-shaped *stupika* to the top of the *vimana*. With its many superimposed rows of miniature buildings, the steeply terraced tower looks like a Hindu hill-town, a densely populated World Mountain.

During the Chola period, the Brihadesvara temple housed many bronze and copper sculptures, which were carried through the temple in ritual processions. Some of them may have resembled the statue of *Shiva as Nataraja, Lord of the Dance* (FIG. 3.25). The idealized, impassive god, with long hair (a sign of asceticism) and smooth features, who resembles sculptures in the niches of the Brihadesvara temple, dances within a flaming circle. His raised leg symbolizes the need to escape from the ignorance of the world below, represented as a demon, on which he dances. Shiva's *tribhanga* pose resembles that of figures from earlier periods of Indian art at Harappa and Sanchi. He dances to the rhythm of the heartbeat of the cosmos, symbolized by the fire on the ring encircling him. His lower right hand makes the gesture of blessing (*mudra*). According to one interpretation, Shiva's dance, performed periodically, destroys the universe, which will be born again in a perpetual cycle of death and rebirth.

The fire symbolizes the destruction of *samsara* and *maya*, the illusions of this world created by ego-centered thinking. Thus, dance embodies liberation, the freedom the believer gains through *bhakti*, the love of Shiva.

Shiva's dance also celebrates life as an eternal "becoming" in which nothing begins or ends, in which creative and destructive forces are unified and balanced. Shiva holds a flame which symbolizes the fire that will consume the universe and a drum, symbol of *akasa*, the prime substance from which the universe will be rebuilt. The drum is also a common instrument of the ascetics, of whom Shiva is the patron god.

HINDU ART AND ARCHITECTURE IN NORTHERN INDIA

In contrast to southern Hindu temples such as that at Tanjore, Hindu temples in the north tend to be very compact, with high bases and tall central towers. Many regions in the north have excellent stone for carving and there is a wide variety of architectural sculptures, ranging from delicately carved decorative reliefs to nearly freestanding, lifesize sculptures.

The Kandarya Mahadeva ("Lord of Lords") temple in Khajuraho, capital of the Chandella dynasty, is widely regarded as the classic example of the northern Indian Hindu temple type (FIGS. 3.26, 3.27). As such, it illustrates some important differences between the northern and southern Hindu temple types. Unlike the sprawling temple complexes of southern India, the temple at Khajuraho is compacted into a unified, organic whole on a single high platform. It is a double crucifix plan with short arms extending from the long, east–west axis at the *mandapa* and *garbhagriha*. Although the original white gesso coating on its exterior has disappeared, the tall buff sandstone structure still resembles the crests of the Himalayas, the inaccessible snowy homes of the gods.

The axial approach leads visitors up a set of stairs through a porch to the *mandapa* and the sanctuary, holding a Shiva *lingam*. The rhythm of the closely spaced horizontals on the base seems to create pulsating waves of energy that rise through the columns on the porches and give birth to the towers and the *amalaka* ("sunburst") crowns at their summits, pointing to the other world of the heavens. The hypnotic power of these repetitive, echoing horizontal lines has been compared to the rhythms of Hindu chants, with their carefully constructed patterns of repeated words and phrases. The manner in which these horizontal accents blend into the vertical lines of the towers allows the eyes to move upward and inward along the roofline turrets to a central tower known as a *shikara*. The gently curved ribs of the interlocking network of towers bend inward and hug the towering peak of the *shikara*, reaching magnificent climaxes in the *amalaka* over their capstones as the towers link the terrestrial and celestial realms. Such northern, parabolic *shikaras* stand in stark contrast to the tall, pyramidal *vimanas* of the southern temples. Like an unopened, tightly

3.26 (top) Kandarya Mahadeva temple. Khajuraho, India. c. 1000 CE

3.27 (bottom) Plan of the Kandarya Mahadeva temple, Khajuraho, India. With numbers keyed to main features: (a) *garbhagriha*; (b) cult image; (c) *mandapas*

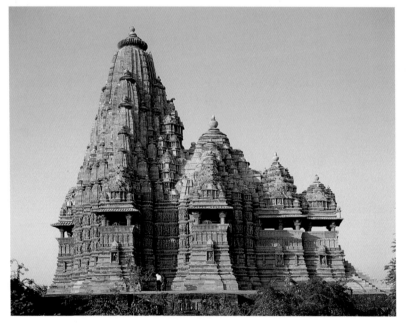

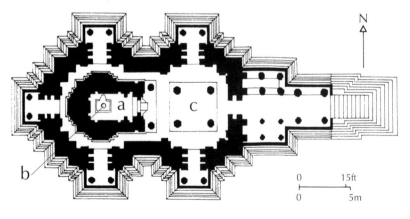

packed lotus bud, the cluster of engaged towers clinging to the *shikara* seems to be filled with all the potential energy of the Hindu cosmos and ready to blossom forth. The manner in which the architectural forms multiply or subdivide, yet remain part of the overall structural logic and energy of the plan, parallels the way in which the Hindu gods assume manifold, interlocking, and overlapping forms and identities.

Although the builders used masonry techniques to build this temple and image of the Hindu cosmos, it seems to have been conceived as a large, organic piece of sculpture. The sense of massiveness is no illusion: that is what holds the stones together. Indian masons used no mortar and few clamps to secure the stones.

Over 800 sculptures on the Kandarya Mahadeva turn and twist on their pedestals in dynamic poses that give a sense of movement to the piers and walls, further animating the masses of the structure. Like the sculptures on the other surviving Chandella temples in and around Khajuraho, the figures tend to be tall, with elongated, tubular legs and bodies, and some are arranged in erotic poses. They may illustrate the ideas of the Tantric (Vajrayana, or "diamond vehicle") variety of Mahayana Buddhism. It taught that the female force (*shakti*) was the prime one in the universe because it could activate the male force. Consequently, the female consorts of the male gods assumed new importance in the religion and its art. Images of sexual union represented the fusion of female wisdom and male compassion. Devotees link, symbolically, with Shiva and achieve a sense of unity and wholeness through sexual union with one another. Thus, the sculptures on this and other temples around Khajuraho, which are famous for their eroticism, would appear to reflect Hindu metaphysical speculations about the reconciliation of opposites, the cosmic unity of all beings, and the desire to bond with Shiva. Descriptive accounts of the art of love were recorded in the *Kama Sutra* (fourth century CE), but no known text explains the erotic sculptures at Khajuraho in this light and scholars have only assumed that they are Tantric metaphors for the linking of the human soul with the divine.

The Tantric joy found in the human body may be evident in the figures of Vishnu and Lakshmi from the Parsvanatha temple (FIG. 3.28). Their idealized bodies are unified in a single long C-shaped curve, a swaying, dance-like pose as Vishnu clutches Lakshmi's breast and presses his groin against her buttocks. The manner in which the thin scarves and ribbons accent the smoothness of their flesh and the gracefulness of their movements makes this figure group one of the masterpieces of Khajuraho sculpture.

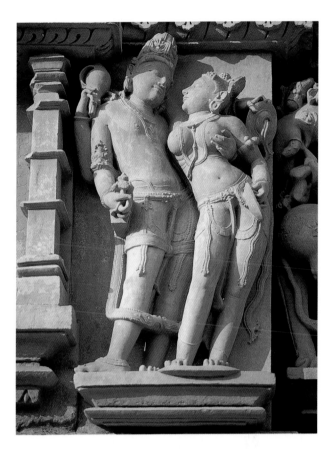

3.28 *Vishnu and Lakshmi.* Parsvanatha temple, Khajuraho, India. c. 1000. Stone, height c. 48" (1.22 m)

THE SPREAD OF HINDU ART

Hindu art of the Gupta period spread from India southeast to Burma and Cambodia, where it developed a new and distinctive imperial character under the patronage of the Khmer (Cambodian) monarchs. As a "king of the gods" (*devaraja*), a Khmer ruler was deified during his own lifetime. By the twelfth century, the powerful monarchs, ruling out of Angkor (Khmer, "city" or "capital"), about 150 miles (240 km) northwest of Phnum Penh, controlled an area that included portions of Thailand and Vietnam. The city of Angkor, crossed by an extensive network of broad avenues and canals, covered about seventy square miles (180 km²). The royal palaces, built of perishable materials, have long disappeared, while the temples, constructed out of brick and stone, remain in a relatively good state of preservation.

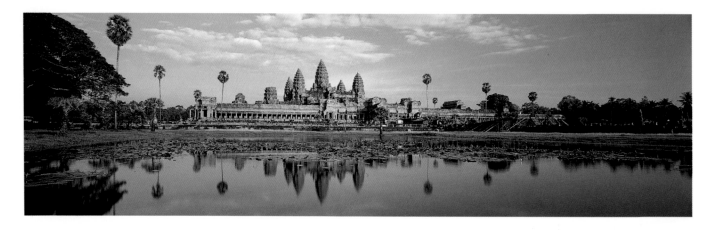

3.29 Angkor Wat, Cambodia. Aerial view. Early 12th century

The largest of these temples, Angkor Wat ("temple of the capital"), was built during the reign of King Suryavarman II (1112–c.1150). Its central spire is about 200 feet (61 m) tall and the moat surrounding the complex is over two miles (3.2 km) in circumference (FIG. 3.29). The broad moat and the outer wall symbolize the oceans and mountains ringing the edge of the world. Within, the five towers stand for the peaks of Mount Meru, the heart of the Hindu universe. The temple is oriented so viewers passing through the western gate at sunrise on June 21, the beginning of the Cambodian solar year, would see the sun rise directly over the central tower. This orientation may further tie the architecture and deified king with the cosmos.

It is startling to note that the entire complex, with a detailed, symmetrical plan and fitted with miles of reliefs, was built in the short span of about thirty years. Even more astonishingly, this and the other lavish Hindu temples constructed by the mid-twelfth century would not meet the needs of Suryavarman's son and successor, Jayavarman VII (ruled c. 1181–1218). He expanded the empire to its greatest dimensions by conquering portions of Malaya, Thailand, and Laos and founded a new royal city for his court, Angkor Thom, with Buddhist and Hindu monuments. Like the rest of the city, the Bayon, the massive mountain-shaped Buddhist temple in the center of the city surrounded by temples and

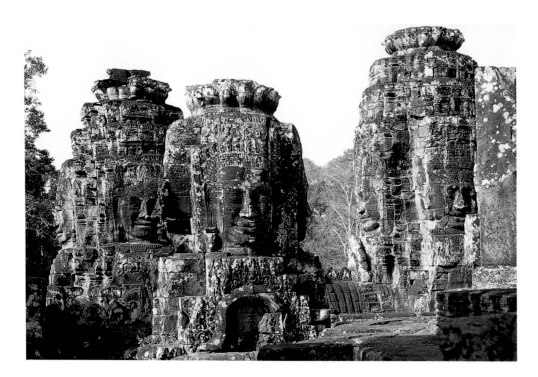

3.30 The Bayon temple. Angkor Thom, Cambodia. c. 1200

palaces, is now in ruins (FIG. 3.30). It was dedicated to the *bodhisattva* Lokeshvara, a manifestation of Avalokiteshvara, of whom Jayavarman believed he was an embodiment. The famous giant smiling faces with their broad rounded features on the towers at Angkor Thom blur the line of distinction between sculpture and architecture. They represent the ruler as the *bodhisattva*, looking outward in all directions from the center of his great kingdom. The multiplication of heads, facing in every direction, radiated the presence and power of the divine king in every direction to every province in his empire. These places were included in the temple inscriptions in the chapels, which were provided with statues of the favored local provincial deities.

The temple–mountain is a giant *mandala*, one appropriate to the complexities of Mahayana Buddhist thought. The Bayon, like Mount Meru, is surrounded by tall walls (mountain ranges) and a moat (the oceans of the world). The Bayon owes more to Hindu sources than Buddhist ones, and illustrates how these two religions exchanged ideas, insights, and art forms throughout their history. The city was unfinished when Jayavarman died around 1218 and the kingdom was soon being pressured by the all-conquering Mongols from the north and from Thailand. Eventually, the court retreated and its arts were perpetuated in the folk traditions of this region.

JAIN ART AND ARCHITECTURE

Although only about one half of one percent of Indians are Jainists and very little was known outside India about their religion until recent years, there are many important Jain monuments throughout India (see *"Religion:* Jainism," below). While some Jain art resembles that of the Buddhists and Hindus, the Jain identity of certain statues of nude, meditating heroes (*jinas*) standing in stiff military poses is unmistakable. An ancient Jain text says the standing jinas should be shown "with posture straight and stretched, with youthful limbs and without clothes… the fingers reaching the knees." Their fingers are cupped inward but do not touch the legs.

RELIGION

Jainism

Jainism is an ascetic tradition without a supreme deity that broke away from the Vedic, Brahmanic, or Hindu tradition. Jainists believe their religion was revealed to humankind by a series of twenty-four *tirthankaras* ("pathfinders"). The last of these "pathfinders," Mahavira ("The Great Hero") (599–527 BCE), from northeastern India, lived in the same century as the Buddha. The *tirthankaras* are also known as *jinas* ("victors" or "heroes"), hence their followers, the "sons of visitors," are called Jains. Devotees subscribe to the principle of nonviolence and live in great purity in their quest to join the pathfinders in the realm of pure spirit at the apex of the universe. Jainists believe in *samsara*, the ongoing cycle of birth and death. By living pure lives they hope to perfect their *jiva* ("soul" or "higher consciousness") and escape *samsara*. One who does is called a *jina*.

Jainists do not kill living things of any description and avoid hurting others with abusive language or negative thoughts. Possessions, they believe, enslave them, so they tend to own very little. They form few personal or emotional attachments to others, even family members or gods. Jainist monks are famous for their asceticism and indifference to pain. Jainists do not believe in absolute truths, try to remain open-minded and nonjudgmental. They focus their attention inward and work toward the perfection of their own souls. To conquer oneself is to conquer everything.

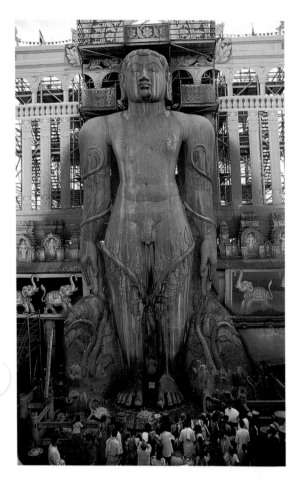

A colossal image of this type of meditating *jina*, c. sixty feet (18.3 m) tall, was erected on a high hill in Karnataka in the tenth century. It represents a famous ascetic, Gommata, the second son of the first "pathfinder" (*tirthankara*). He is shown in the nude as he meditated without interruption for years on end (FIG. 3.31). A Jain text tells how Gommata,

plunged in the nectar of good meditation ... was unconscious of the sun in the middle of the hot seasons ... In the rainy season he was no more disturbed by streams of water than a mountain ... He was surrounded completely by creepers with a hundred branches shooting up. Hawks, sparrows etc. in harmony with each other, made nests on his body... Thousands of serpents hid in the thickets of the creepers.

The image of Gommata and the many statues it inspired are used daily by many Jainists as aids in their meditation. Every twelve years, groups of nude Digambara ("sky clad") monks, for whom Gommata is an important role model, bathe the colossus at Karnataka. The nudity of this and other Jain images of *jinas*, as well as the Digambara monks, is not intended to be sensual. In fact, it expresses quite the opposite in their renunciation of the world and indifference to the needs of their bodies. The rigidity of the pose in which Gommata and the monks meditate, exposed to the elements of nature, expresses the severity of their asceticism and the discipline required to fulfill their religious goals. "Meditate on the oneness of the self alone," says a Jain text. "Thereby you will attain liberation."

While Jainism in its purest form preaches that material possessions enslave their owners, many of the finest Jain shrines and temples are very lavish. Ancient Jain texts explain in detail how the temples were to be built, giving the numbers, names, and proportions of the superimposed layers of the base and walls, and the system by which the compound tower is clustered. All the parts are interrelated by a precise system of mathematically determined ratios. Many Jain temples are cruciform, like those of the Hindus, and they have columned porches or *mandapas* around a small, enclosed sanctuary.

The finest Jain temples, such as those at the important pilgrimage site of Mount Abu, have highly ornate pillars and cusped arches with finely detailed carvings on their domed ceilings. From 1032 to 1233, as the Islamic kingdoms were expanding in India, the Jain artists at Mount Abu created some of the most important Jain monuments on this holy summit. The Jain love of wealth and finery is displayed in spectacular fashion in the white marble sculptures on the ceiling of the *sabha mandapa* (assembly hall) of the Vital Vasahi temple (FIG. 3.32). A profusion of radiating foliate and geometric forms provides a sumptuous background for the sixteen figures of women, the *maha-vidyadevis* personifying knowledge and forms of magic used in Jain rituals. All sense of the architectural structure is obscured by the pearly radiance of the seemingly weightless, embroidery-like white marble filigree. The very slender figures, with tubular limbs, blend well with the ornate background, expressing the Jain belief in the absorption of the individual in the patterns of the cosmos. The Jain sense of purity and lack of interest in sensual and material matters seem evident. The bodies of the *tirthankaras* and dancers in the outer circle are reduced to lean, simplified tubular forms. They are revered as models of existence, but worshipers ask nothing of them. The tremendous sense of concentration on the details of the foliate motifs is a reminder that in addition to the sense of denial practiced by the Digambara monks, the religion was also one of great theological complexity that appealed to royal patrons.

3.31 *The Ascetic Gommata.* Indragiri Hill, near Sravanabelgola, Karnataka, India. 10th century. Basalt, height c. 60' (18.29 m)

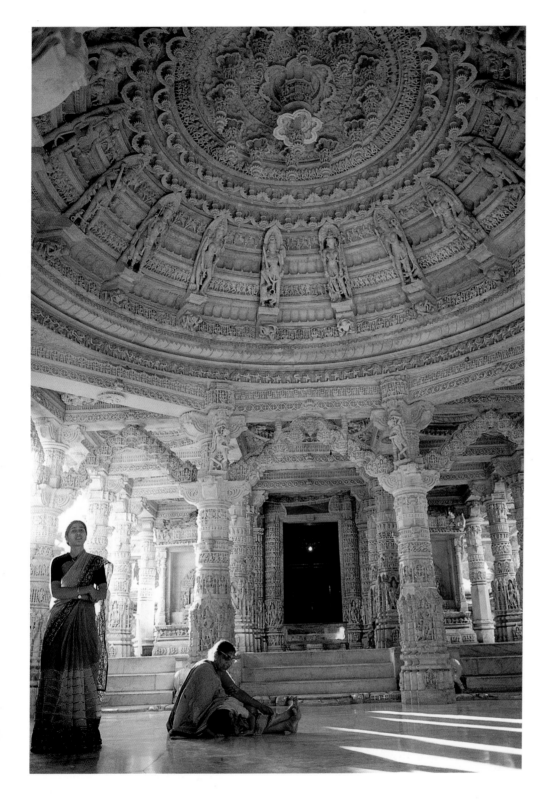

ISLAMIC INDIA

Islamic groups from Central Asia moving through the northern passes of the Hindu Kush began arriving in India around 1000 and, by 1200, Islamic dynasties or sultanates ruled portions of northern India from their capital at Delhi. Delhi became a great center for art and architecture as the Muslim traditions of Central Asia and Persia blended with those of India. In the early sixteenth century, a group of Turco-Mongol *Sunnis* known as Mughals, led by Babur (ruled

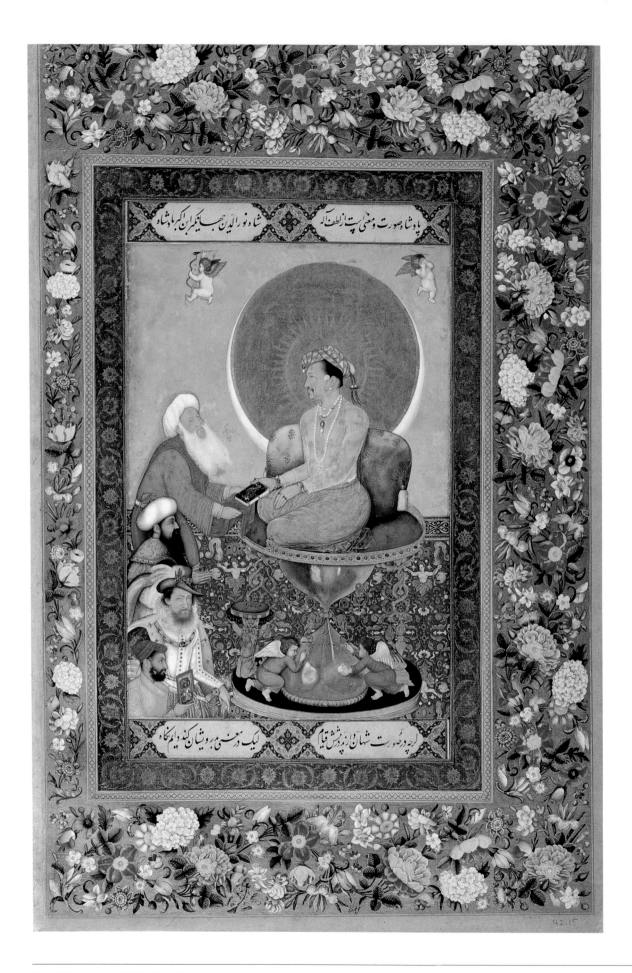

1526–1530), established a strong empire in northern India, with capitals at Delhi and Agra. They claimed to be descendants of two great conquerors, Tamerlane from Central Asia and Genghis Khan of Mongolia.

When the Mughal leaders were temporarily expelled from India (1540–1555), they took refuge at Tabriz, Persia, in the court of Shah Tamasp Safavi, a great patron of the arts. While the *Koran* forbade artists to represent the human figure in art, the Persian artists had been allowed to overlook this prohibition and they developed an important style of miniature painting. When the Mughals reconquered India, with the aid of Shah Tamasp, under Akbar (ruled 1556–1605), they created palaces, tombs, and cities that rivaled the finest monuments of the great Islamic capitals at Isfahan, Samarqand, and Cairo. Akbar, who had studied Persian art and culture as a youth when his family was in exile in Tabriz, established a school of painting in India run by Persian masters who taught Islamic and Hindu students the techniques of Persian figure painting on paper. Shortly thereafter, in the 1570s, when the Portuguese arrived in India with European oil paintings and prints, Akbar instructed his artists to see what they could learn from them. Thus, the new "Akbari" style of figural paintings, which upset some of the orthodox Muslims around his court, became a truly international style of art.

Under Akbar's son Jahangir ("World Seizer") (ruled 1605–1627), who commissioned artists to make portraits and illustrations of historical events taking place during his reign, Mughal painting became highly realistic. A complex and detailed miniature by an artist named Bichitr, *Jahangir Seated on an Allegorical Throne*, shows the ruler handing a book to a Muslim teacher (FIG. 3.33). Jahangir is seated on an hourglass throne before a large halo or nimbus recalling those behind earlier images of the Buddha. Below the teacher are portraits of an Ottoman Turkish ruler who had been conquered by his ancestor Tamerlane, of James I of England, and, perhaps, of the artist himself. At the bottom of the hourglass, a pair of winged children known as putti, taken from European paintings or prints, writes the words "Oh Shah, may the span of your life be a thousand years."

In fact, the span was much shorter; the Shah, addicted to wine laced with opium, died in 1628, about three years after this miniature was completed. The brilliant traditions of Mughal painting began to decline under his son Shah Jahan (ruled 1628–1658), who was a great patron of architecture. Although the name of his architect, Ahmad Lahawri of Lahore, is not well known, the tomb he built near Agra in northwestern India, the Taj Mahal, is the principal icon of Mughal Indo-Islamic culture (FIG. 3.34).

3.33 Bichitr, *Jahangir Seated on an Allegorical Throne*. Mughal, Jahangir period, c. 1625. Opaque watercolor, gold, and ink on paper; $10 \times 7^{1}/_{8}$" (25.4 \times 18 cm). Freer Gallery of Art, Smithsonian Institution, Washington, D.C.

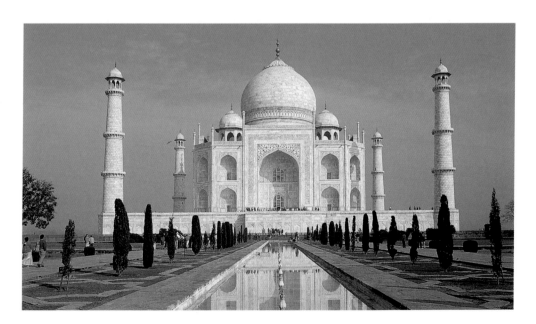

3.34 Taj Mahal. Mughal, Shah Jahan period. Completed 1648

THE TAJ MAHAL

The Taj Mahal ("Crown of the Palace") was commissioned by Shah Jahan as a memorial to his wife, known as Mumtaz Mahal ("Light of the Palace") (died 1631), who had borne fourteen children. The basic design of this famous central-plan domed tomb has its roots in the Timurid traditions established in India by Mughal leaders in the sixteenth century. Visitors enter the complex pass through an outer southern gate, an open green area, through a much larger inner gate, and large symmetrically arranged formal gardens with reflecting pools. Beyond the gardens stands the tomb on a podium flanked by a mosque and a large guest house.

The Taj Mahal is a white marble building inlaid with semiprecious colored stones. The outline of its gracefully proportioned bulbous central dome is echoed by the superimposed arches on the corners of the building, the four smaller domes, and the crowns of the surrounding minarets. Tall, gracefully pointed arches pierce the walls facing the outside world. The rich network of interlocking domes and arches gives the Taj Mahal a sense of visual unity from all vantage points.

Patterns of floral ornament around the central arch inlaid in black marble and semiprecious stones, mixed with shadows lightened by reflected sunlight from the marble terraces and shallow pools, give the entire structure a soft, dreamlike quality. All the color contrasts and decorative motifs—flowering plants in low relief—are highly restrained. The smooth, unpolished white crystalline marble has a translucent quality and reflects the sunlight in such a way that for centuries visitors to the Taj Mahal have insisted that it is blue in the morning sun, white at noon, and yellow at dusk.

The original plan included a bridge over the river to connect this tomb with a matching black marble one for the Shah, which was not built. In Shah Jahan's last years, his son Aurangzeb (ruled 1658–1707) usurped his throne, confined his father to the Red Fort of Agra, and reinstituted orthodox forms of Islamic law and worship. From his gilded prison, with gardens and fountains, the aged Jahan could look out over the Jumna River and muse upon the tomb where his wife lay.

> Like a garden of heaven a brilliant spot,
> Full of fragrance like paradise fraught with ambergris.
> In the breadth of its court perfumes from the nose-gay of sweet-hearts rise.
> (SHAH JAHAN ON THE TAJ MAHAL)

After the death of Shah Jahan in 1658, the Muslim rules of orthodoxy regarding figural art began to be reinstated. Many of the Mughal figural painters went to work for the Hindu nobles in Rajasthan as the Mughal empire and its traditions in the arts in India began to decline.

LATE HINDU ART IN INDIA

While Hindu art languished in many parts of India under Muslim rule, it flourished in the south under the Nayak rulers at Madurai in the sixteenth and seventeenth centuries. The Great Temple of Minaksi-Sundareshvara at Madurai, with temples to Shiva and the goddess Minaksi, was built under the rule of a great Nayak patron of the arts, Tirumalai (ruled 1623–1659) (FIG. 3.35). It is an enormous complex of columned courts and covered corridors arranged within a network of enclosing walls. It has been estimated that there are about 33 million sculptures in the complex. As such southern temple complexes were expanded and surrounded by taller and longer walls, the attention traditionally lavished on the central *vimana* was redirected to the *gopuras* (entrance towers) at the cardinal points along the outer walls. The *gopura* of the temple at Madurai, derived from early *vimanas*, is divided into levels or stories of diminishing size and has graceful concave or bowed outlines that give it an impression

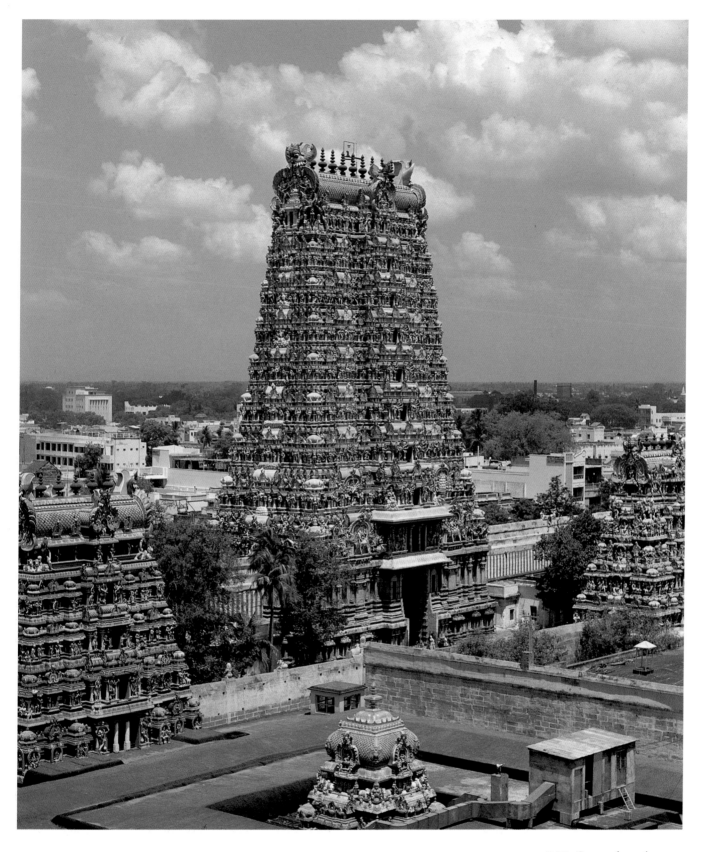

3.35 *Gopura* from the Minaksi-Sundareshvara temple, Madurai, India. 17th century

3.36 *Radha and Krishna in the Grove.* India, Pahari, Kangra. c. 1780. Paint on paper, 5¹/₈ × 6³/₄" (13 × 17 cm). Victoria and Albert Museum, London

of great lightness. In reality, to lighten such enormous pylon-shaped skyscrapers, the sculptors worked with painted stucco. As a testament to the iconographic and decorative richness of the polychrome reliefs on the *gopuras*, which include tens of thousands of figures in the round, no complete photographic record and study of the sculptural programs has yet been undertaken.

While the collective effects of the sculptures and paintings in this and other Nayak temples are fascinating, perhaps the most innovative examples of Hindu art from this late period are painted illustrations accompanying new types of Hindu texts written in the vernacular. In the past, such works had been written in Sanskrit, the knowledge of which

was restricted to a small audience of priests and nobles of the Brahmin caste. In the vernacular languages, even those who were illiterate could listen to the stories and epics when they were read. The content of the new literature was also "popular." Often, it described romantic encounters of the gods and humans, stories interesting in themselves, and ones with important religious messages about the all-important bonding of the human soul with the gods through love. This idea is not new in India: traditionally, the devotional cults (*bhakti*) had used images to visualize deities and bond with them, but in the vernacular the illustrated narratives had a new level of appeal.

Two of the favorite lovers in the literature and art of this period were the herdsman–warrior Krishna (a manifestation of Vishnu), and a lovely herdswoman, Radha. This enabled the artists to depict the union of the lovers in lovely pastoral or bucolic settings. *Radha and Krishna in the Grove* was painted in Kangra in the Punjab hills during the rule of Sansar Chand (1775–1823), a great patron of miniature painting (FIG. 3.36). The lovers lie on a bed of plantain leaves in a grove near a river. As they touch one another, nature blossoms forth around them. To the left, a vine in union with a tree, wrapping around it, rises toward pairs of lovebirds in the branches.

In 1805, when Chand's kingdom was under attack by mountaineers from Nepal, he appealed to the British for help. The presence of the British East India Company, which had been gaining political power in portions of India since the eighteenth century, laid the foundations for the official British rule of India (1858–1947) and the decline of the traditional forms of native Indian art and culture.

COLONIAL INDIA

In 1858, Queen Victoria became the Empress of India and for nearly a century, native Indian artists were forced to deal with a myriad of issues created by the presence of the British in India. Under the Mughals, European art had been an exotic curiosity item that was imported and enjoyed without being understood and incorporated into the culture. Under the British, however, art became part of a much broader program to Westernize India. With the industrial and technological superiority of the British, along with their political hegemony and rights to act as patrons of the arts, came the tacit assumption that everything else British, including the arts, was superior to that of India. In the late nineteenth century, the most influential British artists and patrons in India had a strong preference for portraiture and historical painting, aggrandizing images of events from the past with moralizing or ethical messages. In architecture, many of the wealthy British in India wanted to live in palatial Neoclassical homes that expressed the authority of Greco-Roman and European thought, including the philosophy of colonialism.

As in many parts of Asia and elsewhere in the non-Western world where colonial European governments were established at this time, the native artists under the colonial rule were pulled in several directions. Was it best to become fully Westernized, or should they ignore the foreign traditions and continue to work in their traditional native styles? Or were there ways to select the best from both traditions, to find some middle ground where they could satisfy the needs of both cultures? But was this progress, or a form of capitulation? Could they become partially Westernized and still maintain their self-respect? Dealing with these issues, the history of Indian art in the colonial period underwent many changes which cannot be seen in simplistic terms, as that of an inferior tradition attempting to assimilate and imitate a superior one. The artists and their patrons in India were not passive and had many, varied individual responses to the art of their foreign rulers.

Many of the late nineteenth-century Indian artists were English-speaking, pro-Western thinkers who embraced European art. Art schools teaching Western techniques

and ideals were established as part of the British effort to spread their civilized learning, improve native tastes, and humanize India. Students, mainly English-speaking young men from upper-caste families, made drawings after still lives and plaster casts of Western masterpieces. Many of these Indian artists found that using, the European techniques of linear perspective, anatomical rendering, and modeling while working with oil paints, they could make images of the world around them that would have been impossible to create using the traditional Indian painting techniques and materials. Even the perception of the artist in India changed as the traditional artisans working for aristocrats who controlled matters of taste were replaced by highly skilled individuals pursuing their own ideals. Oil paints and forms of printmaking began to replace the traditional materials used by painters, and architects began to work in the British Neoclassical style, creating mansions for the rulers, who often filled them with European art.

3.37 Ravi Varma, *The Triumph of Indrajit*. 1903. Oil on canvas. Sri Jayachamarajendra Gallery, Mysore

Within this milieu, one artist rose to such prominence that he became a national hero. Ravi Varma (1848–1906), who was called a "prince among painters and a painter among princes," was largely responsible for reshaping the traditional image of the Indian painter. Varma did not work in the traditional Indian manner, as an artisan tied to a powerful patron and a single region of India. He became a European-styled artist–entrepreneur, a professional society portrait painter who was at ease among all classes, Indian and British. With his network of agents and associates throughout India, he moved through the country, where his work was always in demand. In essence, Varma succeeded in building a bridge between the Indian and European traditions and created a new and popular image of the modern Indian artist.

Born in the province of Kerala to an aristocratic family related to the rulers of Travancore, Varma saw examples of Indian and European art as a youngster and took painting lessons from an uncle. His early paintings from the 1870s tend to be flattened and matter-of-fact, like those of many other early colonial Indian painters of this period, without the chiaroscuro, richness of illusion, and drama of his works after 1880. Varma's British and Indian audiences admired his romanticized historical paintings based on the Sanskrit classics for the grandness of their style and the loftiness of their messages. In *The Triumph of Indrajit*, Varma adopts the time-honored figure types, gestures, and compositions of European history painting to illustrate a narrative from a Sanskrit classic (FIG. 3.37). The characters, their dress, and the architecture are Indian but the composition and techniques of painting owe much to European history painting, especially the British painters of fancy-dress oriental fantasies. For Varma, an avid theatergoer who enjoyed Indian and British dramas in Bombay and Madras, this European genre helped him restore the dignity of his people's past.

A genius at self-promotion, Varma was the first major Indian artist to use inexpensive printing techniques. With them, he reproduced his images of Hindu deities and legends that found their way into almost every home in India. His interests in popularizing Hindu thought were part of a growing pan-Indian nationalism and, along with his millions of prints, the Indian gloss he added to the European salon-styled historical paintings contributed immensely to the development of the twentieth-century Hindu identity. So great was the fame of this image-maker that his own life became surrounded by myths as colorful as those he painted. As the romantic image of the artist–hero who forged new paths through the colonial world, triumphing over all obstacles, Varma became the model for all Indians searching for their identities in a changing world.

The death in 1906 of this national hero who had transcended class, region, and ethnicity ended what has been called the "optimistic phase" of colonial art in India. In the rapidly changing political and social climate of early twentieth-century India, Varma's posthumous fame was very short-lived. Well before his death, advocates of indigenousness (*swadeshi*), fighting against the Eurocentric thinking of the British who continued to hold Indian culture in low regard, opposed Varma and others who embraced Western art so willingly and lovingly. Writers who were part of this new form of nationalism, championed by what is known as the Bengal Renaissance, centered in Calcutta, called for artists to reject outright European conventions in the arts, examine their own past, and find a new, optimistic Hindu-Indian identity within their own heritage.

The champion of the *swadeshi* movement in the visual arts was Abanindranath Tagore (1871–1951), the son of a wealthy, high-caste family in Calcutta. He was raised among the literati of the Bengal Renaissance, which included members of his family who were devoted to the recovery of ancient Indian culture. Tagore inherited a love for traditional forms of Indian culture, including book illustrations. Most of his imagery was drawn from the rich past of Indian literature, Hindu legends, and myths, but, unlike Varma, he did not turn to the techniques of Western art to illustrate them. Instead, he developed a hard-edged style of painting, essentially colored drawings, in which his Hindu subjects were based on Mughal and

Hindu miniatures, folk art, and ancient Indian murals. With his interest in all Asian cultures, Tagore studied Japanese paintings and woodblock prints and was fascinated by the way they simplified and abstracted forms to their very essence. Works such as *Bharat Mata*, an image of Mother India as a Bengali lady, provided the *swadeshi* movement with icons around which they could crystallize their beliefs and feelings about nationalism (FIG. 3.38). Living under British rule, they had a strong romantic, primitivist longing to recreate a pre-industrial and purely Indian society. Tagore's legacy goes beyond his own art; he was famous as a teacher and his pupils became some of the most influential artists, teachers, and art school administrators in early twentieth-century India.

As in the case of Varma, Tagore's grand position in the arts was soon eclipsed, in this case well before his death. In the 1920s, abstract and non-objective styles of European modernist painting and sculpture arrived in India. Since these avant-garde works were part of a Western rebellion against the classical traditions of the past—values that were part of the philosophy of colonialism in India—the abstract art styles were welcomed and widely imitated by the emerging avant-garde in India. There-after, movements in Indian art for much of the twentieth century closely followed those in the West. The art of India in the late twentieth century following independence is discussed in Chapter 8.

SUMMARY

The major religions developed in India—Brahmanism, Hinduism, Buddhism, and Jainism—all derive from the Indian philosophical writings of the first millennium BCE. They state that the material world is an illusion and that only the spiritual world of *Brahman* is real and everlasting. To strive toward the *Brahman* and the attainment of pure bliss, members of all the religions use yoga, a form of meditation and discipline for the mind and body. With meditation, they practice *darsana*, visualizing the gods. Indian art, which gives visual forms to the gods, helps worshipers in this process of visualization. Temples and other places of worship not only provide homes for images: they are microcosms of the Buddhist, Hindu, and Jain worlds. Viewing the art, meditating, and moving through the temple spaces, devotees can make symbolic journeys along spiritual paths through these religious universes, transcend the material world of illusion, and enter the transcendental realm of the Brahman.

3.38 Abanindranath Tagore, *Bharat Mata*. 1903–4. Watercolor on paper. 10¹/₂ x 6" (25.67 x 15.24 cm). Rabindra Bharati Society, Calcutta

With their powerful messages and spectacular forms, the arts of India spread in all directions north as far as Afghanistan and Tibet and southeast to Indonesia. Some Buddhist art in Afghanistan along a spur of the Silk Road influenced the art of China in the fifth century CE, when that country was first embracing Buddhism.

While the arts of India spread beyond its borders, the country's art and architecture were also influenced from outside. For more than 900 years, Muslim art has been part of Indian history. Under British rule, the arts of India were heavily influenced by European styles and techniques. Indian artists found many productive ways to combine their heritage and Western art in a series of movements leading up to India's independence in 1947.

CHAPTER FOUR
CHINA

CHINA

The traditional Chinese name for their own country, Zhong-guo ("Middle Kingdom"), may date back to the Xia dynasty (c. 2205–1700 BCE). It envisions China as the hub of the world, the place through which all power flows. The emperors, sons of heaven, mediated between the hub of the world, humankind, and the heavens. The modern name "China" comes from Qin (pronounced "chin"), the name of the first imperial dynasty, established in 221 BCE.

Over its long history, China has had many capitals and border changes. Often, it has been much smaller than its present borders, with two main cultural centers, in the southeast near the mouth of the Yangzi River and in the north along the Huang Ho ("Yellow") and Wei rivers. Periods of stability and prosperity under the rule of a centralized government with powerful Chinese or foreign rulers have alternated with eras of anarchy during which China was fragmented into rival kingdoms. The historical existence of the Xia leaders who are said to have taught the Chinese the techniques of irrigation and the arts of pottery and weaving remains debatable.

INTRODUCTION

Little remains of the ancient river valley civilizations that developed along the Indus in present-day Pakistan, the Tigris–Euphrates in Iraq, the Nile in Egypt, and the Yellow and Yangzi rivers in China. Only in China has the early culture managed to survive in part to modern times. It has often been said that the Chinese attached such value to their ancient cultural traditions that they were able to absorb or "sinicize" (acculturate to Chinese ways) the foreigners who tried to conquer them. In actuality, Chinese art and culture changed greatly over the centuries as they absorbed foreign ideas and redefined their own traditions. China has traded with its neighbors by land and sea, has been invaded and ruled by foreign powers, and for nearly 500 years, Chinese artists have been exposed to Western art, including the modernist, abstract styles and the social realism adopted by the People's Republic. As a result, Chinese art has changed constantly, and each of the many periods in its long history has its distinct character. We can see the changing interests of the Chinese artists and their patrons in the archaeological record, ancient inscriptions, and philosophical writings on art from the fifth century CE to the present day. In short, the history of Chinese art from Neolithic times to the present is as complex as the history of art in the West during these centuries. To examine it, it is important in this Introduction to look at a number of important ideas about art, religion, and culture in general that developed at different times, ideas that will be reintroduced and studied in detail where they apply in the pages that follow.

The Chinese believe that their deceased ancestors have a posthumous, spiritual form of existence that gives them access to the gods. Since the ancestors remain powerful after

death, the living need to continue to pay them respect and provide their upkeep in the spirit realm. Today, this often takes the form of paper models of food, luxury goods, and money which are then burned so that they are transmuted to the spirit world. This tradition grew out of a much older one that by at least the Shang period (c. 1700–1045 BCE) required the furnishing of graves with all the implements that the deceased would need to carry on their terrestrial life in the next world. While the cities and palaces of the living from this period have long since vanished, tomb art is plentiful and much of what scholars know about early Chinese life comes from these "homes" for the dead.

This respect for tradition and other aspects of Chinese morality as it developed over the centuries from Shang times was codified in the social ethics and teachings of Master Kong, known in the West as Confucius (c. 551–479 BCE). Confucius was born during a period of civil unrest when the Chinese were looking for ways to rebuild their ancient

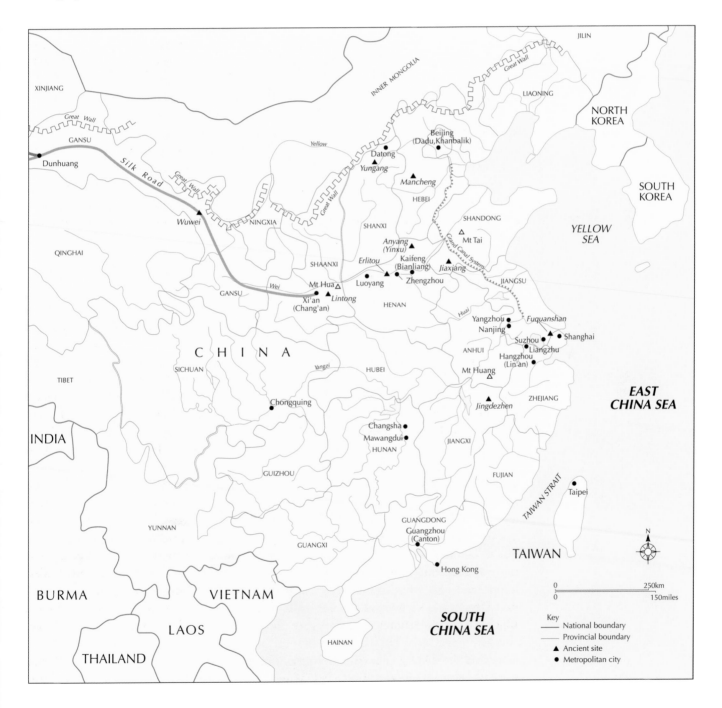

society, which they believed had been a reflection of a higher, universal order in nature. He taught that people of his time could regain this earlier sense of order by self-discipline and following the proper codes of behavior. Confucius' concept of *ren*, or human-heartedness, is embodied in his image of the ideal Chinese gentleman, the educated, broad-minded, loyal, and just individual with empathy and good etiquette or deportment. Confucian respect for age, authority, and morality made this philosophy a popular one among Chinese leaders and the artists they patronized for centuries to come.

While Confucianism might govern an individual's public life, Daoism ("The Way") provided important principles to guide the individual's private or spiritual life. Daoism is a general term for the animistic beliefs that lie at the core of the Chinese understanding of the world and which sought an intuitive balance with nature. Daoist priests were often court divinators and shamans, and at various times the ideals of Daoism have been applied to a variety of local religious practices. The principles of Daoism recorded by Lao Zi ("Old One") (born c. 604 BCE) and elaborated by later writers teach one how to live in harmony with nature and the universe. Lao Zi's work, the *Dao de jing* ("The Book of the Way"), explains that the *Dao* (similar to the Hindu *dharma*) is embedded in the heart of nature. To ex- perience the *Dao*, one must release one's ego and become attuned to the flow of life. Through contemplation and spontaneity, Daoists may find this harmony with their natural instincts and the flow of nature. In *ming*, the ultimate inward vision, the two vital forces of nature, the *yin* and *yang* (female and male principles, represented by the moon and sun), become one as the Daoist's sense of self and outer world dissolve into an experience of the oneness of all creation.

Buddhism, which arrived in China in the first century CE and became widespread by the fifth, introduced the Chinese to a new organization of the cosmos and a new pantheon of divine beings; it brought to Chinese artists Indian styles of painting and sculpture. From the sixth century there appeared a new sect of Buddhism called "Chan" (later Zen in Japan), which like Daoism stressed the importance of meditation, instinctive actions, and living in harmony with nature.

The works of the earliest Chinese art critics and aestheticians have been lost. However, some of their thinking may be reflected in the earliest extant treatise on the philosophy of art by a painter named Xie He (active c. 479–502). (See "*In Context*: Xie He and his Canons of Painting," page 129.) His *Gu hua pin lu* ("Classification Record of Ancient Painters") includes a set of canons or principles of Chinese painting. The first calls for a "sympathetic responsiveness" to the *qi*, which in this context refers to the character or spirit of the painted composition. It is manifest in an artist's brushwork and expresses that individual's harmony with natural process or nature. The remaining canons stress the importance of instructing artists in the traditional techniques of Chinese painting so they can become innovative within these traditions.

But how was it possible for Chinese art critics and philosophers such as Xie He to tell if an artist had a "sympathetic responsiveness" to the *qi* and was aesthetically superior to other artists? Over the next 1,500 years, this issue was to become increasingly divided along the lines of those painters who were amateurs and those who were professionals. The amateurs were almost always from the Chinese élite, scions of great or wealthy families who had received an extensive education in preparation for a career in government service. These "scholars" were known as *wenren* ("literati") and many of them painted as an expression of their cultural refinement, of their *qi*. They denigrated the work of painters who worked for hire and who, while technically proficient, painted works devoid of the *qi*. Some literati were Daoists and Chan Buddhists who believed they were enlightened instruments through which the spirit of nature could work (See "*Religion*: Chan (Zen) Buddhism, Enlightenment, and Art," page 136.) They believed that the academic court painters recorded nothing more than the simple, external appearance of nature while their own expressive works captured the very essence of nature.

TIME CHART

Neolithic Period (c. 7000–2250 BCE)

Xia Dynasty (c. 2205–1700 BCE) [disputed, traditional dates]

Shang Dynasty (c. 1700–1045 BCE)

 Yinxu (Anyang), last capital of Shang dynasty (1300–1045 BCE)

 Tomb of Lady Fu Hao (died c. 1250 BCE)

Zhou Dynasty (1045–480 BCE)

 Lao Zi (born c. 604 BCE) writes Dao de jing ("The Book of the Way")

 Confucius (c. 551–479 BCE)

Period of Warring States (480–221 BCE)

Qin Dynasty (221–206 BCE)

 Qin Shihhuangdi ("First Emperor") establishes Qin dynasty (221 BCE)

 Capital at Xianyang, near Chang'an (modern Xi'an)

Han Dynasty (206 BCE–220 CE)

 Gao Zu establishes Han dynasty (206 BCE)

 Sima Qian, historian (136–85 BCE)

Period of Disunity: Six Dynasties (220–589)

 Wei dynasty in northern China (388–535)

 Wei capital moved to Luoyang (494)

 Xie He establishes his six "canons" of painting (c. 500)

Sui Dynasty (581–618) and Tang Dynasty (618–907)

 Capital at Chang'an

 Invention of block printing in China (c. late eighth century)

Five Dynasties (907–60)

Northern Song Dynasty (960–1127)

 Capital at Kaifeng until 1127

 Jin Tartars conquer northern China, capture the emperor–artist Hui Zong. Surviving members of his court flee south and establish themselves at Hangzhou (1127)

Southern Song Dynasty (1127–1279)

 Genghis Khan unites Mongols (1206)

 Polo family in China (1275–92)

 Khubilai Khan conquers Hangzhou and establishes Mongol capital at Dadu (present-day Beijing) (1276)

Yuan Dynasty (1279–1368)

 Mongols subdue rebel remnants in the south and establish the Yuan dynasty (1279)

Ming Dynasty (1368–1644)

 Yongle emperor (ruled 1403–24)

 Ming capital of Beijing established on the ruins of the Yuan capital, Dadu (1407–21)

 Xuande emperor (ruled 1426–35)

 Portuguese arrive in Canton (1514)

Qing Dynasty (1644–1911)

 Manchurians establish Qing dynasty (1644)

 Opium Wars open ports to foreign trade (1839–42)

 Taiping Rebellion (1850–65)

 Boxer Rebellion (1900)

Modern China (from 1911)

 Chinese Republic ends dynastic system (1911)

 Chinese People's Republic established (1949)

 Great Proletarian Cultural Revolution (1965–79)

The dynastic names given to historical periods are not the family names of the imperial lines. Some are names of locations identified with the establishment of the dynasty or the territorial title of the dynasty's founder. For example, the name of the Han dynasty comes from the official title King of Han (a region now in Sichuan province), which the first Han emperor held before he united the country and established his imperial line. Therefore the dynasty he founded was the dynasty of Han. Other dynastic names such as Yuan ("Primal"), Ming ("Bright" or "Brilliant"), or Qing ("Clear" or "Pure") refer to ideals that the particular dynasties felt they represented. Similarly, the names of emperors are in fact titles representing ideals, such as the Xuande ("Proclaiming Virtue") emperor. This emperor's actual name was Zhu Zhanji, but his imperial reign title was Xuande. Before the Ming dynasty, an emperor might change his reign title several times in the course of his reign; therefore pre-Ming emperors are not known by their reign titles, but by the titles given to them after their death and engraved on their ancestral temple. The Mongol emperor Khubilai Khan had two reign titles, Zhongtong (1260–1264) and Zhiyuan (1264–1294). History therefore calls him by his temple title, the Shizi emperor, and his two reign titles are used to denote eras within his reign: hence phrases such as "during the Zhiyuan era of the reign of the Shizi emperor."

The art of writing—calligraphy—developed concurrently with painting, and often an excellent painter might be an even better calligrapher. Using the same brush, the calligraphers developed scripts that enabled them to work freely, often, as in painting, in flashes of inspiration that allowed inventive "accidental" effects to happen, ones that gave their calligraphy meaning beyond that of the words they "painted." To display a fine calligraphy was the same as displaying a fine painting.

Similarly, the finest Chinese ceramics almost always have something of spontaneity and revelation about them, especially those made in the twelfth century for courts of both the Northern (960–1126) and Southern (1126–1279) Song dynasty. These imperial wares were vessels of simple, but highly refined forms coated with thick glazes of subdued colors that took on distinctive "crackle" patterns after their firing in the kiln. As in calligraphy, the "accidental" effects in the crazing pattern appealed to refined Chinese taste and they often valued works with these features above the vessels meticulously painted with detailed and colorful images.

Refined simplicity is also at the heart of Chinese architecture. By the Han Dynasty (206 BCE–220 CE), the Chinese had developed a traditional or classic style of hall or temple design that lasted until modern times. Rows of stout wooden poles set on a low base or platform supported wooden lintels, interlocking brackets, and a roof with broad overhanging and upturned eaves and ceramic tiles. While the basics of this design remained intact, builders were constantly finding new ways of refining its proportions and elaborating upon its decorations.

This spirit of search, discovery, and refinement would seem to characterize the ideals of the Chinese artists throughout the ages. They found numerous ways to sustain elements of the Chinese traditions of thought and technology within the changing world around them and created a long-lived and exciting tradition that has lasted for over 4,000 years.

Note: This text uses the Pinyin system of transliteration for the Chinese language developed in 1949 and more widely used than the older Wade-Giles system.

THE NEOLITHIC PERIOD (c. 7000–2250 BCE)

The transition from a nomadic hunter–gatherer existence to a sedentary one based on farming began around 7000 BCE with the domestication of millet, rice, and pigs. Many of the early, Neolithic Chinese societies developed in the warm and humid southeast, around the mouth of the Yangzi River, and in the north along the Yellow and Wei rivers. The Yellow River is so-named for the large quantities of yellowish silt it carries much of the year.

Neolithic ceramists in the north working with clays deposited by the Yellow River painted a wide variety of golden-brown vessel types with dark brown geometric forms and schematic images of animals. But the most spectacular works from this time are the nephrite (commonly known as jade) carvings of the Liangzhu culture in southeastern China. They produced beautifully colored jade animals, replicas of functional weapons, and two abstract geometric forms which later Chinese writers called the *bi* and the *cong*. The hardness of jade, which could only be worked slowly through a laborious and time-consuming process of slicing and drilling with abrasives, made this stone a symbol of religious and secular power in later times. We might guess that it was used in religious rituals and other ceremonials in Neolithic times, and associated with ideals of power, but we do not know the precise meanings the *bi* and *cong* held for their original audiences.

Perhaps the most mysterious of these jades is the *cong*, a rectangular stone with a large hole through its center and box-like registers at its corners (FIG. 4.1). Unlike most early Chinese jades, the *cong* is not a copy of any known everyday Neolithic object. In some

cases, the registers frame the heads of monsters with large round eyes, broad noses, and fangs. Occasionally, a schematized human figure may appear behind a monster head as if holding it. Similar head types appear in later Chinese art and may represent guardian figures. While it is tempting to interpret the early art of China or any other culture in terms of what is known about the later art of that tradition for which written documents may exist, cultures change over time so this is not a safe practice. In the absence of written records for Neolithic art, the meaning of the *cong* and other jade pieces may never be known.

THE XIA (c. 2205–1700 BCE) AND SHANG DYNASTIES (1700–1045 BCE)

The Bronze Age in China began around 2205 BCE with the rise of the semi-legendary Xia dynasty in northern China around the Yellow and Wei rivers. The Xia (c. 2205–1700 BCE) may have developed the technology to cast bronze (an alloy of tin and copper) and built walled palace cities such as Erlitou. Chinese records tell of a King Tang who overthrew the Xia and established the Shang dynasty (1700–1045 BCE).

The Shang used an early form of the Chinese script that is the direct ancestor of the one in use today. Their religion combined a veneration for animistic deities and shamanistic rituals with a very strong cult of ancestor worship. It may have included sacrificial rituals to appease the dead spirits and enlist their help. Shang royalty may have been linked with a supreme god, Shang Di, who lived in *Tian* ("heaven") and controlled the forces of nature.

The massive earthen walls of an early Shang metropolitan center (c. fifteenth or fourteenth century BCE) lie beneath present-day Zhengzhou. The ancient city was more than a mile (1.6 km) in diameter and had special districts for artisans. However, little remains of this and the other great ancient capitals of China. With plentiful supplies of timber and other perishable materials, but very little good building stone, the imperial cities so praised by writers throughout Chinese history fell prey to fires and vandals. Thus, ironically, in the country with many of the oldest surviving cultural traditions in the world, virtually nothing remains of its many large capitals, some of which rivaled their Western contemporaries (Babylon, Athens, Rome, Constantinople, Cairo, and Paris) in size and splendor. Much of our information about early Chinese art comes from their royal tombs, which have yielded rich treasures, including thousands of lacquered items, paintings, and sculptures in wood, stone, jade, bronze, and other precious metals.

The last Shang capital and royal burial center at Yinxu (modern Anyang) (1300–1045 BCE) had palaces or temples on raised platforms and it has yielded the only known undisturbed royal tomb from this period. It belonged to a consort of King Wu Ding, Lady Fu Hao (died c. 1250 BCE), whose name appears on bronze vessels and inscribed bones.

By the Shang period, the Chinese envisioned the afterlife as an extension of this life and equipped their royal tombs to be functioning homes for the deceased. Tombs such as that of Lady Fu Hao were deep pits over which walled buildings were constructed to house rituals honoring the dead person. Unfortunately, for many centuries, treasure hunters have probed the rockless silt in this region with long, pointed metal poles, searching for unmarked graves. Luckily, they did not find that of Fu Hao. The scale and opulence of the tomb give a sense of what other royal tombs of this early period may have once housed. It contained horses, dogs, about 440 cast and decorated bronzes (originally containing food or drink), 600 jades, chariots, lacquered items, weapons, gold and silver ornaments, ivory inlaid with turquoise, and about 700 cowrie shells (a Shang form of coinage). Silks found in Shang

4.1 Jade *cong*. Liangzhu culture, from Fuquanshan, Jiangsu. c. 2000 BCE. Width 6" (15 cm). Fuquanshan, Jiangsu

Chinese Writing

Before the rise of modern societies and widespread literacy, the written word and the ability to read were signs of religious and secular power. An early shift in Chinese culture that replaced the military leaders with an élite group of educated, literate officials at the center of the government gave special importance to writing, art, and philosophy in Chinese society. The value of writing as a tool to organize and unify China, which often had a large empire, was magnified because of the unusual nature of written Chinese. Unlike Western systems of writing, it is not alphabetic; Chinese characters or signs combine pictographic, ideographic, and phonetic devices that stand for words and ideas, not sounds.

Since writing was not tied to any of the different language groups and diverse dialects of Chinese, individuals who could not communicate through speech could do so through writing. Today, the thousands of Chinese signs can be understood by speakers of all the Chinese languages and dialects, many of which are not mutually intelligible. And although the spoken and written Chinese have changed over time, the written language has provided a strong thread around which elements of Chinese thought have been preserved. This script, which crossed over linguistic and historical barriers, made it possible for all Chinese to share common religious, philosophical, and artistic traditions with each other and subsequent generations. The durability of Chinese culture may be tied in part to this unique system of writing and thought.

Early forms of the script are found on Neolithic pottery and oracle bones (often chicken bones, shoulder blades of oxen, or pieces of tortoiseshell) in Shang tombs (FIG. 4.2). After being marked with written messages and questions such as "Will the king be victorious in battle?" they were heated in fires until they cracked. The crackle patterns were then examined by shamans who could divine the future through their patterns. Many of the earliest written characters are pictographs that resemble objects in nature, but by historical times they had become more stylized and abstract.

The many surviving examples of writing on oracular bones and shells suggest that writing emerged in China as a means of divination and communication with the spirit world. Thereafter, as in many societies around the world, writing most likely remained the prerogative of an élite within the ruling minority, although, by the time of the first empire of Qin Shihhuangdi, literacy had almost certainly spread to the merchant classes. The Chinese script in its traditional form was codified in the Qin and Han periods (c. 221 BCE–220 CE). The tremendous importance attached to the written word and its appearance might also explain why calligraphy emerged as an early and lasting art form of major importance in China.

4.2 Oracle bone. Shang period, c.1766–1122 BCE. The British Library, London

Chinese Piece-Mold Casting

The Chinese techniques of piece-mold casting appear to have been developed independently from the lost-wax method used in Western Asia, the Mediterranean, and China after about 600 BCE (FIG. 4.3). To make a bronze vessel, the sculptor began by making a fully detailed clay model of the vessel. After the model had dried and hardened, pieces of soft clay were pressed against it to create a negative mold of its shape and decorations. When dry, the mold was removed in sections, touched up, and fired to give it greater strength. The model was then shaved down and the pieces of the negative mold were reassembled around it, leaving a thin space between the model and the mold. Mortises, tenons, and spacing devices were used to hold model and mold in place. Another outer layer of clay was added to strengthen the mold and ducts were cut to receive the molten bronze and release gases as the bronze was poured into the cast. The molten bronze filled the spaces between the model and mold, the spaces corresponding to the thin layer clay that had been shaved off the model. After the metal cooled, the outer cast was removed and the surface of the bronze was touched up and polished with abrasives. Even among modern industrial societies, few bronzecasters have been as skillful at piece-mold casting as the Shang technicians.

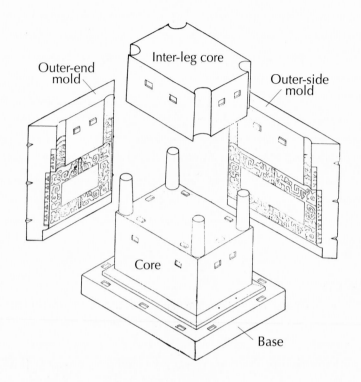

4.3 The piece-mold casting technique

tombs may have been shrouds for the deceased. (Sericulture, the complex techniques for rearing silk worms and producing silk, was perfected in China by about 4000 BCE.) Skeletal remains of twenty-two men and twenty-four women (executed servants or captives?) were discovered in Fu Hao's tomb along with the axes used to behead them.

The magnificence of this royal burial illustrates the wealth and power of the Shang leaders and the reverence they paid to their deceased royal ancestors and the past. Grave goods from this period often included Neolithic jades and replicas of other pre-Shang art forms. Bronze vessels used in banquets where offerings were made to the ancestors and gods were buried with high-ranking dead so they could continue these rituals of life after death as they acted as intermediaries between the natural and supernatural realms of existence. (See "In Context: Chinese Writing," page 114.)

The Shang leaders who so admired metal art probably controlled the workshops that designed and cast over thirty distinctive types of ritual bronze vessels. Many of the bronzes were derived from existing ceramic or wooden prototypes, while others appear to be new Shang inventions. Given the religious importance of the bronzes, the complexity of the techniques by which they were manufactured, and the wealth of their symbolically charged decorations, it is possible that bronzeworking masters had the status of shamans or priests. (See "Materials and Techniques: Chinese Piece-Mold Casting," above.)

Like many Shang bronze vessel types, the very popular *ding*, a vessel with three feet for cooking, is derived from a well-known Neolithic ceramic type (FIG. 4.4). The rounded, rectangular scrolls and animal forms on this and other Shang bronzes, as well as the ceramics and small hard stone sculptures of this period, may have been developed in pre-Shang times for use on wooden objects painted with lacquer. A highly stylized face type on this and many other Shang bronzes, the so-called *taotie* ("ogre or glutton mask"), may represent a number of gods and monsters—guardians that protected people from evil spirits. The mask, which is formed by the juncture of two profile faces with prominent beady eyes, can also be read as a flattened face viewed from the front. The reappearance of this frontal-profile face in the much later arts of the Maori of New Zealand and the Native Americans of the Northwest Pacific Coast and Mexico raises an important question. Was this image and concept diffused across the Pacific, or was it reinvented independently in the South Pacific and the Americas? The Diffusionists, who believe there were significant contacts between Asia and the Americas through the Pacific, would say the former. But, in some areas of the Americas, there is archaeological evidence for a separate local line of development, and

4.4 *Ding* (ceremonial food vessel). Shang dynasty, 11 th century BCE. Bronze, height 8³/₈" (21.27 cm). Seattle Art Museum

many scholars believe the forms were invented independently in several areas. The question thus remains open.

The blue, green, and reddish patinas so loved by modern collectors of ancient Chinese bronzes are an accidental phenomenon; they result from the interaction of the bronze with minerals in the soils around the tombs. Originally, the bronzes were highly polished and some were brushed with black pigments that remained in crevices to accent the lustrous colors of their reflective metal surfaces.

Unlike the simple lines of the *ding*, another bronze form called a *yu* can be a very complicated sculptural form. The vessel in figure 4.5, representing a bear or a tiger squatting on its haunches and holding a man in its paws, may be a new Shang form. The handle terminating in a boar's head arches over a small deer standing on the predator's neck. A network of miniature scrolls covering the man and beast mixes with the larger serpentine forms decorating the animal's paws and flanks.

The ultimate source of this decorative vocabulary may be the so-called "Animal Style" of Central Asia. Central Asia is a vast region of deserts, mountains, and arid lands stretching over 4,000 miles across the largest land mass in the world, from Mongolia and western China to the Black Sea. The systematic study of the art of the early nomadic and seminomadic peoples living in this sparsely populated land is still in its infancy, and little is known about the earliest phases of its development.

The patterns and rhythms of the decorations are carefully arranged to accent and complement the shapes of the vessel, enhancing its appeal as a sculptural form. The skillful use of the complicated bronzecasting techniques and the integration of the vessel shape, animal heads, and scrolls into a tense, compact, and energetic sculptural form, represents the climax of a long period of formal and iconographic development that may date back to pre-Shang times.

THE ZHOU DYNASTY (1045–480 BCE)

An inscription on a Zhou bronze says that Wu Wang, a Zhou leader from the west, conquered the Shang dynasty in 1045 or 1050 BCE. The Zhou established their capital at Xi'an on the Wei River. During the Zhou rule, Chinese culture was transformed from a mixed agricultural–hunting society with an animistic form of religion dominated by shamans to a highly organized urban and feudalistic society with a hierarchy of priestly and secular authorities. Absorbing the artistic traditions of the Shang, the Zhou gradually changed the fluid contours of the Shang bronzes into much larger vessels with boldly projecting three-dimensional forms and decorative inlays of precious metals. This love for expansive and dynamic forms, already evident in the late Shang period, is carried to extremes in a tall *yu* of the tenth century (FIG. 4.6). Zhou sculptors created many such new forms with increasingly complex and irregular profiles that expand the formal vocabulary of the Shang tradition. In the eighth century BCE, the Zhou lost some of their western lands to foreign invaders. From this time forward, as regionally based aristocratic families started to create their own kingdoms, the period was a very creative and productive one for bronze, jade, and the arts in general.

Even though most of the Chinese jades were imported from Central Asia and Siberia, in ancient times as well as modern, jade has been closely associated with the mainstream of Chinese art and philosophy. With the development of bronzecasting techniques, some

4.5 *Yu* (ceremonial wine vessel) in the form of a bear or tiger swallowing a man. Shang dynasty. Bronze, height 12⁷/₈" (32.7 cm). Sen-Oku Hakuko Kan, Kyoto

4.6 *Yu.* Early Zhou dynasty, c. 10th century BCE. Bronze, height 20⅛" (51 cm). Freer Gallery of Art, Smithsonian Institution, Washington, D.C.

pre-Shang jades found in Shang period tombs may have been venerated heirlooms. By the late Zhou period in the time of Lao Zi and Confucius, the Chinese philosophy of jade was fully developed. A divination text, the *Yijing* or "Book of Changes" (c. 200–100 BCE), explaining early Chinese views of the cosmos, discusses the qualities of jade. It had divine qualities and was the perfect material for the carving of objects used in religious rituals.

Confucius summarized the importance of jade in late Zhou times in the *Liji* ("Book of Rites"). He explained that the men of ancient times equated the gleaming surface of jade with benevolence, its luminous quality with knowledge, and its unyielding nature with uprightness. He also said that jade is compact and strong, like intelligence, that it symbolizes truthfulness because it does not conceal its own flaws, and that it is like moral leadership because it can pass from hand to hand without blemishing.

4.7 Plaque with interlaced dragons and birds. Late Zhou dynasty. Jade, width 1³/₄ × 3" (4.8 × 7.5 cm). The Cleveland Museum of Art

All of these qualities may have been understood by the artist who carved the plaque with interlaced dragons and birds (FIG. 4.7). The late Zhou hook motifs covering the web of scrolls on the plaque are derived from those used on Chinese bronzes for more than a thousand years before. Its design can be read in two ways: the solid areas represent the undulating bodies of dragons, while the open spaces can be read as a grinning *taotie*.

THE PERIOD OF WARRING STATES (480–221 BCE) AND THE QIN DYNASTY (221–209 BCE)

After the Zhou rulers lost some of their western lands to nomads from the west in 771 BCE, they moved their capital east to Luoyang on the Yellow River. By 480 BCE, their rule was effectively ended and China entered the period of Warring States (480–221 BCE) as feuding regional Chinese warlords battled for the control of the country. The orderliness and idealism of Confucius' socially oriented philosophy developed in the waning years of Zhou rule seem to reflect the needs of the time as the old order was passing away. Eventually, China was reunited in 221 BCE under King Cheng of the Qin kingdom from the western edge of the old Zhou kingdom. Cheng and his associates followed a harsh philosophy or school of law known as Legalism, which had grown out of the turmoil of the Warring States period. It was an extreme form of absolutism—unquestioned devotion to the king—which eventually broke the power of the regional, feuding factions. Cheng's empire was roughly twice the size of the old Zhou state and he took the name Qin Shihhuangdi ("August First Emperor of Qin"). Once Cheng had conquered all the different feudal kingdoms that had comprised the old Zhou state, he established a new form of government in which power was centered completely on himself as emperor, and was not shared with the landed, feudal aristocracy. In this system, only the imperial family had true hereditary governing privileges is that of the imperial line. Within the Qin imperial government there existed an aristocracy,

as there would exist in all successive imperial dynasties, but their aristocratic privileges and titles were determined not so much by their birth as by the emperor's whim. An aristocrat's status therefore depended entirely on his favor with the emperor. Qin Shihhuangdi also instituted a structure of ruling through government bureaus whose sole loyalty was ideally also to the imperial throne. From the Qin period onwards, the officials who staffed these bureaus would increasingly come to be chosen on the basis of their merit—their knowledge and experience—rather than their birth. In time, this would entirely erode entirely the concept of hereditary aristocracy, as those able to pay for the education required to become a government official would in time come from all classes, not simply that of the great landed families.

The emperor's bloody conquests were followed by a period of extreme totalitarianism. He executed some of his political opponents and established other ruling families in replicas of their palaces in a district (seven miles—11.25 km—long) near his capital west of modern Xi'an, where they could be closely watched. Qin Shihhuangdi banished some of the Confucian scholars, buried others alive, and burned Confucian writings that did not support his new political program. The rich literary past of the Shang and Zhou periods was forced underground, where it survived in oral traditions and hidden texts as the emperor instituted history's first recorded literary inquisition. In the subsequent Han dynasty, the *Shiji* ("Record of the Historian") of Sima Qian (died c. 86 BCE) salvaged what still remained of these ancient histories; Sima Qian also wrote a history of the Qin dynasty and the first half of the history of the illustrious dynasty under which he served.

On the positive side, as an absolute imperial sovereign or emperor, Qin Shihhuangdi was able to upscale his political operations and mobilize resources on a much larger scale than any of his predecessors. He established standard forms of script and coinage and established a system of government that lasted, with some variations, until the twentieth century. Qin China may also have been the first country in the world to base its production on large-scale factories in which workers performed specialized tasks to mass-produce goods. A slightly later record from fourth century CE lists the tasks of twelve workers and supervisors involved in the production of a single lacquered and painted wooden cup with gilt bronze.

Since China was vulnerable to attacks by the Mongolian horsemen to the north, the emperor united and enlarged the sections of walls built by earlier feudal lords along the frontier dating back to the fifth century BCE, laying the foundations for the Great Wall of China (*changchen*, "Long Wall," as it was known locally), most of which was greatly enlarged in the dynasties that followed.

THE TOMB COMPLEX OF QIN SHIHHUANGDI

According to Sima Qian, the construction of the tomb of Emperor Qin Shihhuangdi employed 700,000 workers and was marked by a mound over 600 feet (183 m) high. Sima Qian also said the emperor's tomb contained a network of underground rooms with mountains and streams of mercury propelled by waterwheels and ceilings representing the heavens. Although the tomb has not been opened in modern times since its rediscovery, the description is plausible. The tradition of building funerary buildings beside tall mounds over deep multi-roomed tombs dates from late Zhou times. Some emperors in the Han period (206 BCE–220 CE) built tombs with two or three high vaulted chambers that resembled sections of the palaces in which they had lived. Qin Shihhuangdi's funerary mound, originally surrounded by an inner and outer wall, also follows the concentric and symmetrical pattern of construction used in the Chinese imperial cities, including that of Beijing, which was built 1,700 years later. As such, the tomb precinct reproduced the Qin image of the cosmos, the world of the gods where the emperor lived on after death.

Like Homer's *Iliad* and *Odyssey*, which were regarded as mythological fantasies about early Greek leaders and their exploits until modern archaeology proved their historical value, Sima Qian's descriptions of the tomb were long discounted as colorful legends. But in 1974, workers digging a well at Lintong near Xi'an in the Shaanxi province discovered the first of three large burial pits filled with sculptures from the Qin period near a tall mound.

Before the roof collapsed in what is now known as Pit 1, the army, numbering over 8,000 lifesize polychrome terracotta soldiers, stood at attention, in correct military formation, according to Chinese military procedures described in contemporary texts. The somewhat smaller Pit 2 contained more than 1,400 chariots (some inlaid in gold and silver), bronze horses, archers, infantry men, and cavalry (see FIG. 1.3). A much smaller group of élite special forces was discovered in Pit 3.

The artists and helpers called upon to produce this incredible spectacle used a modular system of production and prefabricated molded body parts. The plinths, legs, torsos, arms, hands, and heads were cast separately, painted, and joined. In many cases, the finishing touches of the costumes and faces were carved and modeled in a thin layer of fine moist clay added to the surfaces of the mold-made parts. The simplified volumes and rigid poses of the four horses drawing a gilt-bronze chariot seem to express the militarism of the emperor's reign, which did so much to reorganize war-torn China and establish its enduring cultural and political traditions.

Many of the faces seem to be studies of the diverse ethnic types that made up the imperial forces, drawn from throughout the empire. Were these statues conceived as portraits so the spirits of the individuals would accompany the statues and serve the emperor? The emperor seems to have wanted his entire court and army in full colorful ceremonial regalia to protect his resting place and accompany him (in effigy) to the afterlife. However, shortly after Qin Shihhuangdi's death in 206 BCE, the citizens of the empire revolted against his harsh but weak successors. Undaunted by the emperor's army of effigies, warriors of the rebellion entered the tomb pits, burned the wooden poles and roof, and buried the effigies of the Qin army along with the memory of that short-lived dynasty.

THE HAN DYNASTY (206 BCE–220 CE)

In 202 BCE, Liu Bang, a peasant, was elevated to emperor and became known as Han Gaozu ("Exalted Emperor of Han"), the founder of the Han dynasty. Building upon the imperial ambitions of Qin Shihhuangdi, the Han dynasty created an empire that reached into Central Asia and rivaled the size and splendor of its Roman contemporary in the West. The Han designed large capital cities (long since vanished) with their borders aligned to the points of the compass and conceived as diagrams of the universe. The noble residents of these cities moved around the palace and emperor, who, like the sun, occupied the center of the Han cosmos.

Zhang Qian, a diplomat to Central Asia (138–126 BCE) for Emperor Wudi (140–87 BCE), helped open the trans-Asian Silk Road, a 5,000-mile (8,000-km) trail following a series of oases through Central Asia connecting the heartland of China to India, Iran, and the ports of Tyre and Antioch on the Mediterranean Sea. Over this road, caravans of two-humped Bactrian camels transported enormous quantities of silk and lacquered goods to the West in exchange for silver and gold. The Han emperors also opened up sea routes to Burma and India.

Like their Roman contemporaries in the West, who gave Europe its language and visual culture, the Han rulers shaped the character of the region's art and culture for centuries to come. While the West continues to write with the Latin alphabet and script, the

4.8 *Lady of Dai with Attendants.* Detail of a painted silk banner from the tomb of Dai Hou Fu-ren, Mawangdui Tomb 1, Changsha, Hunan. Han dynasty, after 168 BCE. Silk, height 6'8³/₄" (2.05 m). Hunan Museum, Changsha

modern Chinese say they use "Han characters." And while the Romans were converting Hellenistic thought into the philosophy of Roman imperialism, the Han intellectuals were reviving the pre-Qin teachings of Confucianism and Daoism and fusing them into doctrines that supported the ideals of their imperial Han leaders. During the Han period, as the earlier Qin ideals of imperial organization became realities, other aspects of Chinese thinking about religion and art seem to have become increasingly complex. While little remains of the wooden palaces, temples, and murals in the great Han capitals which are mentioned in the literary sources as documenting these changes, the tombs of this period have preserved some very important early examples of the Chinese pictorial arts. In them, the philosophies of Confucianism and Daoism and Chinese legends and folklore clearly provided artists with their subject matter and inspiration in this period of empire.

THE TOMB OF THE LADY OF DAI

One of the best examples of Han painting comes from the tomb of the Lady of Dai, near the city of Changsha in Hunan south of the Yangzi River (FIG. 4.8). ("Lady," a Western term, is used here to indicate the roughly equivalent European rank of this Chinese woman.) The body of the lady, sealed within a multilayered coffin and robed in many layers of finely woven silks, was miraculously well preserved when the tomb was opened in 1972. The tomb is not a single deep pit, like the Shang burials, but a set of rooms resembling a dwelling. The literature from this period suggests that such tombs were entryways to the land of the dead where powerful individuals such as the lady could interact with the spirits of the deceased.

The painted T-shaped silk banner found in the innermost of the nested coffins may have been a personal name banner and symbol of the deceased around which the mourners assembled during the lady's funeral and the procession to the grave. The inventory list found in the tomb calls this a "flying banner," perhaps because it was designed to help elevate the soul to the upper world. In Han times, the Chinese believed that one part of the soul, the *po*, stayed with the body (as long as it was preserved and provided with ample offerings) while the other, the *hun*, underwent a long and perilous journey to paradise.

The banner represents the lady within the Han conception of the cosmos. Near the center of the banner, two kneeling figures face the lady, who holds a thin walking stick and wears an elegant silk robe with swirl patterns. Three female attendants stand in a straight line behind her. The group is arranged on a platform supported by open-mouthed dragons and cloud forms that rise up beside them. Over their heads, a foreshortened bat-like creature hovers below a canopy flanked by long-tailed birds. Above, a pair of figures at the base of the crossbar of the T-shaped silk banner squat beneath a large bell. These may be the officials who performed a funeral ceremony known as the *Summons of the Soul*. This was an attempt to call the part of the soul headed on the perilous route to paradise back to the tomb for its own protection. The heavenly realm in the crossbar of the T contains a crow silhouetted against the sun (right side) and a toad on the crescent moon (left) flanking a man entwined within a long, scaly serpent tail. The lines in the *Summons* recited by the officials warned the soul to avoid the "water-dragons [that] swim side by side, swiftly darting above and below." These monsters and the "coiling cobras... rearing pythons and beasts with long claws and serrated teeth" described in the *Summons* may be the creatures around and below the platform supporting the lady and her courtiers. A canopy in the underworld suspended from the circular jade *bi* through which the serpents loop covers a platform supported by a dwarf and holding ritual bronze vessels with food and drink for the lady. This may represent a portion of the tomb itself, the lady's home in the afterlife with all its luxurious provisions.

The artists have paid great attention to the sinuous qualities of the long, flowing, whiplash lines that outline forms and unify this composition and image of the cosmos. The

4.9 Detail from a rubbing of a relief in the Wu family shrine. Eastern Han dynasty, c. 151 CE. Stone, 27½ × 61" (70 × 155 cm). Jiaxiang, Shandong, China

Bas-reliefs are often difficult to photograph. They are therefore sometimes reproduced as drawings, or in this case as a rubbing. A rubbing is made by placing a piece of moistened paper over the reliefs and pouncing it with a wad of inked cloth. The portions of the paper over the projecting forms will be blackened while the paper over recessed areas remains white.

flat patches of brilliant color added within the outlines are used decoratively, not structurally, in the organization of the composition. Even at this early date, the fluidity of the lines in Chinese art enabled artists to suggest the illusion of three-dimensional sculptural forms, the primacy of these lines, and the secondary role played by the added colors.

THE WU FAMILY TOMBS

During the Eastern Han dynasty (25–220 CE), the Wu family from Shandong province created a complex of tombs dated between 151 and 170 CE. The Wu did not come from the aristocracy, but were members of the newly emerging official class that served the imperial government. Unlike the deep, sealed pit tombs of earlier times in China, the Wu family tombs were designed to be reopened periodically for the reception of newly deceased family members. Since funeral parties would assemble there, the tombs were decorated with images that included stone bas-reliefs praising the family's Confucian virtues, which were designed to help the souls of the deceased reach paradise.

These reliefs are some of the most important surviving examples of early Chinese pictorial art. The rubbing of the relief in figure 4.9 shows the complexity of one of these highly didactic scenes. In the bottom register, a procession of chariots and foot soldiers moves to the left. Above, on the right, figures pay homage to a man seated in a pavilion, a roofed structure supported by columns. Directly above is a banquet in a low-roofed pavilion with birds on its roof. The horse, birds, chariot, and archer on the left around a leafy tree with hooked branches represent a scene from an ancient Chinese legend. The archer shoots all but one of the crows around the mythical tree of the sun so there will be only one sun in the sky and the earth will not be scorched. To represent these narratives, the artists have used a matched set of large round silhouetted forms for the wheels of the chariots, the necks and flanks of the thick-bodied Central Asian horses, and the men's shields and robes. In some cases, space is indicated by placing figures in the distance above those in the foreground.

THE CULT OF SACRED MOUNTAINS AND THE *BOSHAN LU*

Members of the Han imperial clan, however, had much more lavish burials. When Liu Sheng (King of Zhongshan; died 113 BCE), son of the emperor Jingdi (ruled 157–141 BCE), was buried, he was encased in a suit of jade made from over 2,000 pieces of the precious stone fastened with golden cords. The suit was designed to preserve his body and provide a permanent home for his *po* while the other part of his soul went to paradise. Han thinkers held

a number of images of paradise, one of which may be represented by a bowl-shaped container on a stem with a conical lid and gold inlay that was found in Princess Tou Wan's tomb (FIG. 4.10). It is known as a *boshan lu* ("hill censer") and it represents the sacred rivers that descend from the mountains and the Isles of the Immortals in the Eastern Sea, where Daoist philosophers can achieve immortality.

Many of the mystic and cosmic powers in Chinese thought are associated with mountains, where the realms of the earth and the sky are united. Daoist hermits flocked to the mountains to be close to the spirits of the immortals, and many Confucian scholars went there to escape the pressures of city life. In a prayer to the sacred mountain of Heng, the emperor Taizong (ruled 626–49 CE) of the Tang dynasty said, there the "dragons rise to heaven… rainbows are stored… Its rugged mass is forever solid… Its great energy is eternally potent, in the span from the ancient to the future."

This cult of the sacred mountains may have inspired the censer found in the tomb of Princess Tou Wan. The mountains on this and other similar censers are indicated in shallow reliefs and here the profusion of wavy mountain peaks rise upward like tongues of fire. The undulating, whiplash shape of the metal inlays is known as the *yunqi* ("cloud spirit" or "cloud force"). Archers and animals in flight blend with the flow of the lines and forms. The style of the tiny, wiry lines and elegant flowing rhythms of the painting in the tomb of the Lady Dai seems to have been expanded into three dimensions to create this lively image of the Daoist Isles of Immortals.

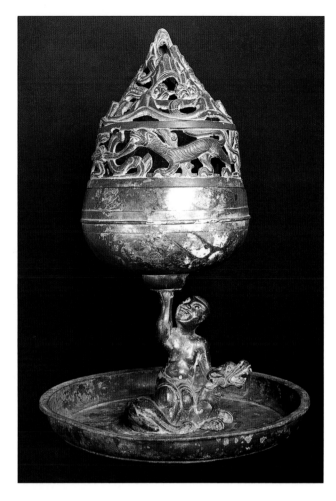

4.10 *Boshan lu* ("hill censer"), from the tomb of Princess Tou Wan, Mancheng, Hebei. Han dynasty, late 2nd century BCE. Bronze with gold inlay, height 12³/4" (32.4 cm). Hebei Provincial Museum

To complete the illusion of the mountain-water image, such *boshan lu* were often set in shallow basins of water when the incense within was lit. Small holes behind the pinnacles allow curling ringlets of smoke to rise from them, giving the impression that the sculptured peaks had real vapors. Together, the *yunqi* motifs on the burner, and the *yunqi*-shaped curls of the smoke symbolize the spirit, force, or *qi* of the sacred mountains.

This same sense for energetic lines and forms with the elasticity and "vital spirit" of nature animates the movements of a small bronze horse discovered in a tomb of General Zhang Wuwei in Gansu (FIG. 4.11). Writers from this period tell how Zhang Wuwei and other Han emissaries traveled to Ferghana in Western Asia to buy this "celestial" or "blood-sweating" breed

4.11 *Flying Horse Poised on One Leg on a Swallow*, from the tomb of Governor-General Zhang at Wuwei, Gansu. Late Han dynasty, 2nd century CE. Bronze, 13¹/2 × 17³/4" (34.5 × 45 m). National Palace Museum, Beijing

of barrel-chested horse with flaring nostrils. While military men such as the general depended heavily upon the strength and speed of their horses to maintain the empire, artists of the Han period were fascinated by the lightness and agility of the horses' movements. The stiffness of the horses standing at perpetual attention in the tomb of Qin Shihhuangdi has been replaced by a new sense for movement as the trotting, airborne horse balances as if weightless on a single hoof resting on a swallow.

THE PERIOD OF DISUNITY: SIX DYNASTIES (220–589 CE)

Like the period of the Warring States, the years following the fall of the Han dynasty in China witnessed the rise and fall of many governments and ongoing, bloody civil wars. Central Asian groups conquered portions of northern China, forcing many Chinese out of the greater Yellow River area to the southeast. In this turmoil, many Chinese, especially those who had been dispossessed, felt that the time-honored ancestor cults and Confucian ethics had failed to meet their political, social, and spiritual needs and maintain the peace. While the populace at large practiced Daoist-derived forms of magic and superstition, many Daoist intellectuals became hermits and ascetics who developed a great appreciation for nature in all its forms.

This period also saw the spread of Buddhism in China. Although it had appeared in China in the first century CE during the Han dynasty, it was not until the fourth and fifth centuries that Buddhism became widespread. Buddhism in China borrowed ideas from Daoism to communicate with the Chinese, and Daoism assumed some of the institutional character of Buddhism to consolidate its place in Chinese society. Chinese rulers often used the combined wisdom of their Daoist, Confucian, and Buddhist advisors. In time, the new sinicized Buddhism helped the ruling dynasties of China unify their ancient culture and rule their subjects, and it gave Chinese artists a wealth of new subjects and styles to enrich their ancient artistic traditions. Very little architecture of any kind from the Period of Disunity remains in China but Chinese-inspired temples in Japan such as the Horyu-ji (seventh century) have survived (see FIG. 5.00).

THE WEI DYNASTY IN NORTHERN CHINA (388–535)

The Central Asian Wei, who ruled portions of northern China after 388, created important Buddhist religious centers with cave-temples and monumental sculptures. Moving east along the Silk Road, the Wei established their first capital in northern China at Datong, west of present-day Beijing, on the very edge of northern China by the Great Wall. Living near the eastern end of the well-traveled Silk Road, the Wei rulers maintained contact with Central Asia. They also played host to Buddhist monks and artists who were familiar with the sculptural traditions of Bamiyan, and the other rock-cut cave sites along the Silk Road leading to India.

The influence of these impressive Buddhist monuments may be evident in the colossal Wei sculptures and cave temples near Datong at Yungang ("Cloud Hill"), begun around 460. Some earlier rock carvings had been done in China, but nothing on the scale of the Indian rock-cut temples had been attempted here before. The carvings were commissioned around 460 by Emperor Wen Cheng, whose Daoist father had persecuted Buddhism with great voracity from 446 to 452. In this tremendous outburst of energy to atone for his father's

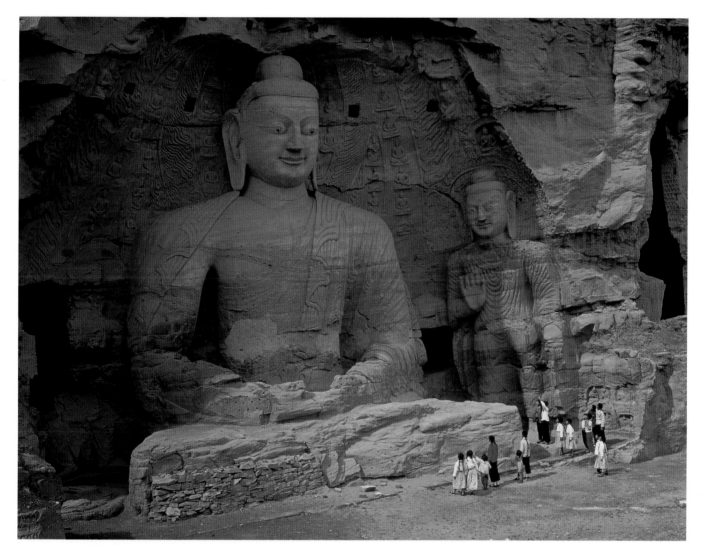

4.12 *Colossal Buddha.*
Cave 20, Yungang, Shanxi.
Late 5th century. Stone,
height 45' (13.7 m)

acts, a workforce led by monks and nuns, many of whom had no connection with the court, carved fifty-three caves along about a mile (1.6 km) of the cliffs. The Wei rulers, who considered themselves to be embodiments of the Buddha, may have seen these colossal images as self portraits and protectors of the Wei kingdom.

The façade of the rock-cut temple in figure 4.12 has fallen, exposing the 45-foot (15.75 m) statue which was intended to be seen in the darkness of its enclosed niche. The face, long ears, *ushnisha* (a bony knot of hair over the head symbolizing superior spiritual knowledge), and pose of the seated, cross-legged Buddha—with the *mudra* or hand position signifying meditation—reflect the stylizations of the Gandhara Buddhas of this period. With its sharply cut features, inscrutable mask-face, and colossal scale, the Buddha has an authoritative presence that symbolizes the spirit and strength of the religion that joined the Daoist and Confucian traditions to shape Chinese art for centuries to come. After about a decade, work ceased at Yungang when the Wei court, which had become sinicized, moved south to Luoyang, which had been a capital in Shang, Zhou, and Han times, to be closer to Greater China.

PAINTING AND CALLIGRAPHY

The large murals from the palaces of this Period of Disunity have not survived. It is possible to get some sense of their style from later copies of hangings and handscrolls from this

4.13 Portion of the handscroll *Admonitions of the Instructress to the Ladies of the Palace*. Possibly a 10th-century copy after Gu Kaizhi (c. 344–406). Six Dynasties period. Ink and color on silk, height 9¾" (24.75 cm). The British Museum, London

Many artists added inscriptions to their paintings listing their titles, the date, patron, other commentaries on the work, and a signature seal. Seal or colophon inscriptions, usually impressed in red, indicating ownership, appear by the seventh century. Around the eleventh century, the subsequent owners or connoisseurs began adding their own colophons.

By the seventh century, owners of paintings began to mark or stamp them using finely cut stone emblem seals carved with the old Seal script and red inks. Later, to give a work their "seal of approval," connoisseurs affixed their own seal marks to this and other paintings. While some viewers might find these seal marks intrusive, to traditional Chinese collectors the "autographs" of the owners and respected critics give a painting added value.

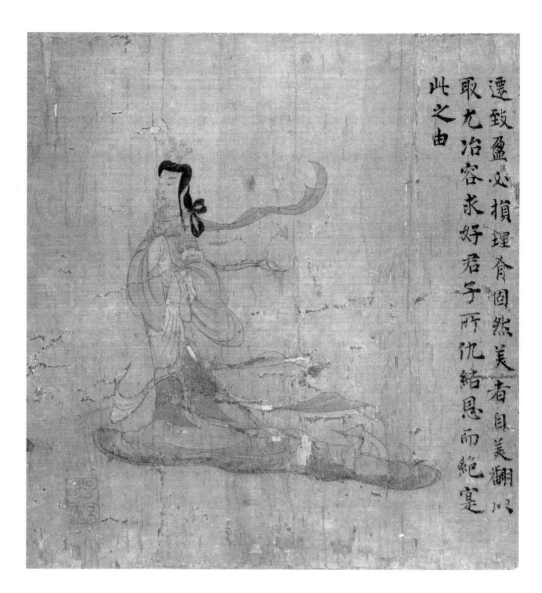

period. The small segment of a possibly tenth-century copy of *Admonitions of the Instructress to the Ladies of the Palace*, by Gu Kaizhi (c. 335–406), who worked in the court of the southern Jin dynasty at Nanjing, illustrates a text by a Confucian poet, Zhang Hua (232–300) (FIG. 4.13). The text and image explain the virtues expected of a good wife and the proper behavior of the women attached to the court, including those in the imperial harem. This segment of the painting shows the willowy figure of the instructress prescribing the rules.

The painting is on silk, which was woven in long narrow bands for handscrolls, about twelve inches (30 cm) wide and up to thirty feet (9.15 m) long. Such instructive scrolls were designed to be rolled from spindle to spindle and read segment by segment by a small group of admirers. The images and text were to be experienced slowly, over a period of time, like music or drama. Working over a preliminary sketch of thin, pale red lines, Gu Kaizhi's copyist has demonstrated his mastery of brushwork. Portions of the instructress' robe are enlivened and seem to flutter before implied but unseen forces. The artist has created a composition of well-matched long, flowing lines that capture the melodic character of Zhang Hua's poetry and the atmosphere of the luxurious but well-disciplined court.

While the date of the *Admonitions* piece remains debatable, it is of very high quality and seems to reflect some important concerns of fourth-century Chinese painters and their courtly patrons. Artists of that period used very fine lines to detail facial features and supple lines for their subjects' hair, clothing, and bodies which were capable of conveying a person's

Xie He and his Canons of Painting

In the late fifth century CE, a painter named Xie He, active around Nanjing, wrote the earliest extant treatise on the philosophy of art in China. In much the same way that medieval and Renaissance artists and writers on art in the West accepted Christian ideas about God as the Creator, Xie He followed the Chinese ideas of his day about nature and creation. His *Gu hua pin lu* ("Classification Record of Ancient Painters") includes a set of canons or principles of Chinese painting. They are:

1. Sympathetic responsiveness of the *qi*.
2. Structural method in the use of the brush.
3. Fidelity to the object in portraying forms.
4. Conformity to kind in applying colors.
5. Proper planning in the placing of elements.
6. Transmission of experience of the past in making copies.

Xie He's first and foremost principle revolves around the concept of *qi* (chee), a word rich in meanings, from "breath" to "spirit resonance" to "rhythm" to "character." At the same time, the word carried other notions about the natural world and how it worked. It could refer to the circulation of water vapor and energy from which life arose. Thus, an artist's *qi* was manifest in his body movements, especially the motions of his brushwork as it expressed a harmony (*yun*) with nature.

While the first canon stresses the importance of an artist's personal character and spontaneity, the others address the need to develop technical skills. Many of these skills were learned by studying and copying works by past masters. But even here the emphasis was on learning techniques that would free the artists to be creative. Xie He was certainly not the first writer on art to express some of these canonical ideals. While it is tempting to think that his canons reflect earlier writings and can be applied to earlier styles of Chinese art, the degree to which Chinese art and culture had changed in the centuries immediately preceding Xie He's time make it dangerous to apply his thinking retrospectively.

inner feelings and character. Long flowing scarves helped amplify the most subtle arm and hand gestures. When Xie He, who worked in Nanjing about a century later, wrote that a good painting must be full of vital energy (*qi*), harmonious (*yun*), alive (*sheng*), and full of motion (*dong*) in its execution, he was almost certainly referring to compositions such as Gu Kaishi's *Admonitions* scroll. (See "*In Context*: Xie He and his Canons of Painting," above.)

The *Admonitions* scroll was wrapped in an eleventh- or twelfth-century panel of woven silk representing a cluster of peonies (FIG. 4.14). Silk-making was well organized as an industry by the Zhou period and in Han times enormous quantities of raw and woven Chinese silk were exported along the Silk Road to Central Asia, Iran, and Europe. Designs could be woven into the fabric of the cloth in tapestry fashion or embroidered on the surface.

Traditionally, the types of brush used by painters were also used by those practicing the art of fine writing, known in the West as calligraphy. (Our word comes from the Greek words for "beauty," *kallos*, and "writing," *graphia*.) Calligraphy became an accepted art form in China during the Period of Disunity by the third century CE, and in the last thousand years Chinese writers have generally regarded it as their country's principal art. At times, important pieces of calligraphy were the most expensive works of art in China.

In Shang times, the Chinese inscribed characters on bones that were used in religious rites of divination by their leaders. (See "*In Context*: Chinese Writing," page 114.) This tie connecting writing, religion, and government—that the written characters were to be seen by

4.14 Detail of a silk tapestry (*kesi*) of peonies. 11th–12th century. The British Museum, London

the gods and leaders—may help account for the tremendous importance the Chinese attached to written characters and their appearance. While writing has often been a tool by which the élite could exercise their control over society in many parts of the world, including China, here, at an early date, individuals outside the court were able to challenge the court's hegemony over the prevailing styles of calligraphy.

Characters in the Seal script (developed c. 1200 BCE) are carved in reverse on clay seals and are highly formalized. The Clerical script (c. 200 BCE), records brushed in ink made of soot, glue, and water on bamboo or strips of silk, was less formal. Paper was invented in China around the second century BCE and by the first century CE many artists and calligraphers were working with ink on absorbent papers that were capable of capturing the most subtle nuances of brushwork. With these materials, the Chinese developed new rounded or cursive forms of writing. The Cursive script (fourth century CE) allowed writers the freedom to be highly inventive when forming their characters and became the classic form of Chinese writing. The later Drafting script (seventh century), with its spirals and flowing forms, provided calligraphers with even more opportunities to be creative. Often, their brushwork was highly spontaneous and done in sudden flashes of inspiration after prolonged periods of meditation and contemplation. Works in the "crazy drafting script" are so inventive that the texts are almost illegible. But such writings are especially valued because they are believed to be very highly inspired, to capture a Daoist sense of revelation, the very essence of the *qi*. The calligrapher working in this spirit goes far beyond the basic ideas expressed by the characters in search of brushwork effects capable of expressing broad and deep philosophical ideals that enhance the text. With the development of "poem-paintings" in the eleventh century, images painted with ink and brush might be accompanied by a related poem. Thus, the linking of the two art forms (painting and calligraphy) was complete.

The importance attached to writing and the exchange of personal correspondence among the literary élite in the Chinese courts eventually made calligraphy the most important and widely practiced art form in China. Works by the recognized masters of calligraphy were well known in literary circles by the third century. Some of the early calligraphers who were responsible for elevating the status of calligraphy to an art form and teaching it to students, such as Lady Wei (272–349), were upper-class women. Except for a small fragment of one text, these early works have perished. They are known, however, through the work of later calligraphers who often copied masterpieces as part of their training, just as Renaissance masters and later Western artists learned to paint by copying examples of Classical art from antiquity. Each canonical Chinese master was regarded as having his own *ti*

("style") and *fa* ("methods"). Once a calligrapher had mastered his favorite style, he would then exercise it in his own personal way, much as a Western composer might produce new melodies while working in a Classical or Romantic style.

The calligraphy of Wang Xizhi (c. 303–361), a student of Lady Wei, which is freer than earlier styles yet very elegant, remained the courtly ideal until the eleventh century, when certain critics challenged the court's authority to dictate aesthetic standards (FIG. 4.15). The example of his Cursive script illustrated here is called the "walking" style because Wang Xizhi did not lift his brush off the paper and individual characters may "walk" or run together. Only a well-trained calligrapher can work in this style and maintain a consistent sense of energy, spontaneity, and movement while creating characters that are also easily readable. The long history of Chinese literature gave each character a wealth of associations that encouraged scribes to treat the individual characters like relics or icons. Westerners accustomed to reading mechanically reproduced typescript pages and communicating through e-mail and computer-generated messages may find it difficult to grasp the full importance of calligraphy in the Chinese tradition.

THE SUI (589–618) AND TANG DYNASTIES (618–907)

The short-lived Sui dynasty (589–618) reunited China under a single emperor and paved the way for the Tang emperors, who ushered in a golden age of Chinese civilization. It was a period of Chinese culture characterized by a sense of majesty, dignity, and confidence in all the arts. By expanding their frontiers east into Korea and Vietnam and west through Central Asia to the Caspian Sea, the Tang rulers created an empire that was larger, wealthier, and stronger than that of their Muslim contemporaries with whom they traded. The emperors maintained diplomatic relations with Persia and began the construction of the Grand Canal system that linked the Yellow, Huai, and Yangzi rivers. Supported by trade along the caravan routes—the Silk Road to the West through Dunhuang and Turkestan—the size and splendor of the Tang capitals at Luoyang and Chang'an (modern Xi'an) became legendary. With a population estimated variously from one to two million, including Korean, Japanese, Jewish, and Christian communities, Chang'an was the most cultivated metropolitan center in the world. Literature, the arts, philosophy, and religion, including new forms of Buddhism, flourished in the liberal atmosphere of Tang prosperity. The doctrines of some of these sects bore little resemblance to the original teachings of the Buddha.

4.15 Wang Xizhi, portion of a letter from the *Feng Ju* album. Six Dynasties period, mid-4th century CE. Ink on paper, height 9³/₄" (24.75 cm). National Palace Museum, Taipei, Taiwan

4.16 Isometric view of the timber-framing, Main Hall, Foguangsi Buddhist Temple. Mount Tai, Shanxi. c. 857

ARCHITECTURE

A drawing of the main hall of the Foguangsi temple (c. 857 CE) at Mount Tai, Shanxi province, illustrates some of the basic principles of Chinese architecture dating back to at least the Han period (FIG. 4.16). Traditionally,

Chinese temples and secular halls were timber-framed: rows of wooden poles supported an elaborate wooden superstructure and ceramic tiled roofs. By Han times, Chinese builders were using superimposed groups of upward-curving brackets to transfer the weight of the roof and lintels to the poles. Over time, the bracketing system became more complex; the inner rows of poles in the Foguangsi temple have four such brackets, and the outer poles carry sets of levers that reach out beyond the brackets to support the overhanging roof and its heavy tiles. The interlocking sets of superimposed brackets, levers, and lintels are joined by mortises and tenons which allow the building to give very slightly in high winds and earthquakes, without breaking. The carefully fitted brackets, along with the upturned or flared tips of the roofline, remain enduring characteristics of Chinese architecture through the ages.

PAINTING

Many of the delicate and innovative paintings on silk from this period have disappeared. Works by such celebrated masters as Li Zhaodao (670–730) and Wang Wei (c. 700–760) are known only through later copies. Some of the best-preserved and most important paintings and sculptures from this period were found in the cave shrines at Dunhuang, Gansu, in western China, built between the fifth century and the eleventh. This site was a very important stopping place on the Silk Road where the northern and southern tracks of the road

4.17 *Western Paradise.* Section of a wall painting, Dunhuang, Gansu. Tang dynasty, late 8th century

skirting the Tarim Basin converge. Originally, there may have been a thousand cave shrines carved into the soft gravel cliffs, but only about half of them have survived. While much of the Buddhist art along the trade routes in this area was destroyed by a succession of anti-Buddhist uprisings and Muslim invaders in the eleventh century, the remoteness and arid climate of Dunhuang protected its wall paintings and sculptures.

Some of the paintings illustrate themes central to Pure Land Buddhism, a sect in which the faithful were promised a place in the Western Paradise of Amitabha Buddha. In the tradition of the rock-cut and painted cave-temples of India such as those at Ajanta, the artists showed the *Western Paradise* in an opulent, courtly manner (FIG. 4.17). Amitabha is seated among *bodhisattvas* in a celestial garden filled with other *bodhisattvas*, elegant birds, a collection of devotees around a magnificent carpet, and musicians. Smaller, framed *jataka* tales, scenes from the life of the Buddha, surround the main image. Pavilions illustrated in the Dunhuang mural, with upturned roofs, reflect the building styles of the Six Dynasties and Tang periods. Together, the courtly gathering and architectural background may represent the opulence of court life in contemporary Chang'an as an earthly reflection of the Western Paradise.

Guanyin, a *bodhisattva* of mercy who had been revered at an earlier date in Central Asia, became highly popular in China at this time. Traditionally, *bodhisattvas* are sexless and in the case of Guanyin their androgyny is deliberate; it expresses a universal or celestial form of love unlimited by issues of gender. In a tenth-century painting on silk from Dunhuang, *Guanyin as the Guide of Souls*, Guanyin is swaddled in finely patterned, semi-transparent silks, a costume the Chinese artists thought might be appropriate for a wealthy Indian prince (FIG. 4.18). He has floated down from his heavenly mansion (upper left) on a thin purple cloud to meet a diminutive devotee with bowed head. The painter has devised a magnificently orchestrated set of soft, flowing lines in the *bodhisattva*'s red, flaming halo, soft fluttering draperies, and curling clouds. Together with Guanyin's gestures, these create an image of princely dignity and utter calm.

One of the best surviving works reflecting the culture and authority of the imperial court at Chang'an, the *Scroll of the Emperors*, was painted by Yan Liben (died 673) (FIG. 4.19). Yan Liben was a high-ranking official who served as prime minister to the emperor and was equally skilled at architecture, sculpture, and painting. His images of the great emperors of the past are accompanied by moral lessons. The ancient Chinese traditions of ancestral worship and Confucian regard for authority figures encouraged the production of such portraits with accompanying texts. Yan Liben's use of modeling and broad forms make his figures appear much fuller and more massive than those of Gu Kaizhi. Although the modeling is limited, it is skillfully and consistently applied. Facial types are idealized, not idiosyncratic, and regalia, along with inscriptions, are used to identify rank. This tradition of painting idealized portraits of royalty achieves its classic form in the Tang period.

The late Tang dynasty was a period of rapid and momentous change that gave rise to new kinds of expression previously unseen anywhere in the world. Chan (or "Zen") monk–artists began to flaunt the "rules" of art and decorum by painting wildly, sometimes using their

4.18 *Guanyin as the Guide of Souls.* Dunhuang, 10th century. Painting on silk, 31 × 21" (79 × 53 cm). The British Museum, London

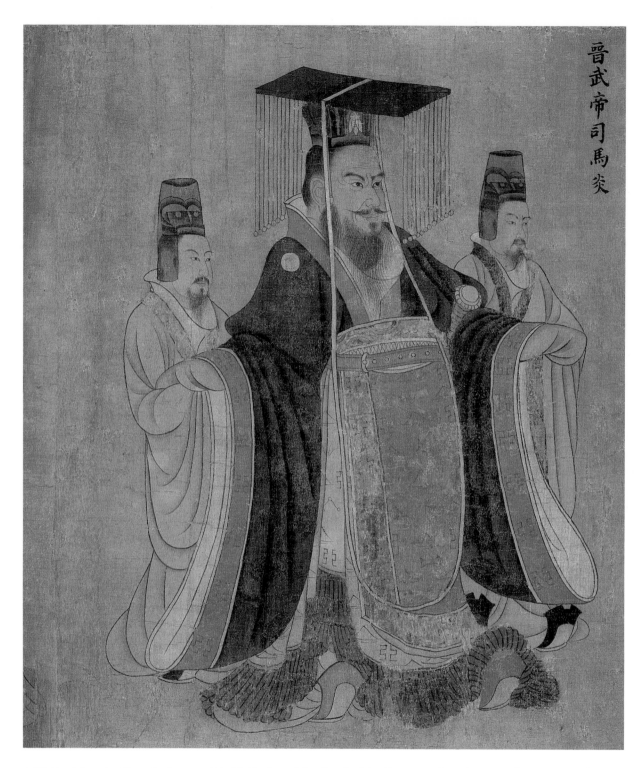

晉武帝司馬炎

4.19 Yan Liben (attributed), *Emperor Wu Di*. Portion of the *Scroll of the Emperors*. Tang dynasty, 7th century (11th-century copy). Handscroll, pigment, ink, and gold on silk, height 20¹/₈"(51 cm). Museum of Fine Arts, Boston

The earliest wall paintings in China appeared around 1100 BCE. Screen paintings and hand- or horizontal scrolls date from c. 100 CE, hanging or vertical scrolls appear after 600 CE, and album leaf or screen fold paintings date from c. 1100. Unlike the wall paintings, which were very popular up to the Tang period and could be seen by a relatively large audience of courtiers, the smaller and very portable scroll paintings that became increasingly popular by this time were designed for occasional viewing by a small audience.

Chinese ink (cakes of animal or vegetable soot with glue) and pointed brushes made of bound animal hairs glued into a hollow end socket of a holder appear around 1200 BCE. The Chinese began painting with water-based pigments on plastered walls about this time, on silk around 300 BCE, and on paper c. 1000 CE. The artists' brushes, inks, inkstones, and papers became known as the "four treasures."

own hair or feet. Writers such as Han Yu (768–824) and Bai Juyi (722–846) advocated more vernacular styles of writing, expressing a social consciousness. Liu Zongyuan (773–819) wrote a scathing critique of hereditary privilege and argued that the only stable form of government was one based on merit. These rebels criticized the corruption and special privileges enjoyed by the Buddhist community which worked hand-in-hand with the ruling aristocracy, as did the church and state in Europe at this time. Buddhism had become a powerful force in Chinese society by the ninth century and these criticisms of it ultimately led to the violent proscription of Buddhism in the 840s, when thousands of monks were defrocked, temples were closed, and serfs governed by the temples were released. Although the persecution lasted only a couple of years, Buddhism never recovered its wealth and status within Chinese society and government. By the end of the Tang dynasty, another group also made its effective exit: the hereditary nobility were completely eclipsed by the bureaucracy of appointed officials.

THE FIVE DYNASTIES (906–960), NORTHERN SONG (960–1127) AND SOUTHERN SONG DYNASTIES (1127–1279)

With the collapse of the weakened Tang dynasty in 906, China entered another period of civil war and anarchy that lasted for much of the tenth century until the Song dynasty came to power at Bianliang (present-day Kaifeng) in 960. In 1126, the Jurchen tribes of Manchuria, who took the dynastic title of Jin, captured the Song capital at Kaifeng and imprisoned the emperor. Surviving members of the court moved southeast to Lin'an (meaning "temporary safety"), the present-day Hangzhou, and established the Southern Song dynasty. Under the Song, southern China became the world's greatest producer of iron and had maritime trade routes reaching Southeast Asia, a flourishing merchant class, and four cities with a million inhabitants.

While the merchant class prospered and grew, the nobles, many of whom had depleted their resources by fighting one another in the late Tang and Five dynasties period, were on the decline. Some of the merchants sent their sons to public, private, and religious schools where they could study from books including encyclopedias illustrated by the newly developed woodblock printing technique. Many of those young scholars from merchant families excelled in the government examinations and thus entered the ranks of official-dom, often displacing those scholars from aristocratic families. This new class of scholar–official contributed to the Song period philosophy of government, which stressed the ideals of efficiency and civility and the belief that a well-run society reflected the higher and unchanging principles of moral order.

By the Song period, as merchants and scholar–officials outside the court gained wealth and power, and began collecting art, China developed a commercial market for art that was increasingly independent of the imperial and regional courts. Earlier imperial collections had often been assembled as emperors looked for ways to legitimize and represent their power. The Tang nobility, for example, had collected technically refined and brightly colored paintings of religious and mythological subjects, their own aristocratic activities, and courtly beauties—arts that reflected life in the courts around them. The new non-aristocratic patrons of the Song period also wanted arts that reflected the ideals of their world outside the emperor's court. Some artists began portraying solitary figures in rugged mountain landscapes and wintry scenes with roughly brushed strokes of black ink with little or no color. Instead of glorifying the court, which included many corrupt aristocrats, these artists celebrated nature, which they saw as a map of an unchanging moral order. Some

Chan (Zen) Buddhism, Enlightenment, and Art

"Chan" derives from a Sanskrit word, *dhyana*, meaning "contemplation" or "meditation." Chan Buddhism is better known by the name of its Japanese equivalent, *Zen* (the Japanese pronunciation of "Chan").

While the followers of the Pure Land variety of Buddhism repeated formulaic prayers, and the Esoteric or Tantric Buddhist performed elaborate rituals, the Chan Buddhists stressed meditation. In the tradition of Daoism, Chan Buddhism teaches that one can find happiness and success by achieving harmony with nature. Therefore, enlightened Chan Buddhist artists and poets become instruments through which the spirit of nature might be experienced and expressed. Dispensing with the traditional and official trappings of Buddhism, the scriptures, rituals, and monastic rules, the Chan Buddhists taught that the Buddha was a spirit that lived in everyone's heart. Because the Buddha belonged to the internalized world of thought, the Chan Buddhists used the yoga techniques of the brahmins to strive for a oneness with the *Dao* ("way") and the Confucian *li* ("innate structure of nature").

The Chan artists paid little attention to the traditional Indian and Chinese images of the Buddha and his many *bodhisattvas*. Instead, they often portrayed Chan masters in moments of inspiration and enlightenment, along with images of nature with which the masters had achieved a sense of oneness. To capture this sense of revelation, the Chan painters had to work in the Chan spirit, creating images spontaneously, in moments of great insight.

artists moved to barren mountain regions, studied nature first-hand, and made images that celebrated the integrity of those who chose to live austere lives close to nature. Even though many of the individuals who created and collected this new art served the government, they still admired the concept of the hermit or artists who did not. Painting a landscape, or simply contemplating one, was a spiritual act for city and country dwellers alike. The taste for simplicity and natural forms also influenced the ceramic artists who began producing vases with mat monochrome glazes and simplified shapes.

This strong contrast between the "refined and superficial beauty" of the Tang court and the "rugged integrity" of the new breed of mountaineer artists and their patrons is discussed in a very important text by a Five Dynasties painter, *Notes on the Art of the Brush*, by Jing Hao (c. 870–c. 930). This work epitomizes the spirit of the strong anti-aristocratic sentiments of this period and the association of the mountaineer's lifestyle—in which only the determined could succeed—with "integrity."

Of all the Buddhist sects, Chan Buddhism best survived the persecutions of the ninth century (see "*Religion*: Chan (Zen) Buddhism, Enlightenment, and Art," above). As a religious philosophy that stressed the importance of discipline and self-reliance, it too became closely associated with the artists and writers who lived austere lives close to nature.

PAINTING

The new interests in painting are well illustrated in the work of Fan Kuan (active c. 990–1030), a hermit and mountain dweller who was renowned for the sternness of his character. His *Travelers amid Mountains and Streams* is one of the best-known of all Chinese paintings (FIG. 4.20). Fan Kuan was one of the first artists to develop a characteristic type of textured stroke, one that would be closely associated with his style. He was the master of the raindrop or *cun* ("wrinkle") brushstroke, which was used inside ink contour lines to shade, model, and texture forms. The *cun* strokes were used to make forms appeal to the sense of touch and give them great mass. Chinese writers identify about twenty-five varieties of such textured strokes.

Fan Kuan's painting shows a thin shaft of water falling from a crevice in the cliffs, which feeds the mist-shrouded lake that cascades through the boulders into the stream below. The inspiration for this work and many others, as well as many Chinese poems, comes from a group of towering, picturesque breadloaf-shaped peaks along the Yangzi river in Anhuan province west of Shanghai. A pack of horses on the lower right is easily overlooked as the ancient Chinese cult of mountain worship seems to find one of its most memorable expressions in art. The landscape is not conceived in the Western tradition, as a back-drop for human activities, but as the vast context within which people are a small part of the larger scheme of nature. Nor is it intended to be the record of a single visual experience, but an accumulation of experiences flowing out through the artist's brush in a moment of great exaltation.

The ever-changing body of nature, exploding with energy, is softened by enveloping veils of clouds and fog. Rising, powerfully, like a cluster of giants, with trees for hair, the broad-shouldered pinnacles with *cun*-stroke detailing seem to take on a life of their own. The sense of monumentality in this painting, nearly seven feet (2.10 m) high, comes from its scale and from the contrast between the smallness of the figures in the foreground and the vastness of the mountains emerging from the mists. Allowing our eyes to move past the figures in the foreground, the rocks and water in the middle ground, through the mists and up the cliffs past the thin waterfall, we move from the human and terrestrial realm of existence to the celestial realm above the mountains in the sky. The character of each brushstroke is inextricably bound to the character of the object it represents as the artist, technique, and landscape exist in perfect harmony. Chan Buddhist in spirit and inspiration, the painting is also Confucian in the way in which it achieves a perfect ordering of all the parts of the work in a single system of relationships. In a manner similar to the one in which such hanging scrolls were to be viewed section by section, the viewer is invited to "walk through" Fan Kuan's world and savor each part of it with timeless attention to each detail.

Many of these Song artists now admired who worked outside the conventions and restricted world of the professional court painters were known as the *wenren* ("literati"). The literati were part of the highly educated, upper-class scholar–official class and most of them did not have to sell their art to make a living. Often, the literati used the austere technique of *shi mo* ("ink painting") without color and absorbent papers that could capture the most subtle nuances of their brushwork. Writers of the day attached great value to this kind of independence—the fact that they did not work for the court like hirelings or servants—and regarded these lofty-minded literati as the intellectual élites of the art world. They portrayed the literati as free thinkers who valued inspiration, spontaneity, and creativity, and looked beyond external appearances to capture the very essence of their subjects. These writers considered the works of the literati to be vastly superior to those of the academic painters who worked for the court and other wealthy patrons and focused

4.20 Fan Kuan, *Travelers amid Mountains and Streams*. Northern Song dynasty, c. 990–1030. Hanging scroll. Ink on silk, height 6'9¼" (2.06 m). National Palace Museum, Taipei, Taiwan

on exterior realities and the simple appearances of things in nature. "There is one basic rule in poetry and painting: natural genius and originality," wrote Su Shi (1036–1101).

Nevertheless, there were painters of the scholar–official class throughout the history of literati painting who did work for the court. Perhaps the most famous case is that of Ma Yuan (active c. 1190–1225), whose official degree was within the painting academy of the Southern Song court at Hangzhou. He came from a prominent family at court: his father had also served in the academy. Thus Ma Yuan was a government official and a gentleman, but his profession was painting. Until the twentieth century, Ma Yuan and those who followed his distinctive style were generally reviled by the Chinese literati painting establishment; his works were used frequently as examples of how not to follow Xie He's canons. In spite of that, Ma Yuan's painting seems to have been highly prized by almost everyone else, and in Japan it formed one of the prime references for the emerging school of Japanese literati painting. In *Scholar Contemplating the Moon* Ma Yuan has captured the immensity of nature with the simplest of means (FIG. 4.21). The moon hangs within the vast, open chasm of space unfolding behind the single most clearly defined form in the composition, the jagged limb of a pine tree. Exploiting the powers of suggestion by using empty space to represent water, mist, and sky, Ma Yuan captures the cosmic rhythms of the Daoists in his image of the vast, empty silence of infinity. In this and other of the few surviving masterpieces of literati ink painting from this period the longstanding Chinese interests in calligraphy, linear description, and landscape are combined in new visual forms. In its spareness, Ma Yuan's painting pushes the idea of pictorial suggestion to its seeming limits. This style, associated with Ma Yuan and his contemporary Xia Gui (active c. 1180–1224), is often called the Ma–Xia style.

By the thirteenth century, increasing numbers of Chan Buddhists were living in the spirit of Ma Yuan's contemplative scholar, as hermits, cloistered in remote mountain retreats in search of harmony and unity within the spiritual forces of nature. Working in this manner, Liang Kai (active in the early thirteenth century) shows *Hui Neng, the Sixth Chan Patriarch, Chopping Bamboo at the Moment of Enlightenment* (FIG. 4.22). According to legend, Hui Neng passed beyond all limits of rationality and received enlightenment while he was performing this routine task. The painting, too, seems to have been painted in a sudden flash of insight. The brushwork in the hastily executed bamboo, the quick broken washes defining the tree in the background, and the sketchy rendering of the Patriarch's folded limbs are filled with "happy accidents" that work in perfect harmony. It is the work of a master so well tuned to his subject and materials that matters of technique have become second nature and his hand and brush can respond directly to his *qi* and lifetime of experiences. Ultimately, the influence of Ma Yuan, Liang Kai, and other Chan painters of the Southern Song period reached outside China to Japan, where they remained strong in the centuries to come.

4.21 Ma Yuan, *Scholar Contemplating the Moon.* Southern Song dynasty, c. 1200. Hanging scroll. Ink and color on silk, height 22³/4" (57.5 cm). MOA Museum, Atami

CERAMICS

Like Tang paintings, Tang ceramics were often very colorful and had complex shapes. Although some of this tradition persisted into Song times, the most celebrated works from Song times express the ideals of sobriety and simplicity discussed above with painting. The works that are now considered to be the classics of this period have simplified forms,

soft monochrome mat finishes, and a sense of unity in which all features are subdued in a perfect sense of oneness and harmony.

In what some scholars consider the culmination of the Song tradition, the ceramists produced wares with glazes that are nearly monochromatic (off-whites, soft blues, grayish-greens, and pale green-buffs) for the imperial court. A rare northern imperial ware, Ru, produced for a short time before the demise of the northern branch of the dynasty, inspired the Guan ("official") ware in the south that has come to be known as the "classic" expression of the Chinese ceramists (FIG. 4.23). As on the Ru wares, ornamentation on Guan wares tends to be minimal and the vessel shapes, glazes, and decorative patterns seem to be perfectly integrated. Like some other courtly styles of porcelain, the Guan wares simulate the appearance of jades and their lustrous mat surfaces appeal to the sense of touch.

The very distinctive crackle pattern in the glaze on the *Bottle Vase* appealed to the refined, educated tastes of the day in China, as it does to many contemporary viewers. A pattern such as this may develop after the

4.22 Liang Kai, *Hui Neng, the Sixth Chan Patriarch, Chopping Bamboo at the Moment of Enlightenment.* Southern Song dynasty, c. 1200. Hanging scroll. Ink on paper, height 29¼" (74.3 cm). National Museum, Tokyo

4.23 *Bottle vase.* Southern Song dynasty. Guan porcellanous stoneware, height 6⅝" (17 cm). Percival David Foundation of Chinese Art, London

glazed ware has been fired in a kiln if the glaze contracts slightly more than the clay body beneath it during the cooling process. With age, the crackle or crazing pattern may continue to develop. Although this process is predictable to some extent, the precise patterning of the crazing cannot be controlled. The Chinese saw aesthetic value or beauty in such serendipitous effects, as they did in the semi-accidental effects of the brushwork of painters and calligraphers. The ornamental qualities of the crackled glaze work in harmony with the basic sculptural qualities of the vessel with a perfect synergy, in a way that reflects the aesthetic, introspective, and meditative spirit of thinkers around the Southern Song court. The final effect is that of a lustrous glaze suspended on a dematerialized body, an experience that complements the effects of Song paintings. The interplay of the prescribed form and irregularity of the crackles mixing intention with accident—rationality with instinct and irrationality—has its parallel in Chan Buddhist thought. In the post-Song period this delicate balance of forms and ideals changed as the ceramists moved toward a wider variety of brighter glazes and sharper, more defined decorative motifs.

THE YUAN DYNASTY (1279–1368)

The Mongols who ruled in China as the Yuan dynasty came from Mongolia, north of the Great Wall. Groups of Mongol horsemen had been making sporadic forays into China since the eighth century and, in 1206, they were united by Temuchin, or Temujin, known in the West as Genghis Khan (1162–1227). Under Genghis Khan and his successors, the Mongol cavalry swept across Asia, conquering lands from the Danube to the Pacific, creating an empire larger than that of the Romans, Arabs, or earlier Chinese. By 1279 his grandson Khubilai Khan had overrun China, where he ruled as the first Yuan emperor until 1294. He relocated the capital of China to Khanbalik (present-day Beijing) in the far north of China, close to his Mongolian homeland.

Mongol leaders following the Tibetan form of Buddhism, Lamaism, and esoteric forms of Daoism formed a separate class at the apex of Chinese society. Chinese art and culture had long played an important role in the lives of the Mongols, but the Yuan leaders distrusted the wisdom of Confucian literature, abolished the traditional literary examination for administrative officials, and gave many of these positions to Mongols and other non-

4.24 Guan Daosheng, *Ten Thousand Bamboo Poles in Cloudy Mist*. 1308. Handscroll. Ink on paper, height 6" (15 cm). National Palace Museum, Taipei, Taiwan

Chinese allies. Under these circumstances many of the educated Chinese turned away from government service to the visual arts and writing.

The Yuan leaders commissioned large quantities of religious and secular art. They were particularly interested in carpets, metalwork, and ceramics. The sister of Emperor Renzong (ruled 1312–1320), Princess Sengge Ragi, established a large royal collection that artists belonging to the Yuan aristocracy could study. Breaking the Confucian hold on writing, the Mongol leaders encouraged would-be authors to produce popularized forms of non-Confucian drama, music, and poetry that their Mongolian and non-Chinese associates might enjoy. They also imported large quantities of foreign goods over the ancient trans-Asiatic Silk Road, all of which lay at that time within the protective boundaries of the Mongol empire. (See "*Cross-Cultural Contacts*: Marco Polo and the Mongol Court," page 142.)

PAINTING

While some writers have long regarded the Yuan period as a dark age, others feel that the Mongols did relatively little to alter the natural course of Chinese art and culture. The art of the well-educated, upper class literati scholar–artists in the southeast around Hangzhou, far removed from the Mongol court in the north at Beijing, continued to reflect traditional Chinese values. In accord with Xie He's sixth canon ("Transmission of experience of the past in making copies"), they studied past styles of Chinese painting (Tang dynasty art in particular) and produced historically based paintings. Many of them reacted against the softness of Southern Song painting as a manifestation of the highly refined aesthetics and passivity of the Song leaders who had allowed successive foreign invasions to take place. Working mainly on paper, not silk, sweeping away the veils of mist, they create a solid, hard-edged tradition of ink painting that seems to express the austerity of this period of foreign occupation.

Working in this spirit, some artists, such as Guan Daosheng (1262–1319), managed to find new ways to treat traditional subjects. Like other well-educated women painters of this period, Guan, a renowned calligrapher and muralist, was held in high esteem by the serious art collectors of the day. A segment of her short handscroll *Ten Thousand Bamboo Poles in Cloudy Mist*, the earliest surviving work by a woman in China, uses a favorite Chinese subject to comment on the spirit of the age (FIG. 4.24). As is typical of Guan's work, the bamboos are shown in large clumps along the side of a river. Bamboo had

Marco Polo and the Mongol Court

Khubilai Khan, who generally distrusted his Chinese subjects, enlisted the services of many non-Chinese, including three Venetian merchants from the Polo family. Bearing a letter of introduction from Pope Gregory X, they had traveled along the Silk Road through Mesopotamia and Afghanistan to China. The Mongol conquests of Muslim-held areas in Central Asia made such travel possible for Europeans. Marco Polo (c. 1254–1324) was about twenty-one when he arrived in Beijing in 1275 with his father and uncle and served Khubilai Khan as an ambassador until 1292. He spoke in glowing terms about Chinese civilization and called Hangzhou the grandest city on earth. He was also impressed with the grid pattern of streets in the new capital in the north, a plan the future city of Beijing retained when it was built in Ming times on the ruins of the Yuan capital.

With the disintegration of the Mongol empire and conquests of the Ottoman Turks in the fourteenth century, overland trips to the East became increasingly difficult, stimulating European explorers to search for sea routes to Asia. Until they found them, Marco Polo's *Travels*, written after he returned to Italy, constituted arguably the only eyewitness account of China available in Europe. Since Marco Polo's times, however, many scholars have doubted that he actually saw the marvels he chronicled.

4.25 Zhao Mengfu, *Sheep and Goat*. Yuan dynasty, c. 1300. Handscroll. Ink on paper, length 19" (48 cm). Freer Gallery of Art, Smithsonian Institution, Washington, D.C.

long been a popular subject in Chinese painting because of its appearance and symbolism. Its long, thin, tapered leaves provided painters with opportunities to demonstrate their mastery of brush techniques. The plant's apparent fragility belies its ability to bend before adverse winds and waters and survive under the worst of conditions. For male painters, this ability to remain unbroken in the face of adversity was a masculine virtue. However, in the hands of Guan Daosheng, the bamboo shoots may represent marital fidelity, symbolizing the faithful wives of a mythical sage and emperor who threw themselves into a bamboo grove on a river at the emperor's death.

Guan Daosheng's husband, Zhao Mengfu (1254–1322), an eleventh-generation descendant of the first Song emperor, was a favorite of Khubilai Khan. Although Zhao Mengfu worked with the Yuan government and was seen by many of his Chinese contemporaries as a traitor, posterity nevertheless gives him great credit as a writer and artist. In addition to being a master calligrapher and painter of traditional studies of bamboo, Zhao was a painter of horses, which made him popular among the equestrian-minded Mongols. In a section of a short handscroll that belonged to the former imperial collection, *A Sheep and Goat*, Zhao shows his amazing ability to capture the contrasting characters of the animals (FIG. 4.25). Using his skills as a calligrapher, Zhao emphasizes the differences between the motionless sheep with its benign expression and thick, dappled coat, and the intensely curious goat with its long, flowing hair.

THE MING DYNASTY (1368–1644)

A succession of weak rulers following Khubilai Khan's costly attempts to invade Japan in the late thirteenth century enabled native leaders in China to drive out the Mongols. A new Chinese dynasty called the Ming ("bright" or "brilliant") took power in 1368 and ruled out of Nanjing until 1420, when they moved their capital north to Beijing to keep a close watch on the still dangerous Mongols. Neo-Confucianism, the official religious philosophy of the Ming rule, did little to soften the conservative backlash of their regime. In his efforts to purge the country of Mongol influences, the first Ming emperor, the Hongwu emperor, instituted the most radically despotic government in Chinese history. Untold numbers of Chinese workers perished enlarging the Great Wall of China as the Ming emperors defended China against future attacks from the north. Many of the artists who had suffered under the Mongols found their freedoms even more severely restricted under home rule. While the traditional Confucian civil service examinations for government posts were reinstituted, as in earlier periods, many artists preferred to live and work outside the imperial and regional courts.

With the decline of the Mongolian empire, which had protected the Silk Road, the Yongle emperor (1403–1424) launched exploratory expeditions in the Indian Ocean that reached the Arabian peninsula and east coast of Africa. The Yongle emperor also undertook two enormous projects at home, the compilation of an authoritative 11,095-volume encyclopedia of Chinese learning, and the construction of the Imperial Palace in Beijing over the ruins of Khubilai Khan's capital.

CERAMICS

The first Ming emperor established a kiln at Jingdezhen to produce high-grade porcelain for his court. Jingdezhen was named for the Song emperor Zhenzong, who founded the ceramic industry there around 1004 CE and whose reign title at the time was Jingde Dazhongxiangfu. This region has exceptional fine porcellanous clays, a good wood supply for firing the kilns, and it is close to the Yangzi River. Most of the wares produced at Jingdezhen were mass-produced in workshops or factories and designed for everyday use in Southeast Asia, the Middle East, China, and later, the West. During the Yuan dynasty, the kilns there first started producing porcelain for these markets on a massive scale. With the establishment of the Ming kilns that made the imperial porcelain, Jingdezhen was arguably the single most important kiln site in the world.

The Ming painters often painted detailed, hard-edged images, using the rich blue cobalt glazes the Mongols had discovered in Kashan, Persia. The famous blue-on-white designs of Ming porcelains are underglazes. The blue (water and cobalt oxide) designs are painted

4.26 A pair of porcelain vases painted in an underglaze of cobalt blue. Ming dynasty, Xuande period (1426–35). Height 21¾" (55 cm). The Nelson-Atkins Museum of Art, Kansas City

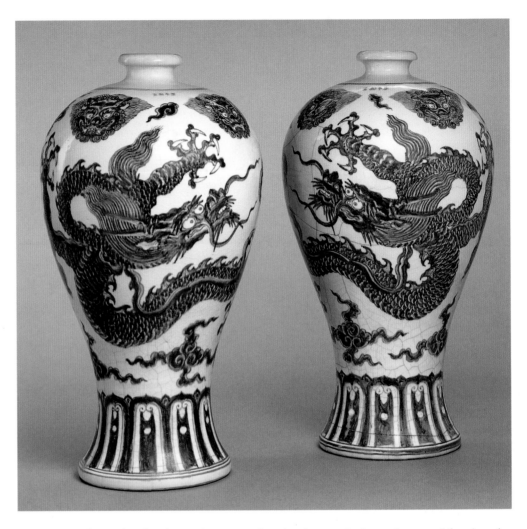

onto the surface of unfired vessels, covered with a layer of white glaze, and fired in the kiln. This tradition of Chinese blue and white painted porcelain continues to be an important part of Chinese art to this day. (See *"Materials and Techniques:* Porcelain," below.)

Many of the ceramic painters working during the reign of the Xuande emperor (1426–1435) created clearly outlined and detailed images such as the scaly, wide-eyed monster that floats weightlessly among scattered clouds around the silky-smooth glazed

MATERIALS AND TECHNIQUES

Porcelain

The Chinese may have developed the techniques of firing clay in ovens, or kilns, at high temperatures to produce what is known as porcelain while working with bronzecasting techniques. While porcellanous wares were known in Tang times, the classic examples of porcelain come from the Yuan and later periods. Porcelain, a fine white hard-paste ceramic, is made from volcanic porcelain stone clay (containing the minerals quartz, kaolin, and feldspar) and other clays rich in kaolin. When these clays are fired or heated in kilns at very high temperatures (1100–1300°C), they develop needle-shaped mullite crystals and a high amount of body glass. Thin, glass-rich porcelains transmit light and make a clear ringing sound when struck. Glazes used on porcelains and other wares contain silica, the primary glass-forming oxide, alumina, minerals for coloring, and fluxes to lower the melting temperature.

surface of the vase in figure 4.26. With his bony claws, razor-toothed spine, and long, serpentine whiskers, the mythic monster is part of a long tradition of creatures depicted in Chinese art from Shang times onward. To the populace, the dragon was a bringer of rain and an emblem of the emperor.

LACQUER

A similar but more detailed dragon appears on a lacquered chest made at this time (FIG. 4.27). The imperial patrons who purchased great quantities of porcelain also had a taste for lacquerworks of extraordinary richness. The art of lacquerwork, developed in the Neolithic period, reached the height of its popularity around the fifteenth century. Lacquer, made from the sap of the Chinese *Rhus verniciflua* tree, is a clear, natural varnish-sealant. A lacquer finish will make wood, textiles, and other perishable materials airtight, waterproof, and resistant to heat and acid. The lacquer is applied in many very thin polished coats, each of which may take up to a week to dry. A thick, smooth, glass-like lacquer surface can be carved or inlaid. Carving through the layers of multicolored lacquer can produce exciting

4.27 Chest. Ming dynasty, Xuande period (1426–35). Lacquer with incised and gilded design, width 22³/₈" (57 cm). Victoria and Albert Museum, London

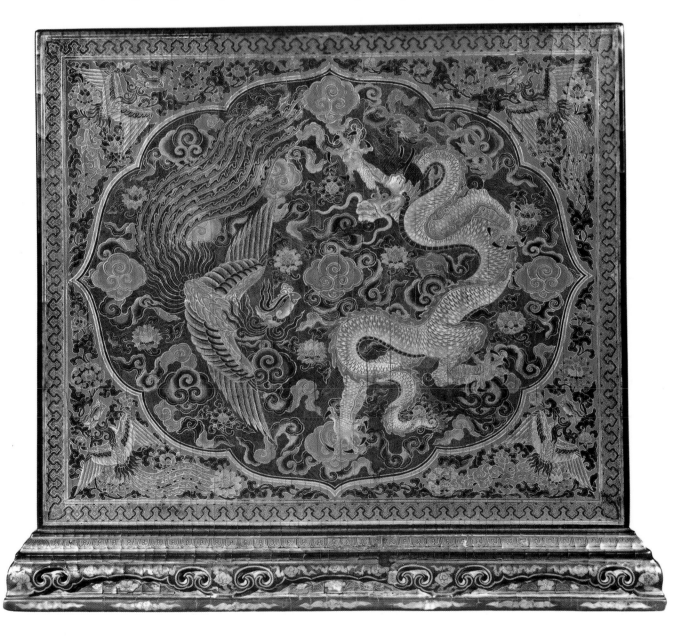

marble effects. The lacquered surface of the Ming chest has multicolored lacquers, incised detailing, and gilding, and has been sealed with final layers of very thin and highly polished lacquer. In its richness, the well-embellished dragon, bird, and surrounding floral and cloud motifs reflect the rich patterning of Ming textile designs as well as ceramic paintings.

PAINTING

The Ming court favored artists who worked in the illusionistic manner of Southern Song painters such as Ma Yuan. As the austerity of the early Ming restoration of Chinese rule began to soften, literati critics began expressing their dim view of this new style, regarding it as imitative and vulgar. They championed the work of Wen Zhengming (1470–1559) and other members of the "Wu school," named for the area around Suzhou where they worked. In the thinking of the literati of the day, the poem and painting in Wen's *Cypress and Rock* (1550) have equal importance (FIG. 4.28). Wen made this work as a gift for an ill friend, a writer, and the poem urges the young man to have the strength of the detailed, gnarled cypress tree and rocks. As in some other works by Wen, the tightly composed tangle of limbs has a bristling character like the dragon on the vases in figure 4.26.

Members of Wen's family continued the traditions of the Wu school into the seventeenth century, but its prestige and that of Suzhou as an art center were to be challenged by artists and theorists including Dong Qichang (1555–1636) from nearby Songjiang. Dong, a late Ming literatus, bureaucrat, teacher, artist, calligrapher, and art historian, wrote a theoretical essay that had a tremendous influence on later Chinese artists and writers. He said there were two parallel traditions in Chinese painting: one conservative, academic, formal, decorative, and courtly, and another that was progressive, innovative, expressive, and free. The second and superior tradition was represented by Wen Zhengming and others, including himself. Dong Qichang emphasized the abstract nature of painting, its distinctness from nature, and said that the quality of a painting lay in the expressive character of its brushwork. In this regard, he substantiated the closeness of Chinese painting to calligraphy and poetry. Although many critics from Dong Qichang's time to the present have felt that,

4.28 Wen Zhengming, *Cypress and Rock.* Handscroll. Ink on paper, 10¼ × 19¼" (26.1 × 48.9 cm). The Nelson-Atkins Museum of Art, Kansas City

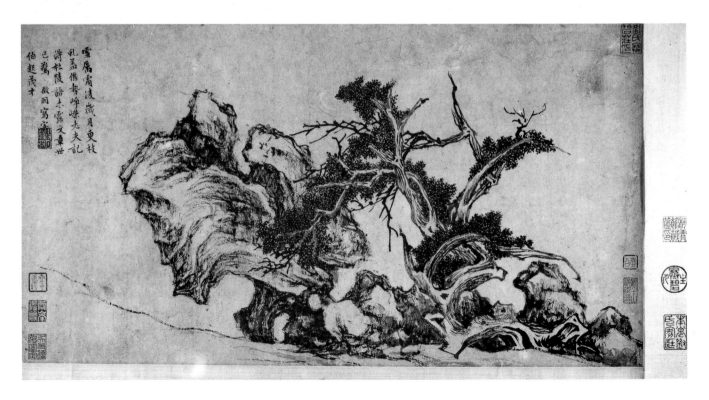

his duality theory was over-simplistic, his thinking influenced artists well beyond the Ming period.

Many of these ideals are illustrated in his own works, such as *Landscape in the Manner of Old Masters* (FIG. 4.29). It is not intended to be a topographically accurate and recognizable image of Jingxi. The open spaces among the large rocks and clusters of trees are not to be understood as real space in a real landscape. The artist has followed a line of thinking in Chinese art articulated in the tenth century by Su Shi, which valued "natural genius and originality" and a rustic lifestyle. The emphasis here is not on illusionism, but on the quality and style of Dong Qichang's brushwork and the ideal of rustic nature as a place for retreat and meditation.

THE QING DYNASTY (1644–1911)

As the political and economic power of the Ming dynasty declined, China was once again occupied by foreigners from the north—the Manchus, or Manchurians, who captured Beijing in 1644 and held it and the entire country until 1911. The Qing ("clear" or "pure") Manchus had enjoyed the benefits of Chinese culture for centuries before 1644, and by 1680 they began supporting and encouraging the traditional forms of Chinese art and thought. While the Qing rulers summoned many artists to work for periods in the court, the art market in China was changing. Many of the "court" artists did most of their work for wealthy patrons in their home cities.

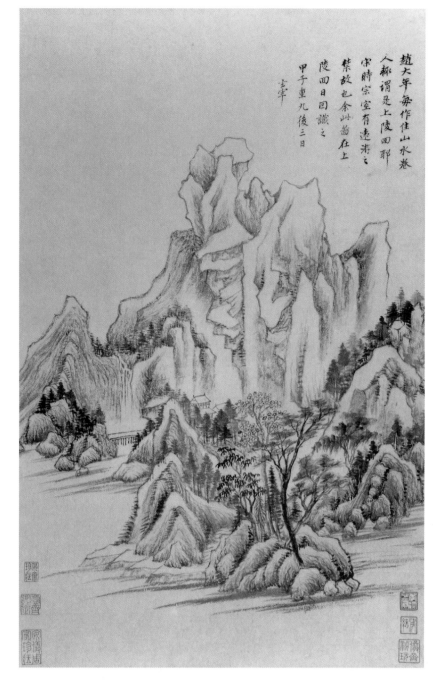

4.29 Dong Qichang, *Landscape in the Manner of Old Masters.* 1611. Handscroll. Ink on paper, 22 × 14" (56.2 × 35.6 cm). The Nelson-Atkins Museum of Art, Kansas City

The Qing imperial collection of art (now divided between the National Palace Museum in Taipei and the Palace Museum in Beijing) grew enormously under the long rule of the Qianlong emperor (1736–1795). The tastes of that era determined which arts from the past would be preserved and still shape views of Chinese art.

ARCHITECTURE

While the Imperial Palace in Beijing may preserve many of its Ming features, the present structures were largely rebuilt in the eighteenth century under the Qing emperors (FIG. 4.30). In fact, the basic plan of the palace complex is a traditional one in China, and elements of it date back to Chang'an of the Tang period and the earlier structures of the Han dynasty. Beijing and Chang'an were both walled cities laid out on a grid plan along a north–south

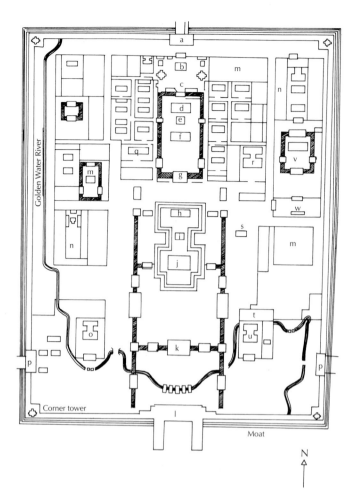

4.30 Plan of the Imperial Palace, Beijing. Begun 17th century. Numbers keyed to major features:
(a) Gate of Divine Pride;
(b) Pavilion of Imperial Peace;
(c) Imperial Garden;
(d) Palace of Earthly Tranquility;
(e) Hall of Union;
(f) Palace of Heavenly Purity;
(g) Gate of Heavenly Purity;
(h) Hall of the Preservation of Harmony;
(i) Hall of Perfect Harmony;
(j) Hall of Supreme Harmony;
(k) Gate of Supreme Harmony;
(l) Meridian Gate;
(m) Kitchens; (n) Gardens;
(o) former Imperial Printing House;
(p) Flower Gate;
(q) Palace of the Culture of the Mind;
(r) Hall of the Worship of the Ancestors;
(s) Pavilion of Arrows;
(t) Imperial Library;
(u) Palace of Culture;
(v) Palace of Peace and Longevity;
(w) Nine Dragon Screen

axis with imperial compounds on the north end facing south. (See *"Analyzing Art and Architecture: Feng Shui,"* page 149.) The scale of the project is enormous; the high walls and towering brick gateways surrounding the halls of state protecting the royal family from the outside world are fifteen miles (25 km) long. Following a tradition at least as old as the Han period, the Imperial Palace itself covers about 240 acres (97 hectares) and is built on a rectilinear plan, oriented to the points of the compass. The entire structure, built around a central axis and focused upon the ritual activities of the emperor, was conceived as a microcosm of the universe. The order and symmetry of this plan, as a reflection of those qualities in the makeup of the cosmos, emphasize the closeness of the emperor to the gods.

The emperors and their families seldom left the compound of the Imperial City. Those who were permitted to enter the palace came through the Meridian Gate and over one of five bridges crossing the Golden Water River to a bow-shaped court. Beyond it lay the Gate of Supreme Harmony, a rectangular court, and the Hall of Supreme Harmony (FIG. 4.31). This hall housed the throne of the emperor, where ceremonies celebrating the winter solstice, the new year, and the emperor's birthday were performed. The hall and buildings behind it, elevated on a three-leveled white marble platform, are approached by gently sloping stairways. Behind the three elevated halls, the Gate of Heavenly Purity leads to an enclosed complex housing the emperor's Palace of Heavenly Purity and the empress's Palace of Earthly Tranquility. The buildings in the city, many of which have been refurbished since the fifteenth century, follow traditional patterns of post-and-lintel construction and decoration dating back to the Shang or Zhou periods.

The true weight of the enormous tiled roof of the Hall of Supreme Harmony and the other buildings in the city is disguised by the playful, festive quality of their flaring

Feng Shui

Feng shui ("wind" and "water") is a colloquial Chinese name for a Daoist belief that people and nature are linked in an invisible dialogue. Certain "dragon lines" of energy or *qi* flowing along the surface and within the earth are believed to have the power to influence the lives of people near them. The flow of this *qi*, which may run from mountains along the outlines of hills and watercourses, is not static; it may vary every two hours throughout a sixty-year cycle of time in the Chinese calendar.

The flow of the existing *qi* of a locality may be altered and improved through landscaping, plantings, and the building of canals. Looking ahead, builders often consult with *feng shui* experts to determine the proper location and orientation of a tomb, building, or city, or the best way to arrange furniture in a room. Since the emperors were divine and closely connected to the cosmological forces, the practice of *feng shui* was especially important in site selection and planning of their imperial cities. Since Zhou times, imperial cities have been arranged on a north–south axis with the imperial enclosure at the north end of a walled, grid-planned complex. This put the evil forces and spirits of the north to the emperors' backs.

The principles of *feng shui* reflect the Chinese belief in the wholeness of the universe and the necessity of living in harmony with nature. In theory, *feng shui* provides a means of defining one's position in the physical universe by understanding this harmony and invisible dialogue. In practice, *feng shui* is a very complex combination of mystical knowledge, common sense, and aesthetics in which the Chinese still have great faith.

corners and the glowing yellow of their glazed tiles (a color reserved for imperial structures). In a manner similar to that of traditional Chinese painting, where conspicuously bright colors were often applied to the linear structure of the image, the structural parts of the buildings are highlighted with blazing colors. The broad, upswept eaves are supported by a complex system of decorative yet functional brackets resting on the lintels, which often extend out beyond the posts holding them. The complex collection of brightly lacquered red and gold cantilevered brackets rise out of the slender columns like the branches of a severely pruned and shaped tree. Reaching out to support the upturned eaves, these energetic forms have the gestural qualities of the finest Chinese calligraphy, and repeat many of the

4.31 Hall of Supreme Harmony, Imperial Palace, Beijing. Begun 17th century

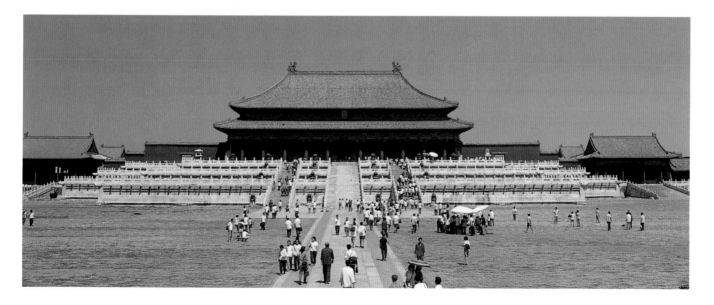

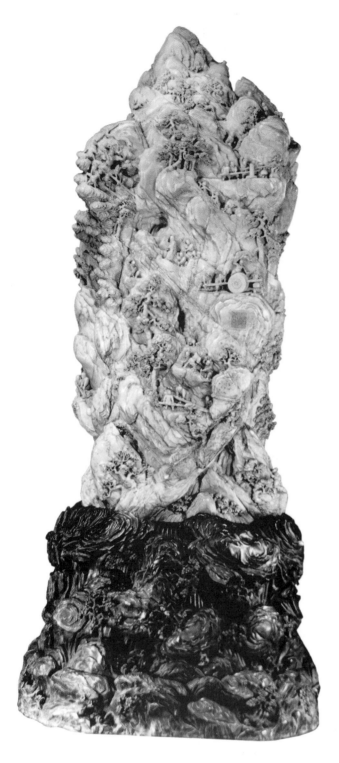

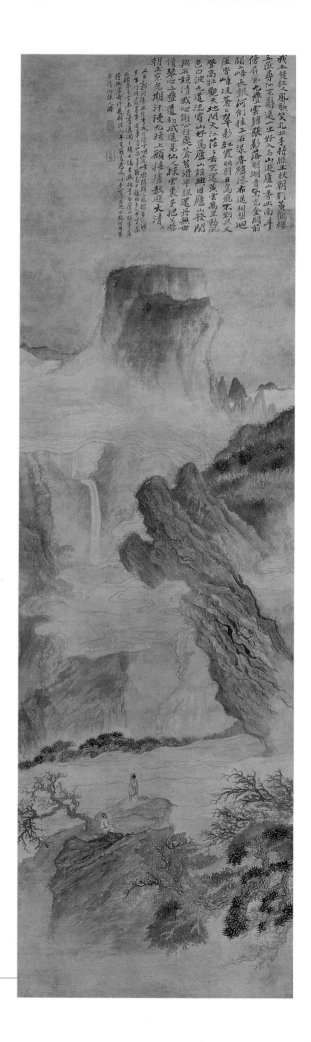

4.32 *Yu the Great Taming the Waters.* Completed 1787. Jade carving, 7'4" × 3'1¾" (224 × 96 cm). Palace Museum, Beijing

4.33 Shitao, *View of the Waterfall on Mount Lu.* Qing dynasty. Hanging scroll, ink and color on silk, 8'9" × 2'7⅞" (212 × 63 cm). Sen-Oku Hakuko Kan, Kyoto

decorative shapes used on Shang and Zhou bronzes while drawing attention to the roofs. The walls are little more than thin membranes strung between the solid posts that support the brackets and wing-shaped roofs.

SCULPTURE

The Qianlong emperor is also famous for commissioning the largest of all Chinese jade sculptures (FIG. 4.32). It was found near Khotan in eastern Central Asia, a region that had long supplied Chinese emperors with jade, and one they had only recently reconquered. It took three years for 100 horses and 1,000 workmen to transport the enormous stone, which weighs about six tons (6096 kg) from Khotan to Beijing. A wax model of the jade was carved with an image taken from a Song painting showing a mythical emperor, Yu the Great (2205–2197 BCE), taming a flood. As the first emperor to control the rivers in China and make the land safe for habitation, the legendary Yu was a grand image of imperial power.

Eventually, the Qianlong emperor decided that the local jade carvers were not qualified to work on his precious stone. He shipped it south to Yangzhou and made a second model in wood because the wax might melt in the heat of southeastern China. It took about eight years and 150,000 working days for a team of sculptors to carve the jade, which was returned to Beijing in 1787 and still stands where it was installed by the Qianlong emperor.

PAINTING

The traditional distinction between the professional and literati painters continued into Qing times, but it could not quite encompass a new group of artists, sometimes called the "Individualists." Some of the most original Individualists were Ming loyalists who did not acknowledge the authority of the Manchu government. One of the most prominent, Bada Shanren (1626–1705), the son of a Ming prince, developed a drastically simplified and highly personal style of painting. Another important Individualist and descendant of the last Ming emperor, Shitao (1641–1717), designed gardens and wrote a complex account of his philosophy on the unity of people and nature. In his essay, Shitao argues against using the traditional or canonical methods of the ancient masters and says that one must paint without inhibitions, indeed that the very act of painting allows the artist to shed his inhibitions. In his image of *View of the Waterfall on Mount Lu*, Shitao ignores the traditional ideas of scale, texture, and space, treating the massive rocks as if they were transparent (FIG. 4.33).

While eighteenth-century Europeans were utilizing features of Chinese garden theory and social theory, the Chinese artists were also responding favorably to European artists working in China. (See "Cross-Cultural Contacts: Europe and Chinoiserie," page 152.) Giuseppe Castiglione (active 1715–1766), trained in Genoa and known in China as *Lang Shi'ning*, combined elements of the Eastern and Western traditions in works that made him very popular around the court. A section of his scroll *One Hundred Horses at Pasture* follows a traditional Chinese compositional scheme (FIG. 4.35). The knurled limbs of a conifer in the foreground frame a composition of horses and people in the middle and background. However, the details of the rough tree bark, the modeling of the horses, which accentuates their massiveness, and the details in the foliage, rocks, and tent are Western in character.

The Eastern–Western features in Castiglione's work may not be as completely integrated as the Chinese-inspired decorations on eighteenth-century European porcelains, but Castiglione's work is important because it raises an important issue. Are we to reject works that mix Eastern and Western art as hybrid or impure and thus aesthetically insignificant? Or is there creative potential in such diverse combinations of imagery, which retain traces of the East and the West? A postmodern perspective, which accepts pluralism,

Europe and Chinoiserie

The first Portuguese trading ships arrived in China in 1514, and by 1715 the major European shipping nations all had offices and warehouses at the Chinese port of Canton. While some Jesuit missionaries from Europe living in China were making systematic studies of Chinese culture, and such major European thinkers as Dr Johnson and Voltaire were intrigued by the egalitarian spirit of the Chinese civil service examinations, for many Europeans, conflicting reports on China gave rise to exaggerations of all kinds, positive and negative.

The traders, returning to Europe with porcelains, reverse paintings on glass, wallpapers, carved ivory fans, boxes, lacquers, and patterned silks, created a vogue for *chinoiserie* (French for "Chinese style" or "things Chinese") that was part of this infatuation. Chinese porcelain, or "china" as it came to be known in the West, was especially popular in Europe. To meet the rising demand for it, ceramists at Meissen near Dresden, Germany, learned how to make their own porcelain in the early eighteenth century.

Chinese art and European reproductions of it influenced the development of the Rococo style in France. In 1742, François Boucher painted an idealized Chinese fantasy using blue-on-white (like a Chinese porcelain) in which an obsequious Chinese man with a broad-brimmed straw sun hat is shown paying homage to a European woman with a parasol (FIG. 4.34). The porcelain vase on the stand beside her is shaped like an ancient Chinese bronze. Above, a cross-legged and portly Buddha-like figure is seated on a tall platform with Asian palms near a Chinese hut with upturned eaves.

Chinese gardens of the Qing period were greatly admired in Britain and France. As early as 1700, Sir William Temple wrote how Chinese gardeners prized irregularity and imagination in their designs over symmetry and beauty. By the mid-eighteenth century, James Cawthorn lampooned the English fascination with Chinese aesthetic ideas in a satirical poem describing a "Mandarin"

"Whose bolder genius, fondly wild to see
His grove a forest, and his pond a sea,
Breaks out—and whimsically great, designs
Without shackles or of rule or lines."

By the end of the eighteenth century, many of the ideals of Chinese aesthetics had been assimilated into the Romantic movement. Today we are in a unique position to revisit the history surrounding these East–West interchanges and appreciate it for its complexity and cultural richness.

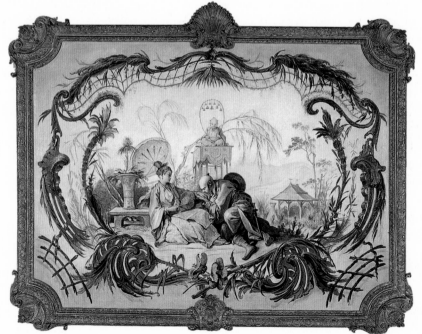

4.34 François Boucher, *Le chinois galant*. 1742. Oil on canvas, 41 × 57" (1.04 × 1.45 m). David Collection, Copenhagen

diversity, and contradiction as valid realities, would support the latter argument. In fact, we need not redraw the sharp boundaries between "East" and "West" that were fashionable a century ago. Some phenomena, such as the eighteenth-century "natural" garden or the paintings of Castiglione, may best be understood as transnational or cooperative ventures, artistic creations that could not have happened within the confines of a single cultural tradition.

The problems confronting Chinese artists became increasingly important as contacts with the West and its art intensified in the nineteenth century. Some Chinese painters trained by resident Europeans became fully Westernized and worked outside the Chinese traditions. Others in the newly emerging southeastern commercial cities such as Shanghai looked for ways to mix their native traditions with Western art. The art market there was part of the emerging urban lifestyles in the cities where businessmen worked in the commercial districts by day and enjoyed the recreational or pleasure quarters at night. The great demand for detailed and inexpensive works of art illustrating life in these districts inspired entrepreneurs to establish print shops. Working with draftsmen, woodblock carvers, and printers, they produced large and profitable editions of inexpensive prints of city life. Suzhou was an especially important center for the production of these highly informative, topographic woodblock prints, in which the city was presented from a bird's-eye view. Figure 4.36 shows the area around the Changman gate in Suzhou, where this print was published. Such inexpensive, mass-produced works were novel, fashionable, and very saleable.

4.35 Lang Shi'ning (Giuseppe Castiglione), *One Hundred Horses at Pasture*. Qing Dynasty, 1715–66. Section of a handscroll. Ink and color on silk, height 37¼" (94.6 cm). National Palace Museum, Taipei, Taiwan

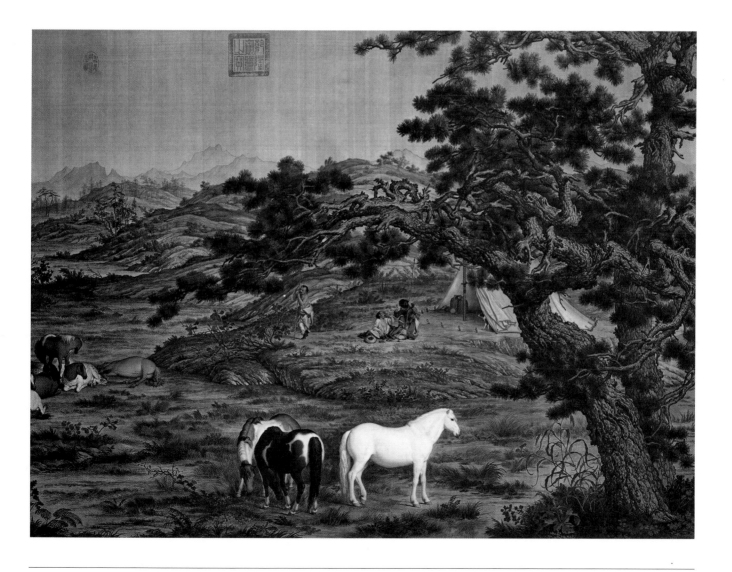

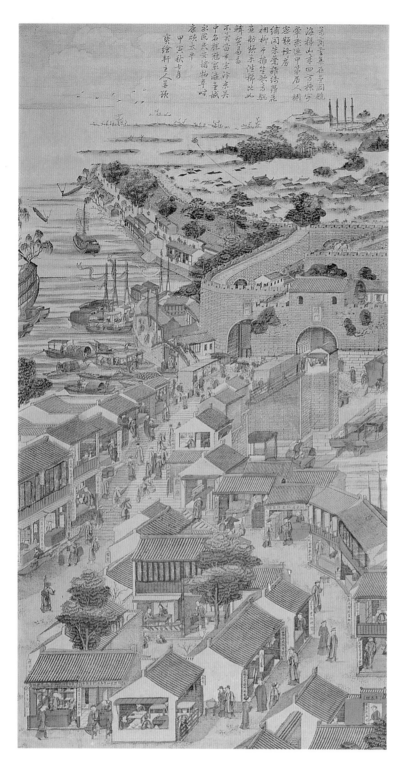

While the longstanding distinction between professional and literati artists remained an important one into the nineteenth century in China, as social conditions changed, so did the roles of artists. Elements of the old and new mix in the work of Ren Xiong (1823–1857) of Shanghai. His *Self-Portrait* done in the 1850s incorporates certain traditional Chinese ideas; it is a hanging scroll with bold brushwork and an inscription (FIG. 4.37). But the repetitive brushmarks of uniform thickness along the jagged folds and outline of his robe give the work an unusual sense of movement, as if the robe were charged with energy. This vibrant quality is emphasized by the contrasting smoothness of the brushwork Ren Xiong has used to portray his bare flesh. As a result of this contrast and the immobility of his intense, frozen gaze, the artist seems to be deeply withdrawn within a great maelstrom of forces. Perhaps the poem inscribed beside him can help explain the meaning of this most unusual self-portrait. Its political overtones suggest that the artist was not entirely loyal to the Qing dynasty, which at this time was embroiled in the Taiping Rebellion (1851–1864). It is always dangerous to interpret styles and changes in style through events in history and social movements. But, in this period of rapid social change, living in a port city that was not a bastion of tradition, Ren Xiong's revolutionary image of himself as a Chinese artist may in some way reflect the conflicts in Chinese society, which was being tugged in two directions: from within by its own traditions and from without by Western ideals.

MODERN CHINA (FROM 1911)

The Western victory in the Opium Wars (1839–1842) and a series of rebellions engineered by Chinese peasants and secret societies in the nineteenth century seriously weakened the powers of the Chinese emperors and further opened the country to Western trade and influences. The Boxer Rebellion (1900), which attempted to eliminate the foreigners who were reducing China to a colonial status, presaged the overthrow of the Qing dynasty in the Republican revolution of 1911. The arts played a prominent role in the heated debates that followed the revolution as the Chinese looked for ways to synthesize the best parts of their traditional culture with modern Western thinking to create a new China. This philosophical ideal of blending the East and the West was inculcated in the educational approach of the new art schools, museums, and government-sponsored exhibitions of art.

4.36 Color print from woodblock. 1734. 42³/₄ × 22" (108 × 56 cm). Ohsha'joh Museum of Art, Hiroshima

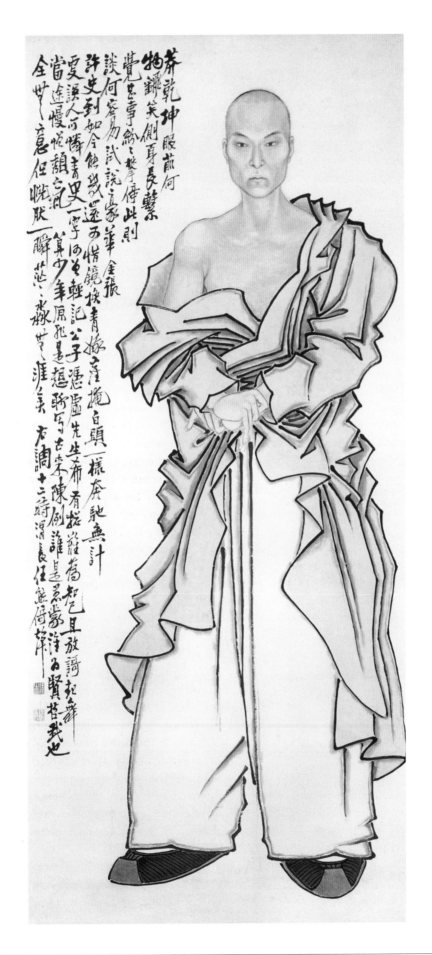

4.37 Ren Xiong, *Self-Portrait*. 1850s. Hanging scroll on paper, 5'9⁵⁄₈" × 6'6¹⁄₄" (1.77 × 1.99 m). Palace Museum, Beijing

Not all artists, however, were seeking an East–West synthesis. Some conservatives continued to work in time-honored historical styles while an avant-garde including artists who had studied in Europe struggled to find markets for their work. Even though the most innovative and respected Chinese painters, the literati, had long avoided realism, the abstract styles of Europe appealed to a very small group of Chinese patrons.

This openness to Western thinking in the arts was stifled by the civil war between the Communists and Nationalists, the Japanese invasion of China (1937), World War II, and the establishment of the People's Republic of China (1949). Traditional Chinese art was seen as a symbol of the feudal society that the People's Republic wanted to eradicate. The socialist control of the art world also marked the end of the private patronage and the commercial art market as it had been developing in China since the ninth century. In the mid-1950s, Russian painters came to China, taught the principles of their social realist style, and encouraged the best students to go to Moscow (not Paris or London) for advanced study. The visual arts became a propaganda machine in the service of the People's Republic. The traditional styles of Chinese painting and abstract works of the avant-garde were ill suited to this kind of reportage and were virtually swept aside. Enormous efforts were also made to destroy and hide the long history of Chinese art during the "Great Proletarian Cultural Revolution" (1965–1979) under the rule of Mao Zedong (1893–1979), as the infamous Red Guard is reputed to have destroyed thousands of buildings and works of art.

Some artists were sought out for political purposes, so the government could claim them as part of the "New China." Many of them, however, were installed in artist collectives where their work was absorbed in communal forms of expression. The large paintings by these social realist communes often show happy Chinese workers serving the state along with an image of Mao Zedong raising his hand, making a grand gesture over his state and its future. During his rule, so many mass-produced prints and inexpensive statuettes of Mao were made by the collectives and circulated in China and around the world that the ruler's face has become an icon for this era in Chinese history. They depict the full-faced, mature Mao as the supremely confident leader of his people, smiling benignly, as if promising prosperity for all. The large sculpture of Mao commissioned for his mausoleum shows him as a man of the people, seated in a large upholstered chair, wearing his usual thick-weave uniform and sturdy shoes (FIG. 4.38). But unlike most works produced during the Cultural Revolution while Mao was alive, the sculptor of this piece, Ye Yushan (born 1935), was acknowledged as the professional artist that produced the work. As a posthumous image of Mao, still greeting the future, it has become a fitting marker for the end of the era it symbolizes.

With the death of Mao and subsequent arrests of many of his close associates in 1976, the state's interest in the activities of the artists declined. Many artists who had been assigned to the countryside to learn from the peasants were now free to return to the cities, where they could reconnect with the surviving remnants of the art world in China. In the outburst of creativity that followed in what was called the "Peking Spring," artists began to recover from their long period of suppression and to experiment widely with new and more sophisticated ways to combine traditional Chinese and the new Western ideals in art.

4.38 Ye Yushan, *Statue of the Seated Mao Zedong.* 1976. White marble, height 11'5³/4" (3.5 m)

One of the artists sent to the provinces after he graduated from the Sichuan Academy in 1968, Luo Zhongli (born 1950), did sketches of the peasants during the decade of his isolation before returning to teach art in Chongqing in 1978. His much-publicized over-lifesize portrait based on these sketches, *Father*, which won first prize in the National Youth Exhibition of Beijing in 1980, was inspired in part by the photorealist paintings of Chuck Close he had seen in magazines (FIG. 4.39). It represents an aged Chinese peasant with dark, weathered, and wrinkled skin and provides something of a contrast to the large, officially sanctioned, eternally smiling images of Mao surrounded by romanticized images of adoring peasants produced a few years earlier that had hung everywhere in China. It represents the true face of Chinese peasants as Luo had known them. The artists seem to be saying that, after a generation of promises by Mao, the life of this *Father* was little changed or improved. The ballpoint pen behind the subject's left ear was added at the request of the director of the Sichuan Artists' Association to "modernize" the man and quiet critics who found the work upsetting. If anything, however, it further emphasizes the distance between the fiction and reality of peasant life.

4.39 Luo Zhongli, *Father*. 1980. Oil on canvas, 7'5" × 5'1½" (2.27 × 1.54 m). Chinese National Art Gallery, Beijing

SUMMARY

The long history of Chinese art extending from the Neolithic period (c. 7000–2250 BCE) to the present day is exceedingly complex. Periods of stable rule by native Chinese dynasties alternated with times of anarchy and foreign rule. Over the centuries, the political boundaries and ethnic makeup of China were constantly changing. Trade along the Silk Road and by sea kept China open to new developments throughout Eurasia. While the Chinese attached great value to their existing cultural traditions and managed to sinicize many foreign ideas, Chinese art and culture were in a constant state of change. The great religious and social philosophies operating in China that helped inspire the arts—Daoism, Confucianism, and Buddhism—have never been static modes of thought. Patronage of the arts in China has also changed over the years as social changes took place within the country. Up to about the tenth century CE, the court dictated matters of taste. After that time, many of the non-aristocrats who gained wealth and power through the government and trade became important patrons and artists. Moreover, Chinese artists of the last 500 years have had to deal with a constantly changing collection of Western influences operating in China. As a result, the art of each historic period in China has a distinct character and the history of Chinese art is as complex as the art of Europe.

Little remains of the ancient Chinese cities, including the palaces and their decorations. Although the practice of collecting art in China was an ancient one, the works of many early masters of painting and calligraphy whom we know by name have been preserved through later copies. Much of the oldest Chinese art was preserved in tombs. Likewise, the works of the earliest Chinese art critics and aestheticians have been lost. Where the aesthetic dialogues have been preserved, as in the case of the literati and their opposition to the styles of the professional court painters, the philosophical depth of Chinese writings on art is astonishing and illuminating.

As China enters the twenty-first century, some artists are preserving traditional forms of Chinese art and thought. Others have become part of the international world of art and will be discussed in this context in Chapter 8.

CHAPTER FIVE
JAPAN AND KOREA

Equator

JAPAN AND KOREA

The most important Japanese works of art come from Honshu, the largest island in the Japanese archipelago. The major art centers there are located in the vicinity of Nara, Osaka, Heiankyo (present-day Kyoto), and Edo (present-day Tokyo). No single set of dates for the Jomon, Yayoi, and Kofun periods is accepted by all scholars of Japanese art. Because the cultural patterns in outlying areas tended to persist longer than those in the major political centers, some periods—such as the Kofun and Asuka—overlap. Historic periods are often named for the ruling family or their capital.

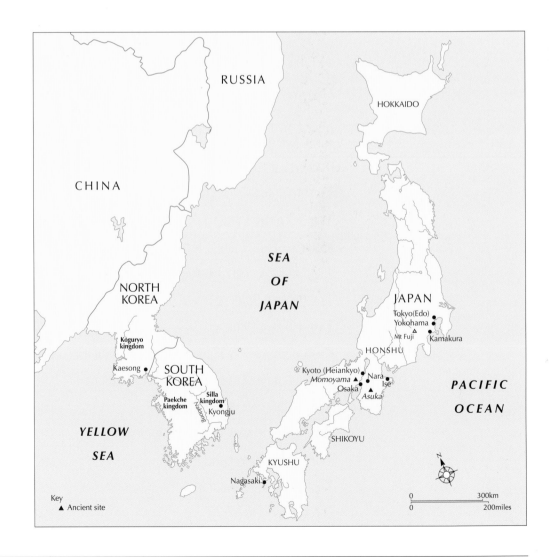

TIME CHART

Jomon Period (12,000/10,500–300 BCE)

Yayoi Period (300 BCE– 300 CE)

Kofun Period (300–710)

Asuka Period (552–645)

Korea: The Three Kingdoms Period (57 BCE–688 CE)

Hakuho Period (645–710)

Nara Period (710–794)

Heian Period (794–1185)

Korea: Koryo (918–1392)

Korea: Kamakura (1185–1333)

Muromachi (Ashikaga) Period (1392–1573)

 Francis Xavier arrives in Japan (1549)

Momoyama Period (1573–1615)

 Father João Rodrigues (1562–1633) active in Japan

 Oda Nobunaga (1534–1582; ruled 1573–1582)

 Sen no Rikyu, tea master (1521–1591)

 Toyotomi Hideyoshi (1536/37–1599; ruled 1582–1598)

Tokugawa (Edo) Period (1615–1868)

 Tokugawa Ieyasu (1543–1616; ruled 1603–1616)

 Foreigners expelled from Japan (1638)

Meiji Restoration (1868–1912)

The Modern Period: From 1912

 World War II in Japan: 1941–1945

 Occupied Japan: 1945–1952

 The Gutai Group: 1954–1972

INTRODUCTION

Long before the Buddhist art traditions of China and Korea arrived in Japan in the mid-sixth century CE, the Japanese had developed their own traditions in the arts around a native set of beliefs known as Shinto ("The Sacred Way" or "Way of the Gods"). Shinto is usually defined as a religion, but unlike Buddhism, Hinduism, and Jainism, it does not focus upon a major godhead, operate with dogmas, include a complex metaphysical structure, or prescribe an ethical code. In fact, it has seldom encouraged the faithful to make devotional religious images. The participant in Shinto worshiped a large number of *kami*, beneficent nature spirits embodied in rocks, trees, and water, and marked these sacred spots with enclosed,

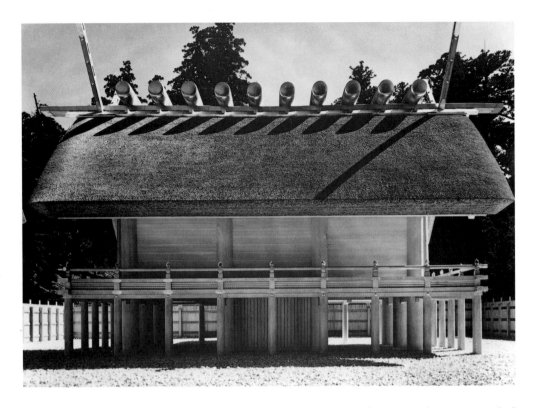

wooden shrines (FIG. 5.1). Visitors to the shrines cleanse themselves, pray, bow as a symbol
of reverence and obedience, and make simple offerings to the *kami*.

Shinto worship, a quest for purity and harmony with nature, encouraged Japanese
artists to respect the nature of the materials with which they worked. As a product of the
early agrarian culture of Japan, Shinto perpetuated a taste for the art forms and aesthetics
of that early age. Even the wealthiest ruling families in Japan who built lavish palaces and tem-
ples for public display, retained a taste for the simple and rustic arts of their ancestors.
These ancient, folkish objects, such as pottery and small wooden shrines, may appear to be
very simple, but in their subtleties and refinements, they are deceptively complex. The endur-
ing Shinto aesthetics—a deeply felt love for unspoiled nature, natural materials such as
clay and wood in art, asymmetry rather than symmetry in compositions, and certain forms
of traditional, rustic, handmade objects—provide a key for an understanding of Japanese
art of every period.

Chinese forms of religion, art, and architecture, which arrived in Japan via Korea,
were incorporated within the Shinto traditions that persist in Japan to this day. In this
process of adaptation, the mainland arts underwent many changes. Forms and ideas were refined
and reduced to their most fundamental and essential elements. Japanese paintings often
have large, open and seemingly empty passages and the most popular form of Japanese poetry,
the *haiku*, has only seventeen syllables. Courtly forms of Japanese drama, the Noh ("talent"
or "performance") theater, move very slowly, with long pauses in the action and script. The
highly ritualized tea ceremonies held in small, sparsely furnished rooms, or in specially
built tea houses, are marked by long periods of silence for contemplation. All these forms
of Japanese expression—poetry, dramas, ceremonials, painting, sculpture, and architec-
ture—are designed to be experienced slowly, thoughtfully, just as they were conceived and
created. Often, the cessation of all imagery and action becomes the most important "activ-
ity" of the artist and observer. This state of inactivity is designed to stimulate the imagination
of the observer, bringing him or her into the world of the artists who created the images
and buildings illustrated in this chapter. The eternal affection the Japanese have held for seem-
ingly simple but deceptively complex arts that stress essential forms and acts of contemplation

is linked in spirit to their veneration of the Shinto *kami* and remains a poignant symbol of the Shinto base of Japanese art and thought.

THE JOMON (c. 12,000/10,500–300 BCE) AND YAYOI (300 BCE–300 CE) PERIODS

The name Jomon ("cord markings") comes from the decorative cord marks the early hunting–gathering culture made on its pottery. The earliest known inhabitants of Japan arrived by land around 30,000 BCE, during the most recent ice age, when the sea level was lower and the Japanese islands were part of mainland Asia. Some of the oldest known ceramics in the world come from Jomon sites. Unlike Western Asia, where pottery is associated with the rise of agriculture, Jomon pottery was made by preagricultural people dependent upon fishing, hunting, and gathering. They did not begin cultivating domestic plants and living in communities until c. 5000 BCE.

The Jomon culture made pottery using the coiling technique, in which long rolls of moist clay are coiled one upon another to form the walls of a vessel. The vessels were decorated by pressing more rolls or ropes of clay against them while they were still moist and by rolling fiber cording across the soft surfaces. As was the custom in many early societies, most of the pottery was probably made by women. By the Middle Jomon period (2500–1500 BCE), these cord decorations had become abstract, asymmetrical sculptural forms and luxuriant, curling shapes (FIG. 5.2). The walls of a Jomon vessel often appear to leap up from its base, and burst with energy like tall cresting waves, leafy plants, or tongues of fire. The decorative vocabulary includes ovals, scrolls, hatching, longer parallel lines, zigzags, lozenges, triangles, scallops, and freeform cord-like meanders that resemble eddying currents in water. While there are some repeating motifs in the patterns, some of which imitate basketry, the compositions are asymmetrical. This taste for free, asymmetrical forms over more regimented, symmetrical compositions has remained an important feature throughout the history of Japanese art. Along with some clay figurines, such Jomon ceramics with irregular curved and spiral cord-patterned surface designs are some of the most spectacular examples of Neolithic art. In the Final Jomon period (1500–300 BCE), the flamboyant character of the earlier decorations was replaced by restricted forms and precisely rendered patterns of incised curves.

The Yayoi period is named after the Yayoi district in Tokyo, where the first objects from this time were found. The techniques of weaving, bronzecasting, and working on a potter's wheel were introduced from Korea at this time. As the cultivation of rice became widespread, communities overseeing the rice paddies increased in size and complexity. They developed hierarchical forms of government and a stratified society that would ultimately produce an aristocracy and the Imperial family that would rule Japan in the centuries to come. The *Wei zhi*, a third-century CE Chinese chronicle, says that Queen Himiko of Yamatai unified Japan around 180 CE, near the end of the Yayoi period. According to Japanese records, she was descended from the first emperor, Jimmu Tanno (c. 660 BCE) of the Yamato clan, who traced his ancestry back to Amaterasu-no-Omikami, the Shinto Sun goddess. This genealogy, from 660 BCE to the present, represents the longest recorded unbroken dynastic lineage in world history.

5.2 Vessel. Middle Jomon period, 2500–1500 BCE. Earthenware, $23^{2}/_{3} \times 13^{1}/_{4}"$ (58.5 × 33.6 cm). Tokyo National Museum

THE KOFUN PERIOD (300–710 CE)

The Kofun period is named for the many large hill-shaped tombs known as *kofun* (*ko* means "old" or "ancient" and *fun*, "grave mound") built during this time. The culture of the mounted warriors from Manchuria or Korea who built the *kofun* provided the base upon which much of the subsequent development of Japanese culture took place. Regional chiefdoms were consolidated under the Imperial family, which traced its origins to the Shinto sun goddess and ruled out of the Osaka–Nara area.

BURIAL MOUNDS

The largest of the Imperial *kofun* mound-tombs illustrate the tremendous power vested in these early Japanese emperors. A *kofun* near Osaka belonging to the emperor Nintoku (fourth to fifth centuries), in the shape of an old-fashioned keyhole, is protected by a double moat and covers about 458 acres (185 hectares) (FIG. 5.3). Originally, it may have been further "protected" by circular rows of *haniwa* (from *hani*, "clay," and *wa*, "circle"). It has been estimated that as many as 20,000 *haniwa* (hollow terracotta cylinders supporting three-dimensional models of shields, singers, armored warriors, ladies, fish, birds, miniature house models, and horses with gear) were set on the mound with their bases plunged into the earth. The earliest *haniwa* were simple cylinders, followed later by objects such as boats or houses and finally by images of people and animals. They appear to have marked the boundary between the lands of the living and the dead, this life and the next.

The warrior in figure 5.4 illustrates the prehistoric Japanese taste for simple forms and textures that emphasize the inherent qualities of the clay. This respect for the intrinsic nature of materials (which may be seen as a way of harmonizing with nature) reflects the Shinto respects paid to the *kami* embedded in nature. This type of respect continued to be a major feature in Japanese art in later periods. Because the Imperial Household Agency in Japan prohibits the excavation of *kofun* belonging to emperors, some of the finest *haniwa* may still remain buried.

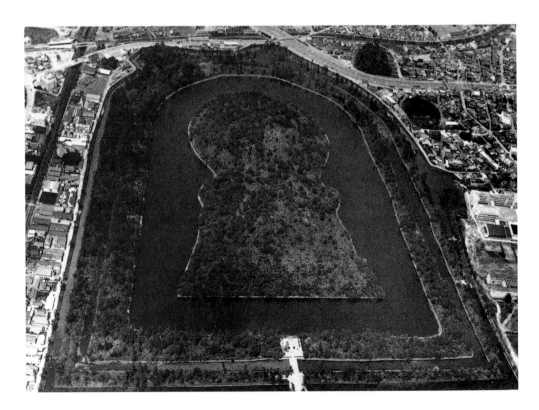

5.3 Mound-tomb of Emperor Nintoku. Sakai, Osaka prefecture. Late 4th–early 5th century

SHRINES

The sacred spots (*iwakura*) where the *kami* resided were often dramatic, highly picturesque locations in the mountains and forests. Before the Kofun period, few if any had temples or shrines. The earliest shrines, which began to appear around the beginning of the Kofun period, have long since perished, but some of their features are preserved in such famous Shinto shrines as Ise (see FIG. 5.1). Legend has it that the original shrine (c. 300 CE) was created to house the sacred mirror of Amaterasu-no-Omikami, the Sun Goddess and ancestor of the Japanese emperors. Along with the sword and jewel the goddess is said to have given Emperor Ninigi no Mikoto, the mirror became part of the official Japanese Imperial regalia, symbolizing the emperors' divine right to rule. Under Suinin, the legendary eleventh emperor, the mirror was enshrined at Ise, one of Japan's two major Imperial shrines.

The shrine at Ise has been dismantled, destroyed with great ritual care, and replaced at twenty-year intervals by a new shrine dedicated in the presence of the Imperial family. While the Shinto leaders may have tried to preserve the design of the original shrine—derived from Asiatic mainland prototypes of the third century CE—over the years, builders have in fact incorporated some later features of Buddhist architecture. Stages in this evolution are evident in other buildings in the Ise shrine complex. Thus, while retaining some of the ancient Shinto architectural traditions, the present struture is also the terminal product of a long process of aesthetic and technical refinement.

Visitors approaching the shrine follow a winding pebble path through a forest leading to two *torii* ("gates"). These sacred gateways in the outermost of the four wooden fences around the structure may be derived from the *toranas* of the Indian stupas (see Chapter 3). For Shinto pilgrims, passing through the *torii* is a symbolic act of spiritual rebirth. Like most Shinto shrines, Ise is to be seen and venerated by the Shinto community from the outside. All of the logs used in the construction of the shrine were chosen for their ideal proportions and cut in the spring when filled with sap. By rubbing the sap-filled logs with a red-orange persimmon juice, they will turn a rich golden brown. The Shinto belief that a newly cut tree must be allowed to rest—to allow its indwelling *kami* time to find a new home—seems to overlap with an understanding that wood should be dried and aged before it is cut and used. The logs and boards are joined in the traditional mortise-and-tenon fashion, without nails. The roof has been meticulously trimmed to make the brown, smoked thatch appear to be one thick textured slab. As in Chinese art, the roof with its large overhang is a very important part of this visual experience. Originally, the *chigi*, the diagonal crosspieces extending from the gables, and the *katsuogi* (wooden weights along the ridge pole securing the roofing materials) were functional parts of Japanese structures built in this manner.

The rhythmic interplay of crisp intersecting horizontal, vertical, and diagonal lines of the structural parts of the building, the contrasting textures and colors of the wood, thatching, and gravel, and the interplay of the patches of sunlight and shadows as they move across the exterior are tuned to perfection in this ancient system of shrine construction. The deceptive manner in which the shrine appears to be a simple piece of rustic architecture is part of the highly sophisticated Shinto philosophy of beauty. It is a manifestation of an early Shinto-based sensitivity to forms and the native qualities of materials that remains part of Japanese thinking in later periods in the arts associated with Zen Buddhism and the highly ritualized tea ceremony, for example in the fifteenth century. The intimate, natural character of the shrine and its garden-like context within the woods resemble that of the rustic houses used in these tea-drinking ceremonies. The purity and dignity of the simplified means of construction can best be appreciated in the manner in which the shrine was meant to be seen, as an object of veneration to be contemplated and adored with reverence.

5.4 Kofun *haniwa* figure of a warrior. Gumma prefecture. Terracotta, height 49" (1.25 m). Aikawa Archaeological Museum

KOREA: THE THREE KINGDOMS PERIOD
(57 BCE–688 CE)

The Korean peninsula, midway between northern China and Japan, transmitted many elements of Chinese art and culture to Japan. However, after arriving in Korea, Chinese art interacted with the native Korean traditions to create Korean styles of ceramics, sculpture, metalwork, and painting that are distinct from those of mainland Asia and Japan.

The Koreans learned the techniques of agriculture and metalworking from the Chinese and became part of their Han empire in 108 BCE. After the fall of the Han, in the Period of Disunity (220–589 CE), the Chinese gradually withdrew from Korea, leaving behind their philosophies of Confucianism and Buddhism (which arrived in 372 CE) as well as the Chinese system of writing. During this time, the Three Kingdoms period, Korea was divided into the Koguryo kingdom in the north, the Paekche kingdom in the southwest, and the Silla kingdom around the Naktong River drainage area facing the Sea of Japan.

Of these three kingdoms, Sillas was the most remote from China, both geographically and aesthetically. Many of the most important Korean works of art come from this area. Kyongju, the Silla capital for almost a thousand years, is dotted with huge tumuli marking the tombs of the rulers. The golden crowns, earrings, necklaces, rings, bracelets, and belts from these royal graves indicate that the Silla were some of the most accomplished and innovative gold artists in eastern Asia in the fifth and sixth centuries CE. The gold crowns, made of thin hammered and cut sheets of embossed gold, are too delicate for regular use and may have been created for some special ceremonials, such as inaugurations, or they may have been made specifically as grave goods for spirit use. The headband of figure 5.5 supports antler- and tree-shaped projections decorated with small gold disks and curved, comma-shaped pieces of jade. The Old Silla gold artists may have learned their techniques of goldworking via works of art that arrived from the Mediterranean world along the Silk Road.

Sculptors of this period working shortly after Buddhism had become the official religion of the country created the most famous surviving Korean Buddhist statue. It is an image of the *bodhisattva* Maitreya, the Buddha of the Future, who would come to the earth and bring enlightenment to everyone (FIG. 5.6). Maitreya was a favorite of an élite group of young aristocratic warriors, the "flower youths," whose leader claimed to be an incarnation of the *bodhisattva*. Like the historical Buddha Shakyamuni, who discovered enlightenment through prolonged meditation, Maitreya is far removed from this world and deeply absorbed in a state of meditation. All the formal elements contribute to this sense of inner peace and oneness. The manner in which the sculptors have organized Maitreya's pose and treated his body parts emphasizes this ideal of otherworldly thought. The refined beauty and harmonious interplay of Maitreya's high-arching eyebrows, the long crescent lids of his downturned eyes, the thin, delicate nose bridge, and the gentle set of his lips convey a sense of utter serenity. Also, the rhythms in the neatly spaced and folded cloth falling in vertical lines and dovetail pleats over the chair, lying in patterns of hyperbolic curves on his left leg, reinforce this ideal of quiet introspection, the slowed-down pace of deep meditation.

The pose itself expresses this ideal of strength within beauty. It is organized around the strong horizontal line of the figure's right leg, which divides the image in half, separating the vertical lines of the other leg

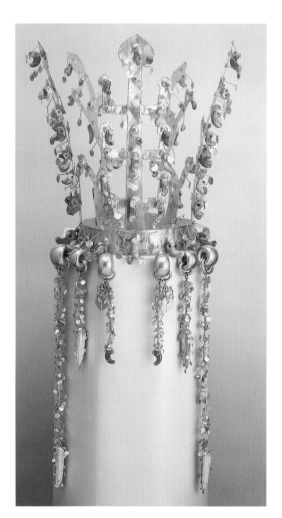

5.5 Crown from north mound, Tomb 98, Kyongju, Korya. Old Silla period, 5–6th century CE. Gold, height 10¾" (27.5 cm). Kyongju National Museum

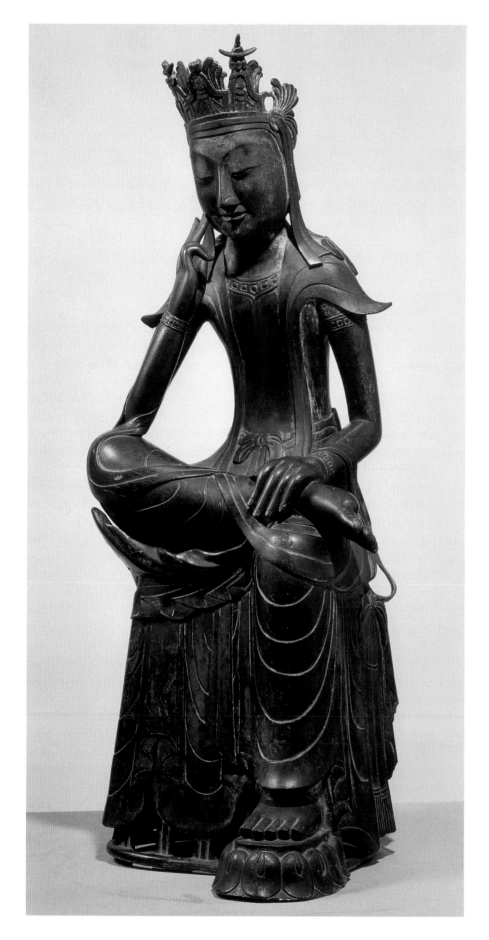

5.6 *Maitreya.* Old Silla or Paekche period, 6th–7th century. Gilt bronze, height 30" (76 cm). National Museum of Korea, Seoul

and drapery below from the softer lines of Maitreya's torso, head, arms, and the long tube-like fingers with which he touches his cheek. This effortless gesture, symbolizing deep thought, engages the viewer with the *bodhisattva's* otherworldly thoughts as he transcends the terrestrial and celestial realms to exist in oneness with all creation. Although the style owes much to sixth-century Wei sculpture in northern China, the smoothness of the forms and the abstraction of Maitreya's features reflect the work's Korean heritage. Of the surviving Korean images of Maitreya and the Buddha, this work best summarizes the Korean contribution to Buddhist sculpture in Korea itself and in Japan.

THE ASUKA (552–645) AND HAKUHO (645–710) PERIODS

The Asuka period, named for a Japanese capital of this time, is also known as the Suiko period, after the powerful empress who reigned from 593 to 628. It was a time of great change as new Korean forms of art, technology, and religion totally transformed Japanese society. The period begins in 552, the year the Buddhist ruler of the Paekche kingdom in Korea sent a bronze image of the Buddha to Kimmei, the emperor of Japan. Unlike Shinto, Buddhism had a hierarchical structure, stressed the doctrinal authority of the Buddha's teachings, and offered the faithful a happy afterlife. Seeing how these features of Buddhism had helped the Korean rulers unify their country, Kimmei and his successors in Japan embraced Buddhism and campaigned to make it their official national religion. They hoped it would weaken the feuding nobles' ties to their regional clan deities. After half a century of civil wars, Japan embraced the elaborate ritualism and arts of Korean Mahayana Buddhism. Buddhist art arrived in Japan along with other forms of continental and Korean Buddhist culture—philosophy, government, Chinese writing, medicine, music, and city planning—that proceeded to revolutionize Japanese society. Perhaps it was because Mahayana Buddhism, with all its culture and emphasis on an afterlife, was so different from Shinto, with its focus on purity and simplicity, that the two forms of thought were able to coexist and complement one another. Therefore, even though the country was officially Buddhist and strongly Korean in character, the spirit of Shinto lived on as part of the intrinsic Japanese system of aesthetics within the newly accepted forms of Buddhist art.

TEMPLES AND SHRINES

Unlike the Shinto deities, which were venerated in nature or at most in modest-sized shrines, Buddha and his host of *bodhisattvas* required the faithful to construct large temples and religious complexes. The most important surviving temple complex of this period, the Horyu-ji (ji means "temple"), is located at Nara, the cradle of Buddhist–Japanese civilization (FIG. 5.7). It was founded in 607 by Prince Shotoku Taishi (574–622), an early champion of Buddhism in Japan, and rebuilt in 670. Many of the artists and architects working in Japan at this date at Nara were Korean or trained by Korean masters. As a result, the tiled roofs with upturned eaves of the buildings and the symmetrical plan of the complex reflect the contemporary building practices of the Six Dynasties period in China and the Three Kingdoms period in Korea—and do so better than any surviving buildings on the Asiatic mainland.

Visitors to the complex proceed along a pebble-strewn avenue leading to the *chu-mon* ("middle gate") in the wall and covered corridor around the precinct. Inside the gate, the *Kongo Rikishi*, fierce guardian deities, protect the tall pagoda and the *kondo* ("golden hall") within. The sources of inspiration for the pagoda, a Chines architectural form, remain a matter of debate. It may derive from Han watchtowers which are known through

5.7 View of existing compound, Horyu-ji. Nara prefecture. 7th century

In 1949, the two-storied kondo in the center of the enclosed court was damaged by fire and heavily reconstructed from photographs. Luckily, a number of building parts had been temporarily removed for repairs and they escaped damage.

terracotta models preserved in tombs, the tower stupas of Ganhara with their tall *yasti* ("umbrellas"), or metal reliquaries (elaborate containers) holding valued religious relics. Whatever its source, to many Western observers, the pagoda is one of the most immediately recognizable forms of Far Eastern architecture. Worshipers may enter the *kondo*, which houses many important early Buddhist treasures. Conversely, this and other Japanese pagodas are reliquaries holding sacred objects and symbolize the vertical pathway uniting the terrestrial and supernatural worlds, and they are venerated from the outside like stupas. The Horyu-ji pagoda has four sculptural tableaux on the ground floor which may be seen through the four doors. There is no access to the upper parts of the pagoda. The lecture hall, library, bell house, and dormitories catering to the everyday needs of the monastic community lie outside this sacred enclosure.

Generally, a *kondo* is filled with statues on a raised platform around which a pilgrim can walk in a clockwise direction. An intricate system of flexible, interlocking brackets allows the wooden supports under the roof to expand and contract with changes in the weather as they transfer the weight of the wide, upturned and tiled roofs onto the thin engaged posts below. The porch on the lower levels is a Japanese addition to the structural type found on the mainland, one that will remain an important feature in Japanese palaces and temples.

A portable cypress and camphor wood replica of a seventh-century *kondo* (c. 650) in the Horyu-ji Treasure House, known as the Tamamushi Shrine, may have been made in Korea, or fashioned by Korean artists working in Japan (FIG. 5.8). It gives another view of early Buddhist Japanese architecture. The shrine is roofed by a gable over a truncated hipped roof with broad flaring eaves supported by sets of long bracket arms. The crescent-shaped decorations rising over the ends of the ridge pole, *shibi*, may represent dolphins. It is the earliest known surviving example of an *irimoya*, the traditional Japanese hipped-gable roof type. In addition to its historical, architectural value, the Tamamushi Shrine is decorated with important examples of early Japanese Buddhist lacquer paintings. The style, with many varieties of thin, delicate flowing lines, is an international Asian one that accompanied the spread of Buddhism from China through Korea to Japan.

5.8 Tamamushi Shrine. c. 650. Cypress and camphor wood with lacquer; height c. 7'8" (2.34 m). Horyu-ji Treasure House, Horyu-ji

THE NARA PERIOD (710–794)

This period is named for the Japanese capital, Nara (finished in 710), built for the empress Gemmei. Little remains of this first permanent center of government in Japan, which is said to have been built along the lines of the Chinese Tang capital at Chang'an. Before that time, each successive emperor had built a new court on a new site, to escape the impurities caused by the death of the previous ruler and to highlight his own ascent to power. While earlier Chinese influences in Japan had arrived mainly via Korea, the highly cosmopolitan, Imperial court of the Tang dynasty (618–907) in China had a direct influence on Nara and Japanese society. Like their Tang contemporaries, the Japanese emperors of this period gained effective control over all their domains and dominions. Using the Chinese script, the Japanese began recording early myths and historical records. The *Kojiki* (712) and the *Nihon Shoki* (720) explained how the Imperial clan had the right to rule the country.

ARCHITECTURE

The name of an important temple at Nara, the Toshodai-ji ("temple brought from Tang"), underlines the strength of the Tang Chinese influences at this time. The quadrilateral complex, oriented to the points of the compass, was designed to give visitors the impression that Japan was ruled by a strong, centralized government. However, this ideal, a reality at Chang'an in China, remained an elusive dream in Nara. The splendor of the palace (which has not survived) is reflected in the Todai-ji ("Great Eastern Temple") complex (c. 759 CE). The *kondo*, known as the Daibutsuden ("Great Buddha Hall"), is many times larger than its Horyu-ji counterpart from the previous century (FIG. 5.9). The present version of the Daibutsuden is about two-thirds the size of the original structure, which burned in 1180. It was 285 feet (87 m) long, 154 feet (47 m) tall, and housed a 52-foot (16 m) gilded sculpture of the Buddha with a large golden halo. Yet, the present Daibutsuden is still one of the largest wooden structures in the world. The plan of the enclosed Todai-ji *kondo*, designed exclusively for the use of the Buddhist monks, includes porches where noble and wealthy lay persons could assemble to listen to the rituals being conducted within. Large screens were set behind the figures on the altar in a brightly painted space that is still capable of housing images up to sixty feet (18 m) high.

5.9 *Kondo*, or *Daibutsuden*, of the Todai-ji complex. Nara. c. 759 CE

THE HEIAN PERIOD (794–1185)

In 794, Emperor Kammu (ruled 781–806) moved his capital from Nara north to Heiankyo ("Capital of Peace and Tranquility"), modern Kyoto, the site after which this period is named. The late Heian period (897–1185) is also called Fujiwara, after the ruling clan that came to power in the late ninth century. In Kyoto, the emperors could escape the weighty, entrenched political power of the Buddhist monks and Confucian authorities in Nara, a miniature clone of Chang'an drenched in the traditions of Tang China. Later, in this rising spirit of independence from mainland Asia, as the Tang power declined during a period of Buddhist persecution and civil unrest in China, Japan closed her doors to contact with the Chinese (838) and made a concerted effort to develop native forms of art and culture. New forms of Buddhist art arose in response to changes in Buddhism in Japan. Equally innovative revolutions took place in the secular arts in the aristocratic circles of Kyoto and are reflected in a sense of courtly refinement and elegance that has seldom been equaled anywhere in the world.

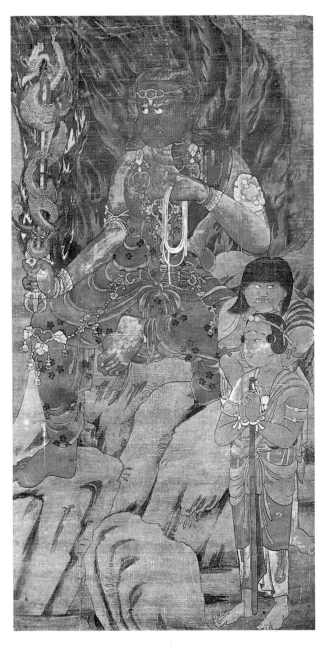

5.10 *Red Fudo.* Early Heian period. Color on silk, height 61½" (1.56 m). Myo-o-in, Koyasan, Wakayama prefecture, Japan

ESOTERIC BUDDHIST ART

As the Buddhist temples in Nara began to lose their importance, new Buddhist reform movements began to surface among the aristocrats in Kyoto. The Tendai and Shingon sects are part of Esoteric Buddhism (*Mikkyo* in Japanese) from northern India, Nepal, and Tibet. In both sects, the universal Buddha (Dainichi, "Great Sun") presides over a complex and colorful pantheon of deities. To explain the complex interrelationships and the attributes of each deity, Buddhist artists created cosmic diagrams called *mandalas* and some astonishingly dramatic images of deities in all their fury. In the *Red Fudo*, the terrifying deity, Fudo (the "Immovable"), is seated on a rock before a wall of flames and holds a dragon sword symbolizing lightning (FIG. 5.10). He and one of his youthful attendants have fangs and intensely glaring, beady eyes. The expressive quality of this fearsome deity is enhanced by the quality of the finely brushed lines that describe the beautiful jewelry he wears over his princely robes.

PURE LAND BUDDHIST ART

In the late Heian period, Pure Land (*Jodo* in Japanese) Buddhism became very popular among the masses in Japan. It had none of the metaphysical and iconographical complexity of Esoteric Buddhism. In *Jodo*, the Amida (in Sanskrit, Amitabha) Buddha ruled over a pure land, the regal Western Paradise that was available to everyone. Traveling evangelists spread the cult, explaining that to enter paradise all one needed do was chant *Namu Amida Butsu* ("Hail to Amida Buddha").

A new type of *Jodo* image called a *raigo* ("welcoming approach") shows the Amida Buddha descending to earth to welcome the souls into his Western Paradise. The *raigo*, which may be a Japanese invention, underlines the difference between the graciousness of the approachable Amida Buddha and the coldness of the remote Buddha worshiped by the Esoteric sects. Portions of a *raigo* sculptural installation, completed in 1053 by the artist

Jocho (died 1057) in a temple near Kyoto, remain intact (FIG. 5.11). The utter repose of the smooth-featured Buddha is emphasized by the richness of the decorative flames rising behind him. This and other *raigo* installations are oriented toward the viewer, as if the viewer were a dying soul that the Buddha was coming to receive and take to paradise.

Unlike earlier sculptures, carved from one block of wood, Jocho used a new joined-wood technique in which multiple blocks were joined in one sculpture. Blocks were hollowed, roughed out, and joined by glues and pegs before the finishing details were carved and painted. Sculptures made using this method are lighter than works carved from a single, solid piece of wood and less susceptible to cracking and warping as the sap within dries out. Also, a master sculptor can assign individual blocks to assistants who might be specialists in the carving of certain parts of the image, thus speeding up production.

When all the original sculptural parts of Jocho's work were in place, the installation work was a stunning replica of the Western Paradise, in an elegant style reflecting the richness of the lands to which believers were headed. Jocho's incomplete *raigo* is still an important image for modern members of Pure Land Buddhism, the most popular Buddhist sect in Japan today.

ARCHITECTURE

Jocho's image of the Western Paradise is housed in an eleventh-century structure known as the Ho-o-do ("Phoenix Hall") on a semidetached island with a reflecting pool in the Byodo-in complex near Kyoto (FIG. 5.12). The Phoenix Hall was originally part of a much larger villa that belonged to a Fujiwara official and head counselor to the emperor. In its opulence, the Chinese-styled pavilion symbolizes Amida's Western Paradise.

The hall takes its name from the bronze phoenixes on its roof (symbols of the empress) and the dramatic upswept lines of the roof, which resemble the outspread wings of a large bird. In the image of the hall reflected upon the gentle waves of the pond, these "wings" are

5.11 Interior of *Ho-o-do* (Phoenix Hall) of Byodo-in, with Amida figure by Jocho. Uji. 1053 CE. Gilded wood, height 11" (28 cm)

5.12 *Ho-o-do* (Phoenix Hall). Byodo-in, Uji. Late Heian period, 11th century CE

literally set in motion—like those of a bird in flight. The pond, shaped like the Sanskrit letter A (symbol of Amida Buddha), is also an earthly counterpart of the great waters in the Western Paradise where the Amida Buddha watches over the newly arriving souls of the faithful, reborn within lotus buds, as they blossom forth.

LITERATURE, CALLIGRAPHY, AND PAINTING

Chinese was the official language of scholarship in Korea and Heian Japan, and it remained the language of scholarship until the nineteenth century. However, for some forms of writing, such as poetry, the Japanese began using their native language. To do this, they created syllabaries (systems of writing in which a sign stands for a syllable) based on the idiosyncrasies of the Japanese language and traditional Chinese-style brushstrokes to create Japanese characters. Over time, the Japanese calligraphers developed a formal and somewhat angular script for official documents (the *katakana*) and a very graceful and cursive script for personal and literary use (the *hiragana*) (FIG. 5.13). Courtly women were seldom taught Chinese, the language of scholarship, but in the late Heian period, many of the Fujiwara noblewomen working in Japanese became accomplished calligraphers and creative writers.

As in Chinese, the Japanese characters are read in columns, from top to bottom and right to left. Some Heian-period anthologies of poetry were written on papers of contrasting colors bearing woodblock print designs and flecks of gold and silver. At times, these elegant, sprawling and asymmetrical marks made by the courtly calligraphers have such a strong sense of energy and movement that they seem to "dance" across the page. Together, the writing format, the loosely flowing inked lines, and the content of the poetry created a distinctively Japanese and Heian literary and artistic experience.

By Heian times, the emperor, a venerable symbol of Japanese culture, had very little effective political power. Some Heian courtiers had administrative duties, assisting the emperor, but others had very few day-to-day duties. With so much leisure, many of them developed highly refined tastes and became known for their extreme aestheticism. They might play the koto, a Japanese musical instrument similar to the Western zither, or excel in the art of calligraphy, writing *tankas*, thirty-one syllable poems using nature as a mirror for their emotions.

These musicians and writers included some important women, such as Lady Murasaki, who wrote the *Genji Monogatari* ("Romantic Tale"), or *Tale of Genji* (c. 1000–1015). She learned to write by accompanying her brother to his writing lessons. After being widowed, Lady Murasaki became a lady-in-waiting in the court of the empress–consort Teishi (976–1001), where she gathered much of the material for *The Tale of Genji*. The lengthy story, with over 400 characters, generally regarded as the world's first novel, immortalizes the intrigues and amorous affairs of the Heian courtiers.

Lady Murasaki's story-line follows the actions and inner psychological life of Genji, the Shining Prince, who tries to retain the support of those in power while indulging in numerous affairs. As the story reflects upon the fleeting nature of life's pleasures, it is tinged with notes of sadness. Much of the story takes place in the shaded, cloistered atmosphere of a *shinden*, a Heian-period country home with a central hall, smaller buildings, a network of covered walkways connecting them, ponds, bridges, and gardens.

In the early illustrations of the story, these distinctively Heian architectural forms providing a backdrop for the narrative seem to influence the way the events are portrayed and add to the sense of sadness in the tale. They are painted in the *yamato-e* or "Japanese" style, one that is as native and Japanese as Lady Murasaki's writing. The name comes from the Yamato plain, in which the city of Nara was built. There are two subtypes of the *yamato-e* style, the popular "men's pictures," *otoko-e*, and the courtly "women's pictures," *onna-e*, of which *The Tale of Genji* is an example.

5.13 Album leaf from the *Ishiyama-gire*. Late Heian period, early 12th century. Ink with gold and silver on decorated paper, 8 × 6⅜" (20.3 × 16.2 cm). Freer Gallery of Art, Smithsonian Institution, Washington, D.C.

5.14 First illustration to the *Azumaya* chapter of *The Tale of Genji*. Late Heian period, 12th century CE. Hand scroll, ink and color on paper, height 8½" (21.6 cm). Tokugawa Museum, Nagoya

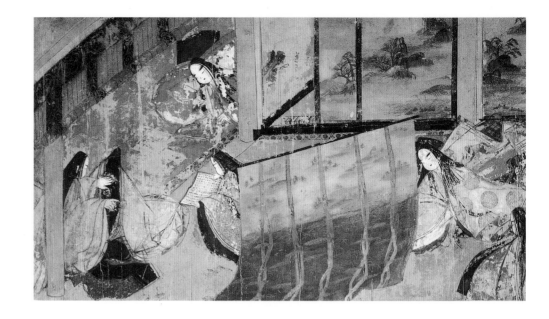

The twelfth-century *emakimono* or hand scroll illustrating a scene from *The Tale of Genji* was painted with ink and water-based colors on paper (FIG. 5.14). Papers were made from the inner bark of the paper-mulberry tree and other fibers. Hand scrolls are viewed segment by segment as they are unrolled from right to left. Sections of Lady Murasaki's text alternate with painted episodes from the novel, which are pictured from an elevated or bird's-eye view, as if the buildings had no roof. One maid reads to entertain Nakanokimi, while another combs her freshly washed hair and Ukifune, her half-sister, looks at a picture-scroll. Nakanokimi, a strikingly beautiful country girl and lesser wife of a high-ranking noble, was attempting to secure her own position in high society through her role as a lady of the court. The illustrations of the Tale, like Lady Murasaki's narrative, emphasize the decorative and anecdotal details of the highly ritualized patterns of behavior in the court. This picture gives no indication that Ukifune is recovering from an attempted seduction a few hours earlier. The women of the court are shown as flat patterns of richly decorated drapery, with conventionalized faces consisting of little more than short lines for eyebrows, eyes, and mouths. At times, emotions are suggested symbolically, by association with colors, plant types, and the composition. The very way in which the *shinden*-styled architecture seen from an oblique bird's-eye view encloses and restricts the characters seems to symbolize the way the highly formalized court etiquette of this period determined what the courtiers could do and which emotions they could—or could not—express. Some of the color notations left by the artist who drew the lines suggests that another artist did the painting. The flat, unshaded colors used for the architecture also emphasize the abstract geometry of spaces in which the startlingly bright, robed figures stand out in high contrast.

The viewer sees the events of the novel as if he or she were observing the private world of court life from aside, with a certain polite detachment—as Lady Murasaki had for years. From this elevated vantage point, the acutely angled floors and walls of the buildings blend into a set of abstract background planes. The complexity of the planes and the oblique point of view seem to act as metaphors for the intricate and convoluted rules of etiquette governing the actions of the courtiers. The sense of tension and consternation created by these interlocking diagonals seems to increase in areas where the scenes are the most dramatic, while the courtly responses of the characters grow increasingly mannered and agitated.

By about 1180, this refined Fujiwara courtly world of fine manners was drawing to a close. Economic problems caused by the absence of valuable properties held by the nobles and temples from the tax rolls contributed to the outbreak of the Genpei Civil War

(1180–1185). The Fujiwara forces were no match for those of the powerful feuding clans which clashed in this bloody war and reshaped the art and culture of Japan for centuries to come.

KAMAKURA (1185–1333) AND KORYO KOREA (918–1392) PERIODS

At the conclusion of the war, the emperor gave Yoritomo (1147–1199) of the Minamoto clan in Kamakura the title of *Seii-tai Shogun* ("Barbarian-quelling General"). A long series of military leaders in Japan would operate under this title until 1868. Kyoto, largely destroyed in the civil wars, retained its ceremonial status, while the real power lay in the clan headquarters at Kamakura, south of Edo (present-day Tokyo). Freed from many of the weighty traditions of the Japanese past, the Kamakura rulers rejected the refined aesthetics of their Fujiwara predecessors in Kyoto to lead more functional, active lives as they attempted to bring order to Japanese society and find new sets of values in life and art. The restrained actions and sentiments of Lady Murasaki's *The Tale of Genji* give way to novels about heroic warriors, feuding clans, and violent deaths.

PAINTING

No single work of art better demonstrates the changes that took place at the beginning of the Kamakura period than a section of a hand scroll illustrating the *Night Attack on the Sanjo Palace* (FIG. 5.15) The scroll (to be read from right to left) is from a novel about the Heiji insurrection near the end of the Fujiwara period (1160), when Minamoto rebels attacked the palace of a retired emperor. The *yamato-e* style used to illustrate the mannerisms of the refined Fujiwara courtiers is updated to express the more robust sentiments of the Kamakuran warrior society. With the traditional bird's-eye view, the viewer can look down upon the

5.15 *Night Attack on the Sanjo Palace* (section of the *Heiji Monogatari* hand scroll). Kamakura period, late 13th century. Handscroll, ink and colors on paper, height 16¼" (41.3 cm). Fenollosa-Weld Collection, Museum of Fine Arts, Boston

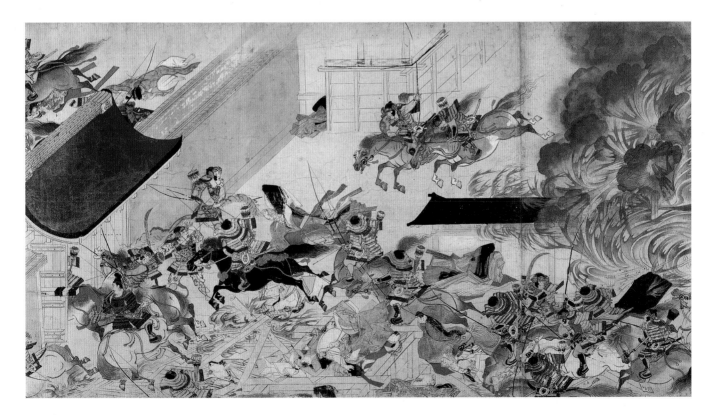

brilliantly colored, swirling masses of stylized flames and surging horsemen as they destroy the wooden buildings of the palace complex. The draftsmen and painters included a wealth of detail showing the warriors' weapons, armor, and horse gear that is not visible in this reproduction, but can be examined by those who see the original as it is unrolled from right to left. This glorification of military force, action, and destruction stands in marked contrast to the contemplative, philosophical paintings by the literati painters in China of this period and the sensibilities of the Fujiwara courtiers in Lady Murasaki's famous novel. Using fast-flowing lines, ultimately derived from the ancient Chinese traditions of calligraphy, the artists have captured the drama of one of the fire storms that consumed most of the Chinese and Japanese buildings of this period.

THE SHOGUNS, *DAIMYO*, AND SAMURAI

The shoguns could not rule Japan without the support of the warrior nobles, the *daimyo* ("great names") and *bushi* or samurai swordsmen. The *daimyo* commanded the samurai, well-disciplined swordsmen who were trained to be profoundly indifferent to sensual pleasures, physical pain, and death—and totally devoted to their noble patrons. The ethics governing the conduct of the samurai was as complicated as the contemporary code of chivalry operating in Europe. It included the ritual of *seppuku* (known in the West as *hara-kiri*), a noble act of suicide performed by a samurai accused of cowardice or disloyalty.

Yoshida Kenko (1283–1350), a lay priest from a family of Shinto diviners working for the Imperial family, seems to have summarized the spirit of the Kamakura period. "If man were never to fade away like the dews of Adashino, never to vanish like the smoke over Toribeyama, but linger on forever in the world, how things would lose their power to move us! The most precious thing in life is its uncertainty" (*Essays in Idleness: The Tsurezuregusa of Kenko*, translated by Donald Keene).

SCULPTURE

The Kamakuran leaders commissioned artists to produce realistic portraits and narrative art forms to commemorate their political and military achievements. Combined with the much older ideas of ancestor worship, the philosophy of self-discipline and meditation helped shape the militaristic character of the fourteenth-century sculptured portrait of Uesugi Shigefusa (FIG. 5.16). Rigidly frontal, the body of the military lord disappears within the ballooning fabrics of his courtly regalia, which emphasize his status in the feudal society. The portrait, which was carved and installed in a family shrine a century after Shigefusa's death, may not be an accurate record of his features, but it captures the spirit of a *daimyo* to whom a host of well-disciplined samurai dedicated their lives.

The interest in realism extended to the work of the most famous sculptor of the day, Unkei (1163–1223), who carved many highly realistic painted wooden portrait statues of priests with inlaid crystal eyes. He was also capable of producing highly dramatic works that express the militaristic spirit of the Kamakura society of the shoguns and made a pair of colossal wooden guardians nearly thirty feet (9.1 m) tall for the Great South Gate of the Todai-ji temple compound in Nara (FIG. 5.17). Unkei's Kongo Rikishi (1203) was made using the joined-wood technique, so he was able to extend the

5.16 *Portrait of Uesugi Shigefusa*. Kamakura period, 14th century. Painted wood, height 27½" (70 cm). Meigetsu-in, Kamakura, Kanagawa prefecture, Japan

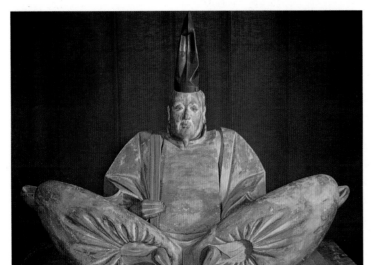

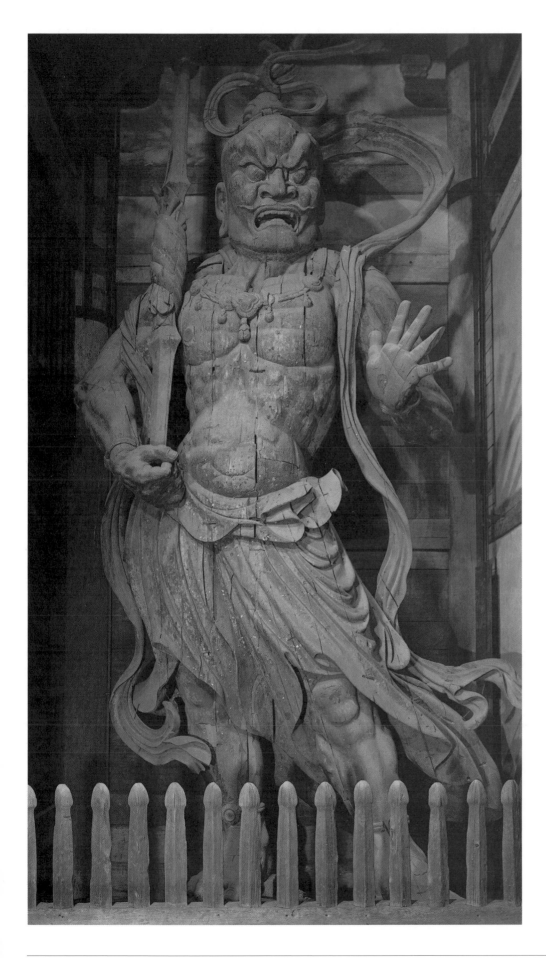

arms, legs, and flowing draperies of this enormous figure into space, giving viewers the impression that the muscular, demonic creature was in motion, making spontaneous and violent gestures. In terms of the way the sculptor has externalized the fury of the angry *Kongo Rikishi*, there are few comparable pieces of statuary to be found anywhere in the world. The energetic, animated quality of its gestures and the weightless, flowing banners fluttering over its head work well in concert with the wooden bracketing and winged-tipped eaves of the surrounding temple roofs. The overwrought expression of the tense, colossal guardian figure, fringing on the grotesque, would seem to express the militarism and single-mindedness of the samurai who guarded and sustained the shogun who commissioned this addition to the ancient temple complex.

KOREA: KORYO

The Silla, who extended their rule over all Korea after 688, were deposed by the Koryo dynasty (918–1392), after which modern Korea is named. They modeled their capital at Kaesong after Chang'an, imported Chinese Song ceramists, and, in the twelfth century, developed a distinctive Korean celadon ware with beautifully clear glazes over incised designs filled with black and white slips. The Korean ceramists also invented some new vessel types never made in China or Japan, such as the covered ewer in figure 5.18, in which the leaves have delicately incised veins. The bluish-green glaze is very thin and highly transparent, and, like the other fine Korean celadons of this period, variations in the glaze from one part of the vessel to another give it an informal and handmade quality. After the Koryo dynasty fell under the control of the Mongols in 1231, the Buddhist leaders in Korea became increasingly corrupt and weak, and the celadon tradition declined.

5.18 Ewer with lid. Korea, Koryo period. c. 1100–1150. Celadon porcelain with incised decoration, height 9⁷/₈" (25 cm). The Brooklyn Museum

THE MUROMACHI (ASHIKAGA) PERIOD (1392–1573)

In 1274 and again in 1281, the Kamakurans successfully repelled invasions by Khubilai Khan's Mongol forces. But the cost of victory was high and Japan was left impoverished. As the strength of the Kamakurans waned, Japan entered a long period of civil strife that ended with the rise of the Ashikaga shogunate in Kyoto. This period is known as the Ashikaga, after that family of shoguns, and the Muromachi, for the area in Heian (present-day Kyoto) where they lived. In actuality, the Ashikawa shoguns had little more power than the emperors, and Japan was ruled by a number of provincial *daimyo*.

For the most part, the *daimyo* of this period, known as "sudden lords," and their samurai swordsmen, were uncultured political upstarts who had very little appreciation for many of the traditional forms of Japanese art. However, they did appreciate the directness and simplicity of the Daoist-influenced teaching of Zen and its affiliated art forms. With its lack of courtly ritual, emphasis on immediate and intuitive perceptions, mental and physical discipline, and self-reliance, Zen ethics appealed to the most basic instincts of the "sudden lords." Furthermore, since Zen philosophy was taught like the martial arts, through a tightly bonded master–disciple relationship, it blended well with the samurai lifestyle.

Zen monasteries became some of the most important educational centers of the day as Zen became the dominant philosophy and religion of the feuding factions in war-torn Japan. (See *"Religion*: Zen Buddhism," below.)

PAINTING

The popularity of Zen Buddhism was accompanied by a renewed interest in Chinese art, especially the Chan Buddhist painters of the Song period. After the Mongols from the north overran China in the thirteenth century, the Japanese imported large numbers of Chinese Song artists and paintings. These influences created a new interest in landscape painting in Japan.

To study Chinese landscape painting first hand, Sesshu Toyo (1420–1506), a *gaso* ("Zen priest-painter"), traveled in China (1468–1469) and made copies of paintings by old masters, including Ma Yuan (late twelfth century–early thirteenth). Sesshu, who could work in a variety of styles, became the master of the traditional Chinese Song style of painting with soft, wet, and highly simplified brushmarks. This mode, which emulates the most extreme forms of monochrome painting by the Chinese Chan Buddhist painters, is called the *haboku* ("splashed ink") style in Japan. Painters working in this style believed there were traces of spiritual inspiration to be found in the accidental and spontaneous patterns of the ink. Working with this style in *Haboku Landscape for Soen*, Sesshu uses very loose brushwork, yet by creating sharp tonal contrasts through a variety of washes and strokes he is able through a few carefully placed marks to capture the spirit of an entire landscape with its rocks, mists, and deep spaces (FIG. 5.19). Although careful analysis might reveal how each mark

RELIGION

Zen Buddhism

At the end of the twelfth century, the militaristic *daimyo* and samurai were attracted to the Daoist-inspired form of Chan Buddhism from China. Chan (pronounced "Zen" in Japanese) Buddhism de-emphasized the traditional scriptures and rituals of Buddhism and placed new emphasis upon self-discipline and self-denial. In some respects, Zen marked a return to the original teachings of the Buddha, that individuals could achieve enlightenment through discipline and meditation. Unlike China, where Chan Buddhism played a limited role in the culture after the thirteenth century, Zen was the dominant religious philosophy of Japan by the fifteenth century, and Zen artists were often as devoted to their art as to meditation and teaching.

Zen Buddhism, with its emphasis on austerity, simplicity, intuitive thought, and appreciation of beauty in nature, worked well with the traditional values of Shinto. Operating in the Shinto manner, with few texts, liturgy, or shrines, Japanese Zen masters sought enlightenment through intuitive thoughts and actions, uncluttered by the complexities of intellectual reasoning.

Zenga, the word Japanese Buddhists have used to describe the art of Zen monks since about 1600, is an aid to meditation and it epitomizes the essence of Zen. It is bold, often rough, sometimes humorous, and always an immediate translation of the inner experience of the artist's mind into an external form.

In their search for the meaning of life and death, the Zen Buddhists meditated while seated in a yoga position with straight backs and crossed legs. They also studied *koan* ("questions" or "exchanges") with a master. These *koan*, which cannot be understood by rational means, are designed to break down traditional, rational patterns of thought, sharpen one's intuitions, transcend one's ego, and create a breakthrough to *satori*, enlightenment and oneness with the universe.

contributes to the representation; the picture does not lend itself to such calculating tactics; in the end, the way in which it was created and how it works as an image remain as puzzles. An inscription on the painting by the artist says, "my eyes are misty and my spirit exhausted." The painting must be understood in the Zen manner and be appreciated for its intuitive character and simplicity, as a dialogue between the memories of the artist and his brush, paper, and ink.

At times, however, the hostile nature of the feudal society in Japan that led to the Onin War (1467–1477), which destroyed much of Kyoto, may have made it difficult for Sesshu and other Japanese artists to find a quiet, peaceful, and harmonic rapport with nature. Sesshu's landscapes, painted on *kakemono* ("hanging scrolls"), are often rendered with jagged, slashing brushstrokes in a style known as *shin*. *Shin*, a term that originally referred to the standard style of calligraphy, like block printing, contrasts with *so*, the cursive draft script. These alarming and strident notes of discord violate the sense of tranquility so cherished by the Chinese landscape painters.

ZEN GARDENS

In addition to painting landscapes, Japanese artists of the period also recreated them, in a symbolic and miniaturized fashion, as gardens. One of the finest examples of these Zen gardens, the Daisen-in in Kyoto, is attributed to the painter Soami (died 1525) (FIG. 5.20). At first glance, it may appear to be no more than a casual combination of uncarved rocks, sand, pebbles, and trees. It is, in fact, the exact opposite; the garden's construction and maintenance involve as much planning and effort as the most formal and well-trimmed gardens being created in Renaissance Europe at the time.

In some gardens, irregularly placed flagstones provide paths for visitors to walk through them. Entry to others, such as the Daisen-in garden, is restricted to the Buddhist monks who tend them; visitors must view them from porches and platforms, as if they were attending a theatrical performance or viewing nature from a mountain-side. However, we may enter Soami's garden spiritually and meditate upon it. Some students of Japanese culture believe in seeing the stones as stones and the sand as sand—no more. For others, the gardens represent landscapes with mountains, cliffs, islands, bridges, rivers, lakes, and oceans. It is as if the imagery of a Sesshu or Soami painting had been lifted out of the pictorial realm and recast in three dimensions as a microcosm upon which they can meditate and envision the unbounded nature of the universe. For the Buddhist monk or other serious viewer, who can look upon the rocks and sand for what they are, and still imagine them as great mountains in the seas and mists, the radical changes in scale and meaning parallel experiences in meditation—like the inner mind and outside world. Also, the idea that rock is mountain and sand is sea can be seen as another Zen Buddhist riddle of the type used to deconstruct the rational patterns of thought and sharpen the instinctual minds of Buddhist monks in search of enlightenment and harmony with the universe. (See *"In Context:* Japanese Poetry and Drama," page 184.)

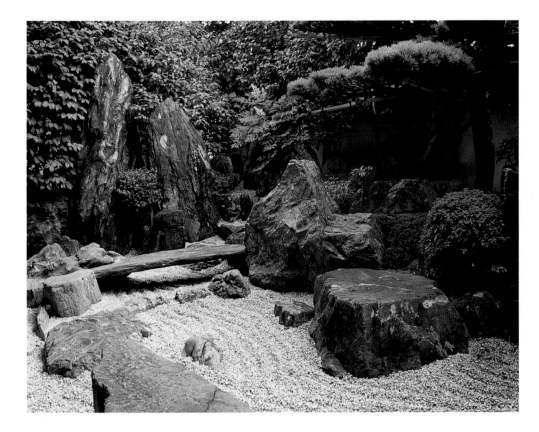

5.19 (opposite) Sesshu Toyo, *Haboku Landscape for Soen.* Muromachi period, 1495. Section of a hanging scroll, ink on two joined sheets of paper, height 58¼" (1.48 m). Tokyo National Museum

5.20 Attributed to Soami (died c. 1525). Garden of the Daisen-in of Daitoku-ji, Kyoto. Kyoto, Japan. Ashikaga period

THE MOMOYAMA PERIOD (1573–1615)

The Momoyama ("Peach Hill") period takes its name from an orchard of peach trees planted on the ruins of the castle of the dictator Toyotomi Hideyoshi, south of Kyoto. The name of this picturesque and popular place for excursions is an appropriate visual metaphor for this period, which has been called the "Golden Age" of Japanese art. However, this short and colorful period of Japanese history was also a time of unrelenting endemic warfare. During the Momoyama period, Japan's decentralized medieval feudal society run by many feuding *daimyo* and Buddhist leaders became a powerful, centralized, and highly secularized state under the rule of military dictators.

The Momoyama period began when Oda Nobunaga (died 1582) triumphed over the last Ashikaga shogun in 1573 and lasted until Tokugawa Ieyasu solidified his control of Japan in 1615. As Nobunaga allowed the Westerners who had been in Japan since 1543 to spread Christianity in Japanese, along with muskets and cannon, the foreigners added to the social and political complexity of the period. (See "*Cross-Cultural Contacts*: Westerners and Christianity in Japan," page 185.)

Although it was a violent period of intense civil strife, during which Buddhist patronage of the arts declined, the militaristic Momoyama dictators were enthusiastic patrons of the arts. Recognizing that the arts could further their political ambitions, the rulers constructed imposing castles with audience halls, shrines, and private rooms decorated with painted screens and furniture with gold leaf, brass, and glowing lacquer finishes. Often, they employed the most respected and famous Japanese artists and workshops of the day. Kyoto, the largest city in Japan, was becoming once again a magnificent capital filled with castles, shrines, temples, gardens, and palatial homes. It was also a festive city because the Momoyama shoguns trying to solidify their control of the country sponsored many grand public events. Some of these spectacles were documented in large screen paintings with gold leaf backgrounds. The color gold, a defining symbol of this age, used sparingly in earlier Japanese art to

Japanese Poetry and Drama

The Japanese developed a number of highly ritualized institutions and art forms that provided something of a counterpoint to the chaotic political upheavals that rocked the country from the twelfth through the seventeenth centuries. In spirit, the art forms seem to reflect and update the ancient Shinto root-stock of Japanese thinking. The fourteenth- and fifteenth-century Noh dramas enjoyed by the Japanese élite moved at a snail's pace. Every word, restrained movement, note of music, and detail of costume was to be contemplated and savored. However, the prolonged silences in a Noh drama and in Zen meditation, what one might call "negative spaces," are filled with significant content and meaning. Through the imagination, the viewer is brought into the empty spaces of a drama and becomes an active participant in the art form.

The Japanese poets who worked with a severely limited number of words and syllables were masters at the art of stimulating their listeners' or readers' imagination. From about the fourth century to the fourteenth, Japanese *tanka* poems had consisted of five lines with thirty-one syllables. Generally, *tanka* poets used images from nature to create melancholic and reflective moods, often laments of love. In the fourteenth century, the shorter *haiku* format (originally called *haikai*), with three lines of five, seven, and five syllables, became very popular. Through these severely limited means, the poets expressed their broadest perceptions of nature by stimulating their audiences to participate in the recreation and detailing of the terse poetic imagery. The following lines are by Basho (1644–1694), one of the acknowledged masters of the *haiku*:

> *White cloud of mist*
> *Above white cherry blossoms*
> *Dawn-shining mountain.*

These principles guiding the literature of drama and poetry have their counterparts in the visual arts wherein the painters will leave open, untouched areas of paper seemingly blank, but filled with suggestions of form that can be perceived by the imaginative viewer. The "simplicity" of the Shinto shrines and the seeming "formlessness" of the sands and uncarved stones in Zen Buddhist gardens are all equally suggestive and meaningful to the receptive viewer.

reflect the glory of the Buddhist paradise, is used here in abundance to symbolize wealth, majesty, and secular power.

Along with this rising interest in showy, public forms of art, the leaders also cultivated the traditional folkish and rustic Shinto-based arts in their private lives. This was manifest most clearly in new forms of the tea ceremony. The extremes and dynamics of this contrast between their worlds of public display in the arts and the quiet restrained and very private world of the small, unpretentious tea houses, reflect the complexity of Japanese art and thought as Japan emerged as a unified and powerful nation.

ARCHITECTURE AND PAINTED SCREENS

With the arrival of guns and gunpowder from the West, the Japanese leaders needed to build large, heavily defended castles to house their families and courtiers. The ostentatious grandeur of the large castles remaining from the roughly forty tall strongholds built during this time remain as lasting symbols of the colorful warlords who united Japan. However, these popular landmarks are architectural responses to Western technology and lie somewhat outside the mainstream of Japanese architectural history.

The Himeji Castle near Osaka, begun in 1581 by Hideyoshi, was rebuilt in its present form between 1601 and 1609 (FIG. 5.21). It is commonly known as the White

Westerners and Christianity in Japan

The first Portuguese traders landed in Japan in 1543 and six years later Francis Xavier arrived with his Jesuit priests and an oil painting of the Virgin and Child. Initially, the Imperial Japanese court welcomed the Jesuits, hoping Christianity would help the court curtail the political power of the Buddhists and unify the feuding warlords. Moreover, the Western traders brought firearms and other supplies that were valuable in the ongoing civil wars. Guns, which had not previously existed in Japan, revolutionized Japanese warfare and helped Oda Nobunaga to take control of the country in the 1570s. During his rule (1573–1582), the Westerners expanded their mercantile activities to many areas in Japan. However, his successor, Toyotomi Hideyoshi (1536/37–1598), wanted to unify the *daimyo* of Japan around Confucianism and saw the Catholics who had converted about 150,000 Japanese by the 1580s as a threat to his authority. Hideyoshi began the persecutions that ultimately led to the expulsion of the Westerners in 1638. Only a few closely supervised Chinese and Protestant English and Dutch traders with the Dutch East India Company were allowed to reside on a small artificial island in Nagasaki harbor on the southern island of Kyushu and trade with Japan.

But, before they were expelled, the Jesuits taught some of their Japanese students how to paint with oils and make copper engravings so they could create their own images for religious instruction. Some Japanese painters made copies of Western paintings, imitating their modeling techniques with great facility, and developed a kind of occidentalism, a fascination with Western art and culture. Even though the Dutch traders were cloistered off the shore of Nagasaki, the influence of *ranga* ("Dutch painting") with its realism continued to influence Japanese painting after the embargo. After 1720, the shoguns allowed illustrated Dutch books and oil paintings (without Christian content) into Japan, and Nagasaki became the major center for *rangaku* ("Dutch learning").

Heron Castle because of its tall white plastered walls and wide, uptipped wing-like roofs lined with rows of beautiful tiles. The storage areas for military provisions and weapons, barracks for troops, and apartments for the owner's family to use in times of siege, rest on tall stone walls that were designed to resist canon fire (first used in Japan in 1558). No single still photo-graph can replicate the experience visitors have encircling the castle and seeing the many complex and changing views of the gently bowed walls and curved, tiled roofs interacting with one another.

The tall central portion of the castle is surrounded by a complex set of multiple and interlocking outer walls, additional living quarters, gardens, and a moat. Even today, visitors to the castle must approach it through a maze of narrow, angular paths, fortified gates, and narrow ladders designed to slow down and confuse would-be attackers.

Many of the most celebrated Momoyama castles were destroyed in the early seventeenth century by the Tokugawa shogunate, to deter any possible rivals to their power, and after 1854, when Japan was modernizing. Some gates, shrines, tea

5.21 Himeji Castle, Hyogo prefecture. Momoyama period, 1581. Enlarged 1601–9

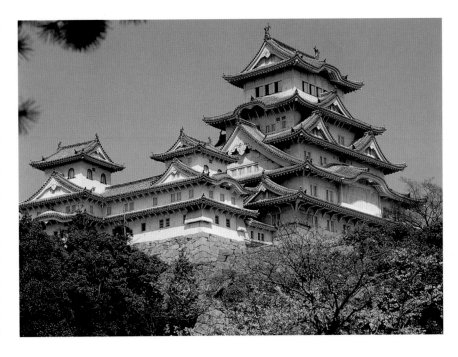

5.22 Interior of Audience Hall, Nishi Hongan-ji, Kyoto. Momoyama period, c. 1630

Traditionally, Japanese palaces and homes had no Western-styled furnishings: beds, chairs, tables, etc. They sat on mats on the floor, served food on low pedestals, and slept on futon bedding. Tatami, thickly woven reed mats (c. 3 x 6'; 90 x 180 cm) were used to cover the entire floor after the Heian period. Interior spaces were measured by tatami. By Western standards, the interior spaces of traditional Japanese homes are sparse, as "empty" as the unpainted white spaces in a Zen painting and as uncluttered as a haiku poem. This attitude toward the beauty of unused space finds substance in the insubstantial, fullness in emptiness, and had a profound influence on the development of Japanese architecture.

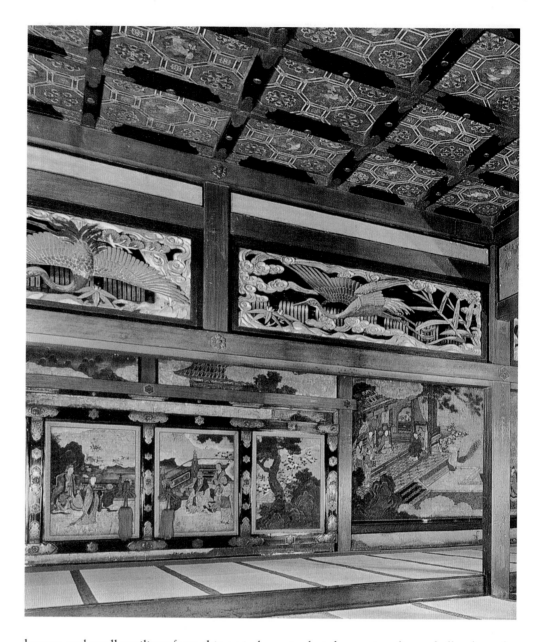

houses, and small pavilions from this period remain, but the great audience halls where the shoguns and their contenders entertained influential guests and plotted their political and military tactics are gone. To get a general image of the White Heron Castle's audience hall, and that of other castles from this period, we may look at the hall of the slightly later Nishi Hongan-ji in Kyoto (FIG. 5.22). The rectangular hall is divided into three parts by two rows of wooden pillars. The colors of the beige reed mats (*tatami*), black lacquered woods, bronze trimmings, and the reddish-brown wooden beams framing the rooms blend well with the ever-present gold leaf highlights. To complete the image, it is important to imagine the hall filled with portable works of art, courtiers dressed in colorful, embroidered robes, and the sounds of music.

The Imperial Household, temples, *daimyo*, and shoguns of this period commissioned artists to paint large portable folding screens (*byobu*). These were usually made in pairs, with two, six, or eight panels and were about five to six feet (1.5–1.8 m) tall. Some of the finest screens were painted by the many talented members of the Kano family, whose works and style are known as the Kano school. Beginning with Kano Masanobu (1434–1530), the Kano school developed the Chinese-inspired monochromatic (one color) style of ink

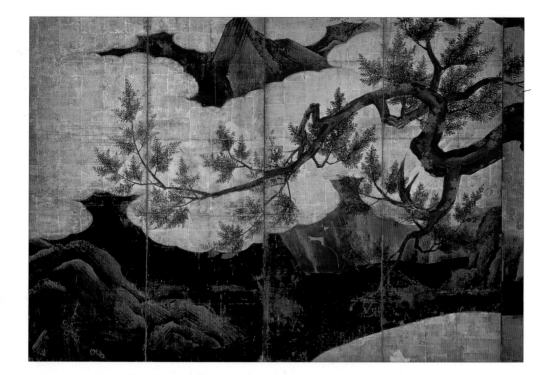

5.23 Attrib. Kano Eitoku, *Cypress Trees*. Momoyama period. Eight-fold screen. Gold leaf, color, and ink on paper; height 67" (1.7 m). Tokyo National Museum

painting of Sesshu's day into a new style of painting featuring bold, overall decorative patterning, rich colors, and gold leaf backgrounds. The style crystallizes in the work of Masanobu's great grandson Eitoku (1543–1590). In essence, the Kano school converted the Southern Song Chinese–Japanese tradition of painting relatively small monotone ink landscapes into a distinctive, native Japanese style with a new sense of scale and boldness that seems quintessentially Momoyama.

Cypress Trees, attributed to Kano Eitoku, originally a set of sliding doors or panels, is now mounted as a folding screen (FIG. 5.23). With its long sea shore and rocky cliffs, Japan has many such picturesque locations where travelers can see old, knurled trees on precipices overlooking small rugged islands. The long-branched tree in the foreground is very close to the picture plane and draws the viewer into the broad panoramic view of the landscape behind. Shown as if looking down from a high cliff, or from a bird's-eye view, the image has no horizon line to give it depth and anchor it in reality. The brilliant golden clouds contrast with the dark but rich patches of green rocks, blue water, and the reddish-brown earthen tones of the tree and give this and other Kano school panels a sense of overall unity. Such large architectural-scale paintings, on folding or sliding panels, gave viewers inside rooms with small windows or distant light sources a sense of being outside, literally surrounded by nature. Together, the undulating cloud formations and winding tree limbs unite this magnificent, sweeping view of nature and create a fantasy world that is as much a sign and symbol of this age as the towering castles of the great lords.

The subject matter of the Momoyama period screens is highly diverse. Some of them represent panoramic views of people gathered in the countryside, cityscapes seen from a bird's-eye view, dramas from the theater, battles, mythological scenes, and the curious spectacle of the Europeans with their large ships. The Japanese called the Europeans the *namban jin* ("Southern barbarians") and the screen paintings of them are known as *namban byobu* ("screen paintings of barbarians"). One such early seventeenth-century folding screen shows Portuguese traders transporting goods from their ship anchored in the harbor to the Japanese merchants and other observers on the near shore (FIG. 5.24). In the typical fashion of the *namban byobu*, the artist shows the Westerners wearing colorful hats, garishly pattern cloaks, and puffy pants. The water and land are surrounded by brilliant golden and puffy, cloud-

5.24 *Portuguese
Merchants and Trading
Vessels.* Early 17th century.
Namban paper screen.
H. M. De Young Memorial
Museum, San Francisco

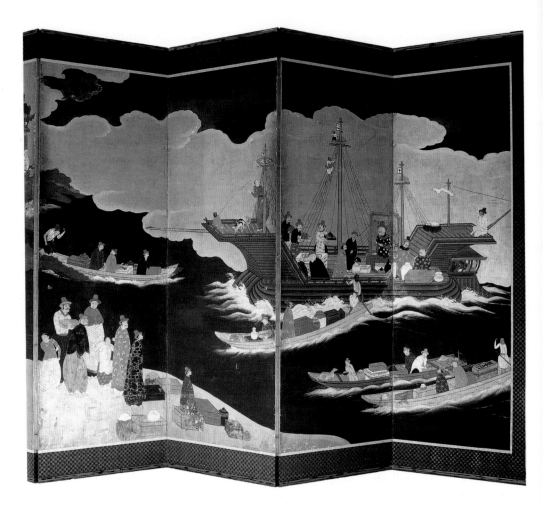

like decorative forms. Japanese painters often made sketches on the spot in the bay at Nagasaki, and some of them continued to make *namban byobu* screens depicting Westerners in combinations of Eastern and Western styles of painting well after the foreigners had been expelled from the country in 1638.

THE TEA CEREMONY: ARCHITECTURE AND CERAMICS

Castles and palaces of this period were usually accompanied by informal gardens and *chashitsu* ("tea houses"). There, members and guests of the court could participate in the *chanoyu* (literally, "hot water for tea"), generally known as the "tea ceremony." As a part of the Chinese Buddhist tradition, monks drank tea as a stimulant to keep them alert during prolonged ceremonies and periods of meditation. Eventually, some cultivated shoguns and nobles began drinking tea and building small garden tea houses out of unpretentious natural materials such as unfinished wood or bamboo, and floored with earth-colored *tatami* mats that reflected the monastic origins of the temple-bound ritual.

Formal tea ceremonies may last up to four hours. Very little is said while the guests partake of tea served with what appear to be the simplest implements. These are, in fact, carefully crafted, with subtle forms and textures. Nothing in the ceremony is precisely planned, yet the rules governing the performance of the tea ceremony dictate every movement, word, and thought of the participants. The tea ceremony is a sublime ritual, one that appears to be very simple, but, in truth, like almost everything about Zen thinking, it is deceptively complicated. The ceremony combines the highly refined aesthetics of the Noh theater with *tanka* and *haiku* poetry, the arts of gardening, architecture, painting, sculpture,

theater, and Japanese etiquette to stand as a ritualized expression of the finest Zen sensibilities. It is also a kind of performance art that stresses the importance of the group and its bonding around a shared experience of refined tastes, a stable microcosmic society separate from the larger unstable social order of the day. Many writers have suggested that the orderliness and values inculcated in the tea ceremony reflected the needs of the Japanese leaders living through the prolonged civil wars during the Muromachi and Momoyama periods.

The ceremony, which began to develop in the Ashikaga period, reached the classic stage of its development under Sen no Rikyu (1521–1591), tea master to the warlords Nobunaga and Hideyoshi. Sen no Rikyu explained that the ceremony fostered harmony, respect, purity, tranquility, and an appreciation of natural beauty without artifice. It is designed to teach participants some Shinto-based virtues that remain fundamental to Japanese thinking today: *wabi* ("humility, honesty, and integrity"), *sabi* ("a preference for stillness and the old and rustic over the new"), and *shibui* ("that which is bitter but pleasing"). These terms and ideals are fundamental to the understanding of Japanese aesthetics. They are refinements that separated the cultured members of Japanese society from the gaudy tastes of the "sudden lords" and the underclasses in Japan. If the writers of this period are correct, in his own life, Rikyu personified the virtues of the ceremonies he directed to the very end—when he committed suicide at Hideyoshi's request.

The significance of the ceremony was explained from a Western point of view by Father João Rodrigues (1562–1633), a Portuguese Jesuit priest who spent most of his adult life in Japan. It was, he wrote, "to produce courtesy, politeness, modesty, moderation, calmness, peace of body and soul, without pride or arrogance, fleeing from all ostentation, pomp, external grandeur and magnificence."

Sen no Rikyu may have designed the Tai-an tea house for his own garden in Tokyo around 1582 (FIG. 5.25). Later it was moved to a nearby Buddhist temple, the Myoki-an. The house is very small, about nine feet by nine (2.7 × 2.7 m), and the area occupied by guests, six feet (1.82 m) long, is dimly lit by three small paper-covered windows. In the spirit of the ancient Shinto shrines, the scale of the house is modest and it is perfectly integrated with its surroundings. To enter it, visitors must stoop and crawl inside—ritual gestures of

5.25 Sen no Rikyu (?), interior and *tokonoma* of the Tai-an tea house. Myoki-an, Kyoto prefecture, Japan. c. 1582

5.26 Hon'ami Koetsu, tea bowl titled *Mount Fuji*. Edo period, early 17th century. *Raku* ware, height 3³/₈" (8.6 cm). Sakai Collection, Tokyo

humility. The conservative design and size of the Tai-an tea house, reflecting the pre-Buddhist aesthetics in Japan, stands in marked contrast to the festive atmosphere of the upturned eaves and ridge poles of such Buddhist-inspired buildings as the Phoenix Hall at Uji and the White Heron Castle.

The men and women invited to attend ceremonies at the Tai-an and other tea houses normally approached the houses along a winding flagstone path that led through the shrubbery and moss-covered rocks of a surrounding garden. Following an old Shinto tradition, participants in the ritual washed their hands and mouths in a natural spring or creek before entering the house. Paths through the gardens to tea houses were usually narrow, winding, and enclosed, with a sense of scale that prepared guests for the tiny spaces inside the tea house. Inside, the already small area was further subdivided and the section where the host prepared for the tea ceremony was hidden from the view of guests. The actual brewing of the tea was part of the ritual and performed in the presence of the guests. Tea houses had very small windows, and were therefore quite dark, like architectural caves, a fully enclosed world divorced from the spaces around it.

While waiting for the host or hostess to arrive, the guests, seated on mats, would have the opportunity to contemplate a floral arrangement with a small painting or calligraphy on a hanging scroll in the *tokonoma*, a shallow alcove or niche. Connoisseurs of the Momoyama period often cut up works by earlier calligraphers, saved the snippets of them in albums, and displayed them in the *tokonoma*. Like the shrine at Ise, the exposed wood surfaces would have been painstakingly rubbed and polished to bring out their natural beauty. All of the textures and colors of the walls, woods, and mats on the floor worked in unison to create an unpretentious atmosphere of utter simplicity. In the words of Father Rodrigues, the gardens and tea house must be "as rustic, rough, completely unrefined, and simple as nature made [them] . . . " The iron water kettle, bamboo tea scoop, whisk, water dipper, tea bowls, and ceramic caddy for the astringently bitter, yet pleasing, powdered green tea used in the ceremonies must be commonplace objects that have a natural sense of beauty.

During the sixteenth century, the Japanese tea masters began using Japanese peasant wares and, later, imported peasant rice bowls from Korea. Compared to the highly sophisticated Ming vases of this period, peasant Japanese and Korean ceramics often have a casual quality as the artists collaborated with the tea masters and cultivated certain accidental effects, giving their works an apparently provincial quality. These qualities were highly admired by Japanese officers under Hideyoshi, who campaigned in Korea in the 1580s and brought Korean ceramists back to Japan.

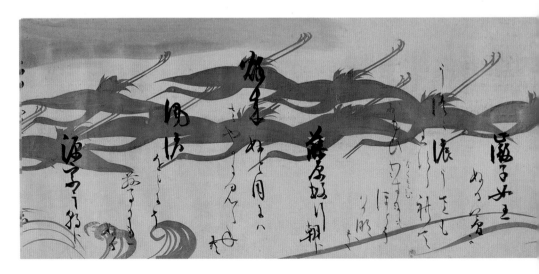

Soon, the Japanese ceramists began making tea ceremony wares to suit the tastes of the tea masters, shaping them by hand without a potter's wheel, giving them rustic qualities and purposeful flaws or irregularities that reflected the spirit of the gardens and nature around them. To the members of a traditional *chanoyu* ceremony, such *raku* ("happiness") wares as *Mount Fuji* by the honored calligrapher, tea master, and ceramist Hon'ami Koetsu (1568–1637) embody the virtues of *sabi* and *wabi* (FIG. 5.26). With its irregular shape (which fits well into two hands), subtle coloration, and crackle pattern, it exemplifies the virtues of the ceremony in which it was used.

Such hand-shaped vessels were made from a ball of clay that was pinched and stretched; they were then fired at low temperature, and set in beds of grass, leaves, and twigs while they were still hot. When this bed was ignited, the resulting chemical reactions gave the glaze mottled patterns of rich musky colors. In marked contrast to the smooth and perfectly shaped Chinese and Japanese porcelain wares of the day, the imperfect shapes, rough incisions, and loosely splashed glazes of these Japanese *raku* wares reflect the folk traditions of the ancient Korean and Japanese potters. Near the conclusion of the ceremony, the host might display the other utensils used in the ceremony for the inspection of the guests. The fact that many of the famous tea bowls had names and were called by them, underlines their importance and sense of individuality.

In the spirit of Zen, there is no liturgy or script for the ceremony, but strict rules of decorum govern every movement made in the serving and drinking of the tea. Nothing is planned, yet everything must be perfect, and each action takes on a sacramental or iconic quality. Conversations might center around matters of philosophy or aesthetics and have "empty" periods of silence that are as meaningful and important as the words themselves. No two tea houses or tea ceremonies are identical; within the traditionally accepted rules of order, the ceremony must be staged with creativity because the ceremony is, first and foremost, a living work of art. At every stage of this ritual, on the path and inside the house, the participant's contact with the everyday world is severely limited—what is not seen is as important as what is. In its utter simplicity, the ceremony would appear to be the single greatest expression of the aesthetics of the Japanese élite.

SCROLL PAINTING AND CALLIGRAPHY

The Momoyama period produced many masters of calligraphy who revived the older styles of writing, particularly those of the Heian period. One of these artists, Hon'ami Koetsu, who produced the *raku* vessel mentioned above, added verses from famous Japanese poets of the past to Tawaraya Sotatsu's background imagery in *The Crane Scroll* (FIG. 5.27). The

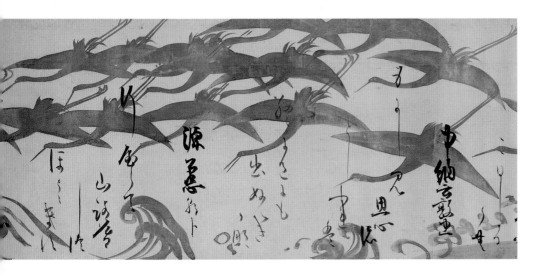

5.27 *The Crane Scroll.* Calligraphy by Hon'ami Koetsu under painting by Tawaraya Sotatsu. c. 1605–10. Handscroll, ink, silver, and gold pigments on paper, 13½ × 56" (34 × 135 cm). Kyoto National Museum

portion shown here is a very small section of the complete hand scroll, which is over fifty feet (15.2 m) long. Some of Sotatsu's elegant silver-colored cranes stand and stretch their wings while others fly and glide against the golden clouds in the background. Most of the birds move from right to left, the direction in which the scroll was to be viewed as it was unrolled. The gold is not bright, like that used by the Kano school screen painters, and, along with soft silver-grey of the cranes, it provides a hazy background for the calligraphy of Koetsu. Koetsu's semicursive characters, seemingly brushed with great ease, have the same wonderfully gentle, gliding sense of motion as the cranes that unify this long composition of image and text.

THE TOKUGAWA (EDO) PERIOD (1615–1868)

The Tokugawa period is known for its founder, Tokugawa Ieyasu (1542–1616), who became shogun in 1603, but it is sometimes called the "Edo period" after his new capital (present-day Tokyo). Tokugawa Ieyasu's castle in Edo (destroyed in 1657) was 192 feet (58.5 m) tall and had about 181 acres (73.25 hectares) of grounds. Edo now housed Ieyasu's entourage of about 50,000 samurai and their staffs and the mansions of roughly 260 *daimyo*. Keeping these influential men in Edo, away from their homes in the provinces, half the year, or every second year, weakened them politically. This helped centralize and stabilize the shogunate, which followed a neo-Confucian philosophy that required the unquestioned loyalty of all to the shogun and state. While the government, which forbade the Japanese to travel outside the country, was often very repressive, this period was relatively peaceful and highly prosperous. The new era saw the growth of large cities, a money economy, the rise of literacy, and a new middle class that included many merchants. The merchants at Edo catering to the shogun's large community of conscripts prospered, and by the eighteenth century, Edo (population about one million) may have been the largest city in the world.

While many of the traditional Japanese art forms flourished at Kyoto and Osaka, some of the arts at Edo reflected the new realities of life in the bustling capital. The pictorial arts often illustrated life in the local entertainment or pleasure district with its kabuki theaters, eating and drinking establishments, and prostitutes. This district was frequented by many of the prosperous businessmen of Edo and the shogun's men, whose families were often far away in the provinces. In contrast to the refined aesthetics of the élitist Noh dramas, the kabuki theater appealed to the tastes of the merchants and samurai, whose forced idleness had eroded their interests in Zen discipline and culture. Literature in Edo tended to be light reading— romances, tales of the supernatural, and travel guides. Some of the leading Edo poets created *kyo-ka* ("crazy verse"), which parodied the traditional forms of Japanese poetry still venerated in the tradition-bound cities of Kyoto and Osaka, the Buddhist monasteries, and the Imperial court. To produce large numbers of inexpensive and colorful images that reflected the new realities of this world, the Japanese developed a magnificent tradition of woodblock printing.

ARCHITECTURE

The dual interests of the Momoyama period shoguns in creating lavish buildings for public display and adopting more modest styles of architecture for private use continued in the Edo period. For many contemporary viewers, the few surviving examples of the profusely decorated early Edo gates are less interesting than the far less ostentatious noble country homes and tea houses of this period. The enduring Japanese interest in refinement, the reduction of elements to their most essential forms, seems to reach its ultimate point of development in the design of the Katsura Detached Palace in Kyoto. The palace, which is still

used by the Imperial family today, was not a full-time residence, but an elegant retreat built for a prince (FIGS. 5.28, 5.29).

Unlike many earlier country homes, temples, and religious complexes laid out along symmetrical lines, the palace is asymmetrical in plan. It consists of three sections or *shoins* joined at the corners, giving the ground plan of the palace an irregular, staggered, or stepped outline. The proportional relationships of all the parts are based on the *tatami* module (c. 3 × 6'; 0.9 × 1.8 m), but within this system of thought the designers created a very wide variety of spaces.

Approaching the palace, visitors may notice that the doorways and windows are not centered in the walls or symmetrically arranged, and there is no grand palatial facade to tell them where to enter. Inside, there is no grand hallway or hierarchy of spaces leading one to a single all-important destination such as a grand audience hall. In fact, the idea of a fully enclosed hall or room with four walls hardly exists, and moving from one semi-enclosed place to another in U- and L-shaped patterns, the visitor cannot anticipate what will come next. The spaces are remarkably open and flow one to the other, in part because the Japanese sit and sleep on the floor, using very little furniture. This openness is further enhanced by the sliding panels (*fusuma*) set in wooden frames so that they can be moved to open or close spaces. Thus, the occupants of the palace have the freedom to reconfigure the design of each *shoin* to meet the needs of any day or moment.

Moving through the palace, the visitor experiences a constantly shifting composition of open and

5.29 Plan of Katsura Detached Palace

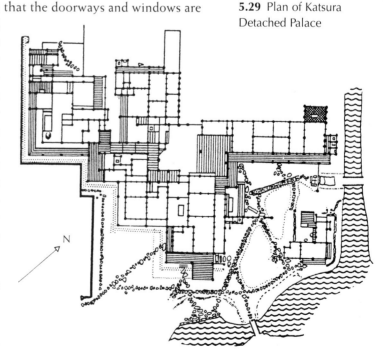

N

closed spaces, surrounding geometries, and exterior views of the surrounding gardens and small, rustic teahouse-style buildings nestled within them. With its many verandas under broad overhanging roofs, there is often no clear distinction between inside and outside spaces. The verandas, designed to offer the Imperial family a wide variety of views of nature as it changes with the seasons, reflect the interests of the *haiku* poets who recorded elegant images of their experiences with nature.

As opposed to the mathematically predictable character of symmetrical designs, asymmetrical compositions such as the Katsura Palace have an inherent vitality that captures the spirit of life, growth, and change. Its design engages the viewer to be an active participant in an experience of it. In fact, the vitality and flow of these "empty" spaces may be the "fullest" and most important experience the palace has to offer. They may reflect the Japanese belief that all things flow freely through the past, present, and future. Time does not march on in linear fashion to a steady beat. Nothing is permanent, nothing is predictable—only change is certain; the events in one's life are not part of a grand and logical plan. These important cultural ideals seem to be deeply embedded in the design of the palace. No single part of it tells a visitor what the rest of the palace will hold, and his or her individual and sequential movements through it are not part of a grand plan for the whole.

While the quality of the woodworking throughout is astonishing, and every detail of the palace is finished like a fine piece of furniture, the overall feeling of the building

MATERIALS AND TECHNIQUES

Japanese Woodblock Printing

Woodblock printing, a Tang Dynasty Chinese invention, appeared in Japan by the eighth century. Black and white prints, some hand-colored, had been used to illustrate books (also printed) and duplicate known works of art in Japan for centuries before printmaking emerged as a highly specialized art form in the late seventeenth century. By the 1760s, the production of multicolored prints was an industry, a collaborative project involving publishers, artists, engravers, and printers.

Publishers would commission artists to do line drawings in ink. Sometimes the artists would make notations, indicating where colors should go, but often the colors were selected by the wood engravers and printers. The engravers would paste the original drawings face-down on a hardwood key block, preferably cherry, and coat the drawings with oil to make them transparent. Then they would begin the difficult task of reproducing the drawn images by removing the wood on either side of the lines with a sharp knife. Next, the rest of the area between the lines would be cut away so the thin raised lines would stand out in relief while the "white" areas of the drawing were recessed. Prints from this key block reproducing the artist's line drawing were used to cut additional blocks where the relief corresponded to areas to be printed in a given color.

The printers began their work by brushing black water-based ink over the relief on the key block with the image of the artist's original line drawing. Next, they covered the inked block with a lightly moistened paper, and rubbed it from the back with a pad until the paper absorbed the ink. The most popular type of paper, *hosho*, was made from the bark of the mulberry tree. Once the paper was removed from the block and the ink dried, the printers could begin printing additional colors on the paper from other blocks. All these blocks had registration marks in exactly the same places, so the printers could place the paper on each of them in precisely the same position, making certain the colors fitted perfectly into the design from the key block. Graduated or rainbow color effects were created by inking the blocks with brushes carrying two or more colors of ink or wiping some of the ink off sections of the block before printing. Prints might be given a luxurious finish of thin glue sprinkled with mica dust. In the end, the quality of any print depended upon the combined skills of the papermaker, artist, woodcutter, and printer.

reflects the values of the tea ceremony, of quiet simplicity, reticence, and a quest for harmony with unspoiled nature. For many students of Japanese art, the Katsura Palace is the quintessential example of the Japanese view of space and form in architecture.

PRINTMAKING AND THE UKIYO-E STYLE

To maintain their authority, the Tokugawa shoguns embraced Confucianism and its social ethics, giving relatively little support to the Buddhist leaders outside Edo. With the growth of literacy in Edo and elsewhere, the Buddhist monasteries and Imperial court began to lose their long-held monopoly on art, literacy, and book illustration. The new tradition of book illustration, along with the production of individual prints, first appeared among the emerging bourgeoisie of Kyoto who were excluded from the élitist world of Noh dramas and tea ceremonies. The inspiration for this movement came in part from the slightly earlier tradition of illustrating city life developed in the commercial centers of southeastern China: Hangzhou, Suzhou, Canton, and Shanghai.

The earliest Japanese prints of the activities and pleasures of everyday life were relatively simple black and white images. As the tradition took root to the north in Edo, the printing techniques changed rapidly—along with the themes the artists illustrated. The name for the new style of printmaking, the *ukiyo-e* style ("pictures of the floating or passing world"), comes from a Buddhist term describing the transience or ephemeral quality of earthly existence. It was originally applied to paintings of such subjects before inexpensive printing techniques were developed to make such images available to the public at large. In its new context, *ukiyo-e* also means images of the "modern" or "fashionable" world; experiences of passing things including the erotic and risqué that might be enjoyed as long as they lasted.

Building upon a native, generic tradition of *yamato-e* painting and popular religious prints, the *ukiyo-e* prints illustrated scenes from daily life, particularly the pleasure quarters of cities—the restaurants, baths, brothels, and kabuki theaters. Colorful prints of attractive young women and famous men actors from the kabuki theater—popular feminine and masculine ideals of the time—often took the place of the traditional images of the Buddha, noted samurai, and Zen masters and black and white images of monasteries, solitary meditators, and misty mountains.

No subculture has ever seen its interests and tastes expressed with such refinement. The *ukiyo-e* prints are magnificent representations of the tastes, desires, and pressures of an expanding social class within the hermetically sealed society that severely restricted its contact with the outside world. While the *ukiyo-e* prints are now highly valued and eagerly collected around the world, originally, they were priced so the working public in Japan could easily afford them. In the mid-nineteenth century, a print might cost about as much as a worker's meal. (See "*Materials and Techniques*: Japanese Woodblock Printing," page 194.)

Utamaro

In the hands of Kitagawa Utamaro (1753–1806), the Japanese print rises above the level of anecdote and narrative. Utamaro had access to a wide cross-section of Edo's intellectual élite and the most progressive thinking in the city through his publisher, Tsutaya Juzaburo (1748–1797). Their clientele included samurai, high-ranking officials working for the shoguns, important authors, and scholars of Western culture. Utamaro used bold lines and monumental figures that fill entire pages to create idealized images of Japanese women. The *Woman Holding a Fan*, from a series of prints called *Ten Aspects of Physiognomy of Women*, is a classic statement of a cultural ideal (FIG. 5.30). The

5.30 Kitagawa Utamaro, *Woman Holding a Fan* from *Ten Aspects of Physiognomy of Women*. Tokugawa period, 1793. Full-color woodblock print, 13 1/2 × 9 1/2" (34.6 × 24.2 cm). The Cleveland Museum of Art

appeal of its style results in part from the qualities of the well-matched colors and the contrasting areas of smooth and richly brocaded patterns. But, what is most important, the image depends upon the qualities of Utamaro's well-orchestrated flowing lines, traditional curves inspired by the ancient techniques of calligraphy and drawing in the Chinese–Japanese traditions. Yet, in comparison with many of the earlier styles of painting in Japan and China, the subject matter and casualness of the composition are revolutionary, and the upper classes in Japan at this time did not hold such prints in high regard as works of art.

Hokusai

Around 1800, as more Japanese traveled to and from Edo for business and pleasure, publishers opened shops along the major roads around the city, selling images previously restricted to books: single sheet maps, guides, and views of popular landmarks. This intensification of the traditional Japanese interest in *meishoe*, images of famous places with poetic associations, is well illustrated in the work of Katsushika Hokusai (1760–1849), the first major *ukiyo-e* artist to illustrate the activities of his day in context with Japanese landscapes. Many earlier Japanese artists had designed prints with landscape settings, but the emphasis was always on the figure, not the landscape. His print *The Great Wave of Kanagawa*, from the *Thirty-Six Views of Mount Fuji*, shows a giant, cresting wave rising high over three slender boats in a trough below (FIG. 5.31). Hokusai and many others considered Fuji, a venerated volcano which had erupted in 1707, to be a source of immortality. Against the distant backdrop of the sacred yet dangerous mountain, the wave in the foreground breaks into a multitude of tiny streams of suspended water and foam that reach out like claws to threaten the boatmen below. The monstrous mountain of water dwarfs everything in the picture, even the wave-shaped peak of Mount Fuji in the distance. The *Great Wave* has long been admired as a classic statement of the *ukiyo-e* aesthetic and widely regarded as a symbol of Japanese culture, and it encapsulates many features of Japanese thought that have been discussed in this chapter. In the spirit of Zen, the obedient oarsmen, samurai of the sea, move and bend in unison with the terrifying powers of the frothing, roaring waters. Working in harmony with the tremendous powers of nature and the sea, they are reminders of the long, unbroken lineage of the Imperial rulers who sustained themselves throughout Japanese history and the samurai code of

5.31 Katsushika Hokusai, *The Great Wave of Kanagawa*, from *Thirty-Six Views of Mount Fuji*. Tokugawa period, c. 1823–39. Full-color woodblock print, 10¹/₈ × 14³/₄" (25.8 × 37.5 cm).

honor, ideals that persisted within the chaotic feudal society of Japan. This understated image of discipline and persistence in the face of violence and chaos provides a fitting metaphor for this period of Japanese history as the unity of Japan as a nation had become a reality.

THE MEIJI RESTORATION (1868–1912)

On July 8, 1853, Commodore Matthew C. Perry arrived in Japan with a United States naval squadron of four ships and 560 men to establish trade relations with Japan. The success of this gunboat diplomacy weakened the shogunate and led to its fall and to the Meiji ("enlightened government") Restoration (1868), which reinvested political power in the emperor. These events underlined the superiority of Western technology and inspired the Japanese to modernize their country, avoid the colonial status to which much of the East had been reduced, and become an independent world power. A Japanese national charter oath in 1868 stated that "Knowledge shall be sought throughout the world so as to strengthen the foundation of Imperial rule."

Between 1862 and 1910, Japan participated in thirty-six international exhibitions where they acquired accurate and up-to-date information about Western art and industry. The Japanese talked of combining "Eastern ethics and Western science," but assimilating the Western traditions while maintaining a Japanese identity was a great challenge. Japan wanted to blend the best of their own past with modern ideas from the West. European artists and architects arrived to work and teach in Japan, and Japanese students matriculated in the West. For Japanese artists, this commitment to "blend" created certain unavoidable problems. They could no longer be Japanese artists in the traditional sense. Many of the time-honored Japanese art forms such as the Kano school-styled screen paintings, *ukiyo-e* printmaking, and calligraphy continued to be practiced in Japan after 1868. But, while those practitioners might be recognized as preservers of the Japanese heritage and cultural treasures within Japan, would they be recognized around the world as artists? Could a Japanese artist become recognized as such outside Japan without breaking ties to the Japanese traditions? An avant-garde emerged in Japan and looked for ways to combine the best of the East and the West. Some artists began where the painters of the *namban jin*, screens representing Westerners and their ships, left off after the Europeans were expelled in the early seventeenth century. Some artists looked for ways to incorporate Western subject matter into *ukiyo-e*-style prints. Others studied with Western teachers, learned how to work with oils, and painted modernist images of Japanese subjects.

At the same time, the Japanese were struggling to find ways to accommodate the cultural changes thrust upon them, the vogue for Japanese art in the West was changing the course of Western art. Ultimately, the intense aesthetic dialogue between Japan and Europe that followed in the next half-century was a major influence in the development of both Eastern and Western art. (See "*Analyzing Art and Architecture*: Van Gogh and *Japonisme*," pages 198–9.)

PRINTMAKING AND PAINTING

Given the importance of printmaking in Edo Japan, it is not surprising that printmaking continued to interest Japanese artists of the Meiji Restoration. Japanese artists schooled in the *ukiyo-e* traditions of printmaking flocked to Yokohama, a harbor and trading center near Edo (renamed Tokyo in 1868), where the first main East–West contacts were being made. Even before the Meiji Restoration in 1868, some Japanese artists began making large and detailed topographic views of the rapidly expanding port. Others, working in the tradition of the *namban byobu* painters, made images of the "black ships" (steam-powered vessels with smokestacks) and exotic foreigners who sailed them.

Van Gogh and Japonisme

When Japan began trading with the outside world, many Europeans, and later Americans, became fascinated by Japanese art and culture. This vogue became known as *Japonisme* (French for "Japanese style"). Many of the leading painters working in Britain and France assembled large collections of Japanese prints. These prints, which had little monetary value in Japan, were often used as packing and wrapping paper for other Japanese goods. The Western artists were fascinated by the prints' brilliant colors, unorthodox points of view, asymmetrical compositions, and images of everyday life, some of which were erotic. This new style of image-making was particularly appealing to artists who were discontent within the classical and academic traditions governing the late nineteenth-century art world in Europe. Many of the best-known Impressionists and Post-Impressionists, the recognized founders of early modernism in the West, were deeply influenced by Japanese art. So much of what we accept as European and modern about the colors and compositions of these artists was, in fact, inspired by Japanese woodblock prints.

The attitudes behind *Japonisme* differed from those which created the vogue for *chinoiserie*. That earlier interest in the exotic and fantastic sides of Chinese art seldom if ever led artists to a deeper understanding of the aesthetics and cultural values underlying the art. For example, Vincent van Gogh (1890), who owned many Japanese *ukiyo-e* prints, wanted to understand the creative impulses behind Japanese printmaking, especially the joy with which the artists used color. This led him to make some "interpretive" copies of prints by Ando Hiroshige (1797–1858), Hokusai's younger contemporary.

Hiroshige had taken advantage of the new opportunities in Japan to travel. His sets of *meisho-e*, images of famous places along the most traveled Japanese roads, were purchased by a public that

5.32 Ando Hiroshige, *Ohashi Bridge in the Rain*. From *One Hundred Famous Views of Edo*. Color woodcut, height 13⁷/₈" (35.5 cm). Fitzwilliam Museum, Cambridge

also enjoyed the new novels and kabuki plays about on-the-road adventures. Hiroshige's final set of topographic prints, *One Hundred Famous Views of Edo* (1856–1859), appeared while Japan was opening its doors to outside trade and many of them reached Europe. Vincent van Gogh made copies of works from this set, the best-known of which is *Ohashi Bridge in the Rain*.

Pedestrians crossing a bridge, caught in the rain, scurry in both directions for cover (FIG. 5.32). The composition is organized around the diagonal accents of the bridge, tree-lined shore, and the thin dark lines of falling rain that connect the black rain clouds in the sky with the dark, shadowed water under the bridge. Making his copy, Van Gogh intensified the blueness of the sky and the brownish-yellow of the bridge while adding green and white wave patterns to the water (FIG. 5.33). He added yet more green to the red-trimmed frame he invented for the work, but removed the rectangular cartouches from the work itself. Along with the bold patterns of brushwork in the painting and red calligraphy on the frame, the changes that Van Gogh made in his "copy" of Hiroshige's print are part of his study of Japanese color and his search to find ways of using Japanese art to enhance the expressive qualities of his own painting.

5.33 Vincent van Gogh, *The Bridge in the Rain.* Copy after Ando Hiroshige, 1887. Oil on canvas, 28³/₄ × 18¹/₄" (73 × 54 cm). Van Gogh Museum, Amsterdam.

A print by Hasimoto Sadahide (1807–1878/79), *Foreigners in Yokohama*, presents an image of daily life in the international sector of that city (FIG. 5.34). A tall Westerner with bony cheeks, nose, and chin, wearing a long frock coat and rumpled scarf, pulls back a pair of window curtains to look out upon a much shorter Japanese man with a parasol and a pair of ducks. This image of Eastern and Western gazes meeting at close range would have been commonplace in Yokohama at this time when the *namban jin* ("Southern barbarians") who had long been restricted to their off-shore trading quarters now shared this part of the trading city with the Japanese.

With the end of the Tokugawa shogunate in 1868 and the beginning of the Meiji Restoration, the sphere of Western influence in Japan expanded from Yokohama to Tokyo and other metropolitan centers. Printmakers began to incorporate more visual information from photography and Western graphics as they documented such topics of interest as the activities of the Imperial family and military actions in the Japanese wars with China and Russia at the turn of the century. However, it was not until the rise of postmodern criticism near the end of the twentieth century, which accepted inconsistency and contradiction as integral parts of contemporary thought, that the eclecticism of these artists' works was accepted as a positive feature.

Western influences became even more pronounced when Japanese artists studied with European oil painters in Tokyo and Europe. The Japanese had been introduced to oil painting before the Euro-

5.34 Hasimoto Sadahide, *Foreigners in Yokohama: Igirisujin (Englishman) and Nankinjun (Chinese).* 1860s. Color print from wood blocks, 13⁵/₈ × 9" (5.5 × 3.5 cm). Victoria and Albert Museum, London

peans were expelled in 1638, but in essence, the medium and its potentialities were new in Japan. While the Western sources for some of the Japanese painters in this period of eclecticism are quite obvious, this is not the case in *Paradise under the Sea* (FIG. 5.35). This is the best-known work of Aoki Shigeru (1892–1911), a graduate of the Tokyo School of Fine Arts.

According to an ancient Japanese legend, Prince Fire-fade visited the Palace of the God of the Sea and fell in love with his daughter. The composition of this encounter, with two women holding a vase in a tall narrow frame, and the theme, a romantic mythological narrative, reflect Shigeru's interest in the English painters known as the Pre-Raphaelites. However, Shigeru worked much more like the French Impressionists, using light, feathery brushstrokes and making sketches from nature. While planning the *Paradise*, Shigeru went a step further in the study of nature than the Impressionists; he used a diving suit and helmet to make sketches of light and color effects of objects under the sea in the bay of Nagasaki. Amazingly, the brushwork in the *Paradise* captures these fleeting effects of reflected and diffused light in the women's wet dresses and the shadowy skin of the prince. While incorporating ideas from Impressionism, Shigeru combines his scientific knowledge of aquatic light with Japanese counterparts to the narratives of the Pre-Raphaelites to produce one of the masterpieces of the Meiji Restoration.

5.35 Aoki Shigeru, *Paradise under the Sea*. 1907. Oil on canvas, 71¹⁄₂ × 27⁵⁄₈" (182 × 70 cm). Ishibashi Museum of Art, Ishibashi Foundation, Kurume

THE MODERN PERIOD (FROM 1912)

Many Japanese artists continued to study in Europe or in Japan with European-trained artists and to experiment with the most current avant-garde, modernist styles until the 1930s. At that time, the Japanese government began to view the avant-garde with suspicion, linking it with subversive, left-wing politics and Communism. Thereafter, the progressive art world in Japan remained essentially dormant through World War II (1939–1945) and the American occupation of Japan (1945–1952). Following nearly two decades of war and suppression, a new generation of Japanese artists burst on the scene and established Japan as one of the major centers of mid- and late twentieth-century art.

ARCHITECTURE

Frank Lloyd Wright (1867–1959), who had been deeply influenced by Japanese architecture as a young man in the 1890s, had just finished the Imperial Hotel in Tokyo when the earthquake of 1923 hit the city. Wright had visited the Columbian Exposition of 1893 and been deeply impressed by the Japanese exhibition, which included a replica of the eleventh-century Phoenix Hall near Kyoto (see FIG. 5.12). This inspired Wright to visit Japan in 1905, collect Japanese woodblock prints, and design buildings that combined elements of Eastern and Western aesthetics and technology. Wright's Imperial Hotel in Tokyo, built of reinforced concrete, survived the earthquake of 1923 which leveled most of the large buildings in the city, and inspired a generation of young Japanese architects to study Western architectural engineering. They looked for ways to use the Western ideals that respected their traditional Japanese interests in modular forms, open and flexible spaces, and their love for natural materials in buildings integrated with their surroundings in nature.

Following the Allied bombing raids near the end of World War II that destroyed most of the large buildings in Tokyo for the second time, new buildings of every kind were needed. Tange Kenzo (born 1913) was one of the architects of the postwar period who rose to meet this challenge—to combine the traditional Japanese ideals with the new materials and technology. When Tokyo was awarded the 1964 summer Olympic games, Tange created a magnificent indoor stadium that became the centerpiece for this international gathering of nations (FIG. 5.36).

5.36 Tange Kenzo, Olympic Stadium, Tokyo. 1964

Many indoor arenas built before this time had used massive pillar roof supports that invariably interfered with the spectators' views of the sporting events. Tange suspended the roof of his stadium from heavy steel cables, giving it an elegant tent-shaped outline that reflected the tall peaked profiles of ancient Shinto shrines. This system of engineering also enabled Tange to remove the troublesome interior pillar supports and give spectators a new sense of being part of the spaces and actions they were watching. Materials are used in a way that respects their integrity, spaces are fluid, and the roof lines make sweeping gestures across the landscape, uniting the stadium with the spaces around it in a dynamic manner that cannot be conveyed in a single still photograph.

PAINTING, FILM, AND VIDEO

In 1954, Yoshihara Jiro (1905–1972), one of the avant-garde Surrealist painters of the 1930s suppressed by the government, reemerged to establish the Gutai Bijutsu Kyokai ("Concrete Art Association") in Osaka. A year later the Gutai group staged the "Experimental Outdoor Exhibition of Modern Art to Challenge the Mid-Summer Sun" in the beach-front town of Ashiya, near Osaka. The exhibition included sculptures made of machine parts mounted in the sand, a pink sheet of vinyl flapping in the wind, and a long painting tied to trees. "Create what has never existed before," Jiro told his Gutai group. During its eighteen-year history, the group experimented widely with new forms of visual expression, making indoor and outdoor installations and working with film, action events, theater, and music in an attempt to combine the ideas from the Japanese past with new ideas emerging in Western art.

Of the thousands of such works produced by the Gutai artists, very few were preserved, except in photographs. To demonstrate the importance of process in their thinking, the moment of creation, and the preeminence of the philosophy inspiring the works, the materials from the first exhibition were deliberately destroyed after it closed.

At the second Gutai art exhibition in Tokyo (1956), Gutai artist Shiraga Kazuo (born 1924) was photographed doing a performance piece, painting with his feet (see FIG. 1.6). He is shown working on the floor, in the manner of the contemporary American Abstract Expressionist and action painter Jackson Pollock. Moving in dance-like patterns, Shiraga creates massive black forms or "characters," a monumental but illegible sort of calligraphy that ties his work to that important Japanese art form while embracing international trends in art in the 1950s. Kazuo's work also recalls the so or haboku ("splashed ink") style of Sesshu and the Japanese belief that such accidental patterns of "splashed" ink can be spiritually inspired.

Some of the ideals of the movement are expressed in its name: Gutai (gu, "tool" or "means," and tai, "body" or "substance") means "concreteness" and symbolizes the concrete nature of the actions and objects in the Gutai works. Jiro said it was his desire to "give concrete form to the formless." In regard to forms and all objects in nature, the group espoused a Shinto-derived respect for their natural or innate qualities as expressed in the Shinto temples and tea ceremony. They also had a Zen Buddhist respect for spontaneity and the "accidental" effects that might take place in the moment of creation. They saw their work as an interaction between the concrete and spiritual realms, as the expression of a universal human consciousness with a childlike sense of freedom and purity.

This philosophy was created in large by their leader, Yoshihara Jiro, the former Surrealist painter. Surrealism, which originated in Europe in the 1920s, incorporated the theories of Sigmund Freud of Austria and Carl Jung of Switzerland, who believed that artists could express certain deep-seated emotions and universal ideas residing in their unconscious minds. This Surrealist concept, combined with the Buddhist conception of the Universal nature of the Buddha, inspired the Gutai group to find ways to express this Eastern–Western concept of universal ideas through their art by uniting and releasing the combined powers of mind and matter.

To a degree, like other movements in the arts of this period, the Gutai philosophy was also a reaction to the brutality and futility of World War II, which ended with the awesome spectacle of the atomic blasts in Japan at Hiroshima and Nagasaki. But the Gutai events and exhibitions were not overtly political in nature, as were those of many Tokyo-based artists of this time. Instead, they pointed to the idea of rebirth and the freedom of Japan from the totalitarian rule of its Imperial government, the hardships of the war years, and the psychological shame inflicted by the postwar occupation. In the first edition of the group's journal, *Gutai*, Yoshihara wrote, "Our profound wish is to prove concretely that our spirits are free." Writing in English, Yoshihara called out to the West, asking readers to see his group as part of the international art world. Historians continue to debate the degree to which modernist movements in the West may have been influenced by the Gutai group.

In 1960, many young Japanese dramatists, writers, and artists were outraged when the Japanese government renewed the U.S.–Japan Security Treaty which allowed the United States to retain armed forces in Japan. The politically active "post-Hiroshima generation" revolutionaries drew upon childhood wartime memories and native themes of suffering and death from the dark side of Japanese legends and folklore to make what became known as "Obsessional Art." Often, their obsessions with madness, sex, primitive passions, and suffering were presented in grotesque ways that were, by design, deeply upsetting to audiences.

This expressionistic side of postwar thought in Japan became manifest in the New Wave films movement. One of most widely circulated and influential of these films, *Suna no Onna* ("Woman of the Dunes") made in 1964 by Hiroshi Teshigahara, is based on Kobo Abe's existential novel of that name (FIG. 5.37). Produced for the modest sum of $100,000, the film won first prize at the Cannes Film Festival (1965) and was nominated for an Academy Award as the best foreign-language film that year.

In the film, villagers in a desert capture a man from the outside world (Niki, played by Eiji Okada) and lower him into a pit in the dunes. A nameless woman there, played by Kyoko Kishida, spends each night digging in the sand, filling a bucket on a rope which the villagers raise so the sand will not engulf her and her small house. Although Niki had been unhappy with the artificiality of his socially constructed identity before being imprisoned in the pit, he tries repeatedly to escape. Gradually, Niki realizes that he is trapped in their pit, just as he had been trapped in society, and he begins to accept his new life.

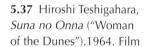

5.37 Hiroshi Teshigahara, *Suna no Onna* ("Woman of the Dunes").1964. Film

The film depends heavily on the viewer's understanding of its symbolism. The most important symbol, sand, portrayed as a constantly moving and changing force that can destroy people, represents society. Using extreme depth-of-focus shots, Teshigahara captures the enormity of the sandy waste land and the smallness of the people within it.

A strong anti-Western, anti-rational, and anti-modernist reaction in Japan was mounting to the pseudoheroism of Abstract Expressionism and the commercialism of Pop Art and other product-driven, New York-based movements of the early 1960s. Artists loosely associated with a Japanese "School of Metaphysics" combined the Eastern aesthetics and non-logical approach of Zen Buddhism with the anti-art, anti-establishment ethics of Dada, a Western anti-war movement born out of World War I. As part of this strong Neo-Dada movement, the Japanese artists played important roles in two of the movements reacting to the mercantile hegemony of New York City and other Western art capitals: conceptual art and Fluxus.

John Cage (1912–1992) of the United States, a composer, performer, aesthetician, Neo-Dadist, and student of Daoism and Zen Buddhism, influenced members of an international group called Fluxus (c. 1960–1978) that included Japanese artists. George Maciunas (1931–1978), founder of Fluxus (Greek for "flowing"), said it attempted to "promote living art," to counter the "separation of art and life." With its many active Asian members, Fluxus debunked some of the Euro-American modernist myths about the transcendent character of art and gave new meaning to the rituals of ordinary daily living. Fluxus also broke down geographic barriers and demonstrated convincingly that movements in the arts could be fully universal and need not depend upon the support of New York City's network of galleries and museums.

The Tokyo-based Fluxus group of the early 1960s included Cage, Yoko Ono, and Korean-born Nam June Paik (born 1932), who had studied aesthetics at the University of Tokyo and worked with the German Fluxus group before returning to Tokyo in 1963. Yoko Ono was one of the first artists to use prescriptive language as an art form, putting instructions on the wall of a gallery for a "painting to be constructed in your head." Other such postings by Yoko Ono included *koans*, riddles like those used by Zen masters to lead students to enlightenment.

A meeting with Cage in 1958 led Paik to see the potential of television and, later, video as art forms capable of expressing ideas that united Eastern and Western lines of thought. Later, Paik said that just "as collage technique replaced oil paint, the cathode ray tube will replace the canvas." Video differs from film in some critical ways. The video image is formed by a series of rapidly moving points of light striking the inner surface of a monitor screen. Therefore, unlike film, photography, painting, and the other two-dimensional media, the observer is unaware of a material surface other than the glass window upon which the light is projected. Video art may also differ from cinema and television in what is shown and the conditions in which it is viewed. Video arts may use multiple monitors, create new spatio-temporal dimensions, and through the use of other electronic devices, particularly computers, create images that are readily distinguishable from television and cinema.

Working with Shuya Abe, a Japanese engineer and inventor, Paik developed a video synthesizer that could alter colors and shapes and superimpose them to create electronic

5.38 Nam June Paik, *TV Buddha*. Video installation with statue. 1974. Stedelijk Museum, Amsterdam

video collages. Pushing the available technology of video to its limits, Paik discovered ways to make the technical circuitry behave in statistically random and "human" patterns. Assembling large numbers of television sets in the shape of pyramids, triumphal arches, and billboards, with complex patterns of changing images keyed to or counterpointing loud electronic scores, Paik produced complex video installations that became powerful and all-encompassing visual experiences. Some of his smaller installations are equally impressive for their subtle wit, Dada-style puns, Cage-inspired Zen riddles, and theories of communication.

Paik's *TV Buddha* (1974) is seated before a video camera and watches his own image on a monitor embedded in a mound of earth resembling a small stupa (FIG. 5.38). The installation is a Dada/Zen-style riddle–pun on the achievement of the original historical Gautama Buddha, who found enlightenment through contemplation and withdrawal from the culture around him. It also juxtaposes the timelessness

5.39 Yanagi Yukinori. *Hinomaru Illumination (Amaterasu and Haniwa).* 1993. Neon and painted steel, with ceramic *haniwa* figures. Neon flag: 118 x 177⅛ x 15¾" (300 x 450 x 40 cm); each *haniwa* height c. 39" (99 cm). The Museum of Art, Kochi

of the Buddha's teachings with the instantaneous nature of television and puts the Buddha on a screen where modern audiences normally watch such non-Buddhist programs as sit-coms, soap operas, and sporting events.

With the death of Hirohito (reign name, Emperor Showa) in 1989, the Showa era that began in 1926 came to an end. Soon thereafter, the Japanese economy broke and their Nikkei stock index lost nearly half its value by the end of 1990. In the crash, some prominent Japanese figures were indicted for illegal financial activities and the Liberal Democratic Party, symbol of Japan's postwar economic boom, was defeated in 1993.

The death of the emperor, who was once considered divine, opened the door to public debates about his role in the imperial wars (1931–1945) and other acts of Japanese aggression toward its neighbors that had been hidden behind the power of *tenno-sei* (the modern emperor system). The art of the post-Hirohito era in Japan soon began to confront some of the myths about this system. Some artists satirized the way the Japanese had "bought" culture during the boom years; others created images that combined the style of Ukiyo-e prints (see FIG. 5.33), images of that earlier "floating world" of Japan, with modern Western images to comment on the character of Japanese society at the end of the century.

Hinomaru Illumination (Amaterasu and Haniwa) by Yanagi Yukinori combines symbols of imperial power from several historical periods to express many of these concerns (FIG. 5.39). Terracotta tomb sculptures, replicas of the *haniwa* tomb figures from the Kofun period that encircled royal tombs (see FIG. 5.4), face a billboard-size neon sign resembling the Japanese "Rising Sun" flag. Although the flag has been banned since World War II, it remains a lasting

symbol of Japanese imperialism and the reign of the Showa emperor. The manner in which the powerful red sun symbol controls the *haniwa* figures seems to symbolize the way in which *tenno-sei* inspired a spirit of nationalism among the mid- and late twentieth-century Japanese and their drive for military and economic power.

SUMMARY

The ancient and native aesthetics of Shinto ingrained in the history of Japanese art and architecture remain part of Japanese thinking to this day. This religion and its aesthetics emphasize purity, harmony with nature, a respect for the intrinsic nature of materials, simplicity, rusticity, obedience, and the value of traditions. The Buddhist arts of China and Korea that arrived in Japan in the sixth century underwent many changes as they were refined and adapted to this Shinto-based aesthetic.

The influence of this aesthetic on the arts of Japan over the years is tremendous. Painting may have many open, seemingly empty spaces, Shinto shrines continue to be built like ancient village granaries, Japanese poems may be very terse, élite forms of drama are highly restrained and formalized, and the famous Japanese tea ceremonies include many long periods of silence for contemplation.

In their subtlety and refinement, the apparently simple forms of Japanese art are deceptively complex. They demand that the viewer take an active part in their appreciation, to contemplate and experience them slowly and literally to meditate on them, as their makers did when they conceived them. In this process, the slowing of action, or even inaction, becomes a very important "activity" of the artist and observer.

Japanese art has survived many foreign influences, from Korea, China, and, recently, the West. After Japan reopened her doors to the outside world in the 1850s, Japanese art entered into an ongoing dialogue with the art and culture of the West. While traditional forms of art are still being produced in Japan, the avant-garde there has made many important contributions to the international art world.

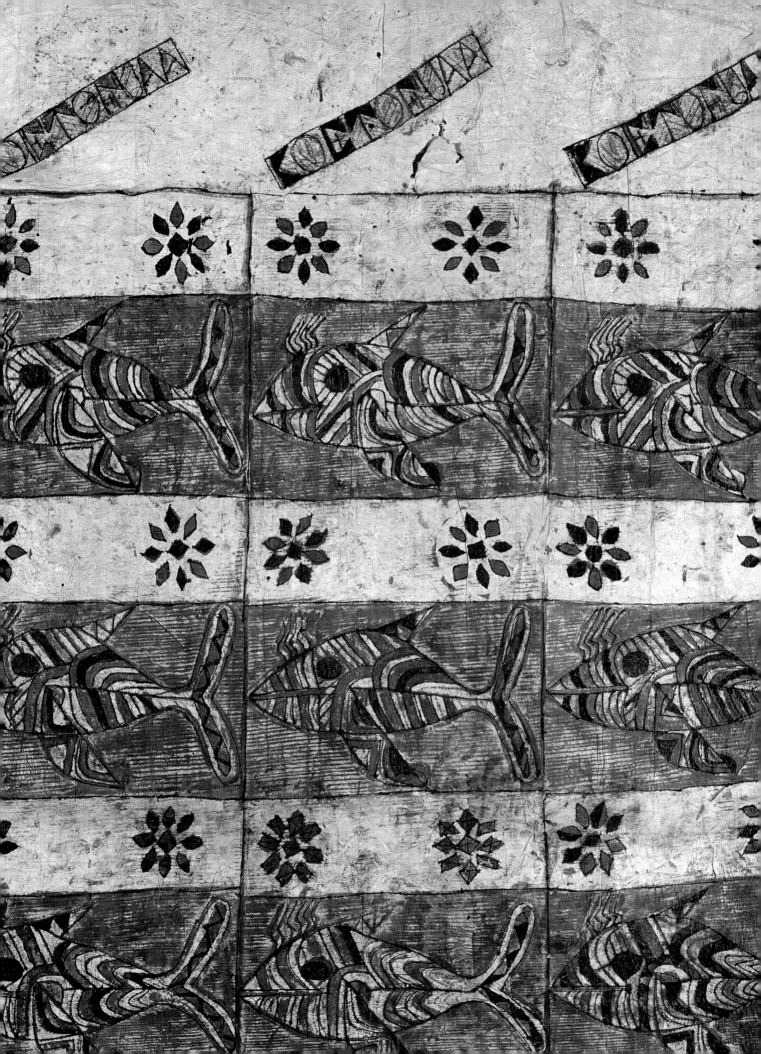

CHAPTER SIX
THE
PACIFIC

Equator

THE PACIFIC

This survey of the art of the Pacific includes portions of northern Australia, Melanesia, Micronesia, and Polynesia. Melanesia ("black islands") is composed of a long crescent of relatively large, closely spaced islands west of Indonesia and north of Australia. Many of the islands of the region to the north, Micronesia ("small islands"), were formed by coral reefs growing over submerged volcanoes. To the east, Polynesia ("many islands") is a large triangular area defined by New Zealand, Easter Island, and the Hawaiian archipelago. Melanesia and Micronesia are also known as Near Oceania, while Polynesia is called Far Oceania.

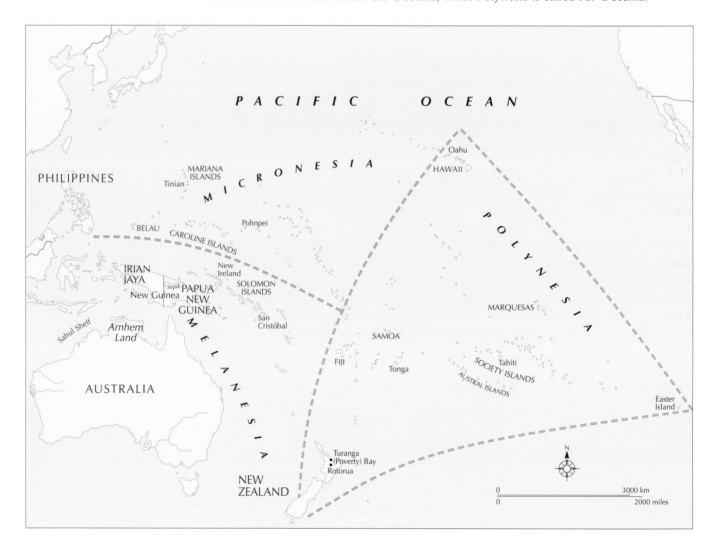

TIME CHART

Aboriginals arrive in Australia (c. 40,000 BCE)

Earliest Aboriginal art (c. 30,000 BCE)

Emergence of the Lapita culture in New Guinea (c. 4000 BCE)

Emergence of Aboriginal "X-ray" or "in-fill" style (c. 2000–1000 BCE)

Fiji, Tonga, and Samoa occupied (1150 BCE)

Marquesas Islands occupied (c. 200 BCE)

Hawaii occupied (c. 300–400 CE)

Easter Island occupied (c. 400–500 CE)

New Zealand occupied (c. 900 CE)

 Nga Kakano—The Seeds (900–1200)

 Te Tipunga—The Growth (1200–1500)

 Te Puawaitanga—The Flowering (1500–1800)

 Te Huringa—The Turning (1800–present)

Easter Island, Ahu/Moai Phase (1000–1500 CE)

Easter Island, Decadent Phase (1500–1722)

Height of New Zealand Poverty Bay School (1840–1875)

INTRODUCTION

Around 1900, a small group of avant-garde European artists and art dealers began collecting art from the Pacific islands. Some of them were moved by an unusual sense of power they found in it. (See "*Cross-Cultural Contacts*: Paul Gauguin and Polynesia," page 212.) That conception of power was equally important to many of the Pacific islanders who made and used the art. It was part of a complex cultural ideal in many locations called *mana* ("sacred power"). Individuals, works or art, and a wide variety of other objects can all have *mana*. In some areas of the Pacific, *mana* is envisioned as an invisible but forceful spiritual substance, a manifestation of the gods on earth that can link people with their ancestors and the gods.

People may acquire *mana* in several ways. Since the lineage of a chief may descend from the gods, he and his immediate family are born with sizable quantities of *mana*. The amount of *mana* other nobles receive depends upon how closely related they are to the chief's family. A noble might increase his or her *mana* through skillful and courageous deeds, or decrease it by cowardice or enslavement. The *mana* residing in a person or object is protected by *tapu*. A *tapu* is not a law as such, but indicates a state of restriction, that an object or person cannot be touched or a space cannot be entered. Violating a *tapu* can seriously reduce the *mana* of a work of art or an individual.

The *mana* in works of art made in the service of the gods comes from the *mana* in the materials of which they are made, the *mana* of the artist, the care and correctness with which the rituals attending the production of the art are performed, and the quality of the workmanship. Later, the *mana* in a work of art can be increased by the status or *mana* of its successive

owners and the importance of rituals honoring the gods and ancestors in which it is used. Valued heirlooms passed down from one generation to the next in royal families can accumulate tremendous quantities of *mana*.

Many Pacific islanders believe the human body is the meeting place of this world of everyday existence and the divine world of the ancestors and gods. Therefore, the body occupies a central position in this concept of *mana*. Individuals of high rank can increase *mana* they have inherited and gained through deeds by wearing certain items of noble dress such as cloaks, belts, and headdresses, and by their own body art—scarifications and tattoos.

Certain locations were believed to have unusually large quantities of *mana*. On many Polynesian islands, sacred places known as *marae* were focal points for rituals dedicated to the gods and ancestors. *Marae* might be walled, have platforms or ledges to display works of art, altars for sacrifices, and storage buildings for precious objects. In the nineteenth century, the Maori of New Zealand began building meeting houses at their *marae* that symbolized the cosmos, the gods, and venerated royal ancestors. This combined symbolism made them magnificent constructs of power, great seats of the *mana* in a society struggling to maintain itself under a European colonial government.

When *mana* is manifest in objects of great beauty, works Westerners call "art," the concepts of *mana* and spiritual power seem to be linked to Western ideals of beauty and aesthetics. At times, the Pacific and Western ideas may coincide, but the pervasive quality of *mana* cannot be entirely explained and understood by this analogy with Western art. As one examines where, when, and how *mana* is manifest in Pacific art, the full complexity and richness of this magnificent cultural ideal of unworldly power begin to unfold. It marks the

IN CONTEXT

The Spread of Art and Culture in the Pacific

Around 50,000 BCE, during the last ice age, which began about 2.5 million years ago, the oceans were about 330 feet (1,000 m) below their present level. Large portions of Melanesia—including New Guinea, New Britain, New Ireland, and Australia—were a single land mass or continental shelf scholars call Sahul. It was separated by a narrow passage of water from Sunda, another continental shelf linking Indonesia and the Philippines. Successive waves of people from Southeast Asia reached portions of Sunda and Sahul by 40,000 BCE. After a long hiatus, with the appearance of the seafaring Lapita culture around 4000 BCE, the ancient voyagers used the islands as stepping stones to populate the Pacific. Through a combination of deliberate journeys, exile voyages, and accidental drifts, they crossed broad expanses of uncharted waters to reached Fiji, Tonga, and Samoa by 1150 BCE. There, basic forms of the Polynesian language and culture were developed. By around 200 BCE, the voyagers discovered the Marquesas Islands, from which they sailed to the more remote Polynesian outposts of Hawaii (c. 300–400 CE), Easter Island (c. 400–500 CE), and New Zealand (occupied c. 900 CE).

In some areas, the art of Melanesia has been influenced by neighboring islands in Indonesia. Some scholars look for influences from the other direction as well and believe that the Polynesians made contact with the Americas. At present, however, there is no concrete evidence to prove this theory. For the most part, the styles of arts in Oceania developed regionally, on islands or island groups, in context with religious beliefs and associated rituals that included forms of oratory, poetry, dance, and music. Together, these systems of communication enabled the Pacific islanders to interact with the supernatural forces and operate their societies. Given the vast distances separating archipelagos and individual islands, it is not surprising to find many distinct regional cultures with distinguishable belief systems, rituals, and art styles, many of which remain vital parts of everyday life.

most important rites of passage in life, explains an individual's accomplishments and status in life, and enables the living to contact their ancestors and gods. It can lift the individual from one station in life to another and from this world to the other world of the spirits. In the tradition of the artists and collectors a century ago who sensed and appreciated this special and pervasive power in the art of the Pacific, we too may focus upon this idea of power or *mana* as we study the art in terms of the ideals through which it was created. (See *"In Context:* The Spread of Art and Culture in the Pacific," page 212.)

AUSTRALIA

In the past decades, the Australian Aboriginals, who account for less than two percent of the country's present population, have produced many of Australia's most respected and internationally famous artists. Their art today reflects some very ancient traditions. The Aboriginals may have arrived in Australia as early as 40,000 BCE when the sea level was lower and Australia was part of a land mass easily accessible from Southeast Asia. As they spread across much of Australia, the Aboriginals developed a variety of regional cultural patterns based on a hunting and gathering economy. They left a permanent record of their existence in rock art, the earliest examples of which in Central Australia are more than 30,000 years old. They belong to the Upper Paleolithic period (c. 40,000–9000/8000 BCE). ("Paleo" and "lithic" come from Greek words for "old" and "stone"; in common usage, the Paleolithic is the "old stone age.") The Australian works have special importance because they predate the oldest known Paleolithic cave art in Europe. They are also plentiful: the World Heritage Kakadu National Park in the Arnhem Land Plateau in northern Australia includes more than 5000 rock art sites.

The vast Australian outback where most of the Aboriginals have lived has long been regarded by the rest of the world as an inhospitable and uninhabitable wasteland. The Aboriginals have never seen it this way. They not only inhabit the land; in spirit they are part of it. To them, there is no difference between nature and culture—they do not exist apart from the land. This belief, very much alive today, continues to inspire many of the most important Aboriginal works of art.

DREAMING: THE SPIRITUAL WORLD

Traditionally, the Aboriginals had no permanent architecture, but some natural sites sacred to particular clans were used for seasonal rituals over long periods of time. During these communal gatherings, they made feather and fiber objects, rock engravings and paintings, portable sculptures, ground markings with sand, sticks, and colored pigments, body paintings, and painted on the bark from the stringbark tree (*Eucalyptus tetradonta*).

To understand how these art forms reflect the Aboriginal world view, it is important to examine the Aboriginals' myths about creation and the land around them. In ancient times, as the immortal, mythic Aboriginal Ancestor spirits traveled, they created the land and became part of it, and they remain within the rocks, flora, and fauna to this day. Within the land, the Ancestors continue to create, causing the changes the Aboriginals see every day. To live among the physical manifestations of these spirits, the Aboriginal must communicate with them and invoke their blessings to survive on these lands. Art and ritual became the conduits through which the Aboriginals linked or bonded with the spirits of their Ancestors and the land. The spirits of the Ancestors, the manifestations of the Ancestors' powers in this world with all its natural features, from creation to the present, and Aboriginal society are all parts of a seamless fabric in Aboriginal thought. Some Aboriginals call this all-encompassing immaterial or spiritual world *Jukurrpa*, which translates as something like

6.1 *Hunter and Kangaroo.*
Oenpelli, Arnhem Land,
Australia. c. 1912. Paint
on bark, 51 × 32" (129 ×
81 cm). Museum Victoria,
Melbourne, Australia

"dreaming" in Aboriginal pidgin English. However, the meaning of this word for the spiritual world should not be confused with "dreaming" in standard English. To the Aboriginals the word signifies the other world created by the supernatural beings and ancestors, along with its religious ceremonies, laws, and art forms. It is a kind of landscaped-based mythology that ties the individual to a place and its spiritual powers which come alive in myths, rituals, and arts.

Each Aboriginal is tied to a particular episode or part of the Dreaming and has certain rights and obligations to that segment of the Dreaming's lands, myths, rituals, and arts. A work of art can be made by an individual artist or group of artists who share in the rights to that portion of the Dreaming.

In Aboriginal thought, the artist does not invent or create art—the original designs created by the Ancestral beings are given to artists who transmit or copy them for others to see. In this sense, the Aboriginal artist represents (literally "re-presents") the power of the Dreaming in the form of earthly visual images. In this system of belief, which denies humankind the creative powers of the supernatural beings, the artist's challenge is to find ways to rediscover, copy, and reactivate the images of the Dreaming. In so doing, the artist performs a very important function for his or her community, giving form and presence to that which was formless and timeless in the Dreaming.

MIMI AND THE "X-RAY" STYLE

According to Arnhem legends, spirits called the *mimi* made the earliest rock paintings and taught the art of painting to the ancestors of the present Aboriginals. In figure 6.1, a *mimi* figure spears a kangaroo whose backbone and organs are visible—as if its hide were transparent. This technique of making conceptualized see-through images known as the "X-ray" or "in-fill" style, may date back to about 2000–1000 BCE. The technique was still being practiced when European settlers arrived in the nineteenth century. The powers of the *mimi* and Ancestors of Dreaming are released through such works of art and their associated rituals, songs, oral literature, and dances, which establish contact between the present and the past. Although two centuries of European contact have changed many aspects of Aboriginal society, this traditional philosophy behind its arts survives and it continues to inspire contemporary works of arts and ceremonials.

RECENT ABORIGINAL PAINTING

In the 1920s, anthropologists began giving crayons and paper to Aboriginals and encouraging them to transcribe images from the Dreaming. It was not until 1971, however, when artists of the western desert began working with acrylic paints on canvas and bark, that the true scope and magnificence of their Dreaming imagery were revealed. Soon, Aboriginal artists working with outside advisors began exhibiting their large and colorful acrylic paintings around the world, often touring with them and publicizing the Aboriginal philosophy of art and culture.

The art of the present-day Aboriginals, like that of their predecessors in ancient times, stems from the Dreaming, and artists working with their part of the Dreaming attempt to rediscover and recreate the images created by the Ancestors. The complex symbolism of one such modern Aboriginal painting, *Sacred Places at Milmindjarr*, by David Malangi from Central Arnhem Land, represents the mythic geography of his clan's homeland (FIG. 6.2).

Sacred Places is a story about the Djan'kawu sisters, who traveled by canoe and walked over the land, creating the people, their languages, water holes, the landscape, and the ocean. Malangi's dot patterns and repeating patterns of abstract lines may resemble the formal features of some twentieth-century styles of abstract and nonobjective painting. These elements, however, have complex cultural meanings in Aboriginal thought. The brightness of the crosshatching patterns reflects the spiritual powers of the ancestors who are manifest in the paintings. The artist's method of telling the story is conceptual, as opposed to perceptual; the geometric forms in the work and their composition follow complex rules of order as they relate the narrative of the myth. The main features of the myth may not be immediately apparent to all viewers and they are identified by numbers in the illustration.

Paintings such as Malangi's are exciting to international audiences: not only are they authentic expressions of a very ancient culture, but they also appeal to the tastes or aesthetics of Western viewers. They explain a traditional world view untainted by Western thinking in abstract or nonobjective forms similar to those used in some modernist movements, forms that seem to have a universal appeal.

MELANESIA

As early as 25,000 BCE, portions of Melanesia as far east as San Cristóbal were occupied by speakers of a Papuan language. At that time, most of Melanesia was part of Sahul, a large continental shelf within easy reach of the Asian mainland. (See "*In Context*: The Spread of Art and Culture in the Pacific," page 212.) A new culture of seafaring Austronesian language-speakers appeared in Melanesia around 4000 BCE. The culture, which scholars have named Lapita, may have come from Indonesia or the Philippines, or developed locally in Melanesia. It is known for its distinctive style of ceramic decoration. Lapita artists use a wide variety of concentric circles, spirals, and parallel lines, some of which are made with toothed stamps. These decorations may have also been used by Lapita textile and tattoo artists whose works have not survived. In figure 6.3, an oval set within a symmetrical composition of triangles and bands of stamped circles may represent a human head with a stylized body. The Lapita culture spread through much of the western Pacific, and elements of this design can be found in many later examples of Melanesian and Polynesian art.

Many of the most important surviving works were originally displayed in or near large communal men's houses, where the most important village rituals took place. Often, these important centers have tall, peaked roofs that tower over the other storage, cooking, and sleeping structures in that village.

6.2 David Malangi, *Sacred Places at Milmindjarr*. 1982. Central Arnhem Land. Ocher on bark. 41 × 31" (104 × 79 cm). South Australian Museum, Adelaide

6.3 Detail of a design from a Lapita pottery vessel. Gawa Reef Islands, Solomon Islands. c. 1000–900 BCE

The use to which such houses are put varies within New Guinea and across Melanesia. Often, during rituals, men within the house are seated according to clan, moiety (a group of clans), and social rank. The rituals performed within the house often include rites of passage in which youths are taught the skills and ritual knowledge they need for manhood, fertility ceremonies, and funerals. During these important ceremonies, elaborate installations inside or near the houses including statuary and other sacred objects are installed to commemorate the rituals and gods attending them.

NEW GUINEA

New Guinea, the second largest island in the world, has an extremely wide range of climates, cultures, languages, and regional art styles. At present, it is divided into Irian Jaya, a province of Indonesia in the west, and Papua New Guinea, in the east. Many of the earliest coastal settlements were submerged as the ocean rose and some of the oldest known works of art come from the highland regions. Road builders and farmers in Papua New Guinea have unearthed many small stone figures that may date from around 8000 BCE. One of the best-preserved examples, known as the Ambum Stone, represents a creature (possibly an anteater?) with an elongated snout and humanoid body (FIG. 6.4). All the volumes are stylized in matched sets of simplified curves, giving the image a sense of grace and power that may reflect the spiritual power of this otherworldly, hybrid being.

Papua: The Sepik River Area

The Abelam people in the East Sepik Province, Papua New Guinea, are known for the elaborate displays of art and ritual objects they install in ceremonial houses to initiate young farmers into their agricultural cults. To have the power and magic needed to grow fullsize yams (which may be up to seven feet, or 2.1 metres, long), an Abelam farmer must pass through a series of instructive ceremonies. Initiates and their instructors enter the ceremonial house through a small entryway behind the tall triangular facade which leads to several small rooms housing images of clan ancestors and a large main room with an elaborate installation. The centerpiece is a larger-than-life manikin of a dressed and masked ancestor made of wood and reeds seated before a large feathered crest (FIG. 6.5). The Abelam believe that if these works of art are properly consecrated, spirits from the other world will take up residence in them and communicate with those taking part in the rituals. This power of art to unite the terrestrial and celestial worlds gives these spectacular installations great importance in Abelam society. The ritual importance of all these objects, including the paintings on the walls and the very sacred leaves, stones, shells, and fruits on the earthen floor behind the low curved wooden fence, will be explained to the initiate. Elders instructing initiates in the presence of these images depended upon their dramatic appearance to give the youths a sense of reverence for the ancestors and Abelam traditions.

While the size and decoration of the ceremonial houses declined during the colonial period, recently, in many communities, the houses, their rituals, and their arts have enjoyed a revival. However, as elaborate, time-consuming, and expensive as the installations in the houses may be, they are not permanent. After the objects assembled in an Abelam house such as this have fulfilled their purpose, their ritual value is spent. It is not a sacrilege for members of a community to destroy or sell them to collectors, who may reinstall them in a museum outside New Guinea.

6.4 The Ambum Stone. Ambum Valley, Western Highlands Province, Papua New Guinea. Prehistoric. Igneous rock, height 7¼" (18.4 cm). National Gallery of Australia, Canberra

Irian Jaya: The Asmat

The rituals surrounding the aggressive act of headhunting inspired many groups in Irian Jaya, such as the Asmat, to create inspired works of art. According to Asmat legends, a cultural hero named Fumeripits carved their earliest ancestors from sago palms. The identification of humans with trees and the importance of the sago palms, the Asmat main source of food, are illustrated in the linked practices of headhunting and cannibalism.

The Asmat believed that by capturing and displaying the head of an enemy, the seat of his power, and eating his or her body, they could possess the strength of that vanquished

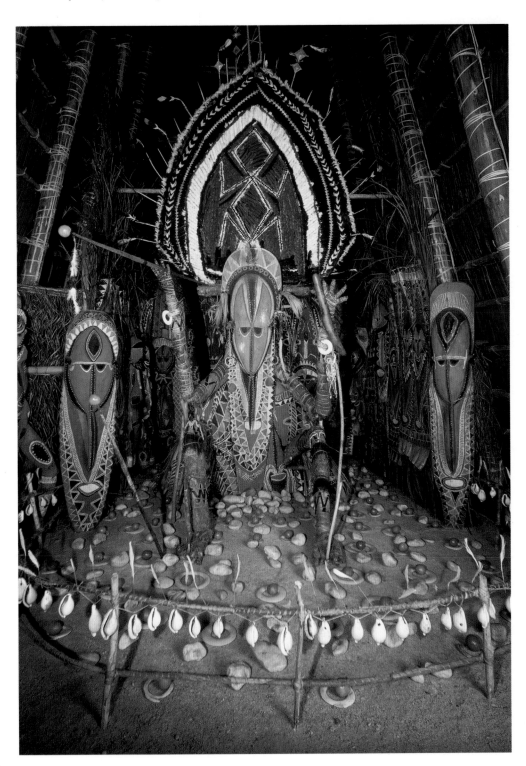

6.5 Interior of a ceremonial house of the Abelam people. Bongiora, East Sepik Province, Papua New Guinea. Collected by G.F.N. Gerrits in 1972–3. Museum de Kulturen, Basel, Switzerland

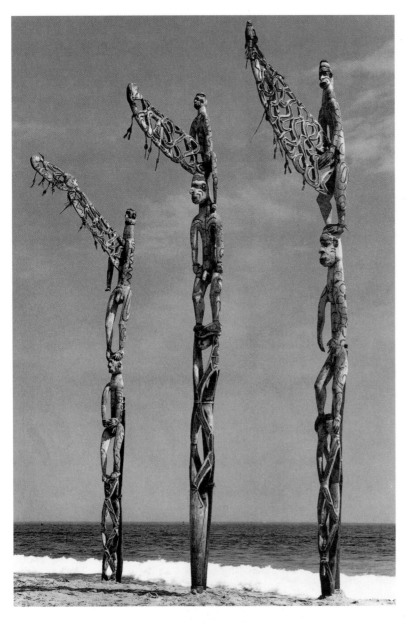

foe. Traditionally, an Asmat boy could not be initiated and become a man until he had participated in a raid or taken a head. Headhunting also helped ensure the fertility of the crops, especially the sago palms. To lose a family or community member to headhunters was to lose power which could be regained only by conducting a successful headhunting expedition against the guilty parties. Meanwhile, since the deceased had not had a proper burial so that its spirit could be sent to *Safan*, the realm of the dead in the west, the spirit might linger about the community and upset the clan's rapport with the ancestral spirits. The wandering spirit could be appeased and harmony between life and death could be reestablished through the *bisj mbu* ceremony. The ceremony involved the erection of a tall sculptured *bisj* pole and the organization of a punitive expedition to avenge the death (FIG. 6.6).

Each stage of the pole's preparation symbolized an act in the process of headhunting. The tree was cut (decapitation of the enemy), bark removed (skinning the enemy), and the sap (blood) was allowed to run before the pole was taken to the village (returning home with the corpse). The tree was carved with images of superimposed figures at or near the *jeu* ("men's house") in preparation for the *bisj mbu* ceremony. The *bisj* poles represent deceased ancestors, contain other headhunting symbols, and emphasize the Asmat identification of humans and trees. Birds carved on the poles eating fruit from the trees symbolize the headhunter who eats the brains of his captive. Cavities at the bottoms of the poles were designed to hold the heads of enemies. The tribal ancestors above, with bent knees like the praying mantis (a symbol of headhunting), have long, crescent projections from their groins that look like ship prows. They are called *tsjemen* (literally, "enlarged penis") and symbolize the virility of the group's male ancestors, the strength of the avenging warriors, and the power they will regain for the community when they return with the head of an enemy.

6.6 Ancestral poles. Asmat, from New Guinea, 1960. Wood, paint, and sago palm leaves; heights c. 17'3", 17'11", 17'9¾" (5.25 m, 5.46 m, 5.43 m). The Metropolitan Museum of Art, New York

The *bisj* are first erected on mounds near the men's houses, where dances and rituals to appease the spirits take place so the figures on the pole can observe them. During the ceremonials they reset the poles to face the nearby river, the "road" to the sea and the ancestors. In this way, the *bisj* act as ritual canoes to take the deceased to *Safan*, the realm of the dead in the west. Later, they move the *bisj* to a grove of sago palms where they will decay and nourish the palms.

NEW IRELAND: THE *MALANGGAN*

Northeast of New Guinea, the artists of New Ireland carve highly ornate poles, figures, and boats for mortuary rituals to honor the recent dead and send their spirits to a final resting

place with the ancestors. The sculptures and the complex communal memorial rites performed in special houses or enclosures in which the art is used are called *malanggan*, or *malangan*. *Malanggan* may also refer to works made for the initiation ceremonies of boys entering adolescence (replacing dead ancestors). Works of art created specifically for that occasion are displayed on the facade of a ceremonial house along with bundles on the ground containing the bones of the deceased. Preparations for *malanggan* ceremonies and the production of *malanggan* art forms may be very expensive and time-consuming, so a single ceremony may be used to celebrate the deaths of many persons over a period of several years.

In a modern museum recreation of one such *malanggan* installation, twelve works and a drum are presented on a facsimile of a porch from a house that was open to the public in New Ireland (FIG. 6.7). As in the case of most *malanggan* sculptures, each of the tall and elaborately decorated figures are carved from a single piece of wood. The sculptors have cut deeply into the core of the wooden blocks used for the bodies, fragmenting the wood into light, thin slivers of projecting forms which represent stylized palm fronds, feathers, birds, snakes, and fish. The complex openwork carved designs are painted with an equally complex pattern of contrasting colors, which gives the works a sense of brilliance and richness that reflects the symbolism of the stories associated with them and the many levels of meaning woven into the ceremonials. The New Ireland artists often mix various species of animals, such as birds and fish, with decorative motifs to create ornate, hybrid creatures. These animals may have special meaning for the clans who organize the *malanggan* festivals. By painting the multilayered and interlocking sculptured forms with superimposed geometric patterns in reds, yellows, blues, and whites, the artists further enhance the already lively surface patterns to make the canoe bristle with life.

The artists and their community believed that the spirits of the figures came to inhabit their images as they performed the *malanggan* ceremonies to send their spirits to the ancestors. Traditional forms of woodcarving and the associated ceremonials survive in parts of New Ireland. At times, when a carver is available, a *malanggan* image will be installed on a grave alongside a Christian marker. By custom, many *malanggan* sculptures were deliberately destroyed, recycled, or set up in open areas to decay after the ceremonies were completed.

6.7 *Malanggan* tableau. New Ireland, Melanesia. Bamboo, palm and croton leaves, painted wood, approx. 8'6" × 16'6" × 10' (2.44 × 5 × 3 m). Museum der Kulturen, Basel

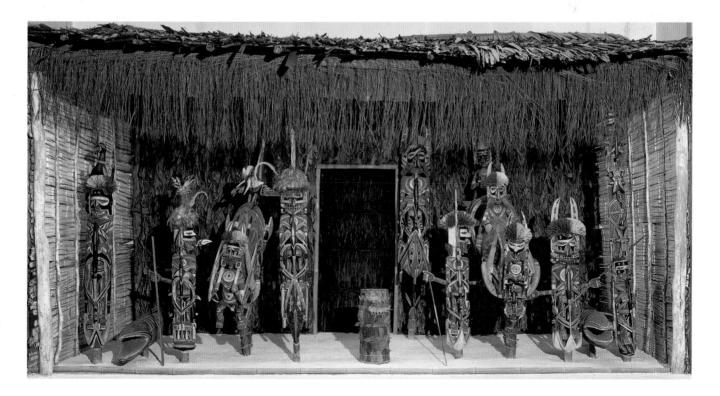

MICRONESIA

Micronesia, a long crescent of small and widely spaced islands north and east of Melanesia, was first occupied around 1500 BCE. The Micronesian societies tend to be very complex and hieratic, and the arts are often used to explain or maintain the social status of individuals or groups. Architecture may be designed to show the wealth and power of a community or group of rulers. The portable arts—textiles, body ornamentation, beads, pottery, basketry, and inlaid shellwork—along with other goods, chants, and dances are widely traded or given as gifts to substantiate family ties and diplomatic bonds.

POHNPEI: THE CEREMONIAL COMPLEX OF NAN MADOL

The ceremonial complex of Nan Madol on Pohnpei ("stone upon an altar") is a colossal administrative and ceremonial center that was built by the Saudeleur ("Lords of Deleur"), who ruled there from about 1200 to about 1700 CE. The complex of ninety-two artificially walled and terraced islets in a shallow lagoon offshore from the island, covering about 170 acres (69 hectares), may be the most picturesque archaeological site in the Pacific (FIG. 6.8).

The complex was protected from the sea by thick walls up to fifteen feet (4.5 m) high and thirty feet (9 m) thick, with openings for canoe traffic and tide water. A central canal divides the administrative side of the complex, with palaces and tombs, from the ritual side, with priests' quarters and tombs. Some of the islets are more than 100 yards (92 m) long and have massive stone walls made of prism-shaped basalts and boulders. At present, the site cannot be adequately photographed because it is choked by a thick mangrove swamp.

Perhaps the most impressive site along the canal is the landing and entryway to the islet of Nandauwas, a large funerary district with two sets of concentric walls (up to twenty-five feet or 7.5 m high), courtyards, and an outer walkway. These areas are connected by an avenue above the boat landing, which leads to a crypt roofed with basalt stones in the heart of the complex. These basalts, also used in stacks for the walls, were shaped by natural forces. One basalt cornerstone is estimated to weigh about fifty tons (50,000 kg). The outer walls of the islet flare upward near the corners, which helps integrate the strong horizontal accents of the precinct with the choppy, scalloped lines of the sea.

In essence, the magnificence of the complex celebrates the wealth and power of its builders and their favor in the eyes of their gods. It is very possible that the complex had other very complex and subtle forms of cosmic symbolism, but the oral traditions of the rulers at Nan Madol have not been preserved. Similar complexes with flared walls appear elsewhere in Micronesia and await further exploration.

ARCHITECTURE IN THE MARIANA AND CAROLINE ISLANDS

When Ferdinand Magellan arrived in the Mariana Islands in 1521, the builders there were elevating their houses with matching sets of tall, well-carved stone supports. These groups of tapered, square or trapezoidal limestone posts with hemispherical capitals are known as *latte* sets (FIG. 6.9). The largest known collection of *latte*—forty-seven sets arranged in groups end-to-end at Mochong—follows the curve of the coast line. The builders of the house of Taga on the island of Tinian carved a set of *latte*

6.8 Landing and entryway, islet of Nandauwas, Nan Madol, Pohnpei, Micronesia. c. 1200–1700

6.10 The Bai-ra-Irrai. Belau, Caroline Islands

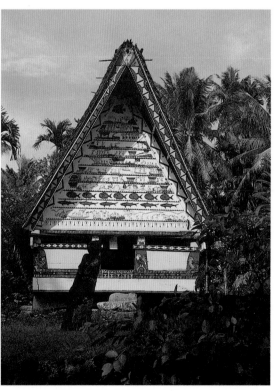

sixteen feet (4.9 m) tall (c. 1600) and an even taller set of unfinished *latte* still lies in a quarry on the island of Rotan, near Mochong.

On the basis of the nineteenth- and twentieth-century houses in this area, the superstructures of these Mariana Island houses were probably made of lashed poles and had tall peaked, thatched roofs. This large house type, which may derive from the men's meeting houses in Indonesia, can be seen in a contemporary *bai* ("community house") on Belau, a volcanic island in the Caroline Islands, near the western edge of Micronesia. The house, called the Bai-ra-Irrai ("*bai* at Irrai"), is one of two such large and important meeting houses remaining on Belau. It has been continually repaired and refurbished since it was built around 1700, so it remains a lasting status symbol of its owners and their ancestors.

The Bai-ra-Irrai is used for dances, feasts, council meetings, and to lodge visitors (FIG. 6.10). At certain times, it is now used by groups of women who had their own *bai* in the past when such structures were more plentiful. Such large, non-dwelling structures are common throughout much of the Pacific, but those of Micronesia such as the Bai-ra-Irrai are distinguished by the solidity of their construction and the richness of their painted bas-reliefs.

A group within a community wanting a new *bai* will contract a *dach el bai* ("master builder") to supervise its construction. The hardwood poles, planks, and beams are shaped and joined with removable

6.11 Josephine Waisemal, *Machiy*. 1976–7. Fais, Caroline Islands. Banana and hibiscus fiber, 2'2³/4" × 6'10⁵/8'" (68 × 210 cm). On loan from Donald Rubinstein to the Peabody Essex Museum, Salem

pegs at a preliminary construction site near the builder's home. Later, the *bai* will be dismantled, moved to its permanent home, and reassembled there. At this time, the *dach el bai* will subcontract the carving of the bas-reliefs to a *rubak* ("village storyteller") who will supervise the work of several carvers. They will illustrate the *rubak*'s stories taken from myths, legends, and important historical events. Most carvings include symbols known to the community and a rich variety of decorative forms, all of which may be brightly painted in a variety of earthen colors, black, and white.

A Belau carver literally owns his own style: an artist who uses that style without paying for the right to do so may be sued in a village court. The current story boards on the Bai-ra-Irrai illustrate the legendary history of the community and underline the importance of clan history. A *dach el bai* whose *rubak* and carvers fail to work together to decorate his *bai* with painted reliefs that are well textured, elaborate, and easily visible to all will be subject to communal criticism. Traditionally, an unsuccessful *dach el bai* will not be asked to supervise the construction of another *bai*.

The Bai-ra-Irrai is an essential part of the social hierarchy and conception of the Belau cosmos. Men are seated within the house according to rank, with the four most important men at the load-bearing corner-posts, symbolizing their supportive role in the community. They are elected by the women elders, who also have power to remove them. The *bai* themselves are also seen as the "corner-posts" of the community, and the four most important communities on Belau symbolize the corner-posts of the island. It is said that the first *bai* was installed as part of this grand cosmic structure during creation, when the sun was first placed in the sky.

TEXTILES

The men in Micronesia and most of the Pacific are in charge of the art and architecture used in the most important public and communal rituals. However, the arts of women, particularly the felted cloth they make from tree bark and plant fibers, are essential to the operation of the island societies. In some areas, the preparation of cloth is sacred and each step of its production is supervised by high-ranking women. Attractively decorated cloths made from fine materials worn by men and women in communal rituals are important indicators of rank and wealth. Highly valued cloths used as trade goods and gifts play an important role in the maintenance of good social and political relationships. The act of wrapping oneself in a textile, removing it, and wrapping it around another person provides a direct means of reinforcing friendships and alliances.

The women of the Carolines have the most highly developed traditions of loom weaving in the Pacific, a tradition they probably inherited from the Indonesians but which

they say was a gift of the gods. Traditionally, they have used mineral and plant dyes to color fibers from the banana palm and bark of the hibiscus. Their favorite motifs are patterns of symmetrically arranged, repeating straight-edged geometric forms that may be highly stylized images of natural objects. In some parts of Micronesia, women own certain decorative patterns that function like family crests to indicate their status in the highly stratified societies.

The association of the *machiy* ("sacred burial shrouds") with chiefs, ancestors, and guardian spirits makes such fabrics sacred (FIG. 6.11). Numerous taboos surround their production and use. By the early twentieth century, the new fashions in dress introduced by the missionaries caused many traditional techniques of weaving to decline.

POLYNESIA

The voyagers from the Tonga and Samoa archipelagos who began to populate eastern Polynesia around 200 CE carried the cultural root stock of the Polynesian culture that eventually developed into the regional art styles in this vast expanse of the Pacific. The Polynesians generally have highly stratified societies and very complex, multilayered pantheons of gods. These usually include the primary figures of the earth (female) and sky (male), secondary gods, legendary heroes, deified ancestors, and spirits. The noble relatives of the chiefs serve as priests, artists, and warriors, and rule the commoners. Most of these noble titles and stations were hereditary and, on ceremonial occasions, a noble using knotted cords and other mnemonic devices might justify his rank by tracing his genealogy back through thirty generations to his deified ancestors, the gods, and creation. Works of art in noble families, passed on through the years, helped facilitate the transfer of *mana* to each successive generation. As these works of art grew older and more venerated, they gained more and more *mana*. Sanctified places of worship where works of art were displayed for all to see enabled the rulers to demonstrate their *mana* in elaborate public rituals. Many of these sacred open-air ceremonial centers were walled and paved with platforms and had pits for sacred refuse, dancing areas, storage buildings to protect rituals objects and works of art, and altars where these images were displayed.

6.12 Great Marae of Temarre, the Mahaiatea, Pappara, Tahiti. 1796–8. Steel engraving from William Wilson's *A Missionary Voyage*, London, 1799

FRENCH POLYNESIA: TAHITI

AND THE MARQUESAS

To commemorate the glory of her son, an aristocratic woman, Purea of Tahiti in the Society Islands, built a sacred religious center or *marae*, called the Mahaiatea. This structure of eleven superimposed platforms measuring 68 by 252 feet (20.7 × 76.8 m) at the base and forty feet (12.2 m) in height was dedicated to the worship of her ancestors and the god Oro (FIG. 6.12). The altars were used for rituals that included human sacrifices to pacify the ancestral spirits and the gods. Captain Cook, a late eighteenth-century British explorer, witnessed one such human sacrificial ceremony in a *marae* as the Tahitians paid homage to their

war god in preparation for a battle against their neighbors on the island of Eimeo. Captain Cook wrote: "The *marae* is undoubtedly a place of worship, sacrifice, and burial, at the same time. At the entrance there are two figures with human faces. Its principal part is a long oblong pile of stones … under which the bones of the Chiefs are buried" (Forman, p. 44). Later, in the nineteenth century, many of the stones from this *marae* were removed and burned for lime to build a nearby bridge.

Although virtually nothing remains of Purea's *marae* and its decorations, monumental stone sculptures of deities have been found in association with other *marae* in French Polynesia. An exceptionally well-carved image of a local deity, Takai'i, was discovered in a *marae* on Hiva Oa Island in the Marquesas. It is composed of large, rounded sculptural masses detailed by linear accents defining its facial features. The deity's bent knees and elbows, large "goggle-eyes," high-arching eyebrows, and massive features are typical of many wood- and stonecarvings in Polynesia.

6.13 Tattooed Marquesan warrior. Engraving of Noukahiwa in N. Dally's *Customs and Costumes of the Peoples of the World*, Turin, 1845. Musée des Arts Decoratifs, Paris

One of the most important rituals and art forms in Polynesia, tattooing, was done in the Marquesas by *Tatau* artists who carried the title *tuhuka* or *tuhuna* ("master") and enjoyed the same rank as other artists and priests. Our word *tattoo* comes from the Tahitian *tatau*. The practice developed out of body painting, one of the oldest art forms in the world. Tattoos and scarifications could be widely displayed as art forms enhancing the status, beauty, and *mana* of their owners. As indicators of status that are inseparable from the body, which is one's link to the ancestors and the other world, tattoos have large quantities of *mana*. Some Pacific islanders still believe tattoos protect them from harm in everyday life and in battle.

An early nineteenth-century engraving of a tattooed Marquesan warrior shows how the *tuhuka* subdivided the man's body into registers of geometric parts by a network of straight lines and body-shaped curves (FIG. 6.13). Accenting joints, the crests of muscles, and the outlines of the skeletal structure beneath the skin, the curvilinear decorations are very skillfully adapted to the irregular contours of the human body. The highly stylized motifs symbolize a wide range of ideas, including warfare and killing. The long, painful process of adding this complex network of abstract decorations according to a well-organized and preconceived plan was part of a lifelong ritual to make the warrior's body a living work of art. The striking end of the *u'u* ("war club") he carries is a stylized head with large, circular eyes. Together, the emblematic body markings and *u'u* document this warrior's bravery and status within his society.

In Tahiti, a spectacle called the *heiva Tiurai*, which has replaced Bastille Day as the major cultural event in July, includes costumed dance competitions, reenactments of *marae* rituals, walking on fire, and tattooing. Some of the ancient rituals had survived into modern times, but sketches made by Captain Cook's artist when *heiva* dances were performed for them in 1768 and other first-hand observations from precolonial times have helped the Tahitians reconstruct their ancient ceremonials. One of the most important aspects of this revival has been the reintroduction of body tattooing. To enhance the authenticity and drama of his dancing and express pride in his heritage, Teve Tupuhia, a professional Austral Islands dancer working in Tahiti, decided to have a full-body Marquesan-style tattoo (FIG. 6.14), made by a Samoan artist, Lese Li'o. Tattoo artists may work in several regional island styles so they can provide appropriate island-style tattoos for their subjects.

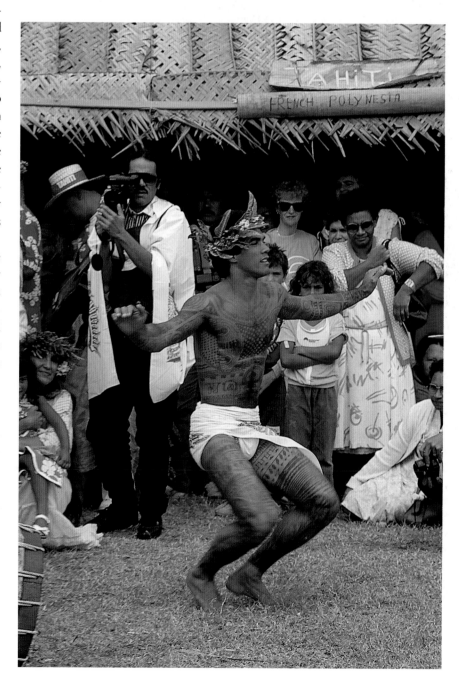

6.14 Teve Tupuhia performing at the Fifth South Pacific Arts Festival. Townsville, Australia, 1988

6.15 Bark cloth with naturalistic impressions of fish. Tonga. Collected betwen 1927 and 1932. 14'1" × 4' 4" (4.3 × 1.34 m). Auckland Museum, New Zealand

WESTERN POLYNESIA: TONGA AND SAMOA

In western Polynesia, the making and decoration of bark cloth are a sacred activity under the direction of the highest-ranking women. Women on Tonga decorate their bark cloth with printed and freehand designs. A cloth placed over a piece of carved wood and rubbed with dye will take the pattern of the woodcarving, which may be highlighted with bold hand-painted designs (FIG. 6.15). Bark cloth and finely woven mats, which are also made by women, are very important commodities on Tonga, Samoa, and elsewhere in western

Polynesia. They are given and exchanged to celebrate rites of passage and establish important social and political alliances. Each woman has her own distinctive style of decoration and the beauty of her work determines its value as a means of exchange. Being in charge of these transactions, for themselves and the men in their families, women have considerable power in western Polynesian societies. (See "Cross-cultural Contacts: Paul Gauguin and Polynesia," page 228)

HAWAII

The Hawaiian archipelago on the northern tip of Polynesia may have been populated by Marquesas Islanders around 300 CE and a later wave of Tahitians between 900 and 1200 CE. It became a territory of the United States in 1898 and an American state in 1959. The power of such rulers as Kamehameha I (c. 1758–1819), who consolidated the islands under his rule, are expressed in such luxury goods as feathered cloaks and statues of the war god to whom he was dedicated. Surviving traditions in the arts are well represented in the fabrics produced by the women of Hawaii to this day.

Sculpture and Featherwork

Kamehameha I was dedicated to the war god Kukailimoku ("Ku the Snatcher of Islands") and installed images of him in a *heiau* (Hawaiian, "temple enclosure") near his home. A well preserved statue of Kukailimoku shows the war god with thick, flexed arms and legs, and a large head (seat of his *mana*) (FIG. 6.16). He juts out his chin and opens his wide, toothy mouth to unleash a great shrieking war cry. It is a dramatic example of a Polynesian war god in full fury. Kukailimoku's wrinkled brow and tall crest of hair seem to vibrate in response to his mighty voice. The artists have attempted to capture the essence of this violent god's bellowing cry to give the statue as much *mana* as possible. This visual image of the screaming god reflects the idea of power in the military hierarchy of Hawaii, wherein warriors were victorious when they degraded (rather than killed) their enemies.

Monumental statues of Kukailimoku and other gods were displayed in the temple precincts where they and warriors carrying wickerwork and feathered images of the god were honored in songs and dances. Feathers were signs of high rank in Hawaii and elsewhere in eastern Polynesia, and some gods had red and yellow (sacred colors) feathered heads. Featherworkers also made feather-covered helmets for the warriors and royal, feathered cloaks with sturdy plant fiber netting backings. Believing that they were robing themselves in the protective feathered bodies of the gods, the warriors wore the feathered garments in preparation for battle. Women of high rank were allowed to wear smaller cloaks and other feathered ornaments as well as human hair, which was considered to be rich in *mana* because it came from the head, the seat of a person's *mana*.

6.16 *Kukailimoku.* Hawaii. Late 18th century or early 19th. Wood, height 7′7″ (2.36 m). The British Museum, London.

Paul Gauguin and Polynesia

In 1883, Paul Gauguin (1848–1903), an amateur French artist and sailor who had lived in South America, resigned his brokerage position and left his wife and five children to become a full-time painter. Gauguin believed he could find inspiration for his art outside Europe in the unspoiled, preindustrial societies that still lived in harmony with nature. In 1891, he sailed to the Pacific and settled in the French colony of Tahiti. After returning to France for two years (1893–1895), Gauguin returned to the Pacific, where he spent the last eight years of his life observing and painting Polynesian life.

Gauguin created many images of the brilliantly colored, patterned textiles worn by the Polynesian women in paintings that mix ideas and images from Europe and the Pacific islands. In *Ia orana Maria* ("Hail Mary"), Gauguin shows a Christian event as if it were taking place in Tahiti (FIG. 6.17). An angel (middle left) with blue, purple, and yellow wing feathers and a lavender gown reveals Mary and the baby Jesus to a pair of Tahitian women. Mary wears a red dress with a white floral pattern and one of the women has a purple and gold skirt. These textile patterns, inspired by the local flora, blend into the richly colored patterns of the Tahitian landscape, the emerald green grass, purple path, and yellow field leading to the thatched houses near the pink, sandy beach in the background. Dark green globes of breadfruit, wild red bananas, and yellow bananas in a bowl have been placed on a small wooden altar in the foreground.

The poses of the two women may have been inspired by photographs of Japanese paintings or the sculptural reliefs on the Buddhist stupa-temple at Borobudur in Java. Gauguin owned pictures of many early or ancient styles of art, including those of Greece and Egypt, from which he borrowed forms and ideas which he mixed with the images he discovered in Tahiti. Gauguin, who also had broad interests in religion and its symbolism, may have been trying to shock his European contemporaries—who saw the painting when it was exhibited in Paris in 1893—by portraying this Christian event with a Tahitian Jesus and Mary.

There were many Europeans with whom Gauguin could have socialized in Tahiti, but his purpose was to escape Europe and mix with the native society. However, even though many of the Tahitians had become Christians and their society was not as cohesive as it had been a century earlier, Gauguin remained an outsider among the people he painted and studied. They saw Gauguin, who did not speak the native languages, as a member of the ruling colonial society. Despite this problem, of all the farsighted European thinkers of this period who were fascinated by the Pacific, Gauguin had the most lasting influence on Western thought. While Pacific works of art were being displayed in European museums and writers were publishing in scholarly journals, it was largely through Gauguin's work that the art of the Pacific islands came to the attention of the art world in the West. He was the only major artist of the day who was thoroughly familiar with the art of the Pacific and he incorporated insightful images of Pacific art and life in his work that continue to intrigue contemporary audiences. Picasso said "African art? Never heard of it!"

6.17 Paul Gauguin, *Ia orana Maria*. 1891–2. Oil on canvas, 44³/4 × 34" (113 × 86 cm). The Metropolitan Museum of Art, New York

IA ORANA MARIA P Gauguin 9

When the brightly colored feathered cloak in figure 6.18 was worn, it became a tall conical form with the yellow crescents meeting at the seam. To increase the *mana* of a long feathered cloak such as this, the featherworkers recited the genealogy of the royal recipient for whom it was intended as they made it. The cloak, which took the yellow feathers of about 90,000 honeyeater birds, was very expensive and men of lesser rank and wealth usually wore shorter capes. When the Hawaiian leader met Captain Cook in 1779, removed his cloak and gave it to Cook, he was parting with a very highly valued and sacred heirloom.

Textiles

The activities of Pacific artists in recent years have demonstrated that the traditional forms of Pacific art remain vital forms of expression to this day. Many of the ancient Polynesian motifs survive in the *tifaifai* ("appliqué and piecework fabrics") made during the last two centuries

6.18 Feather cloak known as the "Kearny Cloak." Hawaii. c. 1843. Red, yellow, and black feathers on fiber netting; 5'9" × 9'6" (1.75 × 2.9 m). The British Museum, London

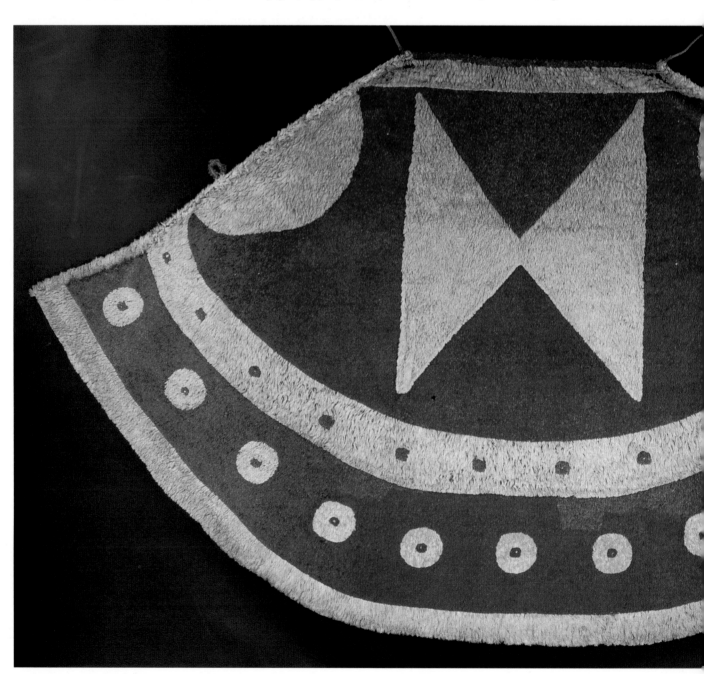

6.19 13. Deborah (Kepola) U. Kakalia, *Royal Symbols*. 1978. Hawaii, O'ahu. Quilt of cotton fabric and synthetic batting, appliqué and contour quilting, 6'6¼" × 6'4½" (1.98 × 1.96 m). Joyce D. Hammond Collection

by the women of eastern Polynesia (FIG. 6.19). The *tifaifai* reflect the broader manner in which Western influences have been modified and assimilated into Polynesian culture. By the early nineteenth century, women missionaries were inviting Polynesian women of rank to their "sewing circles." Before European contacts, women throughout Polynesia had made many varieties of decorated cloth from tree and plant fibers and applied some of these decorative motifs to the new materials. Soon, regional, island group styles of *tifaifai* developed. Traditionally, *tifaifai* have been associated with high status, and the gift or receipt of a *tifaifai* is intended to concrete interpersonal bonds. The making of *tifaifai* has given Polynesian women, working independently or in groups, an effective means of self-expression as artists.

While the women in each region may share many popular motifs, designs become the intellectual property of their creators and may not be copied by others. Many artists have distinct "signature" motifs. In Hawaii, where the women producing *tifaifai* have a reputation for their highly original and complex, abstract designs, the works of Deborah (Kepola) U. Kakalia of O'ahu Island are recognized by the varieties of her eight-pointed star. That star appears in the middle of her quilt, as the matrix for a symmetrical pattern combining heraldic symbols of authority and rule derived from Polynesian and European sources. Often, such symbols may carry hidden iconographic significance which the artists may never reveal. In Hawaii, the concept of *kaona* ("veiled meaning") underscores the way time and use can give such works of art complex, multiple levels of meaning.

EASTER ISLAND

Easter Island, known to its residents as *Rapa Nui* ("Navel of the World"), at the southeastern corner of Polynesia, was probably discovered and colonized by Marquesas Islanders around 300 CE. Around 1000 CE, the Easter Islanders began erecting monumental half-figured heads with torsos known as *moai*, on large stone platforms (*abu*) on the steep hillsides of the island high above the sea (see FIG. 1.4). The *moai* may represent sacred ancestors/chiefs who guarded the villages and ceremonial areas over which they continue to watch. Together, the sculptures, platforms, and open areas around them used for rituals form the Easter Island version of the Polynesian *marae*. While sculptures were set on platforms in *marae* complexes elsewhere in Polynesia, nowhere else are there monumental sculptures with anything approaching the Easter Island sense of scale and drama.

The history of the island before European contact is divided into an Ahu/Moai Phase (1000–1500 CE), when the famous monuments were made under the direction of the hereditary chiefs, and a Decadent Phase (1500–1722 CE), when construction ceased and most of the *moai* were toppled. It is possible that overpopulation and deforestation led to inter-tribal warfare and the economic decline of the island.

In his logs, Captain Cook noted that the Easter Islanders "all dispose of an admirable artistic skill; there seemed to be nothing they could not represent in their carving ... They also had wood carved human figures: although the features of these were not pleasant, the whole carving shows a certain sense of arts" (Forman, p. 92).

Around 1000 CE, the islanders began erecting *moai* on *abu* encircling the island. The *abu* were about 190 feet (58 m) long and twenty-four feet (7.3 m) high, and the largest *moai* are about seventy feet (21.3 m) tall. These giant *moai*, for which the island has become world-famous, were carved from a yellowish-brown coarse-grained tufa found in the extinct volcano of Rano Raraku. It could be worked with harder stones, shells, and bones.

About 1,000 *moai* have survived, including 150 unfinished works still lying in the quarries of Rano Raraku. The earliest Easter Island *moai* are relatively small and have rounded Marquesan-style eyes. Over time, the heads and their features became elongated. The late *moai* have small foreheads, massive brows, long faces, elongated noses, thin pursed lips, and strong pointed chins. Originally, some or all of the *moai* had eyes of coral inlay with dark stone pupils and red tufa topknots mounted on their heads.

The sculptors carved the *moai* out of large rock outcrops that were still attached to the hillsides of the volcano-quarry. They seem to have envisioned the *moai* as if they were lying on their backs, face up, within the outcrops. Working from the front of the face and torso on the top of the outcrop, they carved around the sides of the *moai* to its back until there was only a thin ridge of stone running down the back connecting it to the hillside. After cutting the *moai* loose from the hill, they began the difficult task of dragging the enormous stone on sledges or rollers from the crater of the volcano to the platform where they used ramps, levers, and ropes to mount it. Some of the rutted pathways on which they moved the *moai* are still visible. The *moai*'s inlaid coral and stone eyes were probably finished or "opened" after it was installed on its

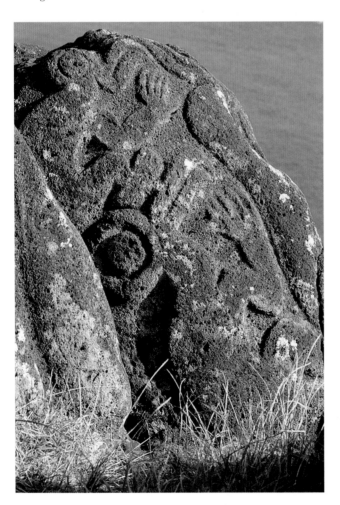

6.20 Birdman petroglyphs. Easter Island, Orongo

ahu. Many heads were crowned with stone *pukao* "topknots" that weighed over five tons (5080 kg). In recent decades, modern engineers using an industrial crane found it a challenge to replace some of these knots.

The cults and industry responsible for the erection of the figures declined by 1600, as deforestation and internal wars led to the toppling of all the statues by the nineteenth century. Some authorities believe that the old order that raised the *moai* was superseded by a new religious order that identified itself with bird imagery. Remnants of that cult may survive in the annual Easter Island "birdman" ritual performed to ensure the fertility of the land. The ritual began at the sacred precinct of Mata Ngarau along the rim of the Rano Kau crater, a dramatic site overlooking the crashing surf below. While priests at Mata Ngarau chanted lines recorded on sacred tablets, representatives of noblemen on the nearby islet of Moto Nui competed to see who could find the first sooty tern egg of the season. For the following year, the winning nobleman carried the prestigious title of *tangata-manu* ("birdman"), which greatly increased his *mana*. Carvings on rock outcrops around the precinct represent images of birdmen and celebrate the renewal of life symbolized by the arrival of the egg from Moto Nui (FIG. 6.20).

NEW ZEALAND: THE MAORI

The Maori, who arrived in New Zealand around 900 CE, may have come from Tahiti but their origins remain a subject of debate. They called their new home Aotearoa ("Long White Cloud"). Modern Maori scholars have established a chronology for their culture with period names that translate as: The Seeds (900–1200), The Growth (1200–1500), The Flowering (1500–1800), and The Turning (1800–present). The early European chroniclers were astonished at the engineering of the Maori agricultural terraces, their lavishly decorated houses protected by tall wooden palisades, and the size of their large dugout war canoes with large carved prows and stern boards. They were also impressed with the Maori's oratory, poetry, and storytelling, literary ideals that are still being expressed in their visual arts today.

New Zealand has an abundance of good soft woods (the totara conifer and kauri pine) that are easier to work than the hard woods found on many Polynesian islands. Working with these woods, the Maori became excellent woodcarvers and transferred their skills to carving ivory, greenstone, bone, and whale teeth. Many of the scrolls and complex spirals used in Maori carving appear elsewhere in the Pacific islands, but nowhere else do artists combine these decorative forms with solid, three-dimensional sculptural forms to create such a powerful sense of the spiritual presence of *mana*.

Many of the finest surviving wood sculptures were originally placed on canoes, village palisades, or houses. Storage houses were often raised on pilings to protect their contents from moisture and marauding animals (FIG. 6.21). By later standards, the pre-contact storage houses and homes of chiefs were very small; visitors had to stoop to enter through their tiny doors.

The somewhat larger meeting houses that began to be built at *marae* in the early nineteenth century became the most distinctive architectural achievements of the Maori in the period known as The Turning. As tensions mounted between the Maori and the European colonialists (*Pakeh* in Maori), some Maori communities began building meeting houses at their *marae* where the noblemen could meet to discuss political and social matters. The houses are basically enlarged versions of the type of homes in which noble families lived. This idea of having large, decorated assembly places may have been inspired by the early nineteenth-century Christian churches of the colonists. The symbolism of the exterior and interior decorations in these Maori meeting houses reflected some of the most important Maori ideals, which supported the culture as it struggled to maintain itself under a foreign colonial European government.

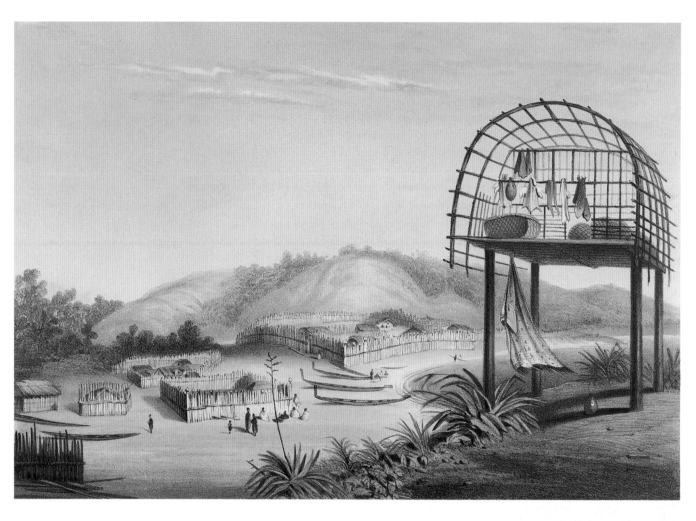

6.21 Maori storage house on stilts, Cooks Straits, New Zealand. c. 1844. Lithograph in George French Angas's *New Zealanders,* 1847

The Te Hau-ki-Turanga Meeting House

The Te Hau-ki-Turanga ("Spirit of Turanga") meeting house (1842–1845), built as part of a *marae* complex, now preserved in the National Museum of New Zealand in Wellington, is one of the most important and astonishing monuments in the history of Polynesian art (FIG. 6.22). It was constructed and decorated by Raharuhi Rukupo (c. 1800–1873), a warrior, priest, and tribal chief, in honor of his late brother from whom Rukupo inherited the chieftainship of his tribe at Turanga (Poverty Bay). Rharuhi Rukupo was regarded as the leading master carver in Poverty Bay in the mid-nineteenth century. Earlier Maori carvers had used basalt and greenstone chisels and drills, but Rukupo and the eighteen Poverty Bay carvers who worked on the Te Hau-ki-Turanga house used Western metal tools. These enabled them to work more quickly than their predecessors, but the new technology did not change the fundamentals of their traditional Maori style of carving. Earlier, pre-contact houses may have had some interior decorations, but it is unlikely that they were as lavish as the Te Hau-ki-Turanga house. Bound together by the strict codes of *tapu*, Rukupo and his assistants created a national Maori treasure. Traditionally, Maori carvings and houses under *tapu* cannot be repaired and are left to decay in the weather. However, the Te Hau-ki-Turanga house was restored in 1935 by artists using traditional techniques and installed in the National Museum, where the public can enter it. Thus, the meeting house, one of the most complete collections of Maori carving, representing a highpoint in Maori art history when the traditional forms were first being carved with metal tools, is one of the most accessible and well-preserved Maori treasures. (See *"In Context:* Maori Images of 'Art,' 'Artist,' and 'Art Criticism,' " page 236.)

Learned Maori such as Rukupo and his assistants would have understood the complex symbolism of the structure as an image of the Maori universe. The ridge pole and rafters represent the backbone and ribs of the sky father, and the carved face boards along the sloping roof line represent his outstretched arms. However, in typical Polynesian and Maori fashion, the thinking and imagery are very complex. The ridge pole also represents the chief's lineage and the rafters symbolize the passage of that lineage through time, linking the family of the chief with the sky father. In some cases, the ridge pole over the porch supported images of the sky father and earth mother in sexual union, linking the house with the creation of the cosmos.

Inside the house, the freestanding poles (*poutokomnanawa*) and wide panel-shaped side posts (*poupou*) supporting the roof (the sky father and royal lineage) are carved to represent venerated ancestors (see FIG. 6.22). To a Maori master carver such as Rukupo, the symbolism of this supportive role was obvious—these noble ancestors had upheld the laws and traditions of the gods and royal lineage in the past. They were there now to protect and comfort the occupants of the meeting house. Because they controlled the *mana* passed on to their descendants, such ancestors were often more revered and honored in the arts than the gods.

The short-bodied, stylized images of ancestors are called *tiki*, the name their creator god Tane gave to the first person he created. A *tiki* is a human figure with additional animal features (bird or lizard) that may represent an ancestor, god, or spirit. Small jade or greenstone *hei-tiki* (suspended *tiki*) ranging from about one to seven inches (2.5–18 cm) in height, worn on short flax fiber cord necklaces, represented ancestors and were often family heirlooms. The large-headed *poutokomnanawa* with inlaid eyes (just visible in fig. 6.22) carved by Rukupo and his assistants was painted with burned red ocher pigments and rubbed with clay and shark-liver oil until it turned a reddish-brown color. The ancestor, with a beaked mouth and three-fingered claw-like hands, thrusts out his tongue in defiance to ward off evil or taunt an enemy, a menacing gesture to outsiders, but not to members of the community.

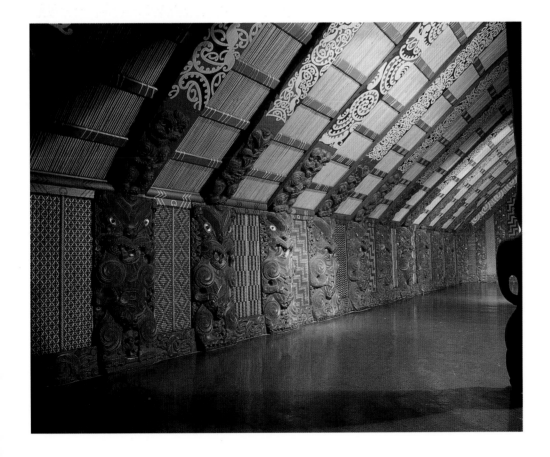

6.22 Interior of Te Hau-ki-Turanga Meeting House, Poverty Bay, New Zealand. Maori. 1842–5, restored 1935. Wood, shell, grass, flax, and pigments

Maori Images of "Art," "Artist," and "Art Criticism"

To understand the Maori view of art, its creation, use, and criticism, it is essential to see the art as it was seen by the Maori who created or commissioned it. They were members of an integrated society in which their everyday lives, rituals, religious beliefs about the gods, ancestors and cosmos, and arts were part of a seamless fabric enveloping them.

According to Maori legends, the first artists were the Maori gods. In time, they allowed certain high-ranking men with distinguished ancestors to become vehicles through which they, the gods, could create art to be used in rituals to venerate them and the ancestors. A *tohunga whakairo* ("skilled woodcarver") of noble status in New Zealand might operate a workshop employing young noblemen apprentices who make the portable sculptures, war canoes, and important buildings. The term *tohunga*, used by itself, means "expert," but in general usage it denotes a priest. Maori artists who had been thoroughly trained in the religious rituals governing the creation of works of art operated like priests under the watchful eyes of Tane, the god of the forests, craftsmen, and creation.

As an agent or representative of the gods, the traditional Maori artist was not an isolated individual acting alone. He had to follow strict ritual guidelines governing every phase of his work. To perform these exacting duties, a *tohunga* had to possess large quantities of *mana*. The tools, works of art in progress, and the artists themselves were sacred. Generally, objects made by nobles were imbued with so much spiritual power that it was forbidden for those of lower rank to touch them.

The Maori definition of "art" and their means of judging its quality reflect their belief that the art belongs to the gods and Ancestors. They may call one of the carvings illustrated here a *taonga whakairo* ("prized decorated object with quality") or a *taonga tuku iho* ("prized heirloom"). They recognize qualities in these objects that rise above the mundane and reflect the world of the gods who worked through the artists to create them and their *mana*.

Not every carving by a Maori qualifies as *taonga*. To achieve this elevated status, the object must have been used in rituals where speeches and incantations were recited over it. It has to have a history of contact with the words, ideas, and *mana* of high-ranking Maori to have *mana* of its own and be a *taonga*. In time, some of the nobles who used a given work of art will join the ranks of the venerated Ancestors, giving the art they used added prestige. Knowledgeable Maori will explain these associations of the art to audiences, repeating versions of the stories and ideas attached to them by the leaders of the past. Once the work of art is linked to the words, ideas, and mana of the Maori élite, its own enhanced *mana* will give the art a sense of authority and invoke awe and *ihi* ("fear") in viewers. This, ultimately, is how the Maori judge their art—on the strength of the audience's reaction to it. While their art needs to demonstrate technical skill, and what Westerners call "beauty" or "aesthetic qualities," the proof that these qualities exist comes when the work of art evokes an emotional reaction from viewers. While great emphasis is placed on rituals attending every phase of the art's production, and the proper training of the artist, the art is ultimately judged on how well it "works" in context with Maori society—ceremonies that link the art and its audience to the Ancestors and the gods who created the first works of art.

In typical Polynesian fashion, the head of the figure (and seat of its *mana* and spiritual power) is large compared with the rest of its body. Along with this, the bent-knee pose and the swirling forms in the reliefs suggest the idea of mobility, strength, and *mana*. While similar forms appear elsewhere in Polynesia, especially in the tattoos of the Marquesan artists, the complexity of these decorative patterns is a hallmark of Maori art. Two of the Maori names for these spiral motifs, *pitau* and *tete*, also refer to the young, curled fern frond, a staple food source in New Zealand and a symbol of chieftainship.

One of the figures on a wooden side post in the meeting house is a self-portrait by Rukupo (FIG. 6.23). In his right hand he holds a *toki-pou-tangata* (a ceremonial adze), the symbol of a master carver. His face is covered with a recognizable Maori style of facial tattooing known as *moko*, characterized by its long, elegant, flowing lines which accent the contours

6.23 Raharuhi Rukupo, *Self-Portrait in the House Te Hau-ki-Turanga*. Wood, height 50" (1.27 m). National Museum of New Zealand, Wellington

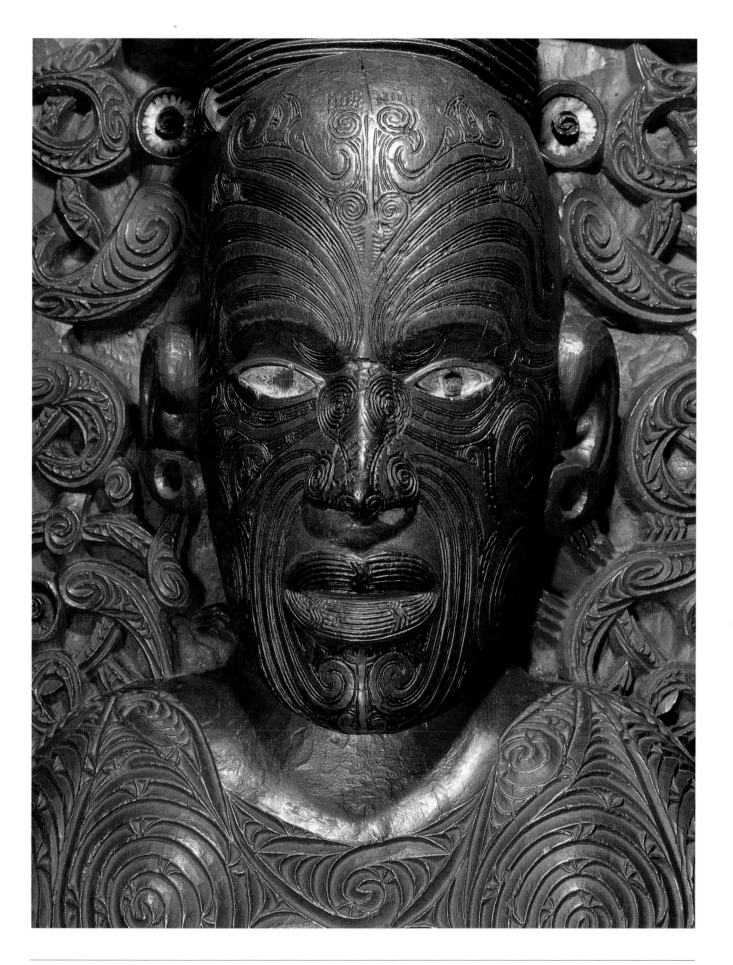

and features of the face. The main tattoo lines are actually engraved into the face with a bone chisel. While each set of facial tattoos was an original work of art, many of them shared some of the basic features of Rukupo's tattoos. Sets of parallel curved lines following the jowls connect pairs of small spirals on the sides of the nostrils with the chin. Larger spirals are placed over the cheekbones and the base of the jaw. A fan-shaped set of curved lines radiates upward and outward from the brow. To the contemporaries of the young and freshly tattooed Rukupo, these patterns of repeating, dark blue lines radiating out from the center of his face would have given the youth's face a sense of authority and strength. As he aged, the tattoo patterns mixed with his facial wrinkles, adding to his noble character. Women traditionally wore less elaborate tattoos on their lips and chins. Such tattoos were highly personal and, in historic times, they could be copied and used as signatures on documents.

Rukupo's carvings are remarkable for their vitality, which comes from the crispness and complexity of their carving and his use of solid, three-dimensional forms. The sense for the individual, visible in Rukupo's long face and full pursed lips, is absorbed in the conventions of the Poverty Bay carving team in which his small, schematized body and large head emphasize the seat and source of his *mana*. Working within the conventions bequeathed him by the gods, Rukupo managed to give his own head a sense of individuality, a kind of dignity that probably reflects his high rank and important place in Maori society. As a carver who used the new technology to give Maori art a new sense of vitality, Rukupo was a very important artist of The Turning period.

The side posts alternate with weavings known as *tukutuku*, made by high-ranking women working with plant stalks and slats of wood tied with grass or fibers from a flax plant with leaves up to seven feet (2.1 m) long. The decorative patterns of the mats have symbolic values and some of them represent gods and cosmic features, a reminder that the house is a symbolic and conceptual image of the cosmos with the gods, ancestors, and rulers on earth who form a complex hierarchy of power around the *marae* where this meeting house was originally located. The Turanga house, created as traditional Maori civilization was being influenced by Western colonialism, is a magnificent and lasting monument to the subtlety and inspiration of Polynesian culture in New Zealand.

Upon finishing the Te Hau-ki-Turanga house, the Poverty Bay carvers began working on a very ambitious project, a new Christian church that was to be decorated with wall posts carved in the Poverty Bay style. But the cohesiveness of traditional Maori art was disrupted as the missionaries encouraged artists to revise their imagery to fit the tastes and needs of the Christian religion. Upon the death of Rukupo, the Poverty Bay carving team declined, but other carvers of Maori art have struggled with adversity and remain active to the present day.

Colonial and Post-Colonial New Zealand

As colonization intensified in the late nineteenth century, the traders, whalers, Christian missionaries, and plantationists introduced the Pacific islanders to alcohol, firearms, and new diseases to which they had no natural immunity. As the numbers and prosperity of the islanders declined and they embraced Christianity, many of the indigenous art and cultural traditions declined. Others survived or have been revived and are now part of the post-colonial traditions in the islands, most of whom have gained home rule. Currently, much research is being done on the surviving ceremonials and artists working in traditional Oceanic styles.

In the past century, the Maori have searched for ways to sustain their culture and incorporate it into the modern identity of New Zealand. The first Maori art school, established in Rotorua (1910), taught students to carve wood in the style of Rukupo. Additional schools, cultural centers, and festivals have been established, but, nevertheless, many Maori have become urban English-speaking Christians without tribal associations or

connections with the art and culture of their ancestors. When the words and rituals associated with older works of art are lost, knowledgeable individuals and groups of Maori attempt to recreate them and bring the old works back into the context of Maori history and culture. (See "*In Context*: Maori Images of 'Art,' 'Artist,' and 'Art Criticism,'" page 236.) In the many aspects of their revivals, the contemporary Maori are not trying to turn back the clock or to replicate their past. Instead, they want to sustain a bilingual Maori culture in New Zealand that will work in concert with the Western, English-speaking population and be part of New Zealand's national identity in the future.

SUMMARY

People migrating from Southeast Asia began populating portions of the Pacific islands as early as about 40,000 BCE. By about 900 CE, they had spread throughout Melanesia and Micronesia in the western Pacific and Polynesia to the east. All or most of the art that developed on the many islands in the Pacific reflects the widespread concept of *mana* or spiritual power. This idea is reflected in the towering roofs of the communal men's houses, the sacred nature of the *marae*, the beauty of the textile patterns created by women, and the complexity of the reliefs carved by the Maori of New Zealand.

European explorers visited most of the islands by the late eighteenth century and ushered in two centuries of colonial domination during which missionaries and governors destroyed much of the islanders' traditional world view and subsistence patterns. However, in recent years, Pacific culture has enjoyed a renaissance. As many areas came under home rule in the late twentieth century, governments established art and culture centers where artists could embrace postcolonial concerns about their cultural and national identities. Contemporary artists are able to reimage ideas of *mana* or power and aesthetics to create works of art that perpetuate and update their traditions for the new millennium.

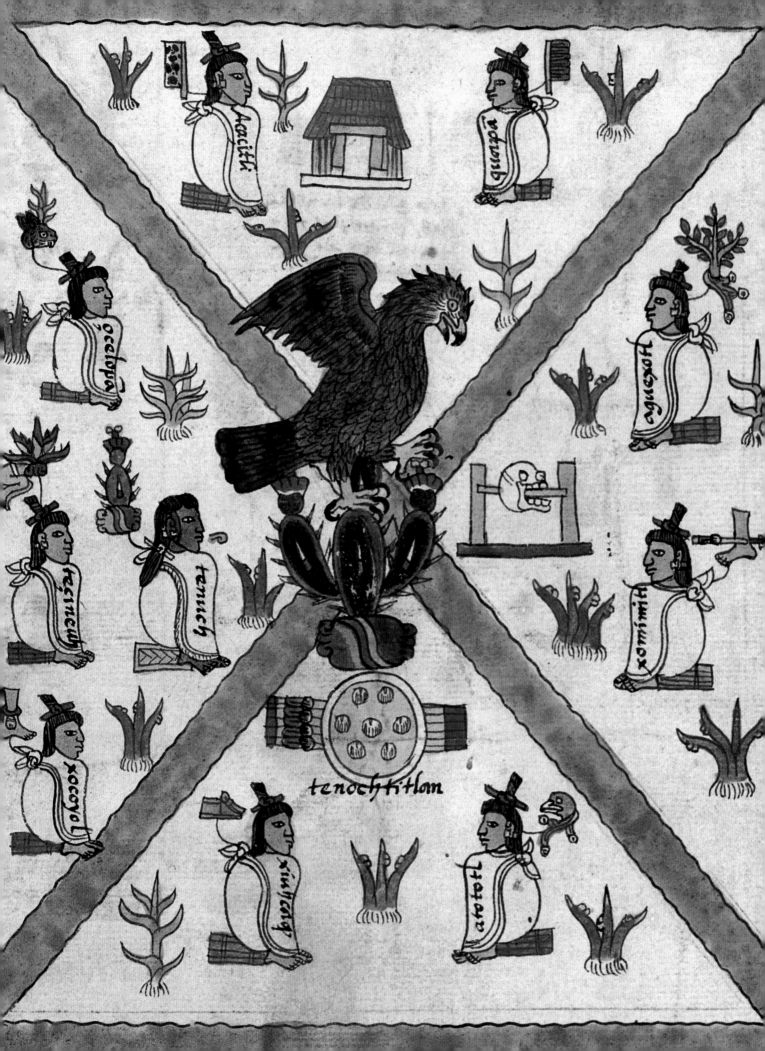

tenochtitlan

CHAPTER SEVEN
THE
AMERICAS

THE AMERICAS

INTRODUCTION

The *Popul Vuh*, a book sacred to the Maya of present-day Guatemala, tells how ancient, mythical Maya twins traveled to the other world of the gods, outsmarted them, and returned to this world. This strong belief in dual worlds—the terrestrial and celestial—and the need for the Maya leaders to travel in both may explain why the Maya built ritual centers with temples, sculptures, and other art forms. With the aid of the art and architecture, the leaders performed rituals that transported them to the other world, where they communicated with the gods and sacred ancestors. They left this world for the other through symbolic mountain caves—the dark cavernous passages inside their temples on tall mountain-shaped platforms. The ancient Maya called these mountain-shaped temples with passages leading to the home of the gods, "his house" or "her house." The sculptures in the plazas below the temples were called "tree-stones" because they were part of this symbolic mountain–forest landscape, a diagram of the Maya other world and cosmos. Through the miracle of transport that demonstrated their god-given powers, Maya leaders using the art and architecture moved back and forth from this world to the other, and used the knowledge and power they gained in the other world to govern and protect their people.

Since the Maya were the only fully literate people in Pre-Columbian America, scholars know far more about their art than about that of other groups. However, many of the Maya's neighbors built elevated, windowless temples and the idea of going to another world, communicating with the powers there, and returning, is a strong one in many parts of the Americas.

In the smaller, less integrated societies of the Americas, it is often the shaman who travels to meet the spirits by going into a trance and returning with special knowledge and messages. The concept of shamanism may have originated in Central Asia, and its presence in the Americas helps us understand that continent's art in terms of ideas common to many parts of the world. The shaman—usually, but not always, a man—was an exceptional individual with great visionary powers and access to the world of spirits. Some groups had shaman societies, and individuals who are not shamans might assume some shamanistic powers. Using drums and rattles, and at times wearing masks representing their animal spirit counterparts, shamans could have visions and out-of-the-body experiences as they traveled from this world or zone of power to the extraterrestrial world of the spirits. It was widely believed that shamans could take on the forms of their animal counterparts. Shamans used their powers to heal the sick, assist hunters or warriors, control the weather, and perform other helpful acts.

The artists who illustrated the sacred activities of the priests and shamans were often held in very high regard. The Maya verb for "to paint" and "to write" (*ts'ib*) is the

same in all of the language's known dialects, and artists may have been called *ab ts'ib* ("noble artist–scribes"). The Navajo artists who made sand-paintings for their rituals were entrusted with the difficult task of restoring the beauty and harmony of the world as they had existed at creation. Aztec artists could achieve immortality by making works of art that embodied the spirits of the gods. This model of the respected artist, caretaker of important sacred information about the other world and its powers, is a key to the arts of many societies that left no written records to tell us specific facts about their other worlds, gods, sacred ancestors, and leaders who maintained order in this world and the land beyond.

THE PRE-COLUMBIAN WORLD

When the first European explorers landed in the Americas in the early sixteenth century, they were astonished to discover societies and empires that had been unknown to the European world. The Aztecs ruled large portions of present-day Mexico and the gold-rich Inca were the powerful overlords of the Central Andes. By the mid-sixteenth century, explorers had discovered more indigenous societies flourishing in the southeastern and southwestern portions of the present-day United States. New archaeological discoveries to this day continue to bear witness to the richness and diversity of the native civilizations in the New World.

The term "Pre-Columbian" means "before Columbus" and refers to the time periods and cultures in the Americas before the arrival of Columbus and the beginnings of the Spanish conquest of Latin America in the early sixteenth century. Some writers also use the terms "pre-contact" and "post-contact" for the periods before and after the arrival of the Europeans in the Americas. Dates for the colonial period vary from one area to another. In some cases, colonial contacts began as late as the nineteenth century, and some Pre-Columbian traditions in the arts continue to the present day. The indigenous art of North America is often called Native American art or American Indian art.

The earliest immigrants to the Americas, hunters with fluted stone spearheads, arrived during the last ice age. At that time, enormous quantities of water were trapped in glaciers and the sea level was about 350 feet below its present level. A 100-mile-wide land bridge connecting present-day Siberia and Alaska existed for thousands of years. These new arrivals could have traveled south along the coast of present-day Alaska and Canada by water or through an ice-free inland corridor that may have been open as early as 30,000–20,000 BCE.

The oldest known Pre-Columbian paintings, at Toca do Boqueirao da Pedra Furada in the state of Piaui in northeastern Brazil, date to around 24,000–20,000 BCE. Over 200 overhanging shelters with remains of art forms have been found in this region. Since there is no evidence that representational works of art were imported from Siberia into the Americas, the idea of representation may well have been invented independently in the New World.

The Americas underwent many of the same transformations at the end of the Paleolithic era as the Old World. Between 7,000 BCE and 5,000 BCE, residents of the Tehuacán valley in Mexico began domesticating animals and cultivating plants. The Pre-Columbian American staples included maize, beans, squash, peppers, potatoes, tomatoes, and avocados. Communities in various parts of the Americas had domesticated turkeys, guinea pigs, llamas, alpacas, guanacos, vicuñas, and dogs. With the acquisition of dependable food supplies came a growth in the population and the emergence of hierarchical societies, the construction of ceremonial centers, and the development of specialized art forms.

Around 3000 BCE, people living near the coast of present-day Ecuador and northern Peru were constructing large platformed temples and making fired clay figurines. By 1200 BCE, the Olmecs on the east coast of present-day Mexico had begun carving monumental stone sculptures for their ritual centers. After the first century CE, sedentary societies with urban

centers and hierarchical societies supported by agriculture and trade were flourishing elsewhere in portions of present-day Mexico, Guatemala, Belize, El Salvador, and Honduras as well as the Central Andes and portions of the southern United States.

The Pre-Columbian Americas lacked some of the basic ingredients of the Eastern and Western civilizations. While llamas and other animals could carry light packs, the Americas had no horses or other beasts of burden strong enough to transport adult riders. In parts of Mexico, small ceramic wheels were used on toys but the wheel was never enlarged for use on carts or wagons. Soft metals such as gold, silver, and copper were known and valued, but the Pre-Columbian Americans did not discover how to process bronze or iron. Wood, stone, bone, and obsidian (a volcanic glass capable of holding a razor-sharp edge) were the preferred materials for weapons and tools. Aside from the Maya, the Pre-Columbian Americans did not develop syllabic/phonetic scripts through which they could pass their knowledge on to future generations. Yet, the Pre-Columbian Americans constructed enormous elevated platformed temples, moved and cut stones weighing in excess of 100 tons (101,600 kg), and created art styles that deserve to be compared with those of the ancient Eastern and Western civilizations.

How is it possible to account for the spectacular development of Pre-Columbian civilization in the Americas? The ancient Siberian roots of the original émigrés and the very short-lived eleventh-century Norse colonies out of Greenland in Newfoundland had little influence, if any, on Native American culture. Scholars known as Diffusionists argue that some aspects of Pre-Columbian civilization derive from Asiatic sources, and arrived via ships crossing the Pacific. Diffusionists believe that the basic concepts of art and culture were created once—in the Old World—and diffused from there around the globe. However, in most cases, the internal lines of development for the art forms in America to which the Diffusionists point are well documented. While it is not impossible that the highly skilled Polynesian sailors could have visited the Americas, the present evidence suggests that Pre-Columbian American art and culture developed without benefiting significantly from outside influences.

SOUTH AMERICA: THE CENTRAL ANDES

The area of high culture in the Central Andes from southern Ecuador through Peru to northern Bolivia and Chile includes highly diverse environments ranging from the Pacific coastal deserts to the cool mountains and high plains region around Lake Titicaca. When the Spanish conquistadors arrived in the Central Andes in the early sixteenth century, the Inca were ruling the Central Andes from their highland capital at Cuzco. The streets of the present-day city are still lined with tall Inca walls made of large, perfectly fitted stones that were

TIME CHART *South America*

Early Horizon: 1000–200 BCE

Early Intermediate: 200 BCE–600 CE

Middle Horizon: 600–1000

Late Intermediate: 1000–1400

Late Horizon: 1400–c. 1535

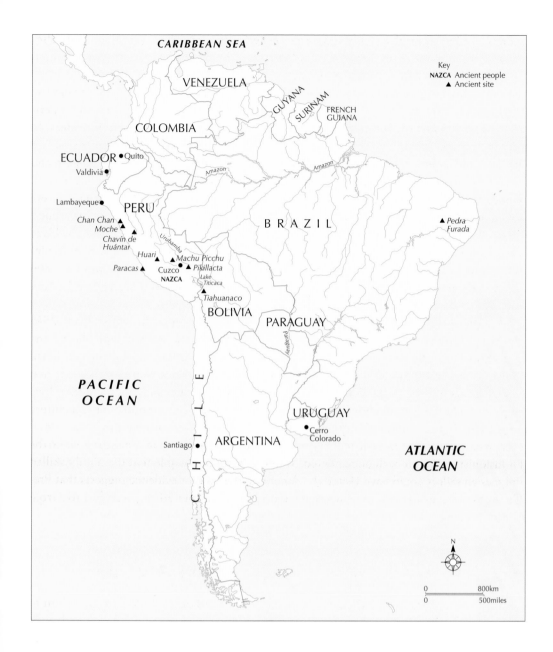

Key
NAZCA Ancient people
▲ Ancient site

CARIBBEAN SEA

VENEZUELA

COLOMBIA

GUYANA
SURINAM
FRENCH
GUIANA

ECUADOR ●Quito

Valdivia●

Amazon

Amazon

Lambayeque●

PERU

B R A Z I L

▲ Pedra
Furada

Chan Chan ▲
Moche ▲

Chavín de
Huántar ▲

Urubamba

Huari ▲ ▲ Machu Picchu
Cuzco● ▲ Pikillacta

Paracas ▲

NAZCA

Lake
Titicaca

▲
Tiahuanaco

BOLIVIA

PARAGUAY

Paraguay

PACIFIC
OCEAN

C H I L E

URUGUAY

●Cerro
Colorado

ATLANTIC
OCEAN

Santiago ●

ARGENTINA

N

0 800km
0 500miles

parts of the imperial temples and offices. The Inca builders excelled at the construction of canals, roads, bridges, and fortifications over which they could move troops and trade goods and information with great speed. However, they did not invent all the engineering and administrative skills they used to build and run their empire. They inherited most of this knowledge and their artistic traditions from the societies they incorporated into their empire.

The antiquity of art and culture along the coasts of southern Ecuador and Peru is amazing. Civilization there was supported by its unusual food resources, the base of which were microscopic plants that the Humboldt Current carried along the Pacific coast of western South America, which fed the other wildlife in the region. With these resources, the region prospered and by the third millennium BCE, northern Peruvian societies were constructing large platformed structures out of mud bricks with grass and twigs and puddled clay (or adobe). The Valdivian culture (c. 3550–1600 BCE) in southern Ecuador, known for its naturalistic clay figures, is older than dynastic Egypt. Along the coast, where clays were plentiful, clay sculpture remained an important art form in northern Peru up to the time of the Spanish conquest.

By 3500 BCE, the coastal people were also growing the sturdy cotton fibers which they eventually combined with the dyed wools to create one of the most astonishing traditions of weaving in the world. Many of the earliest representational images and styles were developed by textile artists who influenced other Central Andean artists for thousands of years to come. (See *"Materials and Techniques*: Fiber Art and Weaving," page 247.) It is difficult to overestimate the importance of textiles in the Central Andes. In fact, the web of the weavers' fabric may be seen as a metaphor for other aspects of Andean life as they "wove" nets of political alliances and connected their world with networks of long threadlike roads.

7.1 Drawing of the Raimondi Stela. Chavín de Huántar. c. 460–300 BCE. Approx. 6'5" × 2'5" (196 × 74 cm). Instituto Nacional de Cultura, Lima, Peru

CHAVÍN DE HUÁNTAR

Many of the early developments in art and thought in the Central Andes are combined in the arts of Chavín de Huántar, an ancient place of pilgrimage in the mountains and type-site for the Chavín style (900–200 BCE). The site, now badly damaged by earthquakes, had open courts, platforms, relief sculptures, sculptures in the round projecting from the walls, and small, secluded rooms. Such rooms, with carved images of guardian figures on their portals, may have housed sacred rituals held in honor of the Chavín deities. The content of Chavín art appears to be taken from many diverse regions—the neighboring coasts, highlands, and the tropical forests. The animals that appear most frequently in Chavín art—jaguars, eagles, and serpents—suggest elements of an Amazonian cosmology, but the diverse origins of the art and religion of Chavín de Huántar remain a matter of debate.

The Chavín love for abstract patterns and complex subject matter is well illustrated in a bas-relief known as the Raimondi Stela (FIG. 7.1). It represents a squat, anthropomorphic jaguar deity with a downturned, snarling mouth, fangs, claws, and serpentine appendages. This composite creature, known as the "Staff God," takes its name from the ornate staffs it holds. To display the headdress with four large, inverted monster heads sprouting serpentine appendages from a frontal point of view, the artists have raised the headdress above the Staff God's head, where it fills the upper two-thirds of the stela.

The decorative forms adorning the Staff God are rigorously organized in a symmetrical fashion, using a well-established vocabulary of stylized forms composed according to set rules of syntax. As in most Chavín sculptures, the straight lines, right-angles, and few curves in this piece seem to reflect the way textile designs are organized within the grid formed by the warp and weft.

Through a process of elimination and substitution, the artists create metaphorical body parts, images in which one form is used to stand for another. In Chavín art, a tongue may become an arm, serpents substitute for hair, and a head at the end of a tail can make the tail appear to be a neck.

The head of the Staff God is a composite of three faces, two of which are inverted and share the eyes and mouth of the central face. In this manner, using visual "puns," natural forms in Chavín art are altered and repeated in rhythmic and symmetrical sequences. These Chavín rules of order and the abstract images they produce have no counterparts in nature and appear to represent supernatural beings. It is possible that this imagery had a counterpart in the metaphors used in the Chavín myths and legends used to describe the supernatural beings honored by the artworks. It has also been suggested that the visual "puns," in which motifs are transformed from one image to another, may be connected with shamanic acts of transformation achieved with the use of hallucinogenic snuffs and other mind-altering substances commonly used in Chavín rituals.

Chavín was the mother culture for much of Peru; its arts appear to have spread with its religious ideals across the region. It is possible that Chavín de Huántar was a sacred shrine and center for a religious cult with subsidiary centers elsewhere in Peru along the coast, in the highlands, and in the tropical forests from which the subject matter of Chavín art was drawn. Elements of the style and content of Chavín art continued to influence Andean artists for centuries to come.

PARACAS

In its early phases, Chavín art spread south along the coast of Peru, where it influenced the local styles of Paracas (c. 700 BCE–1 CE). By the third century BCE, the textile artists of Paracas were designing garments of alpaca wool and cotton with woven and embroidered designs which were placed in tombs as part of an elaborate cult of the dead. In some arid areas along the coast around Paracas where very little rain falls, many of the textiles recovered from the bottle-shaped, rock-cut tombs are marvelously well preserved. The deceased were arranged in flexed positions, adorned with jewelry, and wrapped in many layers of cloth. In the necropolis or cemetery at Cerro Colorado on the edge of the Paracas peninsula, the mummy bundles were buried with unusually lavish offerings. Their wardrobes included as many as 150 well-decorated cotton and wool tunics, scarves, slings, headbands, headdresses, bags, fans, and *mantas* (Spanish, "shawls" or "royal mantles"), none of which showed signs of wear. Such treasures were apparently signs of wealth and status in the afterlife, where the deceased could continue to enjoy the pleasures of this life. The embroidery on the mummy bundles depicted myths, mythical ancestors, zoomorphic beings associated with the earth, sky and sea, and images of the deceased performing rituals. In this regard, the textiles appeared to play an important role in the transformation of their owners from this world to the afterlife. The fact that it may have taken a single artist up to ten years to complete the textiles

MATERIALS AND TECHNIQUES

Fiber Art and Weaving

The weavers (or fiber artists) of the Andes worked with cotton and the wool of llamas, alpacas, and vicuñas. They incorporated their early techniques of knotting, twining, braiding, looping, and wrapping fibers in later works done on backstrap looms (developed in the second millennium BCE). With this type of loom, still in common use in some parts of the Americas today, the warp (lengthwise threads) is stretched between poles attached to a stationary device (often a tree) and a strap looped around the back of the weaver. The weavers, most of whom are women, control the tension on the warp while threading the weft (crosswise threads) through it. Working in the tapestry technique, weavers use special weft threads for each color in the design so the color pattern is woven into the structure of the cloth. This technique is more laborious and time-consuming than embroidery, in which the design is stitched into a prewoven fabric.

Using combinations of tapestry, embroidery, and the earlier techniques mentioned above, the Andean weavers created some of the world's most complex textiles. In some virtuoso displays of their ability, they interwove as many as 500 threads per square inch (6.45 square cm), creating textiles that are so light and smooth they feel much like silk. Specialized weaving techniques and textile types were developed for everyday use, ceremonial costumes, and burial shrouds. Textile designs seem to have influenced styles of painting and other two-dimensional art forms throughout Andean history, and some scholars see parallels between Andean textile patterns and city plans. While the fiber arts elsewhere in the world often imitate other media such as painting, the underlying aesthetic basis of drawing and painting in the Andes seems to derive from the long tradition and technology of woven fiber art.

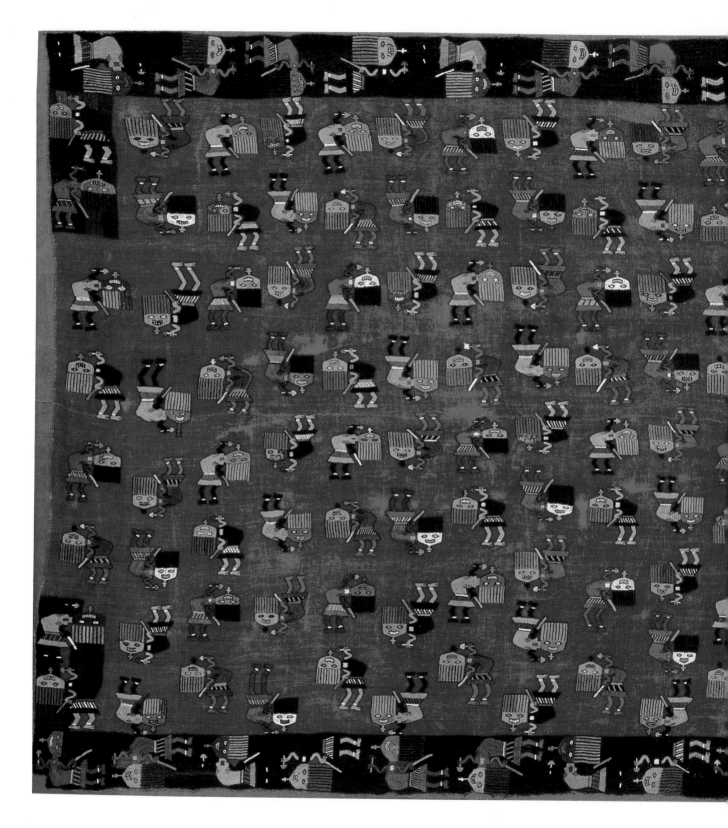

for one mummy bundle gives some idea of the importance attached to grave offerings and the cult of the dead among the Paracas élite. (See *"Materials and Techniques:* Fiber Art and Weaving," page 247.)

In Paracas textiles, the designs inspired by the embellished and composite animal imagery of Chavín art develop into more complex compositions of richly attired persons, shamans, and other ritual performers carrying weapons and trophy heads (FIG. 7.2). Basic motifs

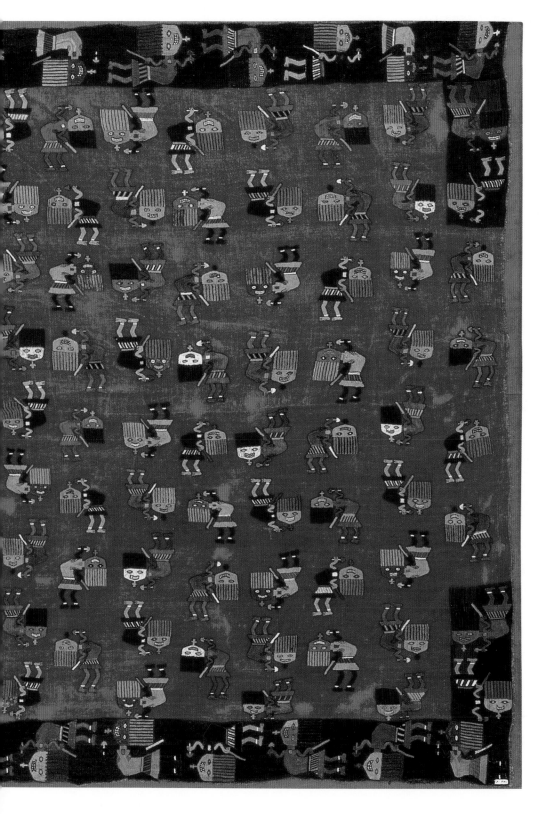

7.2 Embroidered mantle. Paracas Necropolis, south coast of Peru. Late Paracas, 200 BCE–200 CE. Camelid fiber, entire mantle 56 × 95" (1.42 × 2.41 m). Museum of Fine Arts, Boston

are enlarged, diminished, reversed, inverted, simplified, and elaborated in inventive variations that follow numerical and geometric rules of order. Color schemes can be reversed and images inset, one within the other. Images or motif clusters often appear to have established symbolic meanings and some of their variations may correspond with the output of a workshop or an individual artist.

TIAHUANACO AND HUARI

The Chavín-styled arts of Paracas and other early art centers formed the basis of the textiles, paintings, and relief sculptures of the first large Andean empires created around 600 CE. They made their capitals in the highlands at Huari, Peru, and Tiahuanaco, Bolivia, near Lake Titicaca. While there are few remains at Huari, Tiahuanaco is an enormous complex of platforms and plazas with well-preserved monumental sculptures. Tiahuanaco was a religious and cultural center for Aymara speakers of this region, who raised llamas and alpacas in the cold, dry climate of the high plains. The original Aymara name for Tiahuanaco, Paypicala ("the stone in the middle"), implies that the city was the center of the Aymara universe. Inca legends also tell how their creator god, Viracocha, made the sun, moon, and stars at Tiahuanaco.

An image of a god who may be the Tiahuanaco equivalent of the Chavín Staff God stands in the center of the shallow reliefs on the Gateway of the Sun (FIG. 7.3). The pose of the figure here, which is similar to that of the Staff God on the Raimondi Stela carved about a thousand years earlier, shows how the stylistic conventions of Chavín art retained their importance over the centuries. The figure on the gateway has a headdress of serpent-headed projections and a face carved in high relief like a mask, and holds ceremonial staffs with feline and condor-headed finials. Around him are three rows of winged attendants with falcon and condor faces. The abstract, geometric, and linear style of the figures and the composition of repeating units of form reflect the designs of many Andean textiles, including those of the contemporary Huari.

7.3 Gateway of the Sun. Tiahuanaco culture. c. 500 CE. Tiahuanaco, Bolivia

7.4 Huari tunic, Peru. 500–800 CE. Cotton and camelid yarn, 39¹³/₁₆ × 40⁷/₈" (1.01 × 1.04 m). Museum of Fine Arts, Boston

While the Huari tapestries represent a limited number of subjects based in large part on the winged, attendant deities on the gateway, this basic form is presented in numerous variations (FIG. 7.4). The weavers seem to have delighted in finding ways to be creative within their given iconographic limitations, compressing, fragmenting, reversing, and changing the color schemes of their limited number of given forms, retaining the core symbolism of the forms through all their variations. The design, like the structure of the threads in the woven textile itself, is made up of many elements repeating in a grid pattern. There is no single focal point or attempt to organize the elements in distinctive groups. The sameness of the grid pattern throughout is, in itself, the strongest formal expression of the design.

MOCHE AND CHANCHAN

While the textile artists working styles derived from the Chavín tradition were providing the elaborate grave goods for burials along the southern Peruvian coast at Paracas and other localities, clay artists along the northern coast were modeling naturalistic faces, figures, and figure compositions on vases for their burials. This tradition of modeling naturalistic forms, dating back to early Valdivian times (c. 3550 BCE), reached a highpoint around the fifth century CE at Moche, the capital of a large kingdom in the coastal deserts. This region is very arid because the high Andes to the east and the cool Humboldt Current offshore to the west keep most of the rain clouds from the warm ocean and rainforests from reaching the coast. To grow crops in this desert, coastal societies diverted the rivers descending from the Andes through networks of dams and canals to water their fields.

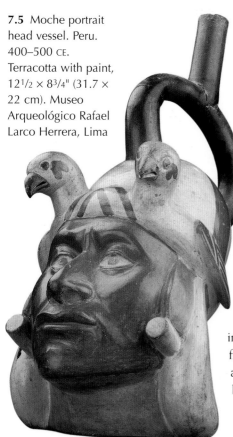

7.5 Moche portrait head vessel. Peru. 400–500 CE. Terracotta with paint, 12½ × 8¾" (31.7 × 22 cm). Museo Arqueológico Rafael Larco Herrera, Lima

From about 200 BCE to 600 CE, the people of Moche controlled a confederation of cities along the northern Peruvian coast and developed a tradition of burying their élite with grave goods that included sculptured vases. These mold-made grave vessels with rounded, stirrup-shaped spouts were hand-finished by sculptors and painted to represent a wide variety of face types, figures, and figure groups. Some of the Moche vases illustrate deformed faces, images of death, and figures engaged in sacrificial or erotic activities that may be part of fertility and death cults. This tradition of naturalism in clay art which had existed along the northern Peruvian coast since pre-Chavín times reaches its apogee in the fifth century in a group of about fifty very mature and dignified face types that may be portraits of Moche rulers (FIG. 7.5).

Unlike the Chavín tradition, which is formal and abstract, the sculptured and painted Moche vessels emphasize details of dress, decoration, actions, and narrative content. The paintings show mortals and supernatural beings taking part in dances, races, sacrifices, and burials. Schematic landscapes with rolling hills, mountains, and simplified plant forms provide backgrounds that indicate whether the events took place on the coast, in the deserts, or in the mountains.

Four rituals from the Moche burial cult are illustrated on a single very important burial vessel in figure 7.6. The image wrapping around the vessel appears flat in this modern, reconstruction drawing. Two men (identified as "Wrinkle Face" and "Iguana") holding ropes lower a masked mummy bundle into a shaft tomb chamber with grave offerings that include many recognizable Moche vessel types. The same two men appear again below on either side of the tomb with other smaller staff-bearing attendants above. Most of their features are rendered in profile, except for their upper torsos and certain items of clothing, which are shown from frontal

7.6 Reconstruction drawing of a painted stirrup-spout burial vessel. Middle Moche culture. 300–600 CE. Height 12" (30 cm). Private collection

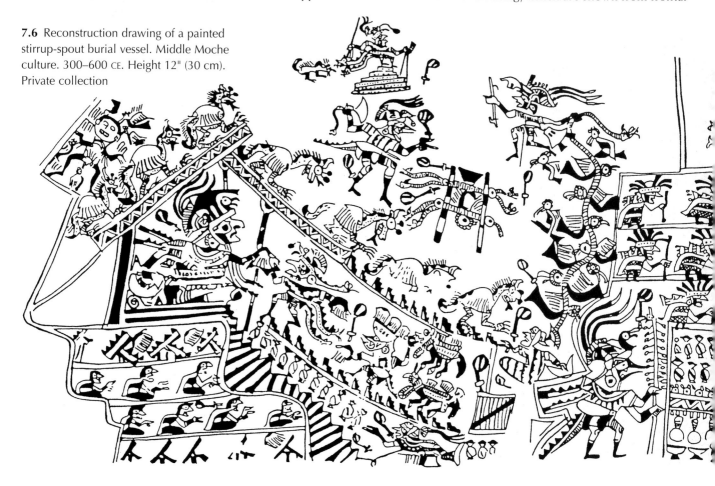

points of view. On the opposite side of the vase, the men offer bird sacrifices and hold an audience with a ruler, presumably as part of the complex of ceremonies accompanying the burial. Studies of Moche paintings are enabling scholars to identify Moche gods and rituals, to recognize important ceramic workshops, and to isolate the hands of individual artists. (See "*In Context*: The Lord of Sipán," page 254.)

After a series of natural disasters and invasions by peoples from the highlands, the Moche empire fragmented. Later, their territories were reconsolidated and expanded under the Chimu empire (1150–1460 CE). The Chimu language, Muchic, may have been derived from that of Moche, and the Chimu revived many elements of the Moche traditions. However, almost all the Chimu buildings were larger than the counterparts built by their predecessors. The new overlords of the coastal desert placed great emphasis on the construction of roads, walls, canals, and secular buildings. The Chimu capital, ChanChan, had a population of c. 50,000 and covered about twenty square miles (c. 52 square km) (FIG. 7.7).

ChanChan, with an abundant supply of fresh water from a network of canals, is the most ambitious example of urban planning in South America. Ten large

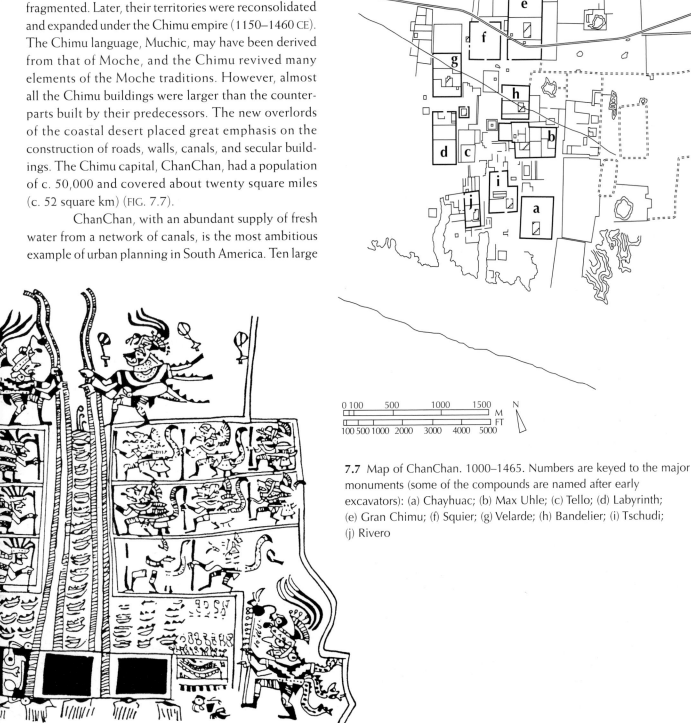

7.7 Map of ChanChan. 1000–1465. Numbers are keyed to the major monuments (some of the compounds are named after early excavators): (a) Chayhuac; (b) Max Uhle; (c) Tello; (d) Labyrinth; (e) Gran Chimu; (f) Squier; (g) Velarde; (h) Bandelier; (i) Tschudi; (j) Rivero

The Lord of Sipán

Most of the tombs excavated by archaeologists have been plundered by grave robbers or *huaqueros* (adobe mounds are called *huacas* in Spanish). In 1987, *huaqueros* working in the Lambayeque Valley near Sipán at Huaca Rajada discovered a cache of antiquities in a temple platform near two large eroded pyramids. When the local authorities discovered the looting, archaeologists were summoned to salvage the site and conduct further excavations. They discovered one of the richest and most important tombs ever unearthed in the Americas. The occupant, a warrior–priest about thirty-five years of age (died c. 290 CE), has become known as the Lord of Sipán (FIG. 7.8). His burial treasures included a gold headdress, mask, knife, jewelry, shield, pottery, and some attendants. Two young women (concubines or wives?), two men (enemy warriors?), and a dog may have been sacrificed to accompany the Lord into the other world. Many works similar to those in this tomb have long been known, but finding them here in their original context enabled archaeologists to reconstruct the Moche burial practices and learn more about their religion and world view.

7.8 Exploded view of the burial of the Lord of Sipán. Huaca Rajada, Lambayeque Valley, Peru. c. 290 CE. Painting by Ned Seidleer. Major features are keyed to numbers in the illustration: (a) Wooden coffin lid; (b) shell and copper bead pectorals; (c) gilded copper headdress with textile fastener; (d) outer garment with copper platelet; (e) gold rattle; (f) copper knife; (g) copper sandals and seashells; (h) gold headdress ornament; (i) gold and copper backflaps; (j) shrouds enclosing contents of the tomb; (k) war club and copper tipped darts

palace compounds, modeled after late Moche examples, averaging twenty acres (8.9 hectares) apiece, had living quarters for the royal family and its retainers, a royal mausoleum, gardens, and areas for audiences. They were surrounded by high walls (up to 30 feet, 9.15 m) decorated with repeating patterns of geometric forms, foliage, animals, and mythical creatures. The compounds appear to be the work of the successive monarchs who ruled the city and kingdom from the late twelfth century to 1460. The Chimu may have followed a system practiced by Inca rulers, who appointed trusted sons to maintain their shrines and cults after they died. When the Inca conquered ChanChan in the fifteenth century, they imported many ChanChan artists to their capital, Cuzco, where they blended elements of the coastal and highland traditions to create their own distinctive styles of art and architecture.

THE INCA

The name Inca has two meanings: it refers to a group of imperialists who emerged in the highlands of southern Peru and Bolivia around 1300 CE, and it designates the deified ruler of those people. Inca legends say that they came from the high plains around Lake Titicaca and Tiahuanaco, where their world was created, but, in fact, they may have been native to the Cuzco and Pikillacta area to the south. In the middle of the fifteenth century, the Inca burst forth and swept across the Andes with an explosive force comparable to that of the armies under Genghis Khan and Alexander the Great. Most of the Inca empire extending from present-day Quito, Ecuador, along the equator to Santiago, Chile, was less than a century old at the time of the Spanish conquest in the early sixteenth century. Yet it was a rigorously disciplined political institution unified by a large network of roads and bridges in which the Inca (ruler) presided over a complex administrative hierarchy. Serfs and skilled workers paid their taxes by working on the roads, agricultural terraces, storehouses, fortifications, palaces, and temples. Inventory records and other important government statistics were recorded on *quipus*, sets of colored and knotted cords of various lengths. Some scholars believe the *quipus* also recorded astronomical and historical events. These light fiber records could be carried at great speed throughout the empire by relay teams of fleet-footed youths. Viracocha, the creator, was the head of a pantheon of gods that included Inti (a male sun god), Quilla (a moon goddess), and the stars. The Inca seem to have linked their religious ideals with patriotism and allowed their subjects to worship certain of their own regional gods as long as they were loyal to the Inca and the empire.

Although the Inca continued many of the earlier traditions of figurative art imported from the coastal regions, as highlanders surrounded by the rocky outcrops of the Andes, they also inherited a passion for stonework. Their myths and legends suggest that they believed stones had intrinsic spiritual powers. Their ruler Pachakuti (ruled 1438–1473) installed a group of stones in a temple at Cuzco which, according to legend, had taken human form to help him in battle. At shrines, the Inca often placed worked stones around large natural stones, as if to contrast these qualities and emphasize the importance and beauty of stones as they existed in nature.

Cuzco

Pachakuti conquered ChanChan, made a thorough study of that city and its imperial holdings, and began rebuilding Cuzco to make it a fitting capital for his rapidly expanding empire. A figure comparable to the Roman emperor Augustus, who said he found Rome a city of brick and left it a city of marble, Pachakuti was the Inca leader who reshaped the image of Cuzco and made it a great imperial center. Set in the rocky highlands, the city was laid out on an irregular plan following the local topography. The central plazas, with their palace, temples, ceremonial halls, and residences for the Incas' secondary wives and the chaste women dedicated to Inti, stood at the heart of the city and the Inca cosmos. Inti's temple,

7.9 Street in Cuzco lined with Inca masonry. Photograph 1970

the Coricancha, housed the mummies of past Incas and its garden contained lifesize golden images of people, animals, and plants.

The major roadways radiating outward from starting points near the center of the city divided the empire into the "Land of the Four Quarters." Forty-one imaginary lines, known as *ceques* ("rays" in Quechua, the Inca tongue), projected outward from the Coricancha-like sunbeams to the Inca *huacas*, which were sacred places such as rocks and streams and the shrines of lesser deities. These *ceques*, some of which were also tied to lines of astronomical observation, linked the *huacas* to the Inca cosmos and expressed the grandness of the society's imperial ambitions. With Cuzco as the hub of a radiating pattern of *ceques* and roads, the conceptual vision of the capital also resembles a giant *quipu* spreading over the mountains.

The narrowness of the streets between the thatched-roof houses, temples, and palaces at the heart of the city is dramatized by the massiveness, height, and sheer power of the walls lining them (FIG. 7.9). While the walls at Cuzco appear plain, they originally supported earthen-toned thatched roofs and the streets would have been filled with Inca dressed in colorful dyed textiles.

The sense of imperial might that is still evident in the Inca walls around Cuzco comes from the technical skills of the stonecarvers and the manner in which they exploited the inherent, expressive characteristics of stone as a building material. Some of the stones with smooth-dressed faces have a sense of lightness and elegance. Conversely, many of the Inca walls where the stones are polygonal with convex surfaces, modeled edges, and sunken joints, appear to be puffed out from the pressure of the stones above and beside them. These polygonal stones, some weighing over 100 tons (101,600 kg), were trimmed and roughly shaped before they were dragged on rollers to the building site. When the stones were ready to be set in place, they were suspended from sturdy tripods on strong ropes, rocked back and forth, and lowered slowly, as they ground against the adjacent rocks and created their own nests. In many cases, portions of the projecting nubbins to which the ropes were attached can still be seen. The time, effort, patience, and technology required to fit stones in this manner are a testament to the organizational skills of the Inca and their imperial ambitions. By using trapezoidal openings in the walls that could be spanned with relatively short lintels, the Inca builders increased the stability of their masonry. Many of the Inca walls have survived marvelously well, withstanding the sixteenth-century civil wars and the powerful Andean earthquakes that continue to damage the later Spanish Colonial churches.

Machu Picchu

Pachakuti also began the construction of Machu Picchu, a ritual center and royal retreat on the frontier of the empire that has become famous in modern times as one of the world's most picturesque archaeological ruins (FIG. 7.10). The buildings and a network of narrow agricultural terraces cling to the crest of a high ridge overlooking an oxbow curve in the Rio Urubamba, a tributary of the Amazon. The city is remarkably well preserved because, until 1911, its existence was unknown except to a few regional inhabitants.

A main road passing through a gate in the city wall leads to the Great Plaza in the center of the complex. Machu Picchu has many of the same types of buildings around its plaza that an Inca traveler might have seen in any of the provincial Inca capitals around 1500: a temple of the Sun, houses for priests, a royal palace, barracks, workers' quarters, storehouses, and baths. In a few places, large rock outcrops have been reshaped and incorporated

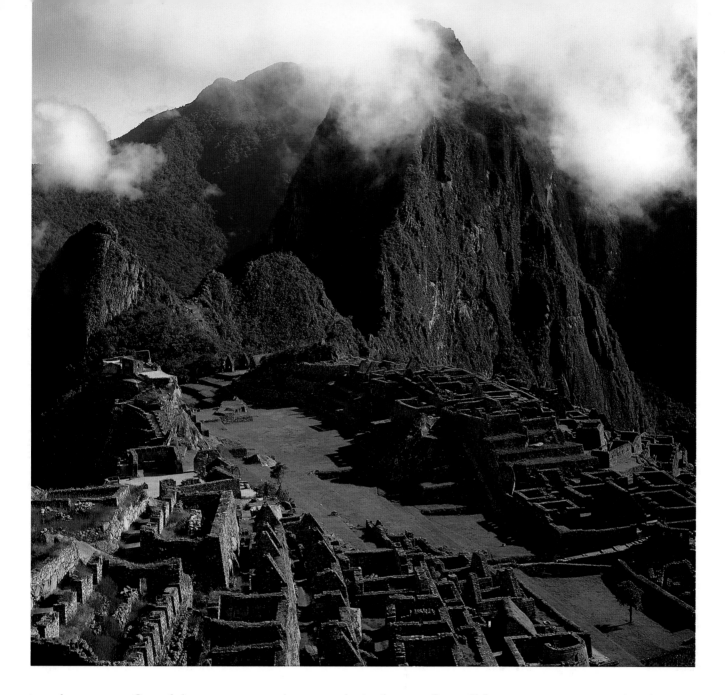

into the masonry. One of these structures is known as the Intihuatana Stone ("place to which the sun [Inti] is tied"). It may have been used as a sundial during celebrations marking the movements of the sun at important dates such as the June solstice (midwinter in the southern hemisphere), marking the beginning of the new ceremonial year.

When Francisco Pizarro, commander of the Spanish forces, arrived in highland Peru and captured Atahualpa, the Inca offered the Spaniards a true king's ransom in gold and silver. Pizarro's secretary, Francisco de Xerez, wrote:

> Atahualpa feared that the Spaniards would kill him and told the Governor that he would give them … enough gold to fill a room twenty-two feet long and sixteen wide to a white line at half the height of the room, or half again his height. He said that he would fill the room to that mark with various pieces of gold—pitchers, jars, tiles and other things …

Thereafter, the Spaniards spent many years in a fruitless search for the legendary *El Dorado* ("The Golden One"), a king with so much gold that for certain rituals, he appeared

7.10 View of Machu Picchu, with Huayna Picchu in the background. c. 1500

in public painted with gold dust. The great empire of the Inca was destroyed, but to this day, outside the metropolitan centers of South America, many of the Pre-Columbian traditions in the arts survive.

MESOAMERICA

TIME CHART *Mesoamerica*

Preclassic: 1200 BCE–250 CE

Classic: 250–900

Postclassic: 900–c. 1520

Mesoamerica is an area of high culture extending from northern Mexico through the Yucatán peninsula, Guatemala, and Belize to the western sections of Honduras and El Salvador. Scholars of Pre-Columbian art and history call the area of Mesoamerica west of the isthmus of Tehuantepec "Mexico." The lands east and north of the isthmus were, and still are, occupied by the Maya.

The history of Pre-Columbian Mesoamerican art is divided into three major periods: the Preclassic (or Formative), Classic, and Postclassic periods. The term "Classic" was borrowed from Greco-Roman studies by early Mayanists to designate what they considered to be the high point of Maya art.

In Pre-Columbian times, the Mesoamericans and South Americans had little if any direct contact: thus, the art of Mesoamerica is clearly distinct in style and meaning from that of the Andes. Together, the architecture, rituals, and arts of Mesoamerica reflect the very complex relationship between the people and their gods. The inhabitants of the region believed the affairs of this world were closely linked to those of an unseen other world underfoot and overhead. Mesoamerican art and architecture reflect these close ties between the two worlds in many ways. Ritual centers were often organized so buildings and roads were aligned to points along the horizon where important heavenly bodies rose and set at predictable intervals. Temples placed on tall, superimposed platforms often had a symbolic as well as a material meaning. Many of them were surrogate mountains rising out of the underworld and touching the heavens. Doorways leading into the temple enclosures might be symbolic entryways to the other world of the gods. Perhaps, by linking their architecture, art, rituals, and lives with natural phenomena and the other world, the Mesoamericans hoped to gain some measure of control over their own existence. The ways in which these ideas shaped the arts will be examined in context with the important regional styles of their art and architecture.

PRECLASSIC ART: THE OLMECS

In recent years, archaeologists have uncovered many new Preclassic sites throughout Mesoamerica. Many art forms originally thought to have originated in the Classic period were well known in the Preclassic period. The earliest works of art in Mesoamerica are attributed to the Olmecs, who carved stone sculptures on a scale that was seldom attempted in later Pre-Columbian times. Olmec is widely regarded as the "mother" culture of the later Classic Mesoamerican civilizations. The name is derived from an Aztec name, *Olman* ("the Rubber Country"), given to the low-lying tropical forests along the lower Gulf Coast of present-day Mexico, where the ancient Olmecs lived by about 2250 BCE. However, the true ethnic and linguistic identity of the Olmecs is open to debate, as is the meaning of the complex symbolism of their art.

Some of the finest monumental Olmec sculptures, ten large colossal heads, come from the earliest important Olmec center, San Lorenzo. They are carved from large basalt boulders that may have been imported from the Tuxtla mountains about eighty miles (128 km) to the west (FIG. 7.11). The broadly curved features of this large head are united in a composition of closely related, simplified forms that give it a sense of weight and authority. Typically Olmec in style, the contours of this intensely somber face reflect the natural shapes of boulders and water-worn pebbles. Differences among the facial features in this set of colossal heads and the signs or emblems in the headdresses of the colossal heads suggest that they may be stylized portraits of rulers. Ten reigns of thirty years would account for the three centuries from 1200 to 900 BCE when the center flourished. When San Lorenzo was destroyed, many of the monumental sculptures were defaced (ritually "killed") and buried around the edge of the city, as if the conquerors wanted to destroy the memory of the kings who had ruled there.

7.11 Colossal head, from San Lorenzo. Olmec culture. c. 1200–900 BCE. Basalt, height 9' (2.75 m). Museo Etnográfico y Arqueológico, Jalapa, Mexico

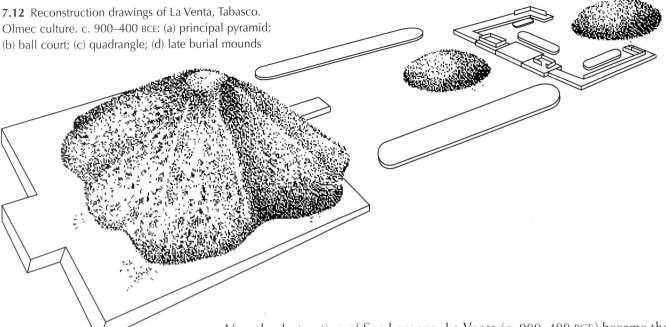

7.12 Reconstruction drawings of La Venta, Tabasco. Olmec culture. c. 900–400 BCE: (a) principal pyramid; (b) ball court; (c) quadrangle; (d) late burial mounds

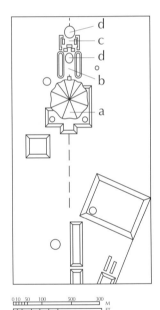

After the destruction of San Lorenzo, La Venta (c. 900–400 BCE) became the leading Olmec center. The layout of the city, with its superimposed platforms and plazas, is more geometric and carefully planned than San Lorenzo and it represents the main line of architectural development that shaped the later Classic and Postclassic cities of Mesoamerica (FIG. 7.12). Like many of the later Mesoamerican sites, the organization of La Venta may have followed certain astronomical lines of sighting, with buildings pointing to locations on the horizon where the solar bodies rose and set at various times of the year.

The main structure of this remote city on a stoneless island in the swamps is a tall conical pyramid. Archaeologists have not tunneled inside, but it may contain the tomb of one of the individuals represented by the four colossal heads found here. This structure, 110 feet (33.5 m) high, which has been described as a "fluted cupcake," has no stairway or structure on its summit. It appears to be a replica of a Mesoamerican volcano: some such volcanoes have deep erosion ditches or flutes alternating with ridges on their soft cinder slopes. Is it possible that the volcano with its passageway to the underworld was seen as a gateway to the Olmec "other world," the realm to which the shaman described above was traveling? If so, with its ability to shake the earth, the volcano–gateway to the other world would have provided the Olmecs with a dramatic image of the gods' powers and activities.

Before and during the ascendancy of La Venta, small Olmec sculptures were transported throughout Mesoamerica. Many of them are made from jadeite and depict figures of infantile creatures with slanting eyes and open, feline mouths known as "were-jaguars." Some writers have suggested that the were-jaguar on the Kunz Axe (FIG. 7.13) is a mythological creature, the hybrid child of human and jaguar parents. Others believe that these human–animal hybrid images represent Olmec shamans being transformed into animals.

The Olmecs seem to have been trying to explain the meaning of their art, religion, and culture through visual forms and developed a hieroglyphic script and system of counting. Their hieroglyphs have not been fully deciphered but they may represent the names of gods, historical individuals, days in their calendar, and other important concepts in Olmec thought.

Olmec culture may have declined around 300 BCE, well before the appearance of the Classic cities in the Maya and Mexican territories, but elements of the Olmec script, belief system, art, and architecture appear to influence Mesoamerican societies throughout the duration of Pre-Columbian history.

CLASSIC ART

By the beginning of the Classic period (c. 250 CE), many regions within Mesoamerica had large metropolitan centers with active workshops of artists who were producing high-quality painted pottery, manuscripts, and sculptures in stone, stucco, and wood. The cultural differences between the Mexican and Mayan halves of Mesoamerica were distinct by Early Classic times and by the seventh to ninth centuries, the Late Classic art of Mesoamerica represented one of the highpoints of Pre-Columbian history.

The Maya

The Maya territory may be divided into three regions: the Central Area, extending from the Usumacinta River drainage area through the Petén district of Guatemala to present-day Belize; the Southern Highlands in Guatemala; and the Northern Maya of the Yucatán peninsula. At the height of their prosperity in the Late Classic period, around the late eighth century CE, the Maya lived in about fifty city-states, the capitals of which contained tall platformed temples and palaces decorated with architectural sculptures and murals. They created finely painted pottery and illustrated books or codices (singular, codex) and worshiped many of the same gods, whom they illustrated in their arts. (See *In Context*: Maya Hieroglyphs and the Historical Record," page 262.) Some of the city-states may have been confederated under such large centers as Tikal, but the Maya were never united in a single large state or empire. City-state rulers representing local dynasties ruled over a complex hierarchy of farmers, merchants, nobles, warriors, artists, and craftsmen. They directed trade, politics, war, and religion, which included the staging of rituals in and around the temples and plazas in the ceremonial centers.

Palenque

The religious philosophy and art of the Maya reflect their beliefs in *Xibalba* ("place of fear" or "worship and reverence"), an otherworldly realm occupied by the gods. The sacred book known as the *Popol Vuh* describes the exploits of mythological twins who outsmarted the gods and survived a visit to *Xibalba*. Like the mythical twins and living rulers, Maya temples and sculptures were believed to have a dual nature that reflected the terrestrial and celestial worlds. The tall platform temples such as the Temple of the Inscriptions in Palenque were conceived in symbolic or metaphorical terms as sacred mountains; their doorways were the mouths of mountain caves reaching to the other world of *Xibalba*, which existed underground during the day and in the heavens at night (FIG. 7.14). The Maya believed that their gods and sacred ancestors lived in the recesses of these temple–mountains, which they called *y-otot*

7.13 *Kunz Axe.* Olmec culture. c. 1000 BCE. Jade, height 11" (28 cm). American Museum of Natural History, New York

7.14 The Palace and the Temple of the Inscriptions, also known as the Ruz Tomb. Palenque, Chiapas, Mexico. Late Classic period, c. 670–80

Maya Hieroglyphs and the Historical Record

Some time before 250 CE, the Maya expanded upon the older phonetic scripts derived from the Olmecs to develop one keyed to their own language. Recent developments in Maya epigraphy make it possible to read with some accuracy the Maya hieroglyphic inscriptions on pottery, manuscripts, sculptures, and buildings (FIG. 7.15). However, there are disagreements among epigraphers, and the names of some Maya leaders mentioned in this chapter may be subject to future revisions.

The word "hieroglyph" comes from two Greek words, *hieros*, "sacred," and *glyphein*, "to carve." Maya hieroglyphs use pictographs, some of which are representational while others are phonograms, signs for spoken sounds in ancient Maya which modern scholars have reconstructed using colonial and modern Maya dictionaries.

To count units of time, the Maya used dots (one) and bars (five) with place values in a modified vigesimal (base twenty) system. They counted their time from a base date, 3114 BCE, when their world and time began. Dates in Maya inscriptions can be correlated with those in our calendar system, which makes it possible to tell precisely when certain Maya buildings and works of art were dedicated.

We know the names of many rulers, their family affiliations, when they ascended to the throne, and when they died. The inscriptions penned and brushed on vases, murals, and codices are generally in the same hand as the associated images. Appropriately, the verb for "to paint and "to write" (*ts'ib*) is the same in all known Maya dialects. The word for "artist" in ancient Maya times may have been *ah ts'ib* ("noble artist–scribe").

The hieroglyphic script was never codified in the manner of the letters and words on this page. Like the medieval European manuscript illuminators who embellished their Latin letters with great flare, the Maya artist–scribes exercised a degree of poetic license and repeatedly found new ways to present variations upon the basic hieroglyphic character-types. In this regard, the creation of hieroglyphs may have been a recognized art form in itself, something akin to calligraphy.

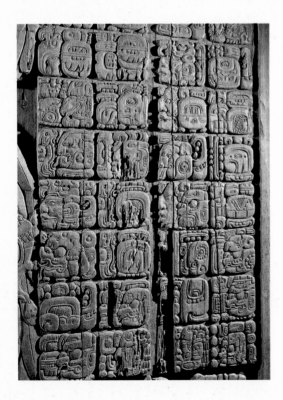

Inscriptions on Maya vases may include the names of the patron or owner of the vessel and the artist, suggesting that the Maya "noble artist–scribes" came from educated, noble, or otherwise wealthy families. Some artists displayed their erudition by using words and hieroglyphs from other ancient Maya dialects.

Using these historical hieroglyphic records, along with archaeological data, Maya writings from the post-conquest period, and ethnological reports, scholars have shaped a remarkably detailed picture of Pre-Columbian Maya art and civilization. New and exciting discoveries of artifacts and ideas are constantly changing our picture of the ancient Maya and not all Mayanists today agree how the dynastic structure was organized and how other aspects of their society worked. Nevertheless, with the deciphering of the Maya script, Maya civilization has joined that of Egypt, Mesopotamia, the Indus Valley, and China as one of the great "cradles" of literate civilization.

7.15 Maya hieroglyphic inscription from lintel, Temple IV. Tikal, El Petén, Guatemala. 741 CE. Wood, height approx. 19" (48.25 cm). Museum der Kulturen, Basel

("his/her house"). Below the temple–mountains, the Maya erected sculptures they called "tree-stones." Today these are called "stelae." In the minds of the Maya, the temples and sculptures represented symbolic mountain–forest landscape diagrams of the Maya cosmos, the other world of the gods. As they performed rituals in these symbolic landscapes, the Maya rulers moved back and forth, from one world to the other, to demonstrate their sacred powers before the public masses assembled in the plazas. This ability of the rulers to move between the two worlds, expressed in their mythology, hieroglyphic inscriptions, and rituals and illustrations, stands at the very core of Maya art and thought.

The sculptures in the Temple of the Inscriptions (also known as the Ruz Tomb, for the archaeologist who excavated it) show a ruler from Palenque, Lord Great-Shield (ruled 615–683), at his death, moving from this world to *Xibalba* (FIG. 7.16). The rounded sculptural forms of the Olmecs have been replaced by two-dimensional linear forms illustrating the complex religious symbolism of such noble Maya rites of passage. Lord Great-Shield, lying on the head of the sun, falls backward in the manner of the setting sun along the path that leads into the jaws of two skeletal dragons—the mouth of *Xibalba*. The "World Tree" behind Lord Great-Shield, erected by the gods in the center of the Maya cosmos at Creation, is also the road to *Xibalba*. With its roots underground, its trunk passing through this world, and its branches supporting the heavens with a celestial bird, the World Tree unites the three realms of existence. Lord Great-Shield's tomb, located at the end of the long tunnel-cave that began at the entrance of the mountain-temple above (itself a path to *Xibalba*), shows art and architecture symbolizing the move of the deified king from this world to the next.

Within the tomb of Lord Great-Shield are images of his regal ancestors. The carved inscriptions in the crypt explain that Lord Great-Shield was descended from a long line of kings and two noble ruling ladies. His mother, whose name translates as Lady Resplendent Quetzal, ruled before 615 and his great-grandmother Lady Maize-Spirit ruled from 583 to 604. Apparently, both women ruled Palenque with the full authority of kings. Resplendent Quetzal may have been the regent for the youthful Lord Great-Shield before he ascended to the throne in 615. In his inscriptions, Lord Great-Shield praised his mother, calling her the "mother of the gods," and double portraits of his mother and great-grandmother appear on the sides of his sarcophagus.

Early in his reign, Lord Great-Shield had begun work on the area around his future tomb, replacing portions of the old palace with light, airy, thin-walled enclosures containing multiple doors and large, decorative vaults. Around 675, when Lord Great-Shield was in his seventies, he cleared

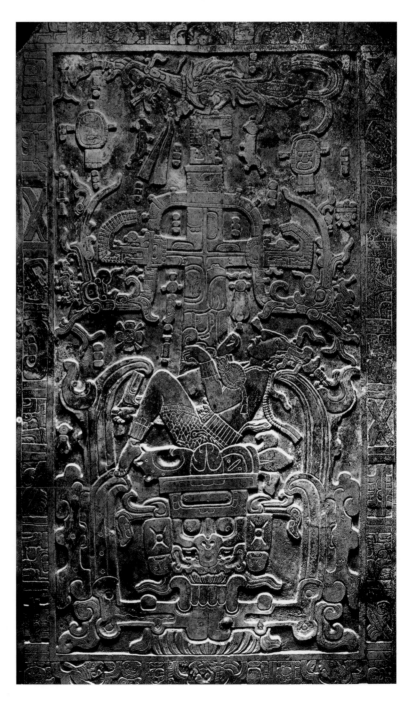

7.16 Sarcophagus lid, Temple of the Inscriptions. Palenque, Chiapas, Mexico. Late Classic period, c. 680. Limestone, approx. 12'2" × 7' (3.7 × 2.2 m)

an area adjacent to the palace and began the construction of his mortuary monument. Both the tomb, the "home" of the deified ruler in the afterlife, and the temple above are stone replicas of the traditional type of Maya house still in use in this area. Maya homes are usually made from lashed saplings and have high-pitched roofs covered with many layers of palm fronds to repel the heavy tropical rains. The steeply inclined and flat-sided corbel vaults of the temple and tomb reflect this domestic prototype. A corbeled stone vault is made by extending the stones on two sides of a room successively closer to the center of the enclosed space as each layer of masonry is added until the inclined faces meet, creating a triangular arch-like space. It is often called a "false" arch to distinguish it from the keystone centered arch used by the Romans.

Tikal

In 682, a year before the death of Lord Great-Shield, a strong ruler named Lord Sky God K (ruled 682–734 CE) took the throne at Tikal, the largest of all Classic Maya cities. This great metropolitan center was occupied from c. 750 BCE to 900 CE. It had enjoyed an earlier period of prosperity in the late fourth century CE after defeating Uaxactún, its neighbor and arch rival. In the years following that triumph, working with Teotihuacán in the Valley of Mexico, Tikal prospered as an international trade center until Lord Water from the Maya city of Caracol conquered it in 562. Monuments erected in the years to follow describe a century of anarchy and economic instability.

Tikal enjoyed a renaissance under Lord Sky God K, who launched ambitious building campaigns. He reconstructed Tikal on a grand scale around a network of broad ceremonial roadways up to eighty feet (24.4 m) wide that may have been used by large ritual processions moving through the city paying homage to the tomb-temples of the deceased kings and queens. The Tikal market also became one of the largest economic and social centers in the Maya lowlands. The nearby temples around the Great Plaza north of the new palace complex had become an important center for rituals and religious activities. The larger of the twin temples, known today as the Temple of the Giant Jaguar or Temple I, is the unofficial symbol of Tikal and modern Guatemala (FIG. 7.17). The patterns of shadow created by the protruding moldings at the top of each platform and the double stepped recesses on either side of the stairs enliven the towering mass of this symbolic mountain and entryway to *Xibalba*. The spectacular design of this temple reflects its importance to the residents of Tikal in the eighth century, and it contains the tomb of Lord Sky God K.

Lord Sky God K's body was placed in a vaulted tomb over which the platforms supporting the temple were constructed. The nine levels of the platform may symbolize the nine layers of the other world above the king's new position at the base of *Xibalba*. The temple at the summit of the platforms was the focal point for funeral rituals performed in his honor. Carved roof beams in the temple illustrate his accession and military prowess. A now eroded monumental stucco image of the enthroned king also appeared on the roof comb of the temple with a serpent looped over his head, the war god Itzamna representing the dome of the heavens. This monument, and the other "skyscraper" temples of Tikal from this period, provided the city with a dramatic skyline that had no equal among European cities of this period.

Protected from the tropical winds and rains that eroded the king's image on the roof comb of the temple, the offerings sealed in his tomb at the base of the temple platforms are very well preserved. Such royal tomb offerings normally included vases painted with fine-haired brushes illustrating mythological events and rituals taking place in this world and *Xibalba*. They may have been designed to accompany and assist the dead on their journeys to the other world. Creating images of *Xibalba* gave the Maya artists marvelous opportunities to exercise their imaginations and give visual form to the poetic imagery in the Maya myths describing activities in the other world. While the manuscripts in which the Maya described

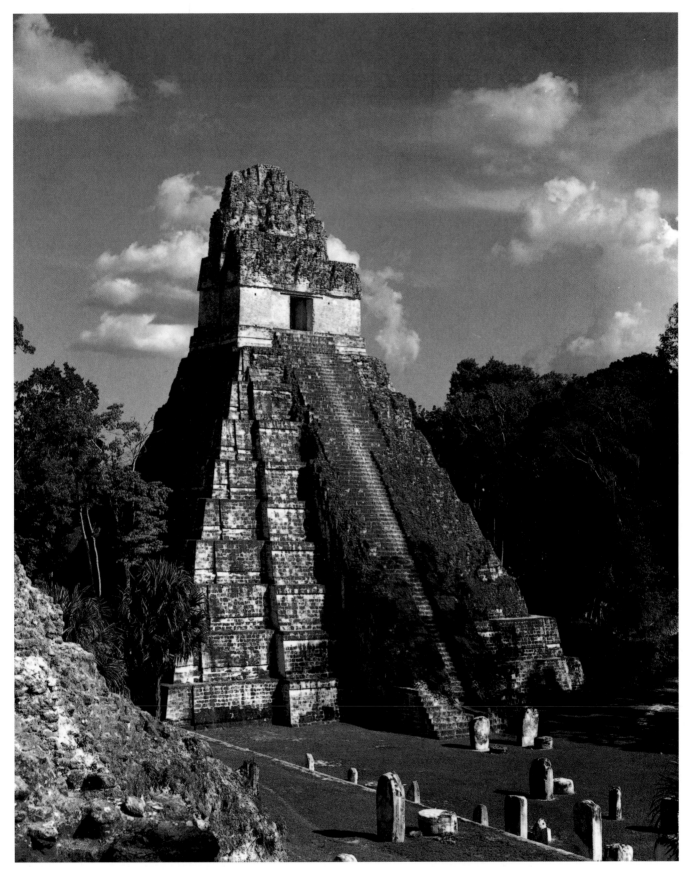

7.17 Temple I (Temple of the Giant Jaguar). Tikal,
El Petén, Guatemala. Late Classic period, 8th century

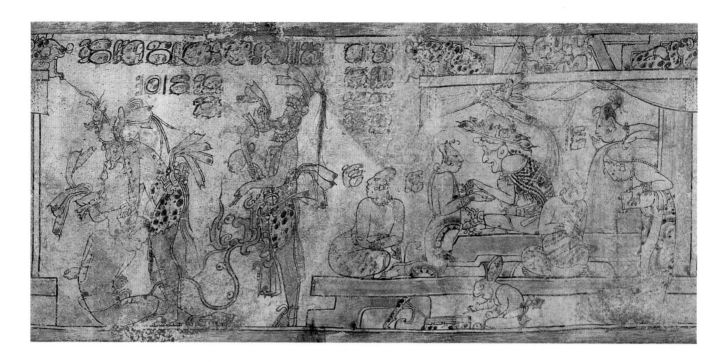

7.18 Cylindrical vessel. Late Classic period, 8th century. Painted ceramic, 8¹/₂ × 6¹/₂" (21.5 × 16.6 cm). The Art Museum, Princeton University

myths of the Classic period have vanished, early post-conquest Maya writings suggest that the ancient Maya had very rich literary traditions. The painters conceived their images in terms of a wide variety of complicated and elegant curvilinear lines, which they applied in quick, confident strokes. The painted hieroglyphic texts and accompanying images on vases of the Late Classic period are some of the most beautiful examples of calligraphy or fine brushwork ever created.

The name of the artist who painted the vase in the Princeton collection is unknown (FIG. 7.18). Consequently, this anonymous master, whose style of drawing and calligraphy has been found on other vases, is known as the Princeton Painter. The aged God L, one of the main lords of the underworld, is seated on a cloth-covered bench within a small building and conversing with one of his five bald women attendants. The artist captures the elegance of the goddesses' movements, arranging each of them in an innovative and casual pose. Their crania were deformed during infancy by presses set on their cradle-boards. These very high, distinctive foreheads, accented by the plucked hair, are signs of noble birth. One of them turns to look at two men on the left who wear spotted jaguar pelt kilts, reptilian masks with long snouts, and hold knives. They are about to decapitate a man whose arms are tied behind his back. The men may be the mythical hero-twins from the *Popol Vuh* demonstrating their power to sacrifice a victim and then restore his life. On the floor below the aged god, a rotund rabbit, brush in hand, is busily painting a manuscript.

There may have been thousands of illustrated books in the libraries of the Maya élite by the eighth century, but none of them survives. The four extant Maya codices come from the Postclassic period. The surviving manuscripts are long screen-folds (folded like an accordion) bearing calendric computations and images of the deities. Maya priests of the Classic and Postclassic period probably used the codices as astronomical and astrological charts when performing rituals to interpret the will and ways of the gods.

Copan and Bonampak

The line types and compositional patterns seen on Maya vases and codices reappear in relief sculptures, many of which were made in perishable materials such as wood and stucco and have not survived. The most productive and astonishing workshop of sculptors was located near the Rio Motagua on the eastern edge of the Maya territory at Copán ("Place

in the Clouds"). In 695, Eighteen Rabbit became ruler of Copán. During the sixty-seven years of his rule, he conquered the neighboring city of Quiriguá and set up a series of stelae around the valley outside Copán, and established his city as a major center of Maya art. When Eighteen Rabbit became king, he began erecting a forest of "tree-stones" or stelae at the base of the mountain-temples surrounding the Great Plaza in the heart of the city. From 711 to 738, Eighteen Rabbit's sculptors created a series of royal portrait statues that combine the decorative brilliance of Lord Great-Shield's sculptures at Palenque with a sense for sculptural form similar to that of the Olmecs. Working with andesite, a stone that is relatively soft when first quarried and hardens on contact with the air, the sculptors were able to model forms fully and carve fullsize figures of the king that are almost freestanding.

Eighteen Rabbit is portrayed on Stela A in full ceremonial regalia, wearing sandals, garters, jadeite-studded loincloths, ear plugs, necklaces, and a multilayered plumed headdress (FIG. 7.19). The rounded masses of the ruler's feet, legs, hands, arms, and face burst forth from a background of decorative details that illustrate his badges of authority and his kinship to the gods. Eighteen Rabbit holds a sacred two-headed serpent bar in the crook of his arms that represents Itzamna, the sky god depicted on the roof comb of the Temple of the Giant Jaguar at Tikal. The beauty and drama of these reliefs as their patterns of highlights and shadows change with the movement of the sun are truly astonishing. The brilliance of the Copán artists' accomplishments in sculpture is even more remarkable given that they operated on a Neolithic level of technology, carving these stelae with flint and obsidian tools.

After around 763, the fortunes of Copán, like those of many Maya cities, had begun to decline. Smoke Shell's son Lord Dawn was an ambitious builder, but was unable to add any monuments to Copán to compete with Eighteen Rabbit's spectacular stelae and his father's Hieroglyphic Stairway. However in 793, when Lord Dawn was celebrating the thirtieth year of his rule, the traditions of Classic Maya wall painting were coming to a dramatic climax in Bonampak. The king of Bonampak, Lord Mythological Bird-Sky, was married to Lady Rabbit of nearby Yaxchilán. As a noble lady steeped in Maya art and culture, she may have played a part in the creation of the Bonampak murals. They commemorate a series of festivals, battles, and sacrificial offerings celebrating a rite of passage for her son, the young heir apparent to the throne at Bonampak.

An audience scene, showing prisoners before Lord Mythological Bird-Sky of Bonampak, may record a specific, historical event that took place on the steps and terraces in front of this building in 790 (FIG. 7.20). The ruler and his military captain at the center of the composition wear royal jaguar pelts and stand on either side of a kneeling captive. Stripped of their regalia, the naked captives no longer display their symbols of rank and prestige. Drops of blood flow from their fingers, suggesting that they have already been tortured in rituals leading up to this audience. In the captive lying at the feet of the king, the artists have attempted to portray a complicated, unorthodox, and sprawling figure type by foreshortening the man's shoulders and legs. A small slit in his chest may indicate that his heart has already been removed.

The formality of the courtly ritual is accentuated by the symmetry of the composition, which places the ruler and his captain in an elevated and central position directly above the entryway. Although the more distant figures at the top of

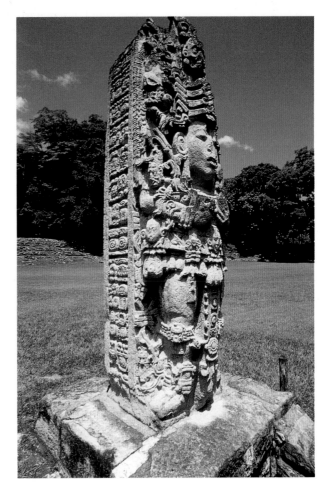

7.19 Portrait statue of Eighteen Rabbit, ruler of Copán. Stela A. Copán, Honduras. Late Classic period, 731. Andesite, over lifesize

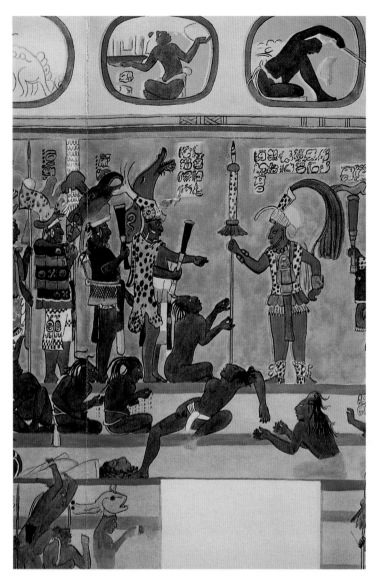

7.20 Detail of Maya wall painting, Room 2, Structure 1, Bonampak. Late Classic period, c. 795 CE. Polychrome stucco, entire wall 17 x 15' (5.18 x 4.57 m). Copy by Antonio Tejeda

the mural are shown on the same scale as those at the bottom, the terrace steps provide the artists with a kind of vertical perspective in which there is no illusion of deep space. The ritual is presented in visual terms that are universally understandable, and its formality expresses the pomp and dignity of the courtly rituals in a Maya ceremonial center. However, the murals were never finished and, despite the apparent strength of the ruling family, Bonampak was abandoned shortly after these rituals took place. Scenes of military activity appear in the Bonampak murals and elsewhere in the art of this region as the Classic period of Maya civilization came to an end around 900.

Mexico

The Mexican half of Mesoamerica produced a number of distinct and important regional Classic cultures. The dates for Mexican art are generally less precise than those for Maya art. The Mexicans had a 260-day ritual calendar (thirteen months of twenty days) that ran concurrently with their 365-day solar calendar. Pre-Columbian Mexican artists often inscribed works of art with the dates in both calendars, so it is possible to determine when a particular work was done within a given 52-year cycle. However, the solar years were not numbered consecutively from a date in the distant past as they were among the Maya, making it impossible to correlate Classic Mexican calendric inscriptions with Western dates.

Teotihuacán

The Aztecs who lived in the Valley of Mexico in the sixteenth century were impressed by the ruins there and called them Teotihuacán ("birthplace of the gods," or "place where the gods walk"). They believed the gods had created this world out of their own bodies and blood at Teotihuacán. While this name may derive from one used by the original inhabitants of Teotihuacán, the names of the monuments in the city used below are modern ones.

Teotihuacán, which flourished from c. 1 CE to 650 CE, had over 200,000 permanent residents in the sixth century, which made it the largest and most densely populated city in Mesoamerica of its day. This great metropolis, a manufacturing center that controlled the lucrative trade of obsidian, had over 500 workshops where painters, potters, and sculptors made trade goods that traveled throughout Mesoamerica. The city also had shrines that attracted many pilgrims. With its religious, economic, and political clout, Teotihuacán influenced the art and culture of many Mexican and Maya cities. The concept of Mexico as a land ruled out of the Valley of Mexico, which continues to this day, seems to have begun with the rise of Teotihuacán.

The Sun Pyramid (begun c. 100 CE) is the largest structure in Teotihuacán (FIG. 7.21). A stairway on its west side leads to its summit, where a temple once stood. The sloping faces on its five superimposed platforms make this massive structure look like a human-made mountain. The monument with royal burials was built over an ancient spring and a cave. In Mesoamerican thinking, caves and springs were often seen as conduits to the under-

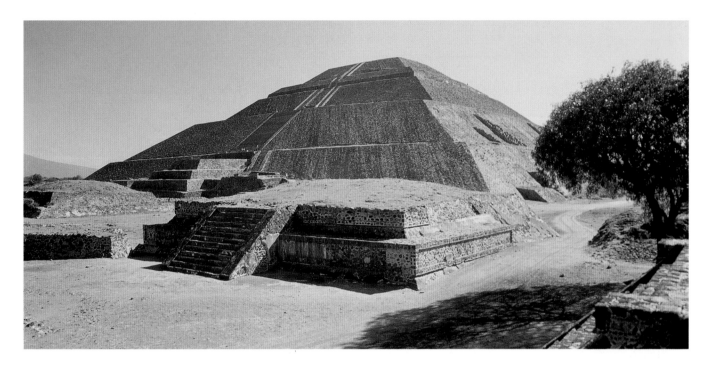

world, while mountains, and their architectural counterparts—elevated temples on platform structures such as the Sun Pyramid—communicated with the heavens. The people of Teotihuacán seem to have envisioned the Sun Pyramid as an *axis mundi* ("world axis"), a gateway to the upper and lower worlds. The Sun Pyramid, the road in front of it, and other monuments begun in the Preclassic period played an important role in the organization and expansion of the city in Classic times. (See "*Analyzing Art and Architecture*: Teotihuacán, City Planning, Pragmatics, and Theology," page 270.)

The finest surviving mural in Teotihuacán covers all four walls of a room in an apartment compound belonging to a wealthy or noble family (FIG. 7.22). Some scholars believe it represents a Teotihuacán version of the paradise of the rain god, the Aztec *Tlalocan* ("realm of Tlaloc"), reserved for those who died watery deaths. Recent scholarship suggests that the figure in the upper portion of the mural with outstretched hands and a tassel-feather headdress is a goddess associated with water and fertility. Streams of stylized water flow from her hands and those of her assistants. A fertility goddess and protectress, she may be the most important deity in Teotihuacán.

The costumes of the figures and their surroundings are filled with a multitude of carefully outlined two-dimensional forms. In marked contrast to the contemporary Maya, who were developing a style featuring sinuous, whiplash curves, the Teotihuacán artists constructed their images from a limited vocabulary of basic curves and straight lines. Naturalistic forms are simplified into patterns that integrate with the stark linear rhythms of the walls, buildings, and streets of the city. This style of painting is often called "architectonic" because the shapes reflect those of the architecture.

7.21 Sun Pyramid. Teotihuacán. Begun c. 100 CE. Base 738 × 738' (225 × 225 m); height 264' (80.5 m)

7.22 *The Great Goddess.* Tepantitla, Teotihuacán. Upper portion of mural. c. 650

Teotihuacán: City Planning, Pragmatics, and Theology

The plan of Teotihuacán reflects the cosmological beliefs of its leadership as well as the practical necessities of building and maintaining a large, densely populated, and urbanized city. The main street, the so-called Avenue of the Dead, is a long narrow, multilevel plaza that runs from the countryside north through the heart of the city to the plaza in front of the Moon Pyramid, begun c. 150 CE (FIG. 7.23). As the ancient residents and visitors to Teotihuacán walked up the avenue to the north, they passed long rows of large public buildings. The Ciudadela with the temple of the Feathered Serpent (begun c. 100 CE) contained the royal palace and enough open space to hold the entire population of the city. Across the avenue was the Great Compound, a market where traders and political leaders from around Mesoamerica gathered. Further up the avenue, the Sun Pyramid was part of a complex including smaller temples and a large plaza. This and other temple groups along the avenue were dedicated to local gods, and, perhaps, those of Teotihuacán's trading partners and allies.

This all-important avenue connecting the most important structures from the Preclassic period provided the central axis for a grid or checkerboard pattern upon which the Classic period city was organized. The strong, repeating horizontal accents of the architecture and the painted decorations on them worked together to reflect and emphasize the rectilinear grid plan of the city. Even the course of the San Juan River through the city was diverted to follow the right-angle pattern of this grid.

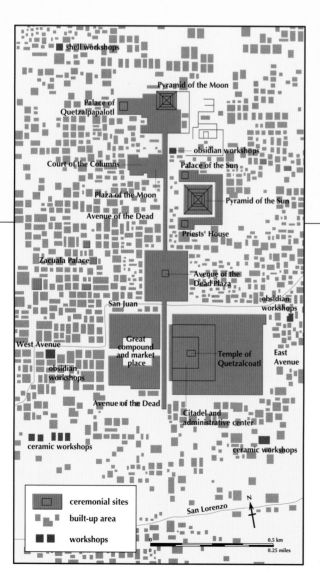

7.23 Plan of Teotihuacán. c. 650, showing major ceremonial sites and artist's workshops

The Gulf Coast and El Tajín

During the Early Classic period, a culture with a distinctive style of architecture and sculpture emerged north of the Olmec homeland in the modern Mexican state of Veracruz. It is called the "Classic Veracruz" or "El Tajín" style after the largest art and ritual center in this region. (The name means "lightning.") The single most important theme in Classic Veracruz art, the ritual of human sacrifice, was part of their so-called "ball game" activities and it is illustrated on a wall of the main ball court in El Tajín (FIG. 7.24). The "game," which had religious significance, was "played" or performed in El Tajín and elsewhere by teams that volleyed large rubber balls back and forth in narrow courts bordered by vertical walls. Many Classic Veracruz sculptures show individuals wearing what appear to be pieces of ball game equipment, thick *yugos* (Spanish, "yokes"), around the waist. Stone versions of such attire were deposited in graves that may have belonged to ball players and/or sacrificial victims.

The pattern is based on a module of about 187 feet (57 m). The Pyramid of the Sun, for example, is four units or modules long and four wide (187 × 4 = 738). Many of the modules correspond to modern city blocks. Here, they are large walled apartment compounds occupied by extended families or manufacturing groups. These compounds were mass produced according to certain prescribed principles of design. Many had a centralized, open patio with an altar or a shrine surrounded by buildings on all four sides. The arrangement of these compounds also reflects the social structure of the city. The Ciudadela compound and other centralized, public spaces commanded by the sovereign and his entourage occupied the center of the city. Around them lay the compounds of the lesser nobles and wealthy merchants. Beyond these were the homes and workshops of the artisans and the lesser-skilled workers in the countryside.

Teotihuacán is also designed to reflect the landscape around it. With their sloping sides, the mountain shapes of the Sun and Moon pyramids are unmistakable. Even the details of their construction and that of other platformed structures in the city seem to refer to the surrounding mountains. The Teotihuacán builders devised standardized systems of design with inclined walls (*taluds*) at the bases of the platforms supporting vertical, framed walls called *tableros* (Spanish, "pictures") that may have been decorated with paintings or sculptures. These *tablero–talud* combinations resemble the bands of stratified rocks running above the scree slopes along the bases of many Mexican mountains.

The citadel, a valley-like space surrounded by ramparts and small mountain-shaped platform temples, may have been conceived as a replica of the Valley of Mexico, or, more specifically, the area around Teotihuacán. Other temple clusters such as those in front of the Sun and Moon pyramids may also represent or symbolize the mountain-valley landscape around the city. The Avenue of the Dead points like a giant arrow to a cleft in one of these mountains on the horizon behind the Moon Pyramid. This orientation aligns the avenue 15 degrees 29 minutes east of true north, and the Sun Pyramid faces the same angle north of true west to a spot on the horizon where the sun sets on April 29 and August 12. This further links the pyramid with the sun as it falls from the sky to the underworld.

In summary, the city was designed in an orderly fashion as a manufacturing center to produce goods that would connect Teotihuacán with the other regions of Mesoamerica. It was also designed as a replica of the landscape around it—part of that world with which it traded. Thirdly, it was conceived as a world axis to link it with the celestial realms above and below the city. As a microcosm of the universe, the city may have been, as the Aztecs said, a "place where the gods walk."

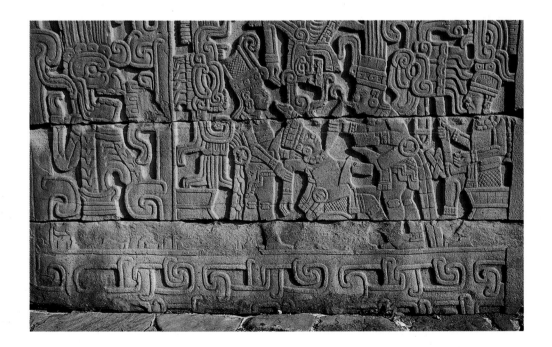

7.24 Relief panel depicting the sacrifice of a ball player. South Ball Court, El Tajín, Veracruz. Late Classic period, 300–900 CE. Stone, 5' × 6'6" (1.56 × 1.98 m)

A wide variety of head types mixing scroll, animal, and human features in Classic Veracruz art illustrate what appear to be deities associated with ball court rituals and other aspects of Veracruz religion. The abstract heads may also represent a Veracruz system of pictographic writing, one inspired perhaps by the hieroglyphic script of the contemporary Maya to the south.

Reliefs on the walls of the South Ball Court at El Tajín illustrate the sacrifice of a ball player wearing a *yugo*. The scene may be mythological or illustrate a ritual taking place in that ball court. A skeletal figure of death with a scroll-formed head descends from the sky as a sacrificial priest with a long stone knife cuts the throat of the ball player. The later Aztecs believed that ball courts were sources of water. The abundant water symbolism in this and other ball court sculptures at El Tajín suggests that the people of El Tajín shared in this belief. Perhaps the performance of the ball game, the sacrificial rituals in the court, and the acceptance of those offerings by the gods would ensure the seasonal rains, success of the farmers, and the perpetuation of Classic Veracruz society.

POSTCLASSIC ART

By the end of the Classic period, many of the major metropolitan art centers discussed above were in decline or entirely abandoned. New centers began to appear in both the Maya and Mexican parts of Mesoamerica. Scholars do not agree on the reasons for the decline of the Classic cities and cultures, but the art of the Postclassic period clearly indicates that some very important economic and cultural changes took place around 900.

The Northern Maya of the Yucatán

The northern Maya on the Yucatán peninsula flourished during the Classic period but their most notable buildings and sculptures are Early Postclassic (c. 900–1200). They excelled in the construction of large architectural sculptures assembled like mosaics from many small pieces of square and rectangular stones. The sculptures on the upper walls of the Palace of the Governor at Uxmal in the Puuc hills may be the finest examples of this technique (FIG. 7.25). The name of this building dates from the colonial period, but the many-roomed structure may have served as a residence for high-ranking royal priests close to the governor or ruler of Uxmal in Pre-Columbian times. The sculptural "mosaics" illustrate the king of Uxmal and the gods in a broad, panoramic view of the northern Maya cosmos. The badly damaged image of an enthroned ruler over the central door sits before a background of seven superimposed, double-headed serpents. They are signs of royalty and divinity and are related to the serpent bar held by Eighteen Rabbit at Copán as well as the double-headed serpent looping over the head of the king on the Temple of the Giant Jaguar at Tikal. Long chains of giant frets symbolize the swirling storm clouds that brought the rains to nourish the farmers' crops.

The most characteristic feature of the Puuc style—one repeated many times on this and other buildings—is the large, abstract mask/face of Chac, the rain god. He is a

7.25 Palace of the Governor. Uxmal, Yucatán. Terminal Late Classic period, 10th century

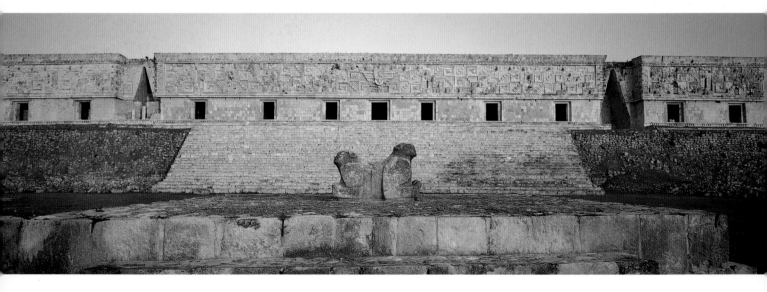

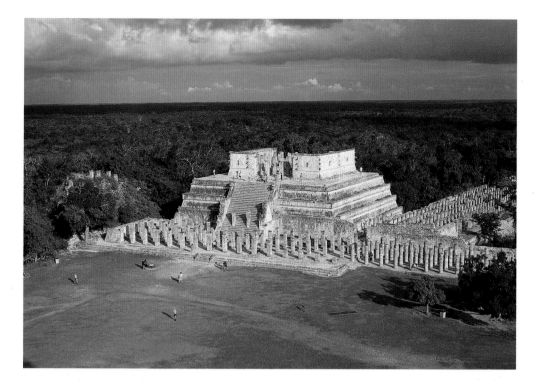

reptilian creature with a long curved nose, an open fanged mouth, and large beady eyes. The Puuc hills are much drier than the rainforests of the Central Area, so the rains in this region were an important issue in the economy and religion. The northern Maya of post-conquest times described Chac as a divine force that gathered the storm clouds and drove the life-giving rains to the fields. The latticework background in the Palace of the Governor and other Puuc-style buildings may represent the mat-covered thrones of the gods in the other world and those of their ruler-associates in the Puuc cities. They, like the Maya rulers, may have undergone ritual transformations and traveled to and from *Xibalba*. In effect, the sculptures unite the authority of Chac with his divine, earthly representative on the throne of Uxmal, who becomes the "bringer of the rains" and source of life for his people.

To enlist the cooperation of the Chacs, the authorities of Uxmal directed rituals that took place in and around the palace and nearby buildings. To ensure that those direct-ing these rituals were pure, the priests—nobles performing them had to be isolated from their normal life activities and to undergo prolonged periods of prayer, fasting, and acts of self-sacrifice. In addition to housing members of the royal family, some of the rooms in the palace may have been used as a cloister for these priests before, during, and after they took part in these important rituals.

However, even as the Palace of the Governor was being constructed, Maya art and culture in the Yucatán were being influenced by the Itzá, a group of Maya with ties to Mexico. Eventually, they established a capital at Chichén Itzá, near the edge of the Puuc sphere of influence. It is one of the few Pre-Columbian cities to have retained its pre-conquest name in modern times. "Chichén Itzá" means "mouth," *chi*, of the "well," *chen*, of the "Itzá," and it refers to a famous local shrine, the Well of Sacrifice. From their capital, the Itzá waged a series of wars that ultimately gave them control over most of the Yucatán peninsula.

The Itzá did not rely upon stelae and long hieroglyphic inscriptions to tie the dynastic activities of a divine ruling family to the movements of the heavenly bodies and the gods in *Xibalba*. Their art, the so-called "Toltec-Maya" style, had relatively thin ties to the arts of the Central Maya area. Using rectangular piers and pillars to support a flat roof (instead of the corbeled vaults used by the Maya in the Central Area), the architects of the Temple of the Warriors in Chichén created a large, airy interior space (FIG. 7.26).

At the head of the stairs lies a *chacmool*, a recumbent figure holding a bowl over its stomach. The bowl may have been a receptacle used to hold the hearts of sacrificial victims. This tense figure, with raised shoulders and a twisted neck, combines several Classic figural types in a new Postclassic image. Behind the *chacmool*, two long plumed serpents descending from the facade of the temple to the floor in front of it double as posts supporting the lintel over the doorway. Similar pairs of caryatid serpents appear elsewhere in Chichén and in Tula in Highland Mexico, where the arts of the Itzá mix with native Mexican styles from that vicinity (see FIG. 7.28). Puuc-style Chac heads on either side of the serpents show how the internationally oriented Itzá would mix the Toltec-Maya and Puuc styles of sculpture on one facade.

By the early thirteenth century, Chichén Itzá was plundered and partly deserted. Its power passed to Mayapan, which was destroyed in 1451 by competing Maya groups. When the Spanish arrived in the Yucatán in the early sixteenth century, very little of the Classic magnificence remained to give them any indication that this land had been one of the great cradles of literacy and civilization.

The Mixtecs and Toltecs in Mexico

The Mixtecs ("cloud people") of Oaxaca were influenced by the arts of Teotihuacán and became highly proficient metalworkers, stonecarvers, and painters. The Mixtec also created codices from sheets of folded deerskin. Surviving examples are painted in what is called the Mixteca–Puebla style of the Cholula region. The book illustrations present figures in ceremonial regalia with hieroglyphic inscriptions in scenes that illustrate mythological and historical events. Through the manuscripts, it has been possible to reconstruct the genealogies of the Mixtec rulers reaching back to the late seventh century.

The Codex Nuttall (c. 1500) documents the rise and fall of the king of Tilantongo, Eight Deer (1011–1063), named after his birthday in the Mixtec calendar (FIG. 7.27). His name (a profile head of a deer with a string of eight dots trailing from its ear) appears in the lower register. The codex shows important events in Eight Deer's life, including his wedding to Lady Thirteen Serpent of Flowers. The couple are shown taking their vows in Mixtec fashion; she presents him with a bowl of frothing chocolate, a sacred drink. The bride's name, Thirteen Serpent, is shown below the bowl as a profile serpent accompanied by thirteen dots. Another hieroglyphic sign below her, Twelve Serpent, records the date of the ceremony, which took place in 1051 CE. Although they are seated in front of a palace decorated with red Mixtec frets, there is no illusion of space in this picture. Their flat, two-dimensional bodies are obscured beneath their garments and their facial features are highly stylized.

Some authorities believe that contemporaries of the Mixtecs known as the Toltecs

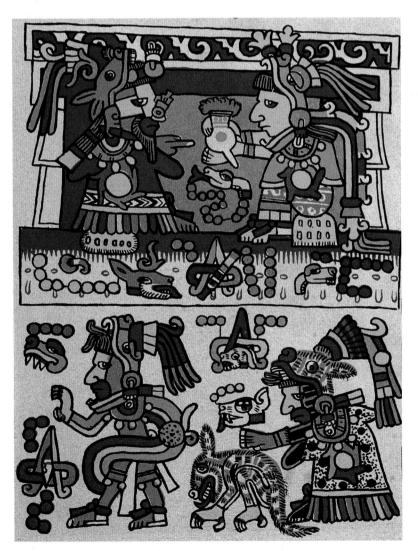

7.27 *Wedding of King Eight Deer to Lady Thirteen Serpent of Flowers*. Detail of page from the Codex Nuttall. Mixteca–Puebla style. Postclassic period, c. 1500. The British Museum, London

("artisans" or "master craftsmen") built Tula and became the political and cultural leaders of central Mexico following the fall of Teotihuacán. The builders of Tula borrowed art forms and ideas from both Teotihuacán and the Maya. The set of four stout warriors wearing large butterfly-shaped pectorals and tall head-dresses originally supported the now missing roof of the main temple, Pyramid B, at Tula (FIG. 7.28). As in the Maya Temple of the Warriors at Chichén Itzá (see FIG. 7.26), two large columns in Pyramid B's doorway were carved in the form of plumed serpents descending from the upper façade and facing a chacmool. Despite the similarity of the sculptures from these two temples, the connection between the Maya of Chichén Itzá and the Toltecs of Tula remains a matter of debate. What is clear, however, is that long after Tula was destroyed and abandoned in the mid-twelfth century it retained a strong hold on the imagination of later residents of the Valley of Mexico.

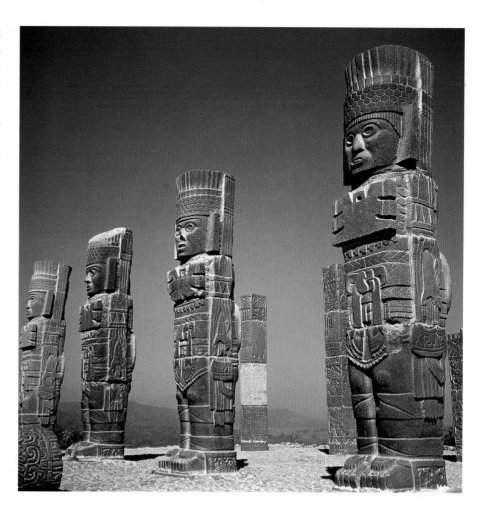

7.28 Pyramid B. Tula, Hidalgo. Early Postclassic period, c. 900–1200

The Aztecs

The Spanish conquistadors under the command of Hernando Cortés arrived at the high eastern edge of the Valley of Mexico in 1519. From there they could look down upon the Aztec capital, Tenochtitlán, a thriving metropolitan complex of about 200,000 residents (founded c. 1325). The Spanish were astonished by its scale and magnificence, but with their horses, gunpowder, and political intrigues they managed to conquer the city and destroy all significant resistance to their presence in Mexico. Most of the arts, crafts, and other material culture of the Aztecs disappeared in this and other sieges during the conquest, and much that remained was destroyed in the colonial period that followed. The Spanish built their colonial capital, Mexico City, over the ruins of Tenochtitlán and set the cathedral of Mexico on the foundations of the main Aztec temple that had stood there in the heart of the Pre-Columbian capital.

From their modest beginnings as a small band of nomads, the aggressive, warlike Aztecs of Tenochtitlán became the masters of a kingdom that exceeded the territories once controlled or influenced by Teotihuacán. The name "Aztec" comes from Lake Aztlan, their legendary homeland. They called themselves the Mexica, from which the name of the present-day capital city and country derives. Aztec legends say that their ancestors, guided by a tribal war god, Huitzilopochtli (Aztec, "hummingbird-on-the-left"), left their native lands to the northwest around 1325 and migrated to the Valley of Mexico. Their gods instructed them to watch for an eagle perched on a prickly pear cactus (Aztec, *tenochtli*) and build their capital there. Seeing that vision on a marshy island in the shallow waters of Lake Texcoco, the Aztecs founded their capital on that spot. Ultimately, this image of an eagle on a cactus became part of the modern Mexican flag.

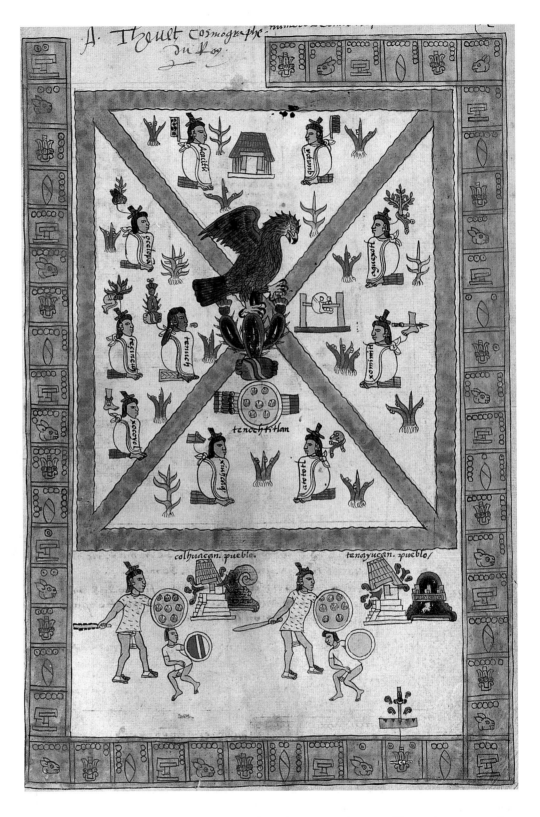

The frontispiece of the Codex Mendoza (1541–1542), painted by an Aztec artist after the Spanish conquest, portrays the vision in a hybrid Aztec–Spanish style (FIG. 7.29). An inscription below the shield and spears and the hieroglyphic sign at the base of the cactus indicate that this is Tenochtitlán, the capital of Mexico and symbolic center of the Aztec cosmos. The hub of the city is surrounded by four canals and men seated on mats with hieroglyphic signs that may represent municipalities or regions subject to the Aztecs. The warriors

below, with shields and clubs, as well as the platformed temples in the background with tilting roofs spouting smoke and flames represent Aztec conquests. No authenticated pre-conquest Aztec manuscripts inspired by the Mixteca–Puebla style of painting survive; under the rules of the Spanish church, natives found in possession of such "heathen" materials could be executed. However, such post-conquest paintings as the Codex Mendoza perpetuate elements of the native Aztec style.

The Aztecs emerged as the dominant military power in the Valley of Mexico under the leadership of Itzcóatl (ruled 1426–1440). The early Aztec imperialists appropriated ideas and images from the past art styles of Mexico. They called the makers of luxury goods (which included what we call "art") the *totecatl*, after the earlier Toltecs, whom they revered as great artists. By learning to paint manuscripts and to write in hieroglyphs from artists working in the Mixteca–Puebla tradition (c. 1000–1521), they could record versions of their own mythology and history.

Aztec society included an élite group of sages and philosophers known as the *tlamatinime* (singular, *tlamatini*), whose metaphysical speculations on art and life are recorded in Aztec poetry. They believed that earthly things were transient and would eventually be destroyed by the wrathful gods. Only "flower and song" (the arts and beauty) were everlasting because they came from the gods. Spiritually enlightened artists who were able to receive these sacred revelations from the gods and please them with their art could become immortal as well. Art, divinity, truth, and immortality were inextricably linked in this world view. Although most of the visual artists, *toltecatl*, in Aztec society were Mixtecs and Toltecs, the critics, patrons, aestheticians, and poets who judged them and articulated this view of art appear to have been Aztec nobles, the *tlamatinime*, who almost surely believed in their own enlightenment and immortality.

By the time Cortés arrived in 1519, Tenochtitlán had expanded and absorbed its neighbors to become one of the largest cities in the world. Portions of the island city in Lake Texcoco appear to have been built on a grid plan, like that of Teotihuacán, and were connected to the mainland by a set of causeways with drawbridges. The two main avenues of the city's central precinct met at the walled central temple area around the Templo Mayor ("major temple"), which was surrounded by palaces and administrative offices. The tall, steep platforms supported two structures dedicated to Huitzilopochtli, a war god, and Tlaloc, the rain god. Furthermore, the orientation of the temple to the passageway of the sun suggests that the Templo Mayor and its precinct may have been conceived as a microcosm of the Valley of Mexico, the empire, and the Aztec cosmos.

A colossal statue raised in honor of Huitzilopochtli's mother, Coatlicue (Aztec, "she of the serpent skirt"), would have greeted visitors to the Huitzilopochtli temple (FIG. 7.30). Not only are there plaited serpents in her skirt, but Coatlicue's arms also terminate in large serpent heads and her broad face is formed by a pair of opposed serpents in profile. The earth goddess wears a pair of skulls at the front and back of her waistband, and a necklace of severed hands and hearts from sacrificial victims. Massive and clawed, "she of the serpent skirt" was a demanding deity. Legends say that the Aztecs offered her plentiful numbers of sacrificial victims to ensure the fertility of her body, the earth. The interplay of the patterns of shadows and high-lighted stone contours as they might have appeared with their original paint in the light of flickering torches would have added to the emotional impact of this monumental piece of sculpture. (See "*Analyzing Art and Architecture:* Diego Rivera, Frida Kahlo, and Aztec Culture," page 278.)

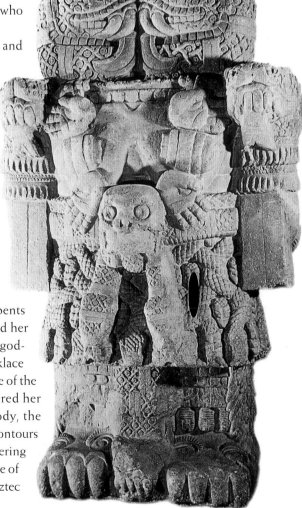

7.30 *Coatlicue*, Tenochtitlán, Aztec. c. 1487–1520. Stone, height 11'4" (3.45 m). Museo Nacional de Antropología, Mexico City

Diego Rivera, Frida Kahlo, and Aztec Culture

In the Mexican Revolution (1910–1920), the philosophy of *indígenismo* ("indigenous orientation") or *Mexicanidad* ("pro-Mexican orientation") espoused by the revolutionaries celebrated the native Pre-Columbian cultures of Mexico. Seeing that some important Pre-Columbian cities such as Teotihuacán, just north of Mexico City, had murals in public places, the revolutionary government of Mexico wanted to revive this art in their attempt to bring the Native American elements of Mexico into the new society. A new generation of artists, led by the *tres grandes* ("three great ones")—Diego Rivera (1886–1957), José Clemente Orozco (1883–1949), and David Siqueiros (1896–1974)—burst upon the scene with a strong sense of purpose: a pride in being Mexican that had not been felt in four centuries, since the fall of the Aztec empire in the early sixteenth century. From 1922, the trio directed a multitude of devoted assistants as they created highly politicized pictorial dramas of Mexican history that drew heavily on the country's Pre-Columbian past. As nationalists shaping the image of their people around their own indigenous history, the politically oriented image-makers for the new society emphasized the repressiveness of the Spanish colonialists and home rule up to the revolution and extolled the brightness of the future.

The best-known figure in the Mexican mural movement, Diego Rivera, had spent fourteen years in Europe, where he made friends with Picasso and studied fresco painting in Italy. Working hard to shake off years of education in European modernism in order to become a spokesman for the people in his native land, Rivera developed a populist style of social realism. His tightly packed, hard-edged forms and narratives filled with Pre-Columbian and colonial figure-types in *The Great City of Tenochtitlán*, a mural in the Palacio Nacional ("National Palace"), Mexico City, incorporate the strength of the native Mexican folk art traditions (FIG. 7.31). Rivera's style was essentially non-European in spirit and, with his American-based Pre-Columbian subject matter, he repudiated the authority of European modernism and Spanish hegemony in Mexico.

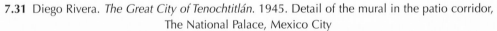

7.31 Diego Rivera. *The Great City of Tenochtitlán*. 1945. Detail of the mural in the patio corridor, The National Palace, Mexico City

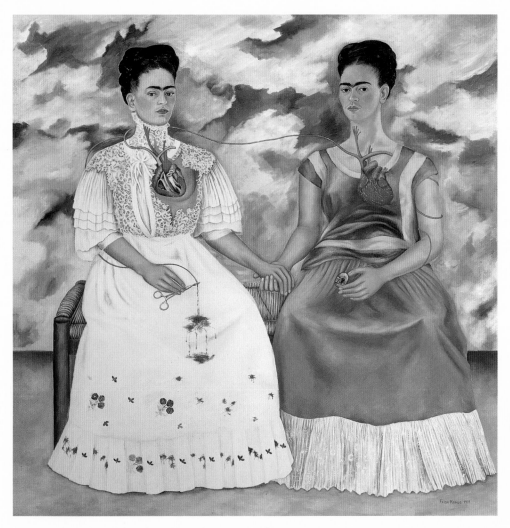

7.32 Frida Kahlo, *The Two Fridas*. 1939. Oil on canvas, 5'7" × 5'7" (1.70 × 1.70 m).
Museo de Arte Moderno, Mexico City

In the early 1930s, Rivera traveled with Frida Kahlo (1907–1954), a painter from Mexico City. After a bus accident in which her spine and pelvis were seriously damaged, Kahlo underwent a long series of delicate operations and she subsequently spent much of her life bedridden, confined to a wheelchair, or walking with the aid of elaborate back braces and body straps. Her life was further complicated by her stormy relationship with Rivera, whom she married in 1928, divorced in 1939, and remarried in 1940. More than Rivera and the other *grandes*, Kahlo, of mixed German–Jewish, Hispanic, and Native American descent, symbolized the roots and the aspirations of the Mexican people as they struggled with government reforms and their national identity in the modern world. Kahlo was a great champion of Aztec art and culture as well as Mexican *retablos*, folk images painted on tin that represent miracles in which the Virgin or a saint has interceded in the life of a devout Christian. Adopting the flat, stark, and highly simplified style of *retablos* and Aztec art, Kahlo painted many self-portraits, including *The Two Fridas* (FIG. 7.32). With the hearts of both Fridas exposed, she reminds viewers of her pain-filled life and divorce from Diego Rivera that year. The image of the two figures in contrasting dresses also underlines the deep rifts in Mexico at that time, its dual Native American and European heritage, its unstable political situation, and its ambivalence toward its wealthy English-speaking neighbors to the north. Many of her works are now in her family home in Coyocán, south of Mexico City, the Frida Kahlo Museum.

NORTH AMERICA

Although the native peoples of North America (present-day United States and Canada) had some contacts with Mesoamerica, they developed their own very personal funds of knowledge about the cosmos and its spiritual powers, and they created art forms that are distinctly North American. Their rituals, which combined visual art objects, music, dance, and oratory, were designed to deal with the essential realities of their own lives—controlling the weather, hunting, agriculture, health, and warfare. Some communities depended upon their shamans to contact the spiritual powers in the extraterrestrial world. In others, individuals might assume some of the powers of the shaman or contact the spirits through personal vision quests. By fasting, isolation, and sleeplessness, many individuals had visions of the extraterrestrial world and expressed them in songs, stories, and the arts.

In addition to taking the traditional view of the arts as expressions of group and individual identity and power, historians are now dealing with issues of gender and how

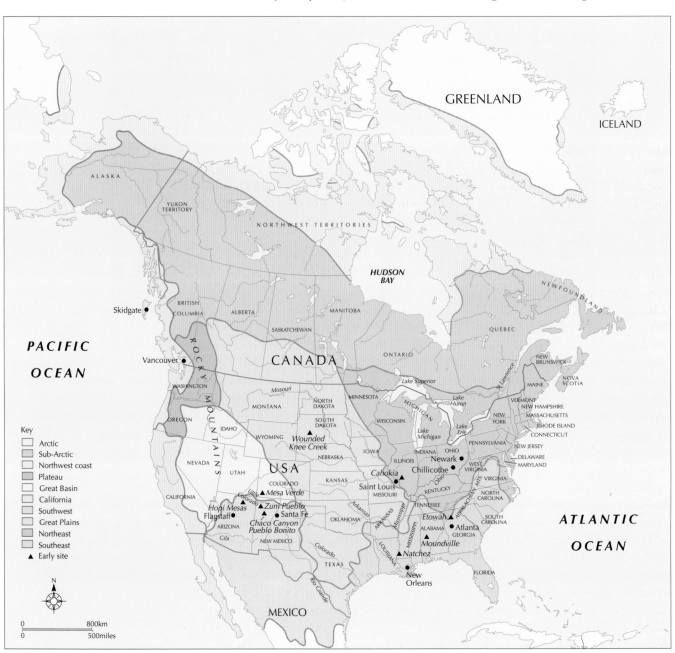

The Eastern United States

 Late Archaic: 3000–1000 BCE

 Woodland: 300 BCE–1000 CE

 Adena: 1100/700 BCE–700 CE

 Hopewell: 100 BCE–500 CE

 Mississippi: 900–1500

The Southwestern United States

 Basketmaker: 100 CE–700 CE

 Pueblo: 700–present

colonial and modern ideals can mix with traditional values in contemporary Native American art. As in most parts of the world, gender distinctions in Native America dictated which arts were produced by men or women. Usually, women made the pottery, basketry, and fiber arts, and undertook their decoration with porcupine quills and beads. Sculpture was usually "men's work," along with some forms of painting and architecture. When both male and female skills were needed to complete a project, the two genders worked together, and, when a man or woman had skill in an art form belonging to the other gender, he or she was often allowed to cross over. In recent decades, these gender restrictions have often been dropped altogether.

The traditional association of the men's arts with sacred activities and the art of women with so-called secular and utilitarian matters is misleading. All the materials used in the arts have intrinsic spiritual powers, making every work of art a spiritual or religious object. Clay, for example, comes from the body of Mother Earth and is highly sacred. Also, the Western distinction between "fine" and "applied" art has no meaning in Native North America: all art was applied to sacred activities. Therefore, the women's basketry, pottery, and decorated clothing had as much prestige as the men's sculptures and paintings.

While artists did not "sign" their works, the people around them often recognized their accomplishments, so the Native North American artists were not as anonymous as they may appear. The arts were so important and valuable in their lives that artists often had a kind of "copyright" that gave them sole ownership of certain images.

The historic development of Native North American art was disrupted by the arrival of Westerners and subsequently changed through a succession of outside influences, including tragedies such as epidemics and other factors such as the work of missionaries, and the establishment of the reservations. In an effort to document what was seen as the "vanishing Indian," in the late nineteenth century, many museums amassed large collections of Native American art. Unfortunately, these museum collections created a biased view of the subject. The works that appealed to Western collectors did not necessarily represent an accurate cross-section of the art valued by those who had made it. Nor do the museum collections generally represent the historical depth of these traditions. Also, this kind of whole-sale collecting hurt the Native American societies, who no longer had the treasures around which they might hope to sustain their identity. As a result, in recent years, some museums have returned or repatriated works of art to the descendants of their original owners.

Terminology

The literature on Native American history is filled with many misleading misnomers and clichés. The early Spanish explorers arriving in the Caribbean thought they had reached the East Indies and called the people they met "Indians." Although this term remains in popular usage, many scholars prefer to use the more accurate designation, "Native American." The way in which Native Americans have been stereotyped in literature, film, and advertising as "brave warriors," or simply "braves," and "princesses" has created a romantic fantasy of the Native Americans as the exotic "other" that clouds our attempts truly to understand their lives and culture.

The United States government recognizes "tribes" and operates reservations, while the Canadian government refers to "bands" and has reserves. The most important unit in Native American society is, in fact, the clan or lineage, a group with a common ancestor. This ancestor is usually an animal, known as a "totem," whose image may be featured in the clan's art.

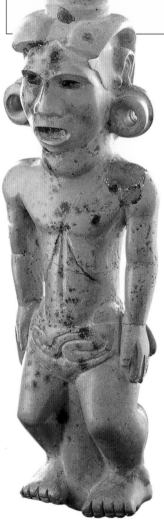

7.33 Adena artist, human effigy pipe. Woodland period, 500 BCE–1 CE. Stone, height 8" (20 cm). Ohio Historical Society, Columbus

The efforts Native Americans are making to force more such repatriations are part of their larger quest to repair and revive their culture. Gatherings called powwows enable artists to hold dance competitions, exhibit their work, and share ideas with artists from other areas. Some contemporary artists are working with Western materials such as oil and acrylic paints. Others are using installations and performance art to present and critique their culture in broadly understood modernist formats for large audiences outside their communities. Some of these revivals of Native American art, however, have raised important questions about whether they are "real" and "pure," like the art in the museums. Traditionally, collectors have valued examples of so-called "pure pre-contact Native American art" over the later post-contact works with Western influences. In recent decades many scholars have challenged this thinking, arguing that change has always been part of the Native American traditions. Moreover, those works reflecting Western ideas are, in fact, accurate reflections of the modern Native American cultures in which they were made. (See "*Methodology*: Terminology," above.)

THE EASTERN AND SOUTHEASTERN UNITED STATES

Scholars have divided the pre-contact history of the eastern and southeastern United States into an Archaic period (ending in 1000 BCE), the Woodland period (300 BCE–1000 CE), and the Mississippi period (900–1500). Some large mounds marking ceremonial sites and burials with finely carved and polished stone sculptures as grave offerings appear by the Archaic period. The transition from the Late Archaic to the Woodland period accompanied the spread of these traits. There are two major traditions or cultures in the Woodland period, the Adena (c. 1100/700 BCE–700 CE) and Hopewell (c. 100 BCE–500 CE). The influence of those cultures eventually spread from the Atlantic Ocean to the Rocky Mountains.

The Adena and Hopewell

About 500 sites in the central woodlands have been identified with the Adena culture. The Adena are known for their carved stone tablets, which may have been used as stamps, sculptured pipes, and objects made from stone, copper, bones, and sheets of mica deposited in the graves of their élite. An Adena stone pipe (c. 500 BCE–1 CE) carved in the shape of a standing man with large earplugs has a facial type that resembles examples from the somewhat later Central Mexican city of Teotihuacán (FIG. 7.33).

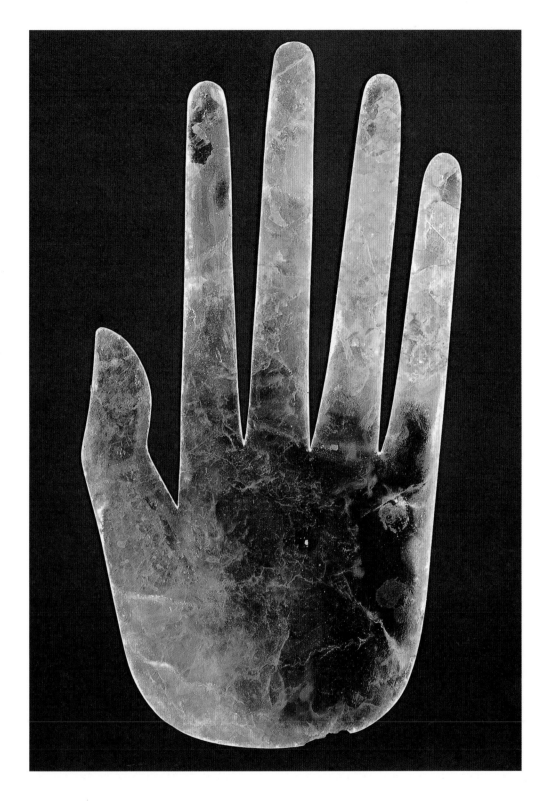

7.34 Hopewell artist, mica in the shape of a hand. Woodland period, 200 BCE–400 CE. Sheet mica, 11³/₈ × 6¹/₄" (29 × 16 cm). Ohio Historical Society, Columbus

The Hopewell culture, which originated in Ohio and Illinois, spread over most of the eastern United States. The largest known Hopewell constructions are the earth ramparts covering four square miles (10.3 square km) near Newark, Ohio. A road or processional way ran sixty miles (96.5 km) south from Newark to a center near present-day Chillicothe. In addition to these earthworks, the Hopewell created small objects, such as the highly stylized mica hand with long slender fingers in figure 7.34. Two holes in the palm suggest that it was suspended on a cord, perhaps worn as a pendant with the fingers pointing downward.

The Mississippi Period and the Southern Cult

After the Hopewell tradition disappeared around 500 BCE, artistic activity renewed in the southeastern states in the early Mississippi period, possibly through trading contacts with central Mexico. Many large, new urban centers appeared, including Etowah, near present-day Atlanta, Moundville in Alabama, and Cahokia, near St. Louis. Cahokia, with a resident population of about 20,000, was the largest city of its time in North America. The volume of the main structure there, Monk's Mound, 1080 by 710 feet (329 m) at its base and about 100 feet (30.5 m) high, may once have been greater than the Pyramid of the Sun at Teotihuacán, but it is now eroded badly and has not been restored.

There is considerable evidence that the Mississippi period cities such as Cahokia had a hierarchical form of government and the leaders were associated with the sun, the source of their spiritual power. The Natchez along the Mississippi River north of New Orleans were observed by late seventeenth-century European missionaries and explorers and represent a late form of this culture. They regarded their leader, the "Great Sun," whom they carried in a litter so his feet would not be contaminated by the earth, as a manifestation of the sun and a god.

Incised shells and copper plates found at Mississippi period sites throughout the southeastern states share so many stylistic and iconographic traits that they may reflect a widespread set of religious and political ideas. This has been called the "Southern Cult" or "Southern Ceremonial Complex." It incorporated ideas from the Adena–Hopewell traditions and Mesoamerica as it spread across the southeastern United States. Southern Cult artists engraved stylized images of fantastic animals such as plumed serpents and lavishly attired ritual performers on pottery, shells, and sheets of copper. The subject matter also included birds of prey, arrows, skulls, bones, eyes set in open hands, and eyes decorated with a forked motif. Images of men with balls or disks may represent the players who parcticipated in a type of ritual game. Severed heads appear to represent trophies of war or honored ancestors. The popular hand-eye motif may symbolize the sun and the supernatural powers of the cult leaders.

The figure wearing a mask with a long nose, resembling the Chac figures from the Maya site of Uxmal in the Yucatán holds a type of mace that has been found in Southern Cult sites (FIG. 7.35). It is possible that this and other images in Southern Cult art are related to ceremonies still practiced in this area in historic times, such as the Green Corn Ceremony. In this event, fires are extinguished and relit from the chief's fire and the young corn is roasted to celebrate the power of the sun and renewal of life.

By the time of European contact, many of the Southern Cult sites were abandoned. In the nineteenth century, as the white population in the southeast grew and the demand for good agricultural lands increased, the United States Congress had passed the Indian Removal Act of 1830. It allowed the military forcibly to relocate Native Americans from the southeast to less desirable agricultural lands west of the Mississippi River. Some of the descendants of the people who created the Mississippi tradition lost their lives on the infamous Trail of Tears en route to Oklahoma (1838–1839), while others now reside there.

7.35 Mississippian artist, copper breastplate from Lake Jackson site. Safety Harbor culture, Florida. Reproduction drawing after Calvin Jones. Courtesy of the Florida Division of Historical Resources, Tallahassee

THE ARCTIC AND SUB-ARCTIC

The Arctic and sub-Arctic region stretches from Alaska through Canada to Greenland. The sub-Arctic forests support game and plants, while the rivers and lakes are rich in fish. North of the Arctic circle, communities along the coast fish and hunt for seals, walruses, and whales. These areas were populated very late, around 4000 years ago, when the receding glaciers allowed people with developed fishing and hunting technologies to move there. The Arctic people of Alaska are called "Eskimos," while those in Canada and Greenland are known as "Inuits."

In this cold part of the world, to survive, a skilled hunter needs good protective clothing and special powers over the animals he is hunting. The summer caribou-skin coat in figure 7.36 belonging to an Innu hunter from Labrador, Canada, serves both these needs. When properly prepared and decorated, a coat such as this, giving its owner an extra animal skin, was believed to retain some of the power and skills of the caribou from which it came. Its painted decorations are also designed to please the spirits of the hunter's prey so they would willingly allow themselves to be killed. This type of de-haired coat, worn in the autumn when the caribou were hunted, has a triangular gusset at the back that may symbolize a magical mountain from which the caribou came. The decorations, registers of parallel colored lines, diagonal lines forming triangles, curves, circles, and spirals, may refer to the mountain and other cosmic concepts designed to impress the animals that the owner of the coat was hunting. The Inuit word *takminaktuk* ("it is good to look at" or "it is beautiful") would seem to apply to such work, from the hunters' viewpoint, and, perhaps, the animals' as well.

7.36 Innu artist, hunter's summer coat, from Labrador, Canada. c. 1805. Caribou skin, sinew, and fish-egg paint, length 42½" (1.08 m). Royal Ontario Museum, Toronto, Ontario

THE NORTHWEST PACIFIC COAST

The prosperous, sea-oriented people living along the 1,500 miles stretch of heavily forested hills on the Northwest Pacific Coast from the California–Oregon border to the panhandle of Alaska produced some of the finest woodcarvings in North America. In pre-contact times, this was one of the most densely populated regions in the world without agriculture. By 1900, the pre-contact population (c. 200,000) had dwindled to about 40,000 and, the so-called "totem poles" installed in museums became universally recognized icons of the "vanishing Indian."

The wealth of the Haida, Tlingit, Kwakiutl, and other groups in this region came from the sea, which is warmed by the Japanese Current. During the relatively short summer season (May–September), "cultivating" the resources of the Pacific coast, the Northwestern groups were able to put up stores of food to sustain them during the long, dark, and rainy winter months. During the winter, they passed the time retelling their myths, legends, and family stories and recorded them on a wide variety of finely painted, carved, and woven objects. Traditionally, the most accomplished carvers received commissions from distant villages outside their own linguistic groups. Their skills were regarded as supernatural gifts and they were honored wherever they went.

Some of the most characteristic features of Northwest Pacific Coast art—its closely matching sets of interlocking, broadly rounded contours and lines—appear on stone sculptures as early as 1500–1000 BCE. Although the tradition is a very ancient one, we know relatively little about Northwest Pacific Coast art before the eighteenth century. Almost all of the wood sculptures and weavings predating this period have disappeared. In

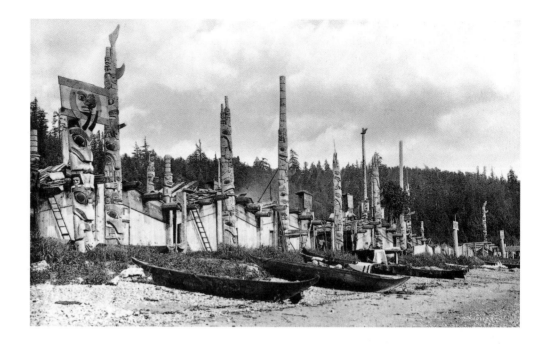

7.37 Mortuary poles and houses. Skidegate, Northwest Pacific Coast. Photograph, 1888. Royal Anthropological Institute, London

many cases, once a carved pole was erected, it would not be repainted or altered in any fashion; such acts might require as much ritual preparation as the original carving. Many poles that fell were not reset or repaired; they were allowed to decay in the rainy climate of the coast and remain part of the ongoing cycle of nature. Aside from the monuments that were moved to museums for safekeeping, most of the sculptures and houses that existed in great numbers as late as the 1880s have disappeared.

Haida Totem Poles

Such was the fate of Skidegate, a Haida village that was photographed in the 1880s (FIG. 7.37). The houses were built in rows following the curvature of the beach with the residences of the chief and high-ranking nobles near the center of the village. The straight grains of the cedar trunks allowed the builders to split the trees into planks up to forty feet (12.2 m) long. Originally, some of the poles were painted to help visitors arriving by canoe to recognize the clan-crest symbolism marking the homes of their friends, relatives, and enemies—and navigate accordingly. In addition to the poles inside houses supporting rafters, and those attached to the facades, tall, freestanding memorial poles and somewhat shorter mortuary poles with hollow cavities to hold burials were set in front of the houses.

All of these so-called "totem poles" display animals and other heraldic signs belonging to the lineage of the family erecting them, along with references to the legends that explain how these family badges were obtained. It was important for families to display their crests, emblems, songs, ceremonies, and other art forms to validate their noble status. As in the European tradition, wealthy Northwest Pacific Coast families "owned" certain crests or image-types indicating their moiety or clan as well as their personal family crests, and they displayed these on their houses and canoes in which they traveled to other communities. The animals in the crests may have had supernatural contact with a mythical ancestor or taken human form to establish the lineage.

Dissolving naturalistic images into complex decorative patterns, the sculptors created images of great complexity to record the heraldic associations of the important families. The mortuary pole on the left is carved with three crests composed of animals that can be identified by their paws, fins, ears, teeth, and tails. The carvers exercised considerable artistic license in the representation of natural forms, and their compact, stylized forms can be difficult to read. From the bottom to the top, they represent a killer whale

with two projecting dorsal fins, a mythological clan ancestor, and a spirit call a *snag*. A second mortuary pole to the right represents a grizzly bear (bottom), a killer whale with a blow hole in its snout and a seal in its mouth, and a wolf or bear at the top of the pole.

Aside from the fins and other boards which have been attached to the pole, the sculptured details are bas-reliefs that follow the rounded contours of the thick cedar trunk. Continuous, primary outlines glide and bend around the pole to form patterns of flowing, interlocking, and inset ovoids, crescents, and U-shaped forms representing decorative motifs and parts of the animal bodies and faces. The complex sets of rules or conventions governing the manner in which the artists shaped and colored the forms were handed down from master to pupil for centuries. Only by mastering these complex principles of visual rhetoric could a Northwest Pacific Coast artist hope to expand upon them and become creative within the traditional parameters of the style. Not only was such creativity allowed; it was actively expected as the linked ideas of tradition and continuity coexisted with innovation and individuality in the arts.

The oval doors in the poles attached to the house facades, which were often painted to represent animal jaws, were called "Holes in the Sky." Passing through them was a symbolic act, representing the arrival of the clan's mythological ancestor in this world or the journey of the shaman to the spirit realm. A framework of heavy cedar poles supported the thick plank floors, walls, and roofs of these large communal structures, which were up to sixty feet (18.3 m) wide and 500 feet (152.4 m) long. Large houses were divided into rooms and apartments occupied by matrilineally linked families belonging to the same clan. Everyone in the house shared a central sunken living room with a fire pit, behind which was the home of the highest-ranking family (FIG. 7.38). (See *"Analyzing Art and Architecture*: A Formal Analysis of the Northwest Pacific Coast Style," page 288.)

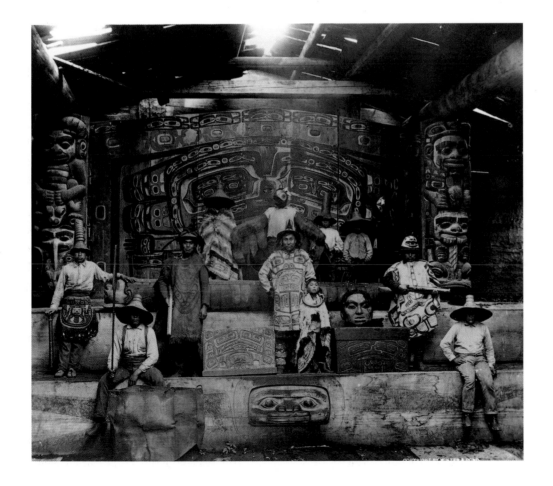

7.38 Tlingit (Ganaxtedi clan) whale house interior, with carved and painted screen, house posts, storage boxes, helmets, hats, masks, decorated clothing, and carved vessels. Photograph, 1888. Courtesy of the Alaska Historical Library, Juneau

A Formal Analysis of the Northwest Pacific Coast Style

The weavings, paintings, and sculptures in this richly decorated house share many common features that one can recognize as parts of the distinct Northwest Pacific Coast style of Native American art. The thick outlines, or formlines, are bold, and provide paths for the viewer's eyes to follow, ones that can be seen from a great distance. They are bent into a few repeating and closely matched, broadly rounded curves, U-shaped forms, and ovals with flattened sides. These gentle sweeping curves with a sense of flowing, controlled movement may change into sharper, tighter, curves, or terminate in pointed tips. Smaller and thinner-lined ovoid forms may be set inside the larger ovoids. The limited colors, often comprising bluish-green, red, and some yellow, are of low intensity. The organic shapes fit together closely and tightly like the pieces of a jigsaw puzzle. Often, their composition reflects the shape of the object on which they are placed.

Animals are not shown in their entirety, in a naturalistic fashion. Generally, the artists will select characteristic, silhouetted forms such as eyes, eyebrows, tails, claws, or fins that enable viewers to recognize the species being represented. These forms are fragmented, distorted, and rearranged to fit into the ovoid shapes defined by the formlines. The images present the core of the myths and ideas they represent in flat patterns, without implied space. As heraldic crests or signs, they are highly abstract, but immediately recognizable to the initiated, who know the culture well enough to "read" and interpret the fragmented forms. Often, a single form may be part of two overlapping or interlocking images and must be "read" two ways, like a kind of visual pun.

The flowing compositions of these well-matched, curved, and organic formlines and shapes have a rhythmic pulse, a vitality, and a strong sense of unity. To characterize them further, we might say that they are slow-flowing, compact, forceful, and that they may echo the flora, fauna, and aquatic shapes of this area. Also, there may be an important kinaesthetic relationship between these rhythms and those of the music and dances that accompanied them in ceremonials.

Those who have seen many pieces of Northwest Pacific Coast art find it quite easy to recognize new examples of the style. But while it is possible to feel a certain sense of familiarity about the style, there is always an element of surprise as each new piece is discovered. The artists were able to create seemingly endless formal variations on their favorite forms using the elements of style discussed above.

The Tlingits

To prove that he was wealthy and successful, a man of the Chilkat division of the Tlingits would pay his wife or daughter to weave a special ceremonial blanket for him (FIG. 7.39). It might take the entire winter or longer to spin the mountain goat wool, dye it (black, yellow and blue-green), and weave the blanket. The Chilkats did not use frame looms for these blankets; the warps were suspended from a horizontal rod and their untrimmed ends became the lower fringe of the finished piece. The Tlingits called these blankets *nakheen*, "fringe about the body," because the long trailing fringe on the blanket would emphasize the movements of the owner as he danced in the winter rituals.

The Chilkat blanket designs are symmetrical and feature animals sacred to the clan. This blanket represents a popular theme, the "diving whale" in pursuit of a seal. As with most Northwest Pacific Coast reliefs and paintings, the internal organization of this composition emphasizes the shape of the blanket. The faces of the two animals in the center of the blanket are flanked by symmetrical sets of body parts and decorative forms, all of which are composed according to the strict patterns of rhetoric controlling the composition of all

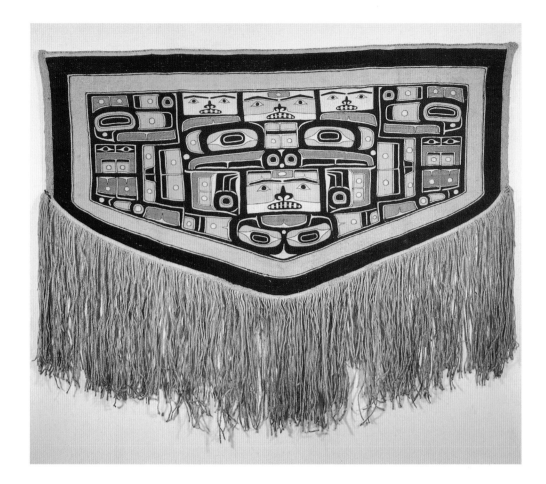

7.39 Tlingit blanket. Cedar bast and wild goat hair, width 64" (1.63 m). Cape Prince of Wales, Alaska. National Museum of the American Indian, New York

Chilkat designs. The blankets, shaped like inverted house fronts, translate the social symbolism of the architecture to a personal scale and context.

Many important Northwest Pacific Coast works of art perished over the years during the potlaches, ceremonies with feasts during which families could demonstrate their crests and wealth by distributing or destroying objects of great value. When the Canadian government outlawed the potlach in 1885, they unknowingly destroyed one of the most important political and religious ceremonials in this area and contributed to the subsequent decline of the Northwest Pacific Coast societies.

In the late twentieth century, some Native American artists, such as Bill Reid (1920–1998), developed styles that drew upon the artistic traditions they had known as youngsters. Reid was born to a family of Haida artists that included his great-uncle Charles Edenshaw (1839–1920), the last major Haida artist to work within a traditional, integrated Haida society. Reid, who drew his inspiration from Edenshaw's art, worked as a jewelry maker before he began carving large wooden sculptures. He combined elements of both media in his large, leaping bronze *Killer Whale*, which was installed over a pool of water at the Vancouver Aquarium in Stanley Park (see FIG. 1.5).

The individual forms of the whale's anatomy are rendered in terms of the traditional Haida vocabulary of curved, flowing lines and crescent-shaped forms. But these motifs have been rendered in bronze and applied to the three-dimensional form of the leaping animal. Speaking in the visual language of his ancestors, Reid's monumental bronze captures the sense of clarity and style of traditional Haida art without being a direct copy of any earlier works. The *Killer Whale* illustrates how contemporary Northwest Pacific Coast artists such as Reid have found ways to create innovative works within their traditions and make the mythic past a living force in the present. And in so doing here, Reid

has also created a truly dramatic and awe-inspiring monument that transcends the parameters of ethnicity and makes him an important late twentieth-century sculptor.

Working in a spirit that synthesizes the Haida traditions with cultural forces around them, Bill Reid and others have played important roles in the preservation of the Haida traditions. Together, as they revived the arts and ceremonial contexts, they have demonstrated that recent work in their ethnic and family styles is not inherently inferior to the art produced in previous centuries.

Speaking on the importance of traditional Haida ceremonials and songs in his work, Robert Davidson, a great-grandson of Edenshaw, said "We are now giving new meaning to the songs, dances, crests, and philosophies. We are updating these ideas, which is no different from what our forefathers did."

THE SOUTHWESTERN UNITED STATES

From 1540 to 1542, Francisco Coronado, of the newly established Spanish government in Mexico, plundered the southwestern section of the United States in search of the gold of the fabled Seven Cities of Cibola. He discovered instead, villages (Spanish, *pueblos*) of multi-story adobe-brick houses. The prized possessions of the *pueblo* dwellers were not golden; they were the decorated ceramics, painted masks, and the costumes they wore in religious rituals. By this time, the southwest was also home to the Navajos, who arrived from northwest Canada between 1300 and 1500. Navajo art is clearly distinct from the arts of the *pueblos*.

The Pueblos

The *pueblos* visited by Coronado were late manifestations of the Anasazi (Navajo, "enemy ancestors") culture that flourished in the Four Corners Area at the juncture of Arizona, New Mexico, Colorado, and Utah. Under the Spanish, the population in this area, known as the "Kingdom of New Mexico," declined from about 60,000 to about 10,000. The secrecy that surrounds

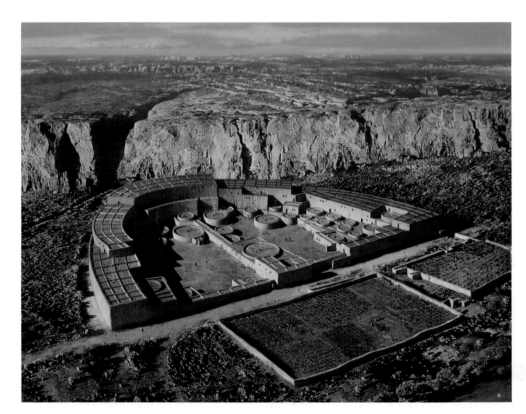

7.40 Reconstruction view of Pueblo Bonito, Chaco Canyon, New Mexico. Great Pueblo period. 13th century

Reliable dates for southwestern archaeology have been established through radio carbon dating and dendrochronology, the study of tree rings. The pattern of growth in the rings of a tree found in an archaeological context can be compared to master charts of tree ring growth from prehistoric to present times in a similar area, to determine the age of the given sample of wood.

their rituals today may stem from the period of Spanish occupation, when missionaries tried to eradicate their religion and culture.

Before 1300 CE, the southwest enjoyed a somewhat cooler and wetter climate than it does today. Enough water flowed through the rivers and creeks to enable residents there to develop effective systems of irrigation. A densely populated seven-mile (11.3 km) stretch of land in Chaco Canyon near the Arizona–New Mexico border with twelve large *pueblos* was one of the major metropolitan centers of the Americas in the twelfth and thirteenth centuries. The region was part of a vast trading network that connected it with Central Mexico and the Great Plains. Roads extending over fifty miles (80 km) from Chaco Canyon connecting this to other *pueblos* in the southwest suggest that these metropolitan centers were economically, if not politically, interrelated.

The largest of the building complexes at Chaco Canyon, known as Pueblo Bonito ("beautiful house"), was begun around 900. It has about 800 rooms and housed at least 1,200 people in the early thirteenth century (FIG. 7.40). Many sections of wall are made with finely cut and well-fitted stones. Roofs were made of beams supporting saplings and twigs sealed by layers of mud plaster. Groups of as many as fifty rooms were planned and constructed as units, which implies that master masons approaching the status of architects directed the growth of the *pueblo*.

All the homes in the D-shaped Pueblo Bonito faced the plaza, where the communal ceremonies were staged in and around a series of round, semisubterranean structures known as *kivas*. Some writers have suggested that entire clans met in the large *kivas*, while the small *kivas* were used, and continue to be used, by smaller, specialized religious societies. In *pueblo* thought, the village is the center of the universe and the *kiva* is the center of the village. A typical *kiva* has a small entry hole in the middle of the roof and a shallow hole (*sipapu*) in the floor, as a symbolic entryway to the subterranean world of the spirits through which people entered this world. As we will see at Kuaua, the vertical faces of the benches and the walls of some *kivas* were painted and repainted many times. The larger *kivas* have stairs on the north and south sides so those who enter are immediately aligned to the cardinal directions of the cosmos. As a map of the cosmos, point of entry into the underworld of spirits, and place where the terrestrial and extraterrestrial worlds meet, the *kiva* and dance areas around it occupy a central place in *pueblo* art, rituals, and thought.

After a long drought lasting from 1276 to 1299, Chaco Canyon and many other cities from this period were abandoned and new cities were founded near more reliable water sources on the Gila, Little Colorado, and Rio Grande rivers. Remains of paintings have been found on seventeen of the eighty superimposed layers of plaster on the walls of a square *kiva* at Kuaua. Fragments of one painted layer have been reconstructed and restored in the Museum of New Mexico, Santa Fe (FIG. 7.41). Using stiff brushes, or their fingers, the painters laid out the basic areas of color and added black, white, or red outlines. The deity with a long, straight torso holding a prayer stick and an offering of feathers is Kupishtaya, maker of lightning.

7.41 Replica of wall painting from *kiva* III, Kuaua, New Mexico. c. 16th century

7.42 Hopi *kachina* dance, Shoughpave, Arizona. c. 1903

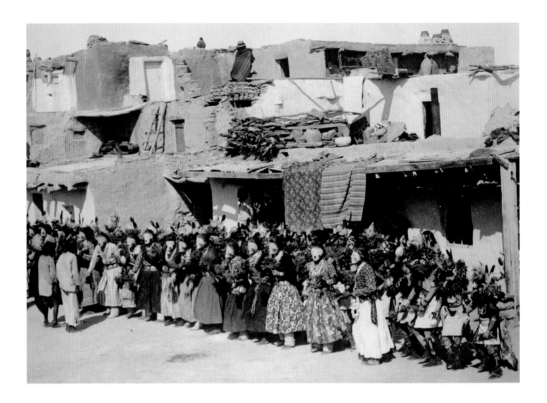

His stick touches the stream coming from the fish, which is linked to a black and white eagle by a thin rainbow. The eagle, bat-like creature, and the vessel below emit streams of seeds or moisture and zigzag-shaped arrows representing lightning. Variations on this theme appear in other reconstructed fragments from this painting. The horizontal bands beneath the feet of the figures may represent a rainbow, the boundary between the *kiva* and the underworld of the spirits. Together, these moisture and fertility symbols express the *pueblo* dwellers' pressing need for rains in a land that continued to grow progressively hotter and drier.

Some of the elevated mesa-topped cities of the Hopi ("Peaceful Ones") founded around 1100 and flourishing during the time of Chaco Canyon and Pueblo Bonito are still occupied today and remain bastions of the ancient *pueblo* traditions. The most important spiritual beings in their religion are called *kachinas*. The term is applied to the spirits, their masked imitators who appear in ritual dances, and the small doll-like figures Hopi parents give their daughters to teach them about the hundreds of spirits that embody many aspects of nature. The tradition of carving *kachina* figures may have been inspired by the images of saints the Spanish displayed in their churches and processionals. The *kachina* spirits said to live on the San Francisco Mountains north of Flagstaff, Arizona, come above ground during the winter solstice ceremony (December 21), and return to the underworld through the floors of the *kivas* in early July. They visit the mesas in the form of masked dancers who robe in secret, in their houses or *kivas*, and keep their costumes carefully hidden when they are not in use. When Hopi performers put on the *kachina* masks and costumes, they believe that they become one with the spirit of that *kachina* (FIG. 7.42). In Hopi thought, the rituals "allow the god to become a living person."

Many of the ceremonies center around themes of fertility. The rest of the ceremonial year is ruled by non-*kachina* societies, many of which are controlled by the women. The Hopi believe that they will join the *kachinas* in the afterlife, become the rain clouds, and remain important parts of Hopi life on the mesas. The cult of the *kachina* appears to have intensified in the nineteenth century as outside influences began to erode the traditional fabric of Hopi life. (See "*Cross-Cultural Contacts*: Leah Nampeyo: Hopi Clay Artist," page 293.)

Leah Nampeyo: Hopi Clay Artist

In the pre-contact period, Hopi ceramic artists produced large numbers of painted vases. The *pueblo* potter is a daughter of Mother Earth and gives prayers, asking for the right to use some of her body. While the women grind the clay, temper it, shape the vases, and fire them, men will often paint the imagery.

In 1895, Leah Nampeyo, a skilled Hopi potter of Hano on First Mesa, saw fragments of the earlier *pueblo* pottery styles from burials being excavated by archaeologists working at nearby Sikyatki ("Yellow House"). Inspired by them, Nampeyo created her own designs which revived the spirit (but not the details) of the stylized birds, reptiles, and sky bands on the ancient Hopi vessels (FIG. 7.43). Using the traditional decorative motifs of her ancestors—tightly composed patterns of curvilinear forms that echo the globular shapes of her vases—Nampeyo's designs preserve the traditions of *pueblo* painting in new and innovative forms. During the past century, four generations of women in Nampeyo's family have kept the Hopi revival alive on the First Mesa.

The Navajo

The Navajo, who call themselves *Dineh* ("The People"), acquired sheep from the Spaniards, are herders, and live in small scattered settlements. Without *pueblos* and communal gathering places, many of their most important rituals are performed in their homes, or *hogans*, poly-gonal log structures. The most important rituals include the production of large floor "paintings." These are actually made by pouring thin, finely controlled streams of colored sands or pulverized vegetable and mineral substances, pollen, and flowers in precise patterns on the ground. The first such paintings were probably elaborations on the diagrams the *pueblo* people made on their *kiva* floors. The largest of these paintings or pourings may be up to eighteen feet (5.5 m) in diameter and cover the entire floor of a *hogan*. Working from the inside of the design outward, the Navajo artist and his assistants will sift the black, white, bluish-gray, orange, and red materials through their fingers to create the finely detailed imagery. The paintings and chants used in the ceremonials are directed by well-trained artists and singers who enlist the aid of spirits, the *yei* ("Holy People"), who are impersonated by masked performers. The twenty-four known Navajo chants can be represented by up to 500 sand paintings. The complex paintings act as mnemonic devices to guide the singers in their ritual songs, which can last up to nine days.

The purpose and meaning of the sand paintings can be explained by examining one of the most basic ideals of Navajo society, embodied in their word *hozho* ("beauty" or "harmony," goodness," and "happiness"). It coexists with *hochxo* ("ugliness," or "evil," and "disorder") in a world where the opposing forces of dynamism and stability create constant change. When the world which was created in beauty becomes ugly and disorderly, the Navajo gather to perform rituals with songs and make sand paintings to restore beauty and harmony to the world so they can once again "walk in beauty." This sense of disharmony is often manifest when a Navajo becomes ill. Thus, the restoration of harmony is a type of curing ceremony.

7.43 Leah Nampeyo displays her work. c. 1900

7.44 Navajo sandpainter, Farmingham, New Mexico. August 1978

Men, who personify the stable or static side of life, make sand paintings that are accurate copies of paintings from the past. Motionless figures with stiff, unbent torsos are arranged in symmetrical compositions within large circles. The songs sung over the paintings are also faithful renditions of songs from the past. By recreating these arts, which reflect the original beauty of creation, the Navajo bring beauty to the present world. As newcomers to the southwest, where their climate, neighbors, and rulers could be equally inhospitable, the Navajo created these art forms to control the world around them, not just through their symbolism, but through their beauty, *hozho*, so they could live in beauty.

The paintings generally illustrate ideas and events from the life of a mythical hero, who, after being healed by the gods, made gifts of songs and paintings to humankind. Working from memory, the artists recreate the traditional form of the image as accurately as possible. Although the Navajo originally allowed completed sand paintings used in rituals to be photographed and published, they no longer want these sacred images designed for short lives in private spaces and ceremonials to be permanently documented for the scrutiny of the public. Figure 7.44 gives some impression of the style of this type of "painting" without violating the sanctity of the work or offending its owners.

The Navajo are also world-famous for the designs on their woven blankets. The Navajo women own the family flocks, control the shearing of the sheep, the carding, spinning, and dying of the thread, and the weaving of the fabrics. Weaving is a sacred activity for women and a paradigm for their existence. A mythic ancestor named Spider Woman wove the universe, a cosmic web that united Sky Father with Earth Mother out of sacred materials on a great loom made of cross poles (sky and earth) with a warp (sun rays), baton (sun halo), and spindles (lightning and rain). It was she who taught the Navajo Earth Mother, Changing Woman, how to weave. As they prepare their materials and weave, the Navajo women imitate the transformations of Changing Woman as she creates the ever-changing forms of the world around them. Working on their looms, Navajo artists create microcosmic and holistic images through which they experience harmony with nature. It is their means of creating beauty and disseminating it to the world. Thus, the weaving is a way of seeing the world and being part of it. While the men who make faithful copies of sand paintings from the past represent the static principle in Navajo thought, women embody dynamism and create new designs for every weaving they make. Thus, their art bears little resemblance to the sand paintings of the men.

The Navajo women may have learned their weaving techniques in the seventeenth century from *pueblo* weavers working in styles influenced by Hispanic art. During the Classic period of Navajo weaving (1650–1865), they incorporated more Hispanic/Mexican motifs, such as serrated diamonds and zigzag patterns, from weavers in the northern Mexican town of Saltillo. This period came to an end when Colonel Kit Carson incarcerated the Navajo and destroyed their flocks. The arrival of the railroad (1882) and building of the Harvey Hotels, which sold Navajo art to travelers, intensified outside influences in the

Transitional period (1865–1895). This gave the Navajo weavers access to commercial dyes and yarns, as well as new patrons, some of whom encouraged them to imitate the designs on Persian rugs. A type of blanket woven during this period known as the "eyedazzler" uses repeating patterns of diagonal and zigzag motifs that appear to vibrate and move like some pieces of Op Art from the 1960s. The period from 1895 to the present is called the "Rug period," because many blankets woven using durable yarns have been marketed as rugs to Anglo-American patrons (FIG. 7.45).

7.45 Navajo "eyedazzler" blanket. 1875–90. Wool, 6'5¾" × 4'6⅞" (1.97 × 1.39 m). Natural History Museum of Los Angeles County

Traditionally, weavers worked with fixed, upright looms made of tree limbs or growing trees, but today most Navajo weavers use portable metal or wooden looms. Some twentieth-century designs have been based on genre scenes, Islamic carpets, and Navajo sand paintings. Many of the traditional forms of Navajo weaving were also revived in the 1920s and 1930s at the Chinle and Wide Ruins trading posts. Yet, in the face of outside pressures and the apparent eclecticism of the weavers who have used many types of commercial yarns and dyes, the Navajo weavers have maintained a recognizable Navajo character in their work. Their dazzling designs, which continue to change from year to year, retain the strength of the traditional Navajo designs and demonstrate the continued vitality of the southwestern traditions in the arts. The way in which the weavers have succeeded echoes the larger picture of Navajo history, how they have continued to absorb outside influences without losing their identity.

THE GREAT PLAINS

The popular image of the Native North Americans as buffalo-hunting warriors ruled by chieftains wearing long, colorful feathered headdresses is based on the Great Plains culture of the nineteenth century (FIG. 7.46). Although the Mandan and Hidatsa have been living on the plains and building sturdy earthen lodges there for nearly a thousand years, the Sioux, Crow, Cheyenne, Arapaho, and other groups were relative newcomers to this area when the French- and English-speaking traders and settlers first arrived. Buffalo hunting had not been practiced on a large scale until the eighteenth century, when the hunters acquired horses from the Spanish and guns from French fur traders. Using horses to drag their sledges made of long slender poles, the hunting societies could take their homes and possessions with them in the summer as they followed the buffalo herds. Their summer homes, *tipis* or *tepees*, were large tents, frameworks of long poles covered with painted buffalo hides. Many of these and other buffalo hides, items of dress, and other utilitarian objects were decorated with signs and symbols that spoke of ethnic pride and identity. These metaphors of power played an important role in the lives of the Plains peoples in the nineteenth century, a time of rapid change and cultural decline.

The richly decorated regalia of the Plains warriors and their leaders intrigued some nineteenth-century painters and photographers who traveled in the frontier lands. Karl Bodmer (1809–1893)was one of the earliest of the American and European artists to work on the Plains. His portrait of Mato-Tope, a Mandan chief in full ceremonial regalia, is based on sketches

7.46 *Mandan Chief Mato-Tope.* 1840. Lithograph, 14 × 10" (35.6 × 25.4 cm). The Thomas Gilcrease Institute of American History and Art, Tulsa, Oklahoma

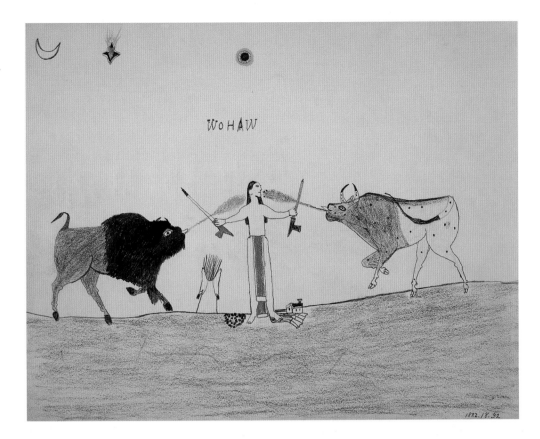

WOHAW

7.47 Wo-Haw, *Wo-Haw between Two Worlds*. 1875–7. Ledger-book drawing. Graphite and colored pencil on paper, 8 × 11" (20.3 × 27.9 cm). Courtesy of the Missouri Historical Society, St. Louis

he did while traveling around the upper Missouri in 1832. As with so many semi-nomadic societies in the world with mounted warrior-hunters, the regalia of the Plains leaders was splendid and theatrical. Bodmer's chief wears a pair of horns over his long trailing feathered headdress. Trophy scalps hang from his chest and the covered blade of his lance. Porcupine quills, fringe, and fur cover much of his knee-length shirt, leggings, and moccasins.

Some women distinguished themselves in battle and earned the right to wear the eagle plumage, the ultimate symbol of courage. But life on the Plains was not focused entirely on warfare and hunting. Women could achieve the same respect as the men by being skillful in the arts. While the men gathered to share stories about warfare and hunting, groups of women were describing their finest works of art to one other at meetings of their art guilds, organizations that controlled the artistic activities of the community. By comparing stories about their most famous works of art, ones that had beautified their world, the women created their own social order. From an early age, mothers taught their daughters the skills they would need to become members of these prestigious guilds.

As the buffalo herds were slaughtered and increasing numbers of settlers under the protection of the United States government began farming on the Great Plains, the traditional way of life for Native Americans in this area disappeared. After 1869, many of them were forcibly relocated or imprisoned on reservations. Some Cheyenne and Kiowa were taken far away from their homelands and incarcerated at Fort Marion, Florida, from 1875 to 1878. Without their traditional art materials, some of the prisoners began drawing and painting on paper, including pages from the fort's ledger books. A self portrait, *Wo-Haw between Two Worlds*, is an intimate look at the conflict Wo-Haw's people felt in prison as their old ways of life were fading away (FIG. 7.47). With the sun, moon, and a shooting star as his witnesses, Wo-Haw extends peace pipes to a buffalo (the Native American past) and a domesticated cow (the colonial present). He plants one foot near a miniature buffalo herd and a *tipi*, the other by the cultivated fields and white frame house of a Euro-American settler. The drawing retains vestiges of earlier Native American styles of drawing and decoration

Basketmaking

The techniques of basketmaking in the Americas are very ancient, and date back to at least 11,000 BCE. Because the techniques of making pottery remained unknown in many parts of North America, basketmaking became a very important industry and means of aesthetic expression. The vast majority of basketmakers were women; they gathered their own materials, prepared them, and created their own designs. In some areas, women continued to work as basket artists long after the men had abandoned their traditional art forms.

The two basic techniques of basketmaking are weaving and coiling. The weaving technique uses a warp and weft, as in loom work, and it produces a checkerboard pattern. This is also known as plaiting or checkerwork. Using colored materials and varying the weave pattern, basketmakers can create a variety of decorative woven patterns. Weaves in which the warp is ridged are known as wickerwork. In the coiling technique, long bundles of tightly wrapped roots, stems, and other plant materials are sewn or whipped together in an ascending spiral coil. Before metal needles were introduced to the Americas, basketmakers used bone awls to fasten the coils.

The Pomo of California in the mountains north of San Francisco have long been some of the most accomplished basketmakers in North America. In 1579, a member of the Sir Francis Drake expedition along the California coast described a Pomo ceremonial basket with red woodpecker feathers. The finest of the Pomo's woven and coiled baskets are decorated with a variety of such attached materials and illustrate important mythological events. The saucer-shaped coiled basket hanging on strings of tiny white clam shell beads in figure 7.48 is a replica of a spirit basket used by the Pomo creator-culture hero, Oncoyeto. He stole the sun from a distant land, carried it home in a basket, and brought light to the Pomo world. To tell the complex story, the artist has used a variety of decorative materials with symbolic meanings understood by other members of Pomo society. The circular abalone disks represent the sun, the crescent disk is the moon, and the arrow-shaped pieces are stars. The fish on shell bead strings below the basket (the island of the earth) swim in the primordial sea where Oncoyeto placed the sun. Colored woodpecker feathers symbolize important virtues: bravery (red), love (black), and success (yellow).

Pomo women often received ideas for their basket designs through visions. Thus, the artists remained spiritually bonded to their works and they owned the designs as well as the baskets. Artists could not use each other's designs because these incorporated intensely personal, spiritualized properties. Since the baskets were so personal in nature, Pomo women might use such elaborate and symbolically meaningful baskets as this while performing routine, everyday tasks, enjoying the beauty of their art and reliving their visions while working. Many of the finest Pomo baskets were worn out in this manner and others were burned with their owners when they were cremated.

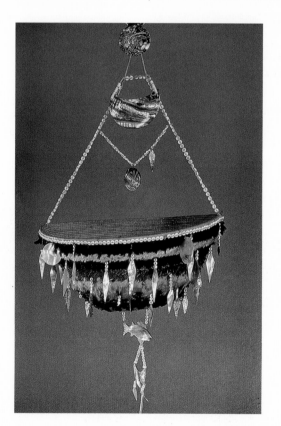

7.48 Pomo hanging basket. Organic fibers with clam shell beads, abalone, and feathers, diameter 13' (3.96 m). Smithsonian Institution, Washington, D.C.

Beadwork

Glass beads were manufactured in Europe by glassblowers. They stretched thin bubbles of molten, colored glass into thin hollow strands, cut them into tiny segments, and polished them in tumblers filled with sand and other abrasives. Beads were sized by number. The Czechoslovakian seed beads (sizes 18/0 to 10/0) were smaller than the Venetian pony beads (8/0 and larger). At the factories, beads of the same size and color were strung on durable threads and crated in barrels for transport. Traders working on the frontier exchanged the beads and other manufactured goods for the Native Americans' furs, particularly beaver.

Most of the beads were stitched to the tanned hides of deer, buffalo, elk, moose, and caribou. Tanning involved scraping, stretching, drying, and treating the hides with the animal's brains, oils, or other natural ingredients to keep them from spoiling. Before needles and threads were imported, beadworkers stitched with bone awls and sinew from animal tendons. Beadworkers employed a variety of stitches to secure rows of beads to the surface of the hides. Often, glass beads were used with metal beads, tacks, and sequins (stamped and flattened loops of silver), bits of brass, copper, feathers, fur, and paint. But it is the brilliant color, translucency, and reflective quality of the glass that have made glass beadwork so popular among collectors of Native American art from the Great Plains.

that mix with Wo-Haw's knowledge of Western images he could have seen in newspapers, magazines, and advertisements at Fort Marion. The image is also a prophetic statement, describing the two worlds with which later Native American artists would continue to struggle as they searched for art forms that would express their experiences in and "between two worlds."

The nineteenth century also saw the development of glass beadwork on the Plains. The small reflective pieces of colored glass so astonished the Plains people that many believed the beads came from the spirit world. At first, the beads were used to accent other objects attached to animal hides such as bones, claws, stones, and quills. Women had long worked with hollow colored porcupine quills, softening, dying, and weaving them in ornamental patterns on animal skins, baskets, and boxes of birch bark. (See "*Materials and Techniques*: Basketmaking," page 298.) After the establishment of the reservations in 1869, beadwork became an increasingly important art form in itself. The buckskin dress by Mrs. Minnie Sky Arrow of the Fort Peck reservation in Montana is beaded on both sides and weighs seven pounds (3.17 kg) (FIG. 7.49). Proud of her Native American heritage, she wore the heavy dress when she gave piano concerts around the country at the end of the century. (See "*Materials and Techniques*: Beadwork," above.)

Just at the time when many Native Americans were losing their hunting and farming lands, non-Native Americans began to discover the art and culture of the "Vanishing Indian," so making their art very collectable. This patronage, however, was accompanied by the development of stereo-

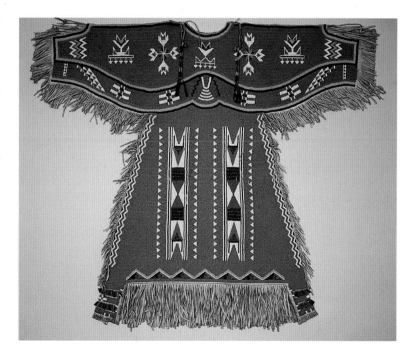

7.49 Mrs. Minnie Sky Arrow, *Beaded Dress.* c. 1890. Glass beads over buckskin. Fort Peck reservation, Montana

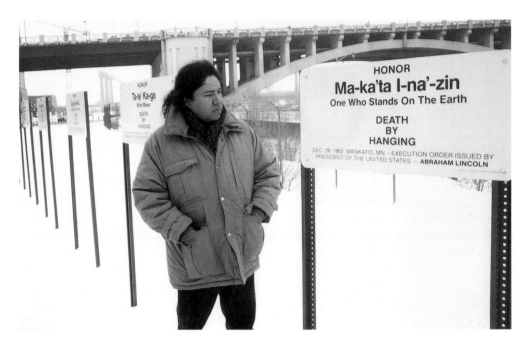

7.50 Hachivi Edgar Heap of Birds. Detail of *Building Minnesota*. 1990. Installation of forty aluminum signs along West River Parkway, Minneapolis

types about "Indianess"—the noble savage, mystic, the exotic "other." Since then, Native American artists who have not conformed to these stereotypes have often found it difficult to attract patrons who continue to look for works reflecting benign forms of ethnographic content. To break down these modes of thought and free themselves from the old constructions of "Indianess," some Native Americans in the late twentieth century began working with installations, video, and performance art.

In one of the strongest attention-seeking statements to date, the Southern Cheyenne/ Arapaho artist Hachivi Edgar Heap of Birds (born 1954) used the modern concept of a road sign for his installation work *Building Minnesota* (FIG. 7.50). It memorializes forty nineteenth-century Dakota tribal men who were executed by hanging in Minnesota in 1862 and 1865 by order of Presidents Abraham Lincoln and Andrew Johnson. The forty men had taken part in a rebellion against the American government after it had failed to honor the terms of its treaties with the Dakota people in the newly formed reservations. Heap of Birds' forty aluminium signs stand in a disrict of Minneapolis once called the Grain Belt, overlooking the Mississippi River. It was along this waterway that grain was shipped downriver to white consumers while the Native tribes were left to starve. The image of the artist standing in the snow beside a sign honoring Ma-ka'ta I-na'-zin ("One Who Stands On The Earth") raises many questions about American history, its values and its cherished icons. Heap of Birds has constructed a number of other site-specific installations which comment on the realities of past and present Native American life in those localities, reminding us that he and other Native Americans are still here—they are not "vanishing."

SUMMARY

While Mrs. Sky Arrow was beading her dress, members of a new, highly emotional cult inspired by Wovoka, a Paiute priest from Nevada, were painting a new kind of clothing, Ghost Dance shirts. They believed their ritually decorated shirts were bulletproof and that wearing them in the Ghost Dance ceremonies tied them to the powers of the spirits and sacred ancestors in the other world. The shirts and ceremonies would bring back their ancestors, the herds of buffalo, and make the foreigners disappear. The massacre at Wounded Knee Creek on the Pine Ridge reservation in South Dakota on December 29, 1890, underlined the

futility of these dreams and that date effectively marks the end of the buffalo-hunting Plains culture.

However, as the European powers colonized the Americas, the art and religious beliefs of the Pre-Columbian and Native Americans did not disappear entirely. Shamans around the Americas continued to use the arts to perform ceremonies in which they left the terrestrial realm, visited with deities and sacred ancestors in the other world, and returned with messages for their communities. In the Southwestern United States, *kachinas* still embody the spirits of the deities and powers they represent as they emerge from their *kivas* to dance in *pueblo* rituals. Elements of Inca, Maya, Aztec, and other Pre-Columbian art forms in Latin America remain part of their folk art traditions, and in some regions, native religious beliefs have been incorporated into Catholicism. In North America, various Native American art traditions discussed above have been revived in recent years. Elements of the original traditions have mixed with colonial and modern art to shape the contemporary post-colonial art styles that continue to reflect the vitality of the Native American culture in the twenty-first century.

However, it is reasonable to ask whether it is possible for a Native American artist to be also an avant-garde contemporary artist and part of the international world of Western art. For some thinkers, this is a contradiction and a logical impossibility. However, contemporary postmodern thinking accepts the fact that some styles do not develop in a linear fashion, that art styles such as those in Native America can decline, reemerge, and strengthen themselves by tapping into other traditions, such as modern Western thought. With these ideas in mind, the future history of Native American art in Latin and North America promises to be an exciting one.

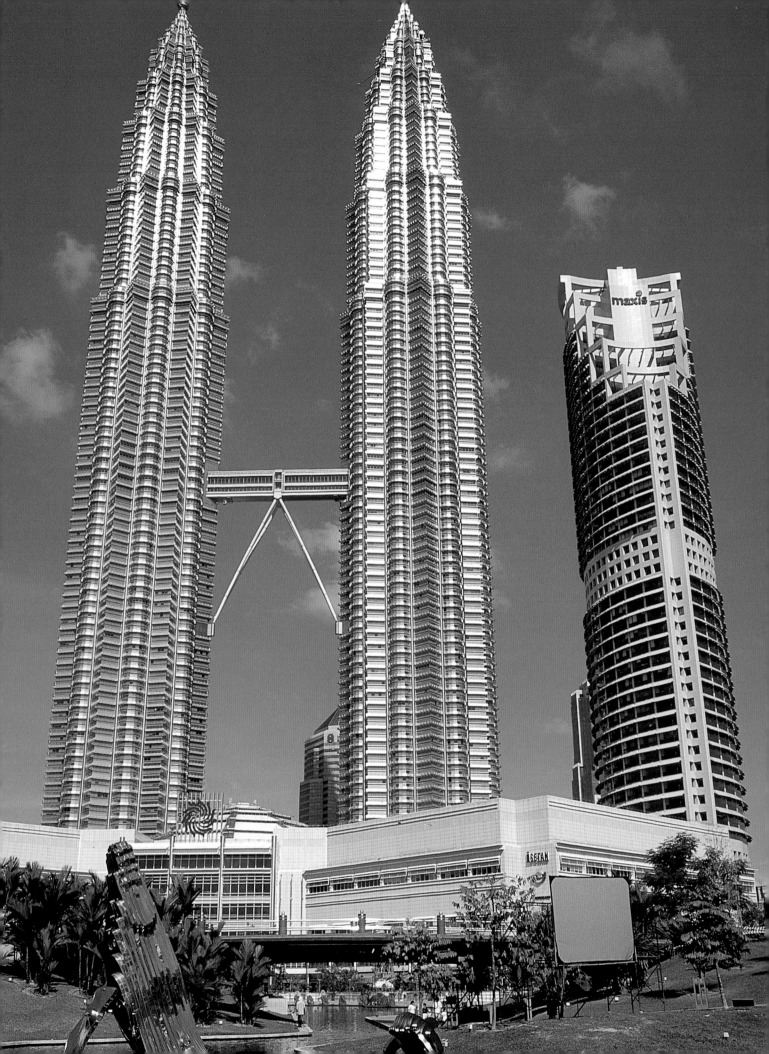

CHAPTER EIGHT
ART WITHOUT BOUNDARIES

Equator

ART WITHOUT BOUNDARIES

INTRODUCTION

Chapters Two through Seven of this book focus on specific times and places where important cultural ideals have been given form in spectacular works of art. These key monuments in the history of art derive from changing networks of thought that are constantly dissolving into new and innovative configurations. This process of change, resulting from outside influences and internal developments, has been the norm for centuries in the areas surveyed in this text. However, that process was accelerated when many parts of Africa, the Pacific, and the Americas as well as parts of Asia fell under Western influences and in many cases were subject to colonial rule. While some writers have suggested that the appearance of Western art damaged those traditions, irreparably, it is also possible to look at this development as just another episode in this long history of change. This final chapter looks at varying artistic responses within these areas and traditions to contact with the West and at subsequent artistic developments in light of the complex and overlapping concepts of postcolonialism, postmodernism, and new forms of internationalism.

Postcolonial artists accept both their precolonial and their colonial experiences as bases for their contemporary art and culture. For each different area of the non-Western world, the postcolonial period began at a different time as indigenous groups achieved home rule. In some localities that change has yet to take place and in others under home rule, the full impact of postcolonialism in the arts has yet to be realized. The broad-based concept of postmodernism, (literally, "after modernism") emerged as a major intellectual and cultural trend around 1970, and continues to be influential throughout the world. This final chapter looks at examples of recent work in some of the areas surveyed in this book to see how contemporary artists there have been influenced by these interlocking concepts of postcolonialism and postmodernism, and how they have helped shape these same concepts as well as the future of art internationally. The story of how certain late nineteenth- and early twentieth-century Western artists such as Vincent van Gogh, Paul Gauguin, and Pablo Picasso expanded their horizons and created exciting works by incorporating non-Western ideals is well known. However, the other side of that story, how non-Western artists of recent decades have been learning from the West and creating works of art that have departed from their ancient cultural traditions and become part of the international world of art is just beginning to be appreciated.

POSTCOLONIALISM

In many parts of the world, the colonial age has come to an end. British rule ended in India in 1947, the post-World War II occupation of Japan concluded in 1952, and with the death of Mao Zedong in 1979, the Great Proletarian Cultural Revolution in China was ended. After a thousand years of Chinese domination, Vietnam was part of the French colony called Indo-China (1858–1955), during which it was also occupied by Japan during World War II. Later, the United States involvement there lasted until 1973. As human rights issues assumed new importance in the late twentieth century, many of the colonial governments in Africa and the Pacific gave way to home rule. By the late twentieth century, Native Americans on the government-run reservations in the United States and reserves in Canada also began demanding a greater voice in the way their nations were being managed by predominantly white, absentee government officials.

Home rule and related civil rights movements rekindled interests in traditional forms of art, and the belief that art can still hold its ancient powers. In many parts of the post-colonial world of the late twentieth century, serious efforts were taken to revive traditional forms of art, dance, music, and literature and to establish new art schools, museums, and libraries. As nations become independent, amid the manifold social, economic, and cultural changes taking place under homerule, the arts helped unite diverse ethnic groups under their new national allegiances and values that included an awareness of their involvement with internationalized, Western forms of art and culture. Some individuals responded as antiquarians, reviving and preserving earlier forms of cultural expression for posterity. Others created what became known as "postcolonial" art, new forms of expression that combined the art forms of their ancestors with Western, colonial forms of art to create a synthesis that reflected the inherent duality of their postcolonial world views.

Some writers have used the term "returnee" artist to distinguish certain postcolonial African-American/European artists who have made a pilgrimage—"returned" to Africa, for example—and then went back to the white-dominated Western countries of their birth with a new understanding of how their lives and art reflect both worlds. In many cases, that journey, in which some pilgrims can retrace the route along which their ancestors were transported to the Americas as slaves, has given "returnees" a new sense of closure and identity. Sokari Douglas Camp (born 1958), a London-based sculptor who studied at the California College of Arts and Crafts in Oakland and the Royal College of Art in London, returns periodically to the Kalabari city of Buguma in the Niger River delta region of Nigeria, where she was born. Douglas Camp is just one of many Nigerian artists who have built careers and attracted critical attention in metropolitan art centers in the West since 1990 while maintaining close ties with Nigeria.

To become an artist, she had to overcome a series of obstacles. "The word 'art' and being an artist are things that have to do with the West," says Douglas Camp. "I'd say an artist in Kalabari culture—if there is such a thing—would be someone who deals with power objects." Although, as a young girl, Douglas Camp was not allowed near these power objects in her own community, she watched many masquerade performances and considers her work to be a kind of dance-performance choreography. At times, the themes in her recent work have curators in ethnographic and historical museums rather than art dealers and gallery owners. Her exhibition *Spirits in Steel: The Art of the Kalabari Masquerade* was initially commissioned by the British Museum in London and then traveled to a number of anthropological museums including the American Museum of Natural History in New York (FIG. 8.1). The figures illustrate and dramatize the importance of the rituals associated with some of the works in the museums' collections, and are meant to be seen from all sides, so viewers can walk around them. They draw their inspiration and strength from several traditional Kalabari themes, such as the mystic connection of the spirit and human worlds, and

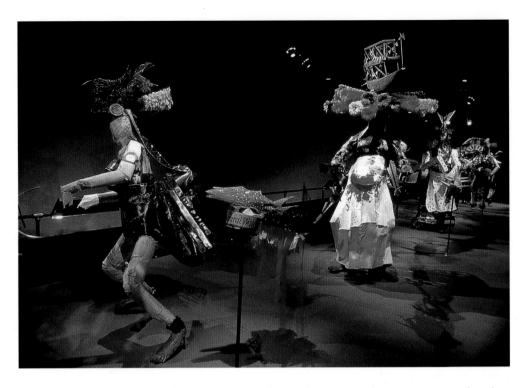

8.1 Sokari Douglas Camp, *Spirits in Steel: The Art of the Kalabari Masquerade.* 1998–9. Life-size, mixed media installation at the American Museum of Natural History, New York

from the original context of Kalabari art in the performances that continue to this day. These and other sculptures by Douglas Camp have a sense of lively and graceful movement, and mix specific iconographic elements associated with the Kalabari masquerade with abstract forms and a wide variety of colorful, textured materials.

POSTMODERNISM

Before the late twentieth century, many potential patrons might have rejected works of art by non-Western artists that openly displayed Western influences, preferring instead, "pure" works that were not "hybridized." By the end of the twentieth century, however, Western attitudes toward this kind of artistic and cultural "purity" were changing. The movement known as postmodernism had a decentering effect that helped artists, historians, and other thinkers to "decolonize" art history and take a fresh look at art around the world. Postmodernism is a comprehensive worldview that embraces, variety, discontinuity, disjunction, and flux. It questions the meaning of some of the key modernist ideas that were dominant from the late nineteenth century to the mid-twentieth, such as "originality" and "creativity." Why did modernism privilege certain artists in a relatively few Western metropolitan centers and call their work "high" or "fine" art at the expense of other traditions and media, which it called "crafts," "decorative arts," and "applied arts"? Postmodernism, the antithesis of modernism, developed as the late twentieth century Western thinkers became more international in their thinking and gave greater respect to cultures outside the Western "mainstream" of thought. The linked ideas of postcolonialism and postmodernism are central to the cultural context in which contemporary art and architecture are developing in many areas beyond the West. Many of the most remarkable artworks of the late twentieth century drew freely on both Western and non-Western traditions, without "privileging" either one or the other.

Perhaps no single monument better expresses this approach in an architectural context than the Petronas Towers in Kuala Lumpur, the capital of Malaysia (FIG. 8.2). Some nineteenth- and early twentieth-century European architects working in India and neighboring countries had looked for ways to combine elements of the local traditions with the Euro-

pean styles of building in which they had been trained. Often, however, because Europe was the technologically superior culture, its architecture became a symbol of this superiority, while local traditions did not enjoy anything like the same prestige. Over the centuries Malaysia has been ruled by Buddhists, Muslims, and Hindus, as well as by the Portuguese and the British. When the Petronas Company, which searches for and produces oil and gas, decided to build their new headquarters in Kuala Lumpur, they wanted a structure that would reflect their diverse cultural background of Malaysia as well as its emerging role in the world economy. Thus, they could not build another modernist International Style steel and glass "box." The Petronas Company wanted an architectural firm with state-of-the-art engineering technology that would also work with local designers to give their new building a distinctive Malaysian look. They found such a firm in Cesar Pelli and Associates of the United States. The Argentina-born Pelli, who had worked on large structures around the world, was well known for his ability to integrate his buildings with the lives and cultures of those who used them. In the end, the architectural firm and local designers created the world's tallest skyscraper (1,483 feet; 452 meters), a pair of towers that reflect the long tradition of Islamic, Buddhist, and Hindu thought in Malaysia.

The cross sections of the towers are based on an Islamic decorative motif, a star formed by superimposed squares with semicircular insets between the corners of the squares. Above the two-story sky bridge connecting the towers, the diameter of the towers diminishes through a series of small setbacks. While similar setbacks were used on such classic American examples of the skyscraper as the Empire State Building, the specific way the setbacks of the Petronas Towers increase in frequency toward the top of the structure gives the towers a tapered look that resembles the shapes of earlier Buddhist temple towers in Malaysia and such well-known Hindu temples as those at Khajuraho (see FIG. 3.31) and Angkor Wat (see FIG. 3.37). The interior of the Petronas Towers, which includes a mosque, is decorated with a wide variety of Islamic motifs. While the Towers may share a certain general features with many Western, postmodern buildings, the specific mix of cultural elements in their conception gives it a distinctive regional character unlike works by Pelli and other Western architects working for Western patrons.

The Towers are part of Malaysia's "Vision 2020," a program to rebuild the business district of the capital and become a fully industrialized nation by 2020. With its high pinnacles, the Towers have in fact become the most recognizable symbols of Malaysia's emerging economy. Along with similarly large and expensive skyscrapers in Shanghai, Hong Kong, Tokyo, and Seoul, the Towers challenge the longstanding identification of the skyscraper with the United States and Europe, and with temperate climates, and they refute the idea that only Western economies have the means to build and support such tall and expensive structures.

8.2 Cesar Pelli and Associates, Petronas Towers, Kuala Lumpur, Malaysia. 1997

INTERNATIONALISM IN THE POSTMODERN AND POSTCOLONIAL WORLD

As Western art viewers began to take a fresh look at non-Western art and culture, many of the old stereotypes about that "other" world and its art began to change. Even as such highly problematic terms as "primitive" and "tribal" were giving way to the slightly less objectionable terms such as "Third World" or "developing nations," many people still assumed that the arts of Native America, the Pacific, and Africa were inextricably tied to certain ancient ethnic and religious traditions, as manifest in village and regional ceremonials. Likewise, Asian art remained linked with the integrated religious societies that produced the monuments there before the arrival of Western influences. From this perspective, the arts in these non-Western cultures could not exist without these traditional contexts and would be incapable of sustaining their vitality if mixed with Western notions of art. This view allows no room for the rise of creative individuals who depart from traditional modes of representation to create works of art that engage with the world around them in new ways. This closed and static image of culture also prohibits artists from being inspired by art and culture from outside their immediate environment. Outside knowledge, especially Western, becomes a kind of pollution that compromises the "purity" of the art and its frameworks of thought.

To discuss contemporary non-Western art, it is essential to brush aside such outdated notions about its societies and define what is meant and understood as art in these areas today. We must first recognize that many of the ancient traditions in the arts survived colonialism and that they have an important and sustained impact on the lives of the people around them to this day. As a dialogue between the past and present, art continues to be produced in the spirit of the pre-contact works that recognized the need to balance the past and the present—tradition and innovation. These vital, living traditions have inspired a large number of contemporary artists, some of whom have studied internationalized forms of Western art and incorporated elements of it in their work.

Artists whose art fuse the past and present, the traditional and the transcultural have helped us define a broader, emerging conception of internationalism without a "Western" prefix. In recent years, the term "internationalism" has taken on new and more diverse dimensions. The late modernist International Style in architecture that spread around the world was a North American and European export that retained its Western character everywhere it went. It was international in its distribution, but purely Western in its character and construction. The technical superiority of the West allowed it to retain this sort of dominance in international relationships as it spread around the globe. In the postcolonial, postmodern world of thought, the role of thinking from beyond the West is being given an increased role in this traditionally uneven field of thought. However, for this to happen, and to continue, thinkers have had to revise many of their attitudes toward non-Western artists and art traditions.

During the thaw following the death of Mao Zedong in 1979 known as the Peking Spring, foreign capital began coming into China and the slowly began to adopt a more liberal approach, economically and cuturally. While the government continued to support highly politicized and official forms of art, exhibitions by the Stars group in 1979 and 1980 and the 85 New Wave movement in the late 1980s marked the rise of a new Chinese avant-garde. Many of these radicals and dissidents had international perspectives on art and were looking for highly innovative and expressive ways to comment on the China of the 1980s. The government made periodic crackdowns on artists who overtly criticized the Communist Party, such as those involved with the controversial *China/Avant-garde* exhibitions, which were linked with the infamous June 4th Movement in 1989. Such censorship, however, did not suppress the avant-garde, and interest in experimental art in China continued to rise.

Some artists managed to avoid government censorship by using traditional features of Chinese art and culture—its literary tradition and calligraphy, for example—in new contexts , such as installations and performance pieces. One of the most inventive of these artists, Wenda Gu (born 1955), from Shanghai, had been trained in the traditional techniques of Chinese ink painting at the China National Academy of Fine Arts, where he graduated in 1981. Even while he was at the academy, he began looking for new and expressive ways to use the traditional forms of Chinese painting and calligraphy. After a work using mutilated Chinese characters was censored in 1987, Wenda moved to New York City. In such pieces as *United Nations—China Monument: Temple of Heaven*, the artist has enlarged the traditional scale of the Chinese ink painting and calligraphy to create a large-scale installation (FIG. 8.3). Wenda Gu's installations do more than cover portions of a wall, like framed paintings, or rest on pedestals, like sculptures; they take over the architectural spaces they occupy. Visitors could become temporary parts of this installation by sitting and drinking tea on the Ming-style chairs which encircle the television sets.

With large curtains on the walls and suspended from the ceiling, the space vaguely resembles a tent, temple, or tomb. It would be natural to suspect that the calligraphy will explain the meaning of this unusual structure, but Wenda's work is filled with many ironic twists. The curtains, which look like large sheets of Chinese rice paper, are made from human hair and the scripts, which resemble Chinese, English, Hindu, and Arabic forms of writing, are in fact illegible nonsense letters and characters. Many of the Chinese characters are in the ancient seal-script, which cannot be read by the modern Chinese public and give the writings an additional obscure and mystical character. The bogus nature of the "rice" paper, along with the tension between the size of the large, bold black characters, which are presented with such directness on a light background, and the cryptic nature of their content can give rise to many meanings. By violating the traditional system of writing in which the

8.3 Wenda Gu, *United Nations—China Monument: Temple of Heaven*. 1998. A site specific installation commissioned by the Asia Society for the P.S.1 Contemporary Art Center, New York. Temple made of human hair, Ming dynasty furniture, TV monitors, and video film. Collection of Hong Kong Museum of Art

characters carry distinct meanings, Wenda's work seems to represent a new form of mysticism—with his installations as the temples where the mysteries can be contemplated.

Knowing that the text does not carry readable literary messages, audiences may also ask if the artist is suggesting that the past, especially the Chinese literary tradition that conveyed its cultural values, has no meaning in the present? Is the artist mocking the ancient texts of China, and by implication, those of modern China as well, especially the words of Mao? With the longest, unbroken literary tradition in the world, the Chinese understand the mixed blessings of writing; it can carry valuable knowledge, or be used as an instrument by propagandists to mystify and confuse the populace. While the Communist Party used the slogan *pochu mixin* ("to destroy superstition"), they themselves created a new form of mysticism that reached its height during the Cultural Revolution of the late 1960s and 1970s. Are the script and installation the artist's metaphor for modern China or the contemporary Chinese artist whom the rest of the world must struggle to understand? Or, is the artist attempting to reinvent China in terms of its much-loved art forms, ink painting and calligraphy, to make its art part of the international art world?

Wenda Gu, who maintains studios in New York City and Shanghai, says his work embodies the "humor of cultural exchange." The hair, his signature material, used in the paper and writings, may be a clue to his intentions. It comes from more than 325 barbershops in many countries and is as international as the scripts, the television sets in his installation, and the concept of the *United Nations*. This installation can be seen as a kind of universal tea house (those participating in the traditional Japanese tea ceremony underwent a subtle form of bonding), a place where many cultures can assemble and transcend their national differences. In fact, hundreds of thousands of people from around the world have visited Wenga Gu's installations in many countries and shared in this experience. It is an intense, ongoing dialogue, not simply between Wenda Gu's native China and the West, but among many contemporary cultures.

At the end of the twentieth century, the debate between the traditionalists and avant-garde or experimental artists in China continued, with the growing realization that Chinese art is destined to be more than a voice of the government; it is becoming part of an international language of form and communication and is destined to become a voice for more than a billion Chinese.

INTO THE TWENTY-FIRST CENTURY: THE FUTURE OF ART BEYOND THE WEST

An overview of just three of the thousands of artworks produced in the world beyond the West in recent years indicates how clearly the traditional cultural boundaries separating the linguistic, ethnic, and religious groups that produced the great styles of art featured in this book have broken down in the postcolonial and postmodern world and become part of a new, emerging internationalism in the arts. The traditional cultural distinctions and parameters have disappeared in a global world of art without boundaries. Artists are able to draw strength and inspiration from any and every source of ideas and forms they find around the world. Given the richness and multiplicity of these sources, what can one predict for the future of art in the non-Western world?

AFTERWORD

THE NEW GEOGRAPHIES OF CONTEMPORARY ART

What do the terms Africa, Asia, the Pacific, and the Americas mean now, at the beginning of the twenty-first century, the start of a new millennium? How do they help us think about the arts, to understand the new forms and practices that constantly emerge as well as the continual evolution of traditions?

In this moment of looking forward, it is important to remember that these terms have a long history in cultural analysis. When the Greek historian Herodotus famously wrote that "soft lands make soft men," he was expressing the belief that geographic location affects the nature and development of human cultures—distinctive cultures emerge in distinctive geographic places. It is easy to see why this idea has been centrally important in European thought. For thousands of years, cross-cultural contact took place in spite of the enormous barriers that existed between the major land masses. We may complain about cramped seats or bad food on international flights today, but these are nothing compared to the severe privations suffered by those who undertook long-distance travel in the past—whether Polynesians on their way to settle new islands, Islamic traders guiding their caravans along the Silk Road or across the Sahara, or European explorers searching for new routes to gold and spices. The distance and the cultural difference between continents were once measured by time and hardship in ways that are almost unimaginable now. And the kinds of cross-cultural exchanges, the formal and intellectual borrowings and influences that have characterized a variety of art traditions in Africa, Asia, the Pacific, the Americas —and Europe, for that matter—were hard won (see FIG. 2.28).

Of course, continents and geographically specific cultures do still exist, and a geographic framework can be a useful and important way of understanding art traditions, as this book has demonstrated. However, it is worth asking what importance we should give to the concept of continents in analyzing contemporary and future trends in the arts. How do new technologies of travel and communication, from the jumbo jet to the worldwide web, affect the practice, and the interpretation, of art today? How do we define and characterize cultural difference and cultural distance when it is possible to travel from Los Angeles to Tahiti (once the paradigmatic exotic, distant island) in just over seven hours, and to ring Zimbabwe from Japan in an instant? Do continents still represent the kind of cultural separation they once did, when artists such as Sokari Douglas Camp can move easily between Nigeria and Britain—both physically and artistically? How cut off is even a relatively closed country such as China, when the protestors of Tiananmen Square were able to fax their message to the world, and when artists, in spite of censorship, have access to American and European art magazines and, like Wenda Gu, travel abroad to work?

This is not to say that local cultures have disappeared, or that localized art traditions, including some of those traditions described in this book, have disappeared. Cell phones may be ubiquitous in Paris, Cape Town, Mombei, and Mexico City, but nearly half the world's population has never used a telephone, much less carried one around. In the arts local traditions do certainly exist—they flourish—but in some senses perhaps they are more permeable now than ever before, less absolutely local. Books, magazines, television, and radio have widespread distribution, bringing with them new images, ideas, ways of seeing. A global popular culture is emerging that has a long reach, and it is constantly appropriating and disseminating imagery. And the movement is certainly not always from international to local culture. There are a number of forces at work that constantly serve to shift art from the local to the global—whether it is the corporate marketer looking for a cheap source of decorative objects, the ambitious village artist heading to the nearest city, the curator or dealer developing an exhibition or collection, or the art historian or anthropologist looking for insight into human culture.

Sometimes it is the very conditions of the contemporary world that renew and strengthen local cultures and artistic practices. Certainly some of the art traditions described in this book have been challenged by the pressure of shifting populations, changing beliefs, and hostile power regimes. Just think, for example, of the profound effect that Christian evangelization has had on the arts in Latin America and the Pacific. But other art traditions have been renewed and strengthened. It is partly through the search for national and cultural identity in a postcolonial world, as described in Chapter Eight, that these art traditions have been strengthened. Sometimes it is the very hallmarks of the contemporary world that foster and reinforce these kinds of local art practices. One tragic example of this is the AIDS crisis in Africa, an epidemic that has been fostered by transcontinental travel and inadequate health care and health education in many areas. In certain parts of Africa, where the HIV infection rate is as high as fifty percent, people attribute the disease to witchcraft. The virus may be the proximate cause of the disease, but it is a witch's malevolence toward an individual that makes the person vulnerable to the virus. In the context of this belief, traditional healing rituals and performances, with their associated art forms, have actually been strengthened.

In the new geography of contemporary art, our analysis must be built on concepts that allow us to move fluidly between the local/regional/national/international/continental, for artists themselves move fluidly between places, artistic practices, and visual vocabularies. So we should give less emphasis to the concept of continents, with their connotations of distance and fixity, and substitute concepts of mobility, communication, and hybridity as key elements of our interpretive framework. To develop this analysis, I want to discuss three emerging artists whose works—as varied and distinctive as they are—develop from this new kind of mobility and exchange of ideas. Their work grows out of both localized cultural practices and international art practice, and their intended audiences are similarly both local and international. These are artists who do not observe any of the traditional boundaries, whether geographic, cultural, or artistic.

Pacific Sisters, a performance group based in Auckland, New Zealand, exemplify the kind of hybrid practice that characterizes much contemporary art. This group challenges just about every standard category that might normally be used to classify them. It includes studio artists, film makers, graphic artists, and fashion designers who are all of Pacific islands descent but who grew up and live in the Pacific diaspora communities of Auckland. Their complex multimedia performances incorporate film and still

8.4 Pacific Sisters, performance at the Seventh Pacific Festival of Art, Western Samoa. 1996

imagery, costume, dance, and music. In this way, they simultaneously participate in the performance art practices of the contemporary international art world—a member once likened the group to "a Polynesian version of Andy Warhol's Factory"—and are true to the performance art traditions that are so centrally important to Pacific ssland cultures. Their costumes exemplify these juxtapositions, for they incorporate barkcloth and raffia, lycra and polyester, glass beads, feathers, and shells. In these dramatic costumes and with their aggressive, powerful performance style, Pacific Sisters challenges the saccharine image of the South Seas dancing girl, a mainstay of pop culture representations of the Pacific for over a hundred years.

Unlike Warhol's Factory, the members of Pacific Sisters has a serious interest in reconnecting with tradition and they frequently perform new versions of Polynesian legends and stories. Pacific Sisters recently traveled to Samoa to participate in the Pacific Arts Festival, a traditionally oriented celebration of song, dance, and the visual arts that attracts artists from all over the Pacific. While there, one of the Samoan members of the group participated in a ceremony in her family's native village, because she by birth was the *taupou*, the sacred maiden of the village (FIG. 8.4). But she performed the ceremony in her own way—in her Pacific Sisters costume, accompanied by all her Pacific Sisters. Although she certainly dressed and behaved differently from the traditional *taupou*, many members of the village expressed satisfaction at her performance, both because she was fulfilling a traditional obligation and because she brought something new to the role of *taupou*.

Lee Bul from Seoul, South Korea, is another artist who explores the representation of women and the construction of femininity in global culture. Her work is oriented toward an international public and utilizes an international visual vocabulary and intellectual framework, and yet emerges very much from her experience growing up in a major East Asian city as the daughter of dissident parents. Her work simultaneously engages in a critique both of Western patriarchy and of the specific forms of patriarchy encouraged by Korean Confucianism, which is still used to silence women and uphold male authority in contemporary Korean society.

Lee's 1993 installation *Majestic Splendor*, exemplifies this doubly directed critique. In this work, she presented plastic bags containing fish beautifully decorated with beads and sequins in an obvious reference to feminine adornment. Strange and lovely as they are, the fish soon begin decompose: their feminine ornamentation is powerless to prevent them from decay and putrefaction. In a Korean context, the feminist critique contained within the work emerges even more strongly. This particular species of fish has feminine connotations—it is a *domi*, a type of red snapper typically found in local markets, which calls to mind women's domestic responsibilities in cooking and caring for their families. Moreover, the word *domi* refer to the legend of Lady Domi, who committed suicide to evade the seductions of a king and remain loyal to her true love. Lee's work calls into question the value of both constructions of femininity and female experience, the quotidian and the mythic.

Among Lee's most recent work is a series of female cyborgs, enormous sculptures depicting the human-machine hybrids that are the stuff of both science fiction and contemporary cultural theory (FIG. 8.5). Lee's cyborgs are simultaneously hyper-mechanical and hyper-feminine: the mechanical articulation of their hard, contoured surfaces contrasts with their nipped waists, curvy hips, and full breasts. Lee notes that what interests her in the pop culture cyborg imagery, of the type found in Japanese animations and comics that have achieved worldwide popularity, is "a superhuman power, the cult of technology, and

8.5 Lee Bul, *Cyborg*. 1999. Aluminum wire, stainless steel, polyethylene resine, polyurethane sheet, 59 x 21½ x 53½" (150 x 55 x 90 cm). Kukje Gallery, Seoul, Korea

8.6 Yinka Shonibare, *Victorian Couple*. 1999. Wax printed cotton textile, approx. 60 × 36 × 36" (153 × 92 × 92 cm); approx. 60 × 24 × 24" (153 × 61 × 61 cm). Collection of Susan and Lewis Manilow, Chicago

girlish vulnerability working in ambiguous concert." Despite their remarkable aura of power and strength, these cyborgs are fragmentary and mutilated, missing heads and limbs. They dangle helpless and useless from the ceiling, calling into question both the myth of technological perfection and the idea that women could find such cyborg imagery empowering. Lee's cyborgs remind us that futuristic fantasies are often based on regressive gender practices.

Yinka Shonibare's work emerges—like that of the Pacific Sisters—from his diasporic background. Shonibare was born in London to Nigerian parents, raised in Nigeria and trained at art school in London. Based now in London, he gained international attention in the mid-1990s with a series of photographs that critiques the power relationships of the colonial past and exposes the absurdity and racism of historical nostalgia. *Diary of a Victorian Dandy* creates elaborate tableaux depicting scenes from the life of an aristocratic gentleman in nineteenth-century England. There is an ironic twist to these images, for the dandy in question is none other than Shonibare himself. The verisimilitude cracks, the illusion is exposed, for we cannot suspend our disbelief so far as to accept this Nigerian man in the role of Victorian gentleman. Racism and colonialism make that subject position impossible.

In the mid-1990s, Shonibare began making works from the kind of colorful, printed fabrics that are worn throughout West Africa. In an amusing and thought-provoking juxtaposition, Shonibare's *Victorian Couple* (FIG. 8.6) presents a very elegant and complete Victorian man and woman's costume made from this fabric. As Shonibare points out, "By making hybrid clothes, I collapse the idea of a European dichotomy against an African one. It becomes difficult to work out where the opposites are. There is no way you can work out the precise nationality of my dresses, because they do not have one. And there is no way you can work out the precise economic status of the people who would've worn those dresses because the economic status and the class status are confused in these objects." Moreover, the piece questions the "Africanness" signalled by these fabrics. The fabrics are actually created by English and Dutch designers, who are themselves inspired by Indonesian batiks. The fabrics are manufactured in Europe and exported to African markets, and then remarketed in the West as something distinctly African. By using such a hybrid and contradictory material, Shonibare refuses any notion of an essential or authentic African identity.

Recently Shonibare has taken this fabric work in two different directions, both more popular and more deeply embedded in art world traditions and practices. He has started making families of space aliens from these textiles, works that he feels are particularly accessible to a larger audience. These aliens play with the notion that Africans "belong" in space as much as anyone else and point out the ways that our fantasies about aliens are still based very much on Euro-American normative values. In a different vein, *100 Years* consists of one hundred square panels covered with this printed fabric and hung in a grid pattern. The grid has been an element of enduring interest in the Minimalist tradition, and by coupling the grid with this cloth—which is anything but minimal and so strongly expressive of African identity in popular culture—Shonibare undermines Minimalism's claims to ideological neutrality and cultural universality. In this way, his work exists in conversation with the work of a number of recent artists, such as Agnes Martin and Sol LeWitt, who have reflected critically and self-consciously on the use of the grid.

Pacific Sisters, Lee Bul, and Yinka Shonibare represent some of the most exciting art being produced today in any context. All of them clearly work from their own particular cultural backgrounds and perspectives but are very much a part of international culture and art. They have a shared interest in critiquing the racism, sexism, and essentialism of international culture: Pacific Sisters, the romanticized notion of the South Seas woman; Lee Bul, the construction of femininity; Yinka Shonibare, the persistent racism inherited from the colonial past and the image of African identity. In doing so, these artists provide us with images that are visually memorable, complex and nuanced, thought-provoking, and sometimes even humorous. In the ways that these artists' concerns intersect, it is clear that none of them is bound or circumscribed by cultural identity or a sense of cultural geography. Their work shows us that to engage fully with contemporary art we do not need to set aside the geographic framework, but we must use other ideas along with it. We, too, must have flexibility of thought and imagination, an ability to move between cultures and ideas, in order to appreciate and understand new images as they emerge.

GLOSSARY

CHAPTER ONE

aesthetics That branch of philosophy which deals with concepts and theories of beauty in art and nature. The history of art appreciation and taste in art.

brahman In Indian thought, an all-inclusive and eternal spiritual reality that extends to all temporal and divine beings.

Buddhism A set of philosophical, ethical, and religious beliefs based on the teachings of the historic Buddha (c. 563–483 BCE).

calligraphy (from the Greek, *kallos*, "beauty," and *graphia*, "writing") The art of beautiful handwriting.

Confucianism A system of moral philosophy originated by Kong Fuzi (Confucius, c. 551–479 BCE), aimed at achieving harmony with nature by following proper codes of behavior.

Daoism ("the Way") In China, a philosophy developed by Lao Zi ("Old One") (born c. 604 BCE), aimed at achieving harmony with nature and the universe.

Hindu, Hinduism Originally, a term for people who lived in Hindustan. The main religion of India, combining many different sects.

Islam Arabic, "submission to the will of God." Followers of the Islamic faith, known as Muslims, believe in Allah ("the One God"), his prophet Muhammad (c. 570–632), and the wisdom of the *Koran* ("revelation" or "recitation").

Jainism Founded by Mahavira (599–527 BCE), the last of twenty-four *Tirthankaras*, ("pathfinders"), or *jinas* (victors or heroes) from which the religion took its name.

japonisme French for "Japanese style." A vogue for Japanese art in culture in Europe and North America beginning in the late nineteenth century that has had a profound influence on Western art.

Koran See ISLAM.

mana In the Pacific islands, a belief that works of art, other objects and people may have sacred powers.

shamanism Also known as sorcery. A belief held in many parts of the world that certain individuals were able communicate with the celestial world. They perform various functions assumed in Western societies by priests, preachers, artists, magicians, actors, doctors, and other healers.

Shintoism ("Way of the Gods") The pre-Buddhist religion of Japan, which venerated nature gods and encouraged the development of apparently simple and rustic, but deceptively complex art forms and rituals.

yoga Literally, the "discipline" of both mind and body; the term also refers to the pose or position assumed by a *yogin* ("holy man") or *yogini* ("holy woman"). A practice common to many traditions in India, designed to enhance mental control of the body and well-being.

CHAPTER TWO

ase Yoruba, "life force," "performance power."

battered The inward slope of walls toward the top that gives them stability.

Chi Wara A Bamana agricultural society known for the headdresses worn by its members in dances performed in honor of a mythic farming beast believed to have introduced the knowledge of agriculture to Bamana.

Gelede A Yoruba ceremony known for its masks and elaborate costumes, performed to insure the benevolence of *awon iya wa* "our mothers" (women elders).

ifarahon Yoruba, "clarity of line and form." The need for an image to include all the most important

information about a subject.

Iguneromwon The gild of bronzecasters in Benin. Named after its founder, Iguegha.

itutu Yoruba, "composed," "controlled," or "cool." An image, action, or event in which everything is in balance.

iyalase Woman head of the Yoruba *Gelede* ritual.

jijora Yoruba, "relative likeness." An image that captures the most essential characteristics of its subject.

mbari Igbo houses displaying statues of communal deities, including the Earth Goddess. Their construction symbolizes the creation of the gods and the world.

nkisi nkondi "Hunter figures" made by the Kongo of Zaire that "hunt" for solutions to domestic and group problems.

Nok style A highly sophisticated style of clay sculpture featuring stylized heads. Appears with the Iron Age in Nigeria, c. 600/500 BCE–200 CE.

nyaa ka Dan, "moving with flair."

ori inu Yoruba, "inner, spiritual head."

CHAPTER THREE

Aryans Indo-Europeans who migrated into India between 1400 and 1000 BCE.

atman Hindu. Used to refer both to the self within all sentient beings and the Universal Self or *Brahman*.

Bhagavad Gita The *Song of the Lord* (*Krishna*), which discusses many ideas basic to the Hindu religion, including *yoga*, *karma*, *bhakti*, etc.

bhakti The belief that freedom from the cycle of rebirth is possible through personal devotion to a deity.

bodhisattva Literally, "one who has *bodhi* (wisdom) as his goal". Mahayana Buddhist beings who have foresaken the attainment of their own nirvana to help humankind.

Brahma Hindu deity. The Creator.

brahman The all-inclusive and eternal spiritual reality that extends to all temporal and divine beings. It is closely related to *atman*, the self in all sentient beings, and *maya*, the cosmic trick or illusionary nature of all creation.

Brahmanism A term often used to refer to the ancient religious tradition based on Vedic rituals. Hinduism grew out of Brahmanism and other indigenous religious traditions.

In part, the Buddhist and Jain traditions are reactions to Brahmanism.

Buddha (563–483 BCE) Also known as Siddhartha Gautama and Shakyamuni. Founder of Buddhism. Recognized in art by his top knot of hair (*ushnisha*), the tuft of hair between the brows (*urna*), and other *laksanas*, the thirty-two marks of a *mahapurusa* or great being.

Buddhism After realizing Enlightenment, or nirvana, the Buddha formulated a philosophical, religious and ethical system that offered an alternative to Brahmanism, the *Upanisads*, and indigenous traditions. Theravada or Hinayana Buddhism ("the lesser vehicle") required great self-discipline, while Mahayana Buddhism emphasized the divinity of the Buddhas and *bodhisattvas* and their role as savior.

chaitya A Buddhist assembly hall and place of worship. Originally, rooms with tall vaulted roofs of bent saplings. Later, rock-cut cave temples retained many of these features.

chattra See STUPA.

darsan The visualization of the divine.

Devi The Sanskrit word for God.

Dharmacakra The teachings of the Buddha. The Buddhist Wheel of the Law or Doctrine, *dharma*. Like the orb of the sun, it is designed to bring light to all the world.

garbhagriha The cubic space (literally, "house of the womb") of a Hindu *vimana* or temple housing the primary image of that temple. In terms of the cosmic structure of the *vimana* as the *purusa* or primordial being, it is also situated at its head. It is at the center of the *vimana* as a *mandala*, a magical diagram of the cosmos.

gopura An entrance gate to a Hindu temple.

harmika See STUPA.

Hinayana Buddhism See BUDDHISM.

Hindus, Hinduism Originally, those people who lived in Hindustan. The main religion of India, combining many different sects. See BRAHMA, VISHNU, KRISHNA, and SHIVA.

Jainism Religion founded by Mahavira (599–527 BCE), the last of twenty-four *tirthankaras*, ("pathfinders"), or *jinas* ("victors" or "heroes"), from whom the religion took its name. Adherents follow the teachings of the *Upanisads*, especially the

quest for freedom from the cycles of rebirth, believe in non-violence, and live in great purity in their quest to join the pathfinders in the realm of pure spirit at the apex of the universe.

jatakas Hundreds of myths about the previous lives of the Buddha, many of which originally may have been folk tales appropriated by early Buddhists to tell the stories of his lives.

Jina See JAINISM.

karma A Sanskrit word meaning "actions" performed in this life. Also, the cosmic record that determines the present and future status of an *atman* in the cosmic cycle of *samsara*.

Krishna Hindu deity. One of the many aspects of Vishnu.

lingam (plural, *linga*) Literally, "sign." A phallus, manifestation of Shiva.

Maha-Vidyadevis Women personifying knowledge and forms of magic used in Jain rituals.

Mahayana Buddhism See BUDDHISM.

mandala A symbolic diagram of the cosmos. See *GARBHAGRIHA*.

mandapa An enclosed colonnaded porch in a Hindu or Jain temple.

maya The pervasive cosmic illusion that animates all creation.

mithuna Literally, "loving or sensuous couples." Male and female figures in sensuous (including sexual) poses. Sometimes found in the sculptures of Hindu temples, most notably at Konarak in Orissa and at Khajuraho in Madhya Pradesh.

moksa Hindu term for spiritual freedom from *samsara*, the endless rounds of the *atman's* return into human or animal bodies.

nagas Cobra-headed spirits of water and the earth.

Nirvana Buddhist term for Enlightenment, which means the awareness that all existence is impermanent and that therefore one is no longer attached to it; freedom from all earthly desires. *Paranirvana* is the ultimate nirvana, the state of nirvana reached at the death of the body.

Parvati See SHIVA.

ratha Literally, "chariot of the god." A Hindu temple or other shrine.

samsara The endless cycle of the beginnings and endings of the universe; also, the cycle of the *atman* returning again and again into human or animal bodies.

shikara The central tower of a Hindu temple.

Shiva (or Siva) Hindu god of destruction and procreation. As other gods and goddesses, he is often represented with two or more pairs of arms to indicate power and to hold objects in the hands or have hand gestures (*mudra*) that helps the worshiper identify that particular deity. The consort of Parvati, the World Mother, in other forms known as Durga (virtue), Kali (warrior), etc. Because his devotees believe he can assume the powers of many gods in his various aspects, Shiva is often regarded as the Mahadeva (Great Lord).

stupa Buddhist shrine and symbolic World Mountain or *mandala*, diagram of the Buddhist cosmos. A large hemispheric mound of earth enclosed by stone or terracotta brick used as a reliquary. It is ringed by one or more "railings" or "fences" (*vedikas*) with gates (*toranas*) and crowned by a square fence (*harmika*) enclosing a pole (*yasti*) supporting three umbrellas (*chattras*). Walking around the stupa, the faithful perform a sacred ritual. Moving in a clockwise direction around the stupa, pilgrims encircle the symbolic World Mountain and *mandala*, diagram of the Buddhist cosmos.

sutras Verses combined together to comprise a longer text (e.g., a book). Texts tied together by a string. Refers to many Hindu, Buddhist, and Jain texts.

Tantrism A religious tradition begun in India that emphasizes the cosmic unity of all being and emphasizes the physical nature of human existence.

Theravada Buddhism See BUDDHISM.

tirthankara See JAINISM.

toranas See STUPA.

tribhanga See STUPA. Literally, "three bends." A complex, fluid pose.

Upanisads Sacred writings (c. 800–500 BCE) that extend the Brahmanical religious tradition of the Vedas beyond rituals performed by *brahman* priests to include individual responsibility for one's relationship to the gods and life, including the practice of yoga to discipline one's mind and body to be released from attachments which hold one in the cycle of *samsara*.

vedas Aryan hymns and other ritual texts (c. 1400–1000 BCE) honoring the gods who control forces of nature and human existence.

vihara A refectory and cells for monks; occurring in both freestanding and rock-cut form, with and without *chaityas*.

vimana Hindu term for a temple, literally "chariot of the gods." Also called *ratha*.

Vishnu Hindu deity. The Preserver. Consort of Laksmi ("good fortune").

yakshi (male, *yaksha*) Female fertility figures, found both in Buddhist

and Hindu traditions and art.

yasti See STUPA.

yoga Meaning "discipline" of both mind and body; also refers to the pose or position assumed by a *yogin* ("holy man") or *yogini* ("holy woman") who disciplines him/herself to control his/her attachments to desires and the material world. May also include exercise and *prana* ("breath control") common to many traditions in India and is designed to enhance mental control of the body and well-being.

CHAPTER FOUR

Amitabha Buddha The Buddha who ruled over the Western Paradise, illustrated in the cave paintings at Dunhuang.

bi See CONG.

calligraphy Beautiful handwriting or fine penmanship, widely regarded as an art form. The word comes from the Greek, *kallos* ("beauty") and *graphia* ("writing") and is sometimes used loosely to refer to any marks made by an artist with those qualities.

Chan Buddhism A mystical form of Buddhism that seeks harmony with the vital spirit of nature. "Chan" derives from a Sanskrit word, *dhyana,* meaning "contemplation." In the West it is better-known as Zen (the Japanese pronunciation of "Chan").

chinoiserie French term, meaning "Chinese style."

Confucianism The philosophy of Master Kong, known in the West as Confucius (c. 551–479 BCE). He believed that one could achieve harmony with nature by following proper codes of behavior.

cong Along with the *bi,* one of two important geometric form jades of unknown meaning and use produced as early as the Neolithic period.

crackle See GLAZE.

cun The raindrop or "wrinkle" brushstroke used inside ink contour lines to shade, model, and texture forms to make them appeal to the sense of touch and appear to have great mass. Chinese writers identify about twenty-five varieties of *cun* stroke.

Daoism A philosophy derived from the *Dao de jing* ("The Book of the Way"), by Lao Zi (born c. 604 BCE). Through contemplation, the Daoist seeks to achieve harmony with nature.

ding A three-legged bronze vessel type produced in the Shang and later periods. It was developed from Neolithic ceramic prototypes.

embroidery The art of working raised designs on the surface of textiles and other materials. In contrast with a tapestry, the design is not woven into the texture of the material.

feng shui The Chinese art of placement. A form of geomancy that looks for topographic signs to help one live in harmony with *qi* ("vital spirit") in nature. The name comes from the Chinese for "wind" and "water."

glaze A thin coating of material applied to ceramics and other materials to be fired, or heated in a kiln. All glazes contain silica, the primary glass-forming oxide, alumina, minerals for coloring, and fluxes to lower the melting temperature. When fired, the glaze provides a hard glass-like surface. If the glaze contracts slightly more than the clay body beneath it in the cooling process, the glaze may develop cracks or a crackle pattern. An underglaze is a glaze painted onto the surface of a vessel that is covered by another glaze before firing.

Huachanshi suibi A theoretical essay by Dong Qichang (1555–1636) that criticized the *Nanhua* (Northern) style of Chinese painting for being inferior to the *Beihua* (Southern) Chinese tradition of Wang Wei and the Song painters.

Individualists A group of late Ming artists who would not acknowledge the authority of the Manchu overlords in China and followed the Song traditions of painting.

lacquer A clear, natural varnish obtained from the *Rhus verniciflua* (lacquer tree). It forms a hard and long-lasting film when dried and is generally applied in layers with impregnated, colored details on flat or sculptured surfaces.

Lamaism A Tibetan form of Buddhism adopted by the Mongol leaders of the Yuan period.

li The Confucian "innate structure of nature." Similar in concept to the *dao* ("way") of Lao Zi and the *qi* of Xie He.

Liangzhu A jade-working culture around the Hangzhou Bay in southern China that emerged

around 4000 BCE.

Liji "Book of Rites." Confucius's summary of the late Zhou philosophy of jade.

literati See WENREN.

ming The ecstatic inward vision of the Daoist in which the inner self becomes a harmonious part of the outer world of the universe. Also the name of a historical period (1368–1628 CE).

Neo-Confucianism A twelfth-century philosophy that combined the teachings of Confucius with those of Daoism and Chan Buddhism.

oracle bones Bones and pieces of tortoiseshell inscribed with early forms of Chinese writing. The patterns of cracks made when they were heated were used by shamans to divine the future.

pagoda A tall, slender tower with accented, upturned eaves that may derive from Han watchtowers, known either through terracotta models, the tower stupas of Gandhara with their tall *yasti* ("umbrellas"), or metal *reliquaries*. The name comes from a Portuguese word of undetermined origin.

paradise sects A form of Buddhism favored by the courtly circles of the Tang period. It promised an afterlife of luxury and pleasure for the faithful.

patina A discoloration of bronze, caused by prolonged exposure to minerals. The main patinas appearing on Chines bronzes are blue (azurite), green (malachite), and red (cuprite) Similar color

effects can be created using solutions of acids.

Pinyin A system of spelling Chinese developed in 1949, which has largely replaced the Wade-Giles system introduced in the nineteenth century.

porcelain A fine white hard-paste and translucent pottery made from volcanic porcelain stone clay (containing the minerals quartz, kaolin, and feldspar) and other clays rich in kaolin. When fired in kilns at very high temperatures (1100–1300°C) these clays develop needle-shaped mullite crystals and a high amount of body glass. Porcelains make a clear ringing sound when struck.

qi The vital spirit embedded in nature, mentioned in the canons of Xie He. It is similar to the Confucian *li* ("innate structure of nature") and the Daoist *dao* ("way").

reliquary An often elaborate container used to hold valued religious relics.

shaman An individual with spiritual powers who performs various functions of priest, artist, magician, actor, and/or healer. Through trances and, at times, the use of hallucinogens, the shaman acts as a liaison between the corporeal and spiritual worlds.

six canons of painting Contained in the preface of the *Gu hua pin lu* ("Classification Record of Ancient Painters"), written around 500 CE by Xie He. The canons guided Chinese thinking in the arts until the twentieth

century.

taotie Varieties of ogre masks formed by the juncture of two profile faces with prominent beady eyes. Used to decorate Shang bronze vessels.

tapestry A cloth in which the design is woven directly into the fabric.

underglaze See GLAZE.

wenren Also known as the "literati" painters. A group of highly educated, upper-class scholar–officials who emerged in the Song period but did not make a living from their art. Writers of the time often considered them to be superior to the professional court painters associated with the academy and praised them for their lofy-mindedness, inspiration, spontaneity, and creativity.

Yijing "The Book of Changes" A divination text (written c. 200–100 BCE) that explains early Chinese views of the cosmos, includes technical terms describing visual forms, and discusses the qualities of jades.

yin and *yang* The female and male principles of nature in Daoist thought. Also associated with darkness, softness and passivity (*yin*) and brightness, hardness and action (*yang*).

yu An ornate bronze vessel type used in the Zhou period.

yunqi Literally, "cloud-spirit" or "cloud-force." A rhythmic, curvilinear scroll form that embodies the energy of the *qi*. It is often associated with clouds and the cult of sacred mountains.

CHAPTER FIVE

Amida (Sanskrit: *Amitabba*, "boundless light") The *Jodo* ("Pure Land") Buddha of the Western Paradise.

chanoyu A highly ritualized tea ceremony that combines the philosophies of many art forms. The ceremony fostered a set of *Shinto*-based ethics, a kind of stoicism encoded in the principles of *wabi* (honesty, integrity, reticence, quiet simplicity) and *sabi* (a preference for the old and rustic over the new). It also taught *shibui*, an appreciation for that which is bitter but pleasing, a quality of the tea drunk in the tea ceremony.

chumon The "middle gate" to a Buddhist temple compound. Often containing *kongorikishi* figures.

coiling A method of making pottery in which long rolls of moist clay are coiled and then smoothed to form the walls of a vessel.

daimyo (Japanese, "great names") Powerful feudal lords, commanders of the samurai.

emaki (also called *emakimono*, literally, "rolled picture") A horizontal scroll associated with a narrative style of painting that emerged in the Heian period. To be distinguished from a *kakemono*, a hanging scroll.

fusuma Painted paper-covered sliding panels or doors mounted in slotted wooden tracks in temples, castles, and other large Japanese buildings. Generally associated with the Momoyama to the present.

gaso A Zen priest–painter.

haboku ("flung ink") A style of painting associated with Zen Buddhism that uses dramatic ink washes and imitates Chan Buddhist paintings of the Song period in China.

haiku The most characteristic form of poetry in Japan since the fourteenth century. Used to express broad perceptions of nature. Usually consisting of three lines of five, seven, and five syllables. Until the fourteenth century the *tanka* format (thirty-one syllables) was the most popular.

haniwa See KOFUN.

hosho A paper made from the bark of the mulberry tree used by printmakers working in the *ukiyo-e* style.

irimoya The traditional Japanese hipped-gable roof type. It may support *shibi*, crescent-shaped decorations at the ends of the ridge pole.

iwakura See KAMI.

Jodo See AMIDA.

joined-wood Sculptures made by pegging or gluing multiple pieces of hollowed-out wood together. Such works are lighter than conventional sculptures made of a single solid piece of wood and less liable to crack or warp.

jomon (literally, "cord pattern") A term for the decorations on pottery from the period 10,500–300 BCE.

kami Shinto nature gods. Often worshiped at *iwakura*, sacred sites marked by shrines.

kakemono A hanging scroll.

koan "Questions" or "exchanges" with a Zen master that cannot be understood by rational thought. They are designed to break down traditional, rational patterns of thought, sharpen the intuitions, and create a breakthrough to *satori*, enlightenment and oneness with the universe.

kofun (from *ko*, "old" or "ancient," and *fun*, "grave mound") Large mound-tombs erected by the rulers of the Kofun period. They were surrounded by rows of *haniwa* (*hani* means "clay" and *wa*, "circle"), terracotta cylinders supporting, shields, singers, armored warriors, ladies, birds, and horses that marked the boundary between the land of the living and the dead.

kondo ("Golden Hall") An area of active worship in a Buddhist temple compound. Also known as a *hondo*.

kongo rikishi Temple guardian figures. Often set in the *chumon*.

koto A Japanese instrument similar to a Western harp.

meishoe Images of famous places with poetic associations.

Miroku The Buddha of the future.

namban byobu A type of sixteenth- and seventeenth century Japanese screen painting representing Westerners and their ships. At the time, the Japanese called Westerns the *namban jin* ("southern barbarians").

noh (or ***no***) (Literally, "talent or performance") A form of drama with restrained actions and prolonged silences, patronized by the noble classes.

potter's wheel A small revolving platform or wheel on which a potter or ceramist will center a ball of softened clay, poke a hole in its middle, and squeeze the sides of the ball as the wheel turns to shape a vessel.

Pure Land Buddhism See AMIDA.

raigo An image in which the Buddha descends to the earth to welcome believers into his Western Paradise.

raku (literally, "happiness") Low-fired

ceramic wares in which the imperfect shapes, rough incisions, and loosely splashed glazes of reflect the ancient folk traditions of the Japanese potters.

sabi See CHANOYU.

samurai (or *bushi*) A noble and professional class of feudal warrior. The samurai code included *seppuku*, a ritual of suicide known in the West as *hara-kiri*.

satori See KOAN.

shibi See IRIMOYA.

shibui See CHANOYU.

shinden Heian-period country homes consisting of a central sleeping area, smaller buildings linked by covered walkways, gardens, and ponds.

Shinto ("Way of the Gods") The pre-Buddhist religion of Japan, which venerated the *kami*, nature gods, and encouraged the development of apparently

simple and rustic, but deceptively complex art forms and rituals.

Shogun ("Military Pacifier of the East") A twelfth-century title under which three dynasties of military rulers of Japan operated until 1868.

shoin A section of a Japanese palace or home. Also, a type of home composed of one or more *shoin* joined at the corners with a resulting asymmetrical floor plan.

so (or *haboku*) ("Flung ink") A style of painting associated with Zen Buddhism that uses dramatic ink washes and imitates Chan Buddhist paintings of the Song period in China.

Tale of Genji (Japanese, *Genji Monogatari*) A novel by Lady Murasaki written (c. 1000–1015) in a native Japanese style and often illustrated in the *yamato-e* style of painting.

tanka See HAIKU.

torii A gateway to a Shinto shrine.

ukiyo-e ("Pictures of the floating world") A generic tradition of painting dating from about 1600. The painting style in which images from the kabuki theater and daily life were presented. They were mass-produced through the medium of inexpensive woodblock prints.

wabi See CHANOYU.

Yamato-e (literally, "Japanese style") A native style of painting that emerged in the Heian period. Named for the Yamato plain in which the city of Nara was built.

Zen Buddhism The Japanese equivalent to Chan Buddhism in China. It arrived in Japan in the thirteenth century. Zen masters sought enlightenment through intuitive thoughts and actions. The painting of Zen is called *zenga*.

zenga See ZEN.

CHAPTER SIX

ahu See MARAE.

bai Literally, "community house." Large structures in the Caroline Islands used for dances, feasts, and council meetings and to house visitors. Constructed by a *dach el bai* ("master builder") and decorated with carvings by a *rubak* ("village story teller") working with carvers.

bisj mbu Asmat, New Guinea. A ceremony that includes the erection of tall *bisj* poles to avenge the death of a person killed by headhunters.

latte Matching sets of limestone pillars with capitals. Erected by the Chamorros of the Marianas Islands to elevate their houses.

machiy A Micronesian burial shroud.

malanggan New Ireland funerary ceremonies in which works of art are displayed.

mana The Polynesian belief that works of art, other objects, and people may have sacred powers.

marae In Polynesia, sacred ceremonial enclosures including stone platforms with sculptures in stone or wood, sacrificial altars, and buildings to store sacred objects. Called *heiau* in Hawaii, *ahu* in Easter Island, and *me'ae* in the Marquesas. In New Zealand, the plaza area in front of the meeting house, or the entire complex of buildings on which the meeting house stands.

mimi Australian Aboriginal spirits from an age (both past and

present) known as "Dreaming." Also, a style painting in which *mimi* spirits are represented.

moai A group of about a thousand monumental figures set on *ahus* and encircling Easter Island. Some were crowned with stone *pukao* "topknots," weighing over five tons.

noranggau A type of storage vessel made in the village of Aibom in the Sepik River area of Papua New Guinea which may be decorated with faces of clan totems and local deities.

Paleolithic In common usage, the Paleolithic is often called the "old stone age." Important Aboriginal works of art in Australia come from the late or

Upper Paleolithic Period (c. 40,000–9000/8000 BCE).

poupou Carved wooden panels found in Maori meeting houses and communal centers and at *marae*.

pukao See MOAI.

taonga (Maori, "prized") A quality in an object that allows it to rise above the mundane and reflect the world of the gods who worked through the maker of that object. A *taonga whakairo* is a "prized decorated object with quality" and a *taonga tuku iho* is a "prized heirloom."

tapu Taboos, rules that must not be broken to protect *mana*.

tifaifai Polynesian appliqué and piecework fabrics made by women.

tiki General Polynesian term for stylized sculptured figures of venerated ancestors.

tohunga Maori craftsmen–priests, often noblemen of high rank with an abundance of *mana*. Called *tuhuka* or *tuhuna* in the Marquesas, and *kahuna* in Hawaii. A *tohunga whakairo* is a skilled Maori woodcarver of noble status.

tukutuku Reed mats made by Maori women to decorate house walls.

u'u A Marquesan war club.

whakairo (Maori, "to carve"). See TOHUNGA.

X-ray Style Also known as the "in-fill style." A technique used by Australian Aboriginal artists in which the inner parts of an animal or person are shown as if the outer skin were transparent.

CHAPTER SEVEN

adobe Any clay-related earthen building material, mixed with grass and twigs and molded into bricks or puddled in liquid form. Also, buildings made with these materials.

architectonic Relating to architecture or construction. Shapes in painting or sculpture that reflect those of architecture.

back strap loom A portable loom in which the warp threads are stretched between a stationary object and a strap around the back of the weaver.

ceques Quechua for "rays." Conceptualized lines radiating outward like sunbeams from the Coricancha (the main Inca temple to Inti, the Sun) pointing to the *huacas* and shrines of lesser deities.

Chac Northern Maya rain god. Represented as a serpent or a mask with a long, curved nose.

chacmool A Postclassic Maya sculptural type representing a recumbent figure holding a bowl on its stomach that may have been used to hold the hearts of sacrificial victims.

Classic Maya A term referring to the "high point" of Maya art and civilization (250–900 CE).

Classic Veracruz A style of art in Veracruz (c. 250–900 CE). Also known as the El Tajín ("lightning") style after the major ritual center in that area.

coatepec (Aztec, "serpent hill"). A tall, mountain- shaped platformed temple built over a cave and/or spring. It is envisioned as an *axis mundi* ("world axis"), the pivotal point in the center of the cosmos that acts as a portal and path connecting the terrestrial and supernatural worlds.

Coatlique (Aztec, "she of the serpent skirt"). Earth and fertility goddess to whom human sacrificial victims were offered. Portrayed as a hybrid human-serpent. Mother of Huitzilopochtli.

corbel vault A vault in which the stones on two sides of a room are moved closer to the center of the room as each layer of masonry is added until the inclined faces of the sides meet in the center.

dendrochronology The study of tree rings. The pattern of growth in the rings of a tree found in an archaeological context can be compared to master charts of tree ring growth from prehistoric to present times to determine the age of the given sample.

embroidery See TAPESTRY.

geoglyphs Literally, "land writing." Lines and images on the desert floor near Nazca.

hieroglyph From the Greek, *hieros*, "sacred," and *glyphein*, "to carve." A writing system that may use combinations of pictographs and phonograms, signs representing spoken sounds.

hogan A Navajo home. Also, the place where curing rituals are performed with sand paintings and music directed by singers to communicate with ancestral spirits known as the "Holy People" who are impersonated by the *yeibichai*, masked performers.

huaca Spanish for "mound" or "pyramid."

Huitzilopochtli (Aztec, "hummingbird-on-the-left"). Son of Coatlicue. A war god.

Inca An ethnic group of Quechua speakers who ruled the central Andes at the time of the Spanish

conquest and called themselves "Sons of the Sun." Also, the leader of that group.

Inti Inca sun god.

Itzamna A reptilian god whose looped body represents the dome of the heavens. The most powerful god in the Maya pantheon.

Kachina In *pueblo* culture, a spirit or its representation in the form of a masked dancer or small wooden doll-like figure. *Kachina* dancers perform in and around the *kivas*.

kiva A pueblo ceremonial structure, usually round, semisubterranean and entered by a ladder though a hole in its roof. Larger varieties may have stairways. A hole in the floor marks the entryway to the underworld of the spirits.

Mesoamerica An area of high cultural development covering portions of modern Mexico, Guatemala, Belize, and the western parts of Honduras and El Salvador.

Mixteca–Puebla A style of Mixtec manuscript produced around Cholula, Puebla (c. 1000–1521).

Olmec Literally, "rubber people." From the Aztec regional name *Olman* ("The Rubber Country"). A modern name given to an early group of people (c. 1200–300 BCE) from the lower Gulf coast of Mexico who produced a distinctive style of sculpture. Portable Olmec works appear throughout much of Mesoamerica.

pictograph A stylized image that acts as a symbol for an object or action. A graphic system using such images is pictographic.

potlatch A Northwest Pacific Coast ceremony in which families demonstrate their wealth by distributing or destroying objects of value.

pueblo Spanish for "village." The name given by the Spanish to the multifamily adobe structures in the southwestern United States. Also, the culture of those people.

Quetzalcóatl (Aztec, "feathered serpent"). The name of an Aztec god and a historical king who may have ruled Tula in the tenth century CE.

quipu Sets of colored and knotted cords of various lengths containing coded messages that were carried by *chasqui*, runners working for the Inca government.

roof comb A tall thin projection from the roof of a building that extends its height.

Southern Cult Also known as the Southern Ceremonial Complex. A cult operating in the southeastern United States from the twelfth century to the eighteenth, which produced incised shells and coppers illustrating aspects of its religious iconography.

staff god Chavín, Peru. A squat, staff-bearing anthropomorphic jaguar deity with a snarling, downturned mouth and varieties of scroll and serpentine appendages.

stela (or stele; plural, stelae) From the Greek, *stele*, "block" or "pillar." Used widely to designate a variety of relief sculptures on slabs or blocks.

tablero and *talud* Architectural forms used in platformed structures at Teotihuacán and other Mexican ritual centers. A *talud* ("inclined wall") at the base of the platforms supports a vertical, framed *tablero* ("picture" or "picture area") which may be decorated with paintings or sculptures.

tapestry A type of loom weaving in which separate wefts are used for each color in the pattern or image. Hence, the design is woven directly into the fabric. Conversely, an embroidered design is stitched into a prewoven fabric.

tepee (or *tipi*) A portable summer home made of saplings and buffalo hides. Used by many Native American groups on the Great Plains.

Tlaloc The Aztec god of water and ruler of Tlalocan ("realm of Tlaloc"), an Aztec afterlife reserved for those whose death involved water.

Tlalocan See TLALOC.

totem poles A misnomer used for several varieties of tall carved poles erected on the Northwest Pacific Coast displaying animals and other heraldic signs belonging to their owners.

Viracocha The Inca god who created the sun, moon, and stars. The central figure on the Gateway of the Sun at Tiahuanaco may be an earlier version of this god.

warp The lengthwise threads in a loom through which the transverse weft threads are woven. These terms also apply to nonloom weaving such as basketry.

weft See WARP.

Xibalba The "other world" of the Maya, which passed underfoot in the daytime and overhead at night. The home of the gods and deified nobles before and after their lives on earth.

Xipe Totec (Aztec, "the flayed one"). A Huastec and Aztec god of vegetation and fertility.

y-otot Maya for "temple" (literally, "his house").

BIBLIOGRAPHY

CHAPTER ONE

ABIODUN, ROWLAND, HENRY JOHN DREWAL, and JOHN PEMBERTON, III, *Yoruba: Art and Aesthetics*. Zurich: Reitberg Museum, 1991

BAHN, PAUL, and JOHN FLENLEY, *Easter Island: Earth Island*. London: Thames and Hudson, 1992

BRAVMANN, RENE, *African Islam*. Washington, D.C.: Smithsonian Institution Press, 1983

DREWAL, HENRY JOHN, and MARGARET THOMPSON DREWAL, *Gelede: Art and Female Power Among the Yoruba*. Bloomington, IN: University of Indiana Press, 1983

DUFFEK, KAREN, *Bill Reid: Beyond the Essential Form*. Vancouver: University of British Columbian Press, 1986

FURST, PETER T. and JILL L. FURST, *North American Indian Art*. New York: Rizzoli, 1982

LEE, SHERMAN E., *A History of Far Eastern Art*. 5th edn. New York: Harry N. Abrams, 1994

MUNROE, ALEXANDRA, *Japan After 1945: Scream Against the Sky*. New York: Harry N. Abrams, 1994

SATO, TOMOKO, and TOSHIO WATANABE, *Japan and Britain: An Aesthetic Dialogue 1850–1930*. London: Lund Humphries, Barbican Art Gallery, and the Setagaya Art Museum, 1991

SCHELE, LINDA and DAVID FREIDEL, *A Forest of Kings, the Untold Story of the Ancient Maya*. New York: Morrow, 1990

CHAPTER TWO

ADAHL, KARIN, and SAHLSTROM, BERIT, *Islamic Art and Culture in Sub-Sahara Africa*. Uppsala and Stockholm: Almqvist & Wikseli International, 1995

ANDERSON, RICHARD L., *Calliope's Sisters: A Comparative Study of Philosophies of Art*. Englewood Cliffs: Prentice Hall, 1990

D'AZEVEDO, WARREN L., ed., *The Traditional Artist in African Societies*. Bloomington: Indiana University Press, 1957

BEN-AMOS, PAULA, *The Art of Benin*. Washington, D.C.: Smithsonian Institution Press, and London: British Museum Press, 1995

BERLO, JANET CATHERINE, and LEE ANNE WILSON, *Arts of Africa, Oceania, and the Americas: Selected Readings*. Englewood Cliffs: Prentice Hall, 1993

BLIER, SUZANNE PRESTON, *Royal Arts of Africa: The Majesty of Form*. New York: Harry N. Abrams, and London: Laurence King Publishing, 1998

BRAVMANN, RENE A., *African Islam*. Washington, D.C.: Smithsonian Institution Press, 1983

COLE, HERBERT M., *Mbari: Art and Life among the Owerri Igbo*. Bloomington: Indiana University Press, 1982

COOMBES, A.E., *Reinventing Africa: Museums, Material Culture, and Popular Imagination*. New Haven: Yale University Press, 1994

DREWAL, HENRY JOHN, JOHN PEMBERTON, III, and ROWLAND ABIODUN, *Yoruba: Nine Centuries of African Art and Thought*. New York: The Center for African Art and Harry N. Abrams, 1989

DREWAL, MARGARET THOMPSON, *Yoruba Ritual: Performers, Play, Agency*. Bloomington: Indiana University Press, 1992

ELISOFON, ELIOT, and WILLIAM FAGG, *The Sculpture of Africa*. New York: Hacker, 1978

ETTINGHAUSEN, RICHARD, and OLEG GRABAR, *The Art and Architecture of Islam, 650–1250*. New York: Viking Penguin, 1987

EYO, EKPO, and FRANK WILLETT, *Treasures of Ancient Nigeria*. New York: Knopf, 1980

EZRA, KATE, *Royal Art of Benin: The Perls Collection in the Metropolitan Museum of Art*. New York: The Metropolitan Museum of Art and Harry N. Abrams, 1992

FAGG, W.B., and John PEMBERTON, III, *Yoruba Sculpture of West Africa*. New York: Knopf, 1982

GILLON, WERNER, *A Short History of African Art*. New York: Facts on File Publications, 1984

KERCHACHE, JACQUES, J.-L. PAUDRAT, and LUCIEN STÉPHAN, *Art of Africa*. New York: Harry N. Abrams, 1993

LEWIS-WILLIAMS, J. DAVID, *The Rock Art of Southern Africa*. Cambridge: Cambridge University Press, 1983

MCCALL, DANIEL F., and EDNA G. BAY, *African Images: Essays in African Iconology*. New York and London: Africana Publishing Co., 1975

MACGAFFERY, WYATT, and MICHAEL D. HARRIS, *Astonishment and Power*. Washington, D.C.: Smithsonian Institution Press, 1993

MCEVILLEY, THOMAS, *Fusion: West African Artists at the Venice Biennale*. New York: Museum for African Art, 1993

MCLEOD, MALCOLM, and JOHN MACK, *Ethnic Sculpture*. Boston: Harvard

University Press, and London: British Museum Press, 1985

NORTHERN, TAMARA, *The Art of Cameroon*. Washington, D.C.: Smithsonian Institution Press, 1984

OGUIBE, OLU, and OKWUI ENWEZOR, *Reading the Contemporary: African Art in the Marketplace*. Cambridge, MA: MIT Press, 1999

PERANI, JUDITH, and FRED T. SMITH, *The Visual Arts of Africa: Gender, Power, and Life Cycle Rituals*. Upper Saddle River, NJ: Prentice Hall, 1998

PHILLIPS, TOM, *Africa: The Art of a Continent*. London: Royal Academy of Arts, and Munich and New York: Prestel Verlag, 1995

PHILLIPSON, DAVID W., *African Archaeology*. 2nd edn. Cambridge: Cambridge University Press, 1993

PRUSSIN, LABELLE, *Hatumere: Islamic Design in West Africa*. Berkeley: University of California Press, 1986

SHAW, THURSTAN, *Nigeria: Its Archaeology and Early History*. London: Thames

and Hudson, 1978

SIEBER, ROY, and ROSLYN WALKER, *African Art in the Cycle of Life*. Washington, D.C.: Smithsonian Institution Press, 1987

SULLIVAN, MICHAEL, *The Meeting of Eastern and Western Art from the Sixteenth Century to the Present Day*. Greenwich: New York Graphic Society, 1973

THOMPSON, ROBERT F., *African Art in Motion: Icon and Act*. Washington, D.C.: National Gallery of Art, and Los Angeles: Frederick S. Wright Art Gallery, University of California Press, 1974

—, *Black Gods and Kings: Yoruba Art at U.C.L.A.* Bloomington: Indiana University Press, 1976

—, *Flash of the Spirit: African and Afro-American Art and Philosophy*. New York: Random House, 1983

TRACHTENBERG, M., and I. HYMAN, *Architecture: From Prehistory to Post-Modernism*. New York: Harry N. Abrams, 1985

VANSINA, JAN, *Art History in Africa*. New York: Longman, 1984

VISONÀ, MONICA, ET AL., *A History of Art in Africa*. New York: Harry N. Abrams, 2001, and London: Thames and Hudson, 2000

WILLETT, FRANK, *African Art: An Introduction*. Rev. edn. New York: Thames and Hudson, 1993

—, *Ife in the History of West African Sculpture*. New York: McGraw-Hill, 1967

VOGEL, SUSAN, *African Aesthetics*. New York: The Center for African Art, 1986

VOGEL, SUSAN, ed., *For Spirits and Kings*. New York: The Metropolitan Museum of Art, 1981

VOGEL, SUSAN, ET AL., *Africa Explores*. New York: Center for African Art, 1991

WILCOX, A.R., *The Rock Art of Southern Africa*. New York: Holmes & Meier, 1984

CHAPTER THREE

ASHER, FREDERICK M., *The Art of Eastern India, 300–800*. Minneapolis: University of Minnesota Press, 1980

BARRETT, DOUGLAS, and BASIL GRAY, *Painting of India*. New York: Rizzoli, 1978

BEACH, MILO CLEVELAND, *Grand Mogol: Imperial Painting in India, 1600–1660*. Williamstown: Sterling and Francine Clark Art Institute, 1978

—, *Mughal and Rajput Painting*. New York: Cambridge University Press, 1992

BEGLEY, WAYNE, and Z.A. DESAI, *Taj Mahal*. Cambridge, MA: 1989

BLURTON, RICHARD, *Hindu Art*. Cambridge, MA: Harvard University Press, 1993

COLLINS, CHARLES DILLARD, *The Iconography and Ritual of Shiva at Elephanta*. Albany: State University of New York Press, 1988

CRAVEN, ROY C., *Indian Art: A Concise History*. London: Thames and Hudson, 1997

DAVIES, PHILIP, *Splendors of the Raj: British Architecture in India, 1660 to 1947*. London: John Murray, 1985

DAVIS, RICHARD H., *Lives of Indian Images*. Princeton: Princeton University Press, 1997

DEHEJIA, VIDYA, *Early Buddhist Rock Temples*. Ithaca, NY: Cornell University Press. 1972

—, *Early Buddhist Rock Temples: A Chronological Study*. London: Thames and Hudson, 1972

FISHER, ROBERT E., *The Art of Tibet*. London: Thames and Hudson, 1997

GHOSH, AMALANANDA, *Ajanta Murals*. New Delhi: Archaeological Survey of India, 1967

GHOSH, SANKAR PROSAD, *Hindu Religious Art and Architecture*. Delhi: D. K. Publications, 1982

GRAY, BASIL, ed., *The Arts of India*. Ithaca, NY: Cornell University Press, and London: Phaidon, 1981

HARLE, JAMES C., *The Art and Architecture of the Indian Subcontinent*. London: Penguin, 1990

HARLE, JAMES C., *Gupta Sculpture*. Oxford: Clarendon Press, 1974

HUNTINGTON, SUSAN L., *The Art of Ancient India: Buddhist, Hindu, Jain*. New York and Tokyo: Weatherhill, 1985

KRAMRISCH, STELLA, *The Art of India*. 3rd edn. London: Phaidon, 1965

LA PLANTE, JOHN D., *Asian Art*. 3rd edn. Dubuque, IA: Wm. C. Brown, 1992

LEE, SHERMAN E., *Ancient Cambodian Sculpture*. New York: International Arts Press, 1970

MEISTER, MICHAEL W., ed., *Encyclopedia of Indian Temple Architecture*. Vol. I, pt. I, South India, Lower Dravidadesa 200 B.C.–A.D. 1324. New Delhi: American Institute of Indian Studies, and Philadelphia: University of Pennsylvania Press, 1983

MITTER, PARTHA, *Art and Nationalism in India: 1850–1920*. Cambridge: Cambridge University Press, 1994

RAWSON, PHILIP, *The Art of Southeast Asia*. London: Thames and Hudson, 1990

ROWLAND, BENJAMIN, *The Art and Architecture of India: Buddhist, Hindu, Jain*. 3rd edn. Baltimore: Penguin Books, 1967

SIVARAMAMURTI, CALAMBUR, *The Art of*

India. New York: Harry N. Abrams, 1977

SRINIVASAN, K.R., *Temples of South India.* New Delhi: National Book Trust, 1972

STRACHAN, PAUL, *Imperial Pagan: Art and Architecture of Burma.* Honolulu: University of Hawaii Press, 1989

WELCH, STUART CARY, *India: Art and Culture 1300–1900.* New York: The Metropolitan Museum of Art, 1985

—, *The Emperors' Album: Images of Mughal India.* New York: The Metropolitan Museum of Art, 1987

WILLIAMS, JOANNA G., *Art of Gupta India,*

Empire and Province. Princeton: Princeton University Press, 1982

ZIMMER, HEINRICH, and JOSEPH CAMPBELL, eds., *The Art of Indian Asia: Its Mythology and Transformations.* Bollingen Series 39. 2 vols. Princeton: Princeton University Press, 1983

CHAPTER FOUR

BILLETER, JEAN FRANÇOIS, *The Chinese Art of Writing.* New York: Rizzoli, 1990

BROWN, CLAUDIA, and JU-HSI CHOU, *Transcending Turmoil: Painting at the Close of China's Empire, 1796–1911.* Phoenix: Phoenix Art Museum, 1992

CAHILL, JAMES, *Hills Beyond a River: Chinese Painting of the Yuan Dynasty, 1279–1368.* New York: Weatherhill, 1976

—, *Parting at the Shore: Chinese Painting of the Early and Middle Ming Dynasty, 1368–1580.* New York: Weatherhill, 1978

—, *The Compelling Image: Nature and Style in Seventeenth-Century Chinese Painting.* London and Cambridge: Harvard University Press, 1982

CHANG, LEON LONG-YIEN, and PETER MILLER, *4000 years of Chinese Calligraphy.* Chicago: University of Chicago Press, 1990

CHASE, W. T., *Ancient Chinese Bronze Art: Casting the Precious Sacral Vessel.* New York: China House Gallery, 1991

CLUNAS, CRAIG, *Superfluous Things: Material Culture and Social Status in Early Modern China.* Urbana and Chicago: University of Illinois Press, 1991

—, *Chinese Export Art and Design.* London: Victoria and Albert Museum, 1987

—, *Art in China.* Oxford and New York: Oxford University Press, 1997

FONG, WEN C., *Beyond Representation:*

Chinese Painting and Calligraphy, 8th–14th Century. New York: The Metropolitan Museum of Art, and New Haven and London: Yale University Press, 1992

GRAY, BASIL, *Sung Porcelain and Stoneware.* London and Boston: Faber and Faber, 1984

LAWTON, THOMAS, *New Perspectives on Chinese Culture during the Eastern Zhou Period.* Princeton: University of Princeton Press, 1991

LOEHR, MAX, *The Great Painters of China.* New York: Harper and Row, 1980

MEDLEY, MARGARET, *The Chinese Potter: A Practical History of Chinese Ceramics.* Oxford: Phaidon, 1976

MUNAKATA, KIYOHIKO, *Sacred Mountains in Chinese Art.* Urbana: University of Illinois Press, 1991

MUNSTERBERG, HUGO, *The Arts of China.* Rutland and Tokyo: Charles E. Tuttle Company, 1972

—, *Dictionary of Chinese and Japanese Art.* New York: Hacker, 1981

POWERS, MARTIN J., *Art and Political Expression in Early China.* New Haven and London: Yale University Press, 1991

RAWSON, JESSICA, *Ancient China: Art and Archaeology.* New York: Harper and Row, 1980

—, *Chinese Bronzes: Art and Ritual.* London: British Museum Press, 1987

—, ed., *The British Museum Book of Chinese Art.* New York and London: Thames and Hudson, 1992

SICKMAN, LAWRENCE, and A.C. SOPER, *The Art and Architecture of China,* 4th rev. edn. London, 1971

SIREN, OSVALD, *A History of Later Chinese Painting.* 2 vols. London, 1938; repr. New York: Hacker Books, 1978

SIREN, OSVALD, *Chinese Painting: Leading Masters and Principles.* 7 vols. New York: Ronald Press, 1956–8

SULLIVAN, MICHAEL, *The Three Perfections: Chinese Painting, Poetry and Calligraphy.* New York: George Braziller, 1980

—, *The Arts of China.* 3rd edn. Berkeley: University of California Press. 1984

—, *Art and Artists of Twentieth-Century China.* Berkeley: University of California Press, 1996

SWANN, PETER C., *Chinese Painting.* 3rd edn. New York: Universe Books, 1967

WALEY, ARTHUR, *An Introduction to the Study of Chinese Painting.* New York: Grove Press, 1958

WILLETTS, WILLIAM, *Foundations of Chinese Art.* New York: McGraw-Hill, 1965

WU HUNG, *The Wu Liang Shrine: The Ideology of Early Chinese Pictorial Art.* Stanford: Stanford University Press, 1989

ZWALF, W., ed., *Buddhism: Art and Faith.* London: British Museum Press, 1985

CHAPTER FIVE

ADDISS, STEPHEN, *The Art of Zen: Painting and Calligraphy by Japanese Monks, 1600–1925.* New York: Harry N. Abrams, 1989

AKIYAMA, TERUKAZU, *Japanese Painting.* Geneva: Skira, and New York:

Rizzoli, 1977

CAHILL, JAMES F., *Scholar Painters of Japan: The Nanga School.* New York: Arno Press, 1976

CHIBBETT, DAVID G., *The History of Japanese Printing and Book Illustration.* New York

and Tokyo: Kodansha, 1977

CLARK, TIMOTHY, and DONALD JENKINS, *The Actor's Image: Printmakers of the Katsukawa School.* Chicago: The Art Institute of Chicago, and Princeton: Princeton University Press, 1994

EGAMI, N., *The Beginnings of Japanese Art*. New York: Weatherhill, and Tokyo: Heibonsha, 1973

ELISEEF, DANIELLE, and VADIME ELISEEF, *The Art of Japan*. New York: Harry N. Abramsx, 1985

GUTH, CHRISTINE, *Art of Edo Japan: The Artist and the City, 1615–1868*. New York: Harry N. Abrams, and London: Widenfeld and Nicolson, 1996

HICKMAN, MONEY L., *Japan's Golden Age: Momoyama*. New Haven and London: Yale University Press, 1996

INOUE, MITSUO, *Space in Japanese Architecture*. New York and Tokyo: Weatherhill, 1985

KIDDER, J. EDWARD, *Early Japanese Art*. London: Thames and Hudson, 1969

LA PLANTE, JOHN D., *Asian Art*. 3rd ed. Dubuque: William C. Brown, 1992

LANE, R., *Images from the Floating World: The Japanese Print*. New York: Dorset Press, 1978

MASON, PENELOPE, *History of Japanese Art*.

Englewood Cliffs: Prentice Hall, 1993

MASUDA. T., *Living Architecture: Japanese*. New York: Grosset and Dunlap, 1970

MEECH-PEKARIK, JULIA, *The World of the Meiji Print: Impressions of a New Civilization*. Tokyo and New York: Weatherhill, 1986

MUNSTERBERG, HUGO, *The Arts of Japan: An Illustrated History*. Rutland and Tokyo: Charles E. Tuttle, 1957

PAINE, ROBERT TREAT, and ALEXANDER SOPER, *The Art and Architecture of Japan*. 3rd rev. ed. Harmondsworth: Penguin, 1981

PARENT, MARY NEIGHBOR, *The Roof in Japanese Buddhist Architecture*. New York: Weatherhill, 1983

PEARSON, RICHARD, ET AL., *Ancient Japan*. New York: Braziller, Boston: Arthur Sackler Gallery, and Washington, D.C.: Smithsonian Institution, 1992

ROSSBACH, SARAH, *Feng Shui: The Chinese Art of Placement*. New York: E.P. Dutton, 1983

SMITH, JUDY, *Arts of Korea*. New York: Harry N. Abrams and The Metropolitan Museum of Art, 1998

STANLEY-BAKER, JOAN, *Japanese Art*. New York: Thames and Hudson, 1984

SWANN, P., *A Concise History of Japanese Art*. New York and Tokyo: Kodansha, 1979

TAKASHINA, SHUJI, and J. THOMAS RIMER, with GERALD D. BOLAS, *Paris in Japan: The Japanese Encounter with European Painting*. Tokyo: The Japan Foundation and St. Louis, 1987

TSUDA, NORITAKE, *Handbook of Japanese Art*. Rutland and Tokyo: Charles E. Tuttle, 1988

WICHMANN, SIEGFRIED, *Japonisme: The Japanese Influence on Western Art in the 19th and 20th Centuries*. New York: Harmony Books, 1981

YAMADA, CHISABUROH F., ed., *Dialogue in Art: Japan and the West*. Tokyo, New York, and San Francisco: Kodansha International, 1976

CHAPTER SIX

BAHN, PAUL, and JOHN FLENLEY, *Easter Island: Earth Island*. London: Thames and Hudson, 1992

BARROW, TERENCE, *An Illustrated Guide to Maori Art*. Honolulu: University of Hawaii Press, 1984

BELLWOOD, PETER S., *Man's Conquest of the Pacific*. New York: Oxford University Press, 1979

BERLO, JANET CATHERINE, and LEE ANNE WILSON, *Arts of Africa, Oceania, and the Americas: Selected Readings*. Englewood Cliffs: Prentice-Hall, 1993

BRAKE, BRIAN, JAME MCNEISH, and DAVID SIMMONS, *Art of the Pacific*. New York: Harry N. Abrams, 1980

BRETTELL, RICHARD R., *The Art of Paul Gauguin*. Washington, D.C.: National Gallery of Art, and Boston: New York Graphic Society Books, 1988

CARUANA, W., *Australian Aboriginal Art*. London: Thames and Hudson, 1993

CONTE, ERIC., *Tereraa: Voyaging and the Colonization of the Pacific Islands*. Papeete: Collection Sorval, 1992

COX, J. HALLEY, and WILLIAM DAVENPORT, *Hawaiian Sculpture*. Rev. ed. Honolulu:

University of Hawaii Press, 1988

D' ALLEVA, ANNE, *Art of the Pacific*. London: Weidenfeld and Nicolson, and New York: Harry N. Abrams, 1998

DARK, PHILIP J.C., and ROGER G. ROSE, *Artistic Heritage in a Changing Pacific*. Honolulu: University of Hawaii Press, 1993

FELDMAN, JEROME, and DONALD H. RUBENSTEIN, *The Art of Micronesia*. Honolulu: The University of Hawaii Art Gallery, 1986

FORMAN, WERNER, *The Travels of Captain Cook*. New York and Toronto: McGraw-Hill Book Company, 1971

HAMMOND, JOYCE, *Tifaifai and Quilts of Polynesia*. Honolulu: University of Hawaii Press, 1986

HANSON, F. ALLAN, and LOUISE HANSON, *Art and Identity in Oceania*. Honolulu: University of Hawaii Press, 1990

JENNINGS, JESSE D., ed., *The Prehistory of Polynesia*. Cambridge, MA: Harvard University Press, 1979

KIRCH, PATRICK, *On the Road of the Winds: An Archaeological History of the Pacific Islands before European Contact*. Berkeley:

University of California Press, 2000

LEE, GEORGIA, *An Uncommon Guide to Easter Island*. Arroyo Grande: International Resources, 1990

LEWIS, DAVID, and WERNER FORMAN, *The Maori: Heirs of Tane*. London: Orbis, 1982

LINCOLN, LOUISE, *Assemblage of Spirits: Idea and Image in New Ireland*. New York: George Braziller, and Minneapolis: Minneapolis Institute of Arts, 1987

MAY, PATRICIA, and MARGARET TUCKSON, *The Traditional Pottery of Papua New Guinea*. Sydney: Bay Books, 1982

MEAD, SIDNEY MOKO, ed., *The Maori: Maori Art from New Zealand Collections*. New York: Harry N. Abrams, 1984

—, *Exploring the Visual Art of Oceania: Australia, Melanesia, Micronesia, and Polynesia*. Honolulu: University Press of Hawaii, 1979

MEAD, SIDNEY MOKO, and BERNIE KERNOT, *Art and Artists of Oceania*. Palmerston No., New Zealand: Dunmore Press, 1983

MORGAN, WILLIAM, *Prehistoric Architecture in Micronesia*. Austin: University of Texas

Press, 1988

MORPHY, HOWARD, *Aboriginal Art*. London: Phaidon, 1998

NEWTON, DOUGLAS, *Art Styles of the Papuan Gulf*. New York: Museum of Primitive Art, 1961

PENDERGRAST, M., *Feathers and Fibre: A Survey of Traditional and Contemporary Maori Craft*. Auckland: Penguin Books, 1984

ROCKEFELLER, MICHAEL C., *The Asmat of New Guinea: The Journal of Michael Clark Rockefeller*. Greenwich, CT: New York Graphic Society, 1967

SCHNEEBAUM, TOBIAS, *Embodied Spirits: Ritual Carvings of the Asmat*. Salem: Peabody Museum of Salem, 1990

SMIDT, DIRK A., *Asmat Art: Woodcarvings of Southwest New Guinea*. New York: George Braziller, and Leiden: Rijksmuseum voor Volkenkunde, 1993

STARZECKA, DOROTA C., ed., *Maori Art and Culture*. Chicago: Art Media Resources, 1996

STUBBS, DACRE, *Prehistoric Art of Australia*. New York: Scribner, 1975

SUTTON, PETER, ed., *Dreamings: The Art of Aboriginal Australia*. New York: Viking Press, 1988

THOMAS, NICHOLAS, *Oceanic Art*. London: Thames and Hudson, 1994

WEST, MARGIE, *The Inspired Dream: Life as Art in Aboriginal Australia*. Queensland: Queensland Art Gallery, 1988

CHAPTER SEVEN

South America

ANTON, FERDINAND, *The Art of Ancient Peru*. New York: G.P. Putman's Sons, 1972

—, *Ancient Peruvian Textiles*. London: Thames and Hudson, 1987

BAUER, BRIAN S., *The Development of the Inca State*. Austin: University of Texas Press, 1992

BENSON, ELIZABETH P., ed., *Pre-Columbian Metallurgy of South America*. Washington, D.C.: Dumbarton Oaks, 1979

BONAVIA, DUCCIO, *Mural Painting in Ancient Peru*. Bloomington: Indiana University Press, 1985

—, *Chavín and the Origins of Andean Civilization*. London: Thames and Hudson, 1992

CORDY-COLLINS, ALANA, and JEAN STERN, eds., *Pre-Columbian Art History: Selected Readings*. Palo Alto: Peek Publications, 1977

CONRAD, GEOFFREY W., and ARTHUR DEMAREST, *Religion and Empire: The Dynamics of Aztec and Inca Expansion*. Cambridge: Cambridge University Press, 1984

DONNAN, CHRISTOPHER B., *Moche Art of Peru: Pre-Columbian Symbolic Communication*. Los Angeles: University of California Press, 1978

—, ed., *Early Ceremonial Architecture in the Andes*. Washington, D.C.: Dumbarton Oaks, 1985

DONNAN, CHRISTOPHER B., and CAROL J. MACKEY, *Ancient Burial Patterns of the Moche Valley, Peru*. Austin: University of Texas Press, 1978

DONNAN, CHRISTOPHER B., and DONNA MCCLELLAND, *The Burial Theme in Moche Iconography*. Studies in Pre-Columbian Art and Archaeology, no. 21. Washington, D.C.: Dumbarton Oaks, 1979

GASPARINI, GRAZIANO, and LUISE MARGOLIES, *Inca Architecture*. Bloomington: Indiana University Press, 1980

GRIEDER, TERENCE, *Origins of Pre-Columbian Art*. Austin: University of Texas Press, 1982

KIRKPATRICK, SIDNEY D., *Lords of Sipán: A Tale of Pre- Inca Tombs, Archaeology, and Crime*. New York: William Morrow and Company, Inc. 1992

KUBLER, GEORGE, *The Art and Architecture of Ancient America: The Mexican, Maya and Andean Peoples*. Pelican History of Art series. Harmondsworth, England, and Baltimore: Penguin Books, 1984

LAPINER, ALAN, *Pre-Columbian Art of South America*. New York: Harry N. Abrams, 1976

LEVENTHAL, RICHARD M., and ALAN L. KOLATA, *Civilization in the Ancient Americas: Essays in Honor of Gordon R. Willey*. Albuquerque: University of New Mexico Press, and Cambridge, MA: Peabody Museum of Archaeology and Ethnology, Harvard University, 1983

MOSELEY, MICHAEL E., *The Inca and their Ancestors*. London: Thames and Hudson, 1992

MOSELEY, MICHAEL E., and KENT C. DAY, eds., *ChanChan: Andean Desert City*. Albuquerque: University of New Mexico Press, 1982

PANG, HILDEGARD DELGADO, *Pre-Columbian Art: Investigations and Insights*. Norman: University of Oklahoma Press, 1992

PASZTORY, ESTHER, *Pre-Columbian Art*. London: Weidenfeld and Nicolson, and New York: Cambridge University Press, 1998

PAUL, ANNE C., *Paracas Ritual Attire: Symbols of Authority in Ancient Peru*. Norman and London: University of Oklahoma Press, 1989

—, *Paracas Art and Architecture: Object and Context in South Coastal Peru*. Iowa City: University of Iowa Press, 1991

REICHE, MARIA, *Peruvian Ground Drawings*. Munich: Kunstraum, 1974

ROWE, JOHN H., *Chavín Art: An Inquiry into its Form and Meaning*. New York: Museum of Primitive Art, 1962

ROWE, JOHN H., and DOROTHY MENZEL, eds., *Peruvian Archaeology: Selected Readings*. Palo Alto: Peek Publications, 1967

STIERLIN, HENRI, *Art of the Incas and its Origins*. New York: Rizzoli, 1984

STONE-MILLER, REBECCA, *To Weave for the Sun: Andean Textiles in the Museum of Fine Arts*. Boston: Museum of Fine Arts, 1992

—, ed., *Spun Gold: Virtuoso Textiles of the Ancient Andes*. Boston: Museum of Fine Arts, 1992

—, *Art of the Andes*. New York: Thames and Hudson, 1995

ZUIDEMA, R. THOMAS, *Inca Civilization in Cuzco*. Austin: University of Texas Press, 1990

Mesoamerica: Olmec and Maya

ADAMS, RICHARD E., ed., *The Origins of Maya Civilization*. Albuquerque: University of New Mexico Press, 1977

ALVA, WALTER, "Discovering the New World's Richest Unlooted Tomb," *National Geographic*, 174, no. 4 (October, 1998): 510–49

BENSON, ELIZABETH P., and ELIZABETH HILL BOONE, eds., Dumbarton Oaks conference reports. Washington D.C.: Dumbarton Oaks, 1968–

BENSON, ELIZABETH P., and GILLETT GRIFFIN, eds., *Maya Iconography*. Princeton: Princeton University Press, 1988

BENSON, ELIZABETH P., and BEATRIZ DE LA FUENTE, *Olmec Art of Ancient Mexico*. Washington, D.C.: National Gallery of Art, and New York: Harry N. Abrams, 1996

CLANCY, FLORA S., and PETER D. HARRISON, *Vision and Revision in Maya Studies*. Albuquerque: University of New Mexico Press, 1990

COE, MICHAEL D., *The Maya Scribe and his World*. New York: The Grolier Club, 1973

—, *Lords of the Underworld: Masterpieces of Classic Maya Ceramics*. Princeton: Princeton University Press, 1978

COE, MICHAEL D., and RICHARD A. DIEHL, *In the Land of the Olmec*. 2 vols. Austin: University of Texas Press, 1980

COGGINS, CLEMENCY, and ORRIN SHANE III, *Cenote of Sacrifice: Maya Treasures from the Sacred Well at Chichén Itzá*. Austin: University of Texas Press, 1984

FERGUSON, WILLIAM M., and JOHN Q. ROYCE, *Maya Ruins of Mexico in Color*. Norman: University of Oklahoma Press, 1977

GRAHAM, JOHN A., ed., *Ancient Mesoamerica: Selected Readings*. Palo Alto: Peek Publications, 1981

GROVE, DAVID, *Chalcatzingo: Excavations on the Olmec Frontier*. New York and London: Thames and Hudson, 1984

HANKS, WILLIAM F., and DONALD RICE, eds., *Word and Image in Maya Culture: Explorations in Language, Writing, and Representation*. Salt Lake City: University of Utah Press, 1989

HENDERSON, JOHN S., *The World of the Ancient Maya*. Ithaca: Cornell University Press, 1981

JOYCE, ROSEMARY A., *Cerro Palenque: Power and Identity on the Maya Periphery*. Austin: University of Texas Press, 1991

KELLEY, DAVID H., *Deciphering the Maya Script*. Austin: University of Texas Press, 1976

KERR, JUSTIN, ed., *The Maya Vase Book*. Vol. I, *A Corpus of Roll out Photographs of Maya Vases*. New York: Kerr Associates, 1989

KOWALSKI, JEFF KARL, *The House of the Governor: A Maya Palace at Uxmal, Yucatán, Mexico*. Norman and London: University of Oklahoma Press, 1987

KUBLER, GEORGE, *The Art and Architecture of Ancient America: The Mexican, Maya and Andean Peoples*. Pelican History of Art series. Harmondsworth, England, and Baltimore: Penguin Books, 1984

LOVE, BRUCE, *The Paris Codex: A Handbook for a Maya Priest*. Austin: University of Texas Press, 1994

MILLER, MARY ELLEN, *The Art of Mesoamerica from Olmec to Aztec*. World of Art series. London: Thames and Hudson, 1995

—, *The Murals of Bonampak*. Princeton: Princeton University Press, 1986

MILLER, VIRGINIA E., *The Role of Gender in Precolumbian Art and Architecture*. Lanham: University of Maryland Press, 1988

PROSKOURIAKOFF, TATIANA, *An Album of Maya Architecture*. Norman: University of Oklahoma Press, 1963

REENTS-BUDET, DORIE, ET AL., *Painting the Maya University: Royal Ceramics of the Classic Period*. Durham, N.C.: Duke University Press, 1994

ROBERTSON, MERLE GREENE, ed., *Primera Mesa Redonda de Palenque*. 2 parts. Pebble Beach: Robert Louis Stevenson School, 1974

—, ed., *The Sculpture of Palenque*. 3 vols. Princeton: Princeton University Press, 1983–5

ROBERTSON, MERLE GREENE, and ELIZABETH P. BENSON, eds., *Fourth Palenque Round Table, 1980*. Vol. 6. San Francisco: Pre-Columbian Art Research Institute, 1985

ROBERTSON, MERLE GREENE, and VIRGINIA M. FIELDS, eds., *Fifth Palenque Round Table, 1983*. Vol. 7. San Francisco: Pre-Columbian Art Research Institute, 1985

SCHELE, LINDA, and DAVID FREIDEL, *A Forest of Kings: the Untold Story of the Ancient Maya*. New York: Morrow, 1990

SCHELE, LINDA, and MARY E. MILLER, *The Blood of Kings: Dynasty and Ritual in Maya Art*. Fort Worth: Kimbell Art Museum, 1986

TATE, CAROLYN, *Yaxchilán: The Design of a Maya Ceremonial City*. Austin: University of Texas Press, 1990

THOMPSON, J. ERIC S., *Maya Hieroglyphic Writing*. Norman: University of Oklahoma Press, 1960

YOFFE, NORMAN, and GEORGE COWGILL, eds., *The Collapse of Ancient States and Civilizations*. Tucson: University of Arizona Press, 1988

Mesoamerica: Mexico

BAIRD, ELLEN TAYLOR, *The Drawings of Sahagun's Primeros Memoriales: Structure and Style*. Norman: University of Oklahoma Press, 1993

BERLO, JANET CATHERINE, ed., *Art, Ideology, and the City of Teotihuacán*. Washington, D.C.: Dumbarton Oaks, 1992

BERRIN, KATHLEEN, ed., *Feathered Serpents and Flowering Trees: Reconstructing the Murals of Teotihuacán*. San Francisco: The Fine Arts Museums of San Francisco, 1988

BOONE, ELIZABETH HILL, ed., *The Aztec Templo Mayor (1983 Conference)*. Washington, D.C.: Dumbarton Oaks, 1987

BRAUN, BARBARA, *Pre-Columbian Art and the Post-Columbian World: Ancient American Sources of Modern Art*. New York: Harry N. Abrams, 1993

BRODA, J., D. CARRASCO, and E. MOCTEZUMA MATOS, eds., *The Great Temple of Tenochtitlán*. Berkeley: University of California Press, 1987

BRODA, J., *The Great Temple of Tenochtitlán: Center and Periphery in the Aztec World*. Berkeley: University of California Press, 1993

CARRASCO, DAVID, *Quetzalcóatl and the Irony of Empire: Myths and Prophecies in the Aztec Tradition*. Chicago: University of Chicago Press, 1983

CLENDINNEN, INGA, *Aztecs: An Interpretation*. New York: Cambridge University Press, 1991

DAVIES, NIGEL, *The Aztecs: A History*. Norman: University of Oklahoma Press, 1980

DIEHL, RICHARD, *Tula*. London: Thames and Hudson, 1983.

DIEHL, RICHARD, and JANET BERLO, eds., *Mesoamerica after the Decline of Teotihuacán, AD 700–900*. Washington D.C.: Dumbarton Oaks, 1989

DURAN, DIEGO, *The Book of the Gods and Rites and the Ancient Calendar*. Norman: University of Oklahoma Press, 1971

FLANNERY, KENT V., and JOYCE MARCUS, *The Cloud People: Divergent Evolution of the Zapotec and Mixtec Civilizations*. New York: Academic Press, 1983

FURST, JILL LESLIE MCKEEVER, *The Natural History of the Soul in Ancient Mexico*. New Haven: Yale University Press, 1995

GIBSON, CHARLES, *The Aztecs under Spanish Rule*. Stanford: Stanford University Press, 1964

GILLESPIE, SUSAN D., *The Aztec Kings: The Construction of Rulership in Mexican History*. Tucson: University of Arizona Press, 1989

GROVE, DAVID, ed., *Ancient Chalcatzingo*. Austin: University of Texas Press, 1987

HEALAN, DAN, ed., *Tula of the Toltecs*. Iowa City: University of Iowa Press, 1989

HEYDEN, DORIS, and PAUL GENDROP, *Pre-Columbian Architecture of Mesoamerica*. New York: Harry N. Abrams, 1975

KAMPEN, MICHAEL E., *The Sculptures of El Tajín, Veracruz, Mexico*. Gainesville: University of Florida Press, 1972

KELLY, JOYCE, *The Complete Visitor's Guide to Mesoamerican Ruins*. Norman: University of Oklahoma Press, 1982

KLEIN, CECELIA F., "The Identity of the Central Deity on the Aztec Calendar Stone," *The Art Bulletin*, 58, no. 1 (March, 1976): 1–12

KRISTAN-GRAHAM, CYNTHIA, *Mesoamerican Architecture as a Cultural Symbol*. Cambridge: Cambridge University Press, 1995

KUBLER, GEORGE, *Esthetic Recognition of Ancient Amerindian Art*. New Haven: Yale University Press, 1991

LEON-PORTILLA, MIGUEL, *Pre-Columbian Literatures of Mexico*. Norman: University of Oklahoma Press, 1969

MATOS MOCTEZUMA, EDUARDO, *The Great Temple of the Aztecs: Treasures of Tenochtitlán*. London: Thames and Hudson, 1988

—, *Teotihuacán: The City of the Gods*. New York: Rizzoli, 1990

MILLER, ARTHUR G., *The Mural Painting of Teotihuacán*. Washington, D.C.: Dumbarton Oaks, 1973

—, ed., *Highland–Lowland Interaction in Mesoamerica: Interdisciplinary Approaches*. Washington, D.C.: Dumbarton Oaks, 1983

MILLER, VIRGINIA, ed., *The Role of Gender in Precolumbian Art and Architecture*. Lanham: University Press of America, 1988

PASZTORY, ESTHER, *Aztec Art*. New York: Harry N. Abrams, 1983

PINA CHAN, ROMAN, ed. *The Olmec: Mother Culture of Mesoamerica*. New York: Rizzoli, 1989

ROBERTSON, DONALD, *Mexican Manuscript Painting of the Early Colonial Period: The Metropolitan Schools*. New Haven: Yale University Press, 1959

SCOTT, JOHN F., *The Danzantes of Monte Albán. Studies in Pre-Columbian Art and Archaeology*. No. 19. Washington, D.C.: Dumbarton Oaks, 1978

SCHEVILL, M.B., J.C. BERLO, and E. DWYER, eds., *Textile Tradition in Mesoamerica and the Andes*. New York: Garland Press, 1991

SHARER, ROBERT J., and DAVID GROVE, eds., *Regional Perspectives on the Olmec*. Cambridge and New York: Cambridge University Press, 1989

TOWNSEND, RICHARD, *The Aztecs*. London: Thames and Hudson, 1992

North America

BERLO, JANET C., "Portraits of Dispossession in Plains Indian and Inuit Graphic Arts," *The Art Journal* (Summer, 1990):133–41

BLOMBERG, NANCY J., *Navajo Textiles: The William Randolph Hearst Collection*. Tucson: University of Arizona Press, 1988

BRODY, J.J., *The Anasazi: Ancient People of the American Southwest*. New York: Rizzoli, 1990

—, *Anasazi and Pueblo Painting*. Albuquerque: University of New Mexico Press, 1991

BROSE, DAVID S., JAMES A. BROWN, and DAVID W. PENNEY, *Ancient Art of the American Woodland Indians*. New York: Harry N. Abrams, 1985

CARLSON, ROY L., ed., *Indian Art Traditions of the Northwest Coast*. Burnaby, B.C.: Archaeology Press, Simon Fraser University, 1976

COE, RALPH T., *Lost and Found Tradition: Native American Art, 1965–1985*. Seattle: University of Washington Press, 1986

COLTON, HAROLD S., *Hopi Kachina Dolls with a Key to their Identification*. Albuquerque: University of New Mexico Press, 1959

CONN, RICHARD, *A Persistent Vision: Art of the Reservation Days*. Seattle: University of Washington Press, 1987

CURTIS, EDWARD S., *The North American Indian*. Vol. 3 (reprint of 1908 edition) New York: Johnson, 1970

DOCKSTADER, FREDERICK J., *The Song of the Loom: New Traditions in Navajo Weaving*. New York: Hudson Hills Press and the Montclair Art Museum, 1987

DUFFEK, KAREN, *Bill Reid: Beyond the Essential Form*. Vancouver: University of British Columbia Press, 1986

FANE, DIANA, IRA JACKNIS, and L.M. BREEN, *Objects of Myth and Memory: American Indian Art at the Brooklyn Museum*. New York: The Brooklyn Museum, and Seattle: The University of Washington Press, 1991

FEDER, NORMAN, *American Indian Art*. New York: Harry N. Abrams, 1969

FEEST, CHRISTIAN F., *Native Arts of North America*. London: Thames and Hudson, 1992

FENTON, WILLIAM N., *Parker on the Iroquois*. Syracuse: Syracuse University Press, 1968

FURST, PETER T., and JILL L. FURST, *North American Indian Art*. New York: Rizzoli, 1982

GALLOWAY, PATRICIA, ed., *The Southeastern Ceremonial Complex: Artifacts and Analysis*.

Lincoln: University of Nebraska
Press, 1989

GIBSON, J. L., *Poverty Point: A Culture of the Lower Mississippi Valley.*
Anthropological Study no. 7. Baton Rouge: Louisiana Archaeological Survey of Antiquities Commission, 1983

GILLILAND, MARION S., *The Material Culture of Key Marco Florida.* Gainesville: University of Florida Press, 1975

HARRISON, JULIA, *The Spirit Sings: Artistic Tradition of Canada's First Peoples.* Alberta: The Glenbow Museum, and McClelland and Stewart, 1987

HAWTHORN, AUDREY, *Art of the Kwakiutl Indians and Other Northwest Coast Tribes.* Seattle: University of Washington Press, 1967

HOLM, BILL, *Northwest Coast Indian Art: An Analysis of Form.* Seattle: University of Washington Press, 1965

—, *Spirit and Ancestor: A Century of Northwest Coast Indian Art at the Burke Museum.* Seattle and London: University of Washington Press. 1974

—, *The Box of Daylight: Northwest Coast Indian Art.* With contributions by Peter L. Corey, Nancy Harris, Aldona Jonaitis, Alan R. Sawyer, and Robin K. Wright. Seattle: University of Washington Press, 1983

HUDSON, CHARLES, *The Southeastern Indians.* Knoxville: University of Tennessee Press, 1976

HULTKRANTZ, AKE, *The Religions of the American Indians.* Berkeley: University of California Press, 1979

—, *Prairie and Plains Indians. Iconography of Religions.* Vol. 10, no. 2. Institute of Religious Iconography, State University at Groningen. Leiden: E.J. Brill, 1973

JENSEN, DOREEN, and POLLY SARGENT, *Robes of Power: Totem Poles on Cloth.* Vancouver: University of British Columbia Press, 1986

JOHNSON, HARMER, *Guide to the Arts of the Americas.* New York: Rizzoli, 1992

JONAITIS, ALDONA, *From the Land of the Totem Poles: The Northwest Coast Indian Art Collection at the American Museum of Natural History.* Seattle: University of Washington Press, and New York: American Museum of Natural History, 1988

JONAITIS, ALDONA, ed., *Chiefly Feasts: The Enduring Kwakiutl Potlach.* Seattle: University of Washington Press, 1991

KENT, KATE PECK, *Navajo Weaving: Three Centuries of Change.* Sante Fe: School of American Research Press, 1985

KING, J.C.H., *Portrait Masks from the Northwest Coast of America.* London: Thames and Hudson, 1979

KLUCKHOHN, CLYDE, and DOROTHEA LEIGHTON, *The Navaho.* New York: The Natural History Library, 1962

LEKSON, STEPHEN H., *Great Pueblo Architecture of Chaco Canyon.* With contributions by William B. Gillespie and Thomas C. Windes. Albuquerque: University of New Mexico Press, 1986

MAURER, EVAN, ed., *Visions of the People: A Pictorial History of Plains Indian Life.* Seattle: University of Washington Press, 1992

MORGAN, WILLIAM N., *Prehistoric Architecture in the Eastern United States.* Cambridge: MIT Press, 1980

MORSE, DAN F., and PHYLLIS A. MORSE, *Archaeology of the Central Mississippi Valley.* New York: Academic Press, 1983

O'CONNOR, MALLORY MCCANE, *Children of the Sun: Ceremonial Art and Architecture of the Ancient Southeast.* Gainesville: University Presses of Florida, 1994

—, *Lost Cities of the Ancient Southeast.* Gainesville: University of Florida Press, 1995

PAREZO, NANCY J., *Navajo Sandpainting: From Religious Act to Commercial Art.*

Tucson: University of Arizona Press, 1983

PENNEY, DAVID, ed., *Art of the American Indian Frontier: The Chandler-Pohrt Collection.* Detroit: Detroit Institute of Arts, and Seattle: University of Washington Press, 1992

PHILLIPS, RUTH, *Trading Identities: Native American Tourist Arts from the Northeast, 1700–1900.* Seattle: University of Washington Press, 1994

RUSHING, W. JACKSON, *Native American Art and the New York Avant-garde: A History of Cultural Primitivisim.* Austin: University of Texas Press, 1995

RUSHING, W. JACKSON, and KAY WALKING STICK, eds., "Recent Native American Art." *The Art Journal.* Vol. 5, no. 3 (Fall, 1992): 6–27

SAMUEL, CHERYL, *The Raven's Tail.* Vancouver: University of British Columbia Press, 1987

SHADBOLT, DORIS, *Bill Reid.* Seattle: University of Washington Press, 1986

SNOW, DEAN, *The Archaeology of North America.* New York: Viking, 1976

SZABO, JOYCE M., *Howling Wolf and the History of Ledger Art.* Albuquerque: University of New Mexico Press, 1994

THOM, IAN M., ed., *Robert Davidson: Eagle of the Dawn.* Seattle: University of Washington Press, 1993

THOMAS, DAVID HURST, *Exploring Ancient Native America.* New York: Macmillan, 1994

TOWNSEND, RICHARD, *The Ancient Americas: Art from Sacred Landscapes.* Chicago: The Art Institute, 1992

WADE, EDWIN, ed., *The Arts of the North American Indian: Native Traditions in Evolution.* New York: Hudson Hills Press, 1986

WASHBURN, DOROTHY K., *Hopi Kachina: Spirit of Life.* San Francisco: California Academy of Sciences, 1980

CHAPTER EIGHT

BERLO, JANET C., *Native North American Art.* Oxford: Oxford University Press, 1998

COLE, HERBERT M., *Icons: Ideals and Power in the Art of Africa.* Washington, D.C., and London: National Museum of African Art and the Smithsonian Institution Press, 1989

D'ALLEVA, ANNE, *Art of the Pacific.* London: Weidenfeld and Nicolson, and New York: Harry N. Abrams, 1998

FERGUSON, RUSSELL, ed., *At the End of the*

Century: One Hundred Years of Architecture. Los Angeles: The Museum of Contemporary Art, and New York: Harry N. Abrams, 1998

GAO MINGLU, ed., *Inside Out: New Chinese Art.* Berkeley, Los Angeles, and London: University of California Press, 1998

LUTFY, CAROL, "Brush with the Past," *Art News* (September, 2000): 140–3

MUNROE, ALEXANDRA, *Japan After 1945: Scream Against the Sky.* New York: Harry N. Abrams, Inc., 1994

PERANI, JUDITH, and FRED T. SMITH, *The Visual Art of Africa: Gender, Power, and Life Cycle Rituals.* Upper Saddle River: Prentice Hall, 1998

RUSHING, W. JACKSON, and KAY WALKING STICK, eds., *Recent Native American Art,* *Art Journal,* vol. 5, no. 3 (Fall, 1992)

SILVERMAN, RAYMOND A., ed., *Ethiopia: Traditions of Creativity.* Seattle: University of Washington Press, 1999

SULLIVAN, MICHAEL, *Art and Artists of Twentieth-Century China.* Berkeley, Los Angeles, and London: University of California Press, 1996

AFTERWORD

FISHER, JEAN, "Yinka Shonibare: Camden Arts Centre, London," *Artforum International,* 39, no.1 (2000): 186

LEE, JAMES, "Yi Bul: The Aesthetics of Cultural Complicity and Subversion," *Asian Women Artists,* ed. Dinah Dysart and Hannah Fink. Roseville East: Craftsman House, 1996: 34–41

OBRIST, HANS ULRICH, and LEE BUL, "Cyborgs and Silicon: Korean Artist Lee Bul about her Work," *Art Orbit ,* no. 1 (March, 1998)

OGUIBE, OLU, "Finding a Place: Nigerian Artists in the Contemporary World," *Art Journal,* 58, no. 2 (Summer, 1999): 30–41

VERCOE, C., and R. LEONARD, "Pacific Sisters: Doing it for Themselves," *Art Asia Pacific,* 14 (1997): 42–5

VOLKART, YVONNE, "This Monstrosity, This Proliferation, Once Upon a Time called Woman, Butterfly, Asian Girl," *Make, The Magazine of Women's Art,* 89 (2000): 4–7

WAXMAN, LORI, "Yinka Shonibare," *New Art Examiner,* 28, no. 3 (2000): 36–7

PICTURE CREDITS

Calmann & King, the author and the picture researcher wish to thank the institutions and individuals who have kindly provided photographic material. Collections are given in the captions alongside the illustrations. Sources for illustrations not supplied by museums or collections, additional information and copyright credits are given below. Numbers are figure numbers unless otherwise indicated.

While every effort has been made to trace the present copyright holders we apologize in advance for any unintentional omission or error and will be pleased to insert the appropriate acknowledgement in any subsequent edition if informed.

Abbreviations
B.A.L. Bridgeman Art Library, London
B.M. British Museum, London
R.H.P.L. Robert Harding Picture Library, London
W.F.A. Werner Forman Archive, London

page 2, Dinodia, Bombay
pages 10, 12, 1.4 R.H.P.L.
1.1 Henry J Drewal. Henry J. & Margaret Thompson Drewal Collection. Eliot Elisofon Photographic Archives, National Museum of African Art, Smithsonian Institution, Washington D.C. # 1992-028-00639
1.2 Archaeological Museum,

Sarnath/A.K.G. London
1-3 John Fleming & Hugh Honour
1.5 Reinhard Derreth, Vancouver
1.6 © Kazuo Shiraga. Courtesy Ashiya City Museum of Art & History, Japan

pages 22, 24, 2–5, 2–7 Heini Schneebeli/W. And U. Horstmann/B.A.L.
2.1, 2.15 Eliot Elisofon. Eliot Elisofon Photographic Archives, National Museum of African Art, Smithsonian Institution, Washington D.C. # XII-R7.12; # 1 BNN 2.4.3 (7590)
2.2, 2.3 David Coulson/Robert Estall Photo Library, Sudbury, Suffolk
2.4 Private collection. Photo: Bernd-Peter Keiser, Braunschweig
2.6 British Library, London # Or. Ms. 516, f.100v-101r
2.8 Christie's Images/W.F.A.
2.9 Musée Barbier Mueller, Geneva. Photo: Roger Asselberghs # 1021-5
2.10 National Commission for Museums & Monuments Lagos, Nigeria
2.11 André Held, Lausanne/Museum of Ife Antiquities
2.12 John Pemberton III, Amherst, MA
2.16, 2.18 B.M. # 1897.10-11.1; # 18.31
2.17 Phyllis Galembo, New York
2.19 Herbert Cole, Santa Barbara
2.20 Marie Pauline Thorbecke.

Historisches Fotoarchiv, Rautenstrauch-Joest Museum für Völkerkunde, Cologne # 19336
2.21 Staatliche Museen zu Berlin -– Preussischer Kulturbesitz, Museum für Volkerkunde, Berlin # III C 33341 a,b
2.23 After K.A.C. Cresswell, Early Muslim Architecture
2.24 John Hatt/Hutchison Library, London
2.25 Dallas Museum of Arts/W.F.A.
2.26 Augusta Museum of History, Augusta, Georgia. Photo: Gordon Blaker
2.27 Museum of Fine Arts, Boston. Bequest of Maxim Karolik # 64.619
2.28 Art Resource, New York/National Museum of American Art, Smithsonian Institution, Washington D.C. # 1970.353.1

pages 58, 60, 3.36 Victoria and Albert Museum, London/ B.A.L.
3.2a Dagli Orti/National Museum, Karachi/Art Archive, London
3.5, 3.21 Scala, Florence
3.6, 3.20 Adam Woolfitt/ R.H.P.L.
3.7, 3.26, 3.28 Richard Ashworth/R.H.P.L.
3.8 Madhusadan B. Tawde/Dinodia, Bombay
3.9 Archaeological Survey of India, New Delhi
3.11 National Museums of Scotland, Edinburgh # L.446.13
3.12 Jean-Louis Nou/Museum

of Archaeology, Mathura/A.K.G. London
3.13 Dinodia, Bombay
3.14 I. Griffiths/R.H.P.L.
3.15 Private Collection/Rossi & Rossi, London
3.16, 3.29, 3.34 Gavin Hellier/ R.H.P.L.
3.17 David Holdsworth/ R.H.P.L.
3.18, 3.19, 3.24 R.H.P.L.
3.25 Museum Rietburg, Zürich. Von der Heydt Collection
3.30 Sassoon/R.H.P.L.
3.31 Julia Ruxton, London
3.32 J. H. C. Wilson/R.H.P.L.
3.33 Freer Gallery of Art, Smithsonian Institution, Washington D.C. # F42.15.a
3.35 Victor Kennet/R.H.P.L.
3.37 Sri Jayachamarajendra Gallery, Mysore/Dinodia, Bombay
3.38 Rabindra Bharati Society, Calcutta/Dinodia, Bombay

pages 106, 108, 4.25 Freer Gallery of Art, Smithsonian Institution, Washington, D.C./B.A.L.
4.1, 4.8, 4.12, 4.17, 4.31, 4.32 Cultural Relics Publishing House, Beijing
4.2 British Library, London/ W.F.A.
4.4 Seattle Art Museum. Gift of Mrs Donald E. Frederick
4.5, 4.33 Sen-Oku Hakuko Kan (Sumitomo Collection), Kyoto
4.6 Freer Gallery of Art, Smithsonian Institution, Washington D.C. # F1940-11-1
4.7 © Cleveland Museum of

Art 2001. Anonymous Gift # 1952.584

4.9 John Fleming & Hugh Honour

4.10 Victor Kennet/Hebei Provincial Museum/R.H.P.L.

4.11 Erich Lessing/National Museum, Beijing/A.K.G. London

4.13, 4.14, 4.18 B.M. # OA 1903.4-8.1 Chinese Paintings 1; # OA 1903.4-8.1; # 1919.1-1,46

4.15, 4.20, 4.24, 4.35 National Palace Museum, Taipei

4.19 Museum of Fine Arts, Boston. Denman Waldo Ross Collection

4.21 M.O.A. Museum, Atami

4.22 National Museum, Tokyo. Unei Kyoryokukai

4.23 Percival David Foundation of Chinese Art, London

4.26, 4.28, 4.29 Nelson-Atkins Museum, of Art Kansas City. Purchase: Nelson Trust. © 2000. Photo: E.G. Schempf. # 40-45/1,2; Purchase Nelson Trust © 1995 # 46-8; Acquired through the generosity of the Hall Family Foundations and exchange of other Trust Properties. © 1993. Photo: Robert Newcombe # 86-3/6

4.27 Victoria and Albert Museum, London

4.34 David Collection, Copenhagen. Photo: Ole Woldbye

4.36 Ohsha'joh Museum of Art, Hiroshima

4.37 National Palace Museum, Beijing

4.38 Keystone Collection/Hulton Getty Picture Collection Ltd, London

4.39 Michael Sullivan/Chinese National Art Gallery, Beijing

pages 158, 160, 5.23 National Museum, Tokyo/B.A.L.

5.1, 5.3, 5.7, 5.28 Japan Information & Cultural

Centre, London

5.2 National Museum, Tokyo/Art Archive, London

5.4 Aikiwa Art Museum/Art Archive, London

5.5 Kyongju National Museum/National Museum of Korea, Seoul

5.6 National Museum of Korea, Seoul

5.8 Horyu-ji Temple, Asuka-en, Nara/B.A.L.

5.9, 5.20 Paul Quayle, South Sheriton, Somerset

5.10 Myo-o-in, Koyasan, Wakayama Prefecture/Sakamoto Photo Research Laboratory

5.11 Art Resource, New York

5.12, 5.25 Sakamoto Photo Research Laboratory

5.13, 5.26 Freer Gallery of Art, Smithsonian Institution, Washington DC. # F69.4; # F1899.3y

5.14 Tokugawa Art Museum, Nagoya

5.15 Museum of Fine Arts, Boston. Fenollosa-Weld Collection # 11.4000

5.16 Meigetsu-in, Kamakura. Photo: Institute for Art Research, Tokyo

5.18 Brooklyn Museum, Gift of Mrs Darwin R. James III # 56.138.1 a&b

5.19 National Museum, Tokyo. Unei Kyoryokukai

5.21 W.F.A.

5.22 Courtesy of the Agency for Cultural Affairs, Tokyo

5.24 H. H. de Young Memorial Museum, San Francisco/W.F.A.

5.27 Kyoto National Museum. Photo: Shimizu Kogeisha

5.30 © Cleveland Museum of Art 2001. Bequest of James Parke # 1940.1031

5.31 Christie's Images, London/B.A.L.

5.32 Fitzwilliam Museum, University of Cambridge/B.A.L.

5.33 Van Gogh Museum,

Amsterdam. Vincent van Gogh Foundation # S114V/1962

5.34 Eileen Tweedy/Victoria & Albert Museum, London/Art Archive, London

5.35 Ishibashi Museum of Art, Ishibashi Foundation, Kurume, Fukuoka prefecture. Photo: Tomokazu Yamaguchi

5.36 Arcaid/Bill Tingey

5.37 Teshigahara (courtesy Kobal)

5.38 Stedelijk Museum, Amsterdam

5.39 Museum of Art, Kochi. Photo courtesy of the Council for the International Biennale in Nagoya. © Yanagi Yukinori

pages 208, 210, 6.15 Auckland Museum/David Bateman Ltd, Auckland/Photo: Krzysztof Pfeiffer

6.1 Museums Victoria, Melbourne, Australia

6.2 © Malangi. Courtesy of South Australian Museum, Adelaide

6.4 National Gallery of Australia, Canberra/W.F.A.

6.5, 6.7 Museum der Kulturen, Basel. Photo: Peter Horner

6.6, 6.17 Metropolitan Museum of Art, New York. Michael C. Rockefeller Memorial Collection of Primitive Art, Gift of Nelson A. Rockefeller and Mrs Mary Rockefeller, 1965 # 1978.412.1248, 1249 & 1250; Bequest of Sam A. Lewisohn 1951. Photo © 1983 the Metropolitan Museum of Art # 51.112.2

6.8, 6.9 From Prehistoric Architecture in Micronesia by William N. Morgan. copyright © 1988. By permission of the author and the University of Texas Press, Austin

6.10 © Adrienne L. Kaeppler,

Washington D.C. 1992

6.11 Courtesy of Donald Rubinstein. Peabody Essex Museum, Salem. On loan from Donald Rubinstein, Guam

6.12 John Freeman/Fotomas Index

6.13 Dagli Orti/Musée des Arts Décoratifs, Paris/Art Archive, London

6.14 Karen Stevenson, Christchurch

6.16, 6.18 B.M. # 1839.4-26,8; # HAW 133

6.19 Joyce D. Hammond

6.20 G. Burrenhult/R.H.P.L.

6.21 Art Archive, London

6.22, 6.23 National Museum of New Zealand, Wellington/W.F.A.

pages 240, 242, 7.29 Bodleian Library, Oxford # MS Arch. Seldon.A.1, f.2r

7.1 By permission of Harcourt Brace Inc. Orlando, Florida

7.2, 7.4 Museum of Fine Arts, Boston. William A. Paine Fund # 31.501; Charles Potter Kling Fund # 1978.46

7.3 Kimball Morrison/South American Pictures, Woodbridge, Suffolk

7.5 Museo Arqueologico Rafael Larco Herrera, Lima

7.6 Private collection. Courtesy Donna McClelland & Christoper Donnan 1979

7.8 N.G.S. Image Collection/Ned Seidler

7.9 Michael Kampen O'Riley

7.10 Tony Morrison/South American Pictures, Woodbridge, Suffolk

7.11 Robert Frerck/Museo de Etnografico y Arqueologico, Jalapa, Mexico/R.H.P.L.

7.13 American Museum of Natural History, New York

7.14, 7.24, 7.25 Robert Frerck/R.H.P.L.

7.15 Museum der Kulturen, Basel/W.F.A.

7.16 © Merle Greene Robertson

7.17 University of Pennsylvania Museum Photographic Archives

7.18 Justin Kerr/Kerr Associates, New York/The Art Museum, Princeton University, New Jersey

7.19 Justin Kerr/Kerr Associates, New York/ Copán Museum of Mayan Sculpture

7.20 © Merle Green Robertson 1976. Courtesy Peabody Museum, Harvard University

7.21 Art Archive, London

7.22 © Esther Pasztory 1972

7.26 R.H.P.L.

7.27 B.M.

7.28 B.A.L.

7.30 G. Tortoli/Museo Nacional de Antropologia, Mexico City/Ancient Art & Architecture, Pinner, Middx

7.31 Palacio Nacional, Mexico City. © Fidelcomiso Banco de Mexico/B.A.L.

7.32 Art Resource, New York/Schalkwijk/Museo Nacional de Arte Moderno, Instituto de Bellas Artes, Mexico

7.33, 7.34 Ohio Historical Society, Columbus

7.35 Drawing after Calvin Jones, Courtesy of the Florida Division of Historical Resources, Tallahassee. Courtesy of Robert S Peabody Foundation for Archaeology, Phillips Academy, Andover, Mass.

7.36 Royal Ontario Museum, Toronto, Ontario

7.38 Courtesy Alaska State Historical Library, Juneau. Winter and Pond photo, 1888 # PCA 87-10

7.39 National Museum of the American Indian, New York. Photo: Carmelo Guadagno

7.40 Courtesy of Santa Barbara Studios and Pathways Productions, Santa Barbara, C.A.

7.41 Museum of New Mexico, Santa Fé

7.42 Underwood and Underwood/Corbis

7.43 Henry Peabody/Corbis

7.44 Ted SpiegelCorbis

7.45 Natural History Museum of Los Angeles County.The William Randolph Hearst Collection # A.5141.42-151

7.46 The Thomas Gilcrease Institute of American History and Art, Tulsa, Oklahoma # 4576.91.47 plate 13

7.47 Missouri Historical Society, St. Louis # 1882.18.31

7.48, 7.49 Peter T. Furst/ American Museum of Natural History, New York.

Dept of Anthropology, Smithsonian Institution, Washington, D.C.

7.50 © Edgar Heap-of-Birds

pages 302, 304, 8.2 Axiom Photographic Agency, London/M. Winch

8.1 American Museum of Natural History, New York. Photo: J. Beckett

8.3 © Wenda Gu/Collection of Hong Kong Museum of Art, Hong Kong

8.4 Karen Stevenson, Christchurch

8.5 © Lee Bul. Photo. Courtesy Lee Bul and Kukje Gallery, Seoul. Photo: Rhee Jae-yong

8.6 Courtesy of the artist and Stephen Friedman Gallery, London. Collection of Susan & Lewis Manilow, Chicago. Photo: Stephen White

INDEX